RUSSIAN

LITHUANIA

Kaunas (Kovno)
Požajlis
(Požaście)
Vilniu
Vilna

BELO-
RUSSI

Kali

Białystok

in (Stettin)

Toruń

R. Wisła

Włocławek

R. Bug

Węgrow

WARSAW
Wilanów

Gniezno

Poznań (Posen)

Ląd

Radzyń
Podláski

P O L A N D

Grodzisk

Gostyń

R. Oder

Ujazdów

Głogów (Glogau)

Brzeżany

Kazimierz

Lublin

Zagań
(Sagan)

Piotrowice Wielkie
(Gross-Peterwitz)

Lubląz (Leubus)

Zamość

Legnickle Pole
(Wahlstadt)

Legnica
(Liegnitz)

(Wrocław) Breslau

Kielce

Sandomierz

Herrnhut

Jawor (Jauer)

Lubomierz (Liebenthal)

Brzeg (Brieg)

Pinczów

Baranów

Jelenia Gorá
(Ilirschberg)

Krzeszów (Grüssau)

Świdnica (Schweidnitz)

Henryków (Heinrichau)

Łancut

itz

Kuks
(Kukus)

Kraków

Žolkwa (Žolki

Smiřlce
(Smirschite)

Pietrowice Wielkie
(Gross-Peterwitz)

Bielany

Wiśnicz

ice (Liblitz)

Opava (Troppau)

L'viv
(Lvov, Lwów)

UE

Sedlec (Sedlertz)

C

H

R E P.

Olomouc (Olmütz)

Žd'ár nad
Sázavou (Saar)

Plumlov (Plumenau)

Křtiny (Kiritein)

S L O V A K I A

UKRAINI

Brno (Brünn)

Slavkov (Austerlitz)

Košice (Kassa, Kaschau)

Rajhrad (Raigern)

Jasov (Jászó)

Louka (Klosterbruck)

Geras

Dyje (Mühlfraun)

Hradiště (Pöltenberg)

nburg

Dreieichen

Göllersdorf

Trnava (Nagyszombat, Tyrnau)

R. Tisza

Stein

Krems

Klosterneuburg

Schlösshof

arnstein

Gottweig

Schönbrunn

VIENNA

Bratislava (Pozsony Pressburg)

Eger
(Erlau)

elk

Heiligenkreuz

Schwechat

Esztergom

Gutenbrunn

Eisenstadt (Kismarton)

(Gran)

R

Halbthurn
(Féltorony)

R. Danube

Y

Győr
(Raab)

BUDAPEST

Fertöd

Vorau

Köseg

Pápa

G

Veszprém

A

Weisberg

Sümeg

R. Danube

Graz

H U N

orcia)

RUMANIA

COURT, CLOISTER, AND CITY

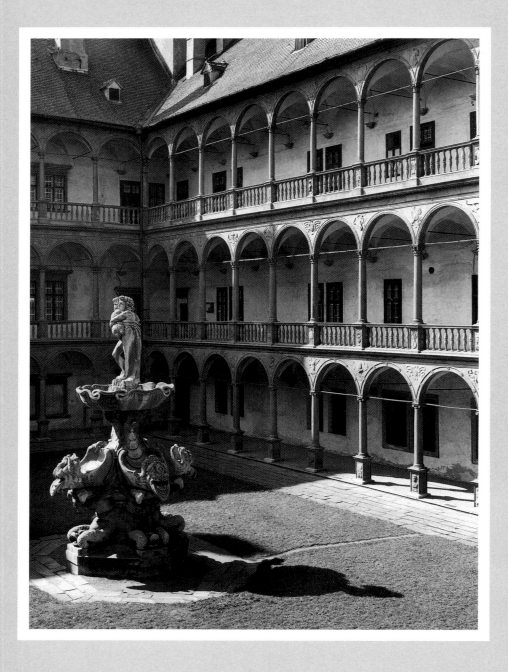

COURT, CLOISTER, AND CITY

THE ART AND CULTURE OF CENTRAL EUROPE 1450–1800

THOMAS DACOSTA KAUFMANN

THE UNIVERSITY OF CHICAGO PRESS

To the Memory of my Father

Thomas DaCosta Kaufmann is a professor in the art and archaeology department at Princeton University. He is author of *The School of Prague: Painting at the Court of Rudolf II* (University of Chicago Press), winner of the Mitchell Prize for art history.

The University of Chicago Press, Chicago 60637
George Weidenfeld & Nicolson Ltd., The Orion Publishing Group, London, WC2H 9EA
© Thomas DaCosta Kaufmann 1995
All rights reserved. Published 1995
Printed in Italy
04 03 02 01 00 99 98 97 96 95 1 2 3 4 5
ISBN: 0-226-42729-3 (cloth); 0-226-42730-7 (paper)

Library of Congress Cataloging-in-Publication Data

Kaufmann, Thomas DaCosta
Court, cloister, and city: the art and culture of Central Europe, 1450-1800/Thomas DaCosta Kaufmann.
p. cm.
Includes bibliographical references and index.
1. Art—Central Europe. 2. Architecture—Central Europe. 3. Central Europe—Civilization. I. Title.
N6754.K38 1995
709'.43'0903—dc20 95-10237
 CIP

Publication of this book has been supported by a grant for illustrations from the Publications Committee of the Department of Art and Archaeology, Princeton University, here gratefully acknowledged.

Edited by Colin Grant
Pictures researched by Joanne King
Maps by ML Design

This book is printed on acid-free paper

Prelim captions:

Half-title: Jindřichův Hradec, rotunda, 1591-1600, by Giovanni Facconi and Antonio Cometa, after plans by Baldassare Maggi. Seen here: relief from interior by G.P. Martinola and G. Bendel

Frontispiece: Courtyard of Bučovice Castle, *c.* 1567-81, perhaps by Pietro Ferrabosco

Contents

ACKNOWLEDGEMENTS

OVER THE YEARS MANY FRIENDS AND COLLEAGUES, INCLUDING MANY FROM THE REGION HERE TREATED, HAVE DISCUSSED WITH ME QUESTIONS OF INTERPRETATION, OR OBJECTS, THAT ARE MENTIONED IN THIS BOOK. I would especially like to recall with gratitude talks in various times and places, and trips that I have taken, with Daniel Rowland, Steven Mansbach, Slobodan Ćurčić, W. G. Rizzi, Gyöngy Török, Miklos Mojzer, Ivan Muchka, Pavel Preiss, Jiří Kroupa, Josef Válka, Ivan Rusina, Jan Bakos, Stanisław Mossakowski, Konstanty Kalinowski, Jacek Tylicki, Piotr Paszkiewicz, Jan Ostrowski, Jacek Purchla, Richard Harprath, Thomas and Barbara Gaehtgens, Hellmut Lorenz, Eberhard König, Karl and Werner Schade, Michael Zimmermann, Sergei Androssov and the late Dimitri Shelest. I would also like to thank all others, too numerous to mention, who have made works of art, monuments, collections, archives and libraries accessible to me.

In addition to my own more specialized researches, for more than fifteen years I have given lectures related to materials in this book to classes at Princeton University. I wish to thank those students who have patiently attended lectures and seminars and made their own contributions to the shaping of what has taken form in this book. Steven Eisenman, Lisa Faber, Holly Getch, Dorothy Limouze and Madeleine Viljoen, in particular, made critiques or suggestions that helped shape or refine my arguments.

I am grateful to colleagues at Princeton, especially Anthony Grafton and John Pinto, who have read parts of the text and made suggestions for its improvement. Jeffrey Chipps Smith of the University of Texas has also provided a most helpful critique of the earlier sections of this text. As always I have discussed various arguments in this book at many times with Virginia Roehrig Kaufmann.

The renewal of a fellowship from the Alexander von Humboldt Stiftung enabled me to do research and travel in Germany and points south and east during the academic year 1989–90. I thank the foundation and my hosts at the Freie Universität, Berlin, and elsewhere in Central and Eastern Europe.

Although I have been studying the arts and culture of the region discussed here for more than twenty years, I would not yet have undertaken to write an

essay such as this, had I not been encouraged by Lord Weidenfeld to do so. I thank him for giving me the opportunity, and I hope that the work that has resulted will make a contribution to understanding that proves worthy of his confidence.

Princeton, New Jersey,
December 1992

Revisions to this manuscript were undertaken at the Herzog August Bibliothek, Wolfenbüttel, for whose support I am grateful, as well as for that from the John Simon Guggenheim Foundation that allowed me to spend time there. A reader's report by Hellmut Lorenz helped stimulate some corrections and additions. I wish to thank Colin Grant and Joanne King for editorial assistance.

Wolfenbüttel,
July 1994

I would like to thank Richard Atkinson for assistance in the final stages of preparation of this book.

While delays in its publication have not I hope affected either its timeliness or its lasting use, in one regard they do occasion a further remark on topography. I have tried to give both current place names, as well as alternatives, some of them of a historical significance, in parentheses. Things have been changing so fast, however, that I have not always been able to keep up with all the changes in nomenclature, especially in the countries of the former Soviet Union, most noticeable in Ukraine, where for the western regions I have used the historical, Polish names first, and at times alone (e.g. Żółkiew and Lwów) – but then again, neither have knowledgeable Ukrainian colleagues.

Princeton, New Jersey,
May 1995

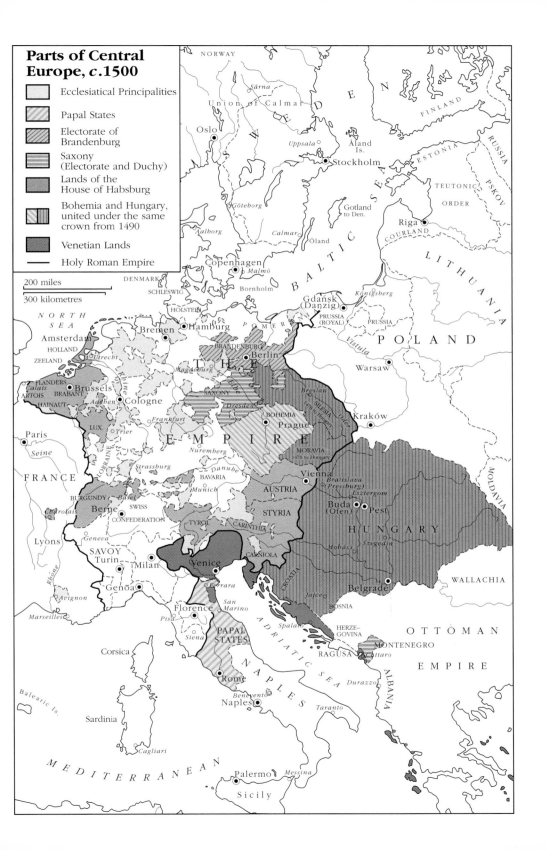

Parts of Central Europe, c.1500

- Ecclesiatical Principalities
- Papal States
- Electorate of Brandenburg
- Saxony (Electorate and Duchy)
- Lands of the House of Habsburg
- Bohemia and Hungary, united under the same crown from 1490
- Venetian Lands
- Holy Roman Empire

200 miles
300 kilometres

NORWAY

Särna

Union of Calmar

Oslo

Uppsala

Åland Is.

Stockholm

FINLAND

RUSSIA

ESTONIA

PSKOV

TEUTONIC

ORDER

Göteborg

Gotland to Den.

Riga

COURLAND

LITHUANIA

BALTIC SEA

Aalborg

Calmar

Öland

Copenhagen

Malmö

Bornholm

Gotland to Den.

DENMARK

SCHLESWIG

HOLSTEIN

POMERA

Gdansk
Danzig

Königsberg

PRUSSIA (ROYAL)

PRUSSIA

POLAND

NORTH SEA

Bremen

Hamburg

Vistula

Warsaw

Amsterdam

HOLLAND

ZEELAND

Utrecht

Rhine

BRANDENBURG

Berlin

THE

Magdeburg

FLANDERS

Calais

ARTOIS

Brussels

BRABANT

Aachen

Cologne

HAINAUT

Frankfurt

SAXONY

Dresden

Breslau

SILESIA
1478 to Hungary

Oder

Kraków

LUX.

Trier

BOHEMIA

Prague

Paris

Seine

EMPIRE

Nuremberg

MORAVIA
1478 to Hungary

LORRAINE

Strassburg

Danube

BAVARIA

Vienna

Bratislava
(Pressburg)

Esztergom

MOLDAVIA

FRANCE

Munich

AUSTRIA

Buda
(Ofen)

Pest

BURGUNDY

Basel

Berne

SWISS

CONFEDERATION

Geneva

STYRIA

HUNGARY

Charolais

TYROL

CARINTHIA

Szegedin

Mohács

Lyons

SAVOY

Turin

Milan

CARNIOLA

Venice

Rhone

Genoa

Ferrara

CROATIA

Jajce

Belgrade

WALLACHIA

Avignon

Florence

San Marino

BOSNIA

OTTOMAN

Marseilles

Pisa

Siena

PAPAL STATES

Spalato

HERZE–GOVINA

RAGUSA

Cattaro

MONTENEGRO

EMPIRE

Corsica

ADRIATIC SEA

Durazzo

ALBANIA

Balearic Is.

NAPLES

Rome

Benevento

Taranto

Sardinia

Naples

MEDITERRANEAN

Cagliari

Palermo

Messina

Sicily

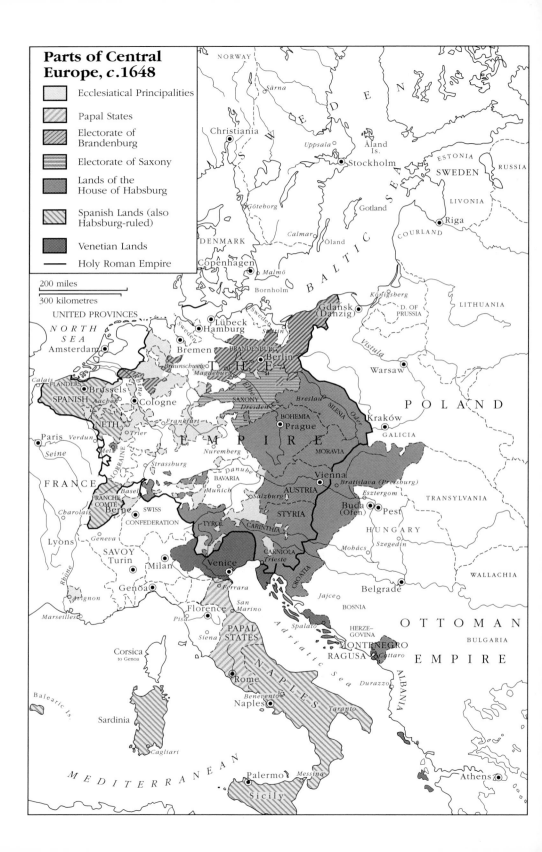

Parts of Central Europe, c.1648

- Ecclesiatical Principalities
- Papal States
- Electorate of Brandenburg
- Electorate of Saxony
- Lands of the House of Habsburg
- Spanish Lands (also Habsburg-ruled)
- Venetian Lands
- —— Holy Roman Empire

200 miles
300 kilometres

NORWAY
Christiania
Sărna
S W E D E N
Uppsala
Åland Is.
Stockholm
ESTONIA
RUSSIA
SWEDEN
Göteborg
Gotland
LIVONIA
Riga
Calmar
Öland
COURLAND
DENMARK
Königsberg
D. OF PRUSSIA
LITHUANIA
Copenhagen
Malmö
Bornholm
BALTIC SEA
Gdańsk (Danzig)
UNITED PROVINCES
Lübeck
Sweden
Hamburg
Stettin
Vistula
Warsaw
NORTH SEA
Amsterdam
Bremen
BRANDENBURG
Berlin
P O L A N D
Calais
FLANDERS
Braunschweig
Magdeburg
Elbe
Breslau
SILESIA
Kraków
SPANISH
Brussels
Aachen
Cologne
Rhine
SAXONY
Dresden
Oder
GALICIA
NETH.
Trier
Frankfurt
BOHEMIA
Prague
Paris
Verdun
E M P I R E
Nuremberg
MORAVIA
Seine
Metz
LORRAINE
Strassburg
Danube
Vienna
Bratislava (Pressburg)
TRANSYLVANIA
FRANCE
Basel
BAVARIA
Esztergom
FRANCHE COMTE
Berne
SWISS
Munich
Salzburg
AUSTRIA
Buda (Ofen)
Pest
Charolais
CONFEDERATION
TYROL
CARINTHIA
STYRIA
H U N G A R Y
Lyons
Geneva
CARNIOLA
Mohács
Szegedin
SAVOY
Turin
Milan
Venice
Trieste
CROATIA
Belgrade
WALLACHIA
Rhône
Genoa
Ferrara
Jajce
BOSNIA
Avignon
Florence
San Marino
Spalato
HERZE-GOVINA
O T T O M A N
Marseilles
Pisa
Siena
PAPAL STATES
Adriatic Sea
MONTENEGRO
RAGUSA
Cattaro
BULGARIA
Corsica to Genoa
N A P L E S
Durazzo
E M P I R E
Balearic Is.
Rome
Benevento
Naples
Taranto
ALBANIA
Sardinia
Cagliari
Palermo
Messina
Athens
M E D I T E R R A N E A N
Sicily

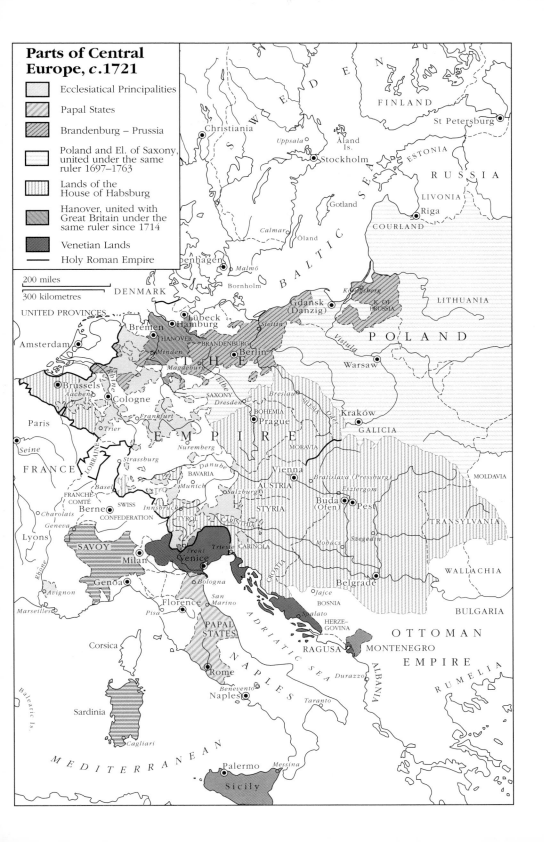

Parts of Central Europe, c.1721

- Ecclesiatical Principalities
- Papal States
- Brandenburg – Prussia
- Poland and El. of Saxony, united under the same ruler 1697–1763
- Lands of the House of Habsburg
- Hanover, united with Great Britain under the same ruler since 1714
- Venetian Lands
- Holy Roman Empire

200 miles
300 kilometres

SWEDEN

FINLAND

Christiania

Uppsala

Åland Is.

St Petersburg

Stockholm

ESTONIA

RUSSIA

LIVONIA

Gotland

Riga

BALTIC SEA

Calmar

Öland

COURLAND

LITHUANIA

Copenhagen

Malmö

Bornholm

DENMARK

UNITED PROVINCES

Gdansk (Danzig)

Königsberg

K. OF PRUSSIA

POLAND

Lübeck

Hamburg

Stettin

Bremen

HANOVER

BRANDENBURG

Vistula

Amsterdam

NETHER

Minden

Berlin

Warsaw

Magdeburg

Elbe

Brussels

Aachen

Cologne

Rhine

SAXONY

Dresden

Breslau

SILESIA

Kraków

Oder

Paris

Frankfurt

Trier

EMPIRE

Nuremberg

BOHEMIA

Prague

GALICIA

Seine

MORAVIA

FRANCE

LORRAINE

Strassburg

Danube

Vienna

Bratislava (Pressburg)

MOLDAVIA

Basel

BAVARIA

Munich

Salzburg

AUSTRIA

Esztergom

FRANCHE-COMTÉ

Innsbruck

TYROL

STYRIA

Buda (Ofen)

Pest

TRANSYLVANIA

Charolais

Berne

SWISS CONFEDERATION

CARINTHIA

Szegedin

Geneva

CARNIOLA

Mohács

Lyons

SAVOY

Trent

Trieste

CROATIA

Belgrade

WALLACHIA

Milan

Venice

Rhône

Genoa

Bologna

Jajce

BOSNIA

Arignon

San Marino

Jajce

Marseilles

Florence

Pisa

Spalato

HERZE-GOVINA

OTTOMAN

BULGARIA

Corsica

PAPAL STATES

ADRIATIC SEA

RAGUSA

MONTENEGRO

EMPIRE

Balearic Is.

Rome

NAPLES

Durazzo

ALBANIA

RUMELIA

Benevento

Naples

Taranto

Sardinia

Cagliari

MEDITERRANEAN

Palermo

Messina

Sicily

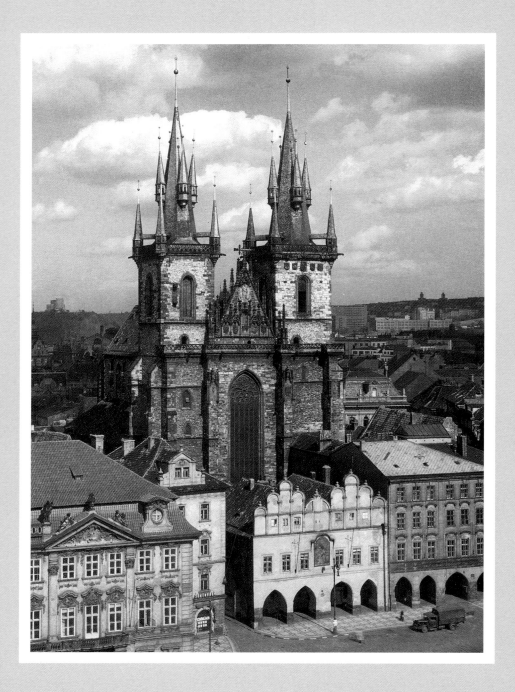

INTRODUCTION

Týn (Tein) Church, Prague,
14th century, with Týn (Tein)
School, after 1562

IN AN ESSAY WRITTEN IN THE 1950S J. H. HEXTER WEIGHED THE QUESTION OF THE HISTORIAN'S RELATIONSHIP TO HIS DAY. While Hexter tried to give a balanced presentation of the problem of the relevance of contemporary concerns to the scholar's consideration of the past, he used an ironic, tongue-in-cheek mode to describe how he himself spent an average day. He talked of mundane pursuits like reading the newspaper, following scholarly debates and perusing literature far removed from the events of his own time. One wonders, however, if Hexter would have written the same description at the end of the decade in which his paper was actually published (it first appeared in print in 1961). At that time he was teaching at Yale University in New Haven, Connecticut, where, as at many other American and Western European institutions of learning, the apparent tranquillity of the academic community was shattered by demonstrations, strikes and sit-ins provoked by discontent and unrest that were forms of response to political and social issues, both national and international.[1]

For a historian living in Berlin in 1989 and 1990, when this book was begun (and consequently delayed), an average day also did not seem so quiet. As East Germans began to pour through the Wall, even the simple details of life Hexter would have taken for granted became complicated. The purchase of a newspaper, bread or other necessities became time-consuming tasks, as long delays could be expected in the shops. Once-sleepy streets and stores became crowded by sightseers and consumers from the east, not just by East

Berliners, who had come to enjoy their freedom of travel and purchase or simply to see a bit of the West for the first time, but also by Czechs, Slovaks, Poles and Romanians. Suddenly the city filled up: public facilities, including libraries, became overcrowded, entailing greater delays in getting to do research than even queues at shops did. The work of some historians living in Berlin at this time who turned away from their usual concerns to write on contemporary events suggests that the fascination of the moment made it difficult to concentrate solely on the past.[2]

The arrival of new visitors from the east in West Berlin was but one sign of the coming of what previously might have seemed incredible: the train of political transformations beginning with the *annus mirabilis* of 1989–90, for which the penetration and destruction of the Berlin Wall is perhaps the most potent symbol. Soon the regimes which had held power for over four decades from the Elbe eastwards all dissolved. Freely elected governments came into office. Market economies were initiated. A chain of events was set in motion that spelled the demise of the great power that had controlled events in the region, the Soviet Union.

The centuries-old monuments and artefacts of Central Europe with which the present book is concerned were obviously not produced in these circumstances. Still, the way in which we see or understand them must also in some way have changed in response to recent events. Although the works themselves were made long ago, the attitude with which we look back at them must in some way have been affected by the momentous changes which have occurred in Central and Eastern Europe during the past few years and which were hardly imaginable when this book was begun. While the physical residue of monuments from the Central European past has not yet been vastly altered since 1989, the situation in which the art and history of the region are to be interpreted has become vastly different, and so will be the conditions in which this book will be received by its readers.

The tremendous transformation of over half of Europe has shifted emphases in the interpretation of history. For instance, the philosophy of dialectical materialism which provided the official ideology for much of the region would earlier have commanded much attention. This approach was supposed to supply the grounding for studies in all disciplines in the area from the German Democratic Republic to the Soviet Union. This line is obviously not being pressed any longer by most people in Central and Eastern Europe. And seen more broadly in the light of the popular demonstrations (proletarian revolutions?) which led to the overthrow of governments in the east, explanations based on Marxist-Leninism seem anyway more questionable than ever.[3]

Instead, national, ethnic and also religious antagonisms, that had been suppressed by Communism, have returned with a vengeance. Internecine conflicts have raged in the Balkans where new countries have emerged; Czechoslovakia has split up; several new states, among them those in the Baltic region, have again become independent; other new states have appeared on the

map in the place where once the Soviet Union was to be found, and ethnic and national conflicts among them abound. As new nations and ethnic groups press artefacts into the service of their cultural ideology, nationalist and ethnocentric claims, always a shibboleth for the historiography of the region, have again been heard.[4] As in the past, works of art are claimed for groups with which they may often have at best a tenuous association.[5] As in the past, unfortunately also cultural monuments, most notably in the area that once was Yugoslavia, have become targets for those who would seek to destroy the remnants of others' heritages, and thus symbolically to eradicate them as well.

These are but some pieces of evidence that demonstrate that the way monuments are treated is often associated with other assumptions, aims and purposes. The twentieth century has made all too clear the place of monuments in the ideological (and actual) battleground of modern history. During the Second World War Nazi occupiers under the supervision of prominent art historians destroyed the Warsaw castle; later most of the rest of the old city centre was systematically demolished. After the war the (then Communist) government authorities of Poland piously reconstructed these and other damaged cities.[6] In contrast the post-war East German authorities had the royal palaces in the cities of Berlin and Potsdam razed, because they were considered symbols of monarchy. This destruction contrasts with the way that the royal castle in Budapest was rebuilt as a symbol of the Hungarian nation. In 1989 and 1990 the iconoclastic attacks on monuments that had been erected by Communist regimes provide one of the most memorable images of the transformation of the region.[7] And, as has already been remarked, the tragedy of Yugoslavia has presented another fate for the cities or monuments of one's enemy.

Recognizing therefore that the treatment of cultural monuments may be affected by the position of the historian who aims to resituate them in their own historical context, the present book can in part be regarded as a response to the transformation of Europe. This essay represents an effort to consider Central Europe as a cultural entity, an attempt to contribute to its reintegration into a unified notion of European culture. In opposition to current tendencies, which lead towards internal fragmentation, and the xenophobic chauvinisms, if not outright racism, that accompanies them, other recent trends still exist that are informed by a more cosmopolitan outlook, that involve among other things an increasing unification of Europe; the reunification of Germany, with its ensuing problems, most dramatically demonstrates both tendencies. Despite some setbacks, efforts to merge the markets and as many other common interests as possible in the Western European countries have been proceeding. A new European federalism, as yet indefinite in its final aspect, is in the air. Despite their internal problems, the countries of the former Warsaw Pact are attempting to establish relationships with the European Union, NATO and other organizations that were previously exclusive to Western Europe.

In parallel with those efforts that aim at reintegration, this book will accordingly seek not only to present an overview of monuments from the region of Central Europe as a whole in the early modern era, between the late fifteenth century and the early nineteenth, but to place them in a broader European context. The division of Europe into two blocks, which until quite recently appeared to be a lasting, seemingly unalterable, state of affairs, now looks as if it was only a passing phenomenon in the longer history of Europe. In retrospect, the always unjustifiable notion that Eastern Europe was somehow distinct from the real Europe of the western Atlantic alliance, can be seen for what it was, an unstudied ignorance or neglect of much of the continent. On the 'map of forgetting' which was charted after 1945 'Central Europe' may have disappeared, but the countries, their peoples, cultures and histories clearly did not cease to exist. Two-thirds of the continent extends to the east; one of the areas of some of the greatest change in the present world also contains much of Europe's population as well as significant cultural achievements. To turn to the focus of this book, Central Europe: certainly no historian or lover of music could forget Bach, Mozart, Dvořák and Chopin, or lover of literature Goethe or Schiller.[8] European culture does not stop at the Alps and the Rhine or Elbe, and much of a quality and interest comparable to that of Western Europe was produced beyond.

QUESTIONS OF DEFINITION

The recent political transformation of Europe raises again the question of what sorts of definitions make sense for considerations of European society, culture and history – in particular, what Central Europe might be. This question has been discussed with renewed urgency as states have been freed from Soviet domination, new ones come into existence and the coherence of larger entities is questioned. In choosing to emphasize the concept of Central Europe in this book, I am expressing my belief not only that it makes sense to treat this area as a whole but also that the concept of East Europe, as it was utilized until recently, is and will in future historiography be regarded largely as a construct of the second half of the twentieth century. As a result of what is now revealed as the temporary division of Europe into two camps, East Europe was the part considered to fall under the Soviet sphere of influence.

Long before the opening of the Berlin Wall, this definition was already regarded as unsatisfactory; it does not fit the earlier history of the region in any adequate way. Many scholars and writers, especially from Poland, (the former) Czechoslovakia and Hungary reconsidered the conceptualization of Central Europe. Among them such distinguished figures as Czeslaw Milosz, Milan Kundera, Václav Havel and Georg Konrad harked back to 'Central Europe' in an effort to preserve an older geographical and cultural-political distinction.[9]

Yet in writings by several such authors, and by some historians as well, 'Central Europe' often became 'East Central Europe', the area of Europe east of the Oder, without the Soviet Union. To put it another way, this concept

basically included the lands of the Warsaw Pact without its largest member (the Soviet Union), and significantly without East Germany (not to mention that it also excluded Austria, whose capital, Vienna, actually lies considerably to the east of Prague). This definition, although still a topic of debate, also seems to be a product of the post-Second World War era.[10]

For others 'Central Europe' has suggested the lands of one of the empires that comprised the region before 1918 – the dual monarchy of Austria-Hungary. This includes the modern countries of Hungary, Austria, the Czech and Slovak republics, Slovenia, Bosnia-Herzegovina, Croatia and parts of Poland, Ukraine and Moldavia, and Romania. But this idea of Central Europe also adheres to a distinction that was determined relatively recently, really after 1866. That Germany should be sundered off from the rest of the region only became apparent after the war of that year: the battlefield effectively determined that the Austrian empire was not to be connected with Germany, but this division has no firmer foundation than the force of arms. Before the war of 1866 there was of course an intense debate about whether Germany should include the Austrian lands (the *Großdeutschland* position) or be limited to an area in effect comprised by the eventual German Empire (the *kleindeutschen* view).

As well as responses to the *kleindeutschen* argument, there is little doubt that some writers' exclusion of Germany from a broader notion of Central Europe may have been provoked by German writings which expressed a hegemonic attitude to the area in general. More restrictive, nationalistic definitions of the region may stem from reactions to ideas such as those of Friedrich Naumann, who coined an important definition of *Mitteleuropa* in a publication that was published during the course of the 1914–18 war.[11] Naumann's *Mitteleuropa* corresponded to the lands of the Central Powers of that conflict, a 'brotherhood in arms' that reconstituted an enlarged *großdeutschen* sphere. Although he himself was not expressly a nationalist, his arguments were derived from a German point of view: since many of the independent nations of the region came into existence (or re-emerged, like Poland) as a consequence of the settlement of that conflict, a view of the region in which Germany exerted cultural hegemony would obviously not be palatable.

Similar responses have been provoked by violent Germanic nationalist and Nazi propaganda, and their parallells in 'scholarly' writing, that claimed the regions to the east of Germany as *Lebensraum*. These theses treated the region either as an area in which the only culture was Germanic, or as one in which Germans had been major bearers of culture (*Kulturträger*).[12] Responses which exclude the notion of a German presence from the definition of Central Europe, and assert other local, specifically Slavic or Magyar qualities for the art and culture of the region are understandable, if not more justifiable, reactions.[13]

As the resurgence of xenophobia and nativism in the 1990s shows, these issues are by no means dead; they have had, and continue to have, obvious

consequences for the treatment of cultural and art history. Historians have tended to shape the outlines of their works according to the division of the area as they have seen them. One effect of the absence of a successful solution to the problem of regional (and local) definition has been that histories and histories of art since 1945 have tended to follow national borders. Accounts have most often been restricted to the art or culture of individual lands, or to their historical antecedents, even of a Germany that corresponded to the *Bundesländer* of the pre-1990 Federal Republic of Germany.[14] One of the few existing surveys of art of more than one country, Jan Białostocki's important book of 1976 on the Renaissance, for all its virtues, may be regarded as characteristic of this kind of restrictive regionalism, in calling the area under discussion 'Eastern Europe'. Białostocki deals with Poland, Hungary and Czechoslovakia, an approach that consciously excludes the German-speaking lands (as well as Russia), thus effectively conforming to a definition of 'East-Central Europe' then current.[15]

In treating the culture of the *ancien régime*, this book will propose that the old regimes of the early modern era as they existed before the nineteenth century, when many of the modern nations of the area originated, supply not only a convenient but also an appropriate geographical definition.[16] For the period before 1806, when the Holy Roman Empire ceased to exist, or before 1795, when the kingdom of Poland (*respublica Poloniae*) was dissolved, Central Europe may be defined as the area comprised by the kingdom of Poland and the Holy Roman Empire. Not to be separated from these regions is the historic kingdom of Hungary, including modern Hungary, Slovakia, Transylvania and the northern part of the Balkan peninsula, which for much of the early modern period was attached through the personal dynastic union of Jagellonian or Habsburg rulers to Poland, Bohemia and the Holy Roman Empire. In this era German-speaking areas and towns, not only in what has become Germany, can be seen to be inextricably intertwined with both Magyar-speaking lands and Slavic ones. Many speakers of German lived in these areas until 1945. In the instance of Bohemia or Hungary under the Habsburgs (the king of Bohemia we should remember was one of the prince-electors of the Holy Roman Empire) or Poland under the Saxon kings, German-speaking dynasts (if we may so designate the later Habsburgs) at times became rulers.

From this perspective, differences between modern states, nations and ethnic groups, as they have subsequently been defined, including that between Germans and Slavs, a notion that still troubles history writing, do not seem to have been major determinants of the cultural distinctions that will concern us here. The older regimes controlled broader areas and thereby facilitated close contacts between different groups, whose interconnections had already been established by patterns of settlement and trade. A definition based on a recognition of the circumstances of contact and intermingling suggests that nineteenth- or twentieth-century notions of nationhood and ethnicity are

inappropriate for the earlier period. Earlier states such as the Polish 'republic' were not just monolingual nations identical with one ethnic (and religious) group, as Poland essentially is now. Nor was the culture of these regions monolithic. In the republic (*respublica, rzeszpopolita*) of Poland six official languages were recognized, and there lived 'nations' of many different ethnic stocks and religions: Lithuanians, Ruthenians, Armenians, Jews, Germans, Scots, Dutch and Moslems, among many others.[17] All could have identified themselves as Poles, while of course they may have wished to define themselves in further ways as well. The kingdom of Hungary was a similar mixture of Slovaks, Hungarians, Jews, Germans and Romany Gypsies. It is only with the late eighteenth and early nineteenth centuries, the period when this book ends, that nationalist, ethnic or racialist definitions start first to be applied to considerations of culture.[18]

These terms seem most inappropriate for earlier periods, for which a microcosm may be provided by the city of Lwów (L'viv, Lemberg). Although it is now a Ukrainian city, in earlier times, especially when it was Polish, not only Ukrainians, but Greeks, Germans, Jews, Italians, Armenians, Poles and even Scots lived, worked and built in Lwów. In Lwów there are cathedrals for four Christian creeds, not to mention numerous churches of religious orders and parishes, and there were also many synagogues before the Second World War.

If we consider the area of Central Europe in the early modern era, before the emergence of countries that exist at the end of the twentieth century, or their immediate antecedents, we encounter not nation-states based on ethnic or linguistic considerations but a conglomeration of many smaller entities, and a few large ones, with no such ordering principles. The tapestry of the Holy Roman Empire, which was comprised of thousands of territories and many different sorts of rulers, provides a good model for this division. These political bodies were conjoined by what may rather be called supranational ideals, as suggested by political organization, religion, language and writing. Politically, rule by a dynastic prince implies that nationality or ethnicity has little to do with political organization or control. Indeed, as throughout Europe, rulers played an important role in nation-building, such as it was. Princes contributed to what eventually became national distinctions, but they did so by pressing their own interests, if also, in seemingly contradictory manner, by raising universal claims.

Moreover, however weak it may in fact have been, the existence of the Holy Roman Empire itself suggested another universal notion, that was in tension with the particularistic interests of individual princes. This notion of universality is evoked by the terms (holy, Roman, empire) by which that entity was described. 'Holy' suggests that this was also an area linked by religion (largely western Christianity).[19] Similar alphabets, and more important, a common basis in Latin culture recall the 'Roman' aspects that also were shared throughout the region. In Central Europe the use of Latin for political as well

as more strictly cultural (that is, literary) purposes persisted longer than in many other places, as it also did in Hungary. Similar points can be made about the supranational kingdoms of Hungary or Poland. This area, including Hungary and Poland, also shared in other aspects of a common European cultural history: during the early modern period, like Western Europe, it experienced the movements of the Renaissance, Reformation, Counter-Reformation, Scientific Revolution, and Enlightenment, albeit in its own way.

More directly to the point of this book, in this era art cannot be claimed exclusively as the product of nationalities or specific ethnic groups. Works of art – cultural products – had little to do with modern definitions of nationality or ethnicity. Throughout the era from the late fifteenth century Italians worked in the entire area. French and Burgundian architects and painters were often active from the Rhine to the Moldau. Netherlanders also penetrated not only the whole Baltic region, but as far as Prague and Vienna. And Germans were active in Bohemia, Poland, Hungary and farther to the east. Often these figures worked side by side. Yet they also often by necessity collaborated with other, local artisans and workers.

While concepts of nation or ethnicity were not absent in this era, they were but one form of cultural identity among many. Other notions seem to have held greater sway. These include notions of family, estate, craft, class, city, religion and region.[20] Regional and local cultural differences can surely also be established (although that goal is not an aim of this book), but they will have to be established on distinctions that take into account these sorts of bases, and not just ethnic ones.

A definition of the area that corresponds to these earlier circumstances also helps establish further geographical limits, although obviously this sort of definition should not be taken so strictly. The area to the south-east, including most of the Balkans, with the exception of Slovenia and Croatia, cannot be embraced in Central Europe, since during most of the early modern period much of this area was controlled by the Ottoman Turks. There was much cultural exchange and interaction with the Ottoman realm – with clocks and other mechanical objects going in one direction, tulips, ceramics, and textiles going in the other – but Turkic civilization in Europe under Islam was fundamentally different.[21] And, beside their distinctive historical experiences, the Christian population of the Balkans were possessors of a different religion, language and artistic heritage to their northern neighbours. As for the Dalmatian coast, during much of this period this was under Venetian rule, or otherwise its cultural hegemony, and thus does not enter this account.

While the delimitation to the east remained fluid, a division in this area may be established roughly at the border of the historic kingdom of Poland in the eighteenth century, considerably to the east of the borders of present Ukraine and Belorussia. A distinction is to be drawn with lands to the east which possessed a different religion (Orthodox), language (Ruthenic or Russian) and history (in the course of the seventeenth-eighteenth centuries,

much of the lands to the east of the Dniester fell under Russian hegemony, in which sway they remained until only a few years ago). These lands also did not have a system of estates (*Stände*) characteristic of the *ancien régime*. There are thus grounds for considering this eastern area as the possessor of a distinctively different cultural landscape, related to the Russian sphere, whose distinction from Central Europe will be discussed further in the first chapter.

While connections with the south, west and north are present throughout the period, historical circumstances can also help to delimit this project in these areas as well. To the west the northern Netherlands engaged in a struggle during the sixteenth and seventeenth centuries, as a result of which they became independent in 1648 and ceased to have any formal connection with the Holy Roman Empire. The southern Netherlands, although often ruled by the Austrian Habsburgs, also had traditions – and above all languages – distinctive from its eastern neighbours. Likewise, the Helvetic Confederation of Switzerland, whose relations with its neighbours were close but often tenuous, also confirmed its independence in 1648. The lands of the French crown provide a clear border to the west, although, as the earlier presence of French-speaking areas in the empire and the incorporation of Alsace into France from 1648 suggest, these borders could be fluid too. A division to the north is somewhat more difficult, although again the Scandinavian states and areas to the east of the Baltic though connected in many ways with Central Europe, can be regarded as distinctive.

In short, the geographical boundaries of this book are the Rhine, the Alps, the Baltic and the Bug (roughly the border between contemporary Poland and its eastern neighbours), or more broadly, the Dniester. A definition of Central Europe in these terms as the areas of the Holy Roman Empire (without its French- or Netherlandish-speaking territories), historic Poland-Lithuania (without some of its most easterly, Orthodox areas) and Hungary, also helps provide one set of coherent temporal limits. There results a clear term for the end of this account, namely the period when the map of Europe was redrawn, as the borders of the Russian Empire moved west, and Poland and the Holy Roman Empire disappeared *c.* 1800. This takes us to the period of Revolution, that also marks the beginning of the era of the modern national state.

ART IN THE CULTURAL HISTORY
OF CENTRAL EUROPE

This project rests on some other assumptions. First, it implies that art is rooted in society and connected especially to other aspects of culture. It thus seems necessary to explain how these ideas may be understood here.

Although these terms are notoriously difficult to define, notions of art and culture in particular are to be related to each other.[22] However, the concept of culture as a 'state or habit of the mind or the body of intellectual and moral activities' when applied to the past takes us 'in search of cultural history'.[23] To

follow E. H. Gombrich, cultural history involves an attempt to read monuments for what they reveal of the culture that created them. It involves an effort of interpreting how styles, forms, symbols, words become charged with cultural meaning.[24]

This effort establishes a project of attempting to recover some of these meanings from the works of the past. Objects may be regarded as documents of history, signs of change, in which visual appearance is thought to be not merely accidental but indicative of some further cultural or societal circumstance. The approach of this book to works of art as social realities thus involves the interpretation of the cultural meaning of artistic styles in the history of Central European society. Styles are to be related to cultural or intellectual movements, as distinct from periods (such as the 'baroque', as it has often been discussed in earlier writings on art history). Even though there remains a problem of how monuments are to be read in relation to culture and society, or cultural and social change, it is here assumed that the visual arts are products of human actions, actions which were the results of complex thought processes, but thought processes which were neither formulated nor expressed in words.[25] To study monuments in these terms means that the cultural historical significance of objects, revealed in style understood as a union of form and content, is what determines their selection for discussion.

But what grounds are there for selecting a monument as having cultural significance? According both to cultural history of an older stamp, as exemplified by Aby Warburg, as well as to the microhistorical emphases and the concern with 'popular culture' of the 'new cultural history', any sort of artefact might serve this purpose.[26] In this book, however, most of the visual manifestations of Central European culture that are to be discussed are examples of what might be considered 'high culture': buildings and works made for courts, churches and other well-to-do patrons and consumers, including what can be called the *haute bourgeoisie*. This means that the works to be discussed are often luxury products, as opposed to everyday objects. The selection of works of art as bearers of meaning may consequently be related to a further connotation of culture, involving notions of design and quality, the latter defined in relation to intention.

There are a number of reasons, theoretical, historical and practical, why the present account deals largely with the kinds of objects which correspond to the traditional fare of art history, and to familiar categories of organization. In theory, it is questionable whether the present distinction between 'high' and 'low' or 'popular' culture can be maintained. The notion of culture conceptualizes what has been described as the coherent, balanced and authentic aspects of shared life, and this underlies both concepts. In practice, it has further been recognized that there is a constant circulation, or relation of high and low culture.[27] This process involves appropriation or expropriation of 'low' or 'popular' cultural goods by 'high culture' on the one hand. On the other hand cultural goods, often produced by artists of high standing and often utilized

by courts for their own purposes, were in turn circulated to other groups, which often used them in their own way, too.[28]

In taking this approach, I am fully aware that the great mass of objects that were produced in earlier times does not fall into the category under discussion. They belong to the realm of other traditions, 'vernacular' or 'popular', which, while not separate from those of court, cloister and city, may have their own rhythms of change, which it would take another effort to chart. But I also firmly believe that a concentration on selected products that are associated with 'high culture' can reveal the processes of change and development that constitute what is generally understood by the history of art or culture.

By emphasizing works of 'high art', this book also seeks to avoid any implication that what was produced in Central Europe is somehow of a different, inferior quality to what is found elsewhere in Europe. In the English-speaking world, with its biases towards English, French, Italian and Nether-landish art, at least of the fifteenth and seventeenth centuries, there is little general awareness of the 'high culture' of the visual arts of the region.[29] Scholarship has not corrected this picture, since only a few Anglophone art historians have paid attention to what is arguably the formative period of Central European culture, before 1900, and especially to the epoch before 1800.[30] Little wonder then that this is the first general synthesis in two generations on art of the region before 1800, taken as a whole.[31]

THE RENAISSANCE IN CENTRAL EUROPE AND ITS ANTECEDENTS

In view of the unfamiliarity of the subject in the English-speaking world, this book emphasizes the way in which, as in many earlier periods since antiquity, Central Europe was clearly conjoined to the rest of Europe. At several times Central European centres became metropolises of ('high') culture, and accordingly of artistic production.[32] From at least the Carolingian period there are links between Germany and other parts of Europe. Gothic and Romanesque churches abound in the region. In the fifteenth century Burgundian (and Netherlandish) artists provided models for German sculptors, painters and print-makers.

By the later Middle Ages, especially from the mid- and late fourteenth century, the easterly realms of the region, Bohemia and Hungary, were also closely tied to the rest of Europe, and in turn made their capitals into supra-regional cultural centres. Hungary will be discussed in the next chapter: as for Bohemia, its mid-fourteenth-century king, also Holy Roman Emperor, Charles IV, effected major transformations in Prague, where he often resided. He set up a new bishopric, and established the first university north of the Alps and east of the Rhine. Charles founded the Prague New City, where the main city square was the largest in Europe at the time. He had the Charles Bridge built. Under his reign many churches, including the Týn Church, were constructed, and St Veit's (St Vitus's) Cathedral was rebuilt. Charles thereby

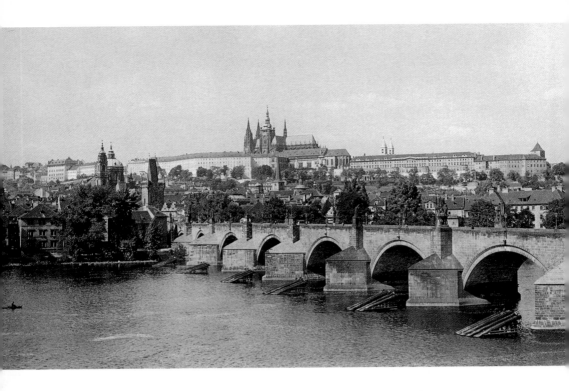

Charles Bridge, Prague (with Malá Strana and Hradčany in background)

sponsored an important new style of late Gothic architecture; the design of St Veit's, with its lofty clerestory windows and unified space, established a type for hall churches in Germany. The masons responsible for this work, Jacob and Peter Parler, can also be associated with the origins of new types of sculpture, including the 'beautiful Madonna' and 'Pietà', which also spread to the rest of Europe.

As a member of the House of Luxemburg, Charles IV was related to the royal family of France, whence he drew artists (such as the architect of St Veit's Cathedral, Matthew of Arras) and works of art. Charles also journeyed to and lived in Italy, where he held fiefs in Belluno and Feltre; in fact, he was king of Lombardy. From Italy he also obtained artists, among them the mosaicists of the south facade of St Veit's, some of the frescoists of Karlštejn (Karlstein) Castle and perhaps panel painters, as well as works of art, including several pictures by Tommaso da Modena. In Prague he was visited by Cola di Rienzo and by Petrarch, who also corresponded with members of his court.[33]

Although the Caroline epoch establishes a precedent, and a context, for the existence of a matrix of cultural connections in which this study is interested, this interlude was broken by the Hussite domination of Bohemia. While the Hussites made some illuminated books and other objects, they also brought on waves of iconoclasm in fifteenth-century Bohemia, and created a situation

in which the survival of court and church art was much in question.[34] Moreover at this time Bohemia, and its Hussite allies in Germany and elsewhere, was pitted against the rest of Europe and targeted for a crusade. This book consequently begins with the traditional watershed between medieval and modern times that many historians now refer to as the beginning of the early modern era in the fifteenth century.[35]

In art and cultural history since Jacob Burckhardt this period has also been identified with the Renaissance. While the definition of the Renaissance as a time period or epoch cannot apply so well here, nevertheless a consideration of what the Renaissance might mean as a period of Italian art with distinctive characteristics is helpful for a perspective on Central Europe. So is the notion of the Renaissance as related to humanism or the revival of classical culture. For Italian culture from the fifteenth century provided a unifying element in European culture, along with Judeo-Christian religious ideas. This is not to say that Italian culture neglected to draw on foreign talents;[36] nor does it mean, as shall also be seen in this book, that other countries (France, the Netherlands) failed subsequently to provide other, similar models, as they had done during the Middle Ages. Indeed, from the fifteenth century onwards, there developed in Central Europe the possibility of a pluralistic, plural society, that was open to many different impulses. From the later fifteenth century, however, Italy may be considered to have provided a model for all of Europe, a model to be emulated or rejected, but in any case not to be neglected.[37] In this way a consideration of the Central European region necessarily compels reflection on broader issues.

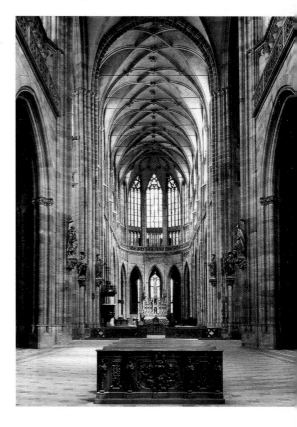

St Veit's (St Vitus) Cathedral, Prague; view of choir

A focus beginning with the Renaissance in Central Europe entails a consideration of questions of cultural reception and response. For the Renaissance can be conceived as one of those movements in European culture which, despite its origins in Italy and therefore its seemingly alien nature, when taken

to the north, became assimilated and reinterpreted locally in various ways. In this process impulses were absorbed, reworked, domesticated and transformed.[38]

The question of the reception of the Renaissance has a special relevance for the visual arts, because those visual forms that we can identify with the notion of Renaissance style stand for a larger cultural movement, in which artistic styles were defined as areas in which individual distinction could be made. Although previously art had long served similar functions, it now consciously became an area for social distinction, a consciously chosen site for leisure activity and self-definition.[39]

It has long been recognized that artistic forms associated with the Renaissance in Italy, and exported from there to the north, from the fifteenth century on also involved certain changes in thinking about art, which may be called artistic knowledge. A consideration of how these ideas were structured into complex and self-reinforcing bodies of thought, and then found institutional and behavioural bases within society, may provide many of the keys to understanding what is particular about Central Europe. As we shall see, a treatment of the Renaissance in relation to Central Europe, raises many of the concerns of what might be defined as the parameters of cultural history.

These ideas involve the relationship of the arts to humanism and more generally to the revival of classical culture. They thus entail reflection on a further series of concerns, including: the common basis for discussions of style in the arts to be found in rhetoric; consequently, the question of dissemination of intellectual and educational ideas, of how imported intellectual commodities are adapted to the specific, social, economic and intellectual conditions of Central Europe; further, the cultural drama in which specific forms of the arts are defined, individual and national identities in the history of the arts asserted and those identities placed within the shared western history of art. A consideration of the way alien artistic and cultural forms could be adopted also raises the issue of technology, or skill, and innovation in relation to technology, craft, design, and pre-existing practices, which either facilitated or impeded their adoption. New techniques and skills, as well as their application to new areas of concern, provided inroads for the arrival of Renaissance art and culture. Finally these issues raise questions about materials, functions and the purposes of objects.[40]

The Renaissance thus offers an instance when Central and Eastern Europe both adhered to a broader pattern and defined themselves in distinct manners. The Renaissance movement, considered first as one involving visual styles, therefore provides a touchstone that is important for establishing the course of cultural diffusion from elsewhere in Europe, obviously from Italy in the first instance in this case. It is also a touchstone for determining what is distinctive about the nature of Central Europe, as opposed to Eastern Europe, as far as the manner in which cultural interaction, interpretation (or misinterpretation), and selection occurred.[41]

By choosing the central issue of the reception of the Renaissance as a point at which to begin this book, I hope that many of the kinds of concerns which occupy a cultural history of art will therefore be raised. In beginning this study at the end of the fifteenth century, it may be possible to gain some ideas about what established the character of the cultures of this region as they emerged into modern times at the end of the old regime. We may thereby begin to gain insights into the making of Central Europe.

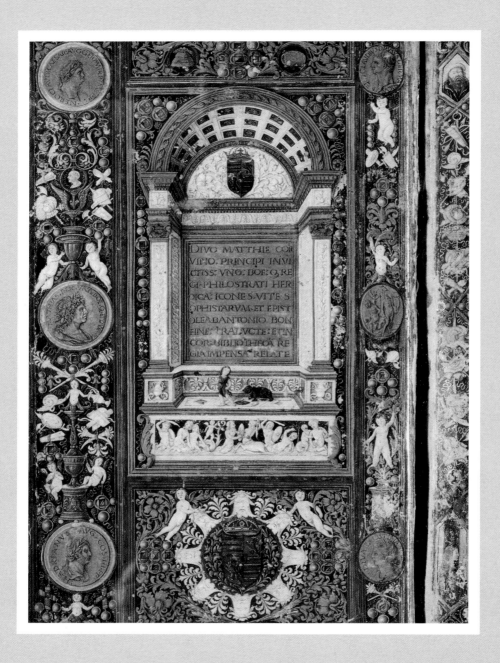

DIVO MATTHIE COR
VINO PRINCIPI INVI
CTISS VNG BOE Q RE
GI PHILOSTRATI HER
OICA ICONES VITE S
OPHISTARVM ET EPIST
OLEA BANTONIO BON
FINE TRADVCTE ET IN
COR VIBLIOTHECA RE
GIA IMPENSA RELATE

Prologue to the Renaissance: Art and Architecture of the Fifteenth Century in Russia and Hungary

Philostratus, *Works*, with translation by
Antonio Bonfini, miniatures by Boccardino
Vecchio, 1487-90, Oszágos Széchenyi
Könyvtár, Budapest, Cod. Lat. 417, fol. 1v

THE STORY OF THE CONQUEST OF CONSTANTINOPLE BY THE TURKS IN 1453 HAS LONG BEEN DESCRIBED AS A TURNING POINT IN THE HISTORY OF EUROPE. As Edward Gibbon told it, with the fall of Byzantium Rome finally fell: the last tenuous links to the Roman Empire were severed. Older histories also held that with the conquest of Constantinople Greek scholars fleeing to the West brought the Renaissance to Italy.

While historians of the Renaissance have radically altered this picture, it is still not generally known that at roughly the same time in the late fifteenth century several realms arose in Central and Eastern Europe which in one way or another also associated themselves with the claim to be successors to Rome. In Western Europe rulers advanced their particularistic aims by making universal claims: they asserted that they had enacted a *translatio imperii*, that imperial authority had been transferred into their hands.[1] Rulers in Central and Eastern Europe did no less. Like the rulers of the Holy Roman Empire who had long maintained that they had inherited the legacy of Rome, henceforth princes of Muscovy/Russia would also make such assertions, as they steadily expanded their dominions in the course of the fifteenth and sixteenth centuries. Art and architecture around the court of King Matthias Corvinus of Hungary (1458–90) directly evoked antique precedents, as the king assumed the imperial mantle. Somewhat later, the kings of Poland also draped themselves in the panoply of Rome.

It is also little known that not so long after 1450, often in ways connected

with these claims, Italians brought the Renaissance to Central and Eastern Europe first of all areas outside Italy. The earliest appearance of works in the style of the Italian Renaissance outside Italy occurs in Hungary, and Italians also had an early impact in Russia. In the case of Hungary, some of the forms introduced were approximately contemporary with those found in Italy itself, and they even pre-date the spread of the newer style to a number of regions in the peninsula. In Hungary the newer forms of the Renaissance also had a broader and longer-lasting impact than they did in the few other, isolated, contemporary instances where they appeared outside of the immediate Italian sphere, for example in France, where in the fifteenth century Renaissance artists like Francesco Laurana also worked. Even though the reigns of some of these monarchs were short-lived – the Hungarian kingdom lasted as an undivided, independent entity effectively only until the victory of the Turks at Mohács in 1526, though Russia continued to expand its power until recently – the introduction of the Renaissance at the court of Matthias Corvinus had profound effects on the history of culture throughout the area, much as it also had in Italy and elsewhere in the west.

The approximately simultaneous arrival of Italian artists and artistic forms in Hungary and Russia permits the Italian Renaissance, conceived as a cultural model, to be used as a control for characterizing variations in visual forms as signs of the culture of Central as opposed to Eastern Europe. The reception of the Renaissance in these regions provides a common point of reference for the examination of how new visual phenomena, to be interpreted as cultural forms, arrived, how they were imported to the north and how they were adapted locally. At the same time the question of cultural exchange with reference to the artistic transformation wrought by Italians is informative about the nature of the local cultures that responded to this transformation, and thus about the question of the reception of the Renaissance in general.

There are several points of similarity to be found between the reception given Italianate art and artists in Russia and in Hungary. The historical moment for response is similar: although they were under direct or indirect pressure from Turks and Tartars, both Russia and Hungary were expanding powers at this time. Under Tsar Ivan III (1462–1505) Muscovy pushed its borders in all directions. To the west the Gulf of Finland was reached, as Novgorod and other old Russian principalities were absorbed, and gains were achieved in the area of the present Baltic states (Livonia and Lithuania); to the east the Urals were passed, to the north the arctic seas were reached and to the south control was pushed far into the areas of the present Ukraine, formerly controlled by the kingdom of Poland-Lithuania. Under Matthias Corvinus historic Hungary (present-day Hungary with Croatia, Slavonia, Transylvania, Slovakia and Austrian Burgenland) also obtained its greatest area of control. Warding off the Turks to the south, where some strips of land in the Balkans south of the Sava river were added to his kingdom, Matthias Corvinus spread his realm far to the north-west, gaining control over Moravia (the eastern part

of the Czech Republic), Silesia (now south-western Poland) and Lusatia (now south-eastern Germany), where his effigy adorns a tower as far away from Buda as Bautzen. To the west he took several cities in Austria, including Vienna, where he died in 1490.

In both Hungary and Russia these ambitious rulers provided patronage for the visual arts. The courts thereby acted as initiators of stylistic change. This is a pattern that was often repeated during the early modern era throughout the regions of Central and Eastern Europe, where a prince's court provided the initial impulse for artistic innovation. The arrival of new modes or fashions throughout the period is often court-inspired, a 'royal fancy' Jan Białostocki has called it.[2]

In both instances the courts effected these changes through the Italians they brought directly into their service. One early arrival, Rodolfo, called Aristotele, Fioravanti, who was summoned north by Matthias Corvinus in 1465, but came in 1467, went on to Russia not long thereafter, in 1474.[3] Fioravanti is one of several such Italians who was passed on from Buda to Moscow and who thus demonstrates the existence of a historical connection between the patronage of these courts. It is also noteworthy that Fioravanti had been active in Rome, where he may have been involved in early papal projects to move the Vatican obelisk, on which he may have collaborated with Antonio Filarete and Leon Battista Alberti; Filarete describes him as skilled in moving heavy objects.[4] He was also active in Bologna, where he had been engineer of the commune. Fioravanti was probably recommended to Corvinus by Francesco Sforza of Milan: his experience provides a prelude for the arrival of many other Italians from the north of the peninsula, and also for the importance of Lombardy, which remained a source and conduit for art.

Moreover, like many other later Italian engineers and military architects, Fioravanti was probably initially brought into employment at both courts to exercise these technical capacities. His service as a designer of fortifications would have answered needs occasioned by the endangered situation of both realms. As suggested, both Hungary and Russia were frontier states, the former in the Christian frontline against the Turks, who from the fourteenth century had advanced steadily northwards through the Balkans, reaching Vienna in 1529, and the latter against the Tartars. In this role Muscovy and Hungary may be regarded as bulwarks of Christendom, a theme that became widely promoted in Poland.[5] Although Fioravanti was probably brought to work as a military architect, like many later figures who subsequently became similarly involved in other artistic or architectural activities that were not directly related to military purposes, he was also employed for tasks such as designing the Dormition (Uspensky) Cathedral on the Kremlin, 1475–9.

The arrival of this architect-engineer in the north also points to the way in which artistic innovation is often to be related to technical or technological expertise.[6] In fortification and other sorts of engineering projects – Fioravanti is said to have worked on a bridge in Buda – technological skill is what made

men like him, whom we now might choose to call artists and architects, attractive to rulers in other parts of Europe. Throughout the early modern period northern Italians and Italian-speakers from the Ticino and Graubünden (Grigioni, Grisons) area of southern Switzerland who worked in the north were sought after because they possessed skills desired from masons and sculptors, skills which local craftsmen did not have, particularly in such matters as making stucco and cutting stone like marble.[7]

Italians were also utilized in Russia and Hungary to evoke ancient Rome, as an ideal rather than a historical reality. In this sense, too, the traditional definition of the Renaissance as a rebirth of classical antiquity, which definition often fits awkwardly outside Italy, might be applied with some justification to fifteenth-century art in Hungary particularly, and to some extent in Russia, too. But in each country there were radically different understandings of the relationship to this past, in the interpretation of what this goal of rebirth might mean, in the realization of the technical abilities of Italians and in response to the intellectual and formal accomplishments of the quattrocento. Hence the tasks to which they were applied also differed radically.

The understanding of the relationship to the Roman past took on a very different form in Russia than it did in Central Europe, and this distinction helps explain some of the relative openness, or closure, of the two areas to artistic or cultural transformation. On the one hand, Moscow had good reasons to pull itself away from the influence of the steppe and to claim its inheritance of the Byzantine-Roman tradition through visual as well as other means. On the other hand, in addition to its sparsely prepared cultural ground, other aspects of the indigenous culture would tend to limit the impact of the Renaissance in Russia.[8]

Long tied to the Byzantine and Orthodox tradition, Russian rulers would not in any instance have needed the west to learn either about certain aspects of the classical tradition or how a court could express its grandeur through representative shows of ritual patronage. Byzantine ceremony, as well as the Greek tradition stemming from Aristotle's teachings about *megaloprepeia* (magnificence), which argued that expenditure on the arts was a fitting occupation for a prominent ruler, could have informed them about these matters. For a long time, however, the Roman aspects of the past that the Byzantines had preserved were not of interest in Russia.[9] Things changed when Tsar Ivan III married Zoë Paleologue, the niece of last Byzantine emperor, and thus came to regard himself as the successor of the Byzantine emperors and through them the Roman caesars. As one sign of this claim, the tsar adapted the imperial symbols of rule, a sceptre with a double-headed eagle, the cap or crown of monomarch, a new orb, a new ritual and significantly the title itself of tsar and autocrator (*samoderzhets*). Such a symbolic transformation does give some sense of the altered self-consciousness and self-assertion that the newly confident rulers of Muscovy possessed, and the staking of their claim to authority in antiquity.[10]

Their simultaneous claim to be protector of the Orthodox faith also indicates the distinctive character of the tsars' assertion that they were rightful successors to the Byzantine emperors. This claim is expressed in the theory adumbrated in the fifteenth century and postulated in the early sixteenth century that Moscow was the third Rome. According to this belief, Constantinople had fallen because of God's punishment. Remaining unshakeable in fidelity, the Russians had not betrayed the true faith, and as a result God's gift had seen to the growth of Muscovy, the new depository of power and religious orthodoxy.[11]

Antagonism to the west, or Latin culture, to which this belief corresponds, was not only a constant in Russia, but had been reinforced since the Council of Florence of the 1430s, when efforts had been made to reconcile the Eastern and Western Churches. In some Russian eyes this effort was regarded as a sign of betrayal. The Metropolitan Isidore of Kiev (Kyiv) was rejected by Muscovites when he returned as a Catholic cardinal; in his place another metropolitan was elected.

While the related resistance to foreign influences can be said to have become much more explicit in the sixteenth century, and xenophobic tendencies recur in many times and places, in Russia they were thus especially strong from an early date. They worked against the establishment of a climate amenable to the reception of the new wave of Italian influences, first brought to Muscovy with Zoë and her Italian court servitors. She had been in Rome as the Pope's ward and had even received instruction from the great humanist prelate, Cardinal Bessarion. This antagonistic attitude reached its zenith in the behaviour of the seventeenth-century Tsar Alexis, who is reputed to have kept a special vase and ewer available to wash away pollution after he had had to meet with westerners.[12]

The patronage of the rulers of Moscow may be interpreted in the light of these attitudes. The manner in which the visual arts were employed to embody the Muscovite claim to be a new Rome was determined by the much more culturally restrictive tasks to which artists could be set. From the outset there were extreme limits to the appearance of Renaissance forms in Russia.

If, for example, we consider Italian innovations of the quattrocento in sculpture, then there could be little place for the Renaissance in Russia. Broadly speaking, one of the signs of the Renaissance in Italy is often taken to be the recovery of plastic and naturalistic representation of the human form in three dimensions. This indeed may be related to the continuation of the heritage of the classical past through the Middle Ages, transformed in the fifteenth century by a realization that the imitation of antiquity and its forms as found in ancient statues could provide an ideal of beauty to be followed in contemporary art. While there is a problem regarding the survival of Russian wood sculpture of earlier periods – much is simply not preserved, and in general works that survive are small in scale or later in date[13] – it may be said that in Muscovy there is no widespread earlier tradition of sculpture of the sort

that may be compared to the monuments of Western or Central Europe, despite the existence of some secular monuments.

Religious prohibitions inhibited the making of sculpture, because of Orthodox opposition to imagery, a result of the long-standing controversy about images in the Eastern Church. According to the Second Commandment in most Western Creeds, graven images were prohibited. This prohibition was often taken to mean carved images and seems to have had a chilling effect on the creation of sculpture, particularly of undraped forms.

Striking differences also separate the Russian tradition of painting from Italian developments during the fourteenth to the sixteenth centuries. The history of painting on panel and in fresco from Giotto to Masaccio, and through the fifteenth century, is usually regarded as one that had a mimetic aim. Working towards the goal of a visual replication of nature, Italian painters gradually developed means to depict figures in three dimensions, creating an illusion of plasticity through various means. These included the use of lighting consistent with the actual location of figures in space, and foreshortening. Devices such as overlapping and perspective were also developed to enhance an illusion that these figures inhabited real space. Moreover, from the later Middle Ages a humanizing vision was created in painting, which stressed emotional empathy and accordingly developed newer types of imagery. These types were supported by a belief in one's immediate relation to the deity. Various movements of religious piety, including Franciscanism and other, mystical trends, have long been recognized as having had a powerful impact on the visual arts through their promotion of such attitudes. Reactions to the plague may have similarly helped intensify religious devotion, although their effect on art is more debatable.

Hence painting in Italy not only developed away from, but in distinction to, the kind of cult image evinced by what is often considered the most Russian of forms, icon painting. Not only expressive but also narrative elements were gradually introduced into cult images in Italy. By the fifteenth century one can even speak of a crisis in the history of the cult image.[14] In contrast, Russian icons may be characterized as static in movement, hieratic in form and repetitive of a type. They even repeat accidents of condition, including darkening caused by candle smoke. The accomplishment of lifelikeness was not their aim; they do not contain narrative elements, nor was aesthetic quality an issue in Russian painting.

Russian icons are rather to be related to the religious goal of evoking the world beyond the senses. In one of the arguments against iconoclasm that iconodules gave as a defence for art, it was said that if images were to be revered, they were to serve the function of leading us beyond appearances. In this kind of painting as it was practised in Russia there is therefore little concern expressed for the conquest of an illusion of the visual world, for the creation of a lively likeness or for the depiction of movement in a convincing spatial setting.

Even the creation of a sense of the human form, which still survived along with some of the inheritance of the classical tradition, was something that was conceived differently in the Russian world. Where the Italians looked back to Rome, as transmitted through a long western pictorial tradition, the Russians were rooted in the Greco-Byzantine translation of the Hellenistic tradition. In particular, to the extent that the suggestion of human presence resided in their painting, the illusion of three-dimensionality in Russian painting, as in the Greco-Byzantine tradition, was often rendered by a web of highlights. This web could be translated into a two-dimensional pattern in which schematic linearity was emphasized.[15]

Whereas the concept of artistic progress and innovation has been regarded as one of the driving forces in Italian Renaissance art, there was also little place for artistic invention or imagination, indeed quite the opposite, in Russian painting. For example, the Council of the Hundred Chapters of 1551 said explicitly: 'Painters will reproduce the ancient models, those of the Greek icon painters, of Andrej Rublev, and other famous painters; in nothing will they follow their own fancy.'[16]

This is a telling reference to Rublev: even where innovation occurs, as it admittedly does in the work of this great master of the late fourteenth and early fifteenth centuries (now, significantly, literally canonized as a saint in the east), it soon becomes a standardized type. Russian religious practices also determined set positions for the

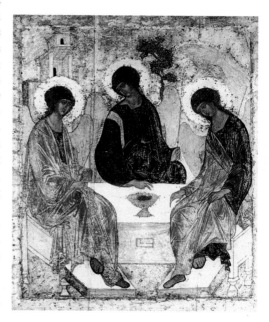

Icon of the Trinity by Andrej Rublev, 1411 or 1422-7; Tretyakov Gallery, Moscow

location of types of icons, as on an iconostasis, as well as the types themselves to be used for icons, leaving little chance for a western inflection.[17]

The main medium in which Italians could be active was therefore in architecture. Here they were involved particularly in the rebuilding of the Moscow Kremlin. Like other similar sites in the region, including Buda, Prague, Kraków, Bratislava, Warsaw and many other places, the Kremlin consists of a hill surrounded by fortifications with a castle palace and churches, and its topography is in this regard somewhat similar to that of these other cities. In building, the technical skills of Italians could be utilized, much as they could be employed to cast cannon and to mint coins. The tradition of

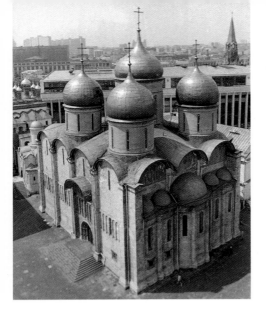

Cathedral of Dormition, 1475-79, by
Aristotele Fioravanti, in the Kremlin, Moscow

wood construction, which remains strong to this day, was evidently found inappropriate for the new aspirations of the tsar. The previous churches in other materials on the Kremlin also appeared too small and probably not grand enough for his court. An early effort at the construction of a more solid building for the Dormition (Uspensky) Cathedral that was begun at mid-century had failed by 1472–4, and this failure is regarded as marking an end to a period of older Russian architecture.[18] The situation was thus favourable for the arrival of a first-class mason-engineer, who might bring a new kind of architecture.

Fioravanti's technical abilities could thus impress the Russians. Fioravanti used a compass, a level and drawings: these tools implied that he not only brought new techniques for measuring to his work but also actual technical devices. In building the Dormition (Uspensky) Cathedral, Fioravanti used high-quality, hard bricks, a high-quality mortar and a construction technique that employed the use of a wall filled with brick and cement, not gravel and sand; he introduced new systems of hoisting material as well. Italians also introduced methods for cutting stone. These techniques enabled the construction of a higher, lighter building, which was completed in 1479.

In place of the traditions of the craftsman and mason, Fioravanti thus introduced both another conceptualization of the builder, more in conformity with the nascent idea of the architect in Italy, and new forms. This connection was transmitted through Hungary, where as we shall see the Italian presence was strong; indeed, the term 'architect' was applied to Fioravanti there. His use of drawings suggests the injection into Russian building practices of an element of intellectual abstraction, in the extension of hand to thought, that is related to this tradition.[19] Italianate elements have also been found in certain details such as the more regular proportions of the Dormition (Uspensky) Cathedral and the disposition of certain features in one of its facades. Beyond these elements, it is however unclear how much effect Italians of the first waves of immigration to Russia actually had.[20]

Similar limitations to those affecting the reception of Italianate painting seem to have influenced responses to the Italianate in architecture. In church architecture, as in painting, there were demands to conform to type, to older design. Consequently Fioravanti was sent by Ivan III to study the twelfth-

century Church of the Dormition at Vladimir when he designed his own Church of the Dormition. He also directly continued the work that his indigenous predecessors had begun on the site. The result is that the ground plan, shape, domes and exterior of the buildings at Vladimir and in Moscow are all similar, as is the system of decoration for the interior.[21]

The inherent conservatism of Russian church design is further demonstrated by the next major building erected nearby on the Kremlin, the Cathedral of the Annunciation of 1484–9: this church is quite similar in many respects to older structures, without much reference to the Dormition (Uspensky) Cathedral. In this building it is true that the symmetrical ground plan, regular proportions and ordered arrangement of space recall Italianate notions that might seem to correspond to an aesthetic ideal of an Albertian architecture of harmony, order and symmetry. Again, however, it is question-

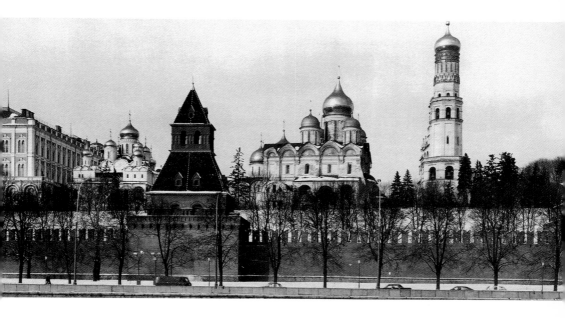

able how intentional these effects were, and more uncertain how visible these features were to Russians, as opposed to recollections of Constantinopolitan or Kievan architecture: it may be that these

The Kremlin, Moscow, with walls and towers largely of the 15th century, and churches of varying dates, including Church of St Michael the Archangel, 1505-09, by Alessio Novi

superficial similarities stem rather from conformity to local traditions of building in which ground plans, proportions and spatial arrangements were also found.

In the Church of St Michael in the Kremlin, 1505–9, by a member of a third wave of Italians, Alessio (or Alevisio) Novi, evidence does appear for

seemingly novel, Italian elements. These include a cornice line, shell motifs, arches, pilasters and capitals. These elements, and the appearance of three windows over the portal, may be compared to motifs which are specifically north Italian or Venetian in character: this is not surprising, in that Novi is called 'da Montagnana', a city in northern Italy. Yet there is no mistaking that St Michael's remains in type a Russian building, whose plan again is Vladimirian.

It thus seems significant that the place in this church where Italian elements do enter is in what may be called the decorative or ornamental aspects of the building. Ornament is the realm of licence, where the constraints and rules of culture and society do not apply so strictly. Decoration and ornament appear on the margins of the church, as in the margins of medieval manuscripts, where they call attention to and frame other elements. Such frames can be treated more freely, in a way reminiscent of the tradition of drollery in medieval illumination. Ornament, in another sense, is also often the realm where the Renaissance enters elsewhere in art in Central Europe. Within the Russian tradition itself the way was prepared for such additions by the extraordinary, characteristic and continuing use of extrados (*zakori*) and gables (*kokoshniki*).

Hence, although the Kremlin churches had an immense impact on later architecture in Russia, the 'Italianate elements' that they introduced recur mainly on external ornamental forms, and repeated decorative details. The famed church of St Basil's shows that later, sixteenth-century Muscovite churches have little otherwise to do with contemporary western structures, as far as features such as their ground plans and massing are concerned.

In secular architecture, where canonical restraints are not so extreme, the chance for assimilation of western art was comparatively greater. The walls and towers of the Kremlin, rebuilt after the Tartar attack of 1451, were constructed in red brick. Between 1485 and 1510 under the direction of North Italians, most notably Pietro Antonio Solario, fortifications were constructed that recall Italian walled cities of the later Middle Ages and early Renaissance, especially north Italian cities such as Montagnana, or else castles such as those at Ferrara and Milan. Similarly the faceted palace of 1487–91 on the Kremlin, a simple structure with faceted walls, closely resembles the Palazzo dei Diamanti in Ferrara. Yet here, too, the interior with features such as a vaulted hall covered with frescoes and gilding still resembles Byzantine or eastern tradition, not a western one.

Thus innovations in secular structures also remained relatively isolated. Consistent patronage for these forms was lacking. Though scattered examples of the adaptation of western elements in Russian ecclesiastical and secular architecture appear in the next centuries, and accelerate towards 1700, there is nothing comparable to the mesh of forms in all media found contemporaneously in the lands of Central Europe to the west, nor to their integration into social or popular life. Before Russia could participate more fully in common

European developments, what was needed for a change in the arts was a more fundamental transformation of social and cultural outlook and values, and hence also of artistic functions. And this change, like so many other changes in Russian history, though to a degree prepared in the seventeenth century, had to await the action of Peter the Great at the end of that century and even more in the eighteenth.[22]

This situation contrasts fundamentally with the history of Central Europe, as indicated by the Hungarian court of Matthias Corvinus. There the Renaissance assumed a vastly different character. While the patronage of Matthias Corvinus also possessed a wider range than merely a taste for Italian artists and architects, in that the king supported other tendencies as well (including works in a tradition stemming from Netherlandish painting, and probably by Germanic sculptors, for both of which this period was a historic high point),[23] the Renaissance at his court means something much like that with which we are familiar from contemporary quattrocento Italy, in its supposedly most progressive or advanced forms.

Unlike the situation in Russia, there were long-standing associations between Hungary and Italy, and other parts of the west. Hungary, in the areas known as Transdanubia, Croatia and parts of Transylvania, had been part of the Roman empire, whose *limes* lay on the Danube. (Romanian, one of the languages spoken by some of the denizens of historic Hungary, is of course a Latin tongue.) The Roman province of Pannonia contains many remains that might have been seen by Hungarians in Buda, Szombathely and elsewhere. From the time of St Stephen Hungary had adopted the Roman confession, and many important religious figures, among them St Elizabeth (also called of 'Thuringia'), had lived there. Throughout the Middle Ages Hungary maintained ties with the west, as are demonstrated for instance by the Norman-inspired architecture of the west Hungarian church at Ják.[24]

These ties were strengthened from the fourteenth century, when Hungary was ruled successively by members of the Angevin and Luxemburg dynasties, who had of course interests in Italy and France. From the fourteenth century there are many traces of Italian trecento art in Hungarian lands: frescoes with a Tuscan character in the Esztergom (Gran) Castle chapel; Italianate wall paintings in Slovakia (then upper Hungary), which have an imagery derived from Tuscany, including depictions of the *volto santo* (Holy Visage) of Lucca; and several luxurious books illuminated by Bolognese manuscript painters.[25]

At the beginning of the fifteenth century King Sigismund of the Luxemburg dynasty, from 1411 Holy Roman Emperor as well, undertook extensive reconstruction of the Buda castle palace, making it over into an edifice in what was probably a current Gothic mode. One of the most extraordinary discoveries of recent decades has been that of a cache of sculptures for this castle: these are datable to the first years of the century and reveal the general qualities of the so-called international style of the time, with Burgundian and immediate Viennese parallels.[26]

During the reign of Sigismund close connections were also established with Italy, which Sigismund had visited, and with Italian humanists. In Rome Sigismund had had contact with the important early antiquarian Ciriaco d'Ancona, and Poggio Bracciolini celebrated his coronation in verse. Several other humanists such as Ambrogio Traversari, Antonio Loschi, Francesco Filelfo and Pier Paolo Vergerio came north to his court in Buda, while conversely Hungarian subjects went south to Italy to study. Italians such as Branda Castiglione, Giovanni da Buondelmonte and Andrea Scolari held bishoprics in Hungary. These prelates, and also Scolari's brother Filippo Scolari (known in Italy as Pippo Spano), called Italian artists north to work for them on building projects and painting. Among the Italians who came north were Manetto Ammanatini, a member of the Florentine circle of Brunelleschi, and the famed Masolino da Panicale, the collaborator of Masaccio in the Brancacci chapel, who worked in Hungary for three years. While widespread destruction caused by the Turkish wars has left little of their work, and for that matter of monuments erected later during the reign of Matthias Corvinus, mention of Poggio, Ammanatini and Masolino demonstrates that even before the Corvinian period Hungary had relations with that centre often regarded as the heart or home of the Renaissance of the quattrocento, Florence.

Corvinus himself was educated by one of the humanists of the previous generation, the Croat János Vitéz, and thus in intellectual as in aesthetic matters was well prepared to adopt an attitude to the cultural values, including innovation in the arts, which would lead towards the acceptance of the latest forms of Italian art. Inheriting great wealth from his father, when he became king he centralized power, introduced severe taxation and gained more revenues. The result was that under Matthias Corvinus Hungary became an early and often comparatively pure centre of Renaissance art in its Florentine form, and also a source for the dissemination of various forms of Italianate art throughout the region.

Matthias Corvinus resembles many quattrocento patrons as far as his background, education and approach to a humanist-inspired art are concerned. Like the bourgeois patrons of the arts in Italy, he was not of royal blood, but the son of the strong man János Hunyadi, who assumed power after a period of internal uncertainty. Like parvenu Italians, he later improved his social position by marrying Beatrix of Aragon, of the royal house of Naples, in 1476. While he also used the arts and letters for representational purposes, like contemporary Italians such as Lorenzo de' Medici and foreshadowing later rulers in Central Europe, Corvinus had a strong personal interest in them. Much like Lorenzo and Federico da Montefeltro, another warrior-patron, he said of himself that he loved to study and loved literature; he corresponded with humanists and philosophers in Florence.

Following an Italian lead, the king also contributed to the establishment of another important precedent in the Central European region by patronizing

the sciences in addition to the visual arts. He brought to his court not only men of letters, but also important astronomers such as Regiomontanus, and Marcin Bylica of Olkusz, for whom he had various technical instruments made. Under Corvinus in 1467 János Vitéz established the Academia Istropolitana as an institution of higher learning in Bratislava (Poszony, Pressburg), now the capital of Slovakia. While the building which once housed this academy still survives, the institution itself dissolved soon after the king's death in 1491; scholars who had served it, including Regiomontanus and Bylica, departed for elsewhere, Bylica to the university of Kraków (the second oldest university in Central Europe, dating to 1364), where he was soon to teach Nicholas Copernicus, a student from 1492.[27]

The humanists around Corvinus had a lasting impact on the treatment of the visual arts. From Vitéz initially, and from the humanists who came north after 1476 such as Antonio Bonfini, Francesco Arrigoni and Francesco Bandini, Matthias would have become familiar with quattrocento views of the arts and architecture. Already in the 1460s humanist notions pertaining to the arts seem to have been expressed in Hungary, perhaps around Fioravanti, who, as remarked, may be placed in Rome, where he could have met Alberti.[28] A Hungarian document of 1467 describes Fioravanti significantly in a way other than that by which he was considered in Russia, referring to him both as engineer and as architect.[29] This is to say, he was considered to have the technical skills of an engineer, who could utilize up-to-date Italian building practices, and he could be associated with the newer definition of an architect as one possessing not only technical mastery but also certain intellectual skills and educational background.

It is not overstated to associate this comparatively early use of the word with the reconsideration of architectural practice that was articulated by Alberti, whom Fioravanti may even have known personally. Manuscript copies of Alberti's treatise on architecture belonged to the extensive library that Corvinus assembled. This also included a manuscript copy of the treatise by Filarete (who did know Fioravanti) annotated by Bonfini.

It has become evident that this and many other terms developed for the arts were in fact employed by the humanists at the Hungarian court. A royal grant made to the sculptor Giovanni Dalmata also indicates that the new humanist rhetoric for the arts was adapted by the king's chancery. In Hungary as in Italy, the language of rhetoric was applied to painting and sculpture, and antiquity supplied the norm for discussions.[30] Descriptions by humanists at Matthias's court accordingly indicate that the projects which the king sponsored were regarded as recreations of ancient forms. *Priscam architecturam in lucem revocasti*, 'thou has called back to light the architecture of the ancients', Bonfini says of Corvinus. This architecture included parts of his palace in Buda, and the new villas the ruler had constructed at Nyék and Visegrád nearby, which are often described with language used for ancient Roman architecture.

Perhaps most important were the ways in which the conscious Renaissance revival of the arts also came to justify the patronage of the arts in Hungary. Much as had happened in the group of humanists around the Medici, and at other courts such as Naples, which can also be linked, through Queen Beatrix of the Neapolitan ruling dynasty, to Buda, the humanists in Hungarian service developed a defence for expenditure on the arts. Against detractors who regarded such activities as ostentatious luxuries, they invoked the virtue of magnificence. This doctrine, which had also been developed in Italy, justified expenditure on the arts as a fitting practice for a prince. It is important that Matthias Corvinus's *magnificentia* was indeed seen as 'following that of the Roman emperors'.

This is another side to the assumption of antique guises that led the king to Latinize his name (from Hunyadi) to Corvinus, thereby associating himself with an ancient Roman *gens*.[31] There is no contradiction between an effort to represent the glory of his realm, which was enmeshed in many conflicts at the time, and at the same time to assert his own personal status, a new man in a king's role. While on the one hand Matthias Corvinus sought to establish, unsuccessfully, a family dynasty, he also adopted the trappings of the arts and the antique to glorify his kingdom and his person. Moreover, the coins and portraits of the ruler found in manuscripts associate him not with republican Rome, as in Florence, but with imperial Rome.

In addition to the effort to enhance his status by a display of liberality, shown in his patronage of buildings and sculpture, Matthias Corvinus was absorbed in collecting items of rarity. In his biography of Benedetto da Maiano contained in the *Lives of the Artists*, Giorgio Vasari says that the king was 'fond of all rare things'. Genuine interest may also have led to one of the foremost signs of activity, the *Biblioteca Corviniana* of which 160 out of 1000 codices remain. This library was assembled not only for aesthetic purposes but also for its contents (regardless of the textual errors they may contain), with much humanist-inspired literature, which, according to the king's testimony mentioned above, was evidently often read by the ruler himself. It contained works by many of the major Florentine illuminators, among them Attavante Attavanti and Gherardo di Giovanni, as well as other Italian artists and scribes.[32]

The king also received or ordered from important Italian artists of the time many other sorts of works. Pollaiuolo designed drapery for his throne. Florentine goldsmiths executed other objects; several fine pieces, including a work attributed to Caradosso, are preserved to this day in the treasury of Esztergom Cathedral. Vasari says that although Filippo Lippi turned down an invitation to come to Budapest, he sent two beautiful panels, including a portrait of the king.

If Lippi would not come, many others, including Caradosso, who was in Buda in 1489, did. Among the Florentines were Benedetto da Maiano, in whose biography Vasari remarks that Matthias Corvinus, 'king of Hungary ...

Base of Cross attributed to Caradosso (Cristoforo Foppa), 1469-90; in the Esztergom Cathedral Treasury

had many Florentines at his court'. While Benedetto did works in intarsia, the painter Albertus Florentinus was active in Esztergom, and the Florentine architect Chimenti Camiccia oversaw work at the Buda court from 1479. Among the sculptors who came to the court was Giovanni Dalmata, who, after having been active at the papal court and elsewhere in Rome, came to Hungary. Italian illuminators, of what has been described as more of a Lombard than a Florentine cast, also established a workshop at the king's court.[33]

The collaboration of a humanist-inspired king, humanist advisors and Italian artists capable of working in the newer antique manner, the *stile all'antica*,[34] meant that a full assimilation of Italianate culture resulted in Hungary. This is evinced by works that are comparable to the most recent developments in Italy. Although much, especially in the way of architecture, must be reconstructed by historians, in Hungary these included such works as the rebuilding of part of the palace on the Buda hill. In the castle Camiccia constructed a courtyard, with superimposed arcades surmounted by a lintel. This form of elevation not only recalls that arcades, especially when superimposed, bore a royal (or imperial) connotation since antiquity, but also resembles the design of the 1460s of the Renaissance castle at Urbino.[35] The courtyard also contained a balustrade, one of the first appearances of this motif anywhere. The first villas north of the Alps, replete with fountains and hanging gardens imitating the descriptions of villas found in the writings of the Roman author Pliny the Younger, were built for the king at Visegrád and Nyék. These are comparable to the nearly contemporary villa at Poggio a Caiano built for the Medici near Florence, and thus are actually some of the first Renaissance villas anywhere.

Inside these buildings both the motifs and the finely wrought carving in stone reveal the hands of Florentines and are also comparable to works done in Italy. The glazed tile floors reveal the sophisticated Italian mastery of this technique; other pieces were made in faience. Intarsia surviving in the cathedral of Zagreb (Zágráb, Agram) in Croatia and in northern Hungary

(Nyribátor) give some idea of what was created for the ruler.

Fountains made for the king also displayed the latest in Renaissance designs. Vasari reports on a work by Verrocchio, and fountains are also known to have contained bronze sculpture by Bertoldo di Giovanni. While much of what was produced in Hungary survives only in fragments, enough of these give an idea of the high quality of work produced by the anonymous masters, perhaps Giovanni Ricci among them, who made the Madonna of Visegrád and other works. A well-preserved pair of fine portrait reliefs depicting the king and the queen done by a Lombard master and attributable to Gian Cristoforo Romano gives some idea of the quality of work done by the court sculptors. In the parish church in Pest surviving waterstoops and tabernacles from the beginning of the sixteenth century, no doubt done by the court workshops, again display features of the *stile all'antica* style of ancient revival. Here they are employed in a church setting, in a way similar to that utilized by Florentine Renaissance sculptors.

An iconography similar to that found in quattrocento art is also evinced by the imagery developed for the king. As remarked, like the Italians, he cloaked himself in the imagery of antiquity. A statue of Athena surmounted the fountain in the arcaded courtyard of the Buda palace, suggesting that the court had been set under her aegis, that of wisdom. The labours of Hercules appeared in bronze reliefs on the doors of the palace in Buda, and Hercules struggling with a Hydra was found on a fountain in Visegrád, whose remains are still there. The recurrence of this motif suggests the idea that Matthias Corvinus is to be regarded as a *Hercules Hungaricus*, a Hungarian Hercules. He is a heroic ruler who struggles against the forces of disorder, especially the Turks, for whom a later symbol is indeed the hydra.[36] A pair of bronze reliefs by Verrocchio depicting Alexander and Darius that Lorenzo the Magnificent sent to the king ('*quem semper vitae habuit archetypum*', 'who always considered [Alexander] as an archetype for living') may also have suggested this sort of contrast: the Asiatic Darius had stood as a similar foil to the European Alexander. The youthful mien of the statue of Hercules in Visegrád may cast

him as a ruler decreed for great things by fate, the *fatalis puer* of antiquity. These associations are comparable to ancient Roman and especially imperial allusions, such as that advanced by Commodus, whereby Roman emperors were identified with Hercules. This identification was also adopted by various later European dynasties, as in the imagery of the French king as *Hercules Gallicus*; it makes Matthias Corvinus first in the line of a number of Central European Hercules, the Hercules Habsburgicus, Saxonicus and Polonus, found in dynastic imagery throughout the early modern era.[37]

In short the whole panoply of Renaissance art was transplanted to the royal court of Hungary. There is no question here of a transformation into, or a compromise with, the Italianate with a local idiom. In form, function and symbolism pure Italian forms and types are adapted and imported to the north.

From its introduction at the court of Matthias Corvinus the Renaissance spread to other parts of Hungary, particularly after the king's death. While work continued in the Buda palace under his successors from the Jagellonian dynasty, and sculptors were, as noted, active in the inner

Portraits of King Matthias Corvinus and Beatrix of Aragon, attributed to Gian Cristoforo Romano, Budapest, Castle Museum

city parish church of Pest, aristocratic and ecclesiastical patrons, and even burghers, elsewhere in Hungary also had the means to employ Italian sculptors and architects. Fragments from the time of Bishop John of Aragon (1480–85) at the residence of the primate of Hungary in Esztergom evince the presence of Italians; under Cardinal Thomas Bakócz (1442–1521) a chapel built onto the cathedral from 1506 is one of the purest and most extraordinary examples of Italian architecture outside Italy. Bakócz was another of those to have ties with Italy where he had been educated and where he visited frequently. He built a centrally planned chapel, which recalls the work of Giuliano da Sangallo; the ornamental motifs of the capitals also point to Alberti, Sangallo and generally Florence. While the chapel is executed in characteristic red marble of the region, inside there is a later altar of 1519 by Andrea Ferrucci.

Bakócz Chapel, Esztergom Cathedral

From the Buda and Esztergom workshops the Renaissance was dispersed to other parts of Hungary proper, where monuments or fragments can be found in Vác, Pest, Tereske and other places. Furthermore Renaissance designs were adopted not only by the highest dignitaries of the realm, like Bakócz, but by wide groups of gentry. Thus in many other parts of the kingdom of Hungary, such as Alba Julia in Transylvania (now Romania) as represented by the Lázói Chapel built from 1511, there can be found relatively pure Italianate structures. Eventually bourgeois patrons were attracted to the new fashion, and local craftsmen thus tried to adapt to the new taste. Even where Italian artisans were not present, tabernacles, tombs and epitaphs in the manner *all'antica* were produced, even in remote regions.[38]

Two examples that are located in the territory of the twentieth-century Czech Republic are informative about the dissemination of the Renaissance from Buda. In Moravia, some patronage results from the remarkable interests of Ctibor Tovačovský z Cimburka, for whom the first translation into a vernacular language of Plato's *Republic* was made between 1484 and 1494.[39]

In *c.* 1475, even before Corvinian dominion over Moravia had been finally confirmed, Ctibor began to lay out the first city built on an ideal plan in Central Europe. For his castle in Tovačov a portal was completed with the date of 1492; its pure Italianate forms deserve the Renaissance language, *'turris quae vocatur formosa'* ('the tower which is called beautiful'), as its inscription reads. While the same sculptors and masons, who probably came to Moravia from the royal Hungarian villa at Nyék, also executed a portal in the town of Tovačov comparable to that of the castle, another similar archway of the same date of 1492, made for the Moravian magnate Ladislav Černohorský z Boskovic in Moravská Třebová, not far away, raises the question of provincialism.

Like many other patrons Ladislav z Boskovic had been educated in Italy, and had served at the court of Matthias Corvinus: his gateway accordingly adds the motif of medallion portraits, taken from coins, a motif recurrent all over Northern Europe, as in the house of Jacques Coeur in Bourges. But in comparison with Tovačov, the gate-front is really rustic: its decoration is simplified, lacking garlands in the spandrels of the arch; a lintel has been added atop the doorway. The result is that the elevation of the arch is misconceived, lacking the *formositas* of the Tovačov arch, since the proportions of the gateway are squatter. The fine Renaissance capitals at Tovačov have also broken down into simpler forms, while the script to be found in the Moravská Třebová inscription is not the bold Roman of Tovačov, but a modified Gothic.[40]

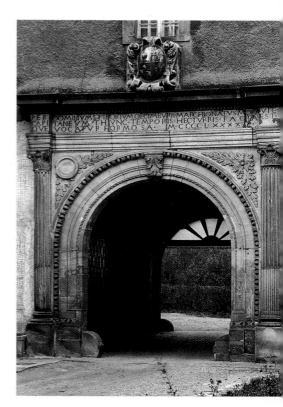

'Turris Formosa', Castle of Ctibor
Tovačovský z Cimburka, 1492, Tovačov

Moravská Třebová thus seems to provide a good example of provincialism in art. Differences in quality in comparison with Tovačov and particularly with works in central Hungary, point to the relative purity of Italian forms as they are assimilated into the royal Hungarian milieu. Moravia, however, was effectively a Hungarian province. Separate from the metropolis, artists there produced works that may be regarded as provincial, in that they seem to display what Adolf

Goldschmidt called the disintegration of forms (*Formenspaltung*). As summarized by Jan Białostocki,[41] this process occurs when 'forms created to express a certain content are taken over in a milieu where acquaintance with the original content has been lost and the actual meaning and function of form are no longer understood'. Moravská Třebová thus exemplifies the phenomenon of the provincial transformation of art, whereby there may sometimes result 'structures superficially similar to highly sophisticated compositions', but lacking their basic qualities.

The comparatively remote location of Moravia, relatively distant from the Hungarian metropolis, thus helps explain the provincial situation. Except for their direct summons to Tovačov, craftsmen who were capable of completely adapting a new style were absent. Having learned the Italianate at second hand, such workers as were available would have lacked the capacity to interpret visually the models they

Gateway (1493), Castle of Ladislav Černohorský z Boskovic, Moravská Třebová

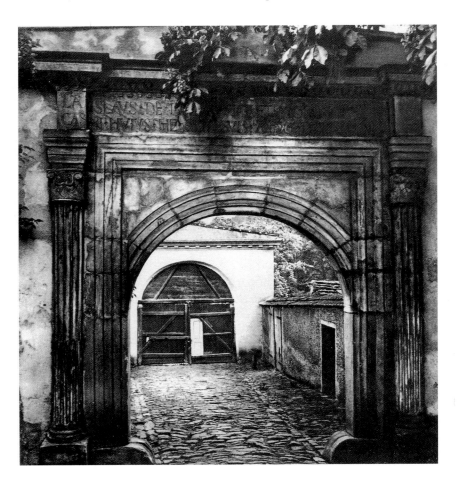

had seen, and hence would have been unable to understand how to make a coherent structure in a new mode: a compromise necessarily was the result. Similar situations are found throughout the region, where what are seemingly hybrid forms may result; we shall return to this issue. These sorts of manifestations reveal a recurring problem in the art of the region, the ability of artists to interpret alien forms. This problem has been resolved by speaking of a vernacular related to the standard style of the region, but at Moravská Třebová this does not seem an apt description. Rather, it can be regarded as one of provincial adaptation.[42]

The contrast of Russia and Hungary and of central Hungary with Moravia, seems to provide a good model for consideration of the differing reception of work by Italian artists. In Russia Italians worked in an alien idiom, suppressing the formal and ideological message conveyed by the style that they had learned at home; in Hungary, however, art in the late fifteenth century involved a direct and immediate assimilation of Italian forms, types and functions. The absorption of such relatively pure forms, and their early appearance at the seat of a large and important empire, can hardly be called provincial even in comparison with Italy; and indeed contrasting the Moravian example suggests both the widespread dissemination of these forms soon after their appearance in what we may call a Central European metropolis, as well as their provincial adaptation. Yet provincialism provides only some aspects of the reception of alien forms. The introduction of Italianate forms into an alien milieu in Central Europe, where different social and cultural circumstances pertained, entailed a whole range of contingencies: the next chapter deals with their appearance at other courts.

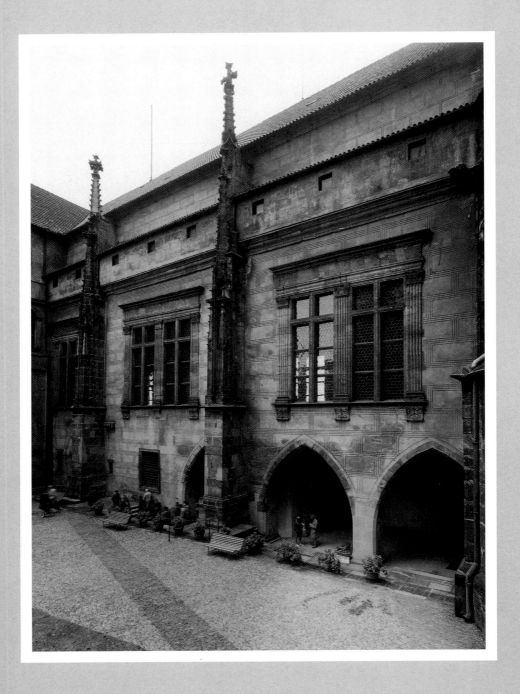

2

Jagellonians and Habsburgs:
Art of the Courts c.1500

Vladislav Hall, exterior showing
windows dated 1493, by Benedikt
Ried, Castle, Hradčany, Prague

In Germany, Bohemia and Poland as in Hungary and Russia
THE HISTORY OF ART OF THE LATE FIFTEENTH AND EARLY SIXTEENTH
CENTURIES CAN BE RELATED TO THE ACTIVITIES OF THE COURTS. Some
historians of art in Germany have called this period the age of Maximilian I
(Habsburg), thus identifying it with the Holy Roman Emperor.[1] In Poland
this period is also associated with the Jagellonian dynasty, during whose reign
the Polish-Lithuanian commonwealth was extended to the steppes of Russia,
and is often called a 'golden age' in the history of the Polish state and its
culture.[2] Kings from the Jagellonian dynasty also ruled in Hungary, after
Corvinus, and in Bohemia, and thus formed with Poland-Lithuania a dynastic
empire that stretched from the Baltic to the Adriatic, where the arts flourished.

The two emerging dynasties in this epoch, the Habsburgs and Jagellonians,
became intimately interconnected just during this time, although the cultural
consequences of these connections have not been sufficiently appreciated.
While their dynasties often stood against each other as rivals, through the pact
of Wiener Neustadt (1506) Maximilian and Vladislav of Bohemia (Ladislas II
in Hungary) arranged for a double marriage that eventually occurred in 1515
and 1516, when Ferdinand of Habsburg wed Anne of Bohemia, and Louis
(Lajos, Ludwig and Ludvík in Czech) of Hungary married Maria Habsburg.
Their rights to succession having been confirmed by Vladislav at a meeting in
Vienna in 1515, Habsburgs eventually replaced the Jagellonians as rulers in
Hungary and Bohemia after 1526, when Louis of Hungary fell at the battle of

Mohács. The Habsburgs' succession to the thrones of Bohemia and Hungary signals the rise of Habsburg domination over large tracts of Central Europe.

Dynastic history also suggests that the courts can be studied in relation to each other in the arts as in politics. Their story can be placed in a more general context of the transformation of the courts at the beginning of the modern age. More specifically in regard to the arts, Jagellonian patronage, both in Bohemia and in Poland, responded to the activity and model of Matthias Corvinus. Inasmuch as the Habsburgs were also embroiled in conflicts with the Hungarian king, their sponsorship of artistic activity in their realm can also be considered a response to that of Buda. Yet the results in these different lands, while sharing some general qualities, also assumed distinctive forms. On the whole the support for monumental (or, as it has been described, mini-) architecture, sculpture and wall paintings at fixed residences in Prague and Kraków contrasts with the patronage of the peripatetic court of Maximilian I, particularly for the graphic media and to a degree painting.[3]

Polish scholars have often noted, with some justification, that the Renaissance outside Italy appears in its purest forms, in Tuscan or Roman terms, in Hungary, Slovakia (then Upper Hungary) and Poland. It is true that, as in Hungary somewhat earlier, throughout the first half of the sixteenth century for more than three generations Florentine artists did work in Poland. The first generation comprised artists such as Francesco Fiorentino (Franciscus Florentinus), who had in fact been directly connected with Buda, whence they came to Poland. The second generation included the architect Bartolommeo Berrecci and other Florentines; to the third generation, taking us to the 'Mannerist' period of the sixteenth century in Italy, belonged such sculptor-architects as Santi Gucci Fiorentino. By this time many other figures from other parts of Italy, such as Mosca,[4] called Il Padovano, workers from the Veneto and especially artists and artisans from the Lombard lakes had come north-east in numbers: we shall encounter them again in later chapters. Much sixteenth-century art in Poland thus displays many Italianate Renaissance characteristics, not only in what may be described as its ideological origins but in its formal aspects as well.

It may also be said that, as in Hungary, so in Poland the ground had been prepared by humanist circles, who then fostered its development.[5] Scholars from many nations were to be found at the university in Kraków, the same city where the royal residence was situated: the Jagellonians had founded this university in 1364, making it the second oldest, after Prague, in Central Europe. Direct associations are also evident with Buda, in that men such as the astronomer Marcus Bylica of Olkusz came to the Jagellonian university after having served the Hungarian king. Like Prague a century later, at the end of the fifteenth century Kraków, where Regiomontanus taught and Copernicus became a student, was thus an international centre for science as well as for the letters and the arts.

As in Hungary, the ruling dynasty in Poland was the moving force behind

the advent of Italianism. From the 1490s the Jagellonians had raised Poland to the status of a great power, at least in regional terms. Already king of Bohemia, Vladislav II Jagiełło, brother of Sigismund and Jan Olbracht, became king of Hungary after the death of Matthias Corvinus in 1490; Jan Olbracht became king of Poland from 1492; and after his brother Alexander had ruled in Poland and Lithuania from 1501 to 1506, Sigismund was elected to the throne.

Sigismund was educated by Filippo Buonaccorsi, called Callimachus Experiens, a humanist who had been associated with the circle of Pomponio Leto in Rome. Sigismund had also lived in Buda from 1490 to 1493, at the court of his brother Vladislav. From this background, later to be reinforced by his marriage in 1518 to Bona Sforza, Sigismund could have obtained an interest in Italianate culture. Soon after 1500, when Sigismund assumed an interest in directing such matters, artists from Buda, including the Florentine known as Franciscus, arrived in Kraków. As in Hungary then, artists who spread

Tomb of Jan Olbracht, c. 1502-5, Wawel Castle Cathedral, by Stanislas Stoss or Jörg Huber and Francesco Fiorentino (Franciscus Florentinus)

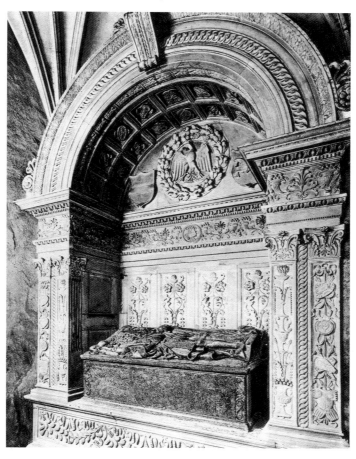

Renaissance forms seem to have been transmitted from one princely residence to another.

In Kraków the first major work completed by Italians was the architectural surround for the niche tomb of Jan Olbracht in the Wawel Cathedral (1502–5). This work is quite up to date in comparison with Italian sculpture: it uses classical decorative language, replete with garlands, pilasters and trophies. In many regards its forms and their sources may also be compared to those of the only slightly later Bakocz Chapel (from 1507/8) in Esztergom, as well as the Corvinian lodge at Nyék, thereby registering their common filiation. The Olbracht tomb has the shape of an arch, thus making one of many imperial allusions to the aspirations of the Jagellonians, who as descendants of the Luxemburg emperors may also have had designs on the imperial throne. The iconography of this form, recalling a triumphal arch, suggests something of the symbolic reasons for the introduction of the new style in Poland, as in Hungary, namely to stress royal or imperial pretensions. And because of its symbolic and formal impact this work initiates a sequence of splendid tomb monuments that persist through the sixteenth century in Poland.[6]

Just as this tomb can be contrasted with the earlier royal tombs in the Wawel, for instance, the only slightly earlier monument for Kazimierz Jagiellończyk (Casimir IV) made by Veit Stoss in a Gothic vocabulary, so too Sigismund made his mark with a splendid new castle building, that contrasts with the many late Gothic town halls and churches in Poland. The rebuilding of the royal castle on the Wawel hill was started more or less simultaneously with the Olbracht tomb. While it is not the first arcaded courtyard even in Poland, where it is preceded by that of the Collegium Maius at the Jagellonian university of 1492–7, with additions 1518–40 (a work which obviously points to humanist, university connections), the Wawel possesses the first surviving arcaded courtyard with Italianate forms in the region. Unlike the courtyard of the Corvinian castle at Visegrád, or the Collegium Maius, it used round arches, Renaissance decorative elements and the classical orders. In these details it perhaps descends from other designs in Buda, where its master builder Francisco Fiorentino had worked, and where the castle also appears to have contained a loggia over an arcade, which recalls forms found in Italy, such as those in the palace at Pienza.[7] In the Wawel courtyard, however, doubled columns, placed one on top of the other, are a distinguishing feature. The Wawel *cortile* also stimulated a sequence of architectural responses that runs through the entire sixteenth century, and beyond, in Poland and elsewhere.

The introduction at the beginning of his reign of these striking new forms give support to the hypothesis that more than just youthful impressions of Buda led Sigismund to be attracted to the Italianate.[8] What Albrecht Dürer called the *neuer Fazon* (new fashion) may have seemed a more broadly impressive vehicle for royal representation than the conventionalised local forms of the late Gothic.[9] The way in which classicizing forms soon spread to the

residences and monuments of aristocrats of the Polish-Lithuanian common-wealth would seem to demonstrate that the introduction of Renaissance forms did involve matters of prestige. Once espoused by the ruler, they became *de rigueur* for the seigneur, even though the process of assimilation was not immediate.

A similar impact was exerted by perhaps the most important work of the early sixteenth century done in Poland, certainly the most influential, the Sigismund Chapel in the Wawel Cathedral (begun in 1517, completed in 1533). Designed by the Florentine Bartolommeo Berrecci, this is a centrally planned chapel, with a drum on top of a cube and walls with niches for sculpted effigies. Again this work was quite up to date compared to similar

Collegium Maius of the Jagellonian University, Kraków, 1492-7 and 1518-40

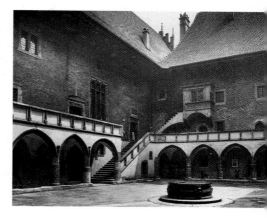

Courtyard of Wawel Castle, Kraków, 1507-36, by Francesco Fiorentino (Franciscus Florentinus) and Master Benedikt

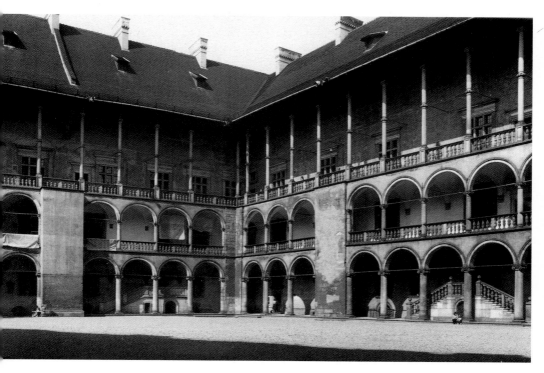

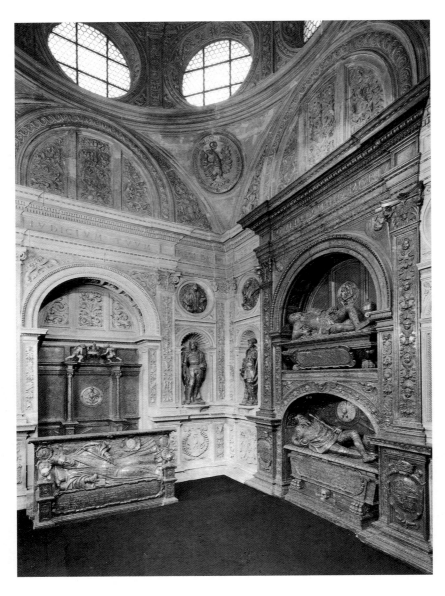

Corner of the Royal Throne Wall and Tomb Wall, Sigismund Chapel, 1517-33, by Bartolommeo Berrecci, in Wawel Cathedral, Kraków

projects in Italy. Although it is anticipated by earlier chapels in the region, it may even be compared to the centrally planned tomb chapel designed for the Medici at this very time by Berrecci's contemporary Michelangelo; both have a source in the tomb of Cardinal of Portugal in Florence.

The distinctive use of red marble from Esztergom in the Sigismund Chapel ties it formally into a regional tradition, and its imagery glorifies the

Jagellonians. Its complicated iconography and manipulation of ancient sources have elicited much scholarly attention. In sum, it seems significant that the chapel manages to appeal both to religious and to pagan images of kingship, including Solomon, and to employ a variety of motifs of triumph. Christian themes are united with classically derived ornament, including grotesques, to glorify the monarch, much like the combination of Platonic and Solomonic references to Sigismund found in contemporary texts.[10] The later design of the sculpted tomb of the king by Berrecci within (1529–31) also set a distinctive pattern: it is the first reclining royal statue. Later still the tomb would be turned into another pattern-making doubled structure, with one resting ruler placed above another. All these forms multiplied in Poland.[11]

The Polish art historian Jan Białostocki could thus make the remark that, as in Hungary, the Renaissance in Poland (at least meaning its Italianate version) came as a royal fancy and was adopted and transformed locally. But for how much art or architecture does this account? Constructions in brick or stone executed in an Italianate or classicizing manner probably constituted only a very small fraction of what was built. The wood or half-timbered buildings that still seem so strikingly characteristic of Central Europe continued to be built often without reference to what might have seemed innovative. Moreover, even if we concentrate on building of greater expense and pretence, the Italianate constituted only one option among many different modes of architecture.[12]

The royal court was moreover responsible for the dissemination of more than pure Italianate forms. Białostocki pointed out himself that the Jagellonian Renaissance in Poland was really a multinational phenomenon: it resulted from an interplay of Polish patrons, Lithuanian and Polish workers, and Germans and Italians from Hungary.[13] Among the leading architects after Francesco Fiorentino was notably a Master Benedikt, a German from Hungary (probably Upper Hungary, that is Slovakia). This master probably possessed only a second-hand knowledge of Italian forms, which he might have gained from buildings or artisans in Slovakia, to be discussed in the next chapter. As in Slovakia, or Moravia, the crew of workers under Benedikt created a quite distinctive, hybrid form of portal which combines Gothic *Astwerk* (branch work) with elements of the classical orders and other decorative elements associated with the Renaissance. These forms also spread elsewhere in Poland; as we shall see, both their appearance, and circumstances that led to their composition, were however not unique to Poland.

Indeed, the description of these sorts of architectural hybrids as particularly Polish does not fully recognize the complicated interplay of figures in the international court ambience in which they appeared. Before Italians arrived, in the 1490s the Jagellonians had favoured Veit Stoss, who executed the tomb of Kazimierz Jagiellończyk in a flamboyant Gothic mode. After Italians had come, Germans not only continued to dominate several media, but worked alongside Italians, in ways that remain to be clarified.

Thus while the role of workers who were most likely German speakers has been acknowledged in the formation of distinctive hybrid forms in the Wawel, more attention needs to be paid to other aspects of their continuing collaboration with Italians. A point at issue involves the tomb of Jan Olbracht. The slab itself as well as the surround deserves some more consideration. It must be by a member of the Stoss workshop, either Stanislas Stoss or Jörg Huber. While some scholars have resolved what they have seen as the apparent discrepancy between the slab and its surround by arguing that this slab must have seemed mediocre or antiquated to the patron, this was not necessarily the case: for how can this be known? The slab is done in the same style as what the Jagiellończyk tomb indicates had until 1500 been the manner most favoured by rulers and magnates. Its appearance together with the Italianate may thus rather be interpreted as setting a pattern for compromise and continuity in regard to the creation of tomb sculpture and architecture in the Central European region, and not simply as a sign of stylistic change within the same monument.[14]

In fact, although the division of labour is not always clear, the pattern of collaboration between Italians and northerners, primarily Germans, seems to have been more the rule than the exception in Poland. For example, the ceilings and walls of the interiors in the Wawel must have possessed a most 'northern' aspect: one ceiling with peculiar human heads in the place of coffering was executed by Sebastian Tauerbach, an artist from Lusatia; walls were frescoed by Hans Dürer, Albrecht's brother; and Flemish tapestries of high quality adorned the walls. The Sigismund Chapel, and other churches in Kraków, were outfitted with works by the painter Hans Süss von Kulmbach, a Dürer pupil who came from Nuremberg to work in the Polish capital. Other altarpieces were painted by the Nuremberger Georg Pencz, a figure of a later generation who had himself visited Italy. Brasses, found in the Sigismund Chapel and in other Jagellonian monuments in the Wawel, remained another Nuremberg speciality, as evinced by the work of the Vischer workshop and of Peter Flötner, the leading Nuremberg brass makers.

A pattern thus seems to have been established whereby certain genres were served by Italians and others by Germans. While the architecture and some of the sculpture may be called Italian, much Jagellonian art could be described as German. Yet it is often impossible to separate Germans from Italians here, as work in an Italianate style in Poland was probably often executed by German masons and craftsmen.

It can therefore be said that in an even more comprehensive sense Jagellonian court art in Poland was an international art, serving the needs of a dynasty with a quasi-imperial and certainly a supranational outlook, which ruled a multi-ethnic state and which had a broad European perspective. Art made for this court was not limited to the hegemony of any one nation, form or genre. This situation indeed seems closely analogous to other typically 'international', that is multi-national and multi-ethnic, courts of this time and

later. 'Eclecticism' of this sort may be the mark of the artistic styles of such empires.[15] Indeed what is called to mind is the even more influential court of Rudolf II Habsburg in Prague at the end of the century, though this comparison has been ignored by Polish scholarship: there, too, an international court of artists and scholars drew upon talents from many different regions.[16]

The case of Bohemia in the late fifteenth and early sixteenth centuries also suggests that the pattern of assimilation, adaptation, collaboration and dissemination was not unique. After the disruption and conflicts of the early and mid-fifteenth century, Jagellonian rule was established with the election of Vladislav Jagiełło as king of Bohemia in 1471. For Bohemia the Jagellonians, originally a Lithuanian dynasty, could represent more of a foreign house than they did in Poland. Their dominion was also contested, especially by Matthias Corvinus, who continued to press his claims on the throne of St Wenzel (i.e. of Bohemia). The Hungarian king succeeded in limiting the actual control of the young king Vladislav to the territory of Bohemia proper (without the other Bohemian lands), by gaining suzerainty, as confirmed through the compromise of Olomouc (Olmütz) of 1479, of Moravia, Lusatia and Silesia.

The interpretation of these circumstances has also led to the creation of an unfavourable image of this Jagellonian monarch, which is curiously mirrored again by a similar view of another great patron 100 years later, Rudolf II: both rulers have been described as alien, incompetent politicians, who were more capable in the arts than in affairs of state. Yet as often seems to be the case in such judgements, this image of Vladislav offers merely a partial view of the situation, seen from the Czech side (and German historians have not considered him in reference to their own art). For when Matthias Corvinus died, Vladislav succeeded him on the throne of Hungary, thereby not only reuniting the Bohemian lands but under his personal union combining Bohemia with Hungary. Furthermore, in 1492 Vladislav's brother succeeded to the throne of Poland-Lithuania: looking from another point of view, Polish scholars have even seen this contemporaneous succession as evidence for cultural and political union in a sort of Jagellonian empire.[17]

Although Vladislav Jagiełło's move to Buda after his coronation is still sometimes interpreted as a limitation on his possible impact on Bohemian affairs, his first major acts of patronage were in fact directed towards building in Prague.[18] At first the king resided in the Prague Old Town, where from the mid-1470s he had the Powder Tower constructed according to designs by Matthias (Matyáš) Rejšek in emulation of the Parlerian Old Town Bridge Tower of the previous century. By 1477 the king had initiated activity on the castle hill; he had moved up to the Hradčany castle in 1485; by 1486 considerable progress had already been made on building there; in 1489 Benedikt Ried was called in, and the initiation of important projects, including the Vladislav Hall in the castle (dated 1493 on the exterior of its windows, finished in rough c. 1500 and vaulted 1502), date from this time.

Vladislav's move to the castle and the work done on it demonstrate the immediate dynastic ambitions of the Jagellonians and their ideological expression in stone. More generally this activity can be regarded as a response to the uncertain circumstances attending his assumption of the throne. The ruler may have felt that a demonstrative statement was necessary, especially in response to Matthias Corvinus, signs of whose authority surmounted buildings in Görlitz and Bautzen in Lusatia and also in Wrocław (Breslau) in Silesia, thus surrounding Bohemia. The use of the arts under Vladislav Jagiełło could also serve a task common to rulers of the day, who were interested in asserting their authority over their own subjects.

Political circumstances in Bohemia affected royal patronage. The question of a residence in Prague assumed an importance which it would never have for the peripatetic Maximilian Habsburg. The Prague castle on the Hradčany hill had been the traditional residence of the kings of Bohemia, and Charles IV and Wenzel (Vacláv) IV had given special attention to its construction and decoration during the late fourteenth and early fifteenth centuries. By returning to the castle Vladislav emphasized the continuity of his reign with that of his predecessors, and indeed the re-establishment of royal authority in the person of the Luxemburg dynasty, from which Vladislav could claim descent. In the face of an immediate conflict over succession, and after the interregnum of the fifteenth century, there were good reasons to stake such a claim.

The crown's patronage of work in St Veit's Cathedral, another structure of the Caroline epoch, can also be seen as a distinctive ideological move. There he sponsored a splendid naturalistic (Astwerk) loggia designed by Hans Spiess in the early 1490s, a prominent expression of the crown's place in the church. The king also paid for further construction and decoration of the chapel of St Wenzel, a patron saint of Bohemia. This patronage had a specific edge, in that the fifteenth century had seen the growth of the Hussite reform movement in Bohemia. Utraquism, the demand for Communion in both kinds, and the egalitarian Taborites had threatened the social order locally and prompted European crusades against Bohemia. Long a hotbed of Hussitism, the Prague Old Town had revolted in 1483, as commemorated in Smetana's nationalist opera *Dalibor*.

Despite the quality of the Hussites' own choir books and their continuing patronage of book painting, many other Hussites had, moreover, been iconoclasts. Hussite image-smashing anticipated the intensified conflicts over the worship of images, the iconodule-iconoclast controversies, which would intensify with the Reformation of the sixteenth century. The originator of the dogma of utraquism himself, Jakoubek ze Stříbra, had been one of several Hussite leaders who had been antagonistic to the arts. Perhaps in partial reaction to the 'beautiful style' (*schöner Stil*) of religious art under Charles IV and Wenzel IV, Jakoubek went so far as to say that art and beauty have no value. Similarly, Jan Matej ze Kaplice had argued that beauty distracts from religion. Whether it was from a response to this extreme position or in

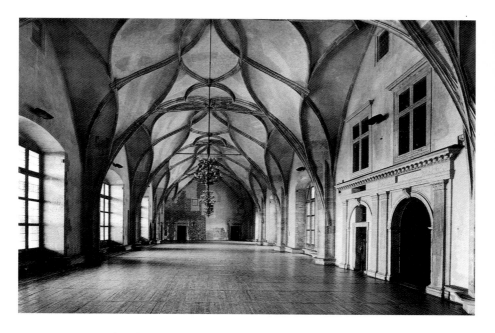

competition with those works that the Vladislav Hall, interior showing vaulting finished Hussites did actually sponsor, it was thus not in 1502, by Benedikt Ried, Castle, Prague only out of a desire to impress Bohemian nobles or other citizens and to reassert his power that the king may have been motivated to commission works of art.[19]

Practical reasons of safety also probably induced the king to retreat to the Hradčany soon after a revolt in Prague in 1483. Indeed one of the ruler's first subsequent commands was to have the fortifications of the castle improved, since the castle had been taken on the third day of a siege during the uprising.

Finally, Vladislav had been educated by the humanist Jan Długosz. Early on, a circle of neo-Latin authors had surrounded the prince. The royal residence in Buda may also have duly impressed him. His partiality to new forms of learning, as of art, may explain why the ruler later tried to introduce humanist teachers to the recalcitrant Charles University, where Hussites with a disposition to older forms of learning remained in control.

Under Vladislav, Prague thus once again became a centre for artistic production. One of the greatest artistic accomplishments of his reign is the completion of the hall in the castle which popularly bears his name. The Vladislav Hall is a splendidly expressive structure, the largest secular hall of its century. Its interior is one of the great Gothic interiors, an immense open space, whose ceiling vault seems to hang free, adorned with ribs that create an intricate interlace of flamelike forms. The exterior is equally startling (so much so that some earlier scholars thought that its elements must have been later additions): it presents Italianate windows decorated with pilasters and half

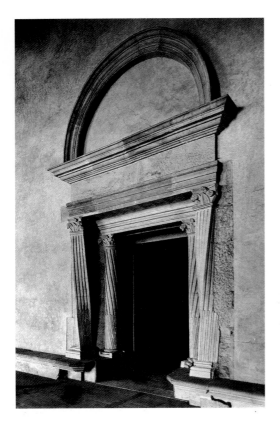

Doorway to *Sněmovna* (Parliament Hall)
c. 1500, by Benedikt Ried, Prague

columns, dated 1493. These are the first artistic evidence of Italian Renaissance forms in Bohemia (properly speaking, as distinct from Moravia).

While these forms are clearly derived from ones in Buda and its environs, comparison with Hungarian examples also suggests they were done by local masons, as were works in Moravia; like the Moravian examples, they may be regarded as somewhat simplified and 'misconceived' variants of the Hungarian style. The word 'provincial' might be applied to this case, since the king had moved his residence back to Buda. Moreover, although Benedikt Ried must have known works in Buda, he was still most likely a German mason who must have received his training in an urban milieu different from that of the Italians in Buda; like his assistant Wendel Roßkopf, the designer of many buildings in Görlitz, he was probably one of the many Franconian or Swabian masons who swarmed to Prague, as workmen from the west would do to other places that offered opportunities at this time, like Annaberg.[20]

It is also understandable that decorative elements would be the first new forms to be adapted, especially by an architect who had not been schooled in the construction techniques of the Renaissance, and also understandable that he and his crew may not have known how to replicate them exactly. Not just in the region discussed in this book, but all over Europe – in Spain, France, England, the Low Countries – this was often the story. But the brilliance of the interior design and the creative use of classical forms elsewhere in the interior indicate that Ried's combination of Gothic and classical elements are not simply a matter of faulty reception or partial understanding. The interior doorway to the *Sněmovna* (parliament hall) consisted, for example, of a rounded pediment, seen later in Slovakia, over a severe entablature, supported by fluted pilasters, within which columns support an architrave. The pilasters are twisted on their axis, and the columns also are treated as spirals. The whole composition represents a creative adaptation of classical forms into a new idiom.

Aspects of the marvellous Gothic 'Knights'' staircase offer other evidence indicating that with Ried a new form of assimilation of the Renaissance occurs. While the exterior portal to this stairway demonstrates that Ried was also capable of working in pure or 'correct' Renaissance forms and the interior stairway has vaulting rivalling that of the Vladislav Hall, the interior doorway to the stairway represents a creative fusing of the two modes. A complicated Gothic arch is inscribed within an ogive arch within a classical frame consisting of two fluted composite columns, which support a heavy architrave.

This brilliant construction suggests the possibility of a different reading of the use of stylistic modes in the Vladislav Hall. As in Poland, there may have been ideological reasons for the introduction of new visual styles. In keeping with one of the functions of the hall, to provide a place for tournaments, which are known to have occurred therein, the interior recalls the Gothic tradition of the Middle Ages. So does the 'Knights'' stairway, which was so called because it was large enough for horses to ascend. There may be an indigenous appeal to the interior as well, in that it resembles Parler's style: like the architecture of the Caroline era, its quasi-fan vaults, without visible supports, seem to be supported merely by ribbing. In the context of the late Gothic, this style choice may further have appeared Czech, in that another contemporary alternative for secular building could have been known, namely the work of Arnold of Westphalia, who in the 1470s had built an impressive palace more in a francophone mode at the Albrechtsburg in Meissen.[21]

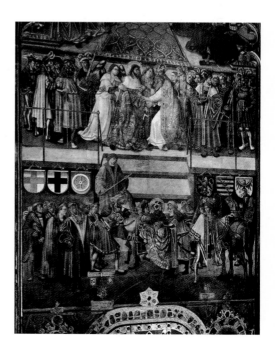

Frescoes of the life of St Wenzel, c. 1505, by the Master of Litoměřice, St Wenzel's Chapel, St Veit's Cathedral, Hradčany, Prague

The location of 'purified' Renaissance forms, windows taken from Buda, as on the portal of the Knights' stairway, makes another statement. These elements appear on what may be called the *Schauseite*, the visible exterior, which would make a public display of the new aesthetic values of the court. They thus may have been intended to be visually impressive. A fine balance is thereby struck: the building manages to appeal with familiar forms on the interior while introducing a new, striking style for the exterior.

A similar combination of Gothic and Renaissance elements is

found in the paintings of the day, such as those by the Master of Litoměřice (Leitmeritz), an anonymous master whose major work, an altarpiece now found in the town of that name, is believed to come from the Prague castle. The landscape found in this artist's work is like that of the Danube school of painting, and his pointed, emotive figures also bespeak a southern German training. His sense of space, however, including a mastery of perspective, already reveals some knowledge of the Italian Renaissance.

Comparable traits are also displayed in the style of sculptors of the era, including the anonymous 'I. P.'. As in contemporary work in Slovakia, I. P. combines finely carved figures, recalling the work of southern Germans, with architectural frames assembled into constructions which are clearly classical. The style of these artists' work would therefore suggest that, as in Poland, non-Italians were often the artists who completed the painting and sculpture done for the court, and they created characteristic hybrids.

The court drew on the Master of Litoměřice in *c.* 1505 for the most significant fresco cycle of the reign, a series of paintings executed in the upper walls of the chapel dedicated to St Wenzel (Vacláv, good king Wenceslas) in the south transept of St Veit's (Vitus's) Cathedral, in which the king himself, his queen and various members of the court retinue figure prominently.[22] This chapel had been initiated by Charles IV in the fourteenth century; the bottom part had been encrusted with semi-precious stones in the manner of Karlštejn Castle, and also supported fourteenth-century paintings and sculpture from the Parler workshop. The royal and Caroline associations of the chapel were increased by the presence upstairs of the actual crown and other regalia of the kingdom of Bohemia, as in a repository.

This form of specific identification with the Bohemian past, and particularly with the saintly past, not only affirms a particular royal Catholic claim but closely approaches the ideological expressions of the reign of Charles IV. Then the argument had also been made that the earthly king was simultaneously a spiritual ruler. The traditional notion that there are two swords, one for each realm, is thus overcome; the king, like the Bohemian patron Wenzel, takes on a saintly or spiritual aspect and thereby becomes a holy ruler. Hence he also raises the claim, which he could in fact legitimately make, that he is an anointed ruler.

The representation of such scenes in the cathedral constitutes a militant reassertion by the court, demonstrating that one of the chief aims of the Jagellonian court in all the arts was the renewal of the tradition of court art of the pre-Hussite period and particularly that of the reign of Charles IV.[23] The renewal of patronage, of the official function of Caroline iconography, of the portrayal of Bohemian patrons, of its very location in Caroline settings, coincide with these political claims. A revival of an earlier era, they also serve the purposes of royal nation-building on the part of early modern monarchs.

This retrospective, 'medievalizing' thrust contrasts with the work done for the court in Poland, where the Jagellonian rulers in Kraków also drew more

directly on the Renaissance tradition as represented in Central and Eastern Europe through its appearance in Buda, and hence through Hungary on Italian sources. Yet though he was not an Italian, Ried also demonstrated that he could master the new architectural language. In his later works Ried built similar structures whose sense of proportion – different to that of the Gothic – correct use of the orders and relation of interior space to exterior elevation certainly seem to be correctly classical. In the royal castle on the Hradčany these include the Ludvík Wing, the entrance to the Bohemian chancellery and (though perhaps from his workshop) the doorway to the exterior of St George's Church nearby, although here too a knightly figure, executed in a northern manner and resembling the work of I. P., is situated within the interior, segmented pediment.

Ludvík Wing of Castle, Hradčany, Prague, probably after 1500-10, by Benedikt Ried

It is also true that the exceedingly specific dynastic character and seemingly antagonistic stance of Jagellonian court art *vis à vis* the Hussite movement may have limited its reception locally: the innovations of Ried and other court artists and architects never found the resonance in Bohemia that comparable developments did in Hungary or Poland. Yet patronage at the Prague court was not limited to the activity of the dynasts themselves. In Bohemia aristocrats were closely connected with artistic patronage at the royal court; in fact because the king was more or less permanently absent, since he resided in Buda from 1490, the real patrons of court art became the high court officials or members of the church hierarchy closely linked with the chapter of St Veit's in Prague, where the cycle of the life of St Wenzel appeared. Other high magnates vied with this group; besides those who acted as stateholders in

Bohemia, other noble families attempted to limit royal authority and in so doing to compete with it in patronage as in other matters.

Benedikt Ried was employed to design castles for aristocrats elsewhere in the Bohemian realm. He worked at Blatná for Zdeněk Lev z Rožmitálů, the highest burgrave of the Czech kingdom, and at Švihov for the lord high judge Puta Švihovský z Rýzmberka, for whom he also rebuilt the fortifications of Rábí. These works resemble his later classicizing structures in Prague, as does a significant Renaissance building designed by him in another Bohemian crown land, for the ruler of Ziębice (Münsterberg). This is the castle of Ząbkowice Śląskie (Frankenstein) of 1514–30. Although it lies in ruins, this castle is not the Gothic horror the name evokes for Anglophones but a Renaissance castle done with symmetrically disposed elements, towers and gateway, traces of an arcaded courtyard and merlon cresting on the battlements, of a sort that became popular in the region.

Furthermore, the influence of Ried and the court circle of masons penetrated to bourgeois milieus. Their impact is especially evident in Kutná Hora, a mining city which had supplied the crown with its wealth, indeed in effect paying for the reconstruction of the Hradčany. Kutná Hora in turn took its lead from the crown by building in a Gothic manner that followed that of the capital. Rejšek and Ried both worked there, in the church of St Barbara, whose interior vault was turned into a maze of ribbed star-like compartments and whose exterior gained a striking profile, like that of a series of tents; the same features were repeated elsewhere in Bohemia, at Louny, for example. Local citizens had already decorated the interior with wall paintings, as for instance in the Smíšek Chapel in St Barbara, where pictures with *trompe-l'oeil* illusionism in the Netherlandish tradition were executed. These paintings point both to the continuation of northern trends in the art of the Jagellonian epoch and to their support by local groups. In its interplay with the court, this royal mining town also provides interesting parallels, as well as a foil, to the Saxon ducal mining towns such as Freiberg, Jáchymov (Joachimstal) and Annaberg.[24]

While the domination of many Bohemian towns by Hussites may have limited receptivity to innovations from Prague, the career of one of Ried's pupils also indicates that his inventions had a wider resonance. Wendel Roßkopf had probably been a student of Hans Spiess and of Ried, whom in a document he calls his *Lehrmeister*, and had carried his innovations to other areas. Roßkopf signed an Annaberg document in 1518 as a master from Görlitz; and he is recorded as a sculptor in Kutná Hora, where he must have worked with Ried. Buildings attributed to him suggest that he worked at Bechyně for Ladislav ze Šternberk, the highest chancellor of the Czech kingdom. Significantly, he also seems to have rebuilt the town hall in the Hussite centre of Tábor, in 1518. Like Ried, Roßkopf was also active in many places in Silesia, including at the town hall in Löwenberg (Lwówek Śląskie). This last work seems a provincial version of Ried's work in Prague; it is done

in a plain Renaissance manner, with window profiles whose symmetrical placing and even spacing recall the Ludvík Wing, or the Vladislav Hall in Prague on which Roßkopf no doubt also worked. Ultimately, after a fire of 1525 Roßkopf was engaged in the extensive rebuilding of Görlitz, which then belonged to the Bohemian lands. After the death of Matthias Corvinus in 1490 Görlitz had returned to the Bohemian crown; there some of Roßkopf's burgher houses and town hall additions also recall the Ludvík Wing.

In the end Jagellonian-inspired court art, combining a local retrospective character with Renaissance aspects, resembles art done for Maximilian I. Like the Jagellonians, Maximilian I also seized upon the possibilities of employing the visual arts to proclaim his majesty. With Maximilian this took on a personal quality, in his desire to stress *Gedecthnus* (sic), remembrance, to chronicle his accomplishments in images as well as in words, and so to preserve his personal memory. It also took on a propagandistic function.[25]

Born in 1459, son of Emperor Frederick III, who was the first in the chain of modern Habsburg emperors, Maximilian also had much cause to press his case. Although the Habsburgs regained Vienna at the death of Matthias Corvinus in 1490 and control over the Tyrol in 1490, and Maximilian had been made Roman King (designated successor to Frederick), he was not crowned emperor until 1508. Maximilian's second marriage, with Bianca Maria Sforza, embroiled him in wars in Italy, where he fought in the 1490s and again from 1509 to 1512 in the War of the League of Cambrai. He also fought a number of wars with the Swiss in 1499 and later. As was evident from by his own two marriages – the first of which occurred in 1477 to Mary of Burgundy, daughter of the last of the dukes of Burgundy – the marriage of their son Philip the Fair to the daughter of Ferdinand and Isabella of Spain and the double marriage of his grandson and granddaughter to Jagellonians, Maximilian seems to have waged a more successful policy of matrimony. This policy eventually established the bases for the worldwide Habsburg empire.[26]

Maximilian's father, Emperor Frederick III,[27] had also been the Maecenas of some important works of architecture and sculpture in Austria, including some works by the noted Netherlandish sculptor called Nicolaus Gerhaert van Leyden, but Maximilian's marital policies and their outcomes also point to other sources of inspiration for his interests in the arts. Through his own campaigns in Italy he could have come to know its culture, particularly that of the courts of northern Italy which also influenced other Central European monarchs. It was not only the impact of Italy but, as in Kraków, the work of local humanists that helped pave the way for the penetration of Renaissance ideas into Maximilian's circle. In fact the most important of these personalities, Conrad Celtis, also had contacts with Kraków. The involvement of humanists in the creation of art and literature around Maximilian's court again indicates that the distinction drawn by historians of the Renaissance between form and content cannot be made.[28] The scholars in Maximilian's court have indeed been called the priests of the *numen maiestatis*.[29]

The humanist circles around Maximilian concocted a curious blend of ideas, as exemplified by the concepts of Conrad Celtis and others of the so-called Vienna humanists, including Johann Nauclerus. These figures, to whom we shall return, presented a glorification of the German past, through a particular reading of Tacitus's *Germania*.[30] They also promoted a consciousness of later German letters, those of the Middle Ages, as a sign of German greatness. In their version of the myth of the transference of empire (*translatio imperii*) after the fall of the Roman Empire, world dominion had been passed on to new, German rulers. The Holy Roman Emperor was now a German Christian, who had been anointed by the Pope; he could be seen as a warrior for Christ on earth. The Augustinian idea that the Roman Empire had fallen because of its corruption was thereby turned into the idea that Rome fell so that a new Roman Empire could be Christian, the city of God in heaven and the city of man on earth could be one, much as in Caroline propaganda. The ancient notion of renewal, of the revival of empire, seen in the person of Charlemagne was combined with this ideal; though Charlemagne's empire dissolved, through the Holy Roman Empire it was thought that its authority had been transferred to the Germans. In the Middle Ages this idea had been harnessed to the chivalric ideal of knighthood and to crusades against the infidel, and these ideas remained current up until the later fifteenth century.[31] They were expounded in Maximilian I's entourage and promoted in the propaganda of succeeding Habsburgs. They may very well be reflected in the choice of Dürer's design of portraits of the emperors Charlemagne and Sigismund along with that of Maximilian for the city castle of Nuremberg, the location of the imperial regalia. Nauclerus's chronicle of 1516 saw a German, Habsburg side to history, in which the coronation of Charlemagne was hailed as proof of the divinely ordained superiority of the German people.[32]

Hence a revival of knightly or traditional, medieval values could go hand in hand with a revival of the antique. Humanist apologetics for Maximilian could thus seek ideological justification for his drive on Rome in medieval precedents and find it in the flourishing of the empire under the Hohenstaufen in the twelfth century. Just as Frederick Barbarossa had then made a trip to Rome to start a crusade against the infidel, so did Maximilian's descent on Italy promise to do the same.[33]

In the culture of Maximilian's court, medieval knightly values were often thus as much revived as were those of antiquity. Through his Burgundian union, which led him to reside in the Low Countries for a while, the ruler would have known this culture as well. His first wife Mary was herself an important patron of manuscript painting, as their daughter Margaret also became. It is fair to think that Maximilian would have learned about the flamboyant display of magnificence for which Mary's father, Charles the Bold, was notorious. From the Burgundian side, he would have learned how a ruler's magnificence could be represented through ceremonial, the revival of chivalric traditions and knightly pastimes.

In a way that parallels Jagellonian patronage, Maximilian's projects thus often combined a classicizing with a medievalizing element. Maximilian could be portrayed as a knight, but he could also be shown as a Roman emperor, or the two images could be combined into one. Thus it came about that a ruler who is often referred to as the 'last knight' also was responsible for promoting some of the first manifestations of the Renaissance in Central Europe.[34]

Like the Jagellonian monarchs, when Maximilian turned his attention more fully to the arts, *c.* 1500, he too had Italian artists brought to his court. In 1499 a Lombard sculptor was sent by his Sforza in-law to work on a project in Innsbruck. Although the significance of their presence is not given the weight it deserves, the Venetian Jacopo de' Barbari and the Florentine Adriano Fiorentino both worked for him. And through their work for other courts, especially that of Duke Elector Frederick the Wise of Saxony, like the Jagellonian court artists, they also helped disseminate new Renaissance forms. Adriano's bronze portrait bust of the elector is the first example of this typical Italianate form of ruler portraiture north of the Alps.

On the other hand, although gunpowder and Swiss pikemen were spelling the end of the sway of the armoured warrior on the battlefield, Maximilian popularized a style of armour with fluted skirts that is known after his name. He had a cycle of chivalric tales in Runkelstein Castle restored. This effort led him to sponsor his own chivalric texts. Among them were some that he wrote himself (including the *Theuerdank* and *Weißkunig*). These works derive from the courtly poetry of the Middle Ages, as exemplified by *Minnesang* and chivalric romances, on the one hand, and from the antique tradition of biography, on the other: the knightly *Weißkunig* is in particular close to an autobiographical form. Maximilian patronized or planned books on hunting, fishing, hawking and even artillery.[35]

While Maximilian continued to possess an interest in luxuriously illuminated manuscripts, as his Burgundian relatives had done, and oversaw the creation of a prayerbook, for which chiefly Dürer, but also Lucas Cranach, Hans Baldung Grien and Albrecht Altdorfer provided marginal illustrations, he was also directly involved in the production of printed books. He had the new technology applied to older forms of literature, creating and disseminating models for a new, educated court society. He wrote an autobiographical romance, the *Weißkunig*, an account of the events surrounding his marriages, the *Theuerdank*, and a tournament book, the *Freydal*. Maximilian took advantage of the new print media to have these works published and embellished with woodcuts by such artists as Leonhard Beck, Hans Schäuffelein and Hans Burgkmair.

Telling examples of Maximilianic art were thus produced by German artists in a number of genres. The images of the ruling family were spread through coins, medals and medallions – all types of objects that may be regarded as Renaissance revivals of ancient practices. On the other hand a project for an equestrian statue has a more complex origin. This work was

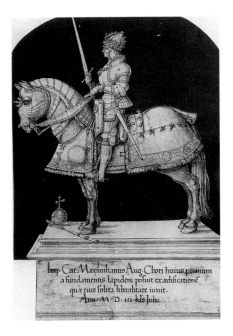

designed by Hans Burgkmair for Augsburg, and its horse was to be modelled by Gregor Erhart. As recorded in a drawing, the statue was to have the words 'Imperator Caesar' written on the base, and thus, like many contemporary coins and medals, clearly evokes an ancient imperial tradition, seen in equestrian monuments, of which the best known is that of Marcus Aurelius on the Campidoglio in Rome. As a statue of a leader on horseback, the monument to Maximilian may also be related to some of the Renaissance monuments which the emperor might himself have learned about in Italy, such as Verrocchio's Colleoni in Venice or Donatello's Gattamelata in Padua. He may also have been inspired by Leonardo da Vinci's plans for a monument for Ludovico Sforza, since Sforza, to whom Maximilian was related by his second marriage, came in exile in 1499 to Maximilian's court in Innsbruck. Yet in the use of stone, the closed

Design for equestrian monument to Maximilian I, Augsburg, to be placed before St Ulrich and Afra's Church, c. 1508-9, by Hans Burgkmaier; drawing in the Graphische Sammlung, Albertina, Vienna

immobile stance of the horse and the presentation of a crowned rider who bears a sword, the figure of Maximilian even more closely recalls the great German medieval equestrian rider figures in Bamberg and Magdeburg, the latter even more closely, in that it was free-standing. These figures too were connected with imperial propaganda advanced by the Hohenstaufen in the twelfth century.[36]

Other works designed for Maximilian present a similar amalgam of imagery of the German past in Roman costume or setting. This is seen in the most extravagant of all of Maximilian's plans, the tomb the emperor planned for himself in the Innsbruck court church (*Hofkirche*). This work was carried out with the assistance of humanist genealogist-scholars and was largely directed by Gilg Sesselschreiber, with many designs by Jörg Kölderer. Maximilian's tomb in Innsbruck was to consist of a tomb with a kneeling ruler on a slab coffin, with the deeds of his life illustrated in an elaborate programme. Initially hundreds of figures in bronze were to accompany him: the plan called for over-life-size gilt bronze standing figures of Maximilian's *Ahnen*, his forerunners and models, rulers from the House of Habsburg, mythical kings like Arthur, and others who were to be emulated like Charles the Bold. The work is a summa of the art of Maximilian's time, combining the

idea of an ancient tomb with that of a funeral procession of the sort known from the later Middle Ages. Something of the paradox and complication of this work is indicated in the way that the two artists who were the most familiar with Italian art did what might be considered the most Romantically medieval of all of the figures in the tomb project: this is Albrecht Dürer's design for the figure of King Arthur cast by Peter Vischer. This monument glorified the Habsburgs and at the same time bodied forth Maximilian's own notion, as he expressed it in the *Weißkunig*: 'He who leaves no memorial in his life will not be remembered when he dies and will be forgotten with the death knell.'[37]

It is characteristic of Maximilian's patronage, however, that the tomb in Innsbruck was never finished, that a similar plan for a monument to other rulers in Speyer was never started and that his equestrian figure in Augsburg was never completed and soon destroyed. Maximilian's constant travels, and his chronic lack of funds, impeded the successful completion of these projects and also meant that his energies could be spent even less on the patronage of significant architecture. So it can be said in a real sense that the best monuments of Maximilianic art remained on paper.

Maximilian I was indeed the first prince to seize on the idea of using the newly developed print media to express his aims, the first to use these media as a form of publicity.[38] His discovery of this occurred

Tomb of Maximilian I, Hofkirche, Innsbruck, designed by Jörg Kölderer, Albrecht Dürer and others, executed by Gilg Sesselschreiber and others, begun 1502

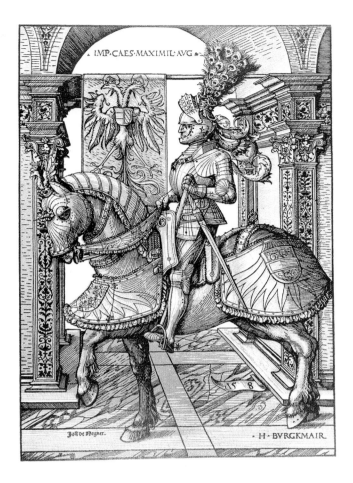

Maximilian I on horseback,
by Hans Burgkmaier,
woodcut, 1508

in *c.* 1500, directly at the time of the first Swiss War, when he was most unsuccessful politically, so it would seem that this response is to be related.

For Maximilian, Dürer made the *Ehrenpforte*, a triumphal gateway composed out of woodcuts. Although Maximilian completed no civic monuments, monuments in print such as this 3-metre-high arch in a way provided a substitute for them. The triumphal arch is another hybrid idea; the conception and forms are Roman, recalling triumphal or honorific arches; at the same time it is adorned with images of Maximilian's ancestors and their accomplishments. The Roman form is also used to embody a Burgundian ideal of direct involvement in the arts, showing the emperor directing things. The whole is surmounted by a hieroglyphic image of the ruler, designed by the court humanist Stabius.

A related monument was the triumphal procession designed and drawn by Altdorfer, Dürer and Burgkmaier, but printed only posthumously. This again

was derived from Roman processions known from descriptions and seen on arches. The practice had been revived in Italy in the fifteenth century and is seen in Italian art, such as the relief on the Castello dell'Uovo in Naples or Mantegna's triumph series (now in Hampton Court). The message of both works is similar: triumph and glory, the accomplishments of the Habsburgs in general and Maximilian I in particular, and his imperial claim. This is a claim not only to rule Germany, but to be Lord of the World: hence the imperial crown appears on the arch, and peoples from all parts of the world are shown in the triumphal procession.

Two other woodcuts by Burgkmaier from the date of Maximilian's coronation as emperor also strikingly blend the antique with the medieval. The first is Burgkmaier's portrait of the emperor on horseback, depicting the emperor in an elaborately ornamented quattrocento architectural setting. It bears an inscription resembling those on coins in Roman letters, pointing to Burgkmaier's collaboration with the Augsburg humanist Peutinger. Yet the figure of the ruler is shown in contemporary armour, recalling of the stress on the 'old German element' by Celtis. The second image of St George recalls more directly a knightly reference and may be related to the emperor's avowed crusading spirit, fitting with the justification given his programmes by those humanists who compare Maximilian to Barbarossa. To understand these images, with their mixture of classical and chivalric Burgundian, it is useful to see them as as the result of a combination of traditions, as a German mixture of modes, suited to various messages.

In the collaboration of these figures, as in many other works done for Maximilian, the Albertian ideal that the artist should collaborate with the humanist on inventions seems to be followed. In this assumption of the intellectual underpinning of Renaissance art, Maximilian's court also mediated Italian ideas to other German courts too. In a letter to Frederick the Wise, Jacopo de' Barbari already argued that painting was a liberal art and to be treated as such.[39] This argument evinces the presence of a theme that was already current in Italy and was later to repeated frequently in the region.

While Italian artists circulated these ideas along with works of art to other courts of the early sixteenth century, the use of prints spread the image of imperial majesty even more broadly. Since prints could also reach bourgeois circles, not only their style and content but also their function for purposes of propaganda could have an impact an impact on urban classes who used them for similar purposes.[40] It was also artists in such milieus who made the images. A consideration of art at the major Central European courts thus leads us to other settings, to urban centres and hence to some of the most important artistic figures of the day, who worked for Maximilian and other rulers among their other activities.

ART OF THE TOWNS:
THE ROLE OF GERMAN-SPEAKING
ARTISTS *c*.1500

Tomb of King Kazimierz (Casimir) IV
Jagiellończyk of Poland, 1492, by
Veit Stoss; Wawel Cathedral, Kraków

IN THE LATE FIFTEENTH AND EARLY SIXTEENTH CENTURIES
CONDITIONS THROUGHOUT THE REGION IN WHICH THE ITALIANATE
RENAISSANCE IDEAS, FIRST INTRODUCED VIA BUDA, WERE RECEIVED
DIFFERED GREATLY FROM THOSE AT THE HUNGARIAN COURT.
Geography affected the availability of materials, ideas, habits and workmen,
and could thus limit the reception of the new art. Much of what was produced
in Central Europe until well into the sixteenth century consequently conforms
more closely to established local patterns than it does to the new Italianate
fashion.

Even where social and economic conditions allowed, where expensive
materials could be used and artists and architects employed for public projects,
in many places in Central Europe, including those under Hungarian control,
buildings, sculpture and paintings were produced that do not resemble those
made in the circles around Matthias Corvinus. For example, a sculpted coat of
arms bearing the royal devices, which was executed in 1488 probably by the
workshop of Briccius Gauske, hardly resembles the sculpture of quattrocento
Italy, as transplanted to Hungary, either in its significance or in the forms of
its accompanying figural supports. The swirling vegetable ornament, fantastic
animal support and elegant, angular knight and maiden adhere to different
visual conventions. They are characteristic of the sort of workshop production
common at this time in much of Central Europe.

If we compare works done in an Italianate mode in Hungary, Poland or

Arms of Matthias Corvinus, 1488, attributed to Briccius Gauske, on the Town Hall (Rathaus), Görlitz (with Statue of Justice, 1591)

Bohemia with much else made in the manner described above, which can be called 'Gothic', and if we compare the Italianate to what is often taken as typical of art of this time in Central Europe, then we can develop a contrast of the sort much practised by art historians. Like the work of Gauske in stone, much other sculpture in wood, as for instance any number of the characteristic winged altarpieces produced by workshops such as that of Tilman Riemenschneider, can be contrasted with comparable works made by Italians. Carved with flamboyant ornamental features in an ogive manner and often filled with expressive, even dramatic, figures, these northern altarpieces differ radically from their Italian counterparts. In contrast, the Florentine altarpiece fashioned for the Bakócz Chapel in Esztergom is designed in a symmetrical, balanced form; like other similar works, it employs antique motifs and figures of harmonious proportions in repose, who are often based ultimately on classical sources. Similar contrasts have been made between the individual Gothicizing forms, naturalistic ornaments and tall proportions of the great churches of the region, such as that of St Anne in Annaberg, and Italian Renaissance buildings.[1] And other comparisons might be suggested for the painting of the time.

Many Central European works of this era are thus often associated instead with that great outpouring, particularly of painting, sculpture and the graphic arts, that is identified with another conception of art and its periodization. As far as German-speaking artists are concerned, this period is often called that of the 'Old German Masters', a name often given to the late fifteenth and early sixteenth centuries. At this time many accomplishments were achieved by important artists in many media. Some of the most famous among them are Albrecht Dürer, Matthias Nithardt called Grünewald, Albrecht Altdorfer, Hans Burgkmair, Lucas Cranach and Hans Holbein in painting; Tilman Riemenschneider, Veit Stoss, Hans Leinberger and many others in sculpture; Dürer, Martin Schongauer and the Behams in the graphic arts; the list could

be continued at length. These figures executed work in traditional genres as well as in new media, such as woodcuts, etching and engraving, whose invention and development coincides with that of printing.

This book does not by any means seek to summarize the work of these masters, about whom an extensive literature exists, but rather to interpret their accomplishments within the larger context of Central European culture and society. Set in this framework of comparison, the conceptualization of their work in relation to the notion of the Renaissance becomes problematic. Although their art is often formally distinctive from the Italianate, the period defined by the activity of the Old German Masters is nevertheless also designated that of the Renaissance in Germany. Obviously the meaning of Renaissance here is something much different to what is meant by the notion as it is applied to Hungary. Since the late nineteenth century, and especially since such important writings as those of Heinrich Wölfflin, Renaissance art in Germany, as this art is called, has in fact been regarded as equal to, but distinct from, the art of the Italian Renaissance.[2]

This application of the notion of the Renaissance seems problematic, however. The chronological period of the Old German Masters to which it is often attached is said to end around 1530, just when what might be described as true Renaissance elements, defined as the revival of classical forms and content, as had occurred in Hungary, Poland, Bohemia and at the court of Maximilian I, became widespread. This is also the time when humanist values begin to become pervasive, not just in the writings of what was debatably a small group of scholarly forerunners but among broader groups of the population, through such means as the establishment of schools, especially under the impact of Melanchthon, to be considered in Chapter 5.

The rival definition of the Renaissance in Germany, when it applies to 'Renaissance' as a period term, is moreover problematic in that it also carries with it normative implications. It has frequently been argued that the period of Dürer and of the other masters of his time forms an acme in German art, after which there came a crisis in art and a decline. It is said that this flow of art was driven on by an increase in spirituality towards 1500 and was thus cut off in part by another of the outcomes of these religious movements, the Reformation. A recurring argument also holds that the effort to assimilate Italianate art itself produced an art that was unauthentic, a new style lacking local roots.[3] The period which might thus seem more identifiable with a truly Renaissance style, when classical motifs, content and ornament appear and spread in Germany, and are sometimes even manufactured by Italian or Italian-schooled artists, is thereby regarded as one of decline from the real, German Renaissance.

This thesis, that the assimilation of the Italianate represents a corruption of the indigenous, often rests, however, either consciously or unconsciously, on questionable ideological – nationalist, and even racist – assumptions about the rootedness or national origins of culture.[4] It misrepresents the place of

'German' artists and art in a wider cultural and geographical surround. It also begs the question of how to account for what is in effect a much more complicated picture of art in Central Europe.

A pluralism or polyphony of artistic forms is to be found in Germany, as elsewhere in Central Europe. Artists who had been trained locally not only reacted against the new forms and ideas introduced from Italy, and afterwards by Netherlanders schooled there, but also came to grips with supposedly alien styles in their own ways, in such a manner that they eventually created new forms. What is, after all, often taken as an authentically northern, German art, drew heavily from Netherlandish/Burgundian sources in painting and sculpture: one thinks here of the impact of 'Old Netherlandish Painting' or of sculptors such as Claus Sluter or Nicolaus Gerhaert van Leyden, who originated or disseminated important sculptural currents throughout Central Europe. The traditional canonization of certain aspects of German art around 1500 does not mean that consideration of other forms, and the wider context for them, should be ignored.[5]

In this book a more complex picture will be sketched of the artistic situation that attended the work of German-speaking artists in Central Europe in relation to other currents of the time, most notably the Italianate. While in the preceding chapter German speakers were seen working alongside Italians in Poland and Bohemia, the present chapter places emphasis first on Germany proper and on apparent differences with the Italianate. As in the contrast of Russia and Hungary, the production of visually distinctive works is interpreted as supplying a key to the responses that occur in different sets of social and cultural conditions. These point to different systems of organization and hence production for the arts, as well as different circumstances affecting their consumption, meaning different conditions of marketing and trade.

Even seen at their extreme, at a time of supposedly marked visual difference, these distinctions reveal that a more complex choice situation existed for artist and patron alike. No media, class or ethnic group fully mark any particular form of art as defining, or resulting from, an independent, specifically German, or northern, 'visual culture', which is rooted in diverse forms of expression, social groups and stylistic alternatives, including the Italianate.[6]

To begin with social patterns: many historians have elucidated circumstances in Germany where bourgeois patricians were more often patrons than were princes.[7] The art which has interested historians is that produced for clients in free towns or cities, many of which became wealthy in this period, *c.* 1500, an era of great prosperity in many areas of Central Europe. In Germany places such as Augsburg grew rich from commerce and banks, and investment in mining in Upper Hungary; Ulm from textile manufacture; and Nuremberg from manufacturing and commerce. And there are a host of other, similar sites.[8] Major works of sculpture and painting often originated in small towns (most outside of Augsburg and Nuremberg had less than 5,000 people). The

Fuggerei, public housing provided by the Fuggers in Augsburg, occupies a deserved place in the history of urban planning. The predispositions of this civic art, and the presuppositions of its patrons, set it apart from that of the Russian or Hungarian court model.

In this milieu patronage of the arts allowed for investment in which economic return was not at stake but where the possibilities for distinction in terms of the public display of one's status, and the expression of one's taste, were open (as they were also of course in court patronage). At this time – as indeed throughout the sixteenth century – there was a proliferation of urban architecture and extensive decoration of domestic interiors. Portraiture was also a favoured form of expression. But in many places like Nuremberg, as indeed in Renaissance Venice, restrictions in the form of either actual sumptuary laws (imposing restraints on luxury) or of subtler social constraints set limits on many kinds of personal display. Hence, while other avenues lay open, secular art did not broadly satisfy the desire for conspicuous consumption, at least not until the mid-sixteenth century.[9]

Other outlets were found for patronage in the ecclesiatical realm. Here they were fueled by many aspects of religious fervour on 'the eve of the Reformation'. Public signs of a renewal of piety are many. The veneration of saints, and their relics, increased. Pilgrimages were ever more popular. Monastic and mendicant orders, among them the Franciscans, were reformed by fiery preachers. Among the laity new movements of piety were set in motion, including the *devotio moderna* (modern devotion), that was spread through such groups as the Brethren of the Common Life. Along with them came a new devotional literature, a notable example of which is the *Imitatio Christi* by Thomas à Kempis (so named from his birthplace, Kempen, near Düsseldorf). Grievances (*gravamina*) decried abuses in the Church and demanded reform. On the individual level, a gnawing concern for one's own salvation also led to acts of piety including endowment and patronage of works of art. In this way a desire for fame could be shaped by a concern for one's own spiritual well-being.[10]

A multitude of different types of objects were thus made to serve the didactic, devotional and liturgical needs of the church. These included altarpieces, reliquaries and other devotional objects, including manuscripts and small images, carved, painted and printed, as well as tombs and epitaphs, sacrament houses, fonts, choir stalls and sculpted calvary mountains. These were paid for by the ecclesiastical institutions themselves, by brotherhoods or other corporations including guilds, and by wealthy individuals.

The combination of these interests, and their expression on a larger scale can indeed be seen in a place like Annaberg, whose church has already been mentioned. Annaberg is one of several boom towns of the era, which grew wealthy from silver and other metal mines. The town put up this church very quickly, in merely a quarter century starting *c.* 1500, indicating the intensity of the impetus involved. Here the church not only served an obvious religious

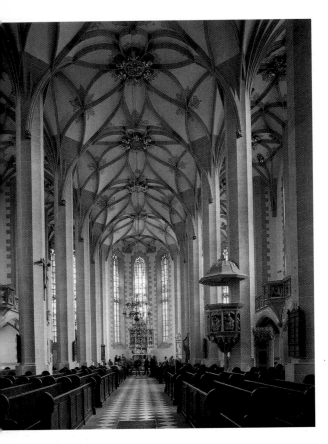

St Anne's Church (St Annenkirche), Annaberg, 1499-1525, by Conrad Swabe, Konrad Pflüger, Peter Ulrich von Pirna and Jakob Haylmann von Schweinfurth

function, but became something of an expression of the importance of the town. The building was obviously necessary for divine services, but it appears its huge size was not determined by strictly liturgical needs, nor was it necessary to accommodate the population of the town. The lofty hall church of Annaberg (it still towers high above the town) made rather a statement about the town's importance as well as providing a visual sign of civic unity and accomplishment. At the same time its elaborately vaulted, painted ceiling recalls in its stone branches the world of nature and thus could suggest another symbolic significance for the church, as a paradisiacal garden and a treasurehouse for holy objects.[11]

The altarpieces and other objects which were commissioned for such a building depended in turn on the existence of highly specialized crafts. These needed, first, access to labour. They also depended upon access to material, often, in the instance of the retable, wood. The demands of the medium in which they worked thereby also determined to a degree what artists might do, although, as we shall see, this point has been overemphasized: the decoration of Annaberg was carried out in a variety of media, including much work in stone, in which indeed the shaping of the material seems to overcome its constraints. These crafts were in turn organized according to a system of guild control (except in Nuremberg, with its system of sworn crafts), which set standards and controlled the market. They also determined the way in which an artist would be trained and become a master himself.[12]

In important ways these conditions thus contrast with the circumstances determined by the freedom (*Hoffreiheit*) to work and also, it should be emphasized, to train pupils, which an artist might enjoy in the employ of a

prince. Specific aspects of the market and its mechanisms affected this urban art, as opposed to the salary or retaining pay an artist might receive from a ruler or other authority, or even a long-term commission for a specific project such as a church or tomb.[13]

Work was done on a distinctly different basis. Like other early capitalist enterprises, the masters of the visual arts employed a system of putting out work and specialization in the effort to complete commissions on time. On the other hand, in the absence of commissions sculptors, painters and print-makers might venture into the market themselves. Among other things, this process might even involve something as direct as Dürer sending his wife out to sell prints at market.[14] As Michael Baxandall has aptly said, the sculptors were the 'Fuggers of art and realise in their carvings the new economic Europe', and this statement is also applicable to Dürer, Holbein and other masters of the pictorial arts.[15]

An artist might thus seek to create a demand not merely for a particular sort of product but for his brand name, as it were. Successful artists eventually created a demand, not merely for a particular type of painted or sculpted altarpiece but for a 'Dürer' or a 'Riemenschneider'. However, even where individuals succeeded in making a name for themselves in Germany, this situation could also mean that such forms of art would be inherently conser-vative. That is, artists could become more dependent upon following successful directions, as suggested by an existing tradition of production or taste, rather than striving for the new, as is seen even in architecture.

This environment has been seen as epitomizing the circumstances surrounding that major task for artists, as far as time, investment and prestige of commission are concerned, the altarpiece. The role of sculptors in partic-ular in this enterprise has been studied recently, but it should be recognized that a more complex organization of tasks was often necessary, involving painters, joiners, gilders and other artisans, as well as sculptors.[16] Painting, not merely of wood figures but on flat panels of the altarpiece's wings, is found together with sculpture, as in the St Wolfgang altar in Austria or Grünewald's Isenheim altar in Alsace: it is thus arguable whether considerations of sculpture in such matters can be separated from those of painting.

It has also been said that the question of the 'German Renaissance' is a major example of the way in which visual forms might stand for as well as mirror a whole set of different cultural priorities to those of the Italian Renais-sance. Differences from the court-originated Italianate may be exemplified by two representative makers of altarpieces: Riemenschneider the sculptor and Albrecht Altdorfer the painter. Riemenschneider was born in Thuringia, son of a mint master. Although little else is known of his background and origins, he probably received some traditional sort of training in carving stone and wood. After an apprenticeship and a period of travelling typical for a journeyman, Riemenschneider joined the St Luke's guild in Würzburg as a *Geselle* (journeyman); in 1485 he completed a standard course of training

when he became a master. His first work is known from the year of Matthias Corvinus's death, 1490, the Münnerstadt Altarpiece.

Like many similar sculptors, Riemenschneider was a townsman and prospered in this bourgeois milieu. In 1505 he held the first of several municipal offices in Würzburg, becoming mayor in 1520–1. As the leading Würzburg sculptor, he had twelve apprentices between 1501 and 1517. Although he also received numerous commissions for tombs of bishops, Riemenschneider by no means sided with them or the milieu of the episcopal court of his city. When the burghers were trying to establish themselves against the bishop, whose residence was established on the Marienberg which dominates the city, Riemenschneider threw in his lot with them. After peasant groups had been let into the city in 1525 during a peasants' revolt, Riemenschneider was imprisoned and tortured, and the legend has it that his hands were broken.

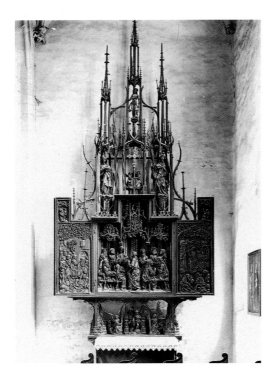

Altar of the Holy Blood, St James's Church (St Jakobskirche), 1499-1505, Rothenburg, by Tilman Riemenschneider

In his career Riemenschneider made works for his own city as well as for small towns all around, including one altarpiece that has been regarded as a paradigm of German 'visual culture'.[17] This is the altarpiece of the Holy Blood completed for the Jakobskirche in Rothenburg from 1501. From the religious standpoint this work has been seen as a great reliquary. It also represents a solution to a theological problem, the question of the granting of grace to a sinner, through its emphasis on Jesus offering communion to Judas in the depiction of the Last Supper. As a craft product, Riemenschneider's sculpture has also been regarded as setting a style for carving. It has easily identifiable marks, such as a standard way of depicting eyes, a recognizable hair style and undifferentiated folds. This was a style that was easily mastered, as it had to be in such a large work, meaning that his shop could expand – and its easy replication also accounts for the difficulties that art historians have had in attributing works to Riemenschneider himself, as distinct from his workshop.

The altarpiece of the Holy Blood has also been taken as evidence for Riemenschneider's consequent establishment of a kind of monopoly over artistic production in the area; Riemenschneider is almost a classic instance of a craftsman manipulating the market, so that works in his style proliferate.[18]

The slightly younger Albrecht Altdorfer, born in Regensburg, *c.* 1480, offers an exemplary career for a painter. Altdorfer became a citizen of Regensburg in 1505 (this being a restrictive position even for those born locally); he also held local office, being elected member of the general city council in 1519 and of the inner council in 1526. He was on the chief city council in 1533 and was chosen as an emissary to the emperor in Vienna in 1535; thus, again, a successful artist from a bourgeois background.

As a member of a later generation, the youngest of the so-called 'Danube school', Altdorfer was susceptible to certain Italian elements, the adaptation of which in his art will be mentioned later; nevertheless both in terms of his social status and his style of art he too may be taken as the paradigm of a northern artist. The pattern of patronage for his work follows the conventions of this different milieu, the bourgeoisie and the abbeys. The style of his work, like that of Riemenschneider, establishes him as a distinctive artist with his own characteristics, which were broadly marketable.

These are evident in one of his most famous works, the altarpiece of St Florian. Made for the monastery of St Florian in Austria, this commission conforms to the pattern of work for monastic or other church patrons, and its subject matter can be

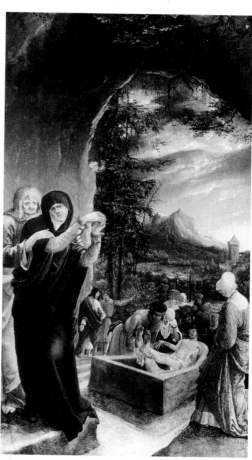

Entombment from the predella of the St Florian altarpiece, *c.* 1515-18, by Albrecht Altdorfer; Kunsthistorisches Museum, Vienna

regarded as rather typical for this sort of altarpiece; it was determined by the demands of the patron for an altar depicting the life of the patron saint and

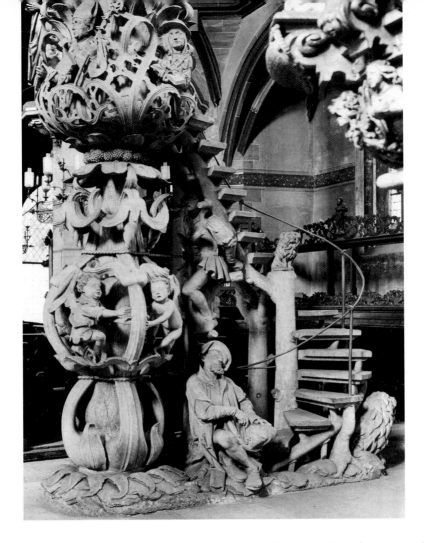

'Tulip' pulpit, Freiberg Cathedral,
c. 1508-10, by Hans Witten

the story of the Passion. But its style is characterized by a fantastic play with light and colours, in which figures are distorted, with distended limbs and physiognomies exaggerated to the point of caricature. Another feature that has been taken as most characteristic of Altdorfer's work is the relationship of figures and action to details of landscape, including alpine trees and settings. Indeed an important aspect of the beginning of independent landscape representation has been found in his art. Landscape in Altdorfer does not provide merely a passive element or setting, nor does it result simply from the artist's interest in realistic detail. Nature is not a background but an active participant in the event: art historians since Otto Benesch have thus sensed in his art almost a religion of nature, which Benesch related to Paracelsus. In any instance, these elements suggested an almost mystical, spiritually charged sense of the world, which is most unlike the supposed rationality of the Italians.[19]

Such works have therefore long seemed to represent a distinctly different alternative to Italianate art. These differences are seen not only in carved wooden or painted altarpieces but in other media. Here Hans Witten's stone 'tulip' pulpit, executed 1510–15 for the Cathedral in Freiberg in Saxony is a telling example. Witten was an artist who worked in both wood and stone, chiefly for such new towns as Freiberg and Annaberg, which were mining centres. In many of his works he also created quite fantastic forms, anomalies, like his full-scale flagellation group in Chemnitz or the *porta formosa* (beautiful portal), now in St Anne's Church, Annaberg, but once designed for the Franciscan cloister there. It was for the miners' guild in Freiberg that Witten designed his pulpit. In it an angel helps a boy who is climbing up what can be described as the calyx of the floral shaft of the pulpit, which so resembles a tulip that the work has been called the 'tulip' pulpit (this of course is anachronistic, because tulips were only brought back to Central Europe from Constantinople later in the sixteenth century). The flower is also to be conceived as a kind of treasure tree, whose root is the gospel, supported by faith. At the foot of the pulpit is a sleeping figure usually identified as Daniel. This is an empathetic identification, for the miner in the dark depths of the earth, faced with uncertainty and possible death, must have felt much like Daniel in the lion's den. As in Witten's baptismal font at Annaberg, where the putti dressed in miners' hoods disport themselves around the basin, or in the altarpiece painted by Hans Hesse in the same church, which shows scenes of mining activity, these images seem quite expressive of a particular environment.[20]

This sort of work has consequently been taken to epitomize a culturally specific art, whose world of imagination is far from the Italianate. It might also be suggested that this art is related to a distinctively different social milieu. Others have, however, gone further and traced such art to its ethnic or national origins. The difference from court-promoted art is resolved by a train of argument that suggests that bourgeois Germans in towns, especially in southern Germany, created one style for themselves, as opposed to another, Italianate design for the court.

This paradigm may also be extended to architecture. A very different style to that found in Hungary, or in Russia, still predominated in Germany. This is a style that is not Italianate or otherwise classicizing. It might rather be described as late Gothic, as characterized by hall churches, such as that in Annaberg.

But are these works to be taken as signs of a distinctively German, or even, as some writing would seem to indicate, south German visual culture, and if so, how?

Relatively similar economic conditions existed all over the region in centres where art was made. In northern Germany, where the Hanseatic League was still important, the major commercial cities of Hamburg, Bremen and, especially important for art, Lübeck were still thriving; the same could be said

of cities such as Danzig (Gdańsk) in the Baltic region. As in Saxony, mining brought wealth to the towns of northern Bohemia, central Slovakia (then Upper Hungary) and Transylvania. In the towns of Spiš (Zips) and Saris (Šariš) in eastern Slovakia, in Bohemia and in places like Kraków in Poland the route of trade to the east brought wealth, particularly in those towns which possesed stapler's rights (*Auflagerechte*). And other places, like Zwickau in Saxony, gained wealth through the production of cloth.[21]

These conditions allowed for and encouraged the creation of works of art in similar milieus outside the court in Bohemia and Poland, as in Germany. Throughout the region wealth created the possibilities, and the demands, to build and adorn new churches, to finish off earlier projects and to modernize what already existed. As in Germany, both ecclesiastical and secular groups, including various sorts of corporations, among them confraternities, played an important role as patrons. Thus large churches were built not only in Slovakia but in Poland, Bohemia and Transylvania. It has already been recognized that in the alpine regions major altarpieces were made for small towns in Austria, as at Kefermarkt or in Feldkirch. In northern Germany as well, the workshops of Benedikt Dreyer, Bernt Notke and Henning van der Heide in Lübeck, or Hans Bruggemann in Schleswig, or similarly many other figures in Hungary or Poland, completed altarpieces, to some extent choir screens, tombs, pulpits and cult images.

An equally wide diversity of media is found in art all over the region, which no one particular form may be said to dominate or characterize. In sculpture, works in limewood have long been admired and of late have gained renewed attention, but limewood was only one medium employed out of many.[22] Even sculptors working in the region where the linden tree grew, primarily south Germans, possessed many different skills; furthermore, artists produced works in this limewood throughout the southern tier of Central Europe, not only in southern Germany. Elsewhere, in northern Germany, hardwood was employed by artists such as Benedikt Dreyer and Claus Berg to achieve the same sort of effects supposedly visible only in linden (limewood). Netherlandish winged retables, mainly in oak, were also imported throughout the North Sea and Baltic littoral.[23]

In fact specialization was not limited to wood-carving. The craft of casting brass, for example, which was centred in Nuremberg, had spread widely from the early Middle Ages; in the fifteenth century brass fonts and epitaphs were shipped to places such as Wittenberg in Saxony, Berlin in Brandenburg and Toruń (Thorn) in Poland.[24] Artists who specialized in stone carving could also ply their craft in a variety of locations. Hans Witten was called to Saxony for this purpose; Christoph Walther was summoned there from Silesia; later Hans Schenck went from the Erzgebirge (Ore Mountain) region of Saxony to work in Halberstadt, Berlin, and as far away as Königsberg in Prussia.[25]

Similar stylistic qualities can be found in works in a variety of media throughout the region and are neither to be attributed to the demands of a

medium nor, as will be argued, to a particular ethnic group. Elements of what has been described as the 'florid' style are found not only in limewood but in hardwood and stone. As noted, it can only be claimed, not demonstrated, that artists like Claus Berg knew examples of limewood sculpture, yet many of the effects he achieves in oak, for example in the swirling garments and expressive folds of his apostle figures in Güstrow Cathedral, are similar to those found in works in limewood. That no single particular medium or region determined how a style should be developed is also suggested by the work of a sculptor from Moravia, Anton Pilgram, who is also documented as a stonecutter (mason) in Vienna. Pilgram worked in Brno (Brünn), the main city in Moravia, where he probably did the sculpture in stone on the facade of the town hall. This stone sculpture is in fact more undercut and therefore apparently more 'florid' in appearance than other reliefs in wood done by him at the same time, or perhaps even slightly later (now in the Moravian Gallery, Brno).

Detail of sculpture by Anton Pilgram, 1511, Brno Old Town Hall facade (Stará Radnice)

The work of supposedly German – or better, probably, German-speaking – artists like Pilgram in areas outside Germany proper highlights the problem of evaluating the effect of social or ethnic groups on art. The presence of significant numbers of what are now called ethnic Germans throughout the area is but one aspect of the mixture of peoples in the early modern era. The population of many Hungarian towns, in the Vojvodina (now a territory disputed between Croats and Serbs in what used to be Yugoslavia), in Transylvania (in Romania) and in Slovakia, was German-speaking. Merchants and bankers in southern Germany itself had interests in commerce and in mining throughout the Slovak towns, where indeed the mines of Banská Štiávnica (Schemnitz, Selmecbánya) and Banská Bystrica (Neusohl, Besztercebánya) were one of the major sources of Fugger wealth (as that of royal Hungary). Commerce, trade, capital were often in the hands of Germans in all of the area, including in Poland. As a result, the language of business was often German, as it is now English; words for economic activities are often German: in Czech one still speaks of doing business as *kšeft* (cf. *Geschäft*) *udělat* and in

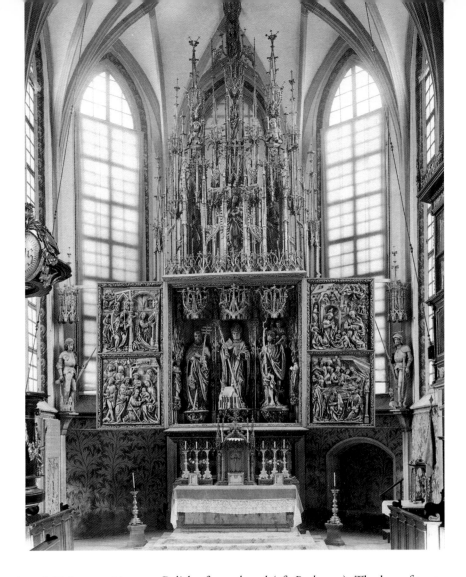

Altarpiece, St Wolfgang parish
church, Kefermarkt, c. 1490-8

Polish of a *rachunek* (cf. *Rechnung*). The law of many
towns was also Nuremberg or Magdeburg law.

There is a cultural aspect to these developments as
well. In Slovakia, in the town of Levoča whose master sculptor is to be
discussed presently, until the law changed in 1608 it was determined that for
someone to become a member of a guild he must be of legitimate birth, the
child of 'free and German parents'.[26] Similar circumstances may account for
the predominance of German sculptors in Poland, in Gdańsk, where Master
Alexis and Master Paul were active, in Kraków, where Stoss was active, and in
Warmia, East Prussia, where sculpture is found in Frombork (Frauenburg);
and in Austria, where there are major altarpieces still *in situ* in Kefermarkt and
Mauer, and formerly in Zwettl (now at Adamov u Brna in Moravia).

In older German historiography these circumstances were interpreted as evidence for German colonization, in which process Germans supposedly brought culture to the east; even some newer literature, including the 'new art history' of the late twentieth century, has not substantially broken with this line, in that scholars have continued to emphasize the supposedly German qualities of this art or of northern art in general.[27] The size, scale and quality of works by Germans in this region have thus been taken as expressions of ethnicity. On the other hand, the same works have been claimed for other ethnic groups and cultures, Slavic and Hungarian as well, with the result that much of this art still remains to be treated adequately.

Consideration of the work of two of the major 'German' masters, the authors of what are in fact the two largest limewood altarpieces in existence, are illuminating in this regard, especially since both of these works were made outside Germany proper. The first of these is by Veit Stoss. Although Stoss made important objects after 1500, after he had returned to Nuremberg, and even sent works to Florence, thereby becoming one of the few Germans whom Vasari bothers to note, Stoss spent a substantial period in Poland, where we have already met his work. In Kraków from 1473 to 1496, he created the altarpiece of the Death of the Virgin for St Mary's Church. To use the words of George Kubler, applied by Jan Białostocki to similar works in the region, this was a 'prime object', which was replicated throughout the area from Slovakia, through Silesia, to Danzig (Gdańsk).[28]

As Stoss's most opulent and impressive work, the altarpiece in Kraków has been given special attention by scholars, who have long acknowledged its importance in the development of German sculpture. Starting from premises which also relate artists and styles to national origins and nationalist intentions, both older and more recent writings have also suggested that the choice of Stoss and the 'florid' style he employed in the Kraków altarpiece was deliberate. This altarpiece is thus described as 'a work of German art in the church of the German community in the capital of Poland, at a time when the German community was increasingly under pressure from the growing power and success of the Jagiełło kings'. It is said to register 'this kind of aggressiveness, as a statement of Germanness in a Polish city – in a quite disturbing way'.[29]

It is worth dwelling on this view of Stoss's work in Kraków, because it reveals an interpretative crux. The interpretation that Stoss's is a deliberately German work represents a serious misreading of the documents and overlooks many other aspects of Stoss's role in Poland.[30] The documentary basis for the interpretation of the altarpiece as especially German is extremely flimsy. A seemingly nationalist account by the humanist Johannes Heydecke, which says that no Poles helped in the preparation of the altarpiece, and that it was paid for entirely by Germans, is first recorded a full century after the altarpiece was made; it is noted in 1585 in Polish, later in Latin, in a context which says the original document had been found in 1533, a date which is also some forty

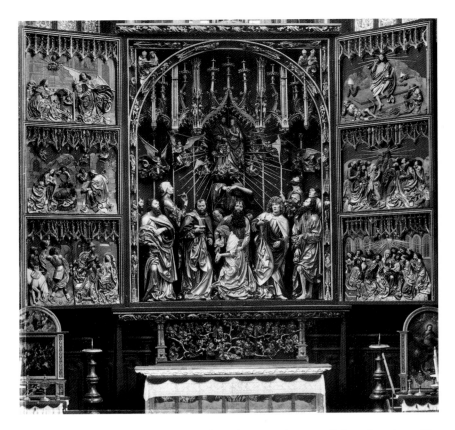

High Altar, by Veit Stoss,
St Mary's Church, Kraków, 1477-89

years after the completion of the altarpiece. Yet this original document does not survive.[31] In any event the document as recorded is self-contradictory and a part of the problematic reception of the altarpiece rather than an immediate source of information.

Contrary to Heydecke's assertions, the altarpiece was not commissioned by the local, predominantly German-speaking parish but by the city council of Kraków. This is an important point, since almost half of the council was Polish: seven out of sixteen senior councillors were Polish; three other councillors had married Poles; according to the initial donation, a document of 5 March 1473, the altarpiece was founded by a Pole; major gifts were made by Poles, and others from alms given by the whole community; it clearly had a mixed audience in the city.

The broader point to be made is that the whole question is much more complex, as complex as the history of the city of Kraków itself is. While Germans may have called Stoss from Nuremberg as a specialist in limewood carving to make a work for them, other citizens of Kraków had contacts with Italy and Hungary as well as with Germany (and Austria); mendicant

orders (Franciscans and Dominicans) tied it to France; there were many other groups, including Jews, Armenians and significant numbers of foreigners in town; Germans themselves often became Polonized. The author of the document under consideration, Heydecke, was himself a member of a *Sodalitas*, a fellowship founded by Conrad Celtis, the German humanist, in the years 1489–91, during the period of Stoss's work, whose values were hardly Germanic.[32] The Florentine humanist Ficino had had an impact on Celtis, and another Italian humanist may be associated with this group. This is the tutor of King Jan Olbracht of Poland, Callimachus (or Filippo Buonaccorsi), mentioned in the last chapter. He had come to reside in Kraków in the years 1472–96, during which period he overlapped and had contact with Stoss.

It is hardly possible to emphasize a split between the Germans in town, their artisans, and the court, because at the very time that Stoss was working on the St Mary's altarpiece, as noted, he also executed the tomb of King Kazimierz Jagielloñczyk, a work done in the previous tradition of earlier Polish tombs. This stone sculpture reveals the same florid style that supposedly pertains to the German medium of wood.[33] Significantly, at the same time as Stoss was working on the high altar of St Mary's Church, supposedly for Germans, he was also definitely working for a Pole, Slacker, for whom in the same church in 1491 he executed a crucifix in another kind of stone.[34]

It is also significant that at the same time Stoss was being employed by humanists: thus it is hardly accurate to consider him exclusively either a limewood or a Germanic sculptor without contacts with Italianate culture. Stoss carved a tomb for Peter of Bnín for the church in Włocławek, for which monument Callimachus himself composed an inscription. This tomb slab is done in red marble of probable Hungarian origin; its inscription is held by *pleurants* (mourners), of a traditional Burgundian form; significantly it has a form of lettering that also conforms to a Renaissance type. Stoss in fact also designed a tomb that was cast in bronze for Callimachus: this is the first tomb made for a humanist north of the Alps.[35] Even though this work was probably cast by the Vischer workshop (to be considered two chapters hence) back in Nuremberg, in its iconography and decorative motifs it announces the advent of the Renaissance to Poland. Its image of Callimachus places the scholar in his study; while the rendering of space and situation of the scholar therein does not reveal a complete mastery of representing the third dimension, such as contemporary Italians possessed, the ornament is clearly classically inspired, perhaps derived from prints, as could be much knowledge of Italianate art. It has further been suggested that Callimachus himself may be found represented on the St Mary's altarpiece.[36]

Finally, although Stoss certainly develops a virtuoso style of carving in wood, it is not unique to this medium. Its traits include folds piled up for their own sake; space created not freely but around the figures themselves, which are arranged in relief-like compositions; a lack of depth of movement of the figures;

and a lack of depth given to folds in middle values. The same characteristics appear in many sculptural media. The same qualities, of emphasized outlines, of folds shown with hatching, of a disposition to fine forms and planar composition, are also found in drawings and prints by Stoss.[37] Inasmuch as this same style appears not only in various sculptural media but also in works in entirely different techniques done by the artist, it cannot be deemed the result of a response to technique or medium, but of an individual disposition, which is either applied to a task at hand or else requested for one. The appearance of this style in two-dimensional media does not seem the result of a transference from three dimensions, but a trait of the artist himself, a sign of his virtuosity.

Epitaph of Filippo Buonaccorsi (called Callimachus), after 1493, by Veit Stoss, Dominican church, Kraków; probably cast in the Vischer workshop, Nuremberg

Of course, like the features of other contemporaneous sculptures discussed above, the characteristic traits of this style can be contrasted with Italian Renaissance designs. To that extent a contrast between the classic and the Gothic, or the Italianate and the indigenous Central European, or, to use some of the language of the time, the *welsch* and the *deutsch*, might seem relevant. It is, however, difficult to know what conscious choices or options might have been open to Stoss, who on his return to Germany was also associated with the most progressive, humanistically inclined group of artists in Nuremberg, to be discussed below. It thus seems necessary to take into account the Renaissance elements in his work; to note that his patrons differ; and also to note that materials – stone for the Wawel tomb versus wood for altars – differ. Commissions and genre may have made demands and caused pressure on the artist; the artist may have found himself caught between native and other circumstances. Indeed, a similar variation may be found in Riemenschneider's work, where

not merely the use of material determines style. The style of florid sculpture was widespread, but one of many alternatives.

This is suggested by the awareness of Italianate elements found in the work of an artist who evidently felt the impact of Stoss, as revealed in the largest winged retable in existence, a work found in Upper Hungary, modern Slovakia. Italianate elements had spread to this region from central Hungary already in the fifteenth century, as is evident from stylistic details of tombs of nobles in Spiš (Zips). Even farther off, in the region of Šariš, near the present border with Ukraine, the citizens of Bardejov (Bártfa, Bartfeld) had also responded to the Italian fashion by the first years of the sixteenth century. Although they had also commissioned many wood altarpieces in a Gothic manner for their parish church, which still houses eleven winged retables *in situ*, they expressly desired that their town hall be constructed *cum italicis finestribus* (with Italic windows). To carry out this work they engaged a 'Master Alexius from Venice' (whom earlier German art historians writing on Slovakia characteristically called Master Alexander and treated as a German).[38] In this structure, the steep proportions, chimneys and finials of whose roof indicate the late Gothic, there appeared from 1501 to 1509 quite correct Italianate doorways and windows, a coffered ceiling and an entrance loggia.

These circumstances also reveal important elements of the artistic milieu of the world in which the largest winged retable in existence, 61 feet high, was created by Master Pavol z Levoča (Paul von Leutschau) in the St James's Church (Jakobskirche) of that town *c.* 1508–17. Like Bardejov, Levoča (Leutschau, Löcse) had grown prosperous as a centre of trade situated on the route from Budapest to Kraków. Pavol z Levoča's high altarpiece is in fact but one of many works still in Levoča churches, including several other pieces from his workshop. The commission for this work may be the result of the expressed wishes of the brotherhood, who paid for it, according to a 1517 payment.[39] The sculptor is referred to in German as Paul Schnitzer, and his sculpture is related to the style of Veit Stoss, but it also seems to rely on the work of other Nuremberg workshops such as that of Michael Wolgemut, Dürer's quondam teacher.

Pavol z Levoča also executed works which are spread throughout areas of central and eastern Slovakia, a region which remained very prosperous until its mid-sixteenth-century decline (caused by the disruption of trade routes by the Turkish wars and the discovery of mines in the New World). Many of these works seem to reveal the pronounced 'florid' style of limewood carving supposedly characteristic of south Germans. However, one of these works, his St George altarpiece of 1516 for Spišská Sobota, which is contemporaneous with the artist's great altarpiece for Levoča, indicates that even at the height of his career he was not producing what might be called purely German works. The figure of St George might be seen as a typically knightly figure, a popular saint on horseback who is the subject of numerous works throughout Central and Northern Europe, spread by Bernt Notke from Stockholm to Talinn

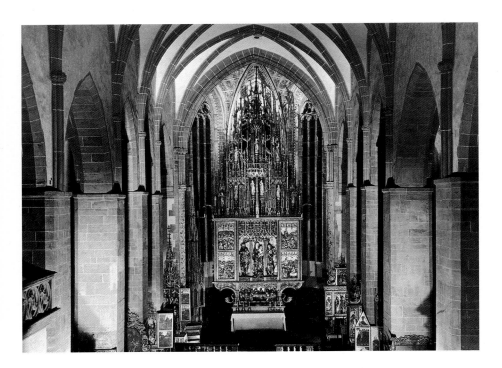

High Altarpiece, St James Church
(St Jacobskirche), Levoča, Slovakia,
1508-17, Master Pavol z Levoča

(Reval) on the Baltic, by Henning van der Heide in Lübeck, by Master Alexis in Gdańsk and by Master Pavol himself in Levoča. In many of these places he is also probably associated with the patronage of merchants and seafarers.[40]

In Spišská Sobota, however, the figure of St George with a dragon was placed in a shrine that includes typically Renaissance motifs such as a garland and putti: these features point to the presence of Renaissance elements even in this seemingly quintessentially Germanic altar. The artist would have been well aware of such forms from the activity of Italianate masons more or less simultaneously in the same church. There, as in buildings of other towns in the area (Rožnava and Lipniany), a Master Vicenzo 'de Ragusa' (Dubrovnik), who had come from the Venetian cultural ambit (as had Giovanni Dalmata, or Francesco Laurana, mentioned in previous chapters), executed a series of doorways, a tabernacle and a pulpit.[41]

This situation suggests that even in provincial Hungary the development of a supposedly Germanic art paralleled the introduction of the Italianate, to which it responded. Many different cultural elements and pressures existed throughout the region. Stoss and Pavol z Levoča may have been associated with efforts at bourgeois self-promotion through art, and their works considered as corporative projects, but there is as much justification, or even more, to say that theirs were civic expressions, as to claim them as German ones.

On the other hand, while Marxist historiography conventionally designated the period *c.* 1500 as the age of the early bourgeois revolution, and associated these sorts of works with that movement, the courts were clearly not isolated from other milieus. The courts themselves were composed of a variety of personalities. The most comprehensive study of culture in relation to society at the court of Maximilian I has indicated that his court is not to be understood as a self-contained entity in the way that Louis xiv's Versailles was.[42] Discussion of humanists in Poland may have already suggested that the situation in Jagellonian Poland was substantially similar.[43] Central European courts in *c.* 1500 consisted typically of a group of retainers, both bourgeois and noble, around the prince. In Maximilian I's case his court cannot even be associated with one fixed abode, since, even though he often stayed in Innsbruck, this peripatetic ruler did not keep a fixed residence.

In its constitution the court thus contained many of the different groups who were vying for prestige and power: the ruling family, their bourgeois servants and also aristocrats and gentry. In Poland and Bohemia, as well as in Hungary, the power of this latter group, of the seignior and the magnate, was on the rise. This estate also managed to increase its income, thus allowing for expenditure on the arts, often in competition with or emulation of the monarch. Against the seigniors' claims of blood, bourgeois servitors, often learned men (*docti*), promoted their status with claims based on learning.[44] Their ambitions, and the patronage that stemmed from them, were not essentially different from those of the newly wealthy capitalists discussed in this chapter, who also had the means to realize their ambitions and the desire to express it through some form of display. And this pattern fits the eastern parts of Central Europe, as well as Germany, where the bourgeoisie could also obtain a kind of symbolic ennoblement through art.[45] Thus all these groups had an interest in representative or symbolic display in which the visual arts could play a key role.

Therefore, although at first the traditional contrasts, if not of ethnic styles, of social groups and art may seem to hold up, the presentation of the northern Renaissance as a bourgeois affair, as it has often been read, may also appear in the end to be itself the result of ideological currents in scholarship, both liberal democratic and Marxist. It is true that in towns and cities wealthy patricians had a lot to do with the patronage of art, as also did church confraternities and groups, but Stoss's case suggests that major artists were at the same time also the recipients of important court patronage. Even at the Hungarian court, where the patronage of Italianate works has been emphasized, it is also likely that the king commissioned winged altarpieces in Germanic and Netherlandish styles, as indicated above. The inflections and choices available in the period *c.* 1500 were much more complicated.

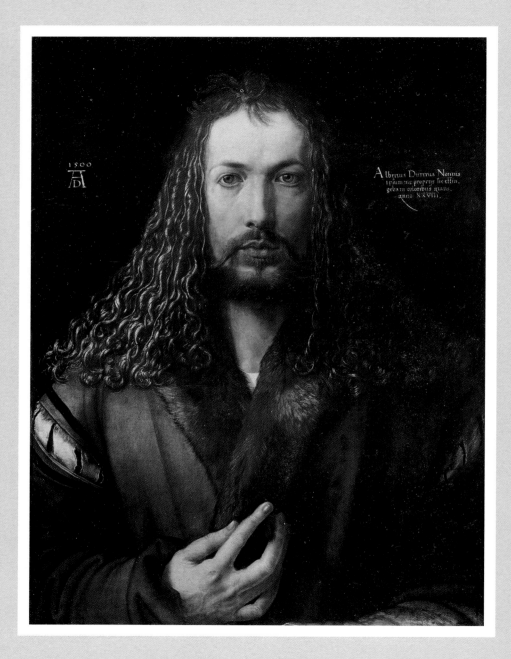

THE RENAISSANCE IN GERMAN-SPEAKING LANDS: DÜRER, HIS CONTEMPORARIES AND HUMANISM

Self-portrait, 1500, Albrecht Dürer,
Munich, Bayerische Staatsgemälde-
sammlungen, Alte Pinakothek

PROMOTED BY COURT PATRONAGE, WORKS IN THE NEW ITALIANATE
MANNER WERE FIRST SPREAD BEYOND HUNGARY IN THE PLASTIC ARTS
OF SCULPTURE AND ARCHITECTURE.[1] Most of our attention so far has thus
been directed towards these media. Yet a consideration of the meaning of the
Renaissance as a common cultural denominator in Central Europe must take
more carefully into account the pictorial arts, including painting. In fact, the
period *c.* 1500 that is identified with the Renaissance by some art historians is
also associated with one graphic artist and painter in particular: this period has
also been called the time of Dürer (*die Dürerzeit*), an artist who, just as
Maximilian I or the Jagellonians have done, has thus given his name to an
entire historical epoch. Albrecht Dürer (1471–1528) can here be taken as a
paradigmatic figure, because his life and work not only illuminate the history
of some media or, even more broadly, of German art, but also pose larger
questions about the interpretation of the Renaissance in Central Europe in
general, since knowledge of his prints and the activity of his pupils were not
restricted to Germany but spread throughout Central Europe, even as far as
Italy.

This chapter will accordingly undertake first a brief review of some major
previous interpretations; then a review of those aspects of Dürer's life and work
that provide salient traits for a consideration of the Renaissance; and finally
some reflections on or generalizations from this example. The treatment of
Dürer by historians indicates that, along with the artist himself, German art

c. 1500 has in general been received in a variety of ways; more important, it also indicates that his art, along with that of his contemporaries, may be situated in a wider cultural context. In the past Dürer has been used for many purposes, many of which have been central to the conceptualization of German art *c.* 1500; in this book his work, and especially his reaction to Italian art and culture, is also to be utilized as a guide to understanding the indigenous interpretation of the Renaissance in Germany.

Dürer has, for example, been used to support a social historical view of the Renaissance as a bourgeois phenomenon. In this light he has often been treated not only as a great master but as the artist most characteristic of the urban, middle-class scene. There is some basis for this interpretation: Dürer's career did centre on his birthplace (Nuremberg). As previously suggested, major sites of artistic production were located in places like Nuremberg, or Augsburg, which with 40,000 to 50,000 inhabitants each were regional foci of civilization.

Speaking of these sorts of circumstances, Erwin Panofsky could say with some justification that

> the German Renaissance movement was bourgeois and, as it were, centrifugal, where the Italian was aristocratic and centripetal. Italian humanism could rely on the gravitational attraction of cosmopolitan centres like Florence, Rome and Venice and on the abiding interest of an aristocracy which produced an unlimited supply of erudite and art-loving princes and cardinals. German humanism had to invade the homes of the better classes, nobility and bourgeoisie alike. It had to create, rather than to answer a demand for the values of "modern" art and to propagandise for culture....[2]

But previous chapters have suggested that the separation between city and court, between bourgeois and aristocratic conditions of production, was not fixed. In Central Europe, as in Italy, both aristocrats and bourgeoisie increasingly had demands for art. While artists themselves may have been townsmen, many of the Central European courts were also located in major cities. Even those artists who made their living primarily through means other than princely patronage were also employed by courts. Not only Dürer but also Altdorfer, Cranach and Burgkmaier worked for Maximilian I; other German artists served the Polish court; moreover Dürer, Cranach and other figures also worked for other German courts, such as that of Frederick the Wise of Saxony. Indeed, Cranach's career followed the fate of the Saxon courts. Although it is not the subject of this book, the trajectory of humanism in the north is also similar.

While earlier in the twentieth century art historians such as Heinrich Wölfflin tried, albeit unsuccessfully, to disprove this older 'Romantic' myth of Dürer as the typical bourgeois, other myths grew up in its place. For instance, Henry Thode gave voice to another line of interpretation. He argued that the appearance of Italian elements in Dürer's art, and their ultimate predomi-

nance, in effect precluded an authentic German expression in figural art. This sort of interpretation points to the way in which the mythic image of Dürer has helped shape an isolated, at times nationalistic, view of German art.

Wölfflin and many others also utilized Dürer's work to define the German-ness of German art, 'the German feeling for form', as Wölfflin put it. Even where Dürer's response to the non-native had to be recognized, the distinct qualities of his art as an expression of Germanness were stressed. While for some writers Dürer's art, like that of his contemporaries, could simply stand for what was best in German art, for others it was what was most German. Hence one work of the early twentieth century could talk of 'Dürer as Führer'. In darker times the thesis of Dürer as the leading, quintessential German artist assumed the colouring that this language implies: he was treated as a hero by the National Socialists (he was one of Hitler's favourite artists). Consequently it would almost seem as if a brake was applied to the treatment of the artist in post-1945 Germany.

Dürer could nevertheless continue to serve as the paragon and paradigm, for the period of the 'Old German Masters', discussed above. Dürer's career encompasses this epoch, and his life demarcates the period: with Dürer's death in 1528, approximately at the same time as that of other German artists, the era of the 'Old Germans' is often thought to end. Treatment of Dürer as a canonical, indeed often the major figure in German art history has been used to reinforce the selection of this epoch as an acme in German culture, after which a decline is said to begin.

Yet it has long been known that Dürer's family came from Hungary. Dürer's father moved to the prosperous town of Nuremberg (where Albrecht was born in 1471), probably in response to disruptions caused by the Hussite wars. Moreover, it now seems likely that the family was in fact Hungarian in origin, rather than German.[3] If so, the fact that a man who has often been called the greatest German artist was not an ethnic German should not only give pause to arguments about the artist's innate Germanness but also be a fitting expression of what this book argues is in any event the multi-ethnic character of art in the entire region.

To counter the nationalistic, and often irrational, view of Dürer, Erwin Panofsky presented his own masterly monograph on the artist. This work bears the significant initial date of publication of 1943, in the midst of the Second World War.[4] Jan Białostocki has said of this book that 'after years of irrational and nationalistic deformations, optimistic, beautiful and reasonable reality was presented.'[5] Like the tradition to which he responded, Panofsky, however, tried to characterize Dürer and the German Renaissance in general, as phenomena distinct from the Italian. Still, in distinguishing Dürer's charac-teristics, Panofsky's monograph, and many of his other publications on the artist, also illuminated a theme that is central to the discussion of the present book. Panofsky offered an account of Dürer's response to the Italian Renais-sance and, through it, to the antique.

Dürer was probably trained in a manner traditional to the area. He learned the craft of a goldsmith and then worked in an atelier involved in the manufacture of altarpieces, like that of Michael Wolgemut mentioned in an earlier charter. Still attracted by works in a 'late Gothic', northern fashion, which he had come to know from prints, Dürer began his journeys in 1493 with the intention of visiting the painter and engraver Martin Schongauer.

By this time, however, Dürer had already become familiar with Italian art. He had done this in the way in which many northern artists of his time learned about the art of the peninsula, even when they had not yet visited Italy or come into contact with the few Italian artists already in the north or with their works in the north, and probably in a similar way to which Dürer came to know about other transalpine artists – he had seen Italian prints. The prestige of Italy, and through it that of ancient Rome, exerted a powerful pull even for artists who lived outside the area where its remains were to be seen, since Rome, and more generally the Latin tradition, represented the language of the church, of learning, of political models and other cultural traditions. Panofsky, and indeed scholars since Aby Warburg, have moreover argued that through Italian prints Dürer in particular learned first of a different manner of depicting emotion and its expression; as he was ultimately later to do through other Italian works, he thus, like many other artists in Central Europe, earned about ancient art at second hand. Images made by Italians also provoked an early interest in learning at least about the Italianate at first hand.[6]

While Dürer's decision to direct his *Wanderjahre* south was perhaps somewhat unusual for artists of his time, the probable route he would have taken in the 1490s was a well-trodden one. When Dürer went to visit Venice and nearby Padua, he would have travelled south along a route taken not only by pilgrims but more particularly one followed regularly by many German merchants, especially from places like Nuremberg, as well as by the numerous German youths, like his friend Willibald Pirckheimer, who went to study at Bologna and Padua.

Although Dürer seems to have gone in search of the Italianate, it is also remarkable that on his way there, and also probably on his return, he became one of the first German artists to paint and draw landscapes which he probably actually executed in nature. Dürer's marvellous watercolour landscapes, which are suffused with atmospheric qualities, are in any event one of the many important innovations in his art, to be considered along with his eventual assimilation of Italian art. Together with his plant and animal studies, his landscapes also represent another lasting aspect of his artistic legacy.

Dürer maintained his interest in nature studies, as evinced by his famed watercolour and gouache *Great Piece of Turf* and his equally well-known *Hare*. Earlier Flemish painters had of course meticulously replicated details of the world around them. Contemporary northern artists, for instance illuminators of books in Ghent and Bruges, also demonstrated an interest in elements of the representation of nature. While he may also have a German forerunner in

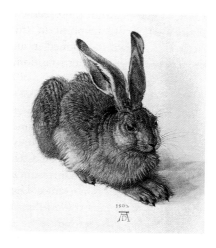

Hare, watercolour and gouache,
1502, Albrecht Dürer, Vienna,
Graphische Sammlungen Albertina

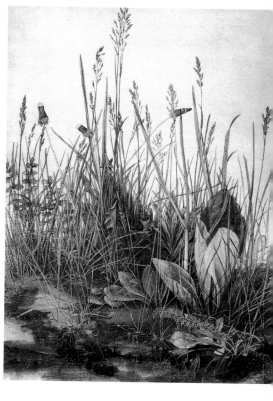

Great Piece of Turf, watercolour and
gouache, 1503, Albrecht Dürer, Vienna,
Graphische Sammlungen Albertina

Martin Schongauer in this regard, Dürer is important as an artist who actually made extensive studies of creatures in nature for use in his paintings.[7]

It might seem as if these interests are independent of what is strictly considered the Renaissance, defined as an Italianate style or one associated with the revival of antiquity, as these issues have heretofore been treated in this book. However, since at least Jacob Burckhardt's *Civilization of the Renaissance in Italy* it has also been been said that the Renaissance experienced a discovery of the world and of man. Burckhardt in fact specifically evoked Dürer's landscape compositions when he described how the beauty of nature had been discovered by Renaissance writers and artists. Dürer's landscape watercolours seem to provide a close illustration of what Burckhardt is talking about when he claims the Renaissance discovered natural beauty.

Burckhardt's views have not gone unchallenged, and since his time substantial debates have arisen about the relationship of art, empirical observation and humanism. In short it may be said that these interests and concerns seem much more interrelated than previous scholarship allowed, particularly in the hands of someone like Dürer.[8] In making landscapes, plant and animal studies based on what he observed, Dürer, like the Italians, created images that may be related to one of the central normative concepts of the Renaissance,

the observation of nature as a guide for art. On the other hand, the products of antiquity were not alien to nature but, in this way of thinking, represented nature purified.[9] Since, as E. H. Gombrich has argued, making comes before matching, following nature and following the model of the antique could even be regarded as compatible.[10]

In Dürer's mind these interests could be conjoined. One of his most famous studies of nature, the wing of a jay, was used precisely in a work that not only displays an extensive landscape but represents a subject taken from classical antiquity, *Nemesis*. Moreover, although it is not obvious at first glance, this engraving presents in the female personification of Nemesis an ideal for perfect human proportions, comparable to that which other Renaissance artists found embodied in classical sculpture. Yet her features are particularized. The two approaches and traditions are fused so seamlessly together that their presence and the meaning of the object is not at all apparent at first glance.

After his return north in *c.* 1500, Dürer was especially stimulated in both sets of interests by an Italian artist, Jacopo de' Barbari. De' Barbari, a Venetian, had, as noted, worked at the court of Frederick the Wise, for Maximilian I and also in Nuremberg – therefore in many of the milieus mentioned so far with which Dürer was also associated. On the one hand, De' Barbari executed prints with classical subject matter, that also seem to be based on antique models; on the other hand, he was also one of the first artists to execute easel paintings with independent still-life subjects, such as birds, that are also based on the close study of nature. De' Barbari was therefore engaged in artistic activities that were similar to Dürer's.

Dürer, furthermore, says that De' Barbari stimulated his interests in the rational and systematic investigation of human proportions by showing him such a study.[11] In this way Dürer became concerned with some of the issues that had become current in Italian Renaissance art. His search for the principles of human proportions was anchored in a belief that there was an ideal of beauty, which was qualitatively identifiable and quantitatively measurable. This ideal was embodied in the vision of nature that had been presented in the works of antique masters. As current thinking in Italy also maintained, however, art could be formed on a basis not only of imitation but of rational construction. In addition to the empirical observation of nature, a process of rational analysis could thus also enter into thinking about and making art.

An interest in theoretical questions, grounded in his artistic practice, ultimately led Dürer to another level of understanding of the Italian Renaissance. Although obviously not the first northern artist to go south, Dürer, unlike many other northern artists who emulated southern models, would eventually be led not to produce superficial imitations of Italian Renaissance prints; he would not even rely on Italian models he had seen directly, like Venetian painting, nor simply depict subjects from the world of antiquity, following a contemporary fashion for representing such themes as Hercules

and Orpheus, which he had indeed derived from Italian prototypes. Rather, he would strive to understand some of what he thought were the underlying principles of Italian Renaissance art.

Some of Dürer's new concept of art and the artist is summarized in his self-portrait of 1500. Although on one level the artist's Christ-like self-image recalls religious ideals such as the notion of the imitation of Christ, it may also be read as a statement about art: the image suggested is that of the divinely inspired artist. It was in the guise of an inspired artist that Dürer was celebrated by Conrad Celtis, who also may have helped him with the proud Latin inscription that takes a prominent place on the painting. This inscription is, moreover, written in *Antiqua* script (Roman lettering) and thus suggests the artist's adherence to the new intellectual tradition, since script is often a key to this sort of attitude.[12]

In this connection Dürer is also tied to the humanist tradition. Throughout his mature years he was friendly with humanists, including Hartmann Schedel, Celtis, probably Sebald Schreyer, and Willibald Pirckheimer, the last of whom was very familiar with Greek, as has now been thoroughly demonstrated.[13] Dürer decorated manuscripts with classical subjects and illustrated works by Celtis. He engraved portraits of Pirckheimer and Erasmus, and portrayed himself together with Celtis in his painting of the *Martyrdom of the Ten Thousand* as a posthumous homage. It has also been suggested that the complicated iconography of some of Dürer's more ambitious prints was done under the direction of a figure such as Pirckheimer.[14] This was clearly the case in the Dürer design for the summit of the triumphal arch of Maximilian I, whose hieroglyphic imagery the humanist Stabius designed.[15] In turn, humanists such as Erasmus and Celtis commented on the artist, who in much of this Latinate literature in the north became the typical artist.

In Dürer's case it is thus obviously incorrect to separate the tradition of the visual arts in Germany from humanism. Dürer may just as well mark the beginning of a continuing and fruitful history of collaboration between artists and humanists in Germany. Dürer was not merely a craftsman, although he addressed the concerns of craftsmen and artists. In his friendships and intellectual interests, he crossed the boundaries that Italians had already transgressed between craft and literature.[16]

In these matters, as his painted self-portrait of 1500 and several of his utterances also suggest, Dürer demonstrated that he was acutely aware of his social position as an artist, to whose elevation in status he helped contribute. His comments on the difference between the respectful reception he enjoyed in Italy and his role as a 'parasite' (*Schmarotzer*) at home are a notorious example of this social self-consciousness. For him, as for Italian artists before him, art could be a theoretical, intellectual activity, with principles that could be learned (in German, a *Wissenschaft*). Hence, painting could become a liberal art, as it had already become for Italian painters. When Dürer came to

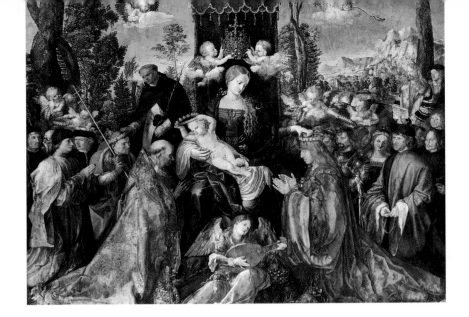

Rosenkranzmadonna (Madonna of the Rosary), Altarpiece, 1506, Albrecht Dürer; Národní Galerie, Prague

relate geometry to the concerns of the craftsmen and the artist, he himself began to approximate the new Renaissance ideal of the artist as thinker.

It was out of his concern with issues such as determining a basis for the rational understanding of human proportion that Dürer went back to Italy in 1504–5. As his remarks just quoted indicate, he gained respect in the south, encountering such painters as Bellini in Venice and executing for the German church his celebrated version of the *Madonna of the Rosary* (*Rosenkranzmadonna*). He also responded to evidence for the treatment of questions of proportion and other pictorial issues that were apparent in the newer art of Italy. The Italian model provided him with an ideal which incorporated the results of his studies of such questions, as well as a knowledge of the antique.

Along with his attention to careful depiction of the details of nature, traces of these concerns thus appear in much of his work. The evidence for Dürer's reliance on the Italian Renaissance and also classical models is well known. In famous images such as his engraving of *Adam and Eve* the figure of Adam is not only derived from classical statuary but represents, as does his Eve, a compilation of proportional ideals. In it, moreover, a literally Apollonian ideal (Adam derived from a recently discovered antique statue, the *Apollo Belvedere*) is combined with an interest in descriptive qualities and naturalistic details, as evinced by the presence of animals and wooded landscape. Similarly engravings, most successfully his *St Jerome*, evince an interest in both the surface qualities of things and their different textures, as the burin can catch them, and also an Italianate fashion for perspective.

Dürer's interests, especially in proportion and perspective. led him to become the first German artist to make a contribution to Renaissance art

theory. His writings include books on instruction in measurement (*Unterweysung der Messung*) and on proportion (*Die Vier Bücher von Menschlicher Proportion*). In these he developed first his ideas on the regular and ideal relation of parts of the body to each other. Dürer adapted Italian ideas to his own concept of 'qualitative proportion'. As his image of Adam had already suggested, the foundation for this idea was the notion that the macrocosm of the universe paralleled the microcosm of man. The universal was paralleled in the individual.[17]

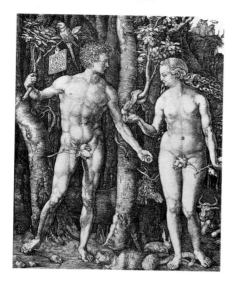

Adam and Eve, engraving, 1504, Albrecht Dürer, Kupferstich, Berlin

The question of proportion was for him related to that of the location of figures in space, and led on to that of perspective. Space could be made rationally commensurable: just as figures could be represented in rationally conceived proportions, so could they be related to each other. Where earlier northern artists had created illusions of pictorial space that may have been emotionally convincing, their works were at best empirically constructed. Dürer did not remain satisfied with this approach, however. He not only developed and illustrated devices that would help represent figures in foreshortening and in a perspective grid but also advanced the work of Alberti, Piero della Francesca and others. Where the Italians had discussed means of constructing a painting according to perspective, Dürer also provided two demonstrations of

Illustration from *Vier Bücher von Menschlicher Proportion* (Nuremberg, 1528), Albrecht Dürer

procedures for achieving this construction. His practical demonstration thus complemented this theoretical approach.

A similar approach was applied to the treatment of light and shadow. Light is an elusive phenomenon, but considerations of illumination are necessary for

making a convincing construction of the three-dimensional world. Light gives clues to the location of figures in space, and the relationship of one figure to another, through cast shadows; it also gives clues to the solidity of figures, and their volume, through the creation of attached or modelling shadows. Dürer developed the first convincing demonstration of the treatment of the projection of shadows in perspective. Dürer thus dealt with a problem that had been implicit in writings on perspective, but had not been substantially considered by Italian writers on art before Leonardo, whose writings were however not published during his lifetime. While a successful solution had eluded Leonardo, Dürer arrived at one and offered it directly as part of his demonstration of perspective.[18]

Dürer also addressed several other concerns of Italianate art theory. He wrote on the representation of the human figure in motion. He also considered other concerns of pictorial composition, that may be related to humanist-inspired art criticism. Alberti had derived the principles of pictorial composition from those of rhetoric. There are many other suggestions implicit in Renaissance writing on art that the principles of poetry and rhetoric apply to painting.

Like the Italians, Dürer also seems to have grasped how visual images could present a kind of pictorial rhetoric. For example, the idea that eloquence depends on both the variety and copiousness of forms represented may be suggested by the multitude of symmetrically placed figures found in his All Saints altarpiece (now in the Kunsthistorisches Museum, Vienna). Other details of his work suggest that he may have incorporated other Italianate motifs. For instance, the complementary uses of *contrapposto* (contrasting pose) that appear in his images of *Adam and Eve* suggest that he was also aware of the functions of a kind of visual antithesis. These observations are borne out by some of Dürer's own comments.[19]

In both artistic and theoretical accomplishments, Dürer can therefore be considered one of the most outstanding artistic and, more generally, cultural personalities of his time. He also originated a modern literature on, to a large extent, a new form of art, that would reverberate in a German context for generations to come. Later German writers of handbooks on art, as well as artists, would pick up on his innovations further.

Yet the vision of Dürer as the great, or quintessential, German figure has ironically also promoted an image of the artist as a unique or extraordinary figure. While Dürer's impact and subsequent canonical status remain unchallenged, just because of his extraordinary accomplishments, an argument has been made against using him as a key to the 'visual culture' or 'period eye' of his time. This has been directed specifically against what have been recognized as the authentic Renaissance elements in his art and thought. It has accordingly been argued that 'in 1500 Dürer with his Italianate intellectual interests and energy was a nonesuch in Germany'.[20] And such an argument has some merit, in that it is perhaps true that the nascent criticism of the German

humanists, with which his theory may be associated, is not consonant with the limewood sculptors; Dürer and the humanists cannot speak for all the artists of the time.

Nevertheless, if we do not seek for some mythic Nordic visual culture that emphasizes the indigenous as something separate from other elements, including the Italianate, there can be found more instances from Dürer's time to which his cosmopolitan interests and accomplishments and not just the local, 'Germanic' features of his art, may be related. Central European art is polyphonous, not univocal, and there is as much justification for relating the Italianate, or supranational, elements, even in German art, to Dürer as there is to seeking some uniquely distinctive character in them. However, discussions of the German Renaissance have, with very few exceptions, so concentrated on the supposedly defining characteristics of art and culture in Germany that, aside from treatments of Dürer, qualities that German art shares with art in Italy or, for that matter, with the Italianate elsewhere in Central Europe, have very rarely been the focus of scholarly study or of popular presentation.[21]

However much such notions have come to dominate thinking about the arts, especially in the English-speaking world, to ignore the way in which the classicizing and Italianate interests that are so important in Dürer's work become those very elements that continue and are developed further by painters, engravers, sculptors and architects in the sixteenth and seventeenth centuries is to misrepresent the history of art in Central Europe. We do not need to overstate the reliance of Germans on Italian art, or what is understood more generally about the Italian Renaissance, to begin to try to become aware of the importance of cultural interchange and transformation, not only in Germany but throughout Central Europe in the sixteenth century.

It seems to be the case that much of the available evidence for the German Renaissance, conceived as part of a broader European phenomenon, has hardly ever been assembled or analyzed, much less compared with that of other Central European lands. The cultural history of German Renaissance art, considered in a stricter sense, as a phenomenon related more closely to the broader European Renaissance, not to mention the history of the Central European Renaissance, as argued here, remains to be written. In this situation only a few brief remarks can be made to point to the sorts of phenomena in Germany that might concern a real history of northern Renaissance art – not just that well-worked compendium of Netherlandish easel painters from Van Eyck to Peter Bruegel the Elder, with Dürer, his German contemporaries and some sculptors thrown in, that mainly passes for the subject in the English-speaking world. For these other Renaissance elements are the phenomena that link art in early sixteenth-century Germany both with its continuing local history and with the culture of the neighbouring lands.

In the first place, Dürer's typicality can be gauged from the effect he had on future developments, from the theoretical and practical innovations that he

introduced into German art and from those elements that he thus interjected more generally into Central Europe, as communicated through his prints and his pupils. This effect is certainly evident in a wide variety of areas. His images became part of a broad, popular tradition. They were copied by many artists. They were used in stone sculpture, prints, secular painting, small-scale works of applied art and in painting. His theoretical writings also initiated a stream of handbooks on art (*Kunstbüchlinnen*).

In his own time, moreover, Dürer had a large impact that ranged far beyond his own immediate sphere of operation, while it certainly started there. From early in the sixteenth century he maintained an important atelier in Nuremberg. The group of artists trained or associated with this workshop include many of the important pictorial artists of the era: Hans Schäuffelein, Wolf Traut, Hans von Kulmbach, Hans Baldung Grien, later Georg Pencz, and Barthel and Hans Sebald Beham. Dürer instructed these men not only in his graphic style but in his interests in such matters as human proportion as well. In turn these artists spread Dürer's style not only in Nuremberg and its environs but to other areas as well. As remarked, these included Kraków, where Kulmbach and Dürer's brother worked and where, in the Wawel, Pencz supplied paintings. Dürer himself contributed to the dissemination of his own art, when he supplied designs for the Fuggers in Augsburg as well as for the Habsburgs in Austria.[22]

It is even incorrect to treat Dürer and his workshop as isolated from the limewood sculptors. Much as Veit Stoss collaborated with the Vischer workshop, which as we shall see also became an important centre for humanist art, so did his workshop (or that carried on by his son) complete designs after Dürer.[23] But the immediate impact of Dürer is only one aspect of the question. A broader context exists for Dürer's art and for the reception of the Renaissance in the north outside the courts.

Evidence not only from Nuremberg, which has been called a 'Renaissance city', but from many other places – Augsburg, Bern, Vienna, Zürich and other cities – bears out the pertinence of this term.[24] The work of many artists reveals signs of the Renaissance. These may be defined as an association with humanists, the recurrence of classical subject matter, often along with the adoption of Italianate, *all'antica* style, including ornament and lettering, and a concern with the pictorial inventions of the Italians, such as Albertian perspective.

The new humanist discourse on the arts may not offer the complete story on the world of the artist in the north, but the manifold connections between German artists and humanists should not be overlooked. Stoss's associations with Callimachus have already been noted, but he was not the only sculptor to design a humanist's epitaph. The Augsburger, Burgkmaier, whose collaboration with Celtis has also been discussed, prepared a woodcut *Sterbebild* (portrait in death) for the German 'arch-humanist', in which the bust-length effigy of Celtis and an accompanying inscription recalling his deeds revive the

tradition of Roman gravestones.[25] The appearance of Apollo and Mercury with Erotes bemoaning the lost humanist also recalls the world of antique imagery. This classicizing form remained current for epitaphs of other humanists, such as that of Johann Cuspinian of 1529 in St Stephen's Cathedral in Vienna or that of Aventinus (died 1534) in St Emmeram's, Regensburg. Other artists like Riemenschneider developed different forms for humanists like Johannes Trithemius, whose epitaph of 1506–16 adorns the Würzburg Neumünster: there a modified classicizing frame surrounds a figure of the dead humanist, who is depicted according to a drawing by the sculptor. Another stunning example of this type of monument is Peter Vischer the Younger's relief epitaph for Dr Anton Kress, in which the prelate is situated in an arched classical niche, with conch decoration.[26]

Many other associations existed between artists and humanists. As early as 1493 Sebald Schreyer commissioned Peter Danhauser to write the *Archetypus Triumphantis Romae*, a work for which Michael Wolgemut supplied woodcut illustrations, some of them based on Italian models. Schreyer's own library, a centre for humanist meetings, was decorated with classical subjects, most likely by someone from Wolgemut's workshop.[27] Cranach portrayed Cuspinian, and it is likely that Celtis helped the Vischer workshop with the design of the tomb of St Sebald in the church dedicated to him in Nuremberg. Vischer was also associated with Pangratz Bernhart *genannt* Schwenther, whose book he illustrated.[28]

Orpheus and Eurydice, plaquette by Peter Vischer, Berlin, Stiftung Preußischer Kulturbesitz, Skulpturen-abteilung

The subject matter of many of these works was of course also classical. This pertains to the drawings of subjects like Apollo and the muses, to brass plaquettes of subjects like Orpheus, or to drawings by Vischer in Nuremberg, as well as to the creation of bronzes. In painting this involves the introduction of classical themes like these found in the subjects of Lucas Cranach's painting, *Venus and Cupid*, the *Judgement of Paris* or *The Nymph of the Source*. And in Altdorfer's oeuvre there are other such treatments of mythical and historical matter.

Besides subject matter, many works by German artists other than Dürer incorporate those other elements we have learned to associate with

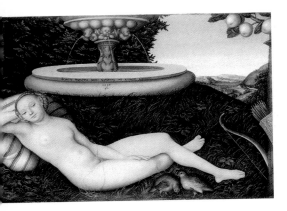

Renaissance style. These include such features as the use of humanist-inspired script, the employment of *Antiqua* writing, or Renaissance lettering, together with Carolingian minuscule (script), or ornament of an architectural variety. These elements may be found in the work of artists whose qualities are not otherwise classical in nature: for instance they appear in the limewood sculpture of Hans Leinberger. Similar classicizing details are also found in many works by the sculptor Loy Hering in southern Germany, by Adolf and Hans Daucher in Augsburg (also found in Annaberg) and by the Vischer group in Nuremberg.[29] By the second decade of the sixteenth century, architectural ornament *all'antica* also began to be introduced into the doorways and windows of structures that also were not otherwise classicizing in appearance. These include the doorway to the sacristy in St Anne's Church in Annaberg, that to the sacristy in the cathedral in Breslau (Wrocław) in Silesia (if this is not by an Italian), where classical pilasters are already found in an epitaph of

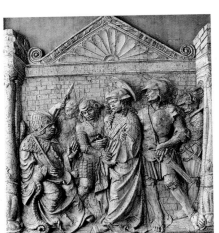

Detail, *St Castulus brought before Diocletian*, High Altarpiece, Stiftskirche, Moosburg, 1514, Hans Leinberger

1488, and by 1520 the portal of the Salvatorkapelle in Vienna in Austria.

Other stylistic elements first utilized in Italian systems for spatial representation, such as the use of perspective and foreshortening, are also found early in German works of art. These include their appearance in works by the Vischer group and even earlier in the painting of Michael Pacher in such works as the St Wolfgang altarpiece, which employs a form of spatial construction that implies a knowledge of Mantegna and northern Italian art. Similar features are also found in the works of so-called 'minor masters', such as those done in Solnhofen stone (honestone) by the Dauchers, one of those workshops also completed the high altarpiece in Annaberg. Other sculpture by Conrad Meit, for example his *Judith*, seem to reveal the use of classical forms; and similar examples are to be found in the sculpture of Hans Weiditz.

Furthermore, the growing prevalence of bronzes and work in brass that is related to them, especially in Augsburg and Nuremberg, as also exemplified by the production of brass plaquettes, may itself represent the reawakening of an antique tradition. Elements of technique include the revival of the lost wax technique in Peter Vischer the Younger's sculpture. Not only the medium of metal and related techniques but also the genre of the medal or medallion are derived from the antique. The Vischer workshop produced medals and plaquettes containing scenes of Orpheus and Eurydice. The figures of ancient gods and heroes in these works could also stand comparison with similar pieces in Italy.

High Altarpiece, St Annenkirche, Annaberg, 1518-22, by Adolf (and Hans) Daucher

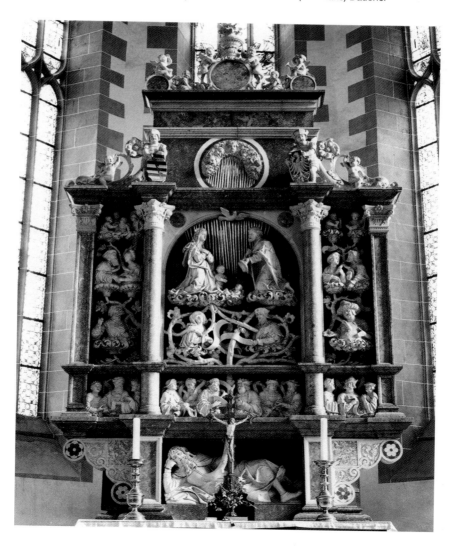

The question of the origins of this art is not at issue here either. Michael Baxandall argues that early manifestations of Italian style in German sculpture were

> *initially affected by a very limited view of Italian art. For the early Welsch, Italian art was not Michelangelo and Raphael, or even Giotto and Donatello; rather it was engravings by Mantegna and bronze plaquettes by such as Moderno, or Venetian art mediated through highly personal talents like Dürer's, or simplified versions of the new Italian art theory.*[30]

Yet this situation is not so different to that which applies in general to the export of Italian forms to all parts of Europe. For example, as we have seen, it was northern Italians – Venetian artists or particular figures from the Lombard lakes - who were the ones to bring art to the north; and there is also a real question of how restrictive and conservative this idea of the Italian Renaissance is itself; to what place outside of Rome or Florence could we then apply the notion?

Before it be assumed that the production of the classicizing Italianate strain in German art was an alien one in some broader social or cultural context, the issue of patronage needs to be reviewed. The adaptation of the new Italianate, Renaissance style at the courts of Central Europe has already demonstrated the way in which a visual style may be chosen to create an air of distinction. Fashion and style can be visible signs of taste that mark off those who espouse them as superior in terms of cultural capital. The introduction of the classicizing style in stone sculpture and architecture seems one such instance.[31]

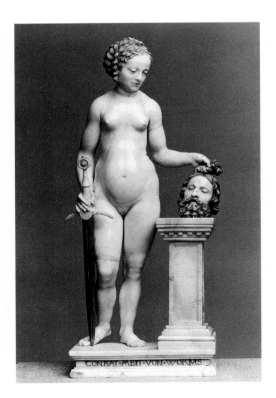

Judith, 1510-15, by Conrat Meit, Bayerisches Nationalmuseum, Munich

It should be recognized, *mutatis mutandis*, that a comparable situation pertained in Nuremberg and Augsburg. Nuremberg and Augsburg merchants and bankers also supported the adaptation of Italian and Italianate art for, it seems, much the same reasons as did the courts. It is, for example, striking that the building that might be considered one of the first German Renaissance architectural

works, namely the Fondaco de' Tedeschi in Venice, was, like Dürer's San Bartolommeo altarpiece, paid for by such men, and this building was adorned by frescoes by Titian and Giorgione.

In these circumstances men such as the Fuggers, the Welsers and Pirckheimer, no less than princes, could promote new forms of architecture, as they did of literature, to demonstrate their superiority in more than one sense. Moreover it was precisely merchants such as the Fuggers and the Welsers who had contacts with Italy. Because of commerce, they also had access to Italian artefacts. They patronized Italian makers of textiles and the work of goldsmiths, including that of the goldsmith who also served the queen of Poland. It thus does not seem an accident that the St Anne's Church in Augsburg contains a chapel erected for the Fuggers which, in both architectural and sculptural style, became one of the first examples of a (modified) Italianate or Renaissance style in Germany. Although the sculpted group of the *pietà* mixes Italianate (resembling the work of Pietro Lombardo) and indigenous (Swabian elements), more clearly Renaissance elements may be discerned in the putti, in the use of perspective in individual reliefs, in the form of its epitaph, in the reliefs, in the general central plan of the chapel, in its use of arches and rounded vaults and in other details of the architectural decoration, many of which recall Venetian forms.[32]

The appearance of the Fugger Chapel suggests that something was happening which 'went beyond the simple importation of a few Italian patterns, tastes and pretensions'. It has also been said that with the arrival of Italianate elements individual workshop styles in sculpture suddenly seem to have been driven out in the search for the new mode, and that this transformation represents the beginning of a pattern of a choice formed out of the tension between the Italianate and the non-Italian.[33] Rather than holding to a unitary notion of indigenous style, however, one might rather attend to the architectural forms of this very chapel and infer that a more complicated process of accommodation and adaptation have begun to occur, in which workshop styles may also redefine themselves according to the latest changes in taste.

In comparison with what was found either in Central Europe or in Florence fifty years earlier, the art that would result from such a process might appear to be 'a hybrid', as it were 'a provincial sideshow in the great European Renaissance'.[34] Yet we have come to learn that hybrids can improve or create better strains. It would only be an extremely atavistic cultural history which would take this argument as more than metaphor, and assume that genetic determination would prove that the pure strain is the best. In any instance, it is questionable if any 'pure' forms can be found. Unfortunately, it is not an overstatement to mention that the whole notion of purity has, at the least, more than distasteful overtones in discussions of German art.

There is, however, another way of talking more positively about the Renaissance outside of Italy as a hybrid. Recently Clark Hulse has noted that

Fugger Chapel, St Anne's Church,
Augsburg, 1509-18, sculpture
probably by Daucher workshop

'"the great European Renaissance" is to a far greater
extent than we have acknowledged a collection of
such hybrids and sideshows'.[35] What is regarded as
a hybrid may thus rather be the sign of an attempt
to reconcile forms of cultural exchange, with attendant aspects of both assimi-
lation and resistance. This process may lead to different results in different
countries: to full acceptance, as in Hungary, to a kind of mixture, as in
Germany and many other countries, and to a form of resistance, as we shall
see in the next chapter.

If the results of such works are not clearly Italian in Germany – and who could claim they are – nor purely German, to take the style discussed at the beginning of Chapter 3 as the basis for comparison, there may be other reasons for the appearance of many of the so-called 'hybrid forms' of German sixteenth-century art that do not necessarily mean they should be disparaged. As we have seen, related forms appear in Poland and in Bohemia.

Furthermore, for the German forms a parallel exists in German humanism. As with Dürer, many of the German humanists like Celtis adhered to a cosmopolitan multinational movement. Because of a feeling of inferiority (and Italian criticism) they reacted defensively. In Germany, as also elsewhere outside of Italy, humanists also tried to relate humanism and antiquity to the local past, thus to work out the German nature of the classical tradition, such as it may have been discovered or invented.[36] This effort may be similar to developments in the visual arts, where the local tradition (often 'Gothic') evolves in relation to an import of classicizing character.

In any instance, it is remarkable that if we are to talk about the adaptation of the Renaissance, it may be in Latinate writing but in vernacular art styles – namely in many of the local products – that its signs first occur. Elements appear earlier in visual areas than they do in literature, and this may account for some of the confusion. For, at the time that Vischer and Flötner were doing their works, Hans Sachs was writing his plays in German. A history of German culture can be, and in general has been, built around this strain.

Yet, though popular, Sachs's plays also had a learned character to them. And this element of learning also can lead on to a broader consideration of culture. It can be better argued that it is the assimilation of the broader European current that is the course of the future.

Many elements, not just the different essence of German art, or its hypothetically distinctive visual culture, accounted for varieties of reaction to the Italianate. What an account of the Renaissance in Central Europe obviously must deal with more fully is the way in which both secular art, with classical content, and sacred imagery, with a Latinate appearance, could be assimilated into another world where other traditional values, religious and social, and other cultural determinants pertained.

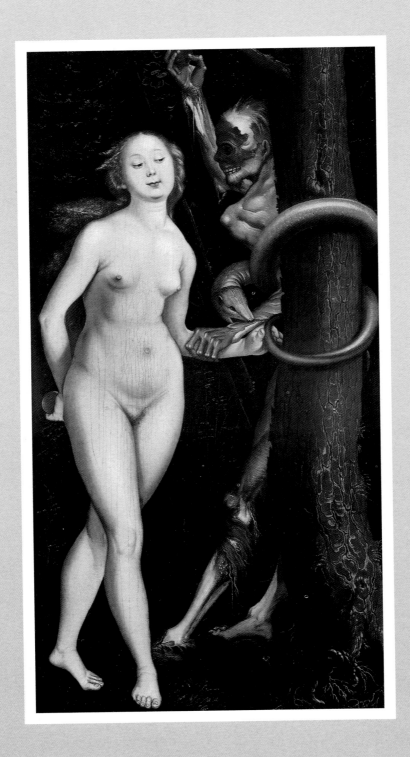

The Problem of the Reception of the
Renaissance: The Reformation and Art

Eve, the Serpent and Death,
c. 1510-12, Hans Baldung Grien,
National Gallery of Canada, Ottawa

THE ASSIMILATION OF THE RENAISSANCE IN CENTRAL EUROPE WAS A COMPLI-
CATED PROCESS. Not only in Russia did constraints exist of an intellectual,
spiritual and religious nature that affected the reception of the Renaissance,
the making of secular and sacred art and eventually the making of any art at
all. Substantial resistance to the Italianate took various forms in various places,
of a social, cultural and, most seriously, religious nature. A study of the
reaction to the Renaissance in Central Europe leads to a consideration of the
importance of religious currents that culminated in the Reformation, and
consequently to reflection on the impact of the Reformation on the creation
of religious imagery and, more generally, on further developments in the
history of art.

Although the subject has not been investigated fully, from the available
evidence the reaction to the Renaissance on the part of local guilds, or of artists
who adhered to an older manner, can well be imagined. Those who could not
or would not adapt to the newer taste may have felt themselves threatened by
outside competition. But even the advocates of assimilation were not
unambiguous in their reactions. Celtis's feeling of cultural inferiority has been
noted in the last chapter, and there is much other evidence for the expression of
antagonism to the *welsch*, the foreign, meaning particularly the Italian. This
ranged from simple ethnic antagonism in Germany, to more sophisticated
expressions of Italophobia in Poland. Although it should not be over general-
ized, by the 1530s a distinction between the *welsch* and the *deutsch*, the foreign

and the native, had also developed in Germany as a means of differentiation in visual matters.[1]

In some areas, particularly in the Bohemian crown lands where proponents of the doctrines of Hus and of the Unity of (Bohemian) Brethren were strong, resistance grew, particularly along religious lines. At first the Italianate stood for the reimposition of traditional religion and also, because of its association with the court, for the foreign. The initial resistance to adopting Renaissance forms in Bohemia thus suggests more generally a way in which signs of the Renaissance could be enmeshed in issues of religious controversy.[2]

Two sets of examples of reactions to the patronage and to the appearance of Renaissance forms indicate how problematic responses could become in a context of controversy. One instance where a negative response to specific Renaissance imagery occurred involved the reception of Dürer's work. As mentioned above, Dürer not only went to Italy but also imbibed Italian art and, like some Italians, produced his own art theory. Although there is no definite evidence that he also fully adapted Italian ideals, and some evidence to the contrary, his notions of human proportion, understood in terms of geometrical relations, were based on the idea that the human body reflects the nature of the cosmos, the laws governing the universe. They can thus also be compared to the precepts adduced by Alberti and other theorists of architecture, whereby geometrical forms, and their equivalents in numerical relationships, become the source for artistic ideals. In any instance, although Dürer had his own idiosyncratic approach, he also sought for an image of beauty.

Knight, Death and the Devil, 1513, engraving by Albrecht Dürer, British Museum

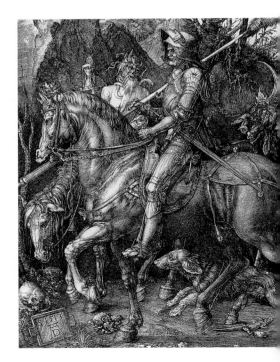

It is characteristic of him that this ideal would be bodied forth in a specific representation, such as his engraving of Adam and Eve, showing the perfect man and woman before the Fall, before the corruption caused by original sin. As explained by Erwin Panofsky, Fritz Saxl and Raymond Klibansky, this engraving presents a vision based on humoral psychology, in which the four humours are related to the four elements, and in turn to the planets and colours. In the first woman and man the four humours are held in perfect balance, a balance reflected in the repose of the creatures

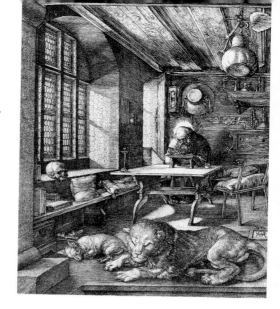

St Jerome in his Study, 1514, engraving by Albrecht Dürer, British Museum

of the natural world, the four animals depicted in the print.[3]

The piety of Dürer is also closely related to the humanist message of his works as well as to his personal religious experience, which is close in spirit to the general atmosphere of Reformation and pre-Reformation piety. This feeling is probably exemplified in *Knight, Death and the Devil.* Although the interpretation of this image has varied widely, the idea that seems most plausible is that it represents a warrior opposed to evil forces, who symbolize sin and death in traditional iconography.

Dürer's *St Jerome in his Study* also seems to approximate Christian humanism of the Erasmian variety, because Jerome was favourite humanist saint. As a scholar he had translated the Bible and was responsible for the Vulgate. Jerome was master of three languages and thus the personification of an ideal of Renaissance learning, as expressed in the *collège trilingue*, the inculcation of learning in the languages of the Scriptures. It seems no accident that Dürer's engraving is one of only two works by the artist in which the system of one-point perspective that he had learned from Italian Renaissance art theory is applied with perfect consistency.

Later, Dürer, like several other artists of his time including Hans Holbein, openly expressed his affinity with Erasmus. He portrayed the Dutch humanist in two famous images, whose iconography and inscriptions place these works themselves in a learned category. In response to a spiritual crisis in 1519, that was brought on by the disappearance of Martin Luther, and perhaps was also reflected in some of his late paintings, Dürer exclaimed, in words that may recall *Knight, Death and the Devil:*

> Oh Erasmus of Rotterdam, where wilt thou take thy stand? Look, what can the unjust tyranny of worldly force and the power of darkness avail? Hear, thou knight of Christ, ride forward by the side of the Lord Christ, protect truth, attain the martyr's crown.

In any event, in these images it might seem that in Dürer's art humanism and religious sentiments can coexist in harmony and that, as in Dürer's remarks about Luther and Erasmus, the Reformation might seem to flow seamlessly from the Renaissance.[4]

The reaction to another famous engraving by Dürer, *Melencolia I*, however, points out that the response to the Renaissance, as embodied in Dürer's work,

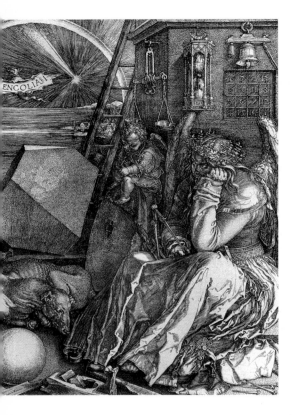

Melencolia I, 1514, engraving by
Albrecht Dürer, British Museum

was not so clear. As explained by Panofsky, Saxl and Klibansky, who have offered the most widely accepted interpretation of this image to date, the female personification of Melancholy in the print presents a figure in which the humours are out of balance; black bile predominates, hence her head is placed on her hand, a pensive gesture which also corresponds to the traditional image of the melancholic. The traditional occupations of the medieval melancholic are also visible in the print, suggested by the measuring, numbering and counting, and by the artisanal objects (e.g. the compass, purse and tools). Panofsky and Saxl suggest that a revaluation of Melancholy occurred during the Renaissance, as achieved in Florentine Neoplatonism, most particularly in the philosophy of Marsilio Ficino. In this new way of thinking melancholy could also lead to deep study, to introspection. Melancholy was the humour characteristic of great men and heroes: Dürer's image is thus said to represent the first stage of melancholy, as suggested by the inscription 'Melencolia I'. This is the humour possessed by inspired artists.[5]

According to Panofsky, Dürer knew of this philosophy through a 1510 manuscript copy of a work by Henry Cornelius Agrippa, *De Occulta Philosophia*. According to Panofsky's explication, Dürer represented in his engraving an image of inspired but frustrated genius, which was also a spiritual self-portrait. Melancholy was inactive and thereby illustrated the suffering condition of creative genius, genius hampered by spiritual or mental conditions. Melancholy was inactive because of a sense of failure and inadequacy. Although, as its title implies, Agrippa's is one of the major works of the occult tradition, Panfosky and Saxl discount any irrational, magical or occult side to the engraving and say that inklings of an interest in the cabbala and magic, manifest in the supposed source in Agrippa, are not evident in the print.

It is nevertheless clear that in Central Europe the adaptation of the forms or, if in the case of Dürer's *Melencolia* the interpretation of Agrippa's influence

is accepted, the iconography of the Renaissance could not be taken as simply neutral without regard to their sources, especially when they touched on such things as the occult or spiritual questions. The turn to Italy and to the past in the arts did not entail merely a formal or abstractly intellectual assimilation of antique images and ideas. Other beliefs, including seemingly irrational ideas about magic inherited from the period of late antiquity, were also revived.

Along with the rational, aesthetic side of the Renaissance, there were thus also revived what might be called irrational systems of belief, such as astrology, alchemy and magic. The popular 'low' magic of the village man or woman of cunning had long existed, but now there came a tradition of learning with much more exalted claims. This was the heritage of thinkers like Agrippa and the Italian philosopher Marsilio Ficino. If writings by these thinkers are to be adduced for key elements in Dürer's image, it seems reasonable to suppose that traces of these beliefs may also be found in *Melencolia*. In fact Agrippa's manuscript was one of the major works of the Renaissance tradition of magic as well as an important source for Christian cabalism. It describes a Christianized version of this Jewish mystical tradition and offers a presentation of the cabala, as guaranteeing safety in the operation of magic. That is, it resolves a major problem that attended the revival of magic in the Renaissance, of how one could know that the spirits that were conjured up were good. This was particularly a problem in the Agrippan presentation of melancholy. If Dürer, or his advisors or associates, used Agrippa's text, it is unlikely that he would have used it so selectively as to ignore this aspect of the description of magic that appeared on the very page of the manuscript from which Panofsky and Saxl demonstrate he drew important aspects of his personification of Melancholy.

It has thus been argued that in Dürer's *Melencolia*, in keeping with the Agrippan vision, the angel of Saturn protects, and leads one upward on the ladder to the heavens, the ladder of Jacob, which is so prominent in Dürer's print.[6] Whether or not such an interpretation is correct in all its particulars, it helps to place Dürer and the reaction to him in context. It is obviously difficult to reconcile these sorts of magical notions with Christianity, especially with the religious beliefs of an increasingly intense spiritual world of *c.* 1500.

Hans Baldung Grien (1484–1545), who had been a pupil of Dürer, was an artist who seems to have been capable of grasping some of the issues involved in Dürer's art and forming his own personal reaction to them. Baldung was one of few artists who came from a well-to-do background. He was well educated, a friend of humanists such as Wolfgang Capito, whom he portrayed; he was also close to the religious reformers in the town of Strassburg.

Although Baldung developed his own way of handling the material, he seems to have been quite familiar with the idealized human forms of antique and Italian Renaissance art, which he probably gained through Dürer. Many of his prints and paintings of the nude reveal his capacity to represent well-

proportioned and modelled figures and suggest that he was also fascinated with beauty, as embodied in the human form. Yet Baldung treats these subjects in a way that subverts classical ideals. Baldung's work can thus be conceived as a kind of visual comment on Dürer and, where he treats the same themes, a negative transformation. He makes what can be interpreted as counter-images of Adam and Eve, of the great horse, Dürer's image of perfect animal proportions and of Melancholia.

Baldung's reaction to Dürer is to some extent one of attraction and emulation. This may come from his own desire to establish his identity or from his independent interests in the psychological interpretation of themes, but the results of these processes are significant. Baldung's images of Eve in most instances emphasize her sexuality, presenting her as a beautiful seductive woman. In Baldung this is hardly an image of perfection. In its most immediate meaning, this corporeal form of beauty is found wanting and wrong, since the pleasures of the senses offered by Eve are associated with sin and death. Beauty is thus linked with the seduction of the senses, which led to the Fall of Man. The linkage of sexuality with sin and death, is made clear in paintings of Death and a nude maiden. In several images of the Fall, or of Eve and Death, Eve is also clearly aware of the sexual allure that is inherent in her beauty, and it can be inferred that this linkage leads to sin.

Given Baldung's learning, his evident cleverness and his association with Dürer, it seems legitimate to see his treatment of themes that his master, the master of the Renaissance ideal of balance, of beauty and harmony, had also handled as making a comment on those themes. Baldung seems to be suggesting that these ideals are never realizable in man, even in that state of harmony which was supposed to have existed before the Fall. Man is inherently sinful and in need of redemption. This treatment seems to represent a negative response to the new image of the nude and of beauty provided by the Renaissance, and it seems fair to regard it as a form of rejection.

In his prints and paintings of witches Baldung also seems to be expressing something similar, when he uses for sorceresses female figures resembling Dürer's embodiment of the ideal in Eve. The use of this visual source material represents a pointed interworking with contemporary popular interest in witchcraft. The presentation of the witch as a nude female in this way is not only misogynistic but also has a further cultural significance. In Dürer the female nude can be associated with beauty, as revealed through the forms of the Italian Renaissance. In Baldung a similar figure is however cast in an obviously negative light by being associated with sin in the form of Satan and devil worship.

If Baldung's comment on Dürer appears to create a kind of 'anti-Adam and Eve', Lucas Cranach the Elder (1472–1553) was even more pointed in his creation of a sort of 'anti-*Melencolia*'. His several versions of *Melencolia* are based directly on the pose and figure of Dürer's. Cranach does not see

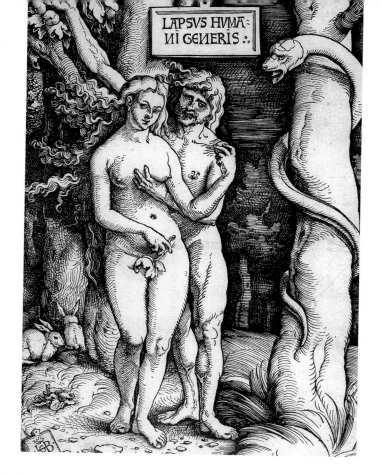

The Fall of Man, chiaroscuro woodcut, 1511, by Hans Baldung Grien, British Museum

Melancholia as an inspired figure, of whatever manner. She is not transported by holy visions, nor protected by demonic powers. In contrast, she is portrayed as a witch. She prepares to join the wild ride to the witches' sabbath that is taking place in the sky. The serious putti seen in Dürer's image, as in the Fugger Chapel, are now sensuous and alert; Dürer's sleeping dog is alert and evil. In Cranach as in Baldung the transformation of Dürer's material makes a negative comment. The accumulation of detail points to a rejection of the occult, hence a rejection of the message of some of what Dürer's image signifies, suggesting that it can lead to a wrong turning.[7] In a similar manner, Martin Luther rejected the doctrine of melancholy and astrology as forces that governed man's behaviour, saying that they provided excuses to take the power of making decisions out of man's hands. As Cranach was a devoted follower of Luther, it is possible that this meaning was also familiar to him.[8]

In any event, Cranach's reaction raises another important issue. Although some pious figures, such as the abbot and cryptographer Johannes Trithemius, sought to accommodate Renaissance occultism and its doctrines of magic, in

the main these ideas posed problems for the faithful. As Protestantism was later to reject the powers of man to work alone for his salvation, so did the pious artist reject the doctrine of magic and hence any effort to call on the world of spirits, and thus possibly demonic powers, seeing it as the work of the Devil. Hence the doctrine of inspiration outside of the Church was also rejected: only faith and the moving power of God were, according to Luther, acceptable. Theurgy, the notion that man can affect nature, in the way man creates gods, was rejected in favour of theology, the notion of God affecting nature, of man being at God's disposal. Hence some of the underlying assumptions of some aspects of thought developed in the Italian Renaissance were questioned from the point of view of Christian piety on the eve of the Reformation.

Another instance in which related principles were called into question involves patronage in Halle, which from 1503 to 1680 was the residential city of a bishop (or, after the Reformation, a bishop-administrator). From the late fifteenth century much of this city, like other Central European residences, was transformed by the patronage of a prince, who in this instance was an ecclesiastic. From 1484 until 1509 Master Hanschke, H. von Packwitz and Andreas Guenther carried out the reconstruction of the episcopal residence in the Halle Moritzburg, where the chapel was dedicated in 1514. Soon thereafter Albrecht of Brandenburg, who, as archbishop of Mainz, was chancellor of the empire and held other sees such as Magdeburg and Erfurt as well, engaged in an extensive programme of patronage.[9] Not just Halle but other cities he controlled, such as Halberstadt, owe some of their first Renaissance monuments to his patronage.

Choosing Halle rather than Magdeburg as his residence, Albrecht turned the Dominican church there into a Collegiate church, having the building transformed in 1520–23 into one of the earliest structures displaying Italianate elements. These include characteristic semicircular gables and doorways with classicizing framing ornament. The church contained dedication tables by Loy Hering in a Renaissance mode as well as an extraordinary polychrome stone pulpit with a figure of Mercury. These formed part of a remarkable ensemble that included large stone statues, probably of Rhenish origin, of Christ and the Apostles and also originally paintings by Cranach and Grünewald.

These works represent only a part of Albrecht of Brandenburg's patronage. The church belonged to a larger complex of buildings which, originally intended as a university, were eventually turned into a second residence. In Halle Albrecht also assembled a large and famous collection of relics in order to gain many years of remission from Purgatory. This collection was known as the 'Hallesches Heiligtum'; the cardinal had this collection illustrated – one of many manuscripts, often with sacred functions, that he had illuminated.

Albrecht's activity seems at first to combine harmoniously a princely taste for the Italianate as well as employment for indigenous artists. Albrecht thus displayed a sampling of those sorts of interests that led many rulers and

patricians to patronize works of art in the late fifteenth and early sixteenth centuries.[10] His patronage may be related to that intensification of piety, which, as already noted, led to the construction of churches, the dedication of furnishings and the commissioning of altarpieces. Like other ecclesiastical patrons, Albrecht could also rely on a defence of religious images. Religious imagery was traditionally regarded as a stimulus to worship (the Bible for the illiterate), as an adornment of the Church and as a good work. The traditional justification of images held that they were not idols, that veneration passed through the painting or sculpture to its prototype. Albrecht's reverence for relics, and the indulgences he and other churchmen granted for their veneration, not only are the source for his own patronage but indeed can also be related to the proliferation of many painted and carved images, often far from austere, as discussed above.

In the early sixteenth century, however, questions of art for the church and the adoration of images came under scrutiny and ultimately under attack. Just during a time when the cult of images increased, and with it the frequency of pilgrimages, problems that had traditionally attended the veneration of images arose. The secular motivations that lay behind commissioning art for the church, needs such as a craving for the visual and the vanity and egoism of the patron, became increasingly apparent.

At this time, moreover, the debate about images was caught up with some of the religious controversies that led to the Reformation. This is of course the transformation of religious beliefs and church organization effected by Zwingli, Luther, Calvin and others. We are accustomed to associate the Reformation most directly with Germany (home of Luther and Melanchthon) and Switzerland (the location of Calvin's Geneva and Ulrich Zwingli's Zürich), but it had an effect throughout the region. For example Austria, now an overwhelmingly Catholic country, had until the Catholic counter-offensive of the 1590s a large Protestant population. An estimated 90 per cent of the aristocracy in Lower and Upper Austria adhered to the new confession; because of the power of aristocrats to determine the religion of those who lived on their property, this meant that much of the whole population espoused this creed.[11] Peasants remained tenaciously loyal to it, and Protestantism had literally to be burned out in the 1620s. Elsewhere in the East the new confessions also spread. German speakers brought Luther's teaching to Bohemia, Poland and Hungary (including Slovakia, Transylvania and Croatia). In Bohemia, the home of Hussitism, the sect of Bohemian Brethren flourished and began to expand from the 1530s. Later they began to approximate some aspects of Calvinism. Along with Lutheranism, Calvinism of a local variety also came somewhat later to Hungary. Poland, because of its tradition of tolerance, reaffirmed by semi-official letters of toleration later in the century, became home to many sects of Protestants, not just Lutherans. By the late sixteenth century one fourth of the churches in Little Poland and in Lithuania were Calvinist.[12] But Unitarianism also began in Poland with Michael

Servetus, and Socinianism flourished there. Other groups such as the Mennonites sought refuge in the *respublica* as well. Consideration of the Reformation and the arts thus has broader implications.

Patronage of the arts, indeed of Renaissance monuments, was intimately entangled with the origins of the Reformation. It was in immediate reaction to the sale of indulgences to raise funds, which would be used both for construction in Rome and for the monuments Albrecht sponsored in Halle, that the Reformation began. Because the costs of building the Moritzburg, the New Residence and the Stiftskirche were so great, Albrecht encouraged additional preaching in his diocese of indulgence (*Ablass*). In reaction to these practices, Luther posted his ninety-five theses; this response was also to the abuse of prebendaries and the piling up of church offices, which provided funds to enable ecclesiastical courts to pay for buildings.

The implicit critique of Renaissance imagery, as seen in artists like Baldung and Cranach, together with the response to the patronage of religious art, became more acute with the onset of the Reformation, and it is fateful that these phenomena occurred more or less simultaneously. Much more than specific sorts of imagery, patronage itself became problematic.[13] In addition to attacking the practices surrounding the granting of indulgences, critics held that the traditional justification for religious imagery, indeed any imagery, was at best confused.

The theological justification for the commissioning of works of religious art was thereby diminished. Traditionally, the doctrine of indulgences had been taught as the notion whereby the acts of the blessed, of the saints, had stored up goods in a treasury of merit, on which one could draw to speed one's time through Purgatory. Indulgences were granted for worshipping at particular spots of pilgrimage, often with sacred or miraculous images, which had to be housed appropriately. After confession and contrition, indulgences were granted for the construction of altarpieces and chapels. They were also given in return for contributions. It was by the latter means that money was collected to be used not only for the construction of St Peter's in Rome but, as we have noted, for projects in Halle.

Both this theological argument, and the underpinnings on which it was based, were rejected by the new religious arguments. The doctrine of indulgences had been founded on a theology which deemed good works efficacious for man's salvation. Several reformers, including Luther and Calvin, directly rejected this doctrine. Works did not and could not bring redemption: only faith (*sola fides*) and the grace of God (*sola gratia*) could do so. Worse still for Protestants, patronage of art, as in the case of Halle, could be seen as egoistical and status-seeking and as a sign of activities or attitudes, which in themselves could be interpreted as sinful.

In these circumstances the long-standing debate over images gained renewed urgency. This problem was created in response to the Second Commandment. In the sixteenth century a conjunction of beliefs led to

iconoclastic practice as well as to a theology which was antagonistic to imagery. In the writing and preaching of iconoclasts such as Andreas Bodenstein von Karlstadt, for instance, Biblical passages were woven into an iconoclastic ideology.[14] This reading was also related to the literal interpretation of the Bible, held by some Protestants, that only the Scriptures (*sola scriptura*) provided a guide to life, a source for justification. Hence, through a strict reliance on the Scriptures, there developed a rejection of the traditional defence of images such as that provided by St Gregory, who had compared painting for the ignorant to writing for the literate.

A further point of antagonism to images was a liturgical one. As the sermon was reconfigured into a central event, the altar was was supposed to be a place of Christ's sacrifice, either symbolically or literally. Hence it was to be stripped of all unnecessary paraphernalia, returned to a plain state. There resulted a general drive to remove idolatrous images from the altar, with a particular animus directed against images of the Virgin and the saints, since Andreas Rudolf Bodenstein von Karlstadt as well as most other Protestant reformers rejected the intercession of the saints and the Virgin and were generally more hostile to imagery of all kinds. This hostility had a particularly devastating effect in some areas on the survival of religious images, in that it has been estimated that images of the Virgin and saints constituted 60 per cent of all pre-Reformation imagery.

The wave of preaching against images by such men as Karlstadt, Thomas Müntzer in Mühlhausen and Zwingli in Zürich led to a tide of iconoclasm, image-smashing that was both unofficial and officially condoned. The hatred and fear of images stirred up by preachers led to riots in places such as Basel in 1524 and in Wittenberg, while Luther was absent, in 1521–2. Official iconoclasm occurred in places where a town council was controlled by or yielded to iconoclasts. In such cities images were quietly removed from churches and frequently saved by patrons or collectors, as for example in Lübeck. More often they were burned or destroyed, as occurred in Zürich in 1521 and in Strassburg in 1524; Zürich provided a model for many south German towns. Northern cities, like Stralsund in 1525 and Braunschweig in 1528, followed, with the result that the large churches in these cites have a paucity of earlier images.

The impact on the making of religious art and on the arts in general that such teaching and action had was obviously negative. First, many older churches were emptied of images, and later churches that were put up by newer sects, particularly those who were unsympathetic to imagery, such as the Calvinists or Bohemian Brethren, were often largely devoid of works of art. Both a major outlet for patronage and a major source of work were thereby eliminated. Immediate consequences were felt especially by artists who had engaged in these traditional forms of production. Contemporary artists voiced complaints about the sad state of affairs, saying that artists lacked the opportunity for work.

Art historians have consequently marked the period of the introduction of the Reformation, especially in areas that became Protestant, as a turning point in German art. More than that, together with the demise of the older generation of artists, this period is supposed to represent the end of an era and the beginning of a decline in German art.[15]

But can the picture be painted in such totally negative colours? Evidence from Bohemia and Poland does not allow for such conclusions, and, to concentrate on Germany, more recent scholarship on Lutheran attitudes suggests that the role of art in the major new faith and its practitioners need to be reconsidered. On the one hand, adherents of the new confession did not necessarily stop working for Catholic patrons. Thus Lucas Cranach the Elder, one of Luther's most loyal followers, continued to execute commissions even for such patrons as Cardinal Albrecht of Brandenburg. On the other hand, although religious works made to suit Protestant practices were more modest in quantity and to some extent in quality than Catholic art, art and architecture of both a secular and a religious nature, which can be associated with Protestants, did originate at this time.[16]

A series of categories of distinctly Protestant images arose.[17] These included first of all a multitude of commemorative portraits of reformers, such as Luther and Philipp Melanchthon. Some of these new images even assumed the aura of depictions of saints. Furthermore, there was also produced at times, to accompany Luther's own writing, a considerable volume of polemical imagery. Such images ridiculed the Roman Church, its priests and its practices.[18]

The production of this sort of imagery resulted from the Lutherans' realization that images as well as texts could possess didactic properties. Hence, just as the Reformation had a positive impact on the spread of vernacular literature, so did it affect the development of a new kind of imagery. The proponents of the new confessions took advantage especially of the new print media, not just of painting. Luther himself believed that popular images could be important in the propagation of his doctrine. Hence, as religious tracts flowed forth, imagery also came to be made 'for the sake of simple folk'.[19] The first publications in the Magyar language occurred in connection with the Reformation, and other publications in the vernacular also served similar ends.[20] Although polemical images could often be independent prints, Protestant Bibles and tracts also contained illustrations along with texts, in some instances supervised by Luther himself. Many Protestant Bibles and tracts also contained images by Dürer or other leading artists.

In painting, the workshop of Cranach in particular served the new cause. Lucas the Elder lived in Wittenberg and then followed the ducal court (of the Ernestine line) in exile to Weimar, where his son Lucas the Younger also later served the court. The Cranachs not only memorialized the reformers by spreading their likenesses but also contributed to the production of distinctly Protestant altarpieces, as well as epitaphs, and what may be considered other kinds of devotional images.[21]

In order to understand the origins and character of these altarpieces and devotional images, it is necessary to comprehend the attitude of Luther towards images and thus the Lutheran view of the religious function of art. Luther himself rejected the doctrine of good works and the doctrine of indulgences based on it, considering a good work to be giving to the poor. He also rejected the intercession of the saints. Accordingly no gain could be had through commissioning works of art, and there was not much reason to make images of saints.

Early in his career Luther went further and praised an orderly iconoclasm. But soon, when during the 1520s he became fearful of the anti-social and disruptive potential of iconoclasm, he took a more moderate position, between that of the iconodules and iconoclasts. In 1524–5 the Peasants' War and the Knights' Rebellion broke out. Leaders such as Müntzer, who had earlier preached against images, were involved in the disturbances, and Luther might have perceived iconoclasm as a symptom or even cause of the dangerous unrest of the time.

Moreover Luther assumed a typically moderate position when he came to consider the theology pertaining to the justification of image-making. Personally he did not fear the worship of images and thought that they might actually be useful. He believed that images might provide a positive memorial and granted that image-making was perhaps a psychological need. Similarly he took a more conservative position in regard to the veneration of the saints and the Virgin, with the result that in Lutheran churches their images often survived, as for example in Nuremberg. In 1524–5 he even began to come to see that the images of saints might have a positive value, in that he believed that the making of images had a pedagogical function in the church. He interpreted the Second Commandment not as applying to religious art, but included it in the First Commandment, thus effectively weakening its impact as an independent proscription.

By 1528 Luther issued a confession concerning Christ's supper, one of the two sacraments – Baptism is the other – he retained, in which he expressed his lack of sympathy for the iconoclasts. Theologically, images were to be considered adiaphora. That is, they were matters of indifference, in the sense that no differences were to be made in regard to their worship that were worth fighting over. They might even provide an outward means for showing inward grace.

By 1530 Luther had come to reject the simple table-type altar. In his commentary of the psalms he even allowed for the presence of paintings as altarpieces. He prescribed specific images such as the Last Supper, the institution of one of the two Lutheran sacraments, as appropriate. Because of Luther's dictum and Lutheran theology, the Last Supper therefore became one of the subjects most frequently represented in art associated with his confession.[22] In Wittenberg and Dessau, centres of reform, representations of this subject were given a particular theological and propagandistic emphasis: the reformers appear as apostles and Christ can be shown giving communion in

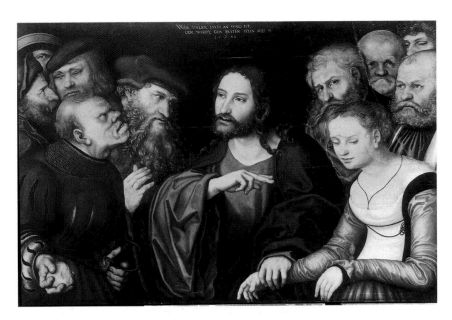

Christ and the Adulteress,
1532, Lucas Cranach the Elder,
Szépmüvészeti Múzeum, Budapest

both kinds, the wafer as well as the wine, a theological issue since the Hussites. As in Riemenschneider's Creglingen altar, he is also shown giving communion to Judas, thus suggesting that grace is freely offered to all, even to sinners who reject it.

As these pictures indicate, the subjects chosen for Protestant altarpieces were not 'new' in the sense that they had not appeared earlier. In Lutheran imagery, however, subjects such as the Last Supper are often excerpted from a large sequence or cycle of images, and made the theme of an independent altarpiece, or given a particular iconographic interpretation. The selection of the subject and the particular interpretation of the theme are the Protestant contribution.

Examples of a newer iconological emphasis are also found in the frequently repeated images (such as in Cranach's Weimar altar in the Church of SS Peter and Paul, 1553–5) of the rule of the Law and the Gospel. In this subject the old and the new dispositions are set against each other. Here the polarization of the Old Testament and the New is used to suggest not only the typological relation of the two Testaments but the message of justification by faith alone.

Another popular theme is that of Christ and the woman taken in adultery. This theme, derived from the cycle of the Life of Christ, is again excerpted therefrom and made into an independent composition. For example, it appears, significantly, on the pulpit in Torgau, one of the first churches built specifically as a Lutheran house of worship, and it is repeated frequently in Lucas Cranach the Elder's oeuvre. In the story a woman is taken in adultery and presented by Pharisees for judgement to Christ, who responds, 'Let him

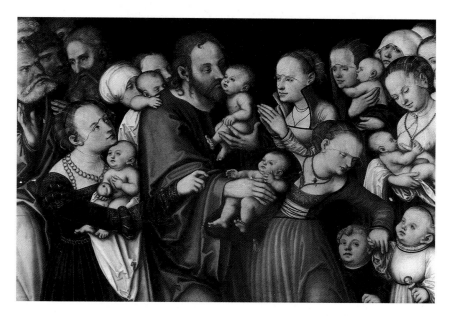

who is without sin cast the first stone', meaning all are born with sin and tainted by it: good works have no effect; sinners can be redeemed. The inference is the

Suffer Little Children to Come unto Me, Lucas Cranach the Elder, before 1537, Städelsches Kunstinstitut, Frankfurt am Main

Lutheran message that grace revivifies and only faith and grace can save.

Another similar theme is represented by depictions of Christ blessing the children, which corresponds to the command, 'Suffer little children to come unto me'. This presents the message that Christ's saving grace is extended to all, including children. There is a further Lutheran theological point here. By depicting Christ with little children, this scene alludes to the second of the sacraments that Luther retained; the words that 'theirs is the kingdom of heaven' reinforces the theology of Baptism, by which the infant man can ultimately enter into this kingdom.[23]

In addition to altarpieces and devotional objects, Lutheranism encouraged the growth of another genre: epitaphs.[24] Epitaphs, sculpted or painted objects that commemorate the deceased, have already been encountered in this book. But a great proliferation of works in this genre, both painted and sculpted objects, occurred from the middle of the sixteenth century. Epitaphs often included portraits of the deceased, but just as frequently paintings with religious subjects. When all religious imagery was attacked by a more extreme Protestant line, including that backed by the Calvinists, these works were supported by Lutherans throughout the century.[25] Although epitaphs are unlike altarpieces in serving a commemorative rather than a sacramental or liturgical function, and thus are secular rather than sacred objects of a personal

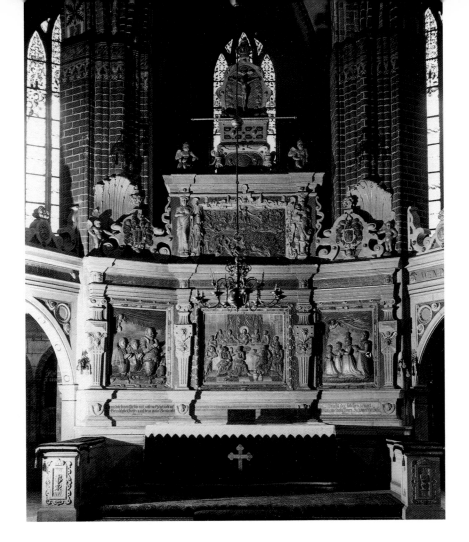

Epitaph-altar of Rochus von Lynar,
1581-2, St Nicholas Church, Spandau

rather than communal nature, they can often assume the appearance of the altarpiece. Indeed both in appearance and as providing an outlet for patronage, the large-scale production of epitaphs meant that the difference between a Roman Catholic church, with its altarpieces and votive offerings, and a Protestant church with epitaphs may often not be so visually apparent in some parts of Central Europe. In fact after the Reformation, when the Catholic Reformation won back churches for Rome in areas like Silesia, the addition of a table underneath an epitaph in the seventeenth century could convert an epitaph into an altarpiece. This feature can be seen in the St James Church in Nysa, or in Kłodzko (Glatz).

The form of these pieces often consists of the defunct shown in prayer or else a large-scale sculpture of the deceased. Many of these images are in format

not substantially different from earlier and indeed from later images in Central Europe or even in the Spanish-speakng world, where a donor is often shown kneeling in adoration before a saint or the Virgin. In style, or formal language, such works are again not so different from work done in areas dominated by other confessions.

The same might be said of the treatment of another form of church furnishing, the pulpit. Pulpits had been important earlier, as discussion of Witten's work in Chapter 3 may have suggested, and their number increased with the prevalence of preaching related to late medieval piety. Neither in form nor in function is there a particular difference between these 'late medieval' pulpits and those built in Protestant churches. But as the Reformation spread, emphasis on preaching the word of God, *solum verbum, sola scriptura*, increased, and thus the decoration and elaboration of pulpits in the sixteenth and seventeenth centuries also became more pronounced; in comparison with other art forms in Lutheran churches, pulpits, particularly in Protestant churches, gained in significance. Moreover, themes dear to the Lutherans appeared on them: the four evangelists, the apostles Peter and Paul, and the Life of Christ.[26]

The effect of the Reformation thus seems to have been on the choice of subject, not on the form or quality of execution of a work of religious art. This last concern may also have been a matter of indifference, as it were. For Luther specifically ordered that one should illustrate the content of the text of the Bible as simply as possible. This literal approach might affect the way works were carried out, so that the subject matter was more important than form: any artist might do. Themes such as, for instance, the images of Resurrection (triumph over death), Crucifixion (through death to eternal life) and Baptism (again an entry into life), or scenes of Christ's Passion, predominated.

From the mid-sixteenth century on Protestantism did, however, have an important impact on another form of art. While at first the new cults used old structures, from the 1530s churches were built expressly for the the intent of providing a place for distinctly Protestant worship. While other groups including Bohemian Brethren also had churches erected at mid-century, this process occurred first in the new castles which were erected for rulers who adopted Luther's confession.

The erection of new churches for the new cult thus points to the way in which Protestantism can be separated neither from the political events of the time nor from the Renaissance. For Protestantism spread and survived precisely because it was taken up and promoted by local rulers and magnates, such as the duke of Saxony, the count palatine of the Rhine, and the landgrave of Hesse. Their confessional allegiance resulted no doubt in part from reasons of personal piety, but it may also have sprung from their political interests, as an expression of differences from the Holy Roman and Catholic Empire and its ruler, and thus as a way to press particularistic causes, local interests, and finally to gain regional control over churches, with the economic advantages

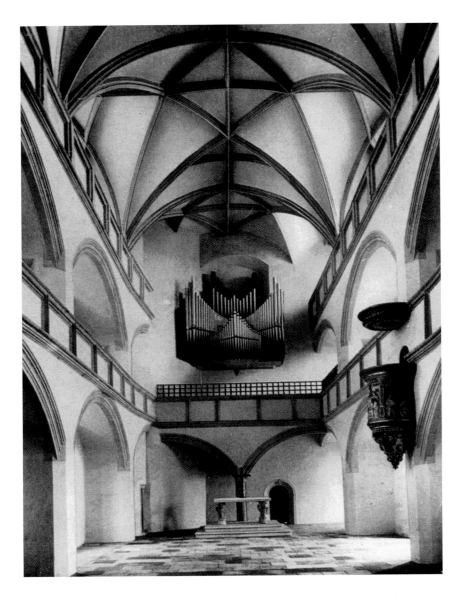

Chapel, with pulpit by Simon Schröter,
1543/4, Torgau Castle, Nikolaus Grohmann

that this might afford. Princes took advantage of the situation presented by religious dissension to introduce secular control over ecclesiastical matters.

Political divisions crystallized around religious differences. By the 1530s these had developed into open warfare, which was not to be ended until mid-century, when the status quo was recognised by the Treaty of Augsburg of 1555. This peace treaty, which adopted the principle commonly expressed

as *cuius regio, eius religio* – the ruler of a region determines its religion – explicitly recognized the relationship of religion to politics, confirming an already existing state of affairs.

The new relationship of church and state, as it were, is effectively already anticipated, even established, by the first structures expressly erected as Protestant churches. These are chapels built in the castles of the count palatine of the Rhine, Ottheinrich at Neuburg on the Danube, dedicated in 1543, and at the castle of the duke of Saxony at Torgau, dedicated by Luther himself in 1544. Torgau was directly connected with Luther, in that the articles of his new confession, that of Augsburg, were read and approved there in 1530. Luther also spoke the first sermon from the pulpit of this church.[27]

The disposition of space in these castle churches was directed to the needs of the new cult. While in Lutheran churches the high altarpiece was usually retained, the pulpit became more prominent. Otherwise the significant change in church design that occurred was the elimination of interior supports such as piers and columns, so that a unified, open space could be created. The creation of this space enabled the whole congregation to see the service and hear the sermon. The emergence of this kind of comparatively open space in a church was of course anticipated by hall churches and has certain parallells in Italy, but the elimination of choir or chancel area makes it distinctive. Clerics were not to be distinguished from the congregation in the new community of believers. Moreover, the same sorts of unified forms were created in contemporary churches built for other religious groups, such as the Bohemian Brethren, where a unified space with elevated choirs on the sides was also erected in the contemporary church at Mladá Boleslav (Jung Bunzlau, from 1544).[28]

What differences existed in the case of the German churches was expressed in the way their design responded to the court setting, which implied the presences of people of 'quality', members of the court. In the castle chapels space in the upper levels – a traditional location for a ruler in the west since Charlemagne's Palatine chapel at Aachen – was reserved for them. In Torgau the triple division suggests that, as in later chapels, for the family of the elector a special level was reserved. This sort of design remained current for Protestant court chapels, at Gottorf, Schwerin, Stettin (Szczecin), Augustusburg, Schmalkalden and elsewhere, in the countryside at Loosdorf in Austria and in cities in Austria, for example at Klagenfurt in Carinthia and in Bohemia, throughout the sixteenth century.

The painted decoration of some of these churches indicates that the reaction of the Reformation to Renaissance art could be more complicated. A painter attached to the Lutheran cause like Cranach could continue to paint classical themes as well as religious works for Protestant patrons, at the same time as he continued to execute altarpieces and portraits for Catholic patrons such as Albrecht of Brandenburg. A good example of the way that painters could come to accommodate the Italianate to the new teaching is provided by

the ceiling paintings executed by Melchior Bocksberger in the castle chapel of Neuburg an der Donau. The subject matter of this cycle was devised by the prominent theologian Andreas Osiander and contained an orthodox Protestant message based on traditional typological references. The individual forms in these paintings, however, recall those of Dosso Dossi and other Ferrarese artists. Moreover, the central image of these paintings creates the illusion that the ceiling, whose perspective is taken from below, opens to the heavens. This sort of representation, *di sotto in su*, had been seen previously in Italy in Mantegna's painting in the Palazzo Ducale and in Giulio Romano's work in the Palazzo del Te in Mantua as well as in Correggio's paintings in San Giovanni Evangelista and the Duomo in Parma. Although these were not the first such examples of this kind of illusionistic ceiling painting in Germany – they were preceded by Georg Pencz in Nuremberg, for example – their appearance in a Protestant setting is noteworthy.[29]

As the century progressed, Renaissance structural and ornamental elements also appeared increasingly in Protestant churches. From the start, most Protestant castle chapels employed arcades. Slightly later chapels, such as that in Augustusburg displays, used the orders. And from the beginning the doorways of these buildings used the decorative language of the Italian Renaissance. It has also been suggested that this later building was put up by an Italian.[30] It is also likely that the church of the Brethren at Mladá Boleslav, which also has arcades, was designed by an Italian.

By the middle of the sixteenth century it would therefore seem that the crisis affecting the reception of the Renaissance had passed. Italian models and examples were used, even in sacred settings, and the Italianate was presented with impunity. Whatever edge or animus had earlier existed was being lost.

This may be because another way existed in which the Reformation may indeed have helped to facilitate the assimilation of new attitudes toward stylistic discrimination. In Italy humanist education in rhetoric had inculcated the ideal of learned eloquence. Eloquence, as applied to speaking or writing, involved the issue of decorum, in which the mode of expression differed according to the subject matter to be expressed. In the Ciceronian ideal, the eloquent person spoke of high things in a lofty manner, low things simply and middling things accordingly.

Beginning at least with Alberti, Italian theorists of art had applied rhetorical notions to painting. Alberti derived his notions of pictorial composition from rhetoric. Similarly, notions of ornament derived from rhetorical concepts like antithesis were applied to pictorial qualities like *contrapposto*.

By the mid-sixteenth century these ideas had also become common in German-speaking regions, in good measure because of the new lessons taught by the Reformation. The reformers instituted new *Schulordnungen*, curricula for schools, in places where the civil authorities, whether princes or city councils, adhered to the new confession. As well as changing the curricula of old schools, reformers like Johannes Sturm in Strasbourg and the *praeceptor*

Germaniae, Melanchthon, opened new schools in many places. As Sturm himself suggested, the ideal of these schools was to promote education that would unite eloquence with piety. In this way the older ideal of humanist eloquence was assimilated into Protestant teaching.

Most important, Melanchthon, himself the author of a treatise on rhetoric used in the schools, in this text and others responded specifically to the visual arts. Both in his encomium of eloquence,[31] and in the crux of his rhetorical treatise where the types of speech, the *genera dicendi*, are defined, he refers directly to examples from the visual arts.[32] Since Melanchthon's handbook became a standard text for rhetorical instruction in the schools, this way of thinking, whereby humanist rhetorical notions were applied to painting, became widely disseminated. When at the end of the century a painter who was probably educated in a Lutheran school found himself responding to questions about the choice of a form of interior decoration, he could therefore easily lapse into an application of Melanchthonian rhetorical language, saying everything is either high, middle or low.[33]

In this way the literal application of a new form of ornament, say on the portal of a court chapel, almost stands as a symbolic expression for a deeper assimilation of the underlying attitudes involved in stylistic choice. In the end, then, it may be that one of the lasting changes wrought by the Protestant Reformation was the transformation in an understanding of style related to the educational innovations it effected.

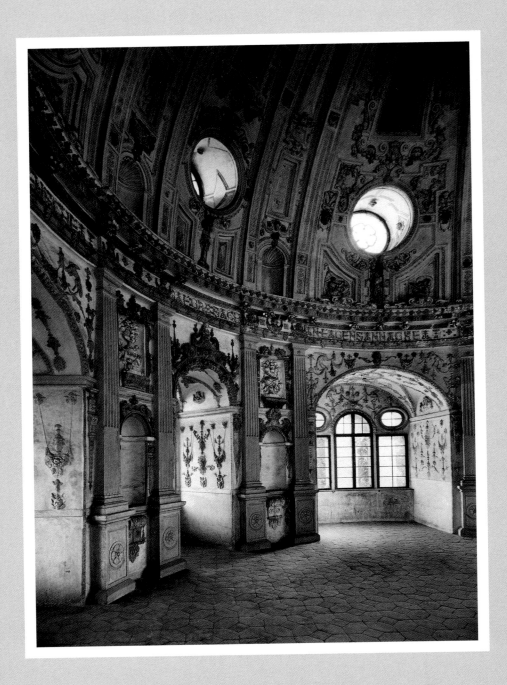

COURT, CASTLE AND CITY IN THE MID-SIXTEENTH CENTURY

Jindřichův Hradec, interior
of rotunda by G.P. Martinola and
G. Bendel and others, 1591-1600

Despite the ravages of time, a visitor to Central Europe today can still encounter a large number of monuments that survive from the mid-sixteenth century. Evidence of the urban architecture that flourished in this period is found in many town centres that remain largely intact, such as Telč or Nové Město nad Metuji in Bohemia. Town halls throughout Bohemia, as at Plzeň (Pilsen), in Poland, as at Poznań (Posen), and all over Germany, as at Altenburg in Saxony or Rothenburg in Franconia, provide further testimony to the erection of important civic structures at this time. Moreover, during this era many surviving princely palaces throughout northern Germany, and patrician residences, like those in Nuremberg, were built, and many other palaces were renovated or decorated.

The sheer volume of buildings erected or redesigned from *c.* 1530 onwards should belie the oft-repeated thesis that a period of decline set in with the death of Dürer and of other 'Old German Masters' or with the advent of the Reformation. The issue is not to be decided simply on the basis of aesthetic arguments, either, since there have been changes not only in the standards of evaluation of historical importance but also in taste. In the late nineteenth and early twentieth centuries mid-sixteenth-century buildings such as the *Schloss* in Heidelberg were in fact celebrated as the most typically German historical monuments; indeed they still remain some of the most famous works in the country, now one hopes devoid of the resonance of nationalism. In Bohemia as well as in Germany nineteenth-century architects also went along with

historians and art historians in echoing nationalistic sentiments, to which they gave voice when they emulated mid-sixteenth-century buildings.[1]

The problem of interpretation thus entails the establishment of an appropriate standard of judgement, involving art and architecture, by which a selection of objects could be determined. While it is true that earlier in the sixteenth century religious paintings and sculpture were made in great abundance by a number of masters, by mid-century architecture, especially in Germany, and to a degree other genres of sculpture command attention.[2] A judgement based either on quantity or quality that concentrated on aspects of the built environment might well determine that works of the mid-century surpass those of the beginning of the century.

Thus although it may be true that many of the older generation of artists were no longer active in Germany, and that Protestant patronage of sculpture, painting and church architecture was limited in comparison with the efflorescence of religious arts earlier in the century, the evidence that still stands indicates that other forms of art and architecture in the epoch from *c.* 1530 deserve notice. While the Reformation undoubtedly altered the demands for church art, changing the standards and conditions of production, Catholic patronage continued; moreover, monuments were made for adherents of all confessions. As suggested previously, these include most notably epitaphs and tombs in Poland, Silesia and Bohemia as well as in Germany. More important, although the continuing Catholic patronage of religious art could not offset the decline in the number of large-scale commissions of churches, chapels and altarpieces, which began with the Reformation, nor for that matter could it counteract what might be regarded possibly as a decline in the quality of execution of works made for Protestants, who seem to have been more interested in placing the emphasis on the didactic or propagandistic presentation of subject matter, impulses that had been directed into religious art began to be diverted into other outlets.

Hence the objects from the mid-sixteenth century that command our attention come from the secular realm. Private architecture and interior decoration provided newer forms for secular satisfaction. A large number of works of sculpture, including not only funerary monuments and ornament related to architecture, but fountains and portraits, were made at this time. Already by the 1520s there may be discerned a development of new genres and media of sculpture for private delectation, to be discussed in the next chapter, in conjunction with the development of a different understanding of the arts. In the pictorial arts of painting, drawing and printmaking, portraiture of secular personages also gained in relative importance.

There seem to have been several reasons why building in particular might provide a satisfactory outlet, especially in regions that became Protestant.[3] A simple economic model, in which a curve of architectural production parallels an upswing in trade, production or consumption, will not do, because in many regions where much bourgeois architecture appears, the mid-century

was in fact a period of stagnation or decline.[4] Yet economic circumstances do assist the formulation of an explanation: many new families did become wealthy around this time. Since financial success did not automatically lead to an improvement in social status, because a person's profession remained the major determinant of such matters, the possession of a house, especially one that was new in style or form, became an essential sign of success.[5] In the absence of other outlets this kind of display was not only one of the few available forms of expression but was also obviously visible.

Other, related motivations may be involved in the mid-century building boom. Where some areas experienced difficulties, times of hardship may have encouraged the desire to show off. It has been suggested in regard to other situations that hard times for commercial investment may make investment in one's own residence all the more attractive.[6] It has, however, also been argued in reference to the economic and social history of Renaissance Florence that a point may be reached where continued growth could only come from investment in capital equipment in the hope of increasing production through new technology; yet in Germany as in Italy this was not to occur for some time to come. Instead, in Germany as in Florence, fortunes were spent on luxury consumption, on building and interior decoration. And, as in the Florentine case, conspicuous consumption may be seen to have accelerated the growth of what can be called the luxury arts sector, thus having a positive effect on the making of arts and crafts for a secular market.[7]

Other notions, that are connected more with the beliefs affected by the sea change of the Reformation, may also even have encouraged conspicuous display, in which both individuals and corporations, in the form of guilds or town councils, indulged when they erected and decorated new structures. Success on earth, especially in the interpretation of certain tenets of Calvinist thinking, could be regarded as a sign of one's election. An unwritten defence of conspicuous consumption was thus conceptualized, in which physical display of one's wealth in the form of private building and the decoration of a residence could give a concrete sign of one's spiritual as well as worldly success.[8]

These ideas cannot obviously be applied without qualification even to areas under other Protestant confessions – Luther for example expressed his anger against desire for gain, and other attitudes may have held more egregious forms of consumption in check. Nevertheless, there were further ways in which the assumption of newer religious attitudes may have encouraged the building and decoration of houses. Luther himself argued that courthouses and town halls should be made painted instruments of what may be called Protestant propaganda. Surely the abundance of painted and sculpted images that one sees on both private and public buildings of this time can be read as a form of self-presentation with a more specific message than the general statement of success and self-importance made by the existence of the structure itself.[9]

Furthermore, the Reformation also led to newer considerations of art, to the formation of different attitudes according to which visual objects would have been perceived. The effect of the educational reforms and related rhetorical considerations introduced by Melanchthon, the impact of Dürer on the development of a literature on the visual arts, the consequent growth of the *Kunstbüchlein* – all facilitated the acceptance of new aesthetic attitudes. The introduction by Dürer, Cranach and others of classical subject matter clothed in classicizing forms was also continued, indeed expanded in the next generation. In addition, other aspects of Italianate and classical art theory were made accessible in German through the mediation of such mid-century publications as those of Walter Rivius, the German editor and commentator of Vitruvius.[10] Through them Italianate stylistic norms became better known. These were some of the factors that accompanied and facilitated the widespread assimilation of Renaissance forms not only at the courts and residences of princes and aristocrats but also in urban areas whither they had not hitherto penetrated.

On the other hand, the previous discussion of the role princes played in protecting reformers, or in personally promoting religious reform, suggests why in the middle decades of the sixteenth century the courts would continue to exercise a major role in social and cultural matters, for many of the same reasons they had done earlier. New spaces for the Protestant cult, as well as new funerary monuments, pulpits and religious paintings, came into being directly as the result of the redecoration of palatial residences. The pattern of assimilation involving imitation, whereby the ruler and his high officials first adopt Italianate forms, and then they are more broadly disseminated, can also be observed in the history of Renaissance architecture of the mid-sixteenth century in Central Europe, the primary subject of this chapter.

This pattern is clearly established by the patronage of the Habsburgs, whose emergence as the most powerful dynasty in the region is certainly one of the most significant series of events that shaped Central European history from the second quarter of the sixteenth century. As mentioned, in 1526 after the battle of Mohács the Habsburgs took over the position occupied by the Jagellonians in Bohemia and Hungary. Together with their control of hereditary lands in the Alpine regions of Austria, northern Italy and the Balkans, Habsburg rule over these regions enabled them to establish the basis for hegemony in the region that lasted for centuries.

The ensuing Habsburg patronage of architecture and its effect in Bohemia thus assumes an almost symbolic significance inasmuch as it too wrought a historic transformation.[11] In 1534 Ferdinand I called Italian artists north to Prague. This action marked the first advent of a major group of Italian masters to the Bohemian lands, as distinct from the sporadic appearance of artists from Hungary and as opposed to the role played by Germans such as Benedikt Ried.[12] However, as was to occur in Silesia starting roughly at this time, the artists who came north were workers from northern Italy. In Poland, too, artists from the Lombard lakes and the Veneto increasingly constituted the

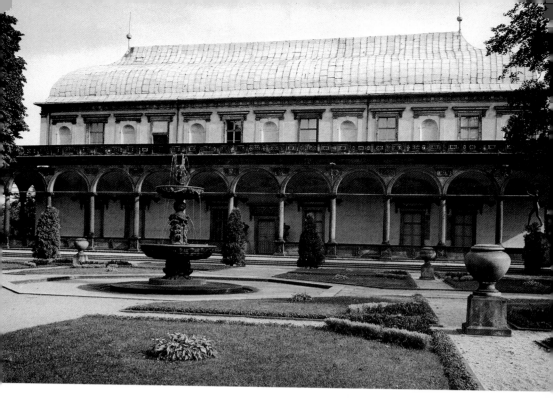

Villa Belvedere, Hradčany, Prague, 1534/8-63, by Paolo della Stella and Bonifaz Wohlmut; with 'Singing Fountain', by Francesco Terzio and Hans Peisser, cast by Tomáš Jaroš

dominant Italian presence. As in much of the rest of Europe, a standard based on Tuscan or Roman models is therefore misplaced in evaluations of art in Central Europe (as historians of Italian art have increasingly been arguing is the case in Italy as well), since after the initial wave of Tuscans the spread of the Renaissance to Central Europe did not flow directly from Florence or Rome.

The call for Italians was connected with the court's demands. In contrast to Maximilian I, Ferdinand I established a number of fixed residences in his various domains: in Prague, where his son Archduke Ferdinand II 'of the Tyrol' resided as statholder 1547–67, in Vienna and, though his son and successor as emperor from 1564, Maximilian II, had more to do with local construction, in Bratislava (Poszony, Pressburg), which replaced Buda as capital of Hungary. In Prague the first fruit of the new designs for the castle complex on the Hradčany was the construction of the Belvedere with its surrounding gardens. The location of this structure can be thought of as a dynastic statement that responded to a local situation in the same way as the Jagellonians had done; by making their own mark on castle hills, here and elsewhere, the Habsburgs also acted analogously to earlier Hungarian or even Russian rulers.

The Belvedere introduces an idea novel in its local milieu, for this structure is essentially a casino set in a garden. In its location close to the Hradčany

palace, but more importantly in its form, it is thus the first garden building of its type in Central Europe, and in this urban setting it differs from preceding Corvinian or Jagellonian villas in Hungary, Bohemia or Poland. Placed at the end of a garden, the building consists of a block surrounded by a colonnade; at a later date the so-called 'singing fountain' cast by Tomáš Jaroš was set in front of it. The form of the Belvedere is to be related to contemporary Italian designs of the cinquecento, of which it might be considered a fine example. Paolo della Stella began its construction with a lower storey executed in an architectural style advanced even in comparison with contemporary Italian architecture, in that it extends some Bramantesque artistic ideas. Although not acknowledged by any of the recent Anglo-Saxon histories of the villa, it deserves attention in any general history of garden architecture.[13]

While the Belvedere's type and form were new to the region, what can be inferred as its ideology, that is, its evocation of the myth of otiose retreat and the values of country life, was indeed all particularly novel in Bohemia. With it wafts in the aura of *rus in urbe*. Both as a garden structure and place of retreat, it thus resembles aspects of Italian palaces, and like them it also served later as a site for court entertainments.[14] Moreover, as the name Belvedere implies, it offers a fine view of Prague. Like many Italian villas and their Roman antecedents, it also served later as a repository for some of the imperial collections.[15]

We can look even farther than Italy for the origins of some of the ideas behind its design, however. While Ferdinand I was familiar with Italian ideas, he had also received his education in Spain. There he could well have come to know the villa-like structures of the Moslems, such as the Generalife in Granada, where a *mirador* (a belvedere) is also placed on an axis at the end of a garden. More immediately, Ferdinand may have been inspired by the contemporary palace of his brother Charles V, which was erected from 1527 in Granada and is another Habsburg dynastic statement: placed in the midst of gardens belonging to the residence of an earlier dynasty, that of the Moslem Nasirids, it is situated on the Alhambra, a site which also resembles that of the Hradčany in Prague, in that it sits on top of a hill which dominates a city.[16]

The role of Spain as a mediator of ideas deserves more consideration. It is not only Habsburg Bohemia which gained new perspectives on the arts from the imperial presence: Habsburg Spain did as well. Furthermore, as in Bohemia, the first Renaissance *Schloss* in the Austrian lands also has a Spanish connection. This is the castle in Spittal an der Drau in Carinthia, which was built for Gabriel von Salamanca, one of the Spanish nobles in Ferdinand's service brought back with him from Spain, and which was probably going up at the same time as the Belvedere. Schloss Porcia incorporates windows and portals of Lombard and Venetian derivation on the exterior of a structure whose interior contains a three-storeyed arcaded courtyard, combining Tuscan and Lombard elements.[17]

Like Schloss Porcia, the Prague Belvedere also bears relief sculptures with scenes of classical subjects placed in the spandrels of arches. Although restorations have made the interpretation of a convincing programme difficult, the general thrust of imagery is clear enough. Unlike those in Schloss Porcia, the Belvedere reliefs appear to make specific allusions, by containing representations both of members of the Habsburg court and of ancient heroes. Indeed

Schloss Porcia, Spittal an der Drau, begun 1530s

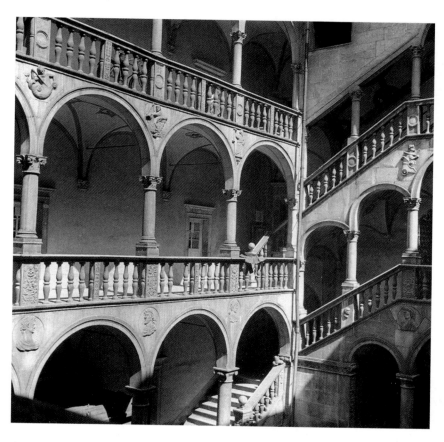

the Belvedere may have emphasized a frequent theme in Habsburg mythologizing, the dynasty's relation to the rulers and heroes of antiquity, by showing Habsburgs in a context where otherwise ancient heroes are represented. In this sense the reliefs may be regarded as a form of dynastic propaganda. Along with its new style, the Belvedere therefore presented a form of Renaissance imagery new to Bohemia.

Later the upper storey of the building itself was finished by Bonifaz Wohlmut, who also carried out other commissions on the Hradčany. These works, which manifest up-to-date Italianate stylistic elements, include the

Organ loft, St Veit's Cathedral, Prague,
1556-61, Bonifaz Wohlmut

Ball Court (*Míčovna*), Hradčany, Prague,
1567-69, Bonifaz Wohlmut

organ loft in St Veit's Cathedral, where the assimilation of ideas of the Italian theorist Sebastiano Serlio are manifest. The latter design, executed in 1556–61, offers the first example of the superposition of orders (that is the placement of Corinthian or Composite, Ionic and Doric one above the other) in architecture in the Czech lands. Such use of the architectural orders is not only a sign of stylistic innovation but perhaps a political statement as well, since with origins in imperial Rome it may carry imperial or royal connotations.[18] Wohlmut also designed the lodge of the Bohemian secretary of state in the parliament hall (*Sněmovna*) of 1551–63 in a form that resembles the *loggetta* on the bell tower in St Mark's Square in Venice. At a later date he designed another garden building for court entertainment, the tennis court building or ball court (*Míčovna*) of 1567–9 in the Hradčany gardens, whose combination of a monumental order with niches seems to reflect contemporary designs by Andrea Palladio and his circle.

The emergence of Wohlmut in a court context also merits comment. Like Ried, he demonstrates that Italian Renaissance ideas could be directly assimilated into a local milieu by indigenous artists and architects. Wohlmut's understanding goes further, however; he shows that Italianate forms could be employed 'correctly' and that they could be utilized for new

purposes. Not only Italian forms and buildings with new functions, like the ball court, appear in commissions he executed but a newer vision informs them. Wohlmut clearly comprehended his sources. He was a learned man: he owned a large library, which contained several theoretical works on architecture, including the works of Alberti and Serlio. From them he evidently derived concepts current in Italian art theory, such as the notion of history painting, '*historiaen*', which he used to describe paintings on the ceiling of assembly hall.[19]

Contemporary with Wohlmut was another unusual court architect: the archduke Ferdinand himself. Ferdinand proudly signed the drawings he designed for another court structure, the Star Villa he had constructed on the White

Star Villa (Villa Hvězda) of Archduke Ferdinand II 'of the Tyrol' by Hans Tirol, Juan Maria del Pambio and Giovanni Lucchese, after plans by the Archduke

Mountain west of Prague, site of the battle that in 1620 sealed Bohemia's fate. The signature is also a sign of the importance of invention in architecture as well as a token of the emergence of the idea of the independent designer in Central Europe. This villa in fact is an early example of the sort of inventive ground plan, which is modified on each floor, of the kind found in Italian Renaissance projects, but seldom executed, especially not for domestic architecture. It is a forerunner of the imaginative designs of the early eighteenth-century Bohemian architect Jan Blažej Santini Aichel, whose architecture also finds little comparable in the region. Inside the villa the stuccoes by Italians are of very high quality and are early Central European examples of this form of decoration. Although not completely deciphered, they also contain depictions of Ovidian tales, ubiquitous in Italian designs.[20]

The design and decoration of the Star Villa demonstrate the presence in Central Europe of the Renaissance idea that a concern with the actual process of making art could be a fitting occupation for a prince. This ideal, long inchoate, had been present since at least the time of the Medici and had been made more broadly current in the Renaissance since Castiglione's guidebook *The Courtier* and its reception. The archduke took it a step further, when he worked on the lathe, blew glass, painted miniatures and, a subject for the next chapter, also assembled an important collection. These occupations would increasingly engage Central European princes in the course of the later sixteenth and early seventeenth centuries.

The growing assimilation of Italianate ideals, as represented in Ferdinand's own activity, in the circulation of Italian theoretical tracts and in the publication of works by Rivius, increasingly meant that an understanding of style comparable to that informed by rhetoric would be applied to architecture. Accordingly, the character or style of a work would be determined with regard to its space, function and the personality of the patron for whom it was made. This suggests that the interpretation of the impact of structures built for a court, such as pavilions in pleasure gardens, needs to be reconsidered. The special function of these buildings would have obviously tended to reduce the extent of their replication to those who had need for them.

However, in spite of the thesis that the Habsburgs and their commissions had a limited local impact, their villas in fact had a widespread resonance in Bohemia, as at Česká Lipa, and elsewhere.[21] In southern Bohemia, at Kratochvíle, a villa whose name implies its use as a place of enjoyment and retreat was built during the 1580s by Baldassare Maggi and placed centrally in the midst of an extensive rectangular garden garden layout. At Jindřichův Hradec another garden pavilion was constructed from 1591 by Giovanni Facconi and Antonio Cometa, according to a central plan by Baldassare Maggi, and contained elaborate stucco designs by G. P. Martinola and others in the interior. Since patrons of both works also had residences atop or adjacent to the Hradčany and court positions (the patron of Jindřichův Hradec, Adam II z Hradce, was for example lord high chancellor of Bohemia,

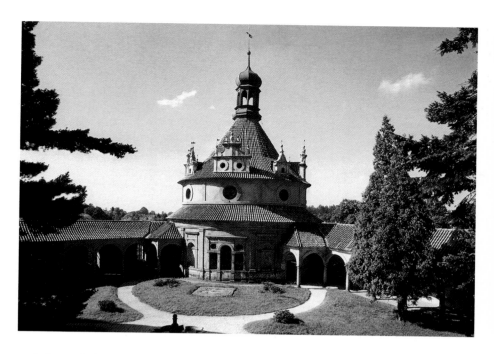

and also a diplomat for the court) and were in
contact with the court during the the time of
construction, it is reasonable to infer an
influence from the Prague designs; connections

Jindřichův Hradec, rotunda, 1591-1600,
Giovanni Facconi and Antonio Cometa,
after plans by Baldassare Maggi

with Habsburg designs in Austria, to be discussed, have also been discerned.[22]

The construction of *Lusthäuser* became a fashion that spread to other regions. The *Lusthaus* of 1553 in Stuttgart by Pietro Cuci, though marked by an independent design, seems to carry on this tradition of garden structures. In Dresden, where the court maintained close contacts with the Habsburgs, the roof and elevation of the *Lusthaus*, designed by Giovanni Maria Nosseni and begun in 1589, but destroyed by explosion in the eighteenth century, are recorded in earlier illustrations as having resembled the Belvedere. Finally another Habsburg garden structure, the Neugebäude outside Vienna, can be seen as the culmination of these garden designs. This work, to be discussed further below, was once an impressive structure which occupied the focus of an extensive layout and was worthy of comparison with any other similar composition. Probably the design of Jacopo Strada (on whom more in the next chapter) it presented a villa within a quadrangular layout, a form that may also have influenced those of Kratochvíle and Bučovice in Moravia.[23]

A new style for castle architecture associated with the Habsburg court also spread throughout the region. Some of the first instances of the type were promoted by the king or his closest servitors, for example at the castle at Kostelec nad Černými Lesý, a royal project (1549–58, by Hans Tirol and

U. and J. M. Avostalis); at Kačeřov, the residence of Ferdinand's secretary, Florian Griesbach (built 1540–56); at Nelahozeves (also for Griesbach, 1553–72); and at Moravský Krumlov for the Berka of Duba and Lipé, hereditary lord high marshals of the Bohemian kingdom (1557–62). In contrast with noble residences of preceding generations, as at Pernštejn, these buildings have a regular ground plan and arcaded courtyard. The superposition of orders in several of these courtyards is again a conspicuous carrier of imperial connotations since antiquity. Kačeřov also evinces a rusticated doorway, a

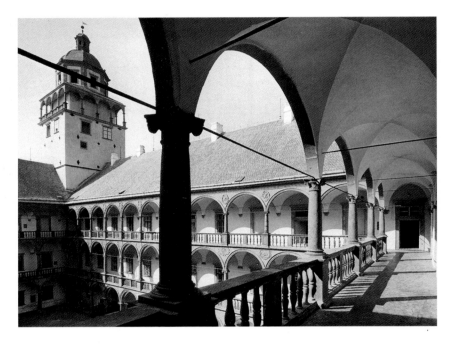

Moravský Krumlov Castle, courtyard, 1557-62, Leone Garove da Bissone

regular garden layout and other elements of decoration which tie it to Italian designs.

Not only in Bohemia but also in Austria, early buildings associated with the court or its agents, such as the castle at Spittal an der Drau, set patterns for further developments. This was the case with the Schweizer Hof in the Vienna Hofburg, a work by the ubiquitous Pietro Ferrabosco, another of those military engineers and fortification designers who capped their careers by acting as architects. The Schweizer Hof was an arcaded courtyard and also possesses a Serlianesque rusticated gateway, the Schweizertor. Its impact can be seen in many aristocrats' residences in Austria, Bohemia and Upper Hungary (that is, Slovakia).[24]

These impressive new Italianate designs initiated a series of castles with arcaded courtyards, at times with rustication or escutcheons, that are notable especially in Bohemia and Moravia, where they are greater in number, more

classicizing in style and thus more Italianate than the better-known French châteaux of the Renaissance. The series of constructions beginning in the mid-sixteenth century continues through the century and on into the next; comparable examples were spread beyond the borders of the Czech lands throughout the region.

After the first structures of the type had appeared, many of the more important castles were also built for nobles who were connected with the court, and often even by court architects; the cosmopolitan tendencies introduced by the court are thus hardly isolated from the local milieu. In Bohemia the series starts with the early reconstruction of the Pardubice castle begun by Vojtech z Pernštejna, the hereditary lord high chamberlain of Bohemia, and continued for the Czech court chamber itself after the building became an imperial residence. They include Litomyšl, designed by Giovanni Battista and Ulrico Aostalli (Avostalis), who had been in court employ, for Vratislav z Pernštejna, a courtier and counsellor in Vienna; Opočno, for Vilem Trčka, who had greeted the emperor on his advent to Bohemia; and Horšovský Týn, for Jan z Lobkovic, burgrave of the Prague castle.

These works suggest that a new style for living may have been imported along with their architectural mode. Much as in France, the medieval castle gave way to palace or villa. Yet despite the claims advanced by Renaissance theorists, the newer forms do not seem to have been introduced because of any Albertian ideal of 'commodity', since open courtyards are inappropriate for a northern climate. Rather, one of the reasons they were constructed seems to have been to make a point: nobles who had been drawn to court emulated its designs as a kind of self-definition and distinction.

The court connection of this new fashion can be seen in Bučovice, in Moravia, which possesses the most splendid interior of them all. This building was put up for Jan Šembera z Boskovic, lord high steward of Bohemia and counsellor to Rudolf II Habsburg. Its triple arcaded courtyard houses a suite of painted and sculpted rooms, including the so-called imperial hall, one of the great decorative ensembles of the sixteenth century. This room with its terracotta and stucco stands comparison with any contemporary surviving Italian or French Renaissance chamber of the epoch. The architect of Bučovice was the imperial servitor Ferrabosco, and it has been suggested that the artists who executed the interior were connected with the imperial court, even perhaps with the Vienna Neugebäude, which may have inspired its system of decoration. At any rate the subject matter of the imperial room, replete with Roman imperial busts, figures of gods and a figure of Charles V treading down a Turk, indicates an affiliation with imperial iconography.[25]

A pattern of dissemination of architecture and decoration from the court has already been observed in Poland; although not stressed in the history of art in Germany, other, related patterns may be observed there as well. The rivalry of the German courts and the lack of any one dominating centre at this time meant that the Habsburgs could not exert the same leading role that they had

in their own lands, nor even was there to be a situation like that of Jagellonian Poland. Maximilian I may nevertheless have provided the impetus for other German princes to seize upon classical imagery and forms when they wished to patronize important new forms of art.

For instance, the Wittelsbach courts in Bavaria, whose ambitions in the arts had previously been limited to the ecclesiastical realm and to a taste for the Gothic, as exemplified by the dukes' outfitting of the small

Imperial Room, Bučovice Castle, probably 1580s, by Jacopo Strada (?)

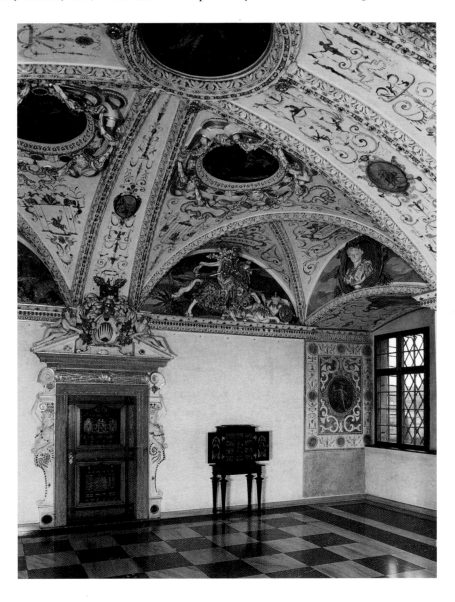

church at Blutenburg near Munich, also effected a transformation of art and architecture *c.* 1530.

Locked in a struggle with a rival branch of the Wittelsbach dynasty, the Munich court of Wilhelm IV commissioned a series of paintings of scenes from ancient Greek and Roman history, which were also intended for the *Residenzgarten.* From 1528 these paintings were executed by some of the leading German painters of the time. To this series belongs for example the magnificent *Battle of Issus* by Albrecht Altdorfer. The artists of this series clearly adopted or changed their style for this purpose, where the choice of a modified Italian style often goes hand in hand with the subject. Careful scholarship (Altdorfer had consulted the humanist Curtius Rufus) relates these figures in the painting of the battles to the texts describing the events. The depiction of Alexander's forces in the guise of contemporary knights or of the Persians in Turkic turbans relates the painting to contemporary events, however.[26] The prominent placement of the ducal coat of arms on several of the paintings suggests that, as with the Prague Belvedere, the duke was not so subtly identifying himself with the ruler heroes of classical antiquity.

The city castle in Landshut begun in 1536 by Ludwig X Wittelsbach can be regarded as making a demonstrative gesture that responds to the competition of his city cousins in Munich, but like the work done for the courts in Bohemia and Poland, it goes several steps farther. Ludwig X had visited Italy, stopping in Mantua in 1530, when he could have seen the Palazzo del Te of Giulio Romano and the Renaissance ducal palace. The inspiration of these works resulted in a cinquecento palace on a Mantuan model, a pure Italian palace in a German town. The elevation of the building comes straight out of Italy, and the interior design also seems purely Italian: the so-called Italienisches Saal with a barrel vault, simulated coffering and medallions in classical style is especially noteworthy. By this time Netherlanders and Germans painted in this mode: it is significant, for instance, that Herman Postumus and Melchior Bocksberger painted in an archaeologically inspired style in the castle, making works which include an image of an ancient statue, the Augsburg Mercury, in *trompe l'oeil.*[27]

The creation of the Landshut palace, in which are evident the needs to impress, to compete with a rival and to be up to date, gives a good indication of the circumstances in which mid-century phenomena originated. Educated and informed rulers, with international contacts, Italian advisers, humanist surroundings, a new literature and a personal involvement in the arts, often provided a forum for the arts throughout the area. But princely particularism, that is, the expression of individual interests of the rulers, shaped rulers' actions in the arts, as it did their approach to politics and religion.

The general consequences were several. A distinctive feature of German culture until unification in the nineteenth century is the presence of many cultural centres. As remarked, no one model was imposed from a metropolis. Thus it was possible that regional variants or local styles might develop. And

it was also the case that local traditions might continue relatively unaffected from outside. At the same time, even where Italian forms were adopted, by the mid-sixteenth century the classic, balanced architecture of central Italy was not current, nor for that matter would German princes in any case be obtaining art, artists and masons directly from Tuscany, but more often art from the north of Italy. The tradition of Italian art nearer to that with which northern patrons would have come into contact would have been a more highly decorated one, as represented by the Certosa di Pavia. Thus, although in Germany as elsewhere an increasingly Italianate architecture existed from the 1530s, and there was a resonance for the designs promoted by the Habsburgs as well as an overlap with

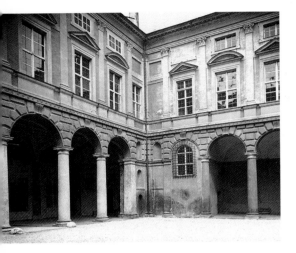

Residence, Landshut, 1543

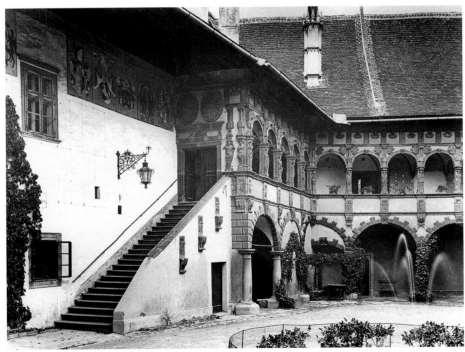

Courtyard of Schallaburg Castle, near Melk, Austria, begun 1572

earlier developments, there are many reasons why a wide variety of seemingly uncanonical forms appeared.

The appearance of the castle at Schallaburg in Austria characterizes the new fashion of architecture of the mid- to late sixteenth century. Schallaburg was erected from 1572 for a Protestant patron, who was therefore not a close court servitor; he may be regarded as following a fashion but also being somewhat distant from the latest trends, for social reasons. Yet his castle contains a wonderful arcaded courtyard, which, like many structures recalling their origins in the château-fort, appears enveloped by a traditional fortress-like exterior. The arcades are covered with terracotta decoration; this primarily Italianate material is combined with patterns taken from German prints by the so-called *Kleinmeister*, giving a different inflection to a Renaissance form.[28]

Formal developments in the Bohemian lands, Silesia, Poland and Saxony and their interaction with Italians, were further complicated by the activity of groups such as the Saxon masons, whose movement and importance has hardly yet been studied. The complicated development in the land of Saxony epitomizes the larger situation. A very rich region, Saxony was divided between rival sovereigns as were other areas in the empire; it thus provides a good example of particularism, of the problematic caused by local interests. Rival dukes were involved in a struggle for power and succession, related to electoral dignity and to the Reformation, and petty principalities also advanced their interests around the larger courts.[29]

Here the new designs of the 1530s came directly out of the architecture that had been promoted from the time of the 1520s, and the new architectural style is especially related to the spread of forms associated first with a group of artists who had been active at Halle. These are evident in the repeated merlon cresting and the gable forms, as seen on the castle at Glauchau, built in 1527–34 by Andreas Günther, who had previously been at Halle; they can thus give us an idea of those originally found at Torgau, put up from 1533. Torgau, already encountered as an example of Protestant church architecture for one of the first Lutheran chapels, possessed a regular, symmetrical layout, designed by Konrad Krebs, who worked at the castle from the 1530s. Its main span is accentuated by a prominent *Wendeltreppe*, a turning stairway which varies a quasi-French design. The flourish of this stairway can also be related to an indigenous Saxon tradition, exemplified by the splendid turning stairs in the Albrechtsburg in Meissen, a spot whose architecture may well have been recalled in the Torgau ducal residence, since Meissen was the traditional centre of the Saxon domains, the original seat of its electoral dignity.[30]

Just as the Torgau castle chapel established a model for Protestant chapels throughout Saxony and beyond, so does this castle courtyard provide an example for architecture throughout the region. Masons and sculptors from Torgau were the source of the architecture of the Renaissance Schloss in Berlin. Similarly sculpture in Brandenburg, and in (East) Prussia, drew much from that of Saxony.[31]

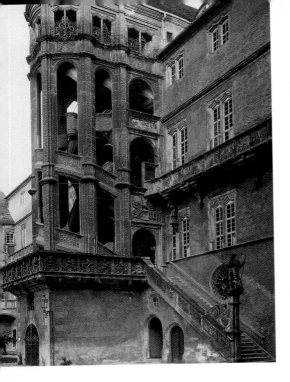

In Saxony itself, Dresden, the seat of a rival branch of the Wettin rulers, began to emerge at this time as a major centre for the arts. At first the architecture there also evinced the impact of Torgau and of the sculpture of the Dauchers, both seen in the Dresden Schloss. There the disposition of forms and the treatment of its gables changed at mid-century, when Dresden became the seat of Duke Moritz. Moritz, although a Protestant, allied himself with Charles v in the 1540s and thus gained the electoral dignity. As part of his desire to express his new dignity, he called forth a new architecture, building a large new Schloss, that began a significant transformation of the city. Other manifestations of this late sixteenth-century change in status include the *Lusthaus*, the establishment of a *Kunstkammer*, to be discussed more in the next chapter, and later, elsewhere in Saxony, the establishment of a kind of familial burial site in Freiberg in Sachsen.[32]

Torgau Castle (Schloss Hartenfels): courtyard with detail of spiral staircase (*Wendeltreppe*), Johann Friedrichsbau, 1533-6, Konrad Krebs and others

The most central setting for a ruler was the residence that he established for himself. The Dresden Schloss thus presented what can be interpreted as an architectural self-image, a combination of local ideas, such as a *Wendeltreppe*, gables and oriel, with a German interpretation of north Italian designs in its ornamented treatment of the orders. These were executed by north Italians, who added an arcaded loggia (by Ricchino and the Tholas) and a very elegant chapel (by Juan Maria del Pambio). The chapel portal also combines pure Italian 'High Renaissance' designs with characteristic sculpture by Germans (the Dauchers).[33]

The Dresden chapel was to be replicated in Schwerin. Its appearance there suggests the way in which not only the Habsburgs but the other major German courts, such as those of the electors, could also influence developments at lesser centres. The lesser courts in turn could emulate ones of middling size.[34]

This kind of mixture is found throughout the region, especially in those areas where Germans worked together with Italians and where similar demands for new buildings existed. In Silesia, for example, the ruler of a petty duchy at Legnica (Liegnitz) similarly attempted to assert his importance. This

attempt is manifested in the portrait medallions introduced into the castle portal of 1533, whose rusticated and rather squat proportions otherwise speak for the presence of a Renaissance design that had been made for a different sensibility, by local artists, who translated it into a decorative version of the form. In comparison, at Brzeg (Brieg) the three-storey courtyard evinces the beginning of the importation of Italian designs to the north by the Parr family from the late 1530s onward. Even if the castle gateway was designed by them, the

Gateway, Brzeg (Brieg) Castle, 1551-3, with sculptures of Piast rulers by Andreas Walther and others

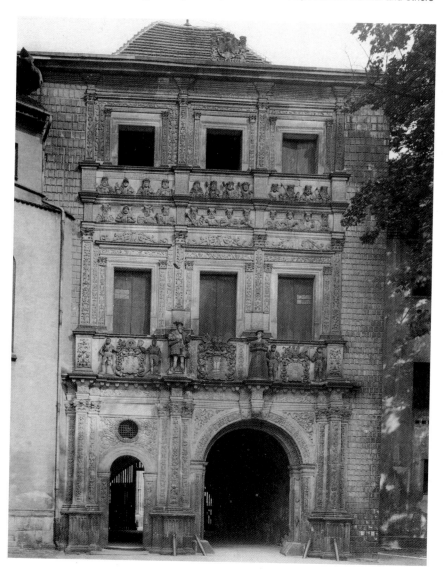

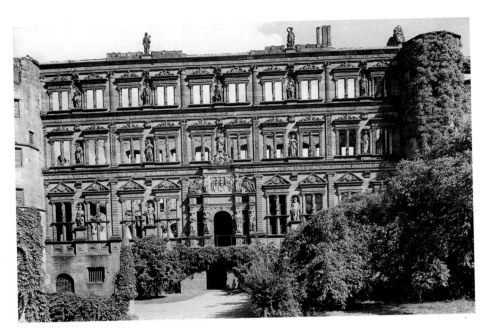

Ottheinrichsbau, begun *c.* 1556, Castle,
Heidelberg, with sculpture by Alexander Colin

sculpture on its facade was, however, probably executed by members of the Walther family, Saxon sculptors, from 1551. Again the connection of the monument with dynastic needs and its statement are clear, because the sculptural programme is a cycle of portraits of members of the ancient Piast dynasty.

A similar pattern of rivalry, innovation and combination, can be found in many castles of the 1550s. In Mecklenburg, for example, the Parr family were also active at the castle in Güstrow, where they again executed an arcaded courtyard and also regularized the facade, which however makes a fantastic impression with its irregular disposition, high roofs and gables. This building seems to respond to that of the rival court in Wismar, the Fürstenhof put up in 1553-4 by Netherlandish *Baumeister* after an Italian scheme. Reliefs in limestone of the Trojan War and a parable adorn it, but the terracotta sculpture on the building is by Statius Düren, a local Lübeck master.[35]

It is in this context of court competition that other works can be placed, such as the construction from 1553 of an arcaded courtyard at the Stuttgart castle by Alberlin Tresch and B. and M. Berwart and that at the Plassenburg in Kulmbach of similar date. A list of all the other arcaded courtyards in Germany of this date would be too long to include here, but some mention should be made of the most famous castle of the time, the Heidelberg Ottheinrichsbau begun in *c.* 1556, which can be seen as another example of a desire for a distinctive, impressive statement. It was but one expression of the

ambitious court in the Palatinate, which had turned to Protestantism. Other signs were its involvement in patronage and collecting, and its gathering of an impressive library, related to a phenomenon to be discussed in the next chapters.

Grand statements were made not only by castles but also by towns, and it is time to return to the question of urban architecture and design. Innovations in urban architecture were often either directly initiated by or else came in response to aristocrats. Residential towns came increasingly under the sway of their lords, who desired to control their commerce; the position of many of the castles rebuilt or constructed in this period, dominating the towns, expresses quite well the relationship.

A striking development of the era is consequently the building or rebuilding of towns by nobles. This could occur after fires, for example at Pardubice in Bohemia, where from 1538 the town was recreated by Jiřík z Olomouc for the Pernštejns. Its symmetrically displaced houses display new forms of stepped or merloned gables, many of which as a seventeenth-century public chronicle suggests were made with high gables or oriels, and in stone, so that they could not be damaged by fires, and at the same time give the town an attractive appearance.[36] Elsewhere in Bohemia, and indeed in other parts of the region, entirely rebuilt towns such as Nové Město nad Metuji, where new forms of gables and a regular plan are evinced, were also built at this time.

Houses, Nové Město nad Metuji, after 1526

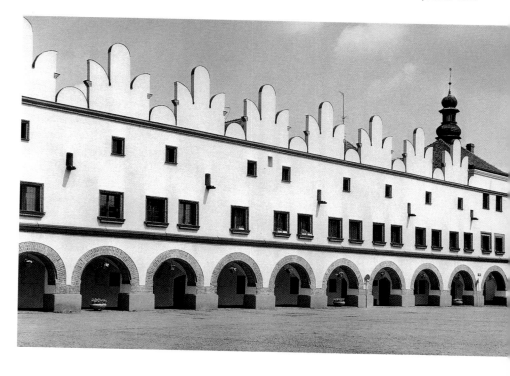

In Poland the best example occurred at the end of the century: the founding of the town of Zamość by the *hetman* Jan Zamoyski. Zamość possesses an ideal plan, and the institutions established in the town, such as the new academy for noble youths and the printing press, also express new Renaissance ideals. Both the architectural motifs, such as arcades and, originally, pediments, and the notion of the ideal town plan can be related directly to Italy, although in Italy, apart from a few places like Vigevano, such plans were seldom realised either in whole or in part. The designer-architect of Zamość was Bernardo Morando, from Padua; various Serlian and other Italian concepts have been found in this work. In such an urban organism the notion that the lord or a ruler orders the world is made manifest: the harmonious geometry imposed on the town mirrors that of the universe. By calling a new town into being, the ruler in a way assumes God's role on earth. This is a vision that also encompasses the diverse groups that constituted the Polish population, for a synagogue, whose structure still survives, was erected in the same style as the the rest of the city.[37]

On the other hand, the efflorescence of architecture in free cities can even be regarded as a sign of self-assertion against the court and aristocrats (the Habsburgs' crushing in 1547 of a revolt by the Bohemian estates, centred in the towns, also indicates where the power relations stood), and viewed against the actual decline in status, political and economic, that often occurred at this time, as an example of symbolic compensation.[38] In this light the structures erected by townsmen can be seen as a response to a more general fashion, in which certain architectural elements become the desired mode. This movement is suggested by the town hall in Poznań, Poland, the major work of its kind in the *respublica Poloniae*. This building was erected during the 1550s under the north Italian Giovanni Battista Quadro. Here the Italian effect is noticeable in the sequence of arcades on the facade. At the same time the high crenellated parapet above calls to mind the castellated appearance of an aristocrat's residence. Other elements of the decoration make further allusions: while the stuccoed decoration inside conforms to up-to-date Italianate patterns, the portraits of kings that originally adorned the exterior not only make a patriotic appeal but associate the town with the royal throne, often a traditional move of towns against nobles. This was especially the case where the town's legal status made it subject immediately only to the emperor or the king.

In some of the instances where institutions rather than individuals were the clients, the appearance of classicizing elements can also appear as a sign of emulation. Thus arcaded structures, a sign of castle architecture, could be adapted for buildings put up for the estates or town halls as well. These appear in the *Landhaus*, or assembly building, in Brno, Moravia, in Graz, Styria, and that in Klagenfurt, which was indeed designed by Domenico d'Allio. Yet they also appear in town halls in Brno and in Bratislava, Upper Hungary (now Slovakia).

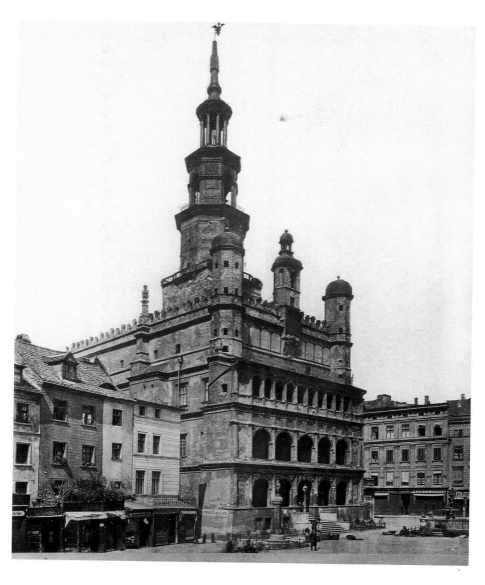

Town Hall, Poznań, 1550-60,
Giovanni Battista Quadro
(pre-war photograph)

This is an indication that the affiliations of style can often not be so clearly assigned to political and social affinities. In Germany, for instance, the characteristic structural and decorative elements are tall decorated gables, often with scrolling, oriels, elaborate portals and ornament, including reliefs and medallions. These elements are found in various combinations. They occur both on public buildings, such as the town hall at Altenburg, of

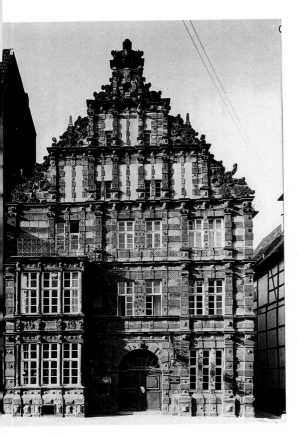

'Ratcatcher's House',
Hameln (Hamelin), 1602-3

1562–4 by Nikolaus Gromann, and also on elaborate patrician residences, such as the Lutsches house and the 'Ratcatcher's House' in Hameln (the house of the pied piper of Hamelin).

The sources of these motifs are as diverse as that of the men who made them. While a taste for the Italianate, for the *stile all'antica* became widespread, contacts with Italy or Italians became more and more tenuous the farther one was from the peninsula. In the absence of Italians, Netherlanders often spread a new style. Through their actual presence, or through the transmission of ornamental prints, their designs had an immense impact on architecture and interior design north of the Main and their influence extended all around the Baltic. The architecture which they sponsored, often marked especially by tall scrolled gables, represents a transposition of Renaissance style when it includes classicizing features. In this architecture the treatment of the traditional orders, when they appear, may often seem irregular from an Italian point of view. Furthermore this sort of building is often executed in brick or combines ashlar decoration set off by brick.

Yet in such works Netherlanders, or those emulating their designs, could stand in for Italians in presenting the new mode, the *stile all'antica*. For example, in a letter of 1545 the Netherlandish *steenhower* (mason) Paul van Hofe offered his services to the town council of Lübeck, saying that he was present 'in order to build here some buildings in the antique manner, which style one now holds for the height of art, but of which art one finds nothing here in town'.[39] Much like Saxon masons, from the 1540s Netherlanders could in this manner also spread the Renaissance style. In the Baltic area model books such as those of Vredemann de Vries were also much used. Later Netherlanders plied their trade throughout the region, including such important figures as Vredemann de Vries, who worked in Wolfenbüttel, Braunschweig, Gdańsk (Danzig) and Prague, and Anthonis van Opbergen, who was in Toruń and Elsinore, Denmark.[40]

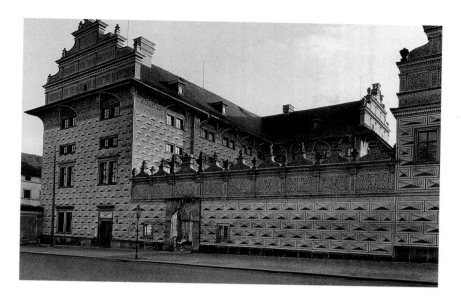

From this review of the complicated interplay of forms found in an even more complicated social and political world certain patterns seem to emerge. Among other things, it

Schwarzenberg Palace (Palace of Jan z Lobkovic), Hradčany, Prague, 1545-67, completed by Agostino Galli

can be determined that while the function of buildings may obviously have differed according to their milieu, the motifs found on structures in various milieus often did not. Hence the same forms can be found in both castle and palace architecture and on town halls. For example, in Bohemia the town hall in Plzeň (Pilsen) of 1554–9 by Giovanni di Statio, otherwise called Hans Vlach, may be compared to the Lobkovic (later Schwarzenberg) palace of approximately the same date (1545–63) by Master Augustin, probably Agostino Galli. The series of gables placed atop a high attic at Plzeň recall the termination of the storeyed gables on the Lobkovic palace; both are also covered by the graffito decoration that adorns many Bohemian structures. Similarly the motifs that are most distinctive in this period recur in both a sacred and a secular setting. Thus the parapet finishing the parish church in Paczków (Patschkau) of 1529 seems to be almost a playful variation of the so-called Silesian gable form found on the house of the Golden Gable in Wrocław (Breslau) of 1521–8, in its alternation of merlon and swallow-tail cresting.

Faced with the recurrence of such motifs as gables and sgraffito some scholars have taken the appearance of such features as signs of a particular aspect of the reception of the Renaissance in Central Europe. Since such elements appear on a wide variety of buildings, their recurrence in patterns that seem to indicate a deviation from a classical norm is interpreted neither as a sign of class or religious origins, nor as a period style, such as Mannerism, an inappropriate concept in any instance. Instead these buildings are said to

represent a provincial transformation of the Renaissance: works such as the cloth hall in Kraków, with its prominent attic, have been taken as characterizing a Polish 'vernacular', while at the castle at Horšovský Týn, rebuilt after 1547 in western Bohemia, the large and complicated gables, often grouped assymetrically, combined with painterly sgraffito decoration are seen as Czech vernacular.[41]

Yet the same features appear all over the region. The special gable parapet that has been identified as Bohemian, and which appears on the Týn School of 1562, a familiar landmark of the Old Town Square in Prague, is nearly identical to that of Melanchthon's House in Wittenberg of 1536. The irregular grouping of such complicated gable forms is also a mark of the so-called Weser Renaissance, as found on buildings such as the castle in Stadthagen, which features alone can therefore not be regarded as constituting a regional style as far as that group of monuments is concerned. The attic form so supposedly Polish is found

Melanchthon House, Wittenberg, 1536

not only in Silesia but all over Germany and Austria, not only in the Weser region but in Anhalt, Mecklenburg, Bavaria, Salzburg, Lower Austria and the Tyrol as well in Hungary. The sgraffito decoration found in Bohemia is also prevalent on many sixteenth-century houses in Austria, where the individual figural and ornamental motifs are also quite similar. And one could point to similar comparisons between forms of interior decoration in the different lands.

Like the classical orders, the arcades, the loggias and the decorative motifs derived from the antique that are more familiar signs of the Renaissance, many of these more picturesque motifs actually seem to have originated in Italy. The parapet form can be traced to Venice and the Veneto; the semi-circular and swallow-tail motifs combined into gables are also found there; and sgraffito is also of course frequent in Italy. Other gable forms seem to appear earlier in the Low Countries. If it is thus possible to talk about local centres and variants of the Renaissance in Central Europe, it does not then seem to be the appearance of individual motifs which would mark them as signs of vernacular adaptation. Rather, their combination and their appearance in different materials (brick versus stone, different kinds of stone, plaster covering brick versus undeco-rated ashlar) mark them as such; these features are dependent upon the materials available as well as the wishes of the patrons and the capabilities of the designers.

The sixteenth-century German sources which spoke about the gables that seem so characteristic of structures in the Weser area spoke of them as *welsche Giebel* and similarly the crowning tower forms found on Bavarian and Swabian buildings were known as *welsche Hauben*. Rather than replacing these terms with inadequate notions such as Mannerism, or debatable conceptual-izations of the vernacular, we might do well therefore to follow them and see even the seemingly most picturesque forms found in the north as signs of the widespread dissemination of the Renaissance, with all its local centres and variants.

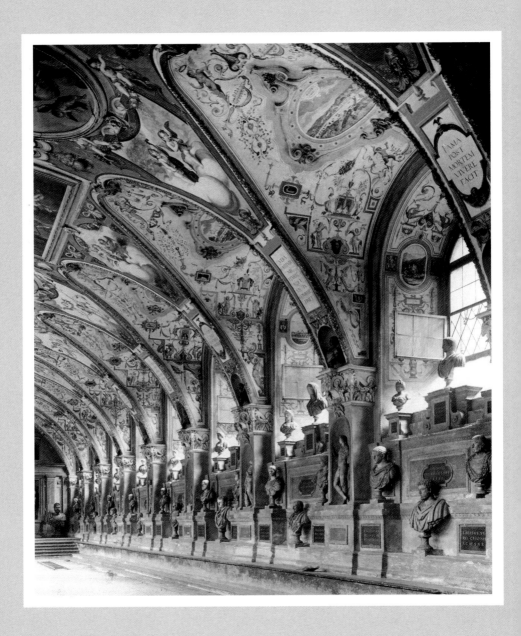

KUNST AND THE KUNSTKAMMER: COLLECTING AS A PHENOMENON OF THE RENAISSANCE IN CENTRAL EUROPE

Antiquarium, Munich Residence, begun
1569, designed by Jacopo Strada,
decorated by Peter Candid and others

DURING THE COURSE OF THE MID-SIXTEENTH CENTURY ART CAME TO
BE CONSIDERED IN A NEW LIGHT IN CENTRAL EUROPE. As elsewhere
where Renaissance culture took root, works of sculpture, painting and the so-
called applied arts began to be made for more than religious or political
purposes. In addition to and in place of older functions, a frequent destination
for art came to be the nascent collections of Central Europe. Central European
collections developed into independent entities during the mid-sixteenth
century; by the end of the century they had attained great size and signifi-
cance, particularly in the residences of rulers.

Already in 1525 there is evidence that a new definition of art was in the
making. In that year Stefan Godl cast a small bronze statuette of a warrior after
a design by Leonhard Magt. This piece, known as the *Ehrenpild*, was made for
Archduke, later Emperor, Ferdinand I, whom we have already encountered as
an important patron of a new form of architecture. In order to cover a wager
that the ruler had made, a nude was stipulated, but the subject was not further
specified. All that was demanded was a clever pose, which was supposed
to demonstrate diligence and the artist's ability, and that it should be nicely
made (with *Artlichkeit*).[1]

In calling for a demonstration of mastery of composition and execution,
the *Ehrenpild* required some of those elements that can be regarded as
pertaining to art as a form of skill or mastery, as it was defined as *ars*, or *techne*.
In German the word for art, *Kunst*, is also expressive of this idea, in that it is

Ehrenpild, 1525, Leonhard Magt and others, Graz, Landesmuseum Joanneum

related to the notion of ability, of *können*, just what was demanded from these artisans. Moreover, in its emphasis on execution and pose, and its neglect of subject matter, the *Ehrenpild* also approached a definition of art as appertaining to the aesthetic, to be discussed later in this book. That is, it was an object which seemed to be made with a purpose, but whose purpose was none other than a demonstration of qualities of how it had been made. Hence just at the time when according to the assertions of historians of German art a decline in art began, a new definition of art was in effect being enunciated, a concept that would ultimately justify the creation of art for the sake of art.

The commission of the *Ehrenpild* coincides with several other currents that led to reconsideration of artistic enterprise. In the same year that it was made, Dürer published his treatise on the *Unterweysung der Messung*. This was a book that, as has been discussed, posits the intellectual nature of art and thus attempts to establish rules for it. Since these principles can be known and learned, it established that the visual arts were moreover to be regarded as what could be called a science, in German a *Wissenschaft*.

A wave of publications followed in the wake of Dürer's writings. Many of these works, published throughout the century from *c.* 1530 onwards by such figures as Hans Sebald Beham, Heinrich Vogtherr and later Jost Amman, expressly identified themselves as *Kunstbüchlinnen*.[2] In these works, which at times speak directly to painters, sculptors and other artisans, the concept of *Kunst* that had formerly been endowed with a more general connotation meaning art, as in a liberal art, was becoming associated with an independent realm of what we now identify as the visual arts.

While some of the *Kunstbüchlinnen* were clearly written for practising artisans, it is also significant that a treatise on perspective like Hieronymus Rodler's *Eyn schön nützlich Buechlin und Unterweisung der Kunst des Messens* could already in 1531 (and in its second edition of 1546) explicitly address

itself to an audience described in general as *Kunstliebhabern*. This term suggests that in addition to artisans or what we might call professional artists, a new category of art lovers (a direct translation) was coming into existence. In any event, we may associate the manufacture of objects such as the *Ehrenpild* with this category of people, who might not only want to read about art but to purchase or commission works.

Magt and Godl's bronze was in fact but one of many similar objects that proliferated from the second decade of the sixteenth century. These include small statuettes of the sort that Conrat Meit had made in stone as well as small works by the Vischer workshop in brass and finely carved works in wood by Hans Weiditz. Cast medallions and medals, small narrative scenes and portrait reliefs in wood, stone, brass and bronze became the stock in trade of many workshops.[3] These are exemplified by such fine products as the brass reliefs of the Vischers and honestone reliefs by Hans Daucher, often with portraits or allegories depicting Charles v or Ferdinand I. As the demand for religious works of art such as altarpieces decreased, this kind of project, often works of a secular character, increasingly occupied the ateliers of Germany.

The creation of objects such as Daucher's reliefs is to be linked with particular patrons, such as Ferdinand I, and their small scale and delicate condition indicate that they were not

Meeting of Emperor Charles V with Ferdinand of Austria (relief), Hans Daucher, after 1526, New York, Pierpont Morgan Library

intended for public display but for an individual, or for a few beholders at most. This tendency corresponds to the increasing direction of aspects of artistic production in Germany towards what may be called private consumption. And this production often aimed at the satisfaction of a demand that was stimulated by another important new development, with whose origins patrons such as Ferdinand I are also associated. This was the origin and development of independent collections.

Collecting is certainly a universal cultural phenomenon. The symbolic displacement involved in gathering rare, valuable or strange objects appears in many times and cultures. During many periods and in many places in human history people have been led to form collections through curiosity or the love of external appearances, or a desire to study items that could be kept close at hand. The desire to collect transcends a strict concern with works of art, and an account of the earlier history of collecting must therefore take more than the history of art into its purview.

In a search for the ancestry of sixteenth-century collecting in Central Europe, we may start with the fabled collections of works of art of antiquity, known to later generations through the descriptions particularly of writers such as Pliny the Elder. Later, during the Middle Ages, church treasuries contained works of art amidst all kinds of other rarities; certainly the vessels meant to house the host or relics could be elaborately exquisite. Medieval church treasuries can thus be counted among the forerunners of such important sixteenth-century collections of relics in the region as that of Archbishop Albrecht of Brandenburg.

Similarly, the secular *Schatzkammer* (treasure chamber), in which a ruler's regalia were kept, formed one of the antecedents of the princely collections of the sixteenth century. An illustration from Maximilian I's *Weißkunig* shows him in the midst of such a collection. Yet as some objects in this illustration may also suggest, from a relatively early date princely treasuries were also enlarged by tribute, gifts and presents from visiting rulers; they also became repositories for gold and silver plate.[4]

By the fifteenth century such collections came to contain costly or rare objects that had been acquired not solely for their representational purpose, like regalia, or their material value, like plate, but for their own sake: collections contained objects that were regarded as beautiful or curious, or had some historical or didactic significance.

In the history of collecting of this time the dukes of Berry and of Burgundy played a particularly important role, because the dukes formed formidable collections that included precious vessels, exquisite manuscripts and impressive tapestries. When royal or high aristocratic personages such as the French kings and Francophone dukes collected, collecting became a field for social distinction. French examples made collecting an aspect of royal activity that might raise a prince in rank and at the same time justify his claims; it was thus all the more important for a ruler with great aspirations, such as the duke of

Burgundy, or for new men like the Medici, as we shall see, to engage in this particular form of conspicuous consumption.[5]

The collections of the Burgundian court were tied into a whole machinery of display, which presented the duke's power and dignity before the populace, vassals and visitors. Occasions for display were many: funerals, weddings, tournaments, banquets, visits of important personages. On such occasions collections could also play a role as a sign of wealth and fine taste; banquets allowed for display of plate on credenzas (chests or cabinets); visitors could be shown the treasury; and recalcitrant (or rebellious) subjects could be overawed with tapestries, precious metals and coins.[6]

As the case of Maximilian I has already suggested, the Berry and Burgundian heritage was especially relevant for sixteenth-century rulers of the Habsburg dynasty, who were direct descendants of the dukes. In particular Ferdinand I changed ceremonial at his court to model it on Burgundian custom. He collected early fourteenth-century French and fifteenth-century Burgundian manuscripts, and patronized manuscript painters from the region once ruled by Burgundy. And he became the first of his line to separate precious objects and paintings from their dispersal throughout his residences and place them in their own location, which was called a *Kunstkammer* (if spelled differently) and named as such for the first time in 1550.[7]

The development of the Kunstkammer in the mid- and later sixteenth century in Central Europe represents a distinctive development in the history of collecting. During this era princely Kunstkammers were established in Vienna, Munich, Prague, Dresden, Gottorf, Cassel, Stuttgart, Ambras and in many other places. Collections like the Amerbach-Kabinett in Basel were also founded by private citizens.

The Kunstkammer of Ferdinand I contained what we might describe as works of art and other objects of value or historical interest, including gems, coins, medals and things taken from the old Habsburg treasury – objects that been gathered for their own sake or evaluated for their aesthetic, historical or dynastic value. In a Kunstkammer fine paintings, sculpture, drawings, books or what may be called *objets d'art* might be gathered, at times in apparently haphazard manner, alongside stuffed animals, birds and fish, or their skeletons, fossils, clocks, automata and scientific instruments. Although in the broader anthropological perspective this kind of eclectic collection may not seem so strange, in the context of the Renaissance, the sheer diversity, apparent disorder and seemingly bizarre aspect of many of its contents have long been taken to be the salient characteristics of the Kunstkammer, defining it as something special and odd.

Scholars have thus long disagreed about the interpretation of collecting in Central Europe. The first great book on the subject by Julius von Schlosser contrasted what he called the *Kunst- und Wunderkammer* of the 'late Renaissance', a term Schlosser used only to indicate a period term in the case of the collections of the Italian Renaissance.[8] For Schlosser the Kunstkammer

belonged more to the world of spooks and superstition of the Middle Ages, that he deemed characteristic of the north. In contrast, Italy was the home of rationality, in which collections of different types were distinguished from each other and organized in an orderly manner; in Italy, not the north, the true origins of the modern art collection were to be found.

While the various Kunstkammers of Central Europe possessed their own peculiar features, which are doubtless not the same as those of more recent collections, much scholarship since Schlosser has found many similarities between them and collections of the Italian Renaissance. Gold, silver and *objets d'art* appeared alongside bones, unworked stones and relics in medieval church treasuries and princely studies both north and south. The tradition of collecting miscellany continued unbroken into the fifteenth and sixteenth centuries in the south as well as in the north, and many Italian Renaissance *studioli* would have served no less as storage facilities than would have Kunstkammers, and would thus also have appeared to be eclectic assemblages.[9] A comparable heterogeneity and organization of contents has accordingly been found in many an Italian *studiolo*. Other spaces for collections in Italy, for example, the Galleria delle Mostre in the Mantuan ducal palace of the sixteenth century, also contained chests and cabinets with scientific instruments as well as small works of art and curiosities.

A taste for the marvellous, the precious and the rare, like that north of the Alps, was also present in Italy. By the mid-sixteenth century the Ferrarese writer Saba da Castiglione could even provide an interesting example of the crossing of cultural contacts when he advised that along with cameos, coins, bronzes and paintings, every studio should contain *bizzarrie*, that he says can be obtained from Germany.[10]

Moreover, much like Italian collections and their contents, the background, ideology, forms of display, symbolism and decoration of collections in Central Europe can be understood as phenomena of the Renaissance. To begin with the question of antecedents: the desire to possess objects that might be regarded as beautiful or historically significant or 'curious' was no different in Berry or Burgundy than in Medicean Florence. As suggested above, the grounds for the conspicuous consumption involved in the establishment of collections in both areas were similar. In fact the humanist Filarete (Antonio Averlino) directly compared Piero de' Medici's passion for collecting 'noble things' such as cameos with that of the duke of Berry. Conversely, we may recall that already in fifteenth-century Central Europe King Matthias Corvinus of Hungary owned works by Filarete, as well as by many other Italian artists and that, soon after, rulers in Central Europe like Maximilian I were already becoming inspired by Italian examples.

The selected use of works of art as a form of ostentation, a familiar aspect of Burgundian propaganda, was not essentially different in sixteenth-century Germany. Tournaments and other ceremonies were employed as a means of promoting prestige. From more recent historical examples we may be

accustomed to expect that the symbolic transference of power and authority is to be attached to buildings, monuments or perhaps to some paintings, but the courts of Berry and Burgundy demonstrate that tapestries, plate and precious objects could function similarly, especially at court banquets. Among other rulers, the sixteenth-century Habsburgs continued the practice of such display at events that were specifically called *Schauessen* (display banquets) and especially at ceremonies whose origins themselves lay in Burgundian ritual. In the *Schauessen* the show consisted of the prodigious consumption not only of food but also of the capital evident the display of such objects.[11] Even in contemporary European boardrooms fine plate continues to be used as a means to impress. And the process of giving fine gifts, which might also impress by their splendour as well as impart a particular message, applies no less to our time than to an earlier era.

Fifteenth-century humanists in Italy had provided a justification for this sort of display in articulating the doctrine of magnificence. In Medicean Florence and Aragonese Naples an ideology was propounded that justified expenditure on the arts for objects bought not for their use but for their splendour. Such a theory not only rationalized collecting what we could call works of art but also inherently implied that the collection of this kind of object redounds to the reputation of the prince. According to Jacopo Pontano, who was one of the promulgators of this doctrine, magnificence is demonstrated in the collecting of objects such as bronzes, paintings, tapestries, furniture, carpets, carved saddles made of ivory, precious boxes, books, and vessels made of rock crystal, gold, onyx and other precious stones. Similar objects could be found not only in earlier collections, those of contemporary Italian rulers and the Medici, but also in the sixteenth-century Kunstkammer.

In Central Europe the doctrine of magnificence had already been applied to the activities of Matthias Corvinus by humanists belonging to his court circle; this Renaissance ethic also served as a rationale for the establishment of the Kunstkammer in the sixteenth century. As part of the redirection of education that occurred in Central Europe from the third decade of the sixteenth century, humanist doctrines would have become more broadly disseminated. In addition to those Central European humanists who themselves had collections, many of the rulers at the courts of sixteenth-century Central Europe where Kunstkammers were established were well-educated men, who would have been well schooled in Renaissance ideals. The founder of the Dresden Kunstkammer had been tutored by humanists and educated at the university of Leipzig. The Habsburg successors of Ferdinand I, the emperors Maximilian II and Rudolf II, were exceedingly learned and, as we shall see in the next chapter, they also gathered at their courts groups of humanists and scientists. The same can be said for the Bavarian dukes and for many other rulers.

Several documents indicate that German princely collections of the sixteenth century were established to promote the prestige of the ruler by

expressing his magnificence. The founding document of the Munich *Schatzkammer* (treasury) states that it was intended to express and increase the grandeur of the Wittelsbachs.[12] Rudolf II's effort to retain the collection of his uncle, Archduke Ferdinand II (of the Tyrol), manifests his intention to uphold the honour of the house of Habsburg.[13] A letter of his successor, Emperor Matthias, justifying the establishment of a central Kunstkammer and Schatzkammer (in seventeenth-century Vienna), speaks similarly of fulfilling the intentions of his deceased brother and of furthering the fame and glory of the House of Austria.[14] A proposal made to the duke of Saxony in 1587 to establish (in actuality to reform) a Kunstkammer by Gabriel Kaltemarckt emphasizes the undying fame gained by earlier and contemporary monarchs through the collecting of works of art.[15] Even the establishment and maintenance of botanical collections in Hesse have been regarded at least in part as an expression of the prestige of a princely demesne.[16]

In addition to Renaissance ethical theories, fashions that had been established in Italy had an important impact upon collecting in Germany. In this development middlemen, humanist-dealer-connoisseurs, played multifarious roles, advising and fulfilling the wishes of their clients and employers. The Mantuan Jacopo Strada was perhaps the best known among them. Strada was active in providing designs, supplying objects and books, collecting drawings of sites and manufacturing manuscripts for private patrons such as the Fuggers in Augsburg, the Bavarian court and to the imperial court, where he was designated *antiquarius*, a word with several meanings but here applied to a new position resembling that of keeper. A painting by Titian (Vienna, Kunsthistorisches Museum) portrays him with some of the sorts of objects that he purveyed, including coins, books and small sculptures. Through the agency of men like Strada several famous antiquities came to Central Europe, such as the antique statue of a Niobid known as Ilioneus (Munich, Glypothek), which had been owned by Lorenzo Ghiberti and Pirro Ligorio and entered the collection of Rudolf II.[17]

The importance of Italian models is also clearly seen in Kaltemarckt's *Bedenken wie eine Kunstkammer aufzurichten möchte* (Remarks on how a Kunstkammer might be formed) of 1587. This work, containing many practical suggestions, indicates that one source for works of art was Italy itself, whence contemporaneous art, antiquities, casts and copies could be obtained. Kaltemarckt also invokes Italian Renaissance collectors, such as the Medici, as a prime examples, along with modern potentates (among them Francis I of France, Henry VIII of England and the emperors Maximilian I and Maximilian II). He thereby also indicates that by the late sixteenth century collecting in Central Europe involved retrospective activity. It relied on the establishment of a canon, not merely capricious selection, that for Kaltemarckt seems to have been established by some sort of sense of historical importance, because in making suggestions for acquisitions he offers a condensed survey of the history of the various visual arts. This survey seems to have been based on contempo-

rary Italian historiography, namely the work of the first historian of art, Giorgio Vasari, with northern artists added. Because of the general problem of the reception of art in post-Reformation Protestant Germany, Kaltemarckt appears, however, to have needed to give further justifications for collecting: his defences repeat familiar Renaissance (and classical) commonplaces, that art not only can provide pleasure, but also can be useful.[18]

Although Kaltemarckt's programme, like other plans related to Kunstkammers, including Samuel Quiccheberg's *Inscriptiones* (1565), remained an unrealized ideal, the establishment of a number of types of collections in Central Europe nevertheless appears to follow Italian models. Strada's activity and Kaltemarckt's proposal suggest that the collecting of ancient works of art spread from Italy to Germany. As a consequence of the revival of interest in classical antiquity, the remains of the ancient past were widely sought after, and large collections of antiquities were founded by the Medici, by the popes in the Vatican Belvedere and others.[19] Strada's mediation and Kaltemarckt's recommendations imply that Italy was a source both for original antiquities and for the copies that could be procured by northern collectors.

If it did not actually originate in Italy, a taste for small bronzes was probably also reinforced by Renaissance examples. Several early Renaissance sculptors in Italy, such as Riccio (Andrea Briosco), attempted to create their own versions of ancient works in bronze,

Astronomy, 1570-5, Giambologna (Vienna, Kunsthistorisches Museum)

and other sculptors tried to imitate ancient works of art in bronze: the first signed and dated small bronze of the Renaissance is indeed Filarete's copy of the statue of Marcus Aurelius in Rome. Works by Riccio and Filarete were sent north; Filarete's bronze was given to the duke of Saxony by the duke of Mantua in 1585, when it entered the Dresden Kunstkammer. Kaltemarckt also specifically talks about bronzes when he discusses the Medici collections. He suggests how bronzes can be shipped north from Italy. He no doubt had in mind works by or after the Florentine court sculptor, Giambologna, which

found their way into the Kunstkammers of the Vienna, Prague, Dresden, Munich and Liechtenstein courts.

As even Schlosser noted, the establishment of picture galleries in Central Europe also followed Italian precedents. Many collections in the region, such as those of Maximilian II, of the Bavarian dukes and even of the Augsburg Fuggers, contained important Italian works. The greatest Central European picture collection of all, that formed at the end of the century by Rudolf II (ruled 1576–1612) contained, in addition to important paintings by northern masters such as Dürer and Pieter Brueghel, many masterworks by Leonardo, Titian, Correggio, Parmigianino, Veronese and Tintoretto.

In some instances Central European collectors also seem to have taken up the forms for display that had been developed in Italy along with the taste for various types of objects Just as the palaces in Mantua had served as the model for the ducal palace at Landshut, so did the design of the rooms for the Gonzaga collections in the ducal palace in Mantua determine the layout of the major space built for antiquities in Munich. This was the Antiquarium built from 1569 in the Munich Residence. In planning the Antiquarium, Jacopo Strada had a series of detailed studies drawn of the rooms designed by Giulio Romano for the display of antiques in the Mantuan palace. Consequently the Antiquarium, a long barrel-vaulted room, employs as its scheme of display a series of bays, punctuated by niches, socles and pedestals, that resembles that in Mantua.

While, like plans for collections, programmes for the presentation of collections often remained on paper, that for display of the part of Rudolf II's collection containing sculpture and antiquities seems to have been derived similarly from Italian prototypes. A preliminary design probably of the 1580s by the court painter Bartholomeus Spranger recalls the display of sculpture in Italian *tribune*, rooms for the display of antiquities, exemplified by the *antisala* of the Marciana Library in Venice; that the drawing was formerly attributed to Strada indicates its proximity to Strada's conception for Munich. Spranger's sketch and the *antisala* alike employ a system of niches, socles and pediments, with sculpture placed on them, and articulate the flat areas of wall with panels or reliefs. Prints of the rooms that were eventually produced in Prague also suggest they were ultimately similar to Italian designs (and they were in fact probably actually executed by Italians). The display of sculpture in the Dresden *Lusthaus* also resembled that of Italian collections.[20]

But what does the seemingly bizarre assemblage of works of art with *naturalia* and scientific instruments have to do with the Renaissance? The notion of skill or of the aesthetic does not exhaust the possible meaning of *Kunst* in the Kunstkammer: another definition of art that had also been articulated in ancient philosophy may be illuminating here. In his *Physics* (199a, 15–19) Aristotle defined art as a kind of imitation by process. In this sense Aristotle says that 'art either completes the processes that nature is unable to work out fully, or it imitates them'.

It does not have to be assumed that either the artisans who made objects for the Kunstkammer, or even, though it is more likely, the patrons who collected them were familiar with Aristotelian ideas to see how this notion of art is applicable to the Kunstkammer. First, in the Kunstkammer works of art complement in a general sense products of nature. Second, in a more direct way, works of art complete those found in nature. This process is not only evinced in theory, or metaphorically, as for instance in the manner in which artisans transform the gold found in nature into *objets d'art*. It is also embodied in some of the more splendid objects made for Kunstkammers, in which seemingly rare specimens, ostrich eggs, pieces of coral, narwhal horns (thought to be unicorn horns) and the like, are mounted in precious materials such as gold, decorated with enamel. At times they may be carved, as are rhinoceros horns, coconuts or Seychelles nuts. They may also be recombined, as in the mosaics composed of semi-precious and precious stones: and here we may remember that the origins of works in cut stone placed in fine gold mounts and made for northern patrons, were often workshops of Italians, that mosaic compositions of precious and semi-precious stones, called *commessi in pietre dure*, originated in Florence and that these Italian ateliers were also transported

Seychelles Nut Jug, 1602, Anton Schweinberger (Vienna, Kunsthistorisches Museum)

north. Or they may form truly wonderful and grotesque combinations, like that Anton Schweinberger composed out of rhinoceros horns, gold mounts, petrified shark teeth and boar horns. Finally the qualities of a piece of alabaster, marble or some other stone may be employed as an effective ground for a painting, in which the veins of the stone become waves of the sea, clouds in the sky, landscape or foliage, as in pictures by Hans von Aachen (see p. 193) and other artists that were to be seen in the Ambras or Prague Kunstkammer.[21]

It can be seen that the objects of nature found in Kunstkammer directly complement the objects of art that were seen in them. Both are part of a larger scheme, which could also include aviaries and menageries. All could partake in a universal system.

This scheme is related to a fundamental assumption north and south of the Alps that long held that there were continuities to be drawn between *artifi-*

cialia, things made by man, including works of art, and *naturalia*, the works of nature that God had created. In having a Kunstkammer, or *studiolo*, that contained *artificialia* along with *naturalia*, one could therefore have a collection that reflected the universe in all its manifold aspects. Hence a Kunstkammer or *studiolo* could be considered to be encyclopaedic.

A sixteenth-century collection could be so considered also because of another commonly held belief of the time. In the Renaissance it was still believed that parallels could be found between different parts of the world. The four seasons of the year were thought to correspond to the four humours of man, and in turn to the four elements; all were linked by comparable qualities. The microcosm, or smaller world, that is man thus corresponded to the greater world or macrocosm. In the little world shaped by man, a man-made collection that had objects that corresponded to all the aspects of the greater world, or macrocosm, might therefore be thought to represent the world in microcosm.

The cosmic dimension of this conception was also related to the goal of universal knowledge. Several schemes of conceptual organization, which resemble those pertinent to the Kunstkammer, proposed that all the universe could ultimately be grasped and understood. One such scheme was the memory theatre created in the mnemotechnic treatise published in 1550 by the humanist Giulio Camillo. Camillo's *Idea del teatro* created a true theatre of the world, a system for assimilating, ordering and retaining knowledge, in which the mind could grasp, order and control the universe. There was even a magical undertone to this belief, by which control might not be merely metaphorical or theoretical but actually effective.[22]

In Samuel Quiccheberg's *Inscriptiones vel tituli theatri amplissimi* of 1565 Camillo's idea of the theatre of the world was directly applied to a guideline for collecting. In Quiccheberg collections are to be organized according to the elements, the ages of man, the points of the compass and the seasons. Arranged in sequence according to materials, a collection would comprehend all types of *naturalia* and *artificialia*. Through its microcosmic organization, a collection would give insight into the macrocosm of the world.

Although no Kunstkammer was actually organized according to this Flemish physician and artistic adviser's plan, Quiccheberg says he had studied many collections, most notably that of Duke Albrecht v of Bavaria (1565–78). While his again was an ideal scheme, some collections both in Italy and in Central Europe did apply principles similar to those proposed by Quiccheberg to their decoration and at times to their organization. Camillo's pertinence has been proposed for the late cinquecento *studiolo* of Duke Francesco I de' Medici in Florence, which does seem to have been designed and organized according to a system recalling Quiccheberg's. The *studiolo* had personifications of the four elements on the ceiling, bronzes of goddesses associated with them on each wall and paintings depicting the manufacture or discovery of objects pertaining to each of them on each wall. For example the excavation of

diamonds, which legendarily were formed out of air, was shown on the wall with other subjects related to this element, and it is likely that behind the panel on which this picture was painted diamonds were in fact stored.[23]

In Central Europe an anteroom to Rudolf II's Kunstkammer in Prague suggests a conceptualization of organization in its decoration, wherein an illusionistic ceiling depicts Jupiter, the king of the gods, in the midst of the four elements and the parts of the year, the twelve months. In the Dresden *Lusthaus*, where some of the Saxon ducal collections were kept, there was depicted a similar combination of the four elements, day and night, and the seven planets (including the sun) known at the time. While the organization of these rooms was not that proposed by Quiccheberg, the Ambras Kunstkammer did distribute objects in painted cabinets according to their materials and have a separate armoury.[24]

Although Ambras may have been a rare instance in which there was a systematic ordering of objects, it would be a mistake to assume that early modern notions of system and display were those of later times; instead they may have followed notional and symbolic considerations that are consonant with the poetic and epistemic structures of their times. Hence, in shaping a universal collection, a ruler may not only have asserted his pre-eminence in the world of men through his lavish display of wealth. In possessing the world in microcosm, he may have symbolically represented his mastery of the greater world. This aspect to cosmological imagery is clearly suggested by the Florentine *studiolo*, where the ruler's portrait forms part of the cosmic decor and by the *tribuna* of the Uffizi as well. For a ruler who was entranced by magic, alchemy and the occult, like Francesco de' Medici or Rudolf II, the underlying assumptions that are also implicit in Camillo's memory theatre, that it was really a magical memory theatre, might also have counted: he may have believed that in having a theatre of the universe in his collection, he could grasp and control the greater world.

This more occult or Hermetic side to collecting was in fact openly articulated at the time. Francis Bacon, the great English thinker, also made a proposal for princes to establish collections, in which collecting constituted part of a larger Hermetic project. Bacon related this project to the conception of a ruler as the thrice-great Hermes, the Egyptian god-king who was also the embodiment of Renaissance magic. (And Rudolf II, with his interests in magic and the occult, was even called the Hermes Trismegistos of Germany.) If a ruler carries through the Baconian project of studying natural philosophy, as facilitated by the establishment of collections Bacon proposes, Bacon specifically says he will become a new Hermes Trismegistos.

Even if we leave open as speculative the possibility that the cosmological aspects of collections may also have had occult implications, there is other evidence for the representational function of collecting. The creation of the modern public museum and of a mass audience for exhibitions have made it hard to grasp that in the sixteenth century the number of men whose opinion

counted was small, and that forms of representation in the past are not necessarily those of more recent times. Yet the restriction of opinion to a small public is consonant with the love for small-scale, intricate and demanding works of art produced at the time. This form of restriction is also consistent with the constraints of a society governed by a strict protocol of hierarchy, that only deemed a few qualified and worthy to see and judge in any event.

And visits to collections did play a role in the diplomacy of the day. Visiting rulers or ambassadors were taken to see them, and showing collections could be used a sign of favour. Only a small group could be expected to, or needed to, get the message, and that they did in the case of Rudolf II's Kunstkammer is indicated by the reaction of visitors, who described it as a treasure worthy of its owner or considered its impact as similar to that of a loudly opened door.[25]

The relative exclusivity of collections, as of earlier treasures, thus does not rule out the possibility that they had a political dimension, even if no one other than the ruler saw them and understood the message. Rulers did not regard themselves as responsible to their subordinates or to the estates, but to God. For rulers such as Francesco I, Rudolf II or Philip II of Spain, all of whom were reclusive, representation may also have been a form of self-representation.[26]

On the other hand, that collecting may have had a political or representational aspect by no means excludes, and in fact can complement, other grounds or interests that may have been served. They may have been kept in a kind of storehouse, where they may have been used for study purposes. It has been noted, for example, that the Prague Kunstkammer provided a source for raw materials to be used by craftsmen as well as examples to be studied by artists, which they might then emulate in their own works. The princely Kunstkammer may also have served as a study collection in another sense, in that it contained examples of *naturalia* for consultation and investigation by the court humanists/scientists. Many collections may also have played an active role in the 'scientific' endeavours of their courts, since they housed instruments and other aids that may have been used in research. In particular the Cassel Kunstkammer of the landgrave of Hesse that contained his books, and scientific automata, and the Dresden Kunstkammer of the Saxon elector, which contained an abundance of technical tools that could have been employed in various investigations, have been regarded as reflecting the interests of their owners. Objects in collections may have served for entertainment. Nevertheless, in those instances where knowledge, either practical or theoretical, may have been the goal of the princely collection, as Bacon suggests in his *The Great Instauration*, in this social context it is open to question if knowledge was not in a real sense power.[27]

This goal of study and a locus for personal intellectual pursuits were probably much more the aim of people who did not possess political power, the private scholars or other personalities who also established collections at

this time. Given the hierarchical nature of society, it is unlikely that elaborate political or cosmological symbolism was attached to their collections. But it has also recently been observed that the collections of scholars and other private individuals nevertheless 'often served as status symbols and sometimes were a means to climb the social ladder. When a private citizen created a cabinet or museum of wide-ranging items, it gave evidence of his catholic taste and the breadth of his learning. In short, it identified him as a gentleman.'[28]

For whatever reasons, many collections were thus established in Central Europe, especially during the later sixteenth century. The late sixteenth and early seventeenth centuries may particularly be called a great age of princely collecting in Central Europe. The collections established in Dresden, Munich, Ambras and Prague were important both for the quality as well as the quantity of objects they contained.

Of these the greatest collection was that of Rudolf II. While the seemingly odd aspects of his collection have long attracted attention, it in fact contained abundant and important works of art. Several thousand paintings, not just the masterworks already mentioned, were to be found in the Prague castle. The emperor owned many fine works of sculpture by Giambologna and Adriaen de Vries. In addition to the Ilioneus, he possessed several other important antiquities, among them the Gemma Augustea. An inventory of the Kunstkammer that pertained only to part of the collection, the *naturalia*, scientific instruments, some of the books, and smaller sculpture and *objets d'art*, ran to almost four hundred folios, and lists hundreds of items, many of high quality. When Karel van Mander, who was familiar with many parts of Europe, came to write in his *Schilderboeck* of 1604 about where to go to see works of art, he therefore singled out Prague of all possible places.[29]

As the story of Ferdinand I and the *Ehrenpild* may suggest, the collecting in this period is also inseparable from patronage, particularly on the part of a prince like Rudolf II. Although there recently has been some debate about the difference between the representational function of collecting versus patronage, patronage may be regarded as a form of conspicuous consumption no less than collecting; both depend upon leisure and sufficient means. Both may serve for the display of magnificence. The formation of a collection may also involve the programmatic or systematic accumulation of objects, and thus necessitate commissions for objects to round out an ensemble.[30] Artists were indeed often employed at courts to provide works for a prince's collection.[31]

Many of the activities involved in collecting and patronage of works or art are in fact closely related. Collectors commissioned copies when originals could not be obtained. Rudolf II is known to have ordered the imperial ambassador in Spain, Count Khevenhüller, to procure a copy of Correggio's *Ganymede* if the original were not attainable. Both the emperor and the Munich dukes also had copies made of works by Dürer and other Old German Masters when they could not obtain the originals.[32] Kaltemarckt proposed to have moulds made of ancient and modern sculpture to enrich the collections

in Dresden.[33] The procedure of procuring copies may account for the frequent record of their presence in collections, as early inventories indicate. In some cases the patronage of objects for collections applies to the *naturalia* as well as to the *artificialia* found in *Kunst- und Wunderkammern.*

As has been in part suggested, several important architectural projects of the later sixteenth and early eighteenth centuries also owe their origins to their connection with collections. One of the most striking examples is the Munich Antiquarium, which was the largest surviving room built for a secular purpose north of the Alps in the sixteenth century. Similarly the edifice known as the Münze in Munich was built not only for the Bavarian mint, but also to provide a home for the the the ducal Kunstkammer. Archduke Ferdinand (of the Tyrol) rebuilt his castle at Ambras near Innsbruck to contain his collections. Ferdinand's brother, Maximilian II (emperor 1564–76 and father of Rudolf II), may have had

Stallburg, Vienna, 1559-64, perhaps by Pietro Ferrabosco

a similar purpose in mind when the Stallburg was put up near the Hofburg in Vienna: this building served not only for stables for the emperor's horses but also to house his art collections. In Prague Rudolf II similarly had the so-called Spanish room designed to be used to house sculpture in the space above the stables he had constructed in the Hradčany castle. In the Hradčany a whole new wing connecting it to an edifice known as the 'Summer House' was also used for the imperial Kunstkammer and painting collections. Similar additions or alterations were made in many places, such as that for the Kunstkammer in Schloss Gottorf near Schleswig.

Artists, including court retainers, were obviously often commissioned to design or decorate these spaces. We have already encountered Strada, Spranger, and Vredemann de Vries in this context. Other examples include the paintings from the workshop of Pieter de Witte (Pietro Candido), which were later set into the Munich Antiquarium, and the fresco Spranger executed on a ceiling in the White Tower in the Hradčany, a room situated in the midst of a sequence of spaces for the imperial collections.[34] In this regard collections as well as patronage could also function as a means of prestige with a political as well as an emotional dimension. A good story to this effect is provided by a fifteenth-century Nuremberg merchant, who judged the Burgundian treasure to be greater than that of the fabled treasures of San Marco in Venice.[35] A similar effect was no doubt intended by the sixteenth-century successors of the Burgunderschatz.

Hence only for the sake of clarity of presentation are collecting and patronage treated independently here. An interpretation of the changing role of art and art collecting in the sixteenth century must lead us to a more extensive consideration of patronage, particularly by princes, in the later sixteenth and early seventeenth centuries.

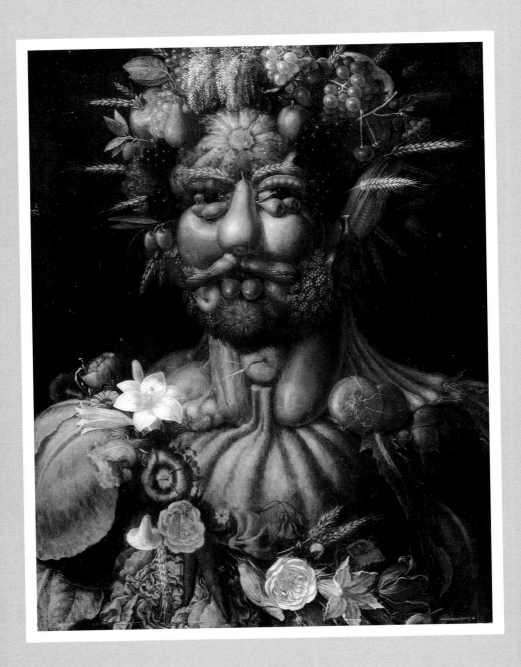

PRINCELY PATRONAGE OF THE LATER SIXTEENTH AND EARLY SEVENTEENTH CENTURIES: THE EXAMPLE AND IMPACT OF ART AT THE COURT OF RUDOLF II

Rudolf II as Vertumnus,
Giuseppe Arcimboldo, *c.* 1591
(Skokloster Castle, Sweden)

WHEN THE WELL-INFORMED NETHERLANDISH ARTIST-HISTORIAN KAREL VAN MANDER SELECTED PRAGUE INSTEAD OF ANY OTHER EUROPEAN CITY AS THE PLACE TO GO TO SEE WORKS OF ART, HE EXPRESSLY RECOGNIZED THE IMPORTANCE OF COLLECTIONS IN CENTRAL EUROPE. Van Mander also called Rudolf II 'the greatest art patron in the world at the present time'. In 1675 his German counterpart, Joachim von Sandrart (1608–88), of whom more later in these pages, wrote with similar authority and emphasis about his patronage. For Sandrart Prague was the Parnassus of the arts, and the ruler who had been resident there, Rudolf II Habsburg (emperor 1576–1612), the most famous patron of the arts.[1] Although most outstanding, and thus chosen for attention here, Prague was, moreover, but one of many centres of princely patronage in Central Europe during the late sixteenth and early seventeenth centuries, just as the imperial collections were but the most outstanding of many collections.

This period can be regarded as a great age of princely patronage as well as of collecting in Central Europe. Along with the proliferation of collections, many princely courts became centres for the production of paintings, sculpture, drawings, prints and works of the so-called minor or applied arts. We are accustomed to thinking of Renaissance Florence as one of the high points in the history of art, but, although Central Europe may not be as familiar, it may be argued that for many of the same reasons there were equally splendid achievements in other endeavours and fields. As noted above, a study

of the building of Renaissance Florence has suggested that a redistribution of capital into luxury consumption promoted the development of industries to serve this end; in Central European cities such as Nuremberg and Augsburg goldsmiths and jewellers flourished for similar reasons *c.* 1600.

This was also a time in which developments in Central Europe attained some of their widest influence. Having assimilated currents from other parts of Europe, patrons in Central Europe ultimately exercised a far-ranging effect on what was done elsewhere in Europe and beyond. Centres like Prague in particular gained not only regional but supra-regional importance. The figures at the top of the social and political hierarchy and the emperor (and also the king of Poland) initiated a series of developments, whose repercussions came to have an impact on the production and consumption of the visual arts in many social milieus, much as it did upon the arts in many areas of Europe and the world.

While rulers continued to support building projects during the late sixteenth and early seventeenth centuries, court patronage was marked by princely interests in the visual arts. The personal involvement of sovereigns in the arts is epitomized by Emperor Rudolf II, who was fabled for his visits to watch, supervise and work alongside his artists and artisans in their ateliers. Hence much has been made of his supposed neglect of affairs of state. But placed in its setting, the emperor's personal involvement does not seem so extraordinary. The cultivation of the arts in Central Europe was something that became a princely passion throughout the region, and one that also conformed to a broader European pattern. An early sixteenth-century woodcut by Burgkmaier shows Maximilian I directing a court painter; it is said that other princes of the earlier sixteenth century, including Francis I of France, Margaret of Navarre and Duke Emanuel of Savoy, had tried their hand at painting, as Rudolf II was to do. The story of Charles V picking up the paintbrush of Titian is also a legendary tale of a great ruler's personal esteem for the arts.

Where Archduke Ferdinand of the Tyrol had designed a building, and Duke Heinrich Julius of Braunschweig-Wolfenbüttel had written plays, many other princes in mid- and late sixteenth-century Central Europe became personally engaged in the practice of the plastic arts. In addition to his interests in architecture, Ferdinand of the Tyrol made glass vessels himself. Duke-Elector August of Saxony, Duke (later Elector) Maximilian I of Bavaria, Archduke Leopold Habsburg and somewhat later Prince Vladislav Sigismund of Poland all worked on the lathe.[2] King Sigismund III of Poland is known to have worked as a goldsmith, stonecutter and painter; Maximilian I of Bavaria a jeweller. Archduke Charles Habsburg (brother of Maximilian II and Archduke Ferdinand of the Tyrol), ruler of *Innerösterreich*, was a joiner.

Princely interest in the pictorial and applied arts became far more than a pastime or entertainment. When many rulers directly engaged in the practice of the arts, it is easy to understand how patronage as well as collecting could

become a matter of prestige, an opportunity for a ruler to represent his importance. In a world of collectors and patrons it could well be expected that the most important ruler would be the most important patron. Although his interests have long been misunderstood, the pre-eminence of Rudolf II as a patron, as well as a collector, was therefore appropriate to his status in protocol. His gathering under the imperial aegis of over twenty-five painters, a number of fine sculptors and many workshops of stonecutters, goldsmiths and instrument-makers forms the pinnacle of princely enterprise in this domain.[3]

View of the Salzach valley near Salzburg, drawing by Paulus van Vianen, c. 1601-3 (Berlin, Stiftung Preußischer Kulturbesitz, Kupferstichkabinett)

Much as the preceding chapter's overview of collecting at this time may already have suggested, patronage as well as collecting thus had its place in the politics and diplomacy of the day. Several communications from Rudolf II speak of the shared interests of rulers in the arts as complementing (it was hoped) their common political cause; the Saxon archives reveal similar intentions.[4] The commissions that artists active at one court, as, for example, the imperial artists Von Aachen, Adriaen de Vries and Joseph Heintz, received from other courts may be thought of in relation to diplomatic initiatives. Artists as well as objects could also pass from one court to the next, as the goldsmith and draughtsman Paulus van Vianen did from Archbishop Wolf Dietrich von Raitenau's Salzburg to Prague. Gift-giving was enmeshed in the

practices of politics: clocks and other objects were sent in tribute to the Porte (court of the Sultan) in Istanbul, for example. This strategy might also necessitate the production of new works, and artists could also be commissioned to create works with an explicit message, such as those that had been sent by the Habsburg emperors Maximilian II and Rudolf II to the Wettin court in Dresden.[5] Before the famed Peter Paul Rubens was employed for the task, artists such as Rudolf II's court painter Hans von Aachen had already served as ambassadors; Rubens's patrons in Mantua may even have been inspired by an earlier ambassadorial mission that Von Aachen had made there to use him similarly.

In these matters as in many others Central Europe thereby adapted patterns familiar from the Italian quattrocento or from those of Renaissance France. Examples could be provided by the Italian ruling houses, with several of whom the princes of Central Europe, including Ferdinand of the Tyrol and Sigismund August of Poland, were united by marriage. For the Habsburgs' earlier emperors such as Charles V, the grandfather of Rudolf II (and ancestor of several other dynasties), could also stand as an exemplar, and for Rudolf II so could King Philip II of Spain, who because of Habsburg intermarriage was at one point simultaneously uncle, first cousin and brother-in-law of Rudolf II; the future emperor was also raised at the court of Spain.

Cultural interchange also characterized court patronage because of the nature of the constitution of the court entourage in Central Europe. Many of the rulers throughout the region not only offered occasional commissions to the artists or artisans settled in traditional centres like Augsburg or Nuremberg but installed artists among their ranks of court servants. The groups of artists who came to work at the courts of Central Europe also hailed from all quarters. German-born artists were in abundance, especially at the minor courts, but even these often had lived a peripatetic existence and, moreover, in many instances, had also travelled to Italy.[6]

Hence artistic circles at the more important courts often acquired a genuinely cosmopolitan character. In this regard as in others the patronage of Rudolf II, drawing artists from all over, may epitomize an imperial ideal, in that he made Prague once again into a supranational centre for the visual arts, as it had been under Charles IV in the fourteenth century. Stonecutters and jewellers from various parts of Italy, such as the Miseroni from Milan and the Castrucci from Florence, worked alongside Netherlandish goldsmiths such as Jan Vermeyen from Brussels and Paulus van Vianen from Utrecht. Germans such as the Augsburger Nicholas Pfaff and the Nuremberger Anton Schweinberger also produced splendid works at this court. Among the court painters for Rudolf II's father Emperor Maximilian II had been the Italians Giulio Licinio, Martino Rota and Giuseppe Arcimboldo, whom Rudolf took over into his employ; he later engaged Fabrizio Martinengo and Marian de Marianis. While Lucas van Valckenborch had worked for Maximilian II, Rudolf brought into imperial service the Flemings Spranger (who had been

engaged on a a piecemeal basis by Maximilian), Pieter Stevens and Joris (Georg) Hoefnagel, who had earlier worked for the Ambras and Munich courts, as well as Roelant Savery and the Dutch Dirck de Quade van Ravesteyn, the Swiss Joseph Heintz and Germans such as Hans von Aachen (also previously at the Munich court), Matthias Gundelach and Daniel Fröschl.

As the production of sculpture by the Dutch-born (in The Hague), Italian-trained (by Giambologna), imperial sculptor Adriaen de Vries for several sites outside Prague suggests, however, the cosmopolitan aspect of court art was not restricted to the most important centre in Prague. De Vries supplied sculpture to Prince Karl of Liechten-stein, who also commissioned works from a great diversity of figures. De Vries made sculpture for Prince Ernst of Schaumburg-Lippe, at whose court other Netherlandish artisans worked; he made an equestrian statuette for Heinrich Julius of Braunschweig-Wolfen-büttel, an important patron himself; and he sent several sculptures to the Dresden court.[7]

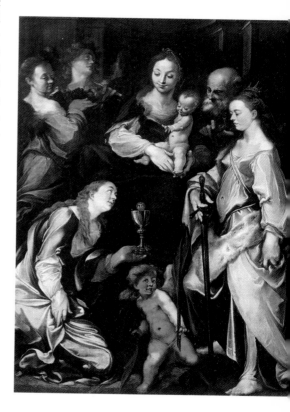

Holy family with Saints Barbara and Catherine, by Joseph Heintz, *c.* 1595-1600, Malá Strana, Prague, St Barbara's Chapel, St Thomas's Church

When such increasingly cosmo-politan court circles of artists were being established, the status of artists was also raised, and the scope of their activities broadened. The inter-est of rulers in the arts lent dignity to what had traditionally been regarded as banausic activity. *Hofrecht* (court rights), governing their employment at court, freed artists from guild restrictions. The emperor also expli-citly raised the status of Prague artists who were not attached to the court, decreeing the Prague associa-tion of painters a 'brotherhood', not a craft. When the emperor em-ployed artists as ambassadors or took them into his counsel, as he did Daniel Fröschl and Hans von Aachen, this was clearly a further indication of artists' rise in status. The exaltation of artists went even further, when, like Charles v before him, Rudolf II either confirmed or raised to the ranks of nobility several artists (including his court servitors Arcimboldo, Spranger and Von Aachen).

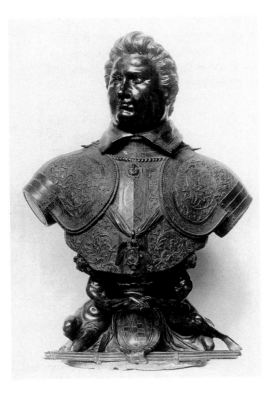

Bronze bust of Elector Christian II
of Saxony, 1603, Adriaen de Vries
(Dresden, Staatliche Kunstsammlung)

These changes in social status lent support to an ideology that artists had advanced since the earlier quattrocento in Italy. Against the claims that the visual arts were not truly liberal arts, because they necessitated manual labour, unfit for a man of higher estate, defences had long stressed the noble and intellectual character of the arts. Although no such tracts were written in Central Europe, there are abundant allegories in paint, sculpture, prints and most often drawings, especially in sheets drawn in albums, that associate the visual arts with the liberal arts. They appear, for example, in several paintings, prints and drawings by Spranger. But the claim that the visual arts involved intellectual activity was made by many other artists, for example in frequent allegories, where Minerva is shown as the protectress of the arts. And many of these allegories are themselves demonstrations that art of this time was increasingly intellectual in its assumptions and the demands it placed on its audience.[8]

Under the aegis of court patronage art was produced, most notably in Prague, that was not only cosmopolitan in its origins and increasingly intellectual in its pretentions, but full of new subjects, in new genres and with newer content, style and stylistic assumptions. To be sure, artists of the later sixteenth and seventeenth centuries in Central Europe carried on tasks that court artists had long performed, and these could also extend to areas beyond the making of objects. For instance, festivities, attending entries, tournaments, marriages and the like occupied court artists in Stuttgart, Munich, Vienna, Prague and elsewhere.[9]

Rulers also continued to commission works of art for placement in a sacred context, just as they continued to build churches. Altarpieces were commissioned for churches by Catholic patrons such as the Munich dukes and the Habsburgs. The decoration of the St Michael's Church in Munich with altarpieces by Christoph Schwarz, Hans von Aachen and others is especially conspicuous. While not as prominent within their total production, Rudolf

II's court artists, including Spranger, also produced altarpieces (a joint enterprise of 1598 by Spranger, Von Aachen, Heintz and Vredemann De Vries for the court chapel in the Hradčany palace is an important sample of Rudolfine art). On the other hand, court artists could also serve Protestant patrons. Spranger made several epitaphs for Prague as well as for clients elsewhere.[10] The replication of the prince's image also remained a task for court artists. Portraiture thus occupied many court artists throughout the empire. Official portraits were produced in Munich, Prague, Dresden and many other centres. In paintings, prints and sculpture the grandeur and virtue of the ruler were to be represented.[11]

Nevertheless, art-making especially in Prague demonstrates a significant shift both in its function, form and content towards 1600. One of the most striking portraits of a ruler made at this time manifests a metamorphosis even within this traditional genre, not only embodying much of what is particular about Rudolfine art but incorporating many of the newer features of art of this age. This is Giuseppe Arcimboldo's (1527–93) striking portrayal (c. 1591) of Rudolf II in the guise of Vertumnus, the Etrusco-Roman god of the seasons. This work culminates the artist's series of anthropomorphic compositions of fruit, vegetables and other sorts of objects conjoined to form the object that they are supposed to represent.[12]

Poems that were sent along with the picture with the artist's knowledge and apparent approval identify the subject and reveal its intent, much as do the poems that accompanied his earlier versions of the four seasons and four elements, when they were presented to Maximilian II over twenty years before. Far from being a simple joke, beneath its seemingly risible exterior the portrait of Rudolf as Vertumnus was meant to suggest that as the emperor ruled over the world of states, so he ruled over the seasons; the harmonious combination of seasonal tokens in the individual depictions of the seasons are gathered together in one image, the visage of the emperor, betokening his unifying rule. Renaissance readings of the sources for Vertumnus also make him into a god of the elements, and hence Rudolf II becomes a ruler who controls the elements of the macrocosm as well as the seasons, parallel to his status as ruler over the world of man, the microcosm. The eternal cycle of the seasons signifies the everlasting rule of the Habsburgs. And as the combination of fruits and flowers from all seasons are compressed into one picture, both the harmony of Rudolf's reign and his undying majesty are projected; his portrait portends further the return of a golden age of peace and prosperity, in which, as in eternal spring, fruits and flowers of all seasons will flourish simultaneously.

The dissemination of Arcimboldo's imagery – cycles of the seasons by or after the artist were in the Dresden, Munich, Liechtenstein and Spanish collections as well as in Prague, and they were imitated by many ateliers – speak for its resonance. Arcimboldo's painting remains compelling, not only because its striking imagery appears so bizarre but because it opens onto various aspects

of art throughout the region at this time. The painting was obviously a personal work, made for a ruler's taste (the Italian artist-theorist G. P. Lomazzo says the emperor eagerly awaited it), not broad display, yet it had a political message that it expressed through a form of allegorical personification. Its source was to be found in ancient mythology. As such, it can be demonstrated that it participated in the Renaissance reception of ancient literature, specifically an elegy by the Latin poet Propertius. The picture is seemingly humorous but presents its apparently humorous exterior in the guise of a serious joke. In this respect, as in its use of allegory, Arcimboldo's work can be related to other aspects of the symbolic imagery of the Renaissance, exemplified by the emblem or device: this painting was indeed expressly equated with the hieroglyph. It was also said that Arcimboldo had taken his sources from studies of nature, and in this regard his work can be compared to several new pictorial genres rooted in naturalism. His seemingly outlandish style indicates the innovative quality of art in Prague. And finally his stylistic conceptualization possesses many rhetorical and poetic parallels, related to literary and academic premises.

Like Arcimboldo's portrait of the emperor, much art made for collectors at this time was of a personal or private nature, and even occasionally of a seemingly bizarre aspect. Many of the distinctly non-functional goldsmiths' pieces could fit this description, works such as Christoph Jamnitzer's spectacular gilt ewer and trays, or the carved rhinoceros horn by Nikolaus Pfaff, with its grotesque boar's horns, or Schweinberger's mounted and carved Seychelles nut. Small bronzes and the refined and functionless cut-stone vessels of the Saracchi and Miseroni are similar, with their grotesque designs and mascarones.

But although it may be a common expectation that larger, more easily legible monuments fulfil such a function, smaller, elaborate collectors' items were also not excluded from possessing a political message. Several works made for Kunstkammer, such as Jonas Silber's *Weltallschale* of 1589, a covered goblet representing the universe, or the fountain made by Wenzel Jamnitzer, which presented the world atop the elements, with a figure of the emperor surmounting all, could also suggest that the emperor held dominion over the world.[13] Although comparatively small in scale, other works such as the bronze equestrian statue of Heinrich Julius by Adriaen de Vries (now lost), or several similar statues of Rudolf II, could also function as forms of representation.

The public that counted in the small world of princes was not the modern mass audience of the present. It would be a mistake to expect that the more accessible and comprehensible means of propaganda that we are used to from the nineteenth and twentieth centuries would be those that a late Renaissance prince might have chosen. There is evidence that a private activity such as the emperor's patronage and collecting could also have a public dimension with an impact even on those who could not see the holdings.[14] And this helps explain both the content and the form of works made at this time.

Fall of Phaeton, oil painting on alabaster by Hans von Aachen, *c.* 1598 (Vienna, Kunsthistorisches Museum, on display in Schloss Ambras)

Indeed much that was made for many of the princes, including images with political content, was not only small in scale but cloaked in allegory aimed not at crowds, but at *cognoscenti*.[15] The abstruse and often complicated character of much imagery of this age is one of its most characteristic features. It speaks both for the learning of the artists who made them (or the humanists who helped them design them) and for that of the patrons, who in this art expected these sorts of qualities.

The use of allegory, often including mythological characters such as Vertumnus, also speaks for their evident assimilation of classical subject matter. As the Central European courts imbibed Renaissance culture, scenes from ancient history or classical mythology became ever more frequent in their art. Already in the early quattrocento Alberti had prescribed the painting of histories as the the main task for painters, and this notion, in the guise of *historien* (or *historiaen*), was certainly current in Central Europe. Mythological subject matter came into vogue throughout the German-speaking world, in drawings and paintings by artists at greater and lesser courts.

Some of the most arresting images of this sort are perhaps the depictions of gods, goddesses, heroes and heroines done in Prague. In paintings by artists

such as Spranger figures appear intertwined, in seemingly lubricious poses. When these images have not been interpreted (inappropriately, it would seem) in an allegorical manner, they have been read as a sign of the emperor's salacious, even perverse interest. Yet a taste for nude subjects and seemingly erotic poses was shared by many courts.[16]

These subjects were nothing new on the European scene, for they had already appeared in works done for such famed patrons as Alfonso d'Este, Federico Gonzaga and Philip II of Spain; several Italian paintings, such as Giulio Romano's painting in St Petersburg, not to mention the artist's notorious *Modi* (the illustrated Renaissance *Kama Sutra*) are much more explicit than any comparable Central European works. In fact such works, no less than Arcimboldo's version of the Vertumnus theme, can also be viewed as part of the Renaissance reception of antiquity. Their subject matter is ostensibly taken from the antique, from sources in Ovid, Homer, Apuleius and Virgil (or from Renaissance literature such as Tasso), among other writers: like Arcimboldo's picture of Vertumnus, they translate poetry into paint. In Italy painting with erotic subject matter such as Titian's mythologies were accordingly called *poesie*: these pictures have been described as having 'revived the style and content of classical painting and were therefore just the kind of composition presenting a secular subject sanctioned by classical precedent that were appropriate for an aristocratic patron'.[17]

One set of Titian's famed *poesie*, his pictures of subjects such as *Danaë* that had been submitted to Philip II of Spain, were replicated for Maximilian II; it was also just this sort of picture that Tintoretto and Paolo Veronese painted for Rudolf II. This conception of paintings as poems, one expression of the old idea *ut pictura poesis*, was no less familiar in Central Europe. Hoefnagel plays off it in poems he had written; tapestries in Ambras were described as *ovidianische poesie*; and Spranger's mythologies were justifiably referred to as '*poetische Mittelstuck*'. Like many other court artists, Spranger had worked in Italy and was no doubt familiar with such notions: Paulus Fabritius, his humanist advisor and collaborator on an arch made for a 1577 entry, some years before his creation of such images for Rudolf, explicitly calls some of his paintings 'poetic personifications'.[18]

Much as Tintoretto painted pictures of the story of Hercules and Omphale for Rudolf II, including an image of Hercules expelling a faun from his bed, Rudolfine artists also treated such scenes humorously. Many of Spranger's images, especially his depictions of *Hercules, Deianira and Nessus* or *Hercules and Omphale,* present their subjects in a similarly pungent manner. In them figures making the sign of the *cornuto* (cuckold) clearly bring these pictures out of the realm of the epic, that Titian may have inhabited, and into that of the epigram; of the epigram the Roman writer Martial, the model for Renaissance epigrammatists, had said that jocular poems are unable to please unless they are prurient. The epigrammatic character of such works, as it were, corresponds well to the predilection in contemporary poetry for the epigram

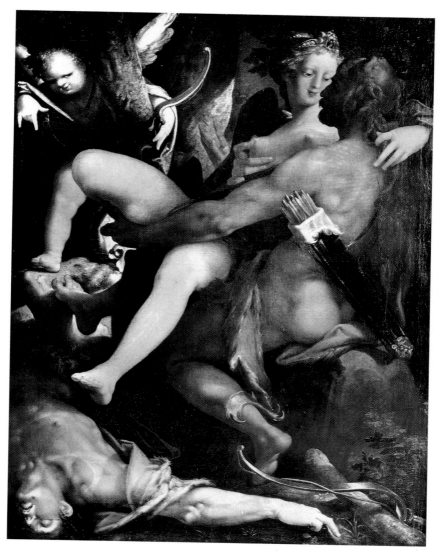

Hercules, Deianeira and Nessus,
early 1580s, Bartholomeus Spranger
(Vienna, Kunsthistorisches Museum)

and elegy (one thinks again here of Propertius and Martial, also a great favourite, among the Jesuits as among other groups). The compression of wit into such highly charged images as Spranger's or Arcimboldo's is moreover both a characteristic of this sophisticated, even Alexandrine court culture and a corollary to other sorts of work that it favoured.

The predilection for paradox found in Arcimboldo's serious jokes, or for that matter in the epigram, has been noted as a distinguishing characteristic of much of the culture of the day. In particular it finds its parallel in one of the

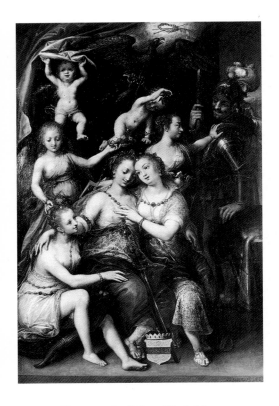

Allegory on the Reign of Rudolf II,
1603, Dirk de Quade van
Ravesteyn, Národní Galerie, Prague

favoured forms of the courts, the emblem, or *impresa*, in which word and image may be combined to express, often paradoxically, a deeper message. These Renaissance hieroglyphs, to use the word employed to describe Arcimboldo's painting, were avidly collected in Kunstkammer. They were also widely produced in the region, where Ottavio Strada, who served as imperial *antiquarius* for a while, circulated collections of *imprese* to many prominent personalities; his collection was subsequently utilized in Rudolfine Prague for a publication by the court printmaker Aegidius Sadeler in collaboration with Jacobus Typotius and Anselm Boethius de Boodt. Earlier at Maximilian II's court Johannes Sambucus had produced another well-known series, and the first Spanish emblem book was actually published by Juan de Borja in Prague in 1581.[19]

Emblematic elements also entered the art of many court artists. Devices (*imprese*) are employed in paintings by the Rudolfine artists like Von Aachen and Van Ravesteyn.[20] A parallel to Arcimboldo is formed by Hoefnagel, who composed works with emblematic content for Ferdinand of the Tyrol, and the Munich and Prague courts. These include his famed Four Elements, a set of four books containing creatures related to each of the elements, such as birds for air and insects for fire.[21]

These studies, with their intellectual presentation and natural historical content, can be related to the activities of the important groups of humanists and scientists who gathered at several courts. In Cassel and Prague important astronomers, mathematicians and instrument makers such as Tycho Brahe and Jobst Burgi enjoyed court patronage, as Johannes Kepler was later to do in Prague; other rulers such as Simon of Lippe also had contacts with Burgi. Rudolfine Prague has gained the reputation of being a magnet for all sorts of occultists, astrologers and alchemists alike, but, much like the court of Maximilian II in Vienna before it, Prague in particular served as a gathering point for many different learned figures. These included not only infamous

occultists such as John Dee but also the famed astronomers Brahe and Kepler and their predecessor Paulus Fabritius as well as the botanists P. A. Matthioli, Carolus Clusius, Rembert Dodonaeus, Hugo Blotius and Oliver Busbeck, and other humanists such as Julius Alexandrinus, Crato von Craftsheim and the historian Johannes Sambucus. Hence the courts of the region could rival and, in some cases such as that of astronomy, even surpass independent universities for the intellectual achievements they nurtured.

Animalia Quadrupedia et Reptilia (Terra): one of a series of four manuscripts representing the Four Elements, plate XXXXVII, representing a hare and other creatures, after 1575 and before 1590 (National Gallery of Art, Washington, D.C.)

Hoefnagel's (and Arcimboldo's) nature studies were just some of the many artistic products that were promoted, particularly in Prague, as a parallel to these endeavours. These interests intersect in many ways, but the present book concentrates on their impact on the arts. [22] Other court artists are known to have completed such studies.[23] Their miniatures were collected in the Prague Kunstkammer along with other similar works by prominent illustrators of *naturalia* such as Jacopo Ligozzi, by whom Rudolf II owned books of birds and fish, and Jacques de Gheyn, who presented the emperor with another book that primarily contained flowers. Although the Prayerbook with nature studies known by the name of its owner Maximilian I (of Bavaria) was probably done in Prague, the Kunstkammer in Munich, where after all Hoefnagel had also worked, possessed other such works. The correspondence of the merchant-

collector Philipp Hainhofer indicates that such studies were sought after elsewhere as well. They also parallel the cast *naturalia* that the Jamnitzers made for the Prague and Dresden courts.

The recent rediscovery of a set of eleven volumes illustrated by and at the behest of the imperial physician Anselm Boethius de Boodt suggests something of the connection of these works with the interests in natural history of the day. De Boodt himself published one of the first works on gemmology, and his painted and published books can be situated within a court context which favoured the study of natural history. In addition to his Kunstkammer, which of course contained a variety of *naturalia*, Rudolf ii, like several other rulers including Maximilian ii and Ferdinand of the Tyrol, established botanical gardens, an aviary, fish ponds and a menagerie of sorts. These establishments supplemented and served the activities of the many natural historians who were at court.[24]

An outcome of this patronage went beyond the production of meticulous studies observed directly from nature, such as are found in the work of De Gheyn or at times Hoefnagel. Hoefnagel's manuscripts, in which plants and animals are depicted with all the techniques of *trompe l'oeil*, of the penultimate steps in the development of independent still-life painting, that is the depiction of still life as an independent subject in full-scale easel painting. Later miniatures by Hoefnagel, and by De Gheyn, form the next step, where presentations of vases and insects, flowers, and plants, though still painted on a vellum page, are freed from any connection with a written text.[25] The depiction of nature in these images already seems to exist as an independent form of representation. It was only a short step from this kind of depiction in miniature to that of the oil painting on panel (or canvas) of the independent still life. Hoefnagel is recorded in inventories as having made just this kind of painting, and some of the first surviving works in the genre were done by De Gheyn for the emperor.

However, the first surviving still-life paintings on panel by a Netherlandish artist are found in the work of the court artist Roelant Savery, as in pictures dated 1603. This kind of painting was also cultivated at court. For Savery not only did several such works while in imperial service, but also painted some of the first landscapes and genre paintings based on studies from life, *naer het leven*, as he signed the drawings made from his observations that provided the basis for these paintings. Moreover Van Mander says that the emperor sent Savery out specifically to draw rare wonders of nature to use in his paintings (see also P. van Vianen, p. 187). In certain ways this was a culmination of the interest in topographical representation by artists elsewhere in the Habsburg lands, as in the views of Jacob (Jakob) and Joris Hoefnagel and the paintings and drawings of Lucas and Frederik van Valckenborch. This kind of patronage of nature and topographic studies was also anticipated by Wolf Dietrich.[26]

The generic innovation found in these naturalistic works indicates that innovation can be located in Central European art in more than the inventive

imagery of Arcimboldo's work. Arcimboldo's witty play has been compared to the use of conceits in contemporary literature, and in turn to what is identified with Mannerism in art. No doubt the

Still Life with Flowers, 1603, by Roelant Savery, Utrecht, Centraal Museum

intricate intellectual content, complicated compositions, occasional eroticism, elongated style of figures, exaggerated gestures and contorted stances of many paintings, sculptures and drawings done at the Central European courts can, in comparison with the *maniera* (mannered style) of cinquecento Italy, be called Mannerist. It can thus be subsumed under the rubric of international

Mannerism. Or, better, it can be taken as a sign of a cosmopolitan court style. But the existence of works whose foundation is in observation, not exaggeration, in nature imitated closely, not distended and idealized for the sake of fashion, as the *maniera* is defined, suggests that there are other ways of looking at the innovations of the time.

Some of these were suggested by Arcimboldo himself, who in a text proposing grotesques for a decorative project suggested his adherence to a modern stance in the perennial conflict of the *anciens* and *modernes*. According to this attitude, an artist has the freedom to invent and not merely to emulate the ancients to show inventions, such as the scenes of sericulture, a manufacture that had remained unknown to antiquity, that Arcimboldo represented in drawings for the interstices of grotesques. Arcimboldo's own paintings were regarded similarly as modern inventions, and several other artists in Prague also indicated their allegiance to this ideal. Arcimboldo's addressee was indeed someone who patronized science as well as art. Invention was supported by the emperor in art no less than in science, and the assumption of a modern stance helps explain how.[27]

The modernity of Arcimboldo's painting has also been described as employing a variety of poetic and rhetorical devices.[28] Although these are merely verbal equivalents sought to describe his work, it is reasonable to assume that such terms are applicable not only to Arcimboldo's works but to a broader category of painting which we can conceive of as poetic. Painters themselves indicated their adherence to this ideal, when they placed their art not only under Minerva but under Mercury, the ideal of eloquence. Consequently the abundance of *contrapposto*, of weight shifts within figures, of contrasting gestures, sexes, ages of characters, colouring and placement within a composition, and even pairing of themes, as in pictures by Spranger of *Glaucus and Scylla* and *Salmacis and Hermaphroditus,* may be read as forms of antithesis, to give one example.

The rhetorical and poetic parallels in this art hint at its literary and academic premises. Although no academies existed at this time in Central Europe, the academic ideal was frequently evoked in allegories by artists active in Central Europe at this time. These are specifically representations of the conjunction of Mercury and Minerva, or Hermes and Athena, which among other things stand for Hermathena, the symbol of the academy. But in this academy the ideal of eloquence entailed not only that there should be a copious variety of ornamental figures – hence the visual equivalents of rhetorical tropes – but also that the form of expression would vary with its content. Visual artists seem to have worked similarly.[29] In tracking the impact of art from the Central European courts, a variety of stylistic trends must therefore be kept in mind.

Patronage, and the art that it promoted at the courts, particularly in Prague, came to have a huge reception; for that reason we have often returned to Prague in these pages. The prestige of the emperor lent importance to his

interests and activities and the compositions and style, especially of the Prague artists, had a lasting impact. While the collections of the courts remained relatively inaccessible, knowledge of the art they sponsored, and what it and that support meant, did not.

There were numerous ways that the inventions of the court artists could be known. Lured by the attraction that Van Mander mentioned, many artists, most famous of whom is Jan Brueghel, came to Prague. Artists also came to study with court figures; the Dresden duke even arranged for a kind of stipend for several of his artists to study in Prague, a clear indication of the attraction of the imperial court even for an electoral court. Although not generally open, artists or personalities with connections, besides princes, could get to see the imperial collections; visitors sponsored by Spranger, and copies after his work, are known from the 1580s.

Otherwise there were many ways to learn about court art. In Prague as elsewhere works by the court artists were publicly visible in churches. Court artists completed commissions for bourgeois and aristocratic patrons in the Bohemian lands, as they did for other courts elsewhere in Germany. Numerous gifts were sent abroad.

Most important, a number of courts employed printmakers. The emperor installed Aegidius Sadeler in the position of court printmaker. There is a prejudice against reproductive engravings, but Sadeler's work, like that of other reproductive engravers of his time is outstanding in its quality, and it can be considered a form of emulation of its source. In any event, much as Jan Sadeler had done in Munich, Aegidius had an immense role in disseminating knowledge of what was done in Prague. Other Netherlandish printmakers, including Jan Muller, Hendrick Goltzius, Jan Saenredam and Jacob Matham, also propagated the imagery of Prague.

As a consequence, starting with Prague, court patronage and its products resonated throughout Europe. Locally, although aristocratic patrons such as the Rosenbergs had different sorts of bases and interests, they responded to the need to representation through the arts, as suggested, rebuilding their castles and forming collections.[30] Collecting also became widespread in bourgeois milieus; the presence of portraits of the emperor as the most frequently represented painting in such collections most likely suggests that they too were responding to the model of the imperial court.[31] Mieczysław Zlat has gone so far as to describe the process of bourgeois patronage as being one of ennoblement through art.[32]

Because of close connections with Wrocław/Breslau (referred to by Zlat), to which paintings and sculpture were sent and from which artists probably came to visit, Prague painting and drawing did have a great impact on the work of artists active there, such as Jacob Walther and David Heydenreich.

Their work is one of many testimonies of the impact of the work of Prague figural painters. When we speak of Mannerism in the region, this may in fact often mean the assimilation of the products of the Prague court circle. This

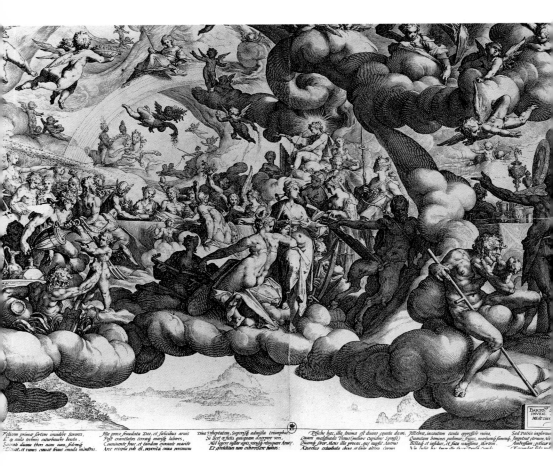

Latin inscriptions beneath the engraving:

Felicem primæ fortem inuidere Sorores, / Illa prece frustrata Dea, et felicibus aruis / Dea Voluptatem, Superosque admissa triumphat, / Psyche hæc, illa Anima est dueno quanta dacon, / Hic labor, incautum tanta oppressere ruina, / Sed Patris implorans / E in aula technis exterbuiere beatis / Post euitatos terræ marisque labores, / Si licet a fidis quicquam discrpere veri, / Quam malefidadis Venus (meliore cupidini Sponsæ) / Quantum homines pestimus, fugies, morbumq, fumenq, fugetur sermone / Sacroriti diuna thori nam num, fidemq, / Comiunte hinc, et tandem coronata marito, / Mel legere nistar apes, verulq reliquere Aure? / Duumq fauor, Mane illa proca, qui nupsit Amoro / Bellusq; et inshbles, et fata nouissima Mortem. / Ambrosiam, potiuse s / Escuat, et ramis causat fines omala mētitur. / Arce recepta poli est, superità omea peronum / Et gentilitios non exheredære penates: / Aquerius exterbuta chous et seire altera Curus / Aut halet hic Amorsthe Gamer Lorila Dandi / Emendat fata tu

BARTO. INVEN. Mde 1585

Feast of the Gods, detail, engraving by Hendrick Goltzius, 1587, after Spranger

observation applies especially to centres such as Wolfenbüttel and Dresden, which were closely attached to Prague. But figures in smaller centres also emulated the imperial artists.[33]

The creations of the Prague court circle also had a lasting effect on art in far-flung parts of the region. Prague paintings remained a source of inspiration for local artists, including Michael Willmann and others, up to the eighteenth century. They also retained their vitality for artists in Poland, Prussia, Hungary and Austria well into the seventeenth century.[34]

The impact of the Prague school spread far beyond Central Europe. Through the prints of Hendrick Goltzius, the figural style created in Prague became one of the bases for what is called 'Dutch Mannerism'. This is the well-known style practised in the 1580s and 1590s and, later, by artists in Utrecht (Abraham Bloemart and Joachim Wtewael) and Haarlem (Cornelis Cornelisz, Goltzius and Van Mander), in which muscularly contorted figures are jammed in eccentric compositions, whose space may be distorted, as are

the colouring and pose of the figures that stand within it. In the Netherlands, the landscapes and genre scenes of Savery were collected and emulated in the next generation by Gillis de Hondecoeter, Herman Saftleven, Lambert Doomer and others. In Lorraine it is demonstrable that Prague prints were one of the sources for the school of Lorraine. Nicholas Poussin began his career by copying Joseph Heintz. Von Aachen's compositions reached as far as Molfetta in Apulia, southern Italy, where a painting dated 1596 by the Flemish artist Gaspar Hovic in the Bernadine church, is a copy of a well-known print by Sadeler after von Aachen.[35]

But the impact of Rudolfine art at this time was not limited to Europe. Moghul miniatures in India have been found that are copied after Spranger; wall paintings in Lima were made after the Sadelers. By the early seventeenth century, then, as most clearly exemplified by Prague court art, Central European art was no longer a follower or receptacle. It had assumed an equal and at times leading role in the play of artistic and stylistic interchange.

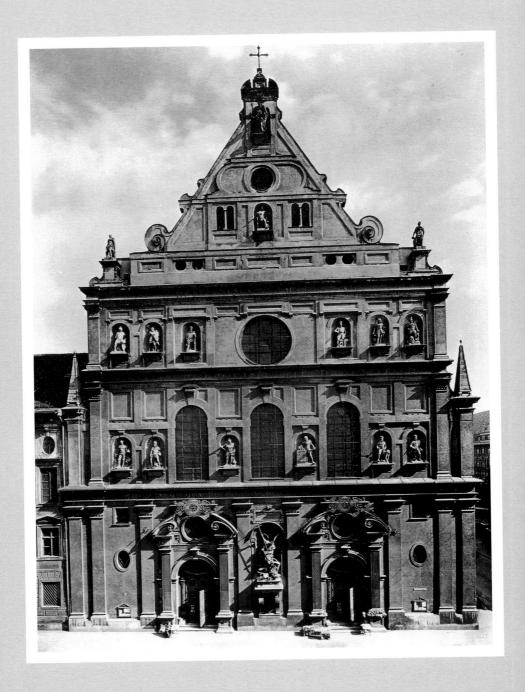

Art on the Eve of the Thirty Years' War: The Catholic Reformation and the Arts

St Michael's Church, Munich, 1583-97,
(exterior), Friedrich Sustris and others

THE YEARS BEFORE THE THIRTY YEARS' WAR COMPRISE ONE OF THE GREAT PRODUCTIVE ERAS FOR THE VISUAL ARTS IN THE HISTORY OF CENTRAL EUROPE. Energies were generated at this time that continued to flow forth even after the fateful events that unfolded from the end of the second decade of the seventeenth century. If the epoch before *c.* 1620 is still often seen at best as a brief interlude, obliterated, or overshadowed, by the catastrophe of the Thirty Years' War (to which other comparably disruptive events in Hungary and Poland may be related) that soon followed, even this account tacitly assumes that there had previously been a time of peace and plenty in which much was produced that was to be destroyed.

Before the war, the courts especially became centres of letters as well as of the visual arts. The construction of the Ottoneum (1608) in Cassel, the first structure built as a permanent shelter for theatrical performances in the German-speaking lands, may stand for court sponsorship of literary production as well as of scholarship. Strolling players travelled throughout the German-speaking lands and English comedians could be heard from Wolfen-büttel to Königsberg, Prussia (now Kaliningrad).[1] In Wolfenbüttel Heinrich Julius of Braunschweig-Lüneburg, one of the patrons of the Helmstedt university, was himself an important and early author of plays in German prose. Heinrich Julius reinvigorated a pattern of patronage and princely activity in Wolfenbüttel that was carried on later in the seventeenth century by Duke August, who founded what was to become one of the great European libraries,

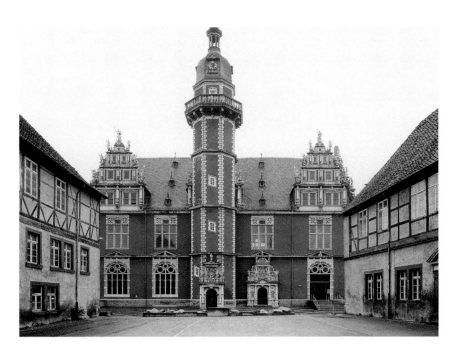

Juleum, Helmstedt,
1592-7, Paul Francke

the present Herzog August Bibliothek in Wolfenbüttel.[2] These developments were also not without further consequences for the visual arts. In this connection one might point to the buildings for the Juleum in Helmstedt or the Ottoneum in Cassel. The first of these structures housed the university founded by the dukes of Braunschweig-Lüneburg (in 1576) and reminds us that this was also a period of increasing intellectual vigour in the Central European lands. [3]

The libraries stand of course as signs of the learning of the period. This was indeed one of the last great eras of universal erudition, when men like Kepler could also write on optics and music, compose learned poetry and delve into humanistic scholarship as well as be a competent draughtsman. Many thinkers of the time sought for a universal system, which would harmonize reason and religion, and in a time of strife bring together the discordant strains of the day.

Recognition of the importance of art and architecture at the beginning of the seventeenth century, along with these other cultural achievements (to which one might add the music of slightly earlier composers such as Orlando di Lasso and Philippo de Monte, or Michael Praetorius), may help alter the standard image repeated in histories that deal with the culture of Central Europe. So much attention has been paid to art in the region, especially Germany, at the end of the fifteenth and the beginning of the sixteenth century, to the neglect and even disparagement of succeeding periods, that it may be too much to wish to claim at least some of that interest for what was done a century later. Nevertheless, there is much that merits consideration in

the period *c.* 1600, so much so that the chapters in this book devoted to the late sixteenth and early seventeenth centuries, much like those for the early sixteenth century, can merely offer a general summary and mention but a few monuments.

A variety of explanations may be offered for the efflorescence of the arts *c.* 1600. The general intellectual vitality of the day is one of them. The discussion of princely collecting and patronage in preceding chapters should already have indicated other factors. And these are interconnected, for library often accompanied Kunstkammer, the latter also being employed for research.[4]

The importance of these interests for court culture, and the high quality of works produced in numerous artistic centres that responded to their demands, stimulated the arts and crafts. The widespread effect of collecting, and the patronage related to it, starting at the imperial court, has been underestimated by later interpreters whose political imagination may have been shaped by considerations of their own later times, when affairs of state were determined by power politics or when propaganda or electronic media moulded mass public opinion. Yet in a world dominated by princes, prelates and patricians, when the taste of a few men could call art into being or collect it, a tone could be set and trends established by a very few, in the empire, as in Poland.

The artistic activities sponsored by the imperial and princely courts were not limited to collecting or to the patronage of works for collections. The design of rooms or structures for collections also constituted but one aspect of the large-scale patronage of architecture that was involved in a continuing history of construction of princely palaces. This is exemplified by the imperial court, where during the 1560s and 1570s Maximilian II Habsburg had had buildings constructed that served the court in and near Vienna, including the Neugebäude and the Stallburg, the monumental arcaded stables where his collections were kept. After his accession Rudolf II completed some of his father's projects, such as the Amalienburg tract in the Vienna Hofburg. When during the 1580s Rudolf II moved his court to Prague, extensive construction ensued at several places in Bohemia. In the Prague Hradčany palace, where the collections were to be housed, the so-called Spanish Stables and Spanish Wing, with the Spanish and New Rooms above them, and also the middle tract of the palace, connecting these elements to the so-called Summer House, were built and put at their disposition. The prominent rusticated gateway to the palace complex, called the Matthias Gate after Rudolf's successor, was also probably erected at this time, as were various other portals (such as that to the Elizabeth Chapel in the palace); many other changes were also made to the interior. At Bubeneč north of Prague Rudolf constructed a grotto and mill, used by the stonecutters' workshop. The gardens around the Hradčany were also redesigned. Elsewhere in Bohemia the palaces and gardens at Lysá and Brandýs nad Labem (Brandeis) were refurbished for the emperor.

Rudolf II also gave money for the construction of several churches in Prague, including monies for Protestant temples. He directly commissioned

the church of St Roch, at Strahov just west of the Hradčany. St Roch's is an early seventeenth-century church in the Gothic style, put up as the result of an expiatory vow for the end of a plague epidemic.[5]

This kind of large-scale patronage for both secular and sacred functions was also carried on by the Polish court. Sigismund III Vasa, first of the dynasty of Swedish extraction to sit on the Polish throne, was, like Rudolf, also an amateur artist, and, also like Rudolf, he was therefore criticized for his interests in art and science; like Rudolf, Sigismund was portrayed by the imperial painter Joseph Heintz. Sigismund's projects can also be related to his need for representational expression. He made a strong dynastic statement when he had the Wawel castle in Kraków, the traditional residence of Polish kings – the equivalent to the Hradčany – renovated and extended. He made an even stronger individual statement by his transference of the royal capital to Warsaw in 1597. In Warsaw Sigismund had Giovanni Trevano, the Italian architect he had engaged in Kraków, build for him an impressive new castle. Like Rudolf, Sigismund also supported plans for church designs, to be discussed presently.[6]

Despite recent publications and exhibitions devoted to art at the princely courts *c.* 1600, it is however still necessary to emphasize that developments at these royal courts were more than private matters or distractions from supposedly more important affairs. Whatever other motivations may have gone into their involvement with the arts, Rudolf's and Sigismund's interests helped establish a pattern by which it became not only *bon ton* but *de rigueur* for a ruler (or an aristocrat) not only to collect but to patronize the arts. As we have seen, they also stimulated bourgeois patronage and collecting. Typically, the courts of the more important princes of the empire followed the imperial lead where they did not actually parallel Habsburg patronage. But they were not alone. Lesser princes and aristocrats followed, and in Poland and Hungary magnates competed with the royal court.

In late sixteenth- and early seventeenth-century politics artistic patronage could assume added significance as an expression of self-assertion and self-aggrandizement. Particularistic interests had been one of the motives behind the construction of Renaissance residences in Central Europe, and they certainly remained some of the driving forces for artistic patronage throughout the early modern period. Aspects of the form and content of what was produced *c.* 1600 can moreover be further interpreted as signs of increasing rivalry, part of the tensions that led to the Thirty Years' War, when antagonisms assumed a much more brutally destructive form.

For whatever reasons, many new castles were built or extended for rulers both Protestant and Catholic in Germany. The ambitious electoral court in Dresden was especially active. Numerous artists, not only German painters, many of whom were in the thrall of Prague, but also Italian architects such as Giovanni Maria Nosseni and sculptors such as Carlo de Cesare were active for the Saxon court, as were German goldsmiths, such as the Kellerthalers, and

sculptors, such as the Walthers. The Saxon dukes continued work on their palace in the heart of Dresden, where the courtyard and *Langer Gang* were completed.[7]

Dresden was but one of many castles built all over Germany at this time. Some merit particular mention: places such as Langenburg, Weikerheim, Bückeburg, Bevern, Glücksburg, Stettin (Szczecin), Schwerin and Tübingen, where many related motifs are found. At Schmalkalden, the landgrave of Hesse had erected in the 1580s a new castle with the necessary appurtenances: impressive gateways, a large chapel, painted interiors and ornamental fireplaces. The castles both at Schmalkalden and at Glücksburg in Schleswig-Holstein (built from 1584) followed the quadrangular format most familiar from French Renaissance châteaux, while the interior of Schmalkalden was decorated in a contemporaneous Netherlandish manner. In Stettin (Szczecin), the dukes of Pomerania, who had already begun construction of a residence in the Renaissance mode in the first half of the century, completed the castle courtyard in several campaigns of the 1580s and added a separate wing in the early seventeenth century. In Schwerin at the beginning of the seventeenth century the duke of Mecklenburg had G. E. Piloot add several gables in a new style to his castle.[8]

In Heidelberg the political, particularistic aspects of patronage are especially clear. The patronage of Count Palatine Frederick iv can be seen to form part of his ambitious political manoeuvring. Frederick became one of the leaders of the militant Calvinist camp, adhering to its Protestant Union formed in 1608. This union of militant Calvinists was one of the eventual outcomes that resulted from dissatisfaction with the solutions that had been imposed by the Augsburg settlement of 1555: in determining that there should be a division according to the principle, *cuius regio eius religio* (the ruler determines the religion of the region), this settlement had not taken Calvinists into its reckoning and had also not made provisions for transfers of territory. In response, a rival Catholic League of the Rhenish and Frankish bishoprics and Maximilian i's Bavaria was formed in 1610; their orientation was directed to the Habsburg lands and especially to the more militant Spanish court, obviously in addition to Rome.

The competition between these camps was also given visual expression. The so-called Friedrichsbau built in Heidelberg for Frederick in the first years of the seventeenth century can be interpreted not only as an extension of the construction begun by Ottheinrich but as one of a series of grandiose projects which were meant to be appropriate for a ruler who possessed royal pretensions. In the Friedrichsbau the introduction of ornamental strapwork and scrolled gables dresses up a facade that combines bilobed windows, surmounted by oculi on the lower level, with upper storeys separated by heavy architraves. Strapwork represented some of the latest elements of a contemporary Netherlandish wave of design and thus announced not only the allegiance of the Friedrichsbau to some of the newest fashions of the day but also

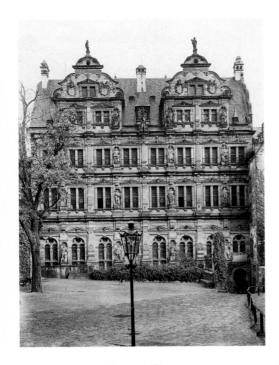

suggested that some of the cultural orientation of Heidelberg, like much of Calvinist, and indeed northern Germany, was towards Holland. The castle also makes another, more obvious, political statement in combining dynastic, political and religious overtones, in a way that is characteristic for the era. It displays statues of Frederick's predecessors at the same time as bearing an inscription which proclaims in part that it was built for purposes of worship. This facade works as a response in stone to what, as we shall see, had been done on a church facade in Munich: the difference is that in the residential city of a Protestant ruler political and religious claims are manifested on a palace, therefore in a secular setting, not on a church.

The erection of the Englisches Bau and the gardens laid out for Frederick IV's successor Frederick V in the second decade of the seventeenth century were possibly even more loaded with meaning. The Englisches Bau is a work in a Palladian manner and has been attributed to the famed English architect Inigo Jones; if correct, this product could be related to the English alliance of Frederick V, who wed the daughter of King James I. The gardens of the Hortus Palatinus were laid out on top of the castle hill by Jones's intimate, the Huguenot garden-architect and engineer Salomon de Caus. The involvement of these men in Heidelberg also suggests the advent of a distinctive form of Vitruvianism, as it was interpreted in the north: both men were versed in those sciences, such as number and proportion, music, perspective, mechanics, that the ancient writer had advised as necessary for the architect.[9]

These interests are reflected in the gardens. It has been persuasively argued that the Heidelberg gardens, while not avant-garde in form, may incorporate a recondite political symbolism in keeping with the hopes that were spun around Frederick V, especially after his marriage with Elizabeth, daughter of James I of England in 1613. These have been connected with the alchemical or Rosicrucian strivings that originated around this ruler. As remarked in Chapter 7, this kind of occultist interest also had a potentially political side to it. The general tendencies towards syncretism could be turned to the effect

that the ruler could thereby be conceived as bringing harmony to the world. In this light the gardens have been read as possessing a coherent programme, that was involved in the potential reformation of the world.[10]

In any event, these ambitions were directly associated with Bohemia and thus may in fact be connected with the continuation of the world of Rudolf II. They came to naught, however: Frederick's election as king of Bohemia in 1619 provoked the conflicts that led directly to the Thirty Years' War, when the Battle of White Mountain, occurring in 1620 at the foot of other gardens, those of the Star Villa in Prague, transformed him into the 'winter king', forcing him into exile in the Netherlands; the Heidelberg palace and gardens were also destroyed then.

The foil to Heidelberg is provided by the Bavarian dukes, who in the Thirty Years' War were indeed to carry out the sack of Heidelberg and seize the Palatinate's electoral dignity. In Bavaria, the ambitious Wittelsbachs engaged a team of Italians and Netherlanders to redecorate Burg Trausnitz in Landshut in the 1570s, and then called them to Munich. For a while an important court circle, rivalling that of Prague, was established in Munich.

In Bavaria a group of Netherlanders, many of them trained in Italy, also joined Italians and German artists at the ducal court. To mention but some of the painters at the Wittelsbach court, the Italian-trained Netherlanders Friedrich Sustris and Pieter de Witte (Pietro Candido), together with Engelhard de Pee and for a

Hortus Palatinus (Heidelberg Castle Gardens 1616-19 by Salomon de Caus), painting by Jacques Foucquières, 1620

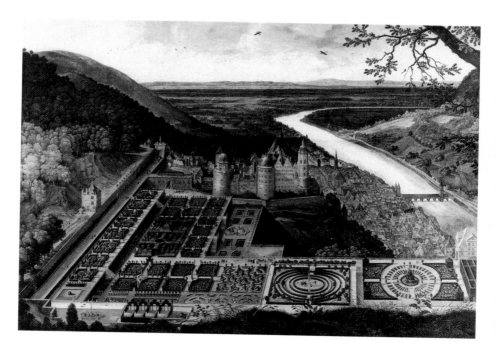

while Joris (Georg) Hoefnagel, gathered with the Italians Antonio Maria Viani and Cosimo Ponzago, and the Germans Christoph Schwarz, Hans Mielich and Hans von Aachen. The variety of sculptors was as diverse as was that of the painters: Hubert Gerhard (1550–1642) from Amsterdam worked alongside Hans Krumper (*c.* 1570–1634) and the Italian Carlo Pallago. They joined Italian stonecutters, such as the Saracchi from Milan, as well as Germans who worked in ivory, such as Christoph Angermaier. Some of this group was later dispersed because of money-saving measures and a stricter orthodoxy introduced by Maximilian I in the 1590s. In any event, the new ducal residence and gardens in Munich were extensively enlarged and redesigned from the 1580s up until the early seventeenth century, albeit with some interruption.[11]

The Bavarian court was also firmly committed to the church, introducing the Jesuits into Bavaria and founding a university for them in Ingolstadt, where the ruler paid in part for the furnishing of a church. The first building in the German provinces for the order is that of St Michael in Munich, another Wittelsbach foundation. This church, situated next to a Jesuit school, was described in an early *Festschrift* as *trophaea Bavarica Sancto Michaeli Archangelo in Templo et Gymnasio Societatis Jesu dicata* (a Bavarian trophy dedicated to Saint Michael the Archangel in the church and school of the Society of Jesus). This inscription suggests that an early Christian church dating from the time of Constantine and dedicated to St Michael served as its model. The choice of a dedication to St Michael, and this particular model, appear to be gestures that can be identified with the spirit of a counter-Reformation. St Michael, the weigher of souls at the Last Judgement, also leads the squadrons of the Lord in the fight against the devil and his minions. Similarly, the militant church would combat Protestant heresy, much as Constantine, the first Christian emperor, had fought pagans. The Constantinian church had moreover been placed on the site of a temple to the Argonauts, who in the Renaissance could be regarded as a knightly band: their quest for the Golden Fleece provided the model for the premier European chivalric order, the order of the Golden Fleece, into which Wilhelm V of Bavaria, the church's founder, had been inducted in 1585; the Argonauts fought a dragon to gain a golden reward (one thinks of heavenly reward here too). The choice of the subject of St Michael, not simply the patron of the church, fighting a dragon near the main portal of the facade was also significant: the fight is against the dragon of heresy, of Protestantism. The Bavarian rulers (Wilhelm V, or his successor, and the ruler who completed the church, Maximilian I) thus also become new heroes of a righteous cause, new Argonauts who combat a dragon, new Constantines fighting pagans, new St Michaels in the fight against the forces of Satan.

The interior of the church, designed by the Italo-Netherlander Friedrich Sustris, creates a unified central space, suppressing side chapels, which become oratories; its relation to other Jesuit designs (it bears an obvious relation to the

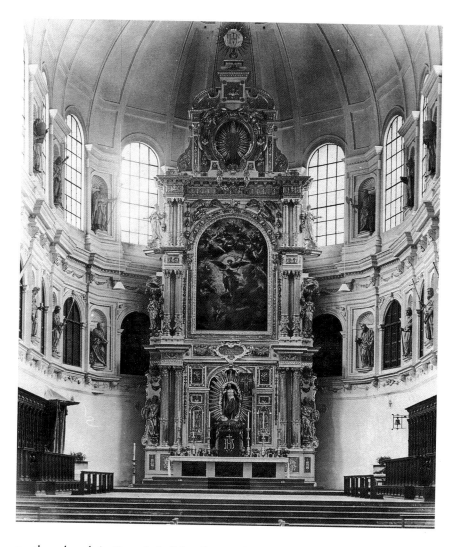

St Michael's Church, Munich, 1583-97, apse, Friedrich Sustris and others; painting on High Altar by Christoph Schwarz, 1586-90

mother church in Rome) shall be discussed further presently. But it also possesses a conspicuous barrel vault, that recalls ancient basilican designs, like the temple of Maxentius in Rome. Motifs in the interior also make repeated reference to a triumphal arch, again appropriate to the combative message.

The church facade moreover possesses a distinctive sculptural programme, that also becomes an instrument of propaganda. The ancestors of the present dukes from the Wittelsbach dynasty are presented as protectors of the church. Their appearance on the facade is comparable to that of other sequences of dynasts, such as the Piasts on the mid-sixteenth-century castle at Brzeg (Brieg)

or the rulers on the Heidelberg Friedrichsbau and of course such sequences were also found on medieval churches. In contrast with contemporary castles, at St Michael's the rulers' images are shifted onto a church facade; the church thus serves as a surface to be covered with images, a *Bilderwand* (picture wall), much as pictures were displayed in a collection; in fact the church was called an antiquarium. Like the Bavarian Kunstkammer, or the Munich Antiquarium, which Sustris, who designed the neighbouring grotto in the Munich residence, knew well, St Michael's can therefore also be interpreted as the product of a desire to increase the reputation of the Wittelsbachs.[12] The converse of this desire was the creation of a kind of Christian Kunstkammer, the Reiche Kapelle of the Munich residence, a chapel adorned with precious stones and gilt bronze, which housed relics and also contained an organ covered with paintings of *naturalia* by Hoefnagel.

Because, since the Reformation, political differences tended to coalesce around religious conflicts and because princes were often simultaneously prelates, princely patronage, as suggested by the St Michael's Church, was inextricably intertwined with the production of art and architecture for sacred settings. Since the Augsburg settlement the establishment of churches was indeed an expression of state policy. Yet the principle could cut two ways. The design of the Schloss erected for a prince-bishop who adhered to the Catholic League, formed in 1609, suggests that prelates also had impressive structures built for their personal purposes: opposing interests could lead to not so dissimilar results. Hence in the years 1605 to 1614 the Johannisburg castle arose in Aschaffenburg, a residence erected by Georg Ridinger for the archbishop of Mainz. This castle has a

Aschaffenburg Castle (Schloss Johannisburg), 1605-14, Georg Ridinger

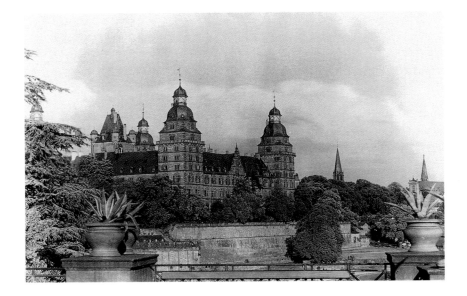

square French plan, with Italian bonnets (*welsche Hauben*) and impressive, large, six-storey towers. While neither structure conforms strictly to an Italian prototype, its fortress-like appearance, position above a river and impressive size seem to answer Heidelberg, less than a hundred kilometres away, some of whose architectural features, such as steeply pitched roofs and scrolled gables (albeit not identical in form), it shares. The Aschaffenburg castle can also be seen, more ominously, as a typically orthodox response to the kinds of interests in the occult that the patron of Heidelberg pursued: its huge cost of 900,000 gulden was covered by money taken from people persecuted as witches, on whose confiscated lands the castle was built.

Luxurious interiors and *villeggiatura* (villa life) were also certainly not restricted to Protestants. A counterpart to the Heidelberg gardens was created by another Catholic archbishop, the prince-bishop of Salzburg. In 1613–14 Marcus Sitticus had the gardens and residence put up at Hellbrunn outside Salzburg by Santino Solari, who, like so many architects, came from the Val d'Intelvi, between Como and Lugano. In so doing the archbishop seems to have continued the luxurious tendencies of his remarkable predecessor Wolf Dietrich von Raitenau. Besides his personal proclivities (he lived with a mistress), Wolf Dietrich loved art: he patronized landscape drawings, even earlier than Rudolf had done; he rebuilt the episcopal residence and had his mausoleum built, both decorated with fine Italian stucco.[13]

On the other hand, the use of art and architecture to represent grandeur or importance and to express an ideology, familiar in the secular context, also came increasingly to motivate a number of substantial ecclesiastical foundations. At a time when Catholic, Lutheran and Calvinist churches competed for souls, the visual arts also played a part in the fray. Indeed the notion of propaganda, in the sense of the propagation of the faith (*de propaganda fide*), originates with the Jesuits in the seventeenth century. The tools supplied by visual instruments were recognized as useful for the Roman Reformation. *Utilitas* came to be a principle recognized as justifying the making of art. Protestants responded in kind. In addition, several new religious orders were established or became active in Central Europe at this time, including most significantly the Jesuits. On the other hand, adherents to Protestant confessions also had needs for appropriate settings, or new structures for their forms of worship. Consequently at the end of the sixteenth and beginning of the seventeenth centuries, many new churches were built, decorated and furnished.

The major carriers of new Catholic architecture were in many instances the newer or reformed orders such as the Jesuits or Carmelites, and their involvement raises the question of the Catholic Reformation in the area. This is the story of a militant Catholicism trying to win back what had been lost to Protestantism, contesting for souls and lands with equally militant Calvinists. The Jesuits played a pre-eminent role in the transportation of new artistic tendencies throughout Europe, especially in the seventeenth century. But their

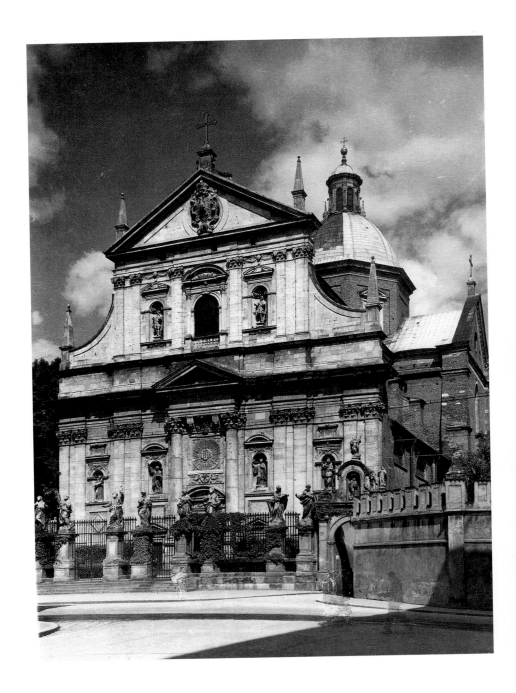

Jesuit Church of St Peter and St Paul, Kraków,
projected 1596 by Giovanni de Rossis; built 1597-1635
by Giuseppe Brizio, Giovanni Maria Bernardoni, and
(with important changes) by Giovanni Trevano

patronage leads to a key question, whether there was a distinctive 'Counter-Reformation' style that went along with the profusion of new churches. This is an old debate that has arisen around the tendency to associate new artistic ideas or new types of art with new orders, especially the Jesuits.

In Italian art history these ideas are now recognized as problematic: no particular style can be identified with any of the specific orders in Rome, for example. Francis Haskell has demonstrated that in the late sixteenth and seventeenth centuries the Jesuits were embedded in society, that they could not have promoted one style if they wanted to and that commissions were dependent on individual patronage anyway.[14] In the north the Jesuits also displayed a capacity for adapting to local circumstances and individual commissions. This capacity is seen in the marked variety of forms used for the first Jesuit buildings north of the Alps.

The first Jesuit church in the German provinces was St Michael's in Munich: there the interior is reminiscent of Rome while the facade not only serves more for the display of sculpture but has a gabled form which is unmistakably northern; reasons for its appearance have already been discussed. However, one might not guess the location of another early Jesuit church, which outwardly resembles the type of Counter-Reformation churches such as the Gesù or Sant'Andrea della Valle in Rome: this is one of the first Jesuit churches in Poland, a work built with royal support in Kraków and begun by an architect who served the court, probably Giovanni Maria Bernadoni (1541–1605), but transformed in 1605–9 by Giovanni Trevano (d. *c.* 1641), the designer of the Warsaw palace.[15] Perhaps because of the patronage of the court, which had a very strong connection with Rome and had long chosen Italianate designs, Trevano (and Bernadoni?) adopted designs that are purely Italian. In these instances there may of course be other requirements to take into account, as there had been in the Roman mother church: facilities for preaching and visibility of the priest were also of great importance.

The first Jesuit church in a north German province presents a significant contrast. The church of St Peter in Münster, Westphalia, was built by the architect Johann Roßkott in 1590–7 according to a basilican plan, but its idiom is Gothic. This seems to be an example of a conscious Gothic survival; the Jesuits may have regarded the Gothic as a sign of the local, medieval past with which they were trying to associate in the Westphalian and Rhenish regions, where the Gothic and Romanesque traditions were strong. In addition, there may also have been strong local tendencies in this direction in Münster, where the sculptor Heinrich Brabender had in 1536 completed the portal of the cathedral with a figure of St Paul, whose style is adapted to its medieval setting. Hence a similar Gothicizing style, if more grandiose in its pretensions and incorporating forms such as arcaded galleries found elsewhere in Reformation and Counter-Reformation churches, is found in the first Jesuit college church (1618), the Church of the Assumption in Cologne, a city conspicuous for its Romanesque and Gothic churches.[16] Hence the effect of

religion and sects was probably exerted more on ideology and iconography, than on matters of style.

A comparable stylistic variety may also be found in ecclesiastical architecture designed for churches not connected with the new orders. The development of a newer sort of church architecture is exemplified in Salzburg, whither Wolf Dietrich von Raitenau, who has already been mentioned, called Vicenzo Scamozzi north in 1604. Scamozzi conceived a partly Palladian plan for the Salzburg Cathedral, and Wolf Dietrich's successor Marcus Sitticus continued the construction of the cathedral when the plan was executed by Santino Solari. Solari designed a large unobstructed space, as in the Gesù (the Jesuit church in Rome), again perhaps with homiletic purposes in mind. However, like building in the earlier indigenous tradition, the cathedral possesses galleries, so that it can be described as a German *Prediger* (preacher's) church influenced by Italian examples. It combines domes, familiar from Roman, if not northern, architecture, with a church facade influenced by Italian prototypes, but it possesses two towers, as seen in German types throughout the region. When Archbishop Paris Lodron finally consecrated the cathedral in 1628, a public plaza was placed in front of it. This building may be considered another one of those 'prime objects', of which many 'replications' subsequently appeared in the Central European region.

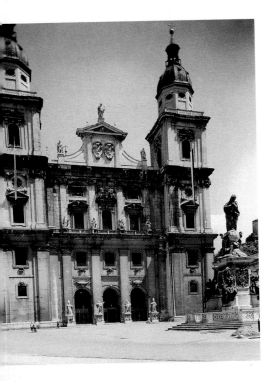

Salzburg Cathedral, building begun 1614
by Santino Solari after design by Vicenzo Scamozzi

Influential as it was, the Italianate design for church building favoured in Salzburg was but one of many styles employed for similar purposes in the region. The diversity among work sponsored by bishops is suggested by the example of Würzburg. In this south central German prince-bishopric, whose status was thus similar to Salzburg, the church on the Marienberg built *c.* 1600 by Bishop Julius Echter von Mespelbrunn has a pitched roof covering an interior with ogive vaults. In this instance the patron's evident preference for a traditional Gothic style is responsible for the cultivation of a post-Gothic style of architecture: the Mespelbrunn style, as it is often called,

appears in a variety of structures in Würzburg.

Stylistic variety in church commissions is also found in sculpture. Here the traditional reasons for patronizing religious art – an expression of piety, a good deed, a way of securing salvation or manifesting one's election to be saved, or a desire to glorify God – continued to motivate commissions for church furnishings as well as edifices. On the one hand this led to work in a more international form, by bronze sculptors such as Hubert Gerhard and Hans Reichle, who had been to Italy. The demand for refurbishing old churches or decorating new ones also meant that in certain centres in southern Germany such as Weilheim, wood sculpture was revitalized, though it has not received the attention it deserves.

In the case of wood sculpture, because of the continuation of religious customs in southern Germany, styles remained close to local traditions, as can be seen in the work of Hans Degler, who was responsible for altarpieces, dated 1604 and 1607, in SS Ulrich and Afra's, Augsburg, and that of Jörg Zürn, who at Überlingen in 1613–19 put up a large altarpiece in limewood. These works incorp-

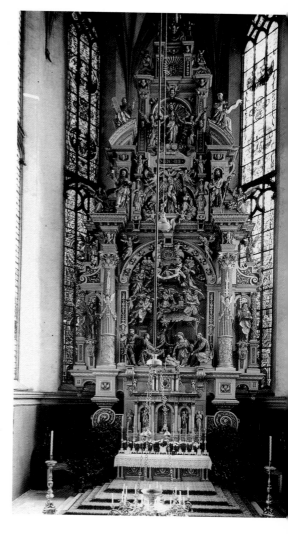

High Altar, SS Ulrich and Afra's Church, Augsburg, 1604-7, Hans Degler

orate various Renaissance ornamental motifs, the orders, masks and volutes, yet in their construction they remain true to the tradition of the winged retable; in Überlingen one is not far from crèche figures, either. They show that demand for new fashions in visual art, as represented by their ornamentation, could be met at the same time as incorporating the supposedly distinctive, 'demotic' forms of organizing visual experience.[17]

Protestant sculpture and architecture on the eve of the Thirty Years' War also lack a distinctive confessional style, further demonstrating how difficult it

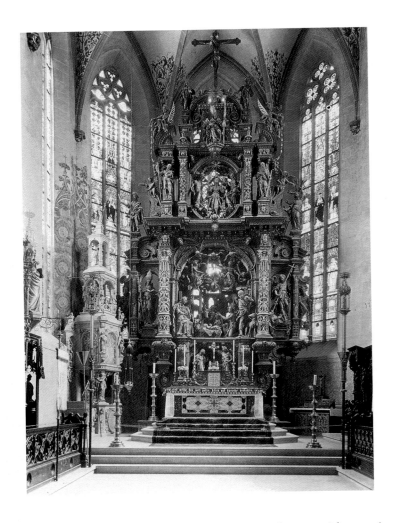

High Altar, St Nikolaus,
Überlingen, 1613-19, by Jörg Zürn

is to associate one style even with a particular confession. For example, Protestant commissions for church furnishings also seem to have felt the impact of the imperial and nominally Catholic court. The Habsburgs had erected impressive dynastic burial monuments, starting in Central Europe with the tomb of Maximilian I in Innsbruck and continuing under Maximilian II and Rudolf II with tombs by Alexander Colin for Ferdinand I and for Maximilian II in St Veit's Cathedral in Prague. The Dresden dukes of the later sixteenth century also transformed the choir of the market church in Freiberg in Saxony into a mausoleum for their (Albertine) branch of the Wettin dynasty. The tomb of Maurice of Saxony, by Netherlanders, was already standing by mid-century, but towards the end of the century the Italians Giovanni Maria Nosseni and Carlo di Cesare remodelled the Gothic

apse of the church. The interior of this remarkable edifice, a Gothic counterpart to the *sacrestia nuova* in San Lorenzo, Florence, is replete with life-size effigies of the deceased dukes in bronze placed in niches, with stuccoed music-making angels above.[18] Similarly Prince Ernst of Schaumburg-Lippe had Nosseni design for him a centrally planned burial chapel in Stadthagen, which contains a monumental mausoleum by Adriaen de Vries.[19]

While it is arguable that dynastic interests account for the predominant motivation for such projects, and thus for the interrelationships, Protestant church designs can also independently be related to Catholic church architecture with regard both to their liturgical needs and, perhaps more surprisingly, their references to Italian models. The rival confessions all required a new form of church, a large open arena for preaching. So it was that Protestant churches, such as the barrel-vaulted, arcaded town church in Klagenfurt, could, after the suppression of Protestantism in places like Carinthia (in the 1590s), be adapted to Catholic purposes.

A similar process occurred in churches associated with Prague. In Prague itself two of the major churches built for the Lutherans were actually ultimately based on Roman models; it can therefore be said that militant Protestant religious groups in Prague took over the forms of militant counter-Reform. The former Lutheran church of the Trinity in the Prague Malá Strana (built from1609), was designed by an Italian, Giovanni Maria Filippi, and modelled after Giacomo della Porta's Trinità dei Monti of the 1580s in Rome; the church of St Salvator, built in 1611–14 as the German Lutherans' church in the Prague Old Town, adopted a similar facade and in ground plan resembled the tradition begun by Vignola's church of the Gesù. The planning of both these churches is connected with that of the church of Neuburg an der Donau, the design of court painter Joseph Heintz, who was also active for other Protestant patrons of the time: the interior consists of free-standing pillars supporting a gallery and a stucco-covered barrel vault, while the exterior has a giant Tuscan order of pilasters, with a massive tower surmounting the facade. All these churches were later successfully adapted for Catholic purposes.[20]

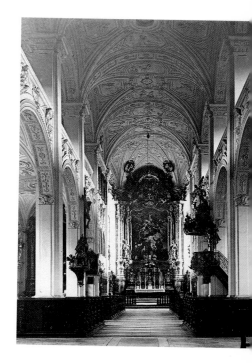

Interior of Hofkirche, Neuburg an der Donau, 1607-18 by Joseph Heintz, with stucco decoration 1616-18 by Antonio and Michele Castelli (and originally three altarpieces by P.P. Rubens)

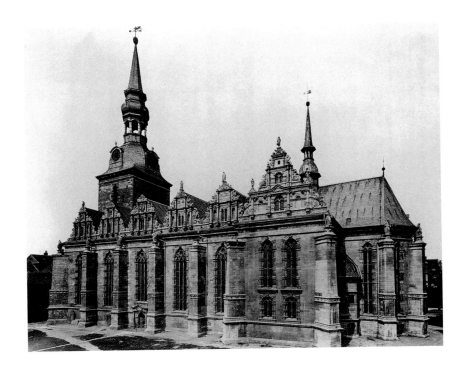

St Mary's Church (Marienkirche), Wolfenbüttel, begun 1608, Paul Francke and others

In contrast, other impressive quasi-Gothic structures were sponsored by princes elsewhere in the region, in the town church patronized by Ernst of Schaumburg at Bückeburg (probably by Hans Wulff, 1610–15) in the Weser region or the Marienkirche at Wolfenbüttel, commissioned by Duke Heinrich Julius (by Paul Francke, begun 1608). Both these buildings are hall churches, with cross vaults and ogive or, in the case of Bückeburg, modified ogive arches and windows, with tracery. The Wolfenbüttel church also employs large buttresses on the exterior and has octagonal piers, as opposed to the cylindrical piers in Bückeburg. The Gothic impression is moderated in the former instance by gables of Netherlandish inspiration and in the latter by a complicated facade, including elements of auricular (*Ohrmuschel*) decoration, with pilasters like the elaborate, Mexican baroque, estipite columns, bearing, seemingly self-consciously, the inscription *Exemplum religionis non structurae* (an example of religion, not of building).[21]

Important architectural patronage was by no means reserved for the princely courts or the church, however. In Poland, for example, it is recognized that the higher nobility, gentry and patriciate also competed with the court, as they did in Hungary. In Poland this resulted in an adaptation of Italianate designs 'according to Polish heavens and habits', as the first Polish-language architectural treatise put it somewhat later.[22] The castle at Książ Wielki

(1585–95), by the royal architect and sculptor Santi Gucci Fiorentino, represents a translation of the Italian *palazzo in fortezza* (palace within a fortress) type, containing a symmetrical rusticated central palace within a system of pavilions. Baranów (1591–1606) or Krasiczyn (1598–1633), on the other hand, are free-standing rectangular castles, with cylindrical corner towers, emphasized gateways and pedimented attics; both contain arcaded courtyards, although Baranów reverses the position of its courtyard, placing it one storey above ground; both employ unusual decorative elements.

Distinctive new forms were also produced in Hungary. At Bytča (formerly Nagybicse, now in Slovakia) Italian masons laid out a residence and made a distinctive separate building for wedding celebrations, decorated with sgrafitto and possessing an elaborate, if not elegant, doorway.[23]

No less than princely and aristocratic commissions, public projects in places like Augsburg could also call for new buildings. Growing public purposes account for the rash of town halls built, enlarged or decorated *c.* 1600, from Constance (*c.* 1595–8) to Stadthagen (1595–6) or Bremen (1595 but mainly 1608–12), and in Hungary (Bratislava in Slovakia, from 1581)[24] and Poland (Gdańsk/Danzig, from the 1590s). They also explain the proliferation of other sorts of public buildings, exemplified in Augsburg by the construction of an arsenal, weighhouse, schools, butchery and more as well as the production there of an impressive series of bronze statues on buildings, bridges, fountains and tombs. Among these are the Augustus fountain, by Hubert Gerhard, and the Hercules and Mercury fountains by Adriaen de Vries. While such works in Augsburg do not seem to have had a coherent iconographic programme, their message about the power and prosperity of the city is clear enough. They could also be more pointed, as in the placement of a bronze statue of St Michael by Hans Reichle (1603–6) above the portal to the town hall: in post-Reformation Augsburg he stood as a response to the Munich St Michael, a *Trotz-Michael* (riposte to Michael).[25]

The impressive new town hall in Augsburg, by Elias Holl, indeed expressed some of the pretensions

Zeughaus (arsenal), Augsburg, 1602-7, by Joseph Heintz, with Statue of St Michael by Hans Reichle, 1603-6

Hercules Fountain, Maximilianstrasse, Augsburg, from 1602, by Adriaen de Vries (pre-war photograph)

of this imperial city. Built in a classicizing style, it makes a number of telling references. Its form is conceived as a Renaissance palazzo; it embodies the idea of an imperial *villa in città*.[26]

The regular style of this building can be compared to that of the Nuremberg town hall, which also eschews elements such as gables, parapets or oriels, often seen in the region, in favour of a classicizing architecture; both are grand, large-scale buildings, whose regular design contrasts with that of other town halls, such as Altenburg in Saxony (1562–4). The facade and anterior parts of the Nuremberg town hall, by Jacob Wolff, stretch instead like a grand palace along the street front; they seem designed as a fitting seat for city government, a representative design, in several senses of the term.[27]

The glory of a city could also be expressed within its major public structures. In Augsburg, the ceiling of the Golden Room (*Goldenes Saal*) in the town hall was painted with scenes of local history and allegories by Matthias Kager and Hans Rottenhammer. The presence of the former imperial painter Matthias Gundelach here is a sign that in the early sixteenth century Augsburg retained its status as a major centre for the pictorial arts, for print-making and painting. The leading painter there until his death in 1625 was Hans Rotten-hammer, who had previously been in Italy, where he had been connected with Netherlandish landscape artists active in Venice, as well as with many Venetian artists. And Rottenhammer was but one of many such painters.

The situation in Augsburg indicates that there were other circumstances favouring the patronage of the arts, as in a number of cities and towns at this time. Even though it was often threatened, the peace that was maintained in the empire allowed for expenditures on Hermes and Athena and not on Ares.

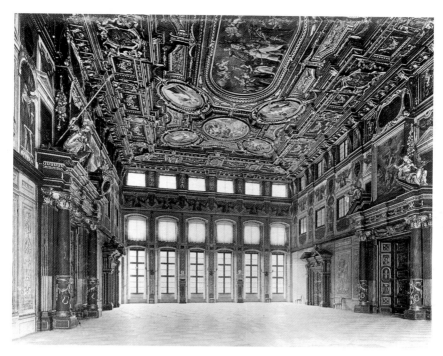

Rathaus (Town Hall), Augsburg (building 1605-20 by Elias Holl); interior of *Goldenes Saal* (pre-war view) with paintings, 1620-1 and following by Matthias Kager (after Pieter de Witte) and Hans Rottenhammer

Rathaus, Nuremberg, 1616-22, by Jakob Wolff

Although it is difficult to assess the relative economic status of the whole region, evidence from many regions that have been studied for this question, from small towns like Nördlingen in Swabia as well as from the north German towns of the Weser region, suggests that they were booming in the years before 1620.[28] By the end of the sixteenth century Augsburg itself had overcome a time of economic difficulty, and while generally economic conditions throughout Germany might not have been so prosperous as they were in *c.* 1500,

and arguments have been advanced to suggest that there was a downturn in the Central European economy even before 1620, conditions varied from place to place. There is also much else that suggests that at least the upper classes, the patrons of art, were well off at this time. In places like Augsburg their support for building certainly does not seem to have betrayed any fears of a downturn; in any instance, both public institutions as well as private individuals in many cities had sufficient means and desire to continue to patronize works of art, with the result that the cities also continued to flourish as centres of patronage and artistic creation in the decades *c.* 1600.

In contrast, religious and civil turmoil in the Netherlands led to an exodus of artists and artisans as well as of tradesmen and capital. Just as northern German and Polish towns profited commercially from the decline of Antwerp after the river Scheldt was blocked, so too did they gain from an influx of Netherlandish artists. As a consequence not only the courts were able to attract Netherlandish artists of the first rank. Frankenthal, in the Palatinate, along with Frankfurt am Main and Cologne became centres for refugee painters. Other major free cities such as Nuremberg, where Nicholas Neufchâtel settled and Augsburg, where Adriaen de Vries and Gerhard worked, also gained from immigration.[29]

A Polish example is instructive here. Gdańsk (Danzig), the major harbour of the Polish republic, an outlet for Silesia and an international entrepôt, grew phenomenally in wealth and importance at this time. In the

Arsenal, Gdańsk (Danzig), west facade, 1602-5, Anthonis van Opbergen

period between the decline of Antwerp and the rise of Amsterdam, before wars in the Baltic and the onset of the Thirty Years' War wrecked trade in the region, Gdańsk also assumed an international importance, especially in the Baltic region. The restored seven-storey houses that still line the city's streets attest to its prosperity. So do the numerous public buildings put up at this time, including a variety of types of structures. These include city gates, such as the Green Gate by the Netherlander Anthonis van Opbergen, the High Gate by Hans Kramer, and the arsenal, main town hall and observatory by Opbergen, as well as the sites of civic and commercial associations, such as the Artushof. Several of these have sumptuous decoration within: these include the Red Room in the Town Hall, with paintings by Isaac van den Blocke and Hans Vredemann de Vries and the Artushof, which from this date contained works by Anton Möller and once was heavily decorated with paintings and sculpture. From this date as well come several major sculptures: these include the Neptune fountain outside the Artushof, and the epitaphs and tomb sculpture in the various churches, by leading Netherlandish sculptors, the equivalent of Vredemann de Vries and Van den Blocke in painting.[30]

For similar reasons, other north German cities such as Bremen, Lübeck (and Königsberg/Kaliningrad in Prussia) and the smaller centres along the Weser River also experienced a profuse development of architecture and some public sculpture.

Outside the courts themselves, where workshops were established, many other cities, not just Augsburg and Nuremberg, thus became flourishing centres for the arts. The implications for some of the arts, as, for example, the effect of the Kunstkammer on the qualities of the decorative arts, have already been noticed. Furthermore the graphic arts, furniture making and carving flourished in many centres in the region.

It is difficult to draw strict distinctions between court and city or, for that matter, often between styles of art created for different religious confessions. Although broad social distinctions help give a general orientation, the particular situation is more complicated, as is often the case in the history of Central European culture. While patronage of the arts before the Thirty Years' War, at least in its upper echelons, may have been dominated more by the courts and their residences than by the free cities, as it had been since the mid-sixteenth century (as opposed to the situation in provincial backwaters), art and artists are rarely exclusively identified with one distinctive milieu. Both court and city could sponsor works by the same artists, who might even create similar works for them. A pattern of artistic interchange that had been established already at the beginning of the century continued to exist, whereby artisans in sites that had long been major centres of production, like Augsburg and Nuremberg, supplied works of art to the courts, and conversely, as workshops came to be set up at princely residences, artists in court employ might work for patricians in the cities. The close relationship of working places is suggested by the interrelationship of Prague and Augsburg, between which

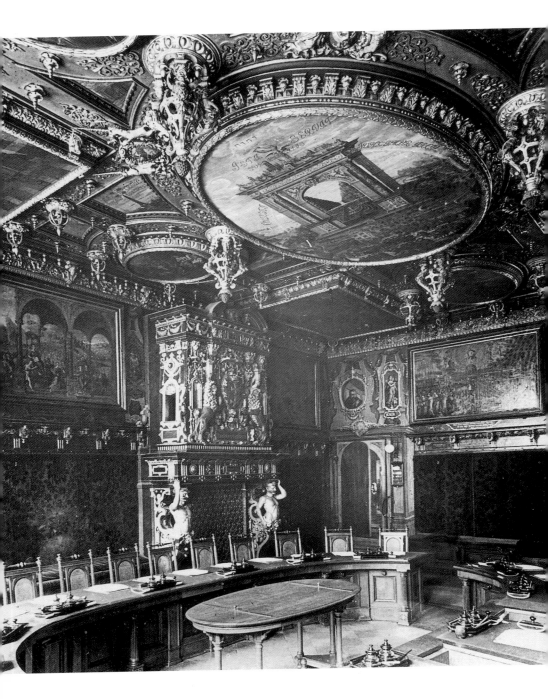

Red Room, Town Hall (Ratusz Głównego Miasta),
Gdańsk, with paintings, 1594-6, by Hans Vredemann
de Vries, and, 1608, by Isaac van den Blocke

personnel circulated: Rudolf's court sculptor Adriaen de Vries and painter Joseph Heintz both worked in Augsburg before coming to Prague, and Heintz continued to supply works for patrons in the Swabian imperial city as well as designing public buildings there. The imperial painter Hans von Aachen, also at a time when he was serving the Bavarian court in Munich, worked for the Fuggers in Augsburg; after the emperor's death his painter Matthias Gundelach went to Augsburg where among other things he painted important canvases in the town hall. Hans Vredemann de Vries went from Wolfenbüttel to Gdańsk and then to Prague.

If earlier it could be claimed, with whatever merit, that there was something separating northern and especially Central European art from that of neighbouring countries, it is difficult to ignore that much of what was now done partakes of more general European currents. To be sure, the specific functions, demands and local traditions of art in Central Europe *c.* 1600 make it distinguishable from what was done elsewhere in Europe. Yet even local products adopted the sequences at least of ornamental language, not only the classical orders but their variations and also strapwork, *Ohrmuschelstil* and the like, that were current throughout much of northern Europe. Moreover, many other circumstances led to the production of a cosmopolitan environment. It is not just that Netherlandish artists and architects, such as Adriaen de Vries, or painters, such as Sustris and De Witte (Pietro Candido), and Swiss artists, such as Heintz, worked in Central Europe; many of them, including all these figures, had previously been to Italy.

The other side of the coin is that major Italian architects including Vicenzo Scamozzi, Santino Solari and Giovanni Maria Filippi, also came to work in Central Europe. Architecture of castles and churches, although obviously not identical in all respects to what was found in Italy, may thus often be said to conform to an Italian tradition. The architects who worked in Central Europe, like Solari in Salzburg, produced buildings similar to what might be found at home.

Beyond their circles, however, many originally Italian ideas had become commonplace. By this time, for example, not only general rhetorical principles had become assimilated in Germany but also many theoretical ideas were well known. Italian treatises, such as that of Serlio, seem to have been disseminated. They encouraged the idea that architecture could be a learned profession and that the architect could be a man of learning, as had already been foreshadowed in mid-sixteenth-century figures such as Wolgemut. They seem to have encouraged ultimately, as we shall see, the development of an indigenous tradition of architectural treatises.

These were written by such men as Joseph Furttenbach and by such masters as Heinrich Schickhardt, the designer of an ideal city at Freudenstadt, who were also encouraged to make trips to Italy.[31] A phenomenon begins to recur at this time, whereby German artists travelled across the Alps, worked in the peninsula for a while and then returned north. This includes sculptors

such as Hans Reichle, who were trained in Italy by Giambologna, and painters such as Von Aachen and Hans Rottenhammer. In fact probably the best-known German painters of the time, Adam Elsheimer and Johann Liss, to be discussed in the next chapter, made their careers extensively in Italy.

One result seems to have been that even those architects, as well as the painters discussed above, who were not openly disposed, even antagonistic, to Italianate designs, such as it has been argued was Elias Holl, the master of the Augsburg town hall, had to deal with the Italianate. As a recent book on architecture at the time of the Thirty Years' War makes clear, German designs came under Italian influence. The classicizing values that had been established during the Renaissance came to dominate much thinking, including that in Germany at this time.[32] Architecture of the early seventeenth century has thus been called one of classicism, and if this term does not mean some restrictive notion of the high Renaissance, nor some false opposition to the baroque, given its limited applicability, this seems to be a reasonable designation. And yet if we use this notion, a further problem of style and stylistic analysis results. For, granting that works were often made for definite functions, if distinctions cannot be drawn strictly on the basis of social milieus, nor of confession, then it is nevertheless true that formal designs in architecture that were derived from outside the region were received and applied differently in different areas: works done by Italians in one place were not like those in another. Netherlandish influences were also handled differently in different locations. As in drawing or painting, a development of regional styles can also be discerned at this time.

These sorts of differences can be discerned within the art and architecture of one realm, such as Poland. As noted above, the 'heaven and habits' of Poland have been regarded as forming a vernacular, but if an artistic vernacular existed, it had many dialects, that themselves seem to be as different from each other as much as they constitute a national language of art. Materials, artists, traditions and tasks all accounted for differences. Thus art and architecture in Gdańsk/Danzig and elsewhere in the north display a Netherlandish-inspired style, related to trade that carried ideas easily through the Baltic, along with Netherlandish ships; the scarcity of stone and tendency to build in brick allowed for the importation of these tendencies; and the religion (Protestant) and business orientation of those who made the commissions all reinforced it.[33] Whereas Netherlanders operated in the north, Italians did in the southeast, around Lwów (L'viv, Lemberg) and in Lublin. In Lublin and surroundings stucco workers, including Jacopo Balin, created a distinctive Lublin style, which is visible in Kazimierz Dolny, Sandomierz and elsewhere. A different style, not so much related only to stucco but present in architecture as well, was on the other hand to be found in the buildings of Lwów. This is evinced by the striking examples of the adaptation of Italians both to traditional tasks, such as the construction of the Bernardine Church there and to building for Orthodox or other sects, such as the Wallachians.[34]

It would be superfluous to continue to enumerate the multiple differences of monuments in Poland or in the German lands. All this variety goes to demonstrate in general the richness of forms in this area, and that also suggests that an extraordinary efflorescence of art and architecture did occur in Central Europe in the years before the beginning of the Thirty Years' War.

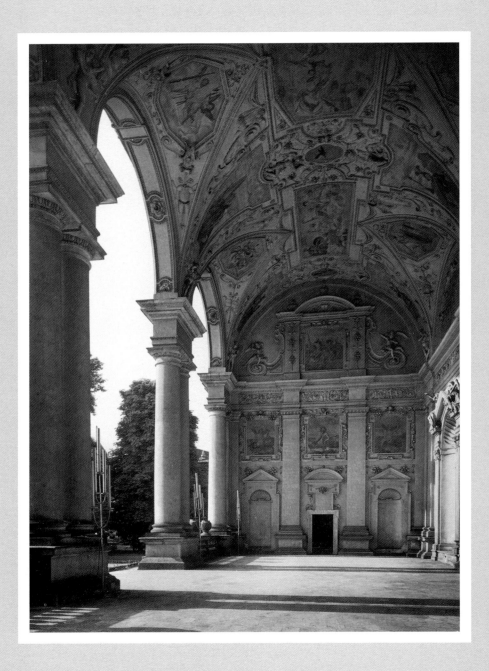

Art and the Thirty Years' War

10

Loggia, by Giovanni Pieroni, with
stucco decoration and frescoes by
Bartolommeo Baccio del Bianco, 1623-9,
Wallenstein Palace, Malá Strana, Prague

IT IS A WIDELY HELD OPINION THAT THE MOST IMPORTANT SERIES OF
RELATED EVENTS OF THE FIRST HALF OF THE SEVENTEENTH CENTURY,
THE ARMED CONFLICTS THAT LASTED FROM 1618 UNTIL 1648,
REPRESENT THE GREAT CATASTROPHE OF THE HISTORY OF CENTRAL
EUROPE DURING THE EARLY MODERN ERA. It has thus long been believed
that the Thirty Years' War was an unqualified disaster for the culture of the
entire region. One of its consequences is supposed to have been a hiatus in the
history of artistic developments: as a result, historians have done little to
correct this overwhelmingly negative view, by investigating what evidence
might actually exist.[1] With the landmark exhibition on German art of the
'baroque and rococo', the *Jahrhundertausstellung*, held in 1914 just before the
outbreak of the First World War, German art historians had already begun to
pay some attention to the period after 1650; for much of the twentieth
century the era after 1680 has been considered as one in which a major revival
occurred. But this recognition has also served to reinforce the general impres-
sion that the preceding era of the Thirty Years' War was a time when destruc-
tion, not creation, was the rule.

There is no doubt that the war brought death, depopulation and disloca-
tion to many regions of the Holy Roman Empire, including a diaspora of
Protestants, among them artists. It also effected a general economic depression
(or in some theses accelerated a downturn), along with the demographic
decline. On several occasions armies fought in Bohemia, where Rudolfine

culture had flowered just previously. The conflicts had begun there, from the spark of the revolt of the Bohemian estates, that had led to the defenestration of imperial officials from the Prague castle in 1618. The election in 1620 of Frederick V of the Palatinate (encountered in these pages as the builder of the Heidelberg Friedrichsbau) was the last straw and brought on open warfare. The local conflict quickly turned into a European one. In the fighting that ensued the estates were crushed at the battle of White Mountain near Prague (the site of the Star Villa) and Habsburg power was reimposed. With the demands for religious orthodoxy, tens of thousands of Protestants were driven into exile. In the 1620s the troops of the Hungarian rebel Bethlen Gabor wasted Moravia; Swedish armies also ravaged Moravia and Silesia on several occasions; in 1648 they sacked Prague. Trade and industry were disrupted in Bohemia. The prosperity of the towns and cities declined. Artificial devaluation of currency further facilitated the dispossession of long-resident landowners and the transference of estates.

In the German regions of the Empire the war was soon brought home to the Palatinate. Heidelberg was taken and pillaged in 1622. The Palatinate now became a battlefield, and where earlier Frankenthal had provided a home to an important school of painters who had come from the Low Countries, it was now a place from which one sought escape; Frederick himself went into exile in the Netherlands.

Many other areas came to suffer a similar fate. Christian IV brought Denmark into the conflict in the mid-1620s, and the war came to northern Germany, in the form of Tilly's and Wallenstein's armies, bringing devastation in their path. In 1630 the major central German trade centre of Magdeburg was torched, with great loss of life. When the Swedes under Gustavus Adolphus swept down on Germany in the early 1630s, the turn came for Bavaria and Franconia to suffer; major battles between Gustavus Adolphus and Wallenstein were then fought in Saxony, whose lands were frequently traversed by armies. The war was carried to Swabia, where Nördlingen became the site of a major battle. When towards the end of the war French armies engaged in fighting, destruction spread further. Other areas, particularly the Rhineland, were repeatedly devastated during the 1640s.

In addition to the direct slaughter, the armies brought starvation, caused by their plunder of livestock and destruction of fields, and disease, carried by the troops and their followers, resulting in huge loss of life. It has been estimated that by the end of the conflict areas of Saxony and Thuringia had lost half their population, and harder-hit regions like Brandenburg and Mecklenburg up to 70 per cent, or more. In many other territories elsewhere the population also declined.

The image of destruction found in Germany and Bohemia covers a broader canvas. Foreign armies repeatedly entered Austria, where there were also peasant uprisings, brutally suppressed, with Protestants being expelled and murdered. In Hungary Bethlen Gabor's revolt also spread disorder and

destruction. The Polish commonwealth (the union of Poland and Lithuania), spared by the Thirty Years' War, was engaged in conflict with Swedish armies from early in the century and also with Muscovy.[2]

Given this panorama of destruction and devastation, there is good reason that posterity has not deemed that much positive would have been preserved or achieved during this time. One contemporary observer, the artist-historian Joachim von Sandrart, has indeed left a memorable description of the fate of the visual arts:

> Queen Germania saw her palaces and churches decorated with magnificent pictures go up in flames time and again, whilst her eyes were so blinded by smoke and tears that she no longer had the power or will to attend to art, from which it appeared to us that she wanted to take refuge in one long, eternal night's sleep. So art was forgotten, and its practitioners were overcome by poverty and contempt, to such an extent ... that they were forced to take up alms or the beggar's staff instead of the brush, whilst the gently born could not bring themselves to apprentice their children to such despicable people.[3]

Sandrart's dramatic depiction does have some truth to it. Places that had been important centres of social or cultural life lost their vitality. Cities such as Heidelberg, with its castle, collections and gardens, and Magdeburg, an important seat for sculptors, were burned and looted. The famed Biblioteca Palatina of Heidelberg was transported to the Vatican Library. In 1648 what remained of Rudolf II's collections on the Hradčany in Prague were sacked. Many other court centres in Germany were not able to maintain their support for artistic projects. As trade declined, where earlier there might have been discrepancies between different areas in the empire, now, as noted, the picture became a general one of economic decline. Demand for artistic production decreased. Many artists, including Sandrart himself, went to work elsewhere. The situation seems all the more stark when comparisons are made, as they usually are, with the contemporary flowering of painting in the Low Countries.

But there is more to the story. More remains to be said about the fate of the arts in Central Europe during the time of the Thirty Years' War. The argument that this was a totally negative period for the region as far as the arts were concerned does not take into account much of what was in fact accomplished during this era. Large areas of Central Europe, including Poland and Hungary (with Slovakia) were not directly involved in the Thirty Years' War. Substantial claims cannot be made about painting in these regions, and perennially this remains a problem, because other arts such as that of the goldsmith are thus often ignored to the detriment of considerations of what else was accomplished in Central Europe, where the applied arts of the goldsmith are often more strongly represented, for example in Hungary,[4] than in other areas of Europe. Yet this period can also be considered one of the high points, at least for architectural accomplishments, in the history of Poland.

Striking developments with important consequences for the future may also be discerned in Germany and Bohemia.

It has been observed that even in our own time, warfare has not stopped artists from working (witness the 1939–45 exiles in America or Picasso in Paris), and armed conflicts in the seventeenth century did not assume the scope of the total war that has been experienced in the twentieth century. The power of destruction was not the same: although losses of life might have been greater in terms of relative percentage, these were not the direct result of military action, bombing, mass murder or 'ethnic cleansing', as in recent times, but more indiscriminate assaults, often of disease that affected all parties equally. Although it would obviously be mistaken to underestimate the amount of human suffering and material destruction that were caused, the actual destruction of the physical fabric, of material culture, as opposed to the plunder of the arts, was, with the noteworthy exception of places like Magdeburg, incomparably less than that of recent wars.[5]

In any instance, warfare in early modern times did not strike all places simultaneously, nor with the same severity: a series of conflicts lasting three decades did not bring the same intensity of destruction as the concentrated devastation of a few years. Hardest hit were the peasants in the countryside, the villages and small towns, not the larger walled cities or residences that had nourished the arts. Some major cities, such as Augsburg, Lübeck and Hamburg, and even some whole regions, the north-west of Germany and the alpine areas, remained more or less unharmed. The question of what was not built or painted thus ignores a situation in which the arts could continue to flower in certain areas that either remained untouched or at least until they were directly touched by conflict.

Late twentieth-century scholarship has finally recognized that a considerable amount of art and especially architecture continued to be produced in the German and to some extent in the Bohemian lands during these decades.[6] When this information is taken into account along with acknowledgement of architectural achievements in Poland and Hungary, then the image of the history of the arts in Central Europe may seem different. A more complex and variegated picture, allowing, as always in Central Europe, for regional and local differentiation, needs to be considered. Despite the experience of devastation, in many areas older functions, styles and types of patronage were continued at the same time as newer themes, types and interests were introduced, along with newer attitudes and ideologies to which they gave form.

Without acknowledging the fact that, along with destruction, these patterns of innovation and continuation actually existed in the first half of the seventeenth century, it is difficult to situate or to evaluate correctly the cultural achievements of the later seventeenth and early eighteenth centuries. This observation pertains to literature and music as well as to the visual arts. For the period of the Thirty Years' War saw the beginning of a flowering of

German letters, with the appearance of Martin Opitz, among many other writers from Königsberg to Württemberg, as well as the emergence of important pedagogues and philosophers, such as J. A. Comenius from Bohemia. Perhaps in part out of a response to the conflict and destruction of the era, late humanist writings often took the form of Utopian and pansophic treatises, as represented by the writing of J. V. Andreae, Jakob Böhme and the Rosicrucian tracts. Utopian schemes offered a vision of a better world, much as pansophy proposed a philosophy or theosophy that reconciled conflicting beliefs, in a way that it was hoped would be acceptable to all parties.[7]

One characteristic work of the time is Andreae's *Christianopolis*, published at the beginning of the war, in 1619. Andreae presents an ideal social plan, in the guise of the utopian city of Christianopolis. The visual arts have a special place here, as teaching and study are facilitated through pictures. Painting is emphasized as an activity and field of learning that incorporates many different sciences, including architecture, fortification and machines.[8]

Books such as this were produced by a lively publishing industry, which a rich tradition of engraving also served. In Prague Aegidius Sadeler continued producing images until his death in the late 1620s and probably trained several leading figures of the next generation, including Sandrart and Wenzel (Václav) Hollar. On the other hand, less orthodox texts were published in Frankfurt am Main or in the Palatinate, where they were equally well served by splendid illustrations. On another level, popular imagery proliferated as a form of propaganda.[9] In particular *Flugblätter* (pamphlets) abounded as a form of report and polemic. While the quality of imagery in these sheets may have varied, there is no denying their impact.[10]

This was also a moment at which German music began to come into its own, when the groundwork was laid for the great accomplishments of the later seventeenth and eighteenth centuries. This was the epoch of Heinrich Schütz, Michael Praetorius and Johann Jakob Froberger, among many others. Much like the visual artists, the composers drew from a variety of sources, mainly Italian and Netherlandish, to form their own distinctive creative idiom.

In the visual arts evidence also exists from all over Germany for the continuation of earlier patterns, both interrupted and uninterrupted. Projects that had been initiated were not simply stopped with the outbreak of hostilities in other regions. For example, in the north, Protestants continued to commission epitaphs and altarpieces. These possibilities, along with the manufacture of choir stalls, pulpits and, in consonance with the musical tradition, organ cases, created many opportunities for sculptors. In some places in northern Germany, around Hamburg, Bremen, Lübeck and Oldenburg, and in Holstein, it was thus possible for sculptors in the traditional media to carry on considerable careers. The remarkable wood (and stone) sculptures of Ludwig Münstermann around Oldenburg and Bremen, or those of the Gudewerdt family in Eckernförde, must be seen in this light. The polychrome works of

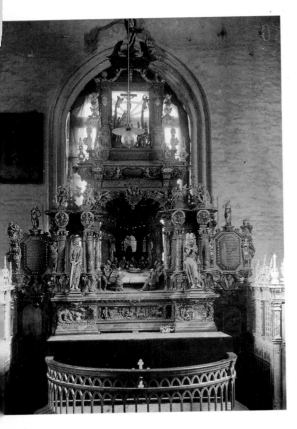

Altarpiece, Rodenkirchen,
1629, Ludwig Münstermann

Münstermann are very often quite elaborate; indeed, they have recently been described as being 'between Protestant asceticism and counter-reformatory sensuality'.[11]

Extraordinary works were also made in the Catholic regions. Important workshops for wood and stone carving endured in Westphalia, as evidenced by that of the Gröninger family in Paderborn and Münster.[12] In the south, as Degler had earlier exemplified, the tradition of local workshops for limewood sculpture remained alive in places like Weilheim. Works continued to be made throughout Bavaria for small churches, and in some instances for major pilgrimage sites like Altötting, for which the Catholic Marshal Tilly commissioned a remarkable tomb that contains his life-size effigy. And, as will be discussed further in the next chapter, limewood sculptors stayed active in the Austrian lands.

In some court centres princely patronage continued until catastrophe struck. At the Wittelsbach court in Bavaria work was carried on into the 1630s in the Munich residence, producing dynastic tomb monuments and public monuments, and at the suburban retreat at Schleißheim, and artistic activity was to a degree resumed even after the Swedish incursions. At the Wettin court in Saxony, work also continued at many of the major and smaller residences. The tradition of fine sculpture in Dresden represented by the Walther family among others persisted right up until mid-century; painters also continued to work there, at least until the early 1630s. The splendour of Dresden was such that Jakob Böhme could in 1624 say that '*Dresden ist jetzt eine Jubelstadt, wie vor der Zeit Prag war*'.[13] (Dresden is now a city of jubilation, as Prague was before this time.)

Other sites might actually have gained in importance, profiting from a decline in competition that resulted when less fortunate places fell onto hard times. In Swabia, at Schwäbisch Hall, the Kerns managed to establish an atelier that had a supra-regional importance. More significant was the

situation of Augsburg, which emerged unscathed from the war.[14] In Augsburg itself many of the major local projects involving architecture, sculpture, painting and interior decoration mentioned in earlier chapters remained in progress during the years of the war. While Frankfurt am Main, which Georg Flegel and several other still-life painters had for a period made into a flourishing centre, and some other free cities entered a period of relative decline,[15] Augsburg emerged as a leading venue for the arts almost, as it were, in compensation. Augsburg was to secure this position in the later seventeenth century and to hold it throughout the eighteenth. During the war many leading political personalities acquired objects from Augsburg: among them were Gustavus Adolphus of Sweden, who received a bronze bust, full-length portrait and a *Kunstschrank* (cabinet) from Augsburg's leading artists. At this time Augsburg furniture makers and metal workers, particularly goldsmiths, attained dominant positions in Germany. A sculptor like Georg Petel also came to enjoy an international reputation: his works were sought all over Europe.

In contrast, while the conflicts made the German and Bohemian lands an international theatre of war, a *Kriegsschauplatz*, it is possible to regard what happened, in terms of the invasion of foreign armies and the exile of artists, not only negatively but also as an era in which the intrusion of foreigners was one of many forms of international contact that accelerated the integration of Central Europe and its artists into common European cultural developments. This is a side of the story that demands further investigation.

Already by the sixteenth century the regions of Central Europe were becoming less isolated, and it had become customary for foreigners to work in Germany and Bohemia. Allowing for the disruption of the war, these conditions did not essentially change after the beginning of the seventeenth century. As had been the case with the appearance of Netherlandish and Italian artists in Germany roughly a century earlier, the question is rather how to interpret the presence of foreign artists and that of the art inspired by them.

The thesis perhaps suggested by the last chapter, that the art and architecture of the earlier seventeenth century took its own part in the conflicts, thus needs to be elaborated. Art continued to serve ideological purposes: for example, some of the artistic innovations of the Catholic party as seen in Bavaria continued to assume a militant character. The revival of the ancient custom of raising victory columns first occurred in Germany with the erection in Munich in 1638 of a column to Mary, the *Mariensäule*. This made a pointed reference to Mary as patron of Bavaria, *Patrona Bavariae*, under whose protection the Bavarians had been successful against what they regarded as Protestant non-believers. It is also true that the role of the Jesuits at this time might similarly be treated negatively as that of the 'shock troops' of Rome, who took on the re-Catholicization of newly conquered territories, spearheading a movement that also entailed the foundation of new schools and new churches.[16]

It has already been noted that at first no one style can be associated with the Jesuits in the north. During these years, however, a newer type of church design came into favour in German Jesuit churches. First evinced in the collegiate church at Dillingen on the Danube (1610–17), this type adopts the plan of St Michael's and creates a structure that from the outside seems little more than a rectangular block, albeit ornamented with classical pilasters, while within a preaching hall is created. This is done by suppressing the pillars into the wall: they become like the buttresses of indigenous Gothic tradition. This type of wall-pillar church, as it is called,

Exterior, St Andreas Church, Düsseldorf, 1622-9

was soon found in churches built by the order in Eichstätt (1617–20), Innsbruck (1619–20) and Düsseldorf (St Andreas, 1622–9). They remained a source for much eighteenth-century building.[17]

On the other hand, because of the religious and institutional allegiances of many Catholic orders, especially the Jesuits, who had pledged themselves to the service of the Pope, during the time of the war the orientation to Italy and especially to Rome also meant that an art closely connected with the latest products of Italian church design and decoration would increasingly be favoured. A style in architecture that grew out of the designs of figures such as Vignola and Carlo Maderno came increasingly to be adopted in Central Europe, especially for churches for the Jesuits and for other religious orders. This phenomenon has led historians to observe that the 'baroque', identifiable in architecture with these Roman developments, came during the period after the battle at the White Mountain to replace the 'Mannerism' of the Rudolfine era.[18]

Whatever the merit of such terms, it has has already been noted that from early in the century the Polish court sponsored the adoption of Roman models for Jesuit churches. In the Austrian lands the Jesuits had had a presence in Vienna since the arrival of Petrus Canisius in the 1550s; once Ferdinand II became emperor, these forms were also adopted there in the 1620s. Ferdinand II had a Jesuit confessor, Father Lamormaini, and in many ways the emperor was tied to the policies of the order and thereby to Rome. Ferdinand was responsible for driving out the Protestants, thereby, provoking peasant revolts,

as noted above, in Lower Austria in 1626, for instance, which were brutally crushed: this gives some further sense of the context of contestation in which big new churches were to be built. It is also worthy of note that in 1627 groundstones were laid for a new Jesuit church and gymnasium (high school) in Vienna: this was the year that may be regarded as a highwater mark for the Habsburgs and the Catholic cause. This was the year which saw the defeat of Christian IV of Denmark as well as the confident promulgation of a *Verneuerte Landesordnung*, a 'constitution' for Bohemia which redistributed property, and established the Habsburgs as hereditary rulers of the country.

In any case, the model followed for the Vienna Jesuits resembles that followed in Salzburg and that for other churches that had been designed by Italians and modified for Central European circumstances. It possesses a Vignolesque central block within a two-tower facade. The older religious orders also adopted the styles of Roman architecture, with designs recalling the church of San Carlo ai Catinari in Rome: a good example is the Vienna Dominican Church, built from 1631 by the Italians Jacopo Spazzo (Jakob Spatz), Antonio Canevale and Cipriano Biasino.[19]

A similar case can be made for the penetration of Italianate architectural styles into Hungary. In the Upper Hungarian (the present Slovak) city of Trnava (Nagyszombat, Tyrnau) it was again the Jesuits who were responsible for the advent of buildings in the newer style. The Jesuit church there was built from 1628, most likely by a member of the Spezza family, in that it resembles the contemporaneous designs of Andrea Spezza for the Carmelite church at Bielany near Kraków, Poland. The exterior relies on a similar Italianate model, where a fronton flanked by two towers appears; the interior possesses a unified central space, with side chapels reduced, as in Roman predecessors. Although this interior conforms to a widespread type, the ground plan and altar placement do not follow the exact prototype of the Jesuit mother church in Rome but resemble more its previous transmisssion through the Jesuit churches in Vienna or Munich. The stucco decoration, designed by G. B. Rosso and executed from 1639, represents some of the earliest of a kind to be spread by Italians in Central Europe. Although in its extravagance it may in a way anticipate the eighteenth-century rococo, this sort of interior decoration, which is characteristic of much later seventeenth-century church decoration, is often called 'stucco baroque', to distinguish it from the 'fresco baroque' of the eighteenth century, because sculpted decorative elements executed in plaster predominate in its design. The final touch to the whole church involved painted emblems. The emblem was a form favoured first in literature and typically consisted of a symbolic picture, motto and explanatory poem; it became ubiquitous in Central European expression and had its place in church decoration as well.[20]

In Hungary the forms created at Trnava became types that had great resonance throughout the century. They are encountered soon thereafter at Györ in western Hungary, from 1673 at Košice (Kassa, Kaschau) in north-

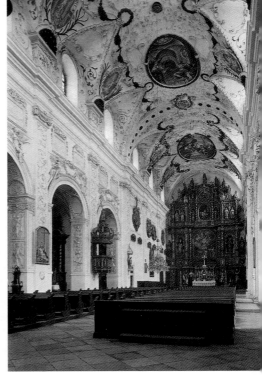

Exterior, Jesuit (University) Church, Trnava,
1622-9, probably Pietro and Antonio Spezza (Spazzo)

Interior, Jesuit Church, Trnava, with stucchi
by Giovanni Battista Rosso and Jacopo Tornini,
1639-55, with nave stuccoes by Antonio Conti,
1699-1700; High Altar, 1636-40, with sculpture
by Veit Stadler

eastern Slovakia and still later in Transylvania (now Romania).[21] Starting with the church at Nysa (Neisse), a similar account of the role of Italian artists collaborating with German-speakers can be given for Silesia in the late seventeenth century.[22]

This account of the dissemination of Italian styles in Hungary echoes what is known from the sixteenth century, and the story of Netherlandish activity in the region is also similar. In the area of Gdańsk Van den Blocke and other Netherlandish sculptors remained active. And representing newer currents, paintings by Peter Paul Rubens, the leading artist of the day, were to be found throughout Catholic Germany. Rubens himself executed altarpieces for churches in Freising, Neuburg an der Donau, Cologne and Prague, the last-mentioned works as late as the 1630s.[23]

On the other hand, even the observation by Sandrart of German artists working abroad can be reinterpreted as evidence for the growing intercon-nectedness of art and artists in Central Europe with those elsewhere. The

phenomenon of German artists working abroad is not to be attributed alone to the dislocations of the Thirty Years' War, but again represents a continuation of earlier developments. It was also nothing new for artists to stay in Italy. If we note that two of the major German painters of the first decades of the seventeenth century, Adam Elsheimer and Johann Liss, in fact made most of their careers in Italy before and during the early part of the great conflagration, it can be observed that their careers there were obviously not induced by the war.[24] A pattern was established by Elsheimer, who was already dead by 1610. Elsheimer was born in 1578 at Frankfurt am Main, a commercial, economic and, to a degree, cultural centre enlivened by Netherlandish emigrés, where he had been first trained by Philip Uffenbach, a pupil of Matthias Grünewald. This sets him squarely in the earlier German tradition. Elsheimer's earliest-known works are moreover designs for windows and sheets in autograph albums (*Stammbücher, alba amicorum*). Album books originated as a distinctive use of Melanchthon's *Theological Commonplaces*, when Protestant students employed them to record famous people and friends they met on their travels. By the seventeenth century their use had become a broad custom among academic and non-academic owners alike.[25] The religious subject matter of Elsheimer's early paintings can be related to traditional functions for art, much as his drawing in autograph books can be tied to a later sixteenth- and early seventeenth-century fashion. Elsheimer executed small paintings on copper, with religious subject matter and pieces for collectors, characteristic genres of the time.

In Italy, by the turn of the century, Elsheimer created subtle, luminous masterworks, religious and mythological scenes set in landscapes or nocturnal surroundings. These in turn had an impact on Rembrandt. Elsheimer's passing was also mourned by Rubens. Elsheimer thus remains one of the very few German painters of the seventeenth century who might claim a place in the European canon. Though not often acknowledged as such, his art thus definitely speaks for a German contribution outside Germany.[26]

The peregrinations of Johann Liss, an artist of European rank who belongs to the next generation after Elsheimer, can also hardly be attributed to the war. Liss hailed from Holstein, but moved first to Holland probably *c.* 1620 and then on to Rome, where he became part of the colony of northern artists to which Elsheimer also belonged; indeed, in a drawing of the time Liss signed himself as a German from Holstein. Liss soon journeyed to Venice, where already in the early 1620s he must have decided that he had better opportunities than in the north, and thus stayed and worked. In recent years Liss has also attained a European status. His adoption of the local, painterly style in Venice can be seen as a contribution to the reinvigoration of the local tradition, and many later seicento and settecento painters gained inspiration from him.[27]

Mention of these figures points out that, if we are to consider the role of the Italians and Netherlanders in Germany, we must also pay attention to the

growing importance of Germans outside the area. Many well-known (and not so familiar) figures in the history of Dutch (northern Netherlandish) painting of the 'Golden Age' of the seventeenth century in fact came from Germany.[28] In England (and for a while in Antwerp) there worked such important figures as Wenzel Hollar and Godfrey Kneller, who both also came from Central Europe. All this suggests the intertwined fates of the arts at this time.

It is no doubt true that during the period of the Thirty Years' War proper some of these artists, and also major painters such as Sandrart and Johann Heinrich Schönfeld, may have chosen to work abroad in part because of unfavourable circumstances at home, but their experience can also be placed in a different, more international perspective. From the small town of Biberach, Schönfeld did choose to spend a long time in Italy, where he learned from Salvator Rosa, Bernardo Cavallino, Giovanni Benedetto Castiglione and other artists. From his experiences in the south Schönfeld picked up subject matter then current in Italian painting, which he was later to introduce into Central Europe. This includes pastoral and landscape scenes, often with Arcadian, that is Italian settings; religious and ancient histories, again with a distinctive Italian flavour, and Italianizing genre subjects.[29]

On the other hand, Sandrart's career does suggest something of the turmoil of the war, which his description, quoted above, reflects. Born in 1606, in the 1620s Sandrart had been a pupil in Prague of Aegidius Sadeler, Rudolf II's court engraver, and the last of the major artists of that circle to remain active there. Later in the 1620s Sandrart had worked in Utrecht as a pupil of the Dutch Caravaggist, Gerrit van Honthorst. In 1626–7 he was in England, where he met the famed portraitist, Sir Anthony Van Dyck, whose social pretensions, as well as style, one thinks may have influenced him. Thereafter Sandrart was in Italy from 1628 to 1635; there he came to know many important artists, among them Poussin and Claude, not to mention contemporary Italian painters. Sandrart was in Amsterdam from 1637 to 1642, at the height of Rembrandt's importance, but his negative reaction to Rembrandt, to be discussed further below, says something about his aesthetic attitudes.

Even if he had been attracted to travel abroad in part by the favourable opportunities available to artists, Sandrart's biography suggests that further motivations may have moved him. Sandrart's itinerary traces in reverse the paths of many artists who had come to Germany; the Low Countries and Italy also remained important as sources for inspiration for art in Central Europe. Sandrart's own teachers and models, Sadeler, the Rudolfine printmaker who had worked in Venice, Honthorst and Van Dyck, had all worked in Italy. In fact, not only Sandrart but many other architects and artists continued to take trips south for learning purposes. As in Sandrart's example, to be discussed further in the next chapter, this might lead not only to the assimilation of Italianate elements of form and content but to the ideas that lay behind them as well, for Sandrart later also wrote his own art treatises.

Furthermore, it must be recognized that this was a time when Italy exerted a tremendous attraction for artists all over the continent. Many important figures, including Rubens, Poussin and, from the other end of continent, Diego Velázquez, came for extended stays. Other outstanding figures in the history of art such as Claude Lorrain and Jusepe (José) de Ribera spent most of their careers in Italy. There were so many northern artists in Rome that they formed their own associations, among them the *Bentvueghels*, the 'birds of a feather' group of northern genre and landscape painters in Rome, to which many Germans also belonged. Yet we would not ascribe the reason for their presence there to the impact of the Thirty Years' War alone.

Sandrart himself spoke of the need for an artist to travel to Italy for his formation. One of the reasons why he praised the Bohemian Karel Škréta, whom we shall meet in the next chapter, was that he had imbibed Italian art at its source. In contrast Sandrart criticized Rembrandt, because the latter did not think such a journey was necessary.[30]

A comparison with what happened during this time to German music and literature again suggests itself. In music such figures as Schütz and Froberger also journeyed to Italy and profited from from what they learned from such major composers as Giovanni Gabrieli and Girolamo Frescobaldi. In letters this was also the period of the conscious formation of a German literature and poetics in dialogue with foreign languages and literatures.

During this period German literary societies were formed, starting with the *Fruchtbringende Gesellschaft* from Anhalt-Köthen. These societies were engrossed in the purification of the German language, hence the nourishing of a German literature and the creation of a German poetics. This last task began early in the century, with a publication of Martin Opitz in 1617, and continued with many mid-century writers. The societies were also involved in the adaptation of Italian, Spanish and French literary forms, such as the pastoral. In many ways, and more will be discussed in the next chapter, these activities may be compared to Sandrart's or Schönfeld's appropriation of foreign elements and assimilation of European artistic tendencies.[31]

But the most widespread example in which changed social circumstances can be related to changed artistic forms, and the eventual integration of Central Europe into a larger picture, was to be found in Poland. Many buildings were erected at this time. As in the Empire, the huge land mass of the Polish commonwealth displayed considerable regional differences during this period. As always social distinctions meant almost exclusively the upper echelons of the population, and thus castles, manors and, to a lesser extent in this period, town halls, where stylistic pluralism persisted.[32]

As noted in the last chapter, the Vasa court in Warsaw, where Sigismund III ruled as king until 1632 and Vladislav (Władyslaw) IV until 1648, was one of the major forces for a cosmopolitan approach to the arts. While Poland did not enter the Thirty Years' War, through religion as well as marriage contacts (Sigismund was the brother-in-law of Ferdinand II) the Polish Vasas,

themselves of Swedish ancestry, possessed inherent sympathies with the Habsburg court. At the beginning of the century Sigismund had been portrayed by the Rudolfine artist Heintz; the court's espousal of the Jesuits, and consequently of a directly Roman style, parallels what the Habsburgs did from the 1620s. Indeed the pure Roman facade of the Jesuit church in Kraków dating from 1622–30 is roughly contemporary with that in Prague. Elsewhere in Poland, in the Vasa burial chapel in the Wawel cathedral in Kraków, in chapels in the cathedral in Wilno (Vilnius, Lithuania), in the design of rooms in the Warsaw castle and in its Serlianesque plans for a castle in Ujazdów, the royal court rapidly assimilated high-quality Italianate designs. For other portraits, Sigismund relied on painters from the circle of Rubens.[33]

Under Vladislav IV French cultural influences also reached the royal court, but in architectural matters Italians such as the Lombard Constantino Tencalla and the Roman Agostino Locci retained royal patronage. The court also continued to use the arts for political purposes. Thus in 1644 Vladislav had a column honouring his father Sigismund placed before the royal castle at an important crossroads in Warsaw. The Sigismund column recalls similar ancient Roman prototypes, and it was built by contemporary Roman architects and Italian sculptors. It depicts the king in his coronation gown and crown, but showing him as a warrior in armour; he is portrayed as a defender of the faith, holding a cross in one hand and a sabre, the Polish weapon, in the other.

The differences between this sort of dynastic monument and the nearly contemporary columns erected to Mary by the courts in Munich and Vienna demonstrate the Polish situation. In Poland during the Vasa age art was frequently used for the purposes of political propaganda.[34] The Sigismund column seems to speak on the one hand to the universal, or at least European, pretensions of the Poles as defenders of the Christian faith and on the other hand to its national character, elements of an evolving topic whose explication we shall return to. As Poland was embroiled in the affairs of Russia, Catholicism confronted Orthodoxy, and it may be that there is some claim here to be the true opposition to the 'Third Rome' upstart. The possibility of employing monuments in this way, as visual statements, was indeed one with a wider resonance in a society whose national self-definition came increasingly at this time to be identified with the culture of its 'magnates'.

In the seventeenth century many magnates owned extensive tracts of land and established their own courts. They also sponsored not only the erection of their own residences but also ecclesiastical foundations, churches and monasteries. In so doing they followed the court in employing Italian architects and artisans and up-to-date designs. In these regards the history of art in seventeenth-century Poland recapitulates that of the previous century, in that international styles were adopted first by the court and then spread throughout the land. But the tone was somewhat different in the seventeenth century: after the Union of Lublin, the Polish commonwealth of Poland and

Lithuania incorporated a wide variety of peoples and religions, and the spread of cultural styles can consequently be seen as one of establishing national identity, especially the Polonization of the eastern territories. Inasmuch as many of the most powerful magnates had lands in the east, the adaptation of European fashions was thus both a means by which the whole commonwealth, including areas that had been more in the Orthodox world, came to share in similar values and one in which regional distinctions were homogenized by the shared artistic fashions, along with those of living in general.[35]

At this time the magnates assumed an ever more ostentatious style of living, much celebrated in accounts of Polish culture. Love of splendour and impressive show at all costs became *à la mode*. Not beauty for its own sake, or public utility, but the desire to demonstrate the high social position of the patron, and thereby to impress and attract members of the gentry (*szlachta*) into their service, were reasons for the scope of investment put into extensive and elaborate constructions.

Ultimately this kind of patronage may be regarded as an expression of the ideal of magnificence, that ancient concept revived by Renaissance humanism according to which a great man demonstrates his status through conspicuous expenditure on luxurious products. However, whereas activities related to these conceptions had earlier often been channelled by European courts into what might be regarded as expenditures on public projects or, at times, as in the later sixteenth century, also on private collections, now a main form of investment was in extensive building projects. And in their expansiveness the Polish developments, while matched, as shall be noted presently, by one significant example in Bohemia, depart from contemporary patterns in Western Europe (as at Venice or Amsterdam) and even anticipate later developments (such as Versailles) as well as many other Central European examples.[36]

Moreover, many of the designs put up for the magnates also relied on Italian designers. The forms that were adopted were often combined with regional characteristics and were even at times idiosyncratic. Thus for example the bishop's palace built at Kielce in 1637–41 and designed by Tomaso Poncino (and also Giovanni Trevano?) includes a loggia at its entrance and windows with broken pediments, and even has decorative obelisks in the latest Roman style: like the royal palace at Ujazdów, it also includes the high pitched roofs and corner towers often found in northern climes.

Extremely idiosyncratic designs also recur in Polish architecture at this time. In church architecture the elongated plan, peculiar massing of domes and even playful use of architectural orders in the church of Grodzisk Wielkopolski, built 1635–48 after designs by Cristoforo Bonadura, typify a sequence of imaginative, even mannered designs in the Poznan region. This tradition was carried on by other architects such as Jan Catenazzi in the next generation.[37] In the secular domain the castle of Krzysztopór built between 1627 and 1644 for Krzysztof Ossolinki, brother of the chancellor of Poland, is a comparable accomplishment. It combined fortress, castle and palace

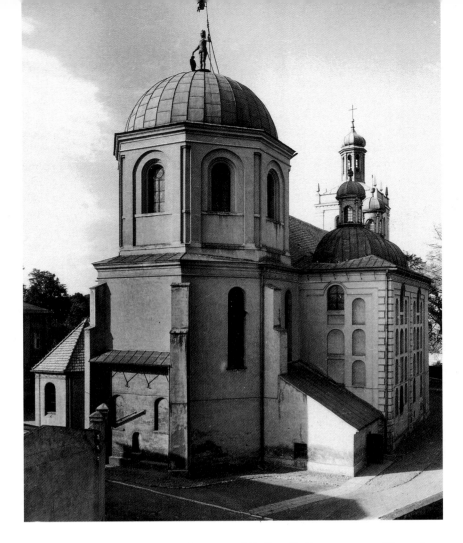

Parish Church, Grodzisk Wielkopolski,
1635-48, Cristoforo Bonadura the Elder

forms, and Italian Serlianesque motifs, such as window and door openings and an oval arcaded courtyard, with an arcane personal symbolism.

Perhaps the finest example of this type of *palazzo in fortezza*, which has been treated as the culmination of the 'decade of palaces' in Poland (the 1640s),[38] is encountered at Podhorce (now Pidgirce, in Ukraine). In this Koniecpolski castle, built 1635–40, an architectural concept of French origins comes to full bloom, combined with a symmetrical French garden: the transplantation of these designs now to lands even beyond the Dniester makes a statement about western influence. Where the layout of the whole and the ground plan for the palace itself, with side wings projecting from a central block, may be French-inspired, the elevations and decorative details are however not; the facade, at least in plan, even recalls one by Vicenzo Scamozzi, while the window designs seem Roman-inspired; the loggias placed on the

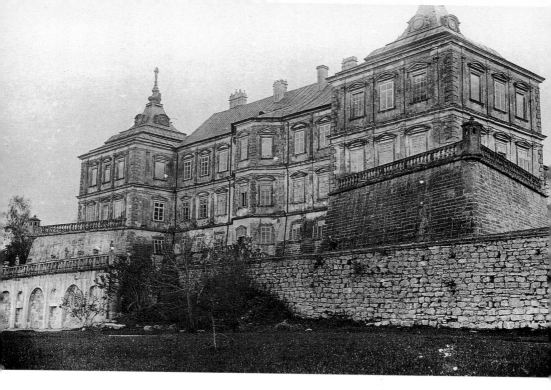

flanks of the entrance side are more
reminiscent of Tuscan prototypes; the
individual decorative elements, including
masks, shields and military paraphernalia,
the reversed guttae and the external finish also bespeak a more mannered
language. The still surviving interior portals also suggest a mannered architec-
ture. Many of these nobles had gained their dominating position relatively
recently, and the expansiveness of their plans can be related to their parvenu
status: a comparable situation can be found in the empire, where even the
architectural elements encountered are not so different.

Koniecpolski Castle, Podhorce (Pidgirce),
Ukraine, by Andrea dell'Agua and Guillaume
Le Vasseur de Beauplan, 1635-40, garden view

This brings us to the final topic of this chapter, to Bohemia, where, in the
person of Albrecht Wenzel Eusebius von Wallenstein (z Valdštejna,
1583–1634) a patron analogous to the Polish magnates is to be found. Wallen-
stein's patronage of the 1620s even antedates that of many of the other nobles
to the east, and his example had even more of an individual impact. More
important, his story elucidates the complicated interplay of the arts and
warfare in the time of the Thirty Years' War.

Wallenstein was a parvenu, who, to an even larger degree than the Polish
magnates, asserted his phenomenal increase in status with whatever artistic
means he could. Born in Zlín in Moravia, a member of what may be called
the local gentry or petty nobility, Wallenstein might be said to have been
a Moravian equivalent to the Polish *szlachta*. A Protestant, he went to
Altdorf, the academy (university) of Nuremberg, from which he was expelled;

politically and socially adept, he soon converted to Catholicism and married a wealthy older woman from established family, thus founding his fortunes. Wallenstein also picked the winning side in the 1620s, the Habsburg and orthodox Catholic party. By his successful economic management, he organized model estates, enabling him to keep armies in the field. For a while he thereby made himself indispensable to the imperial cause, gaining many honours, including a dukedom and lands, until his fall and assassination in 1634.

Along with other Moravian magnates, such as the Dietrichsteins and the Liechtensteins, who also backed the imperial side, Wallenstein thus became one of the great profiteers from the confiscation and sale of goods and lands in Bohemia after the battle of the White Mountain in the 1620s. While the Liechtensteins and Dietrichsteins increased their holdings in Moravia, Wallenstein obtained huge tracts in north-eastern and eastern Bohemia around Jičín (Gitschin), Mnichovo Hradiště and Frýdlant (Friedland), Duchcov in the north-west, and eventually Sagan (Zagań) in Silesia. During the 1620s and 1630s the other aspiring noble houses in Moravia sponsored building there: the Dietrichsteins built residences in Brno and on their site of Nikolsburg (Mikulov), and the Liechtensteins' churches and palaces in Vranov near Brno, and especially in Valtice (Feldsberg) and Lednice (Eisgrub) on the present Austrian border.

But Wallenstein, who in employing Kepler as his astrologer also continued the local patronage of scientists (although Kepler supplied him with horoscopes), engaged in an extensive patronage of the arts that was earlier, more innovatory, more interesting and more important. An *arriviste*, Wallenstein seems to have felt all the more the need for splendid appearances. He had built what remains the largest single palace (as distinct from the Hradčany conglomeration) in Prague, a huge estate, with stables and a garden that is set right in the midst of the Malá Strana of the capital, in place of numerous houses that he acquired from 1621, the year in which the architect Andrea Spezza commenced work for him, to 1623. The product of Spezza's collaboration with the Florentine Giovanni Pieroni and Nicolo Sebregondi, the palace subsequently designed was not only immense, but could be considered up to date in Italy.

Aspects of the interior are even more remarkable for both the style and content of its decoration. The *sala grande*, the main reception room, in the *piano nobile* (first floor above ground) in the centre of the palace contains fine stucco figures by Santino Bossi and possibly the Florentine Baccio del Bianco. Baccio's fresco in the ceiling of *c.* 1623–5 combines motifs from Roman frescoes, Guercino's and Guido Reni's versions of *Aurora*, but, instead of depicting the goddess of dawn, it shows a subject more fitting to the patron and the time, the god of war, Mars, in his chariot. Since Guercino's work dates from 1621–3, and Reni's from 1615, Baccio's painting is extremely modish in terms of visual style: indeed it may be considered the first sign of Italian

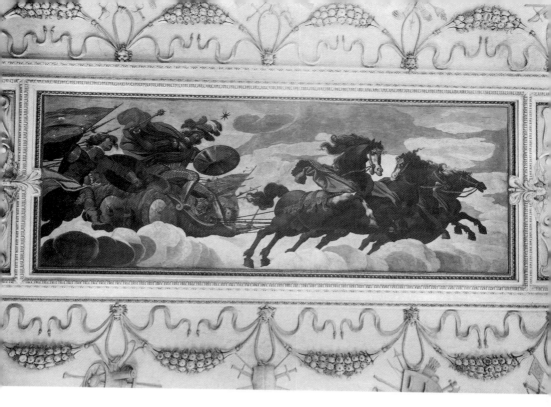

baroque painting of this sort to be executed by an Italian in the north. Moreover, Mars clearly resembles Wallenstein. This painting may thus be considered one of the first examples in the north of what has been called the 'secular apotheosis', the personification of a ruler as a divine figure, in this instance a general. As such it is comparable to the extensive, roughly contemporary cycle of paintings that were executed by Rubens to glorify Marie de Médicis.[39]

Frescoes and interior stucco decoration, detail, ceiling of *sala grande*, c. 1625-8, Santino Bossi and Bartolommeo Baccio del Bianco, in the Wallenstein Palace, Prague, begun 1623 by Andrea Spezza, completed by Giovanni Pieroni and Nicolo Sebregondi

If the imagery in the *sala grande* celebrating Wallenstein assumes the role that had been found in the region with Habsburg iconography, the decoration of the Wallenstein palace chapel – itself an amazing, centrally planned squarish space, which compressed on the ground seems to escape by extending upward for three storeys – is related instead to an older Jagellonian type, in particular the cycle in St Veit's Cathedral in Prague of the life of St Wenzel (Václav), who was also Wallenstein's name saint. Remarkably the imagery of this early chapel is taken a step further by Wallenstein. Where in St Veit's members of the Jagellonian court are shown as present at events in the life of the saint, thereby associating themselves with the Bohemian past, Wallenstein appears as the national saint himself in the painting by Baccio, which is itself at the centre of a noteworthy altarpiece carved by the former imperial court sculptor Ernest Heidelberger, with extremely elongated angels.

To cap things off, the palace contains a so-called astrological corridor, with elements, planets and signs of the zodiac, in which Wallenstein again appears as Mars. It seems that we can look back to the Hradčany for a prototype that may help explain other aspects of this hitherto-unexplained decoration: namely Vredemann de Vries's cosmological *entrée* to the imperial collections, where a similar decoration in the so-called astrological corridor is found. Together with architectural details, iconography and the employment of individual artists, this is one of many instances of Wallenstein's assumption of the Rudolfine mantle.

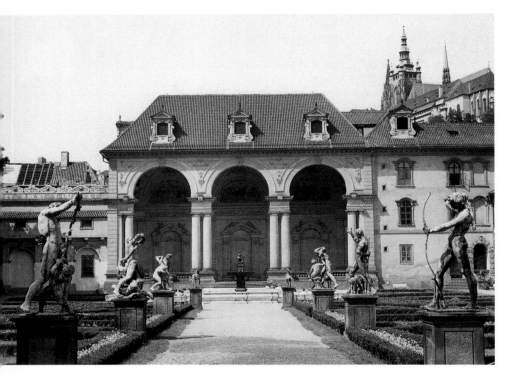

Garden of Wallenstein Palace, Malá Strana, Prague, with copies of sculpture, 1620s, by Adriaen de Vries (originals now in Drottningholm, Sweden)

The ties to the past were also evident in the gardens attached to the palace. There many of the bronze sculptures by the Rudolfine court artist, Adriaen de Vries, had mythological themes, including Herculean messages. Since, as in much earlier royal, and particularly Habsburgean, imagery, Hercules is regarded as an ancestor or personification of the ruler, it is possible that some sort of association is also being made for Wallenstein, here to be seen as a *Hercules Bohemicus*. Similarly a statue of Neptune may embody Wallenstein in one of his new appointments, as admiral of the Baltic fleet. This imagery may be continued in the extraordinary loggia in the garden, one of the first of its

kind in Central Europe, a building that could also have been placed in Italy. This loggia was decorated with stuccoes with naval and military motifs by Baccio, and frescoes of ancient heroes, including Aeneas and Odysseus, suggesting other identifications for the generalissimo.

The exceptional plan of the palace complex also extends to monumental stables and a riding school. These are elements with precedents in Central Europe in the Renaissance, but again they are transformed by Wallenstein. Moreover such elements had not been seen before in Prague, or the Bohemian (or even Austrian) lands, where they begin a tradition that leads to the work of Fischer von Erlach at the end of the century.

Wallenstein's spectacular patronage did not stop with his Prague residence. He also established a residence in Jičín, which he made into a capital, as it were, for his newly granted (1627) Duchy of Frýdlant/Friedland. There, in the tradition of the magnates of the sixteenth century, he started the rebuilding of the city. It seems that his governing conception was to have an appropriately grand capital, not merely a palace, for a new duchy (or kingdom?), with extensive ecclesiastical institutions that may suggest that Wallenstein's desire was to make this small town into a bishopric. And so Nicolo Sebregondi and Andrea Spezza built the parish church of St James, a remarkable, centrally planned church with a square ground plan, over which a cupola sits on four flat, barrel-vaulted arms, with details and elements that recall Palladio. Wallenstein also rebuilt and expanded the adjacent palace, again creating a huge expanse on the town square, and he had the square itself regularized. He called in religious orders, the Jesuits and Carthusians. Both these orders had churches erected in a new international, classicizing style.

From Jičín a tree-lined road led to a *villina*, or a small villa, in Valdice; this concept of employing tree-lined alleys to connect residences precedes anything comparable in Italy. At the end of the route there stood a loggia, with a view, a work resembling in form that found in Prague. The Valdice loggia, however, became an oversized version of this form. It is thus an early example of what might be called gigantism in architecture. As such it seems to offer a fitting conclusion to a discussion of Wallenstein's patronage, for it seems to symbolise the direction in which he was heading.[40]

The contrast of the decoration of imperial Rudolf II's and Wallenstein's palace is instructive about the change in direction, in attitude, that is incorporated in such designs. At times some doubt has been cast on the interpretation of Rudolfine allegory and collecting as expressive of imperial majesty, because these messages seem to be indirect, or executed in small scale, or for a limited audience, even for the emperor himself. But Rudolf II's patronage should not be judged by the standards of a different age, including that stamped by Wallenstein. Works made for Wallenstein represent a meaningful reception of lessons learned from the Rudolfine era, and hence the consequent application of these lessons to different circumstances. The small scale and allusiveness of Rudolfine imagery, much like the apparent seclusion and seeming absence of

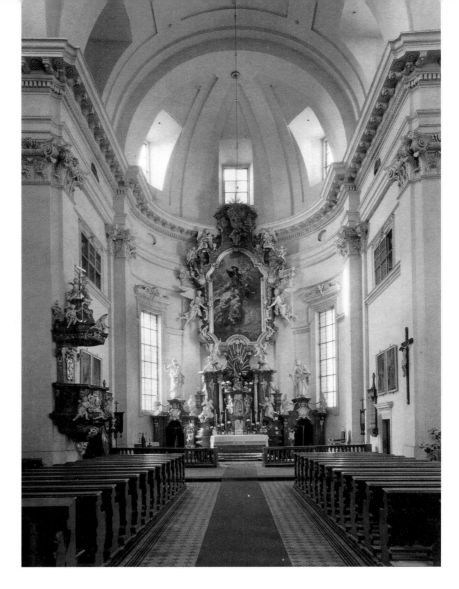

St James' Church (St Jakobskirche),
begun *c.* 1627, Jičín, by Giovanni Pieroni,
Andrea Spezza and Nicolo Sebregondi

triumphalist decoration in the rooms housing
the imperial collections, do not necessarily
indicate that the Rudolfine art and collecting
were lacking in representational messages.
Rudolf's collections and imperial iconography were directed to at most a small
coterie of *cognoscenti*, and even possibly to the ruler himself. In the world
around 1600, a small group of rulers and their advisers were after all all those
who counted, and those who were in the know could have got the message. A
wider public did not matter.[41]

By the time of the Thirty Years' War the situation had obviously changed,
and changed quite drastically. With the struggle in the empire, even imperial

authority had been called into question. The patronage of Wallenstein, overblown in every way, was a response to this changed situation. His own titles were newly created, and his position often insecure. Wallenstein's transformation of earlier elements from the Rudolfine era into the grandiose, his transfiguration of earlier metaphors of rule, including his own self-glorification in more blatant imagery, suggest what is at stake in that culture that has often been called 'baroque' – and, as observed, some paintings done for him specifically invoke the imagery created by masters active in seicento Rome. Here, more than ever, the term 'baroque' does seem justified: in Wallenstein's commissions sheer size and grandeur become metaphors of power itself.

A tone was set for the next generation of patrons of the later seventeenth century in Bohemia. The next group of patrons also consisted in part of parvenu aristocrats, newly ennobled generals. Some of them, such as Rombaldo Collalto, in his plans of 1641 for a church and castle at Brtnice in Moravia, actually employed architects such as Pieroni; others such as Piccolomini followed the example of Wallenstein's taste for newer forms in the stuccoed chapel built 1654–8 by Carlo Lurago at Nachod in northern Bohemia. But the broader example of the shift to grandeur seems to hold. If it is not the direct model for slightly later designs, Wallenstein's patronage certainly seems to parallel the construction of buildings planned but not completed during the war such as the large castles at Weimar (by Giovanni Bonalino, c. 1630, completed 1650) or Gotha (Schloss Friedenstein by Andreas Rudolff and others, planned from 1640, completed 1654). Certainly it provided an impetus for work in Bohemia. One conclusion of the re-examination of the relationship of art to the Thirty Years' War is that an ambitious general promoted an important artistic change; and on this foundation, in the realm of secular and sacred art, the way was prepared for much of what was to come in the art of the later seventeenth century in Bohemia, and analogously throughout Central Europe.

ART AND ARCHITECTURE AFTER THE
THIRTY YEARS' WAR

Portrait of Marie Maxmiliana of
Sternberg (1665) by Karel Škréta
(c. 1610-74), Národní Galerie, Prague

SANDRART'S *TEUTSCHE ACADEMIE* CONTAINS A DESCRIPTION OF THE
DESTRUCTION WROUGHT BY THE THIRTY YEARS' WAR; IT ALSO GIVES
AN ACCOUNT OF THE RECOVERY OF THE ARTS SOON THEREAFTER. While
the text presented in his history speaks of the author himself as the agent in
question, it claims that:

> *Gracious Fate took pity on this darkness, and allowed a new sun to rise in
> the German world of art, that woke again the sleeping Lady Pictura
> (Dame Painting), drove away the night, and made the day break ... as a
> consequence ... in these parts the art of painting is now again loved,
> admired, honoured and richly rewarded.*[1]

But the year 1648, when the Thirty Years' War was formally ended, brought
change in different ways to the Holy Roman Empire and to the kingdom of
Poland. While peace treaties were being negotiated in Westphalia in Germany,
Jan Kazimierz, the last of the Vasa dynasty to rule in Poland, ascended the
throne. Not only did marauding soldiers in fact continue to disturb some areas
of Germany until the early 1650s, but many of the same troubles that had
afflicted Germany and Bohemia struck Poland.

After warring in Germany, Swedish armies, who had fought in Poland
earlier in the century, again invaded. Cossacks rose up in the Ukraine, ravaging
towns and cloisters. The turmoil in Poland ended only after 1669, when the
eastern Ukraine had already been lost to Muscovy and Michael Wiśniowiecki,
a fainéant monarch of whom it is said that he could speak many languages and

say nothing of significance in any of them, was elected king. As a result of conflicts in Poland, it is estimated that the population of Mazovia (the part of Poland around Warsaw) declined by 64 per cent in the seventeenth century. It was in fact only with the accession of the *hetman* (army commander) Jan Sobieski in 1674, the year after he had won a great victory at the second battle of Chocim over the Turks, who had also again been on the move westward in Hungary, that Poland was freed from threats from that quarter.[2] Only then could the arts, which had reached such a high point during the 1640s, again truly flourish in Poland; their subject remains for the next chapter.

Sandrart's description thus applies better to the German and Bohemian lands, where during the third quarter of the seventeenth century circumstances also varied widely. Just as different places were affected by war, famine and disease at different times during the Thirty Years' War, so subsequently signs of recovery were sporadic and diverse. In the process of renewal tendencies leading toward artistic innovation, that may be defined in part as involving the ongoing assimilation of stylistic norms and cultural values from other parts of Europe, appeared alongside the reinvigoration of traditional artistic forms and practices, which might in contrast be described as signs of artistic conservatism. As is so often the case in the region, cosmopolitanism was thus ranged against centripetal regionalism, reassertion of local identity against accommodation to international currents of culture and taste.

As before, artistic developments formed one skein in a complex social and cultural tapestry. Indeed the arts parallel what may be observed in other strands of 'higher' culture, among them aspects of intellectual life. Perhaps in response to uncertainties of the time, the universities of the later seventeenth century are marked by what may be described as a kind of intellectual conservatism. Before the late seventeenth century, the great period of Thomasius and Leibniz, before that 'crisis of European conscience' of *c.* 1685 long ago described with these words by Paul Hazard,[3] German universities underwent a period of restitution and retention, a traditional holding pattern that is comparable to certain aspects of the art of the time. But another older interpretation has been challenged, that values the end of the century, when the pace of innovation in the life of German universities accelerated with events such as the establishment of the university of Halle in 1694. The antecedent period *c.* 1650–85 also had its accomplishments, especially in law and philosophy, and it can be argued that during this time the foundations were established for the important intellectual achievements of the eighteenth century.[4]

This was indeed the period of Leibniz's youth, when his later accomplishments were in a way prefigured. Although their writings often were constrained by, or responded to, the specific social circumstances in which they found themselves, many scholars of this era strove for larger intellectual accomplishments. Universal figure that he was, Leibniz can be related to the tradition of Central European encyclopedism. This was represented by

polyhistors such as D. G. Morhof, who tried to encompass all of learning in their books. Leibniz himself was trained as a lawyer, and his later writings on the subject can also be seen as a working out of issues adumbrated in the third quarter of the century. At this time Samuel Pufendorf (1632–94) reformulated notions of civil and natural law in his *Duty of Man and Citizen* (1673) and *The Law of Nature and Nations* (1672). Poetry and other forms of literature, to which we shall return, also flourished. Intellectual life at this time could thus be characterized as a revaluation of tradition.[5] Much the same could be said for the visual arts.

Artistic developments may also obviously be related to other economic and social considerations. While peace undoubtedly brought many benefits, the notion must be tempered that peace brought a lasting upturn in the economic cycle, which allowed for a recovery of the arts and more generally of culture in Germany. The recovery of German cities in the 1650s and early 1660s seems to have been short-lived. Although the subject has not been thoroughly investigated for the entire region, microhistories suggest that the economic recovery that occurred after the Thirty Years' War was arrested.[6] The French re-initiated military campaigning in western Germany in the 1670s and 1680s, as the Turks had done already in the 1660s in Hungary and Austria. The forced emigration of Protestants from many Catholic areas also had a devastating effect especially on crafts and commerce. The general pattern may therefore rather have been one of irregular upward deviations within a longer curve of economic decline.

And yet conditions that led to decline for some classes in some areas were favourable for others. Social and economic conditions east of the Elbe, and especially further east beyond the Bug, provided the basis for new sources of wealth for other sectors of society. Changing circumstances did create conditions that allowed for extensive patronage, as discussion of the Polish magnate culture has suggested, and also in some significant instances for the collecting of art. Large latifundia were established in some of those regions, not just in Poland, including those that had been devastated or depopulated by war: this was a development repeated later in the century after the Turkish incursions into Lower Austria. Accumulation of large estates was also made possible by the reversion to older forms of owner-tenant relationships and the abolition of peasants' freedom, occurring in Hungary in 1608, in Courland in 1632, in (East) Prussia in 1633, in Mecklenburg (and Muscovy) in 1649 and in Brandenburg in 1654. At this point in history the familiar distinction of forms of land tenure between the lands east and west of the Elbe was in effect established, with serfdom or forced labour on land to be found in the east. Moreover, as the domains of aristocrats expanded at the expense of peasants, the area under arable cultivation declined, with the result that the land was further devastated and depopulated in some places.

What may have been disastrous in the longer term, especially for the labouring groups – the creation of large estates of land in the empire as they

had already existed in Poland, both by secular personages (aristocrats and princes) and by the religious orders – supplied a basis for the renewal of building activity and other signs of artistic revival in the German and Bohemian lands. Large new palaces were built, monasteries were founded and old ones refurbished, especially in regions such as Bohemia, Moravia and Silesia, where, as earlier in Austria, a process of re-Catholicization was continued. Both in these areas and in the alpine lands older abbeys were renovated or restored, and new churches were founded.

While we have argued that the war and related devastation did not terminate cultural life in Central Europe, they may very well have finally put an end to the comparable importance of the smaller free towns for patronage and production. Artists and artisans came to be centred in larger cities like Augsburg, where craft traditions and the workshops that sustained them had been maintained and where, as will be explained, new academies were founded. Although this system of symbiosis really became more evident in the eighteenth century, the vitality of these centres and for that matter of the smaller surviving sites, was however henceforth more than ever dependent on extra-urban commissions, often from nobles and monasteries. Similar circumstances pertained in the world of learning as well, wherein the *Ritterakademien* (schools for the upper estates) and court-employed literati or intellectuals vied with the older universities.[7]

It might thus be better argued that the mid-seventeenth century, not the mid-sixteenth, represents a true watershed in the history of the visual arts for the German towns. The courts and cloisters had always played a role in artistic patronage, but now the scale of their endeavours, as well as that of aristocrats, came largely to eclipse that of the independent towns. In place of the sort of patronage of the late fifteenth and early sixteenth centuries that had frequently flowed from the urban patriciate, in Germany as elsewhere the Church, in the form of the parishes of the, now, older orders, as well as the newer ones like the Jesuits, joined aristocrats and princes in assuming a predominant position.[8]

This is not to say that artistic production was absent in smaller sites, to which this chapter turns first before proceeding to consider the cities, cloisters and courts. In many smaller places from the mid-seventeenth century local traditions were revivified, at times by newer religious movements and newer formal elements were often assimilated onto old stock. But these sites were reduced to the periphery, especially in mountainous regions, and to the south of the region. In these areas workshops had been kept alive through family tradition. This process occurred both in Catholic and Protestant areas, in the latter case, for instance, in the towns of the Erzgebirge (Ore Mountains) region near the Elbe, where the Walther, Heermann and Böhme families kept going throughout the seventeenth century.[9] Furthermore the tension between popular and sophisticated aspects of visual language that is often found in Central Europe took on a new meaning at this time.

The demand for ecclesiastical furnishings continued in the alpine lands, in electoral Bavaria, in Upper Austria, in the Tyrol and especially in the unscathed territories of the

Angel from altarpiece, 1683-6, by Michael Zürn the Younger (1654-98), Kremsmünster, Benedictine Abbey Church

archbishop of Salzburg and other such places where Catholicism had never died out or where the older cult was reimposed, as in Upper and Lower Austria or the Czech lands. Workshops of sculptors could thus remain active for parish, pilgrimage and cloister churches. Among them were the Zürns, who had hailed initially from Swabia, and remained active as sculptors through four generations. They made sculpture in an area from Swabia to Moravia.[10]

Rosary Altar (*Rosenkranzaltar*), 1706, by Meinrad Guggenbichler, Pilgrimage Church, St Wolfgang am Abersee

Detail, Holy Family, from Double Altar, 1675-6, by Thomas Schwanthaler (1634-1705), Pilgrimage Church, St Wolfgang am Abersee

Starting with Thomas Schwanthaler (1634–1705) in this period, the Schwanthalers similarly carried on working in Bavaria and Upper Austria for five generations, well into the nineteenth century. Other noteworthy sculptors of the late seventeenth and early eighteenth century such as Meinrad Guggenbichler (1634–1705) and Andreas Thamasch (1639–97) may be associated with the Schwanthaler workshop.[11]

The location of works by these alpine and sub-alpine regions itself suggests something of their attachment to local tradition. In Upper Austria movemented figures in stone by Michael Zürn the Younger (1654–98) adorn the church of Kremsmünster, an ancient Benedictine abbey. Another Benedictine abbey, Mondsee, is filled with works in wood by Guggenbichler, while the Cistercian convent of Stams was bedecked with works by Thamasch. Other major altarpieces by Thomas Schwanthaler and Guggenbichler are found in St Wolfgang am Abersee, the pilgrimage church where the great Pacher altarpiece

was located. The appearance of new altarpieces in traditional pilgrimage sites like St Wolfgang further indicates something of the connection between these new works and the revivification of popular or local religion.

The rekindling of pilgrimages and the attendant adoration of saints, especially in the countryside, can also obviously be regarded as an expression of the vigorous activity of the Roman church in these regions, one aspect of a turn in direction of the Catholic Reformation in the seventeenth century. It seems no accident that Upper Austria, Salzburg and, to a degree also, the Tyrol were regions in which until most recently large numbers of Protestants had been present (Protestants were expelled from Salzburg as late as 1731). At a time when warfare had demonstrated the stakes inherent in religious questions and theological debates were raging, the making of religious images had become more than simply a traditional task for artists. The construction of altarpieces, of tabernacles and of other devotional images may be

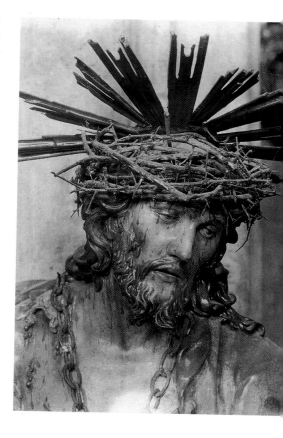

Detail, head, *Man of Sorrows*, c. 1706 by Meinrad Guggenbichler (1649-1723), Pilgrimage Church, St Wolfgang am Abersee

regarded as conforming to or fulfilling several doctrines decreed by the Council of Trent. Most obviously, veneration of the sacrament demanded worthy housing for the consecrated host. The conspicuous presence of saints in many of these works can also be seen as a response to the Protestant opposition to the cult of saints.

The reaffirmation or reassertion of tradition was a process that could involve both patron and artist. Works were made in limewood, often polychrome, by the Schwanthaler, Guggenbichler and Thamasch workshops: this is, needless to say, a traditional medium of the region. While not much can be made about intentional use of medium, it can be seen that artists demonstrated their own respect for local traditions. For example, instead of destroying or removing Pacher's altarpiece from St Wolfgang, as he was ordered to do and as so often occurred when churches were 'modernized'

during the seventeenth and eighteenth centuries, Thomas Schwanthaler made place for it and situated his own works elsewhere in the church.

For all their conservatism and attachment to tradition, these new altarpieces could at the same time respond to contemporary changes in taste. Consequently, newer elements might be assimilated into older forms: and so the work of Jean Delcoeur, a classicizing Flemish sculptor of the sort increasingly to be encountered at contemporary courts, provided a source for Schwanthaler's double altarpiece in St Wolfgang. On the other hand, the memorable increased pathos of many of these works in the alpine regions, the way they employ subtle carving and polychromy to increase the verism of visual effects, corresponds to a European-wide movement. Though most conspicuous perhaps in works of a slightly later date, such as Guggenbichler's bloody *Man of Sorrows* of *c.* 1706 in St Wolfgang, they recall the close attention to natural detail, including emphasis on gruesome particulars, found in sculpture from another part of Europe. The works of these Austrian (and German) sculptors of the later seventeenth and early eighteenth centuries recall namely the Spanish tradition of the seventeenth century, starting with Juan Martíñez Montanes and exemplified in the works of Pedro de Mena, Juan de Mesa and others.

There are however parallels for this form of expressive naturalism to be found in other aspects of contemporary Central European culture, including painting. Beside its counterparts in the visual arts, extremely naturalistic tendencies in polychrome sculpture may be compared to what has been regarded as the extreme visualization of baroque drama, not only works written by Protestants, but more pertinently the drama of the Jesuit schools. Dramatic presentations became a standard part of the school curriculum. Plays like Jacob Biedermann's *Cenodoxus* may be regarded as comparable cultural productions, in that they used all mimetic means possible to move their audience: masses of converts were said to have been gained by the visual effects – the imagery of hell and its torments – of such plays as Biedermann's. Extremely long, such plays were also full of baroque *Schwulst* (bombast). What however seems to have moved audiences then is often what attracts people to films now, the special effects. The sermons of preachers such as Abraham à Santa Clara with their combination of exhortation, wordplay and seeming buffoonery are also comparable to this theatrical mode. In general, the elaboration of ritual and dramatic sermons can also be said to have visual counterparts in the ecclesiastical surroundings that were also designed to move an audience.

The development of a theatrical quality in south German and Austrian altarpieces, to be seen in works well into the eighteenth century, may be compared to other aspects of their visual organization. The saints on these altarpieces often interact with each other or are linked by gesture as well as conception with the painting, which frequently occupies the centre of the ensemble. The placement of a painting as the central object of veneration is an

important element of the seventeenth-century winged retable: in these altarpieces sculpture is mixed with and often flanks one or more central painted easels. Although Italian Renaissance artists also relied on the response of the beholder,[12] this kind of interactive mixture of the arts within one work, as opposed to their rather static juxtaposition or separation often found in the sixteenth-century retable, may be compared to that combination that we associate with the *bel composto* (beautiful composition) of Bernini at this time. This was a kind of composition that frequently appears during the next period of the arts in Central Europe.

For all their newer elements, the more popular or demotic side to art in Central Europe may nevertheless be considered not only retrospective but also, in comparison with stylistic transformation found in works elsewhere in the region, even somewhat retrograde. In any event, the more removed locations in which they appeared were not the sites of the major innovations, formal, intellectual and institutional, that also began to occur in the visual arts, as in other aspects of culture in Central Europe at this time. Rather, these were located in the imperial free cities and also the princely and magnate residences.

In this respect the return to Germany of its two most important mid-seventeenth century painters, Joachim von Sandrart, in the mid-1640s, and Johann Heinrich Schönfeld, in 1651, may be taken as signifying the onset of artistic recovery. The careers of these artists epitomize the fate of German art. During the time of the Thirty Years' War both had been abroad; upon their return they settled or became deeply immersed in the artistic activities of the two major south German 'metropolises', Augsburg and Nuremberg, whither they conveyed the formal and thematic innovations they had learned in Italy and the Netherlands. And they also were directly involved in intellectual and institutional changes.

Through their personal example, as well as their activity as teachers, Sandrart and particularly Schönfeld introduced to Germany the latest forms of seicento history painting in both its classicising and elegiac aspects, while Sandrart also excelled as a portraitist. Both thereby had a decisive impact on the re-inscription of German painting into the broader history of European painting. Although Sandrart's personal influence in Nuremberg seems to have been limited to the formation of portraitists such as Matthäus Merian the Younger, son of the noted graphic artist and brother of the nature painter Maria Sibylla, and to some extent his follower as academy director Daniel Preissler, the founder of another dynasty of artists, Schönfeld singularly redirected the course of painting in Augsburg.[13]

Equally important, Sandrart and Schönfeld also re-established the pattern whereby Augsburg especially became a centre for production to serve ecclesiastical and aristocratic patrons throughout the south German area, a pattern which continued on through the work of Matthäus Günther (died 1788) in the later eighteenth century. In the mid-1640s Sandrart had sent his celebrated suite of pictures of the twelve months from the Netherlands to Duke

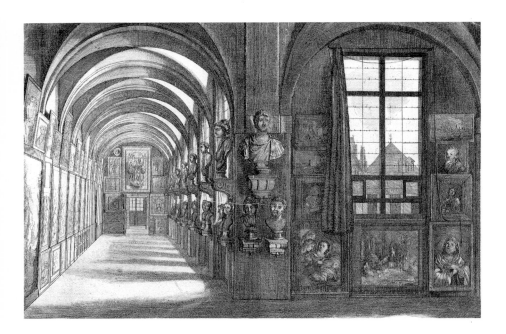

View of Leopold Wilhelm's collection in the Stallburg, by Franz van de Steen, engraving after Niclas van Hoy, c. 1659

Maximilian in Bavaria, and once in Nuremberg in *c.* 1650 he became absorbed in the ceremonies and public celebrations for the end of war, in connection with which he portrayed many participants. Whereas in 1648 Sandrart also supplied an altarpiece for Archduke Leopold Wilhelm, Schönfeld later painted a series of pictures with religious subjects for Karl von Liechtenstein, bishop of Olomouc (Olmütz).

Thus Sandrart and Schönfeld were not only active, at times in conjunction, in supplying works for many of the cloisters, cathedrals and castles in the area but also were implicated in another phenomenon of cultural importance. The Olomouc (Olmütz) archbishop and the Habsburg archduke participated in another aspect of cultural renewal (just as Maximilian I of Bavaria represents its late survival), that of collecting on a large scale. Several other Bohemian and Moravian magnate families, including most noticeably the Černín (Czernin) and Nostic (Nostitz), also established important collections at this time.[14] For his new residence in Kroměříž (Kremsier) the Moravian primate Liechtenstein (no relation to the better known Vaduz branch) accumulated a group of paintings of European fame, containing masterpieces by Titian (*The Flaying of Marsyas*), Van Dyck and other masters, that are still *in situ*.

Like Liechtenstein, Leopold Wilhelm also regained works for the Habsburg collections, as he carried out his activities as stateholder: starting in the Netherlands where he re-acquired works by artists such as Pieter Bruegel that had come from Rudolf II's collection, he then re-established some of the

collection in the Prague Hradčany, which in 1648 had been sacked by the Swedes; finally he settled a collection in the Stallburg in Vienna, where Maximilian II's collection had been installed a century before, and commissioned David Teniers to illustrate it in paint and print; all this suggests a renewal of past activity.

Sandrart, moreover, was not only an important painter, called the German Apelles, he also put German painting on another institutional plane, by establishing the first German academies of art, in both Augsburg and Nuremberg. Although the exact conditions of their foundations are uncertain, these academies were established by their city governments a short while after his initiatives. They also seem to have been emulated by private academies, of the sort depicted in several paintings by Johann Heiss. And they parallel the establishment of *Ritterakademien*, at which drawing was also taught.

Sandrart's academy did not only involve practical instruction, to fulfil a need which he so vividly articulated in his writings; it was also intended to set up a theoretical and technical foundation related to an Italian model that he had known. The establishment of these institutions can be closely related to the work whose title well expresses their aim, and may be read as its written equivalent: the *Teutsche Academie* of 1675–8. This book is similar to the literary productions of other artist-historians, like Giorgio Vasari in Italy or Karel van Mander in the Low Countries. As such it contains lives of the artists; it is the first complete German-language art history. In giving its profession a history, it thereby also serves the practical end of establishing a canon of models to emulate. Moreover, like Vasari's *Vite*, it includes a technical discussion and, like Vasari and Van Mander, contains theoretical sections, thus placing the visual arts on a firmer intellectual basis. Again like Van Mander, it contains a translation of Ovid's *Metamorphoses* and thus gives sources for artists, to enable them to have the necessary familiarity with one of the standard subject matters of European painting, mythology. Finally it includes a description of ancient ruins. Its net effect is to provide both a theoretical and practical basis for German art, and one that was to reverberate in the future: for within a hundred years the first European history of architecture, the first history of art *per se*, independent art criticism and philosophical aesthetics were to appear in German.

In this way Sandrart's accomplishment is again also comparable to the contemporary assimilation of European genres, types and modes in German literature, and its approximation to the antique. Sandrart's connection with literature is immediately apparent. He was both a writer and associated with literati from at least his time in the Netherlands, when the great poet Joost van den Vondel celebrated his paintings of the *Months*. G. P. Harsdörffer, a contemporary German writer in Nuremberg at the centre of the local literary circle, designed programmes for ceremonies as well as emblems for paintings that Sandrart executed in *c.* 1650; to Harsdörffer is also attributed Sandrart's biography, quoted above, on p. 257.

It is noteworthy, too, that the writers with whom Sandrart associated in Germany participated in the creation of poetic (*Dichter*-) and linguistic (*Sprach*-) societies (*Gesellschaften*), mentioned in the last chapter. Their efforts obviously reveal a consciousness of literary questions of style. They simultaneously created a theoretical basis for German literature, just as he did. Like the literary societies, Sandrart's activity can thus be related to a general movement to bring culture in the German language into parity with the rest of Europe.[15] Sandrart and the literati anticipated what was later to be called the 'German patriotic movement'. This included such matters as Philip Von Zesen's efforts to purify the German language, Von Zesen's and Leibniz's efforts to found a *deutsch gesinnte Gesellschaft* (German-orientated society), the attempt to found a German-speaking opera and the introduction of German as a language for academic instruction, initiated by Thomasius in 1687–8 at Leipzig and then at Halle.[16]

Moreover, the literary societies adopted emblematic references for themselves. Even before Sandrart, several of their members were connected with the arts: for example Martin Opitz sang the praises of the Silesian artist Bartholomäus Strobel.[17] This reminds us that during the seventeenth century Silesia had also long been a flourishing centre of literature, from Opitz through the poet and playwright Andreas Gryphius and the poet Angelus Silesius to the dramaturge Daniel Caspar von Lohenstein.

However, leading Silesian painters such as Strobel spent most of their careers in Poland. Only in the 1650s did significant developments occur in the visual arts in Silesia; and then the most outstanding works of the decade are probably more remarkable for the scale of their carpentry than for their architectural design. These are the so-called Peace Churches on what were then the outskirts of Głogów (Glogau), Jawór (Jauer), and Świdnica (Schweidnitz), huge half-timbered structures built of necessity in this material as houses of worship for Protestants, who were forbidden to build their churches within city limits in stone.

In Silesia, a renewal of painting was effected only a few years later, after 1660, with the arrival of Michael Willmann. A native of East Prussia, Willmann, like many other German artists, had passed through Amsterdam in *c.* 1650, where he had learned from Jacob Backer. Willmann had also absorbed many of the painterly innovations of Rembrandt, Rubens, Ruisdael and Van Dyck. After staying in Prague, where the collections also left traces in his later *oeuvre*, and briefly, probably, at the court of the Great Elector in Berlin, he moved for good to Silesia.[18]

It is significant that guild restrictions would not allow the independent Willmann to work in the Silesian metropolis Wrocław (Breslau), so that, in contrast to the situation in Germany, where important painters' workshops were located in cities, it was directly for the rivals of these structures that Willmann found work. From 1660 he was taken in by the Cistercian abbey at Lubiąż (Leubus) and worked for them and for their sister establishments in

Henryków (Heinrichau) and particularly Krzeszów (Grüssau). These abbeys participated in a general efflorescence of architecture and sculpture in Silesia, to which Willmann added a third touch.[19] In Krzeszów abbot Bernardus Rosa gave him numerous commissions, including, towards the end of the century, the frescoing of the chapel of the St Joseph's brotherhood. Also a master of landscape and animal painting, Willmann completed many cycles of religious paintings, most strikingly perhaps a series of martyrdoms at Lubiąż from the 1660s. In truly baroque *Schwulst*, remarkable for free handling of paint, open composition and intense action, Willmann synthesized much of the work of contemporary Netherlandish painting. Like Schönfeld, he also thereby established a local school, that was continued by his stepson and heir, Johann Christoph Liška, and in turn by Liška's heir and Willmann's grandson, Georg Wilhelm Neunherz.

Willmann's paintings in Lubiąż (and elsewhere) have been said to constitute a *theatrum sacrum*; like the services, processions and apologetic literature of the time they were weapons for the Roman Church in the struggle to win souls in Silesia, which because of the presence of a variety of confessions was still a spiritual if not a military battleground in the later seventeenth century. One soul who was thus won over, was Johannes Scheffler, the poet otherwise known as Angelus Silesius: Angelus Silesius was also closely associated with Krszeszów, and thus with Willmann, who illustrated his poetic inventions. Sandrart indeed also described Willmann himself as most dedicated to the reading of histories and poems, as the subjects of his work demonstrate.

The reinvigoration of the letters and the arts does not seem coincidental. The association of writers and artists in Silesia may also be situated in the other major locus of patronage in the region, that of the magnate. In this realm Matthias Rauchmiller collaborated with the dramatist Lohenstein. Much as Willmann illustrated the religious works of Angelus Silesius, so did Rauchmiller make a similar contribution to the title pages of some of Lohenstein's dramas; Lohenstein in return supplied the texts and the programme for the remarkable 1670s burial chapel in Legnica (Liegnitz) for the last of the Silesian Piast dynasties. Here a tradition of presenting series of ancestor portraits which had started at Brzeg Castle (see p. 157), came to a conclusion in equally striking manner: statues of members of the Piast dynasty ranged around the circumference of the chapel communicate with each other across its space. *Theatrum sacrum* becomes *theatrum familiale*: the Piasts are glorified as they become extinct. What is but adumbrated by sculptors such as Schwanthaler, the interworking of painting, text and sculpture, is here realized.[20]

While the sculpture in this chapel was executed by Rauchmiller, the frescoes and stucco are by Carlo Rossi and Domenico Antonio Rossi: and this turn to Italians by a princely patron raises a more general issue, in taking us, along with Rauchmiller's own itinerary, to a consideration of his next patron, the overlord of Silesia, Emperor Leopold I. With the reign of Leopold I

(1658–1705), who was both an outstanding patron of architecture and of music and himself a composer, efforts to resecure the political position of the Habsburg dynasty in Europe can be said to have been matched by the visual arts at least in intention, if not yet in actual execution. Habsburg preeminence in the visual arts of Central Europe had last been demonstrated at the court of Rudolf II. This world of art had been broken apart by the Thirty Years' War, which struck the Habsburg lands with particular force. Older patterns of patronage ended, as the court was moved back from Prague to Vienna, where it was finally to reside. During the reign of Ferdinand III (1637–57) there had, to be sure, appeared some signs of cultural continuity, and to some extent in the visual arts, as indicated by commissions for churches in the 1620s, and the presence of Johann Wilhelm Baur and Tobias Pöck in the 1630s and 1640s. Certainly signs are found in music, with the presence at court until 1658 of Johann Jakob Froberger, with whom starts the tradition of keyboard music at the imperial court that stretches to Mozart. With Leopold's accession imperial patronage of the arts revived on a larger scale.[21]

The initial cultural orientation of the Viennese court, like that of the Silesian Piasts and many other rulers in the region, was towards Italy, as might have been expected from the Habsburg's family ties to the Gonzagas as well as from the traditional patterns of employment in the region, where masters from the area of Como and the Swiss Graubünden (Grisons) continued to be active. The music and opera at Leopold's court certainly point in this direction: at Leopold's court in Vienna Italian musicians dominated the scene, later to be followed by Germans. In contrast to the preference for speaking French at other German courts, the Italian language also ruled in Vienna, as the story of a Tuscan ambassador, Lorenzo Magalotti, underscores. Magalotti wrote to the grand duke of Tuscany that he could not practise his German at the imperial court, because Italian was so much spoken in Vienna.[22]

Along with music and language, an ideal of architecture that was basically Italian in inspiration also persisted in this part of Central Europe. As has been noted in the last chapter, this ideal had already been given new impetus by the Jesuits in the sacred and by Wallenstein in the secular arena. The ideal was also articulated through the emergence of a literature of architectural theory. In Poland there appeared, first, in Kraków in 1659, the *Krótka nauka budown-icza* (Brief Science of Building) and in 1678 the *Collectionum seu de pulchro architecturae sacrae et civilis compendio collectorum Liber unus* of the Jesuit Bartłomiej Nataniel Wąsowski, the architect of the Society's church in Poznań.[23] These works tried to make the 'rules' of architecture more broadly available in Poland, and they were followed by other treatises, although, as the title of the first treatises, a work in the vernacular, literally suggests, the classical tradition was to be adapted to Polish conditions. In the German-speaking world publications presenting the orders of architecture, at least in the form of suites of prints, were of longer standing. In *c.* 1678 the well-travelled magnate, Prince Karl Eusebius von Liechtenstein, composed a

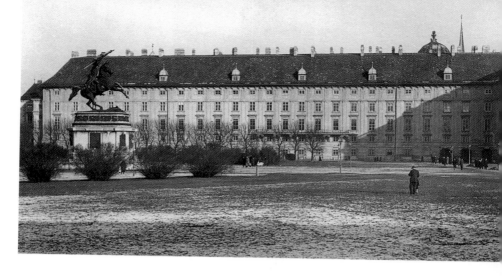

tract on architecture in manuscript. Lukasz
Opalinski, a Polish noble, is thought to have
written the *Krótka nauka*, showing for further
development of this tendency.[24]

In itself the production of Liechtenstein's treatise evinces the widespread
assimilation of Italian ideas as well as fashions; another aristocratic author,
Wolf Helmhard von Hohberg, indeed indicates that it was to be assumed that
aristocrats would know about and be involved in drawing and architecture.[25]
In his treatise on architecture Liechtenstein remarked specifically that 'in its
buildings *Welschlandt* [meaning Italy] surpasses the whole world, so that its
manner and no other should be followed, for it is fine, impressive and
majestic'.[26] In his somewhat unsophisticated emulation of the Italianate and
his advocacy of the use of the architectural orders, Liechtenstein however
articulated a radically different ideal from that which had been found earlier
in Central Europe, for example in Prague. As emphasized above, Rudolf II's
painters and sculptors had created a more subtle art, exemplified by compli-
cated allegories, and at times with erotic content, thus combining erudition
with wit; these small objects were meant for connoisseurs, not for a broader
populace.[27] Liechtenstein's view contrasted with this sort of subtle expression
of princely magnificence and, while emphasizing the importance of the
application of the orders, he made other suggestions as to what would be
sufficiently decorous for an ambitious patron. Liechtenstein seems to embody
the view that was implicit in the transition that Wallenstein had already
wrought in Bohemia, when he speaks of an 'impressive and majestic' architec-
ture. By this he means that 'if a building is to be magnificent it must be long,
and the longer the nobler. For a great row of evenly spaced windows and
columns one after another makes for the greatest effect and splendour.'[28]

The construction during the 1660s of the so-called Leopoldine Tract of the
Hofburg, the imperial residence in Vienna, anticipates what Liechtenstein
wrote, and thus can be regarded as one realization of this ideal. This building

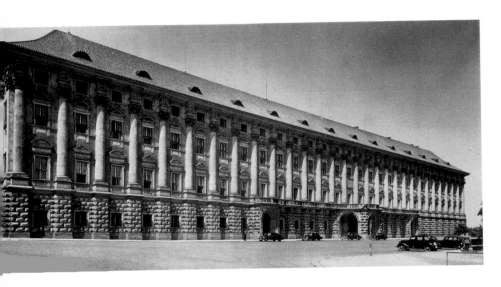

Černín Palace, Hradčany, Prague, by Francesco Caratti, begun 1668

had forty-five window openings and a similar number of horizontal divisions in its elevation. It thus seems to embody an effort to impress by sheer repetition and mass. It also has a giant Tuscan order placed on a base. The formal language of its architecture is derived ultimately from Michelangelo's designs for the Capitoline Palace, where a giant order of pilasters extends through two storeys, and the placement of this order on a rusticated base can also be considered a Michelangelesque idea. Although what was ultimately built at Versailles may in the end not have appeared so different, interpreting the Leopoldine Tract through the language of Liechtenstein may suggest that the Central European idea of the impressive and the majestic can be compared with its exactly contemporary French alternative. In French designs of the 1660s palaces have pavilions or a different form of articulation consisting of a sequence of blocks, and consequently greater internal contrast, together with a subordination of parts to the whole.[29]

As a structure from the 1660s, and thus from an early date in the emperor's reign, the Leopoldine Tract may be construed as a statement of the emperor's intentions to revive the grandeur of his house. Whatever the merits of a recent revision that has challenged the importance of the imperial house in the remaking of Vienna into an imposing capital,[30] the Leopoldine Tract certainly not only offers an early example of palace architecture in a grand style but also anticipates the later residences built for the nobility in Vienna, which, as has been stressed recently, Italians also designed.[31] It may even be said that the Leopoldine Tract was more than a forerunner of this tendency, that it may have inspired the construction of residences designed by Italian architects for these aristocratic families, whose palaces, not those of the Habsburgs, it has newly been argued, really mark the appearance of *Vienna Gloriosa* at the end

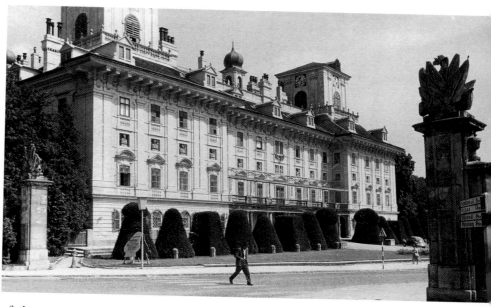

Eszterházy Palace, Eisenstadt, by
Carlo Martino Carlone, rebuilt 1663-72
(after plans by Filiberto Lucchese?)

of the seventeenth century.[32] It seems further justified to link the construction of this tract into a continuing tradition of Italianate design to which the later buildings also belong.

Responses to this kind of architecture soon appeared in the residences of magnates of the Habsburgs' realms. The ideal articulated by Liechtenstein was realized on an even larger scale in the Černín palace on the Hradčany in Prague, which similarly has 44 bays, but is 465 metres long. This was the work of Francesco Caratti, who had come from Lugano and worked for Wenzel Eusebius von Lobkowitz at Roudnice, where he had designed another large residence.[33] Expressions of Italianate *grandezza* can also be found in more provincial locations, where the idea that representation through architecture brought legitimation had taken hold. Thus large castles appear at this time in Lower Austria at Petronell, built for the Trautsons by D. and C. M. Carlone after plans by Filiberto Lucchese from 1673, and in Hungary at Eisenstadt (now in Burgenland, Austria; formerly Kismarton), built from *c.* 1663 for Pál Esterhazy by C. M. Carlone, the residence where Haydn was later to work. This last is a provincial variant of a standard type of rusticated edifice, with an elevation of four storeys and a giant pilaster leading through two of them.[34]

These buildings of the third quarter of the seventeenth century constitute a *Bauwelle*, a wave of building that, if not quite the equal in its results to the ferocious *Bauwurm* (building 'worm') of the eighteenth century, still witnessed the parturition of a prodigious number of constructions. Karl Eusebius von Liechtenstein patronized works done in Moravia, where, as amateur architect, he himself advised on the design of a fantastic five-storeyed Schloss perched on

a bluff in Plumlov (Plumenau) and built by his son.[35] Also in Moravia, Bishop Karl von Liechtenstein, both for his palace in Olomouc and at his summer residence in Kroměříž, employed Italian architects to build a suitably grand block-like residence, whose details are Italianate, again with a giant order of pilasters and regularly spaced windows.

The patronage of structures such as these indicates some of the changed social circumstances behind their construction.[36] For, as remarked above, patrons like the Liechtensteins and Dietrichsteins, much in the manner of Wallenstein before them, were still relatively new men, who had profited from the expulsion of Protestants from Moravia and the confiscation of their land. Their palaces may be regarded not only as a response to the royal model, but as an expression of a kind of competition that was rife especially in Bohemian lands, between the *soldatesca* (professional soldiery), like Wallenstein, Piccolomini and Rudolf Colloredo, the profiteers, like the Liechtensteins, and the remaining older gentry.

The aims behind and sources for this boom in the building of large residences were similar to those implicated in the efforts of the religious orders, who were involved in trying to win back, or win over, the population in the Bohemian lands of Silesia, Bohemia and Moravia (as in Austria, at the same time). The orders also often built huge structures, and they were able to do this, because from the late seventeenth century, they were often the new 'Wallensteins', that is, the successful economic administrators of their estates, which were in effect often run more efficiently than were those of the aristocrats with whom they were at times in competition. And they too had gained from emptied lands.

The results of the newer ecclesiastical patronage are exemplified by the constructions of the Jesuits in Prague, where they built three churches and colleges. Coming right after the Thirty Years' War, this was part of their effort, as they saw it, to subdue Czech heretics in Prague. Their central college in the Old City, the Clementinum, replaced the traditional site of Charles University. The choice of architect for this immense college, built 1644–58 by Carlo Lurago, an architect who also served the *soldatesca* (as at Nachod for Piccolomini) and whose family also served the older aristocracy (such as the Nostic), can be seen as part of their rivalry with both groups. Its size also expresses the power and pretension of the Counter-Reformation, in which grandiosity stands for grandeur.

At same time the Jesuits were well aware of the propagandistic and symbolic functions of art. This consciousness is evident in their employment of the reconverted Lutheran church of St Salvator's, next door, whose exterior abuts their new college (see illustration on p. 280). Where the college expresses their importance in its size, the new facade of the church by Lurago, with sculpture by Jan Jiří Bendl, makes other pointed references. The figures placed on the facade are patron saints of Bohemia, pillars of the local Church, and they are placed on a structure which recalls a tripartite triumphal arch. This

idea of triumph is reinforced by the key position of the facade, which closes off the square and faces the Charles Bridge and the Bridge Tower built by the fourteenth-century emperor Charles IV. The tower, opposite which it stands, has been interpreted as making a statement of triumph, a surrogate triumphal arch, as it were, and parades a series of inscriptions referring to the medieval kings of Bohemia.[37] In answer to this secular statement the Jesuits set up their own ecclesiastical programme on St Salvator's: in place of the state, there stands the Church militant and triumphant.

In mid-seventeenth-century Vienna, the Jesuits, supported by the court, were also associated with the introduction of both the new Italianate style and new iconographic developments, and thus played a similar role to that of the court.[38] In 1646 they erected a *Mariensäule* (column to Mary), which, though preceded by one in Munich, was the first of many in the Habsburg lands. The Virgin was regarded as protector and patron of the land as well as an intercessor, as in Bavaria, and was thus also generalissimo of forces. Her image took on a militantly anti-Protestant character, suggested by its placement on a victory column. The church am Hof, before which it stood, itself recalled both a stage front and a triumphal arch, reinforcing the association.

The most important contemporary church design in Bavaria resulted from the spread of another new order, the Theatine, and was built between 1663 and 1688 for Henriette Adelaide of Savoy, wife of elector Ferdinand Maria, who was successor to Maximilian I as duke elector of Bavaria.

Jesuit Church of the Nine Angelic Choirs, am Hof, Vienna (1662), facade by Filiberto Lucchese (?), with *Mariensäule*, present bronze cast 1664-7 replacing marble of 1646

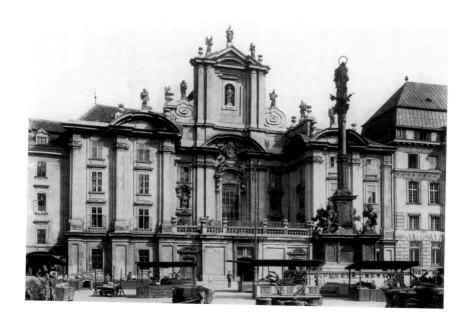

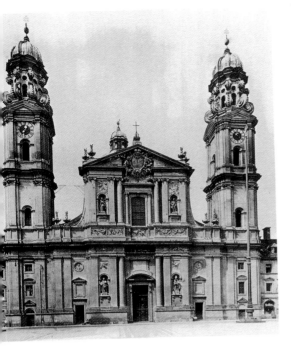

Theatine Church, Munich (1663-88) by
Henrico Zuccali, plans by Agostino Barelli

The Bavarians had tried to get the Theatine Church designed by the great Italian architect Guarino Guarini, whose buildings were to provide important models for Bavaria, but instead settled for Agostino Barelli, an Italian from the Swiss Graubünden (Grisons). Another native of the same region, Henrico Zuccalli, who was to become the most important architect of the Bavarian court at the end of the century working on secular and ecclesiastical projects alike, finished the Theatine Church in Munich, which, however, resembles the order's mother church, S Andrea della Valle in Rome.[39]

The interiors of these churches contained altarpieces by important painters, whose careers also evince a reorientation similar to that found in the architectural design. In the Theatine Church paintings were done by Sandrart and by Johann Karl Loth, a German who like Liss had worked in Venice and who returned to Munich to found a local school of painters.[40] The most important artist to supply altarpieces for Bohemian churches was Karel Škréta. Son of a court functionary, Škréta was born in Prague in 1610 and may have begun his training with Aegidius Sadeler, the last of the major Rudolfine figures left in Prague. Soon, however, he had to emigrate like so many thousands of Protestants, going first in the 1620s to Germany and thence to Italy in 1628. In Rome he encountered major painters such as Poussin and converted to Catholicism; by the end of the 1630s he had returned to Bohemia, where works by him are known from the 1640s on.

Škréta was active both as a portraitist of prelates and noblemen and as a painter of religious subjects, in which latter role he particularly filled the need to create altarpieces and new votive images in new churches and to replace works lost in a wave of iconoclasm (1620–21). Like the architects, Škréta introduces new elements to Bohemian painting, reminiscent of Simon Vouet and Poussin's classicism, combined with fluidity of handling. Though little known outside his native land, he was called the Bohemian or Prague Apelles. Whether we accept Sandrart's judgement of the matter or not, Škréta is important as the first eminent Bohemian artist of his time to go to Rome and

*St Wenzel as Defender of Prague against
the Swedes in 1648*, from the Church
of St Prokop, *c.* 1659?, by Karel Škréta
(*c.* 1610-74), Národní Galerie, Prague

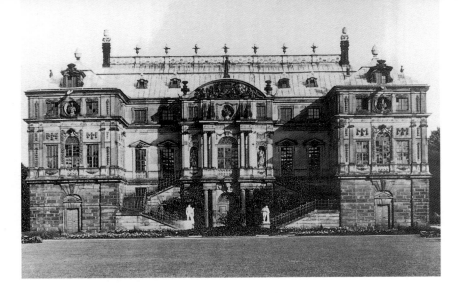

Palais im Grossen Garten, Dresden
(1679-83) by Johann Georg Starcke
(pre-war photograph)

bring back Italianate styles, in this way
forming one of the foundations of the later
development of painting.[41]

While much of the renewal of artistic activity
was thus orientated towards Italy or the Netherlands, by this time Louis XIV's
France also became a source for cultural ideals. In the late seventeenth century,
in a move that seems to suggest a change in the fortunes of Dresden, which
was to become a flourishing centre in the eighteenth century, the electoral
Schloss received rooms in a new taste. An architect so steeped in Italian that
he annotated his drawings in that language, Wolf Caspar von Klengel laid out
a new city north of the Elbe, with streets radiating from a bridge leading to the
Schloss. This design has been called Roman, but it seems also to parallel the
idea of Versailles, where a similar goose-foot pattern was utilized. Though
perhaps relying on a plan by Klengel, there is no question that the Palais im
Grossen Garten built from 1672 by Johann Georg Starcke was inspired by
French designs. The strict articulation of its facades, particularly the
pedimented side facades of its wings, recalls Claude Perrault's facade for the
Louvre; moreover, its symmetrical design, and especially its central block with
rounded pediment placed over double-storeyed composite columns,
themselves over a Tuscan order, recalls a long French tradition going back to
Philibert de l'Orme, even while elements such as the use of consoles and
bracket to support the architrave are not completely correctly conceived in a
classical sense. The adjoining garden incorporated a French design with side
pavilions and garden sculpture, revealing an almost direct and early influence
of Marly le Roi, Louis XIV's residence.[42]

In neighbouring Bohemia similar innovations were brought by the
Burgundian-born architect Jean Baptiste Mathey, who settled in Prague in
1675 and worked there until his death in 1696. From 1679 Mathey worked
for Count Václav Sternberg on a villa outside Prague, the so-called Palais

Troja, a hunting lodge placed in extensive French-style gardens. This major work of architecture is comprised of three wings with a raised central block, French in form, with rhythmic articulation and related to structures such as Vaux-le-Vicomte; as in other contemporary French designs, it also responded however to Berninesque or Roman ideas, such as a giant order of pilasters, alternation of segmented and pedimented windows and rich moulding of windows, with cartouches below.[43]

Mathey's major ecclesiastical structure was the Prague church of the 'Crusaders with the Red Star', built 1679–88 for the only native order of Bohemia. Endowed with a rich history, the order, like the aristocrats for whom Mathey also worked, reasserted itself with the construction of its church on a site full of tradition, right near Charles Bridge, on the royal processional way, and near the Jesuits' college. Although the building has Roman antecedents in its plan, it can be interpreted, at least as far as articulation of the facade goes, as a French classicizing structure, with elevation and ground plan of a central layout with squared-off plot and oval central space with dome.

This architecture may certainly be associated with 'classicizing' tendencies in seventeenth-century art, yet these were not only spread by French architects. They also represent a particular interpretation of classical, Vitruvian tradition, represented in Italy, for example, in the late sixteenth century, by the work of an architect such as Andrea Palladio and they were certainly picked up by followers of Palladio, in the north.

Palais Troja, Troja, Prague (1679-96) by Jean Baptiste Mathey, central block, with sculpture on stairway 'Gigantomachy', 1705, by Paul Heermann

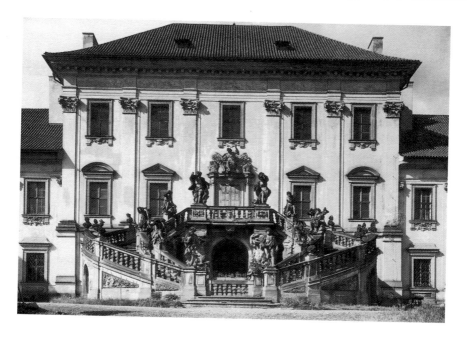

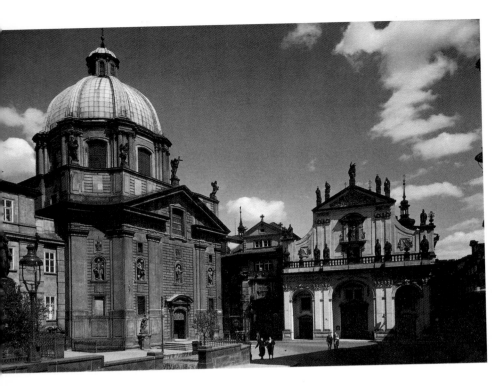

Crusaders' Square, Prague, with Church of the Crusaders with the Red Star (1679-88) by Jean Baptiste Mathey, with view of Salvatorkirche (Church of our Saviour), facade begun 1654 by Carlo Lurago, and others, with statues by Jan Jiří Bendl

In the conclusion to this chapter we may suggest that there was another non-Gallic strain that existed even within that stylistic current that has come to be identified with French classicism. When we find works that seem to resemble the classicism of Versailles, we may actually be encountering the traces of Netherlanders and their pupils, who had an impact in Northern Europe from Düsseldorf to St Petersburg. In architecture this trend had its origins in seventeenth-century Dutch Palladianism; in sculpture it had its source in Rome, in the alternative to Bernini that was represented by François Duquesnoy; in painting it is rooted in what is often called Netherlandish or Flemish classicism. We might well remember that these were some of the sources of the style of Versailles as well. Northern patrons did not need to have recourse to Versailles, however, to have access to these currents, which were mediated by Netherlanders and Netherlandish-trained artists, much as we may recall that Netherlanders had an impact on Versailles itself.[44]

In painting Netherlanders were represented by painters such as Adriaen van der Werff, who worked at the Düsseldorf court. In sculpture the work of Jerome Duquesnoy the Younger itself had an attraction even for those patrons who were otherwise drawn to what we call the Italian baroque. This included

Karl Eusebius von Liechtenstein himself, who procured bronze statues by Duquesnoy for his collection. Netherlandish sculptors from this orbit, including Duquesnoy, were active for Archduke Leopold Wilhelm, who had long resided in Brussels. François Dieussart, who was active in Rome at the time of Duquesnoy, served in turn the courts of the king of England, the prince of Orange, the king of Denmark and in Central Europe Friedrich Wilhelm, the great elector of Brandenburg. Because of his marital ties with the House of Orange, this last ruler in particular made Brandendburg an outpost of Netherlandish classicizing art.

Dieussart's career suggests that, much like Italians earlier, Netherlandish sculptors came to epitomize court art for a ruler like the Great Elector. From the mid-seventeenth century Netherlandish sculptors, often working in the classicizing manner of Duquesnoy, thus came to serve at many of the Central European residences. For example, Bartholomeus Eggers succeeded Dieussart at the court of the Great Elector and later worked in Berlin on several occasions in the 1680s. Around 1660 Artus Quellinus the Younger, who had been in Duquesnoy's ambit in Rome, purveyed garden sculpture to the Brandenburg residences of Cleves and Berlin, and also executed a major monument of Field Marshal Christoph Sparr in Berlin's Marienkirche. He also executed the splendid tombs of the duke and duchess of Gottorf in Schleswig Cathedral. Towards 1700 the Netherlandish wave continued with the work of Gabriel Grupello in Düsseldorf and Mannheim, with Wilhelm de Grof in Munich, and with Thomas Quellinus in Denmark and Poland.

An argument for the importance of Netherlandism has further ramifications. Because the importance of classicism in all aspects of Netherlandish art has not been sufficiently appreciated and also because the wide spread of Netherlandish classicism has not been emphasized, these strands have not been identified as important elements in a process of cultural exchange that is often simply ascribed to the influence of France. Yet it seems that the classicizing current in court art also had Netherlandish origins: much work could be done on its dissemination from Duquesnoy, the Quellinus family and the De Keysers and their pupils. A similar argument could be made for painting and architecture.

The renewal of art in Central Europe hence brought the region further into the play of those parties who moulded much of culture in the mid-seventeenth century: France, Italy and the Netherlands. This interplay continued in the next period when leadership passed to two centres, Vienna and Warsaw, where however new syntheses were also achieved. To the interconnected histories of these centres we now turn.

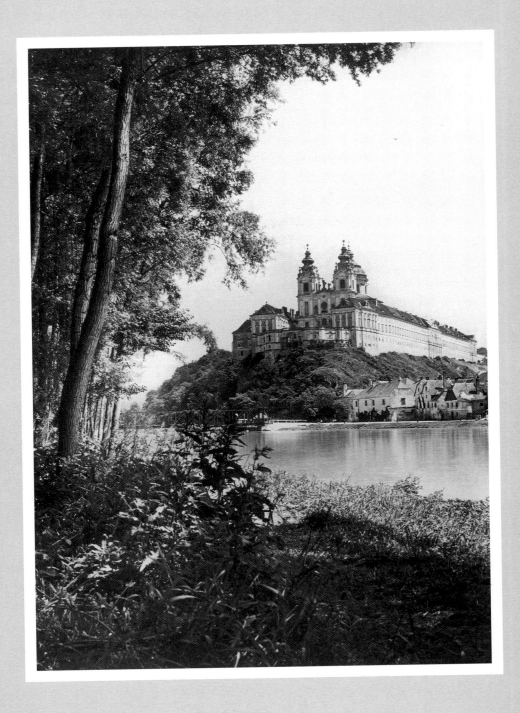

POLONIA VICTORIOSA; AUSTRIA GLORIOSA

Melk Abbey (reconstruction begun 1702)
by Jakob Prandtauer (1660-1726), completed
by Joseph Munggenast, view from northwest

IN 1683 AN ARMY LED BY JAN SOBIESKI OF POLAND, WITH MANY
EUROPEAN PRINCES PARTICIPATING, STORMED DOWN FROM THE
KAHLENBERG HEIGHTS SOUTH-WEST OF VIENNA, ROUTING THE
TURKS WHO WERE BESIEGING THE CITY. The relief of Vienna brought to
a close conflicts that had begun in the 1660s and put an end to the Osmanli
threat to Central Europe, as seen from the Christian point of view.

The victory at Vienna marks a high point for Poland and a turning point
for the Habsburgs. The Poles seized the centre stage of Europe at this moment.
During the reign of Sobieski Poland attained an apex in its political
importance. This position did not however outlast the king's death in 1696.
Thereafter the longer decline of Poland – whose population it is estimated fell
a third between the seventeenth and eighteenth centuries – continued, as the
respublica once again became prey to foreign dynasties.

In contrast, after the Turkish threat had been stopped at Vienna, the
Habsburgs, combining aid from various princes in a new European crusade,
rolled back the Turks in Hungary, Croatia and Serbia, and established
themselves as a major power in south-eastern Europe as well as in Central
Europe. At the same time in Germany the Habsburgs led a coalition of princes
to counter a threat in the west. There they faced the French armies of Louis xiv
in a number of wars, most notably in the War of the Spanish Succession in the
early eighteenth century. As a result of the treaties that ended this conflict, the
Habsburgs gained the Southern Netherlands, and for a time the kingdom of

Naples with Sardinia, Sardinia later being exchanged for Sicily. This series of transformations in power relationships compensated for the check they had received in the Thirty Years' War, and until the late eighteenth century the Austrian Habsburgs played a leading role in the 'European concert of nations', a position they maintained one way or another until the Treaty of St Germain that ended the First World War.

These events had important consequences for the arts. The aftermath of the relief of 1683 is distinguished by what has been called the 'glorious' Austrian artistic achievement: the creation especially of 'baroque' palace and church complexes in the Habsburg lands. In and around Vienna from the late seventeenth into the eighteenth century the imperial court, aristocrats and ecclesiastical patrons, both parishes and monasteries, engaged in patronage on a large scale. Many impressive churches, monasteries and city and country palaces were erected and decorated. Sobieski's reign has been accorded a similar importance in the history of cultural accomplishments in Poland. A boom like that in Vienna also occurred in Warsaw and its environs.

It seems justifiable to emphasize the events of 1683 as setting a symbolic stamp on the arts. While the arts in Poland and Austria from the late seventeenth century are not usually treated in conjunction, and there are manifest differences between them, these differences result not so much because of distinctions in patronage, since in each instance magnates, the crown and the orders were involved. Rather, varying cultural orientations and self-definitions led to preferences for different kinds of artists and styles. The self-consciousness of patrons in Poland and Austria took on new forms of plastic expression, and the choices they made consequently illuminate varying aspects of culture in the region.

In Poland during the period of Sobieski the arts were revived in a manner that adapted international classicizing and Italianate tendencies to uniquely local modes.[1] Sobieski, like Polish kings before him, re-established the importance of the Polish crown for patronage. Starting as a *hetman* (army commander), he possessed estates all over Poland, but their centre, like that of many magnates in this era, lay in the east of the land, in his instance near Lwów (L'viv/Lemberg), now in western Ukraine. He was born in Olesko, whose grounds he later embellished with gardens and garden sculpture; he established residences in Żółkiew (Żolkva/Nesterjov) and Jaworów, and redecorated Podhorce. In Żółkiew in particular Sobieski gave funds for monuments by Andreas Schlüter and paintings by the Roman-trained Martino Altomonte, to be placed in the collegiate church there, which was to become a kind of royal pantheon.[2] It is noteworthy that at the same time he contributed to the construction of the local synagogue, which was executed in a variant of a seventeenth-century vernacular, with the familiar prominent parapet.[3]

Soon after his accession Sobieski promoted royal interests in a far distant part of the realm, in Gdańsk (Danzig), where he established a royal chapel for Catholic worship, attached to St Mary's, the main church in the town. In this

building the classicizing style so striking in his reign becomes prominent. The style was spread especially through the work of the sculptor Andreas Schlüter and the architect Tylman van Gameren. Born in Utrecht, Van Gameren had travelled in Italy; in Poland from the 1670s, he worked in the style that developed from Palladianism and from the works of architects like Vincenzo Scamozzi that he may have seen.[4]

As was the case in Austria, but for different reasons, the style which was to become dominant in the land appeared in the residences of magnates and churches as in those of the king. Other important nobles could indeed have a considerable impact on cultural life in Poland, where the system of election of monarchs meant that the king of Poland was *primus inter pares*, so that he was not the exclusive force in the land. This was all the more true because the increase in demesne holdings had, as mentioned, allowed numerous *szlachta* (gentry-cum-petty nobility) to build up huge estates. Thus a situation developed in which magnates such as Jan Krasiński, who had a splendid palace built by Van Gameren and decorated by Schlüter in Warsaw, or Stanisław Lubomirski, could exercise a role in the arts similar to that which has been acknowledged for the aristocrats in late seventeenth-century Austria.

Funereal Monument (tomb) of Jakub (Jacob) Sobieski, 1692 ff., Żółkiew (Nesterjov), Collegiate Church, by Andreas Schlüter (pre-war photograph)

What was distinctive about this period is that the new style appeared especially in Warsaw and its surroundings, as it also did in Vienna and its surroundings in Austria. Where earlier Kraków, Wilno (Vilnius), Gdańsk (Danzig) and Lwów had been the leading sites of Polish (-Lithuanian) culture, under Sobieski Warsaw, which had been a royal residence from the early seventeenth century, with nearby Wilanów, became effectively the major cultural centre as well as the dynastic residence in the land.[5] Similarly, too, Vienna definitively supplanted cities like Prague or even Innsbruck.

Sacramentarian Church, Warsaw
(1688-92) by Tylman van Gameren

Van Gameren was responsible for building several centrally planned churches in Poland, exemplified by the Warsaw church of the Sacramentarians, a Polish counterpart to Mathey's crusader church in Prague. This restrained Palladian, centrally planned building of *c.* 1689 was built for a new order: it employs a design that had long been employed for burial chapels. On the other hand, Van Gameren's major surviving secular work in Warsaw is the large Krasiński palace, just noted, of the 1680s; this is an impressive structure in a tempered classical architectural idiom. Where the Sacramentarian church resembles the Prague crusaders' church, this is a kind of Polish Louvre, an urban palace whose better-known facade the classicizing exterior of the palace resembles. Its pediments, with sculpture attributable to Andreas Schlüter, are however distinctive: they represent Roman heroes, the ancestors whom the Krasińskis claimed.[6]

A not unrelated series of reliefs with ancient themes, along with statues of personifications (of the virtues and the like), were depicted by Schlüter and other sculptors on the exterior of a suburban palace commissioned by Sobieski himself, and effectively erected from the 1680s. This is the *villa nova*, the villa at Wilanów outside Warsaw, whose name reveals the Italian origins of its conception. The villa was designed by Agostino Locci, a Polonized architect whose family hailed from Rome. This one-storey structure translates the Italian, ultimately Roman, ideal of *otium* (leisure) in the form of a suburban villa to Poland. Its design is comparable to contemporary Roman models of the period, such as the Villa Doria Pamphili, and clearly belongs to the then continuing European-wide revival of Vitruvian architecture. It has a U-shaped plan that connects several pavilions, while its interior features also conform to the latest classicizing taste, as seen in paintings by French and Italians such as the Florentine Michelangelo Palloni. These two designs may stand for the possibilities realized in a host of other palaces, including for example that at Nieborów by van Gameren.[7]

On the other hand, the work by Schlüter for Sobieski and the Polish

szlachta that adorned Wilanów and several contemporary churches represents a sculptural counterpart to Van Gameren. Later in Schlüter's career French sculpture may have had an impact on Schlüter's statues, as will be discussed, but an identification with French classicism does not seem initially to have been what made this Danzig-born sculptor attractive to the royal patrons he served, starting

Krasiński Palace, Warsaw
(1689-95) by Tylman van Gameren,
with sculpture by Andreas Schlüter

Palace at Wilanów, near Warsaw
(1677-96) by Agostino Locci, with
sculpture by Andreas Schlüter and others

with Sobieski in Poland and continuing with Frederick I of Prussia and Peter the Great of Russia.

A letter of 1681 by Locci recommending the sculptor to the king demonstrates this point. Locci says that the *statuarius*, meaning Schlüter, can successfully make putti in the manner of Duquesnoy. It is most likely Schlüter's ability to make works in the manner of this Flemish master, the great alternative to Bernini for seventeenth-century taste, that recommended him to Sobieski: given the strong Netherlandish presence represented by Dieussart and Eggers, along with that of numerous painters and paintings at the Berlin court, it also probably made him attractive there. Indeed just before his arrival the elector acquired a putto by Duquesnoy for his collection.[8]

Schlüter may well have learned this style from the many Netherlandish and Netherlandish-inspired sculptors who continued to work in the Baltic region, including the Polish littoral. Epitaphs in Frombork (Frauenburg) in a manner comparable to that of Duquesnoy can be assigned to him, and both the idealized female virtues and the putti carrying military paraphernalia in his documented tombs of *c.* 1690 for the Sobieski and Danilowicz families in Żółkiew also demonstrate their evident descent from the sculpture of *il Fiammingo*. In several senses, then, Schlüter can be attached to the current of Netherlandish classicism represented by Van Gameren.

In Poland these classicizing tendencies were pressed in to the service of the idiosyncratic movement known as Sarmatism.[9] Although this trend had its roots in sixteenth-century Polish culture, it flourished especially in the seventeenth and eighteenth centuries. Sarmatism was a unique variant of what may be called Renaissance national self-definition.[10] In the Renaissance spirit of a return to sources, the peoples of Europe searched for or created their own (mythic) origins. Sarmatism expressed for the Poles the idea that like other European nations they too had their origins in the peoples discussed by the authors of antiquity, but their ancestors were even older than some of those claimed by many other Europeans. For the Poles identified themselves geographically with the eastern region of the continent, and hence with its people (who of course had been described in antiquity at best in a vague and a quasi-mythical way), the Sarmatians who had been mentioned for example by the Greek historian Herodotus. They thought their ancestors had come from the Black Sea region, and taken over the territories between the Vistula and the Dnieper rivers.

Hence they adopted what they regarded as a distinctive Sarmatian appearance. For the Sarmatian *szlachta*, this amounted to disporting shaved heads with topknots and long robes, that in reality seem to reflect the customs of other Asiatic and Turkish peoples; similarly they fostered their famed winged cavalry. Polish patrons in particular supported some works of art that may be linked with Sarmatism, especially portraits: for example, a distinctive type of funerary portrait evolved, wherein the deceased was depicted in a bust-length effigy on tin that was placed on coffins and subsequently affixed to epitaphs.[11]

Although Sarmatism had little direct impact on the visual arts beyond the extensive production of a distinctive type of portraiture, it has been associated with other ideas that were current in the seventeenth century, and hence has given the name to a cultural movement with implications for the arts. The Poles long regarded themselves as the bulwark of Christendom, chosen by God for this task, and their victories over the Turks at this time would have fed this view. They also cherished their 'Golden Freedom', one of their traits that supposedly made them superior to the other nations of Europe.[12] Under Sobieski this movement has been called enlightened Sarmatism, and Van Gameren's and Schlüter's works have been fitted under this rubric.[13] Their works create a kind of corollary to the way Roman and classical values came to be associated with a newer ideology of rule.

For example, on the magnate dwellings, as on Sobieski's, there could appear visual references to a mythic Roman past. Along with other members of the *szlachta* Sobieski himself could be portrayed by sculptors and painters as a Roman leader, in toga and battle armour, yet unmistakably Sarmatian in his moustache and helmet. These sorts of portrayals, as found in numerous equestrian portraits, crowned a history of propagandistic imagery starting in the late sixteenth century.[14] They befit a nation that in its rescue of Vienna could regard itself as virtuous Romans defending European civilization.

Despite these claims, only increasingly empty vestiges of this grandeur survived Sobieski, after the Saxon Wettin ascended the throne.[15] After his death, the next great period of art that *Polonia victoriosa* made possible did not take place in Poland itself, but in Austria.

In Austria imperial messages had long been expressed in art made for and collected by the Habsburgs; in the late seventeenth century the arts and letters were deployed anew, as the cultural and political mission of the Holy Roman Emperor came to be directed against the Turks and the French.[16] On the basis of this conception art and architecture that can be associated with the imperial house eventually took off after 1683; even if the court was in fact slow to take the lead in the actual patronage of art and architecture, projects that were envisaged for it were soon being planned. Also, and this is unlike the Polish situation, the direct impact of the circle of Gianlorenzo Bernini informed the works that were envisaged for the court in the newer climate of the 1680s and 1690s, when Johann Bernhard Fischer von Erlach laid the foundations for a new imperial style that would finally flourish some decades later.[17]

Born in 1656, in *c.* 1671 Fischer was already in Italy, where he associated in Rome with Bernini, the architect Carlo Fontana and the antiquarian scholar Gian Pietro Bellori.[18] The association with Bernini is worth comment. If we are to conceive of an alternative to the Gallic style, as the epitome of a classicism that was adapted, albeit somewhat idiosyncratically, in Poland, then the Berninesque current certainly represents a counterpole: we can recall the exceedingly cool reception Bernini received in France. The Fontana association is also important, because many of the architects who were to dominate

design at the end of the seventeenth and beginning of the eighteenth century had been connected with this architect or his workshop in Rome.

Fischer returned north in 1687, and it is noteworthy that his first work was in fact for a Liechtenstein, a design for monumental stables at Lednice (Eisgrub), now in Moravia. It is possible to read this project as indicating a certain community of ideas shared with Karl Eusebius von Liechtenstein's heirs. It also indicates that the imperial court itself was not the first to promote the new style.[19]

In any case Fischer's first important designs for a project in Vienna, made shortly thereafter, do programmatically demonstrate the conscious assertion of a new alternative for architecture. Among his other designs for arches for the triumphal entry of the future emperor Joseph I, the son and successor (who ruled 1705–11) of Leopold I, were those for the foreign merchants and the city council. These arches incorporate a traditional Roman idea, much like those that had often been previously employed as temporary architecture for the earlier Habsburgs, but elaborate its ornament with baroque *Schwulst* to communicate its messages.[20] They display Habsburg emblems, such as the *plus ultra*, the doubled columns, that stand for the Pillars of Hercules, the traditional bounds of the world beyond which the Habsburgs had increased their empire. They also portray the prince as a new Hercules, a traditional Habsburg claim to ancestry. In so representing him, Fischer seems to respond directly to the French claims to be descendants of the Gallic Hercules, much as his presentation of the prince as a new sun, a sun king – a motif repeated in another contemporaneous design by Fischer – also answers Versailles.

The challenge made by Fischer's imagery is quite specific. A series of reliefs on one arch depict victories over the Turks and over the French, with whom the Habsburgs and their allies within the Holy Roman Empire had been at war since 1688. Furthermore the form of the architecture Fischer designed was also regarded by his contemporaries as being anti-French: it was claimed that Fischer had provided a new national architecture. In a work that bears the telling title *Ehren-Ruff Teutschlands*, or 'Germany's Call to Honour', (pub. Vienna, 1691), Hans Jakob Wagner von Wagenfels accordingly describes Joseph's entry as follows:

> This was a beautiful triumph and entry in which your royal majesty like an angel sent down from heaven to all-ruling Vienna – to the joy of the assembled populace – not only rode in proclaiming victory, with uncomparable splendour that was well-ordered by German wisdom, but in which also German art and skill attained a marvellous victory in the spirits of all onlookers against the opinion of foreigners.[21]

As the work of a native architect, Fischer's architecture was thus looked upon as the self-conscious expression of a new dynastic spirit. In praise of Germany and its architecture, Wagner also remarked in this light that 'its cities and buildings are said to surpass Paris and at least equal their Italian models'. In this comment a more than superior tone with regard to France and a new

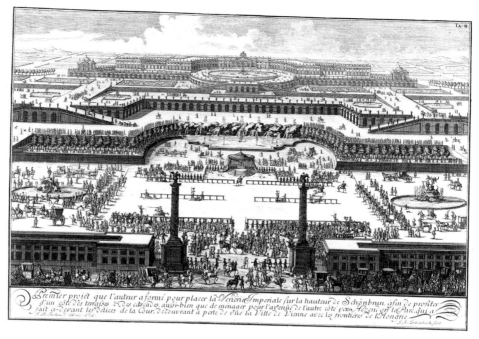

TAB. III.

Premier projet que l'auteur a formé pour placer la Venerie Imperiale sur la hauteur de Schönbrunn, afin de profiter d'un côté des terrasses et des cascades, aussi-bien que de menacer pour l'avenue de l'autre côté vase Hezen, est la Pau, jui à fait a-devant les Delices de la Cour, découvrant à perte de vue la Ville de Vienne avec les frontiers de Hongrie

expression of self-esteem are to be noted: Austrian art is said to equal that of Italy. For the Austrians the ultimate standard for comparison was thus definitely not supplied by Versailles, which had begun to attract German imitators, but, as had earlier been the case in Leopold's reign, by Italy: only now even Italy was to be equalled by local products.[22]

Ideal plan for Schönbrunn Palace and Gardens (c. 1690, executed differently from 1695) from *Entwurff einer historischen Architectur* (1721) by Johann Bernhard Fischer von Erlach (1656-1723)

The immediate expression of this new architecture was manifested in Fischer's design of *c.* 1690 for a suburban palace at Schönbrunn, a plan for a huge structure that was intended to supply a more appropriate residence than the Vienna Hofburg could offer for the emperor's revived claims to pre-eminent status in Europe. This pretension was again clearly articulated at the time by Wagner von Wagenfels, when he said that 'to be emperor is to be nothing else than the greatest ruler in the world'.[23] The gargantuan size of this design stems from seventeenth-century ideas of *grandezza*, but other reasons, not only the challenge of Versailles, help explain the scale of the project. The Turks had ravaged and ruined the area around Vienna, Lower Austria, which had lost an estimated 90 per cent of its population. As elsewhere where similar losses had been suffered, this situation offered a chance to have large tracts of land, providing the economic basis for artistic expansion. Finally, like Louis XIV, the emperor needed to form a court, which could become a focus of the interests of the nobles of his domains and of the Empire in general.

The meaning of the architecture of Schönbrunn may thus well have corresponded to the title of a book of 1684 by the councillor Philipp Wilhelm Hörnigk: *Osterreich über alles, wenn es nur will* (Austria over all, if it only wishes). This book announced the thesis that cameralism, the management of state property, was to produce an independent, self-sufficient Austria, much as mercantilism was to produce an autochthonous France. This was an argument for centralized control and re-organization of court finances, meant to improve production and commerce. Such policies at least certainly supplied the riches necessary for the production of art at this time.[24]

Indeed, an independent style of architecture was to be produced as well. Developing even further the concept of *grandezza* that Karl Eusebius von Liechtenstein had put into words, Fischer's initial plan for Schönbrunn went one better than Versailles, in presenting a design for an even grander residence than did the Leopoldine Tract. A super-Versailles was planned; the initial project for Schönbrunn overtrumps Versailles in size, in its location on a hill and in its stylistic references. Fischer here developed a new form of architecture derived not only from a reaction to forms used at Versailles but from one of the great alternatives found in seventeenth-century designs – that model which, as remarked, had not succeeded in France, namely the art of Bernini. However, in line with its all-encompassing universal and imperial pretensions, Fischer does include references to French modes as well, such as the presence of a spring with tracts of fountains, expansive developments from a central block and a pavilion-style architecture, which had not yet been seen in previous royal architecture in Central Europe. At the same time the curved central block is derived from Bernini's idea for the Louvre, as it was implemented in some of his church designs. Moreover, in some of the symbolic details, such as the prominence given to the Habsburg emblem of the two columns or pillars, the Schönbrunn plan reasserts Herculean imagery against the French: the fountains similarly present Hercules and Apollo, the god who brings light and arts, a fairly clear riposte to the *roi soleil*. These references are also obviously allusions to the Habsburgs.[25]

Although never realized as planned, Fischer's designs were disseminated through their eventual appearance in his book *Entwurff einer historischen Architectur* (first pub. Vienna, 1721). This is the first published history of architecture and demonstrates something of the intellectual as well as artistic creativity of his milieu. In its wide compass this book is comparable to the accomplishments of the polyhistors of the later seventeenth century, by whom he may have been influenced (including Christopher Wren); in fact Fischer may be associated with some of these figures such as the German Jesuit polymath Athanasius Kircher, whom he would have known in Rome. Material from Kircher's books clearly served as the source for some of the more exotic contents of his work. For example, Kircher provided the information that Fischer used for his treatment of Egypt, and Kircher, or other Jesuit sources, probably also served for images of East Asia.[26]

The appearance of illustrations of Fischer's designs in this volume further indicates the universal aspects of Fischer's imperial plan, because his book traced the history of architecture of all peoples and times, reaching its consummation in the appearance of his own buildings, which were illustrated at the end of his book. The message seems clear that this architecture is both grand and all-encompassing; it has a universal historical importance, in that it completes the architecture of succeeding world empires, which had developed from the Near East, through the Greeks and Romans, to the Holy Roman Empire and Vienna.[27] Coming at the end of this historical sequence, Fischer's architecture incorporates all previous ideas, including obviously Roman elements, a Greek temple front and, to use modern stylistic language, Renaissance as well as baroque features.[28] With some merit Fischer's imperial structures have also been seen as the incorporation of a Leibnizean ideal, as it were, in architecture, an ideal of universal harmony and control.[29]

Although this particular plan was not realized – it was only in a reduced manner that Schönbrunn was erected in the early eighteenth century – Fischer von Erlach, along with many other architects, including Italians, executed many other projects whose combined style is not dissimilar: these were designs for palaces in Vienna, and its surroundings. From the 1690s a huge building boom seized Vienna, and more generally the Austrian lands, which did not abate until the Silesian wars (the war of Austrian Succession) in 1740. There sprang up palaces for the Lobkowitz, Dietrichstein and Liechtenstein families from Bohemia and Moravia; for the Trautson and Schönborn families from Austria; and for the Hungarian Batthyany and Eszterházy families.

Despite the seemingly proto-nationalist claims of contemporaries, Austrian architects were not the only ones to satisfy these demands. Italian architects and sculptors remained active in Vienna. For example, Domenico Egidio Rossi and Domenico Martinelli designed the Liechtenstein garden palace, which possesses sculpture by Giovanni Giuliani and paintings by Andrea Pozzo, the master of pictorial illusionism who had come north after working in Rome, in the Gesù and elsewhere.[30] The extensive correspondence of Wenzel Liechtenstein with Marcantonio Franceschini, the leading artist of the Bolognese school, reveals a stated preference for the Italians.[31] In the Liechtenstein palace only one Austrian painter, Johann Michael Rottmayr, participated in the frescoing of the *sala terrena*.[32] Thus, in contrast with Warsaw, not only the ideal plans but many of the palaces that were actually put up resemble the baroque creations of Rome or Bologna. The collaboration of several figures in the Liechtenstein palace indeed also points to the connection of painting, sculpture and architecture in the creation of the *bel composto* in Austria, where, as Pozzo's work indicates, Berninesque means that had once served religious ends were now turned to the glorification of a noble family.[33]

Although recent revisions have consequently corrected an earlier overemphasis both on the role of Germans and on the activity of the imperial crown in the actual transformation of Vienna, at least during the reign of

Leopold I and his son Joseph I, it is still possible to link the creation of these ensembles with the aftermath of the relief of 1683. It still seems likely that the establishment of Vienna in ideal form as the residence of an important emperor, the earlier model of the Leopoldine Tract and finally Fischer's early plans for imperial structures had their effect on aristocratic patronage. In order to respond to the need to retain or express their prestige, noble families had to have large city palaces constructed. These had to be suitably splendid and up to date to represent their dignity. It is also the case that the imperial architect Fischer had a hand in the design of several palaces, notably the city palace for Prince Eugene, victor over the Turks.

The plan for Schönbrunn, if not its finished execution in altered form (1696–1711), also antedates the construction of many of the garden or summer palaces, suburban buildings or *maisons de plaisance* of many of these families. The growth of suburban architecture had been facilitated by the destruction of Viennese suburbs by Turks; large expanses were available right near Vienna for extensive gardens, houses and other structures. These moreover included buildings by Fischer himself, such as the Palais Trautson, often with outbuildings or garden pavilions, such as the Casino Althan of *c.* 1693 (albeit slightly earlier than Schönbrunn). This last design typifies the freedom to invent that is allowed for this kind of edifice, in that not much was required for building a garden structure, in the way of function, other than the provision of a simple shelter. Fischer could thus combine the Borrominesque idea of projecting wings from a circular building with a French X-shaped design.

The acme of accomplishment in these nobles' garden palaces was attained in those designed for Prince Schwarzenberg and for Prince Eugene. Both the Belvedere for Prince Eugene, which had been built by Fischer's younger contemporary and rival, Johann Lucas von Hildebrandt (1663–1745), and the Schwarzenberg palace, a joint project, embrace a garden layout.[34] The Schwarzenberg garden palace, begun in 1697, consists of two wings adjoining an oval central element, whose form suggests a coronet, perhaps appropriate for the family's princely status. The articulation of its elevation with a giant order, and an arcaded portico before the main entrance, which recalls the loggia at Valdice or the Wallenstein palace in Prague, give a more Italianate tone. The Belvedere, on the other hand, a project begun about 1720, comprises two long, unconnecting buildings stretched out at the top and bottom of an incline, the Upper and Lower Belvedere, the upper of which has a splendid view of Vienna (hence its name, the Belvedere). Between these units lay formal gardens inspired by French designs and laid out, along with an orangery to the side, by Dominique Girard, a pupil of the famed French gardener André Le Nôtre, who had previously worked for Max Emanuel of Bavaria (who will be discussed more in the next chapter).

Hildebrandt had however been born in Genoa and was evidently aware of Italian designs such as those of Guarino Guarini; he also had been the pupil of Carlo Fontana, whose ideas are also reflected in his work. Like Fischer, he

entered court service at the same time as serving the noble families of the Empire. Like Fischer, too, he contributed to the creation of a cosmopolitan architecture, in which motifs of foreign origin are recast into something new. Thus French motifs sometimes appear in the designs of the exteriors of his buildings, including mansard roofs and one of the first instances of a trait associated with the French Regency, ribbon work. But while he employed some Gallic elements of ornament, Hildebrandt's architecture also moulds space and contrasts masses in the manner of post-Berninesque designs, seen especially in his church architecture.

Court facade, Upper Belvedere Palace, Vienna (1721-2) by Johann Lucas von Hildebrandt (1663-1745)

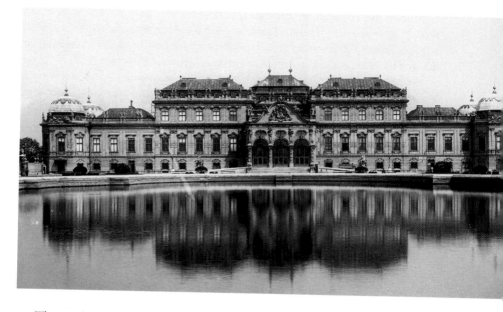

The external decoration of the Upper Belvedere also has a symbolic dimension. It reflects the military exploits of a great warrior, who, like Sobieski, was a victor over the Turks, the commandant of Christian forces in the Balkans. Indeed this grand residence represents the continental counterpart of the monumental architecture of triumph, familiar in England from Sir John Vanbrugh's Blenheim Palace, designed for Eugene's colleague at arms, the Duke of Marlborough. Trophies or military emblems pertaining to the owner surmount the Belvedere, while its corner towers recall the appearance of older *châteaux-forts*, which were of course ultimately the origins of the Schloss *qua* château; the top of the Belvedere can also be read as a series of tents, a military encampment.

In the interior of the Upper Belvedere a design problem was also solved in a masterly way, in that unequal levels on each side were united by a stairway in such a way that they have the appearance of being at the same level. This is

accomplished by the use of a turning stairway, the historical culmination of a sequence of grand staircases that had been anticipated by Fischer and antedated, as we shall see in the next chapter, by Hildebrandt's work at Pommersfelden; here, the stairway is literally made central, uniting the court and carriage facades of the building. Stairways became important in the ceremonial function of such buildings, where an elaborate etiquette determined where an important visitor was to be met and also had an effect on the layout of the rooms throughout the Schloss.[35] The Atlases who hold up the stairs in the Upper Belvedere may make a meaningful allusion, in that they symbolize the support of the building, but just as Atlas carries the world on his shoulders, so the heroic Eugene is the Hercules who supports the empire. Certainly the heroic and Herculean elements associated with Eugene are present in frescoes of his apotheosis by Martino Altomonte in the palace; they are also present in a statue of his apotheosis designed by Balthasar Permoser, the great German sculptor, where Eugene is seen as a Hercules.[36]

In palaces like the Belvedere the *enfilade* (set of rooms) possessed various functions: they include a formal marble room, a *Spiegelkabinett*, or mirror room, a *Spielzimmer*, or game room, and a chapel. It is characteristic of the cosmopolitan combination of this architecture that it combines grand, formal, Italianate spaces with intimate ones. Some of these spaces, for instance the mirror room, again anticipated at Pommersfelden, were perhaps derived from France, but their ultimate derivation was from the Netherlands.[37] And where Eugene owned a great library, a palace like Pommersfelden would possess a picture gallery.

Whatever their stylistic origins, and whether they were embodied in works for the emperor, or in that for his field marshal Eugene (who also built a huge residence at Schlosshof outside Vienna) or in those for other courtiers, monuments such as the Belvedere were recognized by contemporaries as expressions of an ideal of Austrian glory. In a book of 1700 Pater Ignaz Reiffenstüel explicitly called the city *Vienna Gloriosa*, saying that

> *the gardens and places of recreation all whether because of their immense vastness, or from their varied and superb buildings, or from the wonderful flowers and fruits or from other reasons, from the covering trees, whole little woods, statues, pictures, and pleasant with other garden delights, procure the city of Vienna no less glory than they bring to its souls genuine delight and pleasure.*[38]

While in the reign of Leopold the ideal of *Vienna Gloriosa* had already been enunciated by the court or its architects and had begun to be realized at Schönbrunn and in the residences of aristocrats, the actual evolution of a true *Kaiserstil* identifiable with the aims of Habsburg self-representation may be situated during the reign of Charles VI (Holy Roman Emperor 1711–40), as the date of the Belvedere also suggests.[39] Charles VI had the Imperial Chancellery range (Hofkanzleitrakt) built in the Hofburg by the younger Fischer von Erlach, who carried out ideas by his father Johann Bernhard. In

addition to palatial architecture, either for the court or its servitors, the imperial style soon assumed other dimensions during this reign, becoming more broadly associated with culture, in the forms of the arts, religion and learning.

The elder Fischer, for example, designed an imperial (now the national) library adjoining the older Schweizerhof in the Hofburg. This building literally housed the results of, and thereby expressed the support of the court for, the preservation and expansion of learned culture. Its design embodied the concept of a universal, harmonious architecture, comparable to Leibniz's ideals of pre-established harmony, also reflected in the order of the books. Here the connection of Fischer's synthesis with Leibniz is direct, in that one of Fischer's sources was Leibniz's idea for a centrally planned library, replete with a dome suggesting a temple of the Muses. Another idea Fischer worked into his scheme was that of the Spanish royal library of the Escorial with its longitudinal plan, book shelves and open space – a meaningful reference, since Charles VI had had aspirations to be king of Spain. The whole was also combined with a central oval area, such as had already been employed by Fischer in a design for an *Ahnensaal* (ancestral room) at Schloss Althan in Moravia.[40]

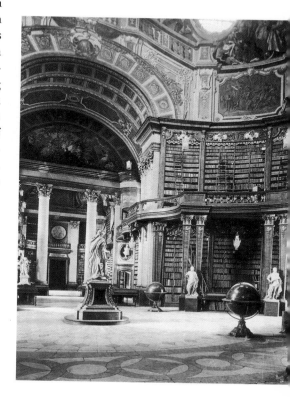

Interior of Main Hall, Imperial Library (building begun 1722), designed by Johann Bernhard Fischer von Erlach, finished by Joseph Emanuel Fischer von Erlach (1735), with frescoes by Daniel Gran (1726-30), with additions by Franz Anton Maulbertsch (1769)

Paintings by new Austrian masters who had been trained in Italy or emulated Italian models could by this time compete with foreigners for place in these structures. Thus one of these leading artists, Daniel Gran, could gain a major commission to paint a fresco on the ceiling of the library in *di sotto in su* ('from beneath') illusionism, of the sort that had been brought to the Habsburg lands from Rome by Andrea Pozzo. The imagery of this fresco also represents a summa of the pictorial devices, the *concetti* that were developed by the artists at this time. Its allegorical programme, devised by one of the scholars at court, is organised by hieroglyphs, *imprese*, iconological personifications and historical figures; it was said that it employs '*hieroglyphisch-historische und poetische Gedanken*'. The theme

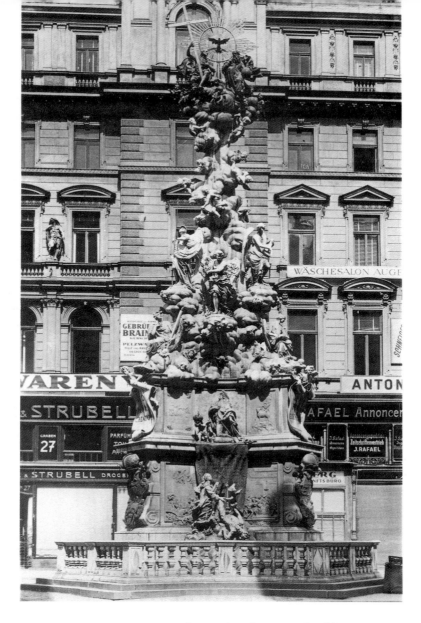

Pestsäule, plague column, Vienna, Graben (1682-94) by Matthias Rauchmiller (1645-86), with much sculpture by Paul Strudel and design by Fischer von Erlach and Ludovico Burnacini

depicted is the triumph of learning over envy and ignorance, a picture in which Fame holding aloft the medallion of Charles VI demonstrates that it is an allegory on Habsburg patronage of the arts and learning.[41] This kind of learned allegory could also be employed for other realms of art.

Indeed, another related side to Fischer's activity that was to be developed during the reign of Charles VI was already anticipated by his collaboration

with Paul Strudel and Ludovico Burnacini on the *Pestsäule*, the column put up on the Graben in Vienna as a votive offering after an epidemic of the plague had been overcome. Burnacini had added clouds to the original design, transforming the whole into a livelier, more baroque conception. More significant, the very fact that this was the kind of public monument that the Habsburgs commissioned says something about their differences with Polish or, for that matter, Silesian patronage. Where Rauchmiller had done dynastic tombs in Silesia and where an earlier Polish king had put up a column to a predecessor (the Sigismund column in Warsaw), the Habsburgs had him work here on a religious monument, that at the same time has audible political overtones.

This monument had originally been conceived in 1679 and hence became the first in a series of plague columns in the Habsburg lands. It represents another aspect to the universal claims of the Habsburgs, which had been conceived around the time of the fateful siege of Vienna. The omnipotent Holy Trinity, seated on clouds, rules over angels, men and the *monarchia austriaca*, symbolized by the emblems of the constituent parts of the realm; the Emperor Leopold kneels in prayer before Faith, acting as an intercessor for his people and realm. It is implied that his victorious beliefs (*siegreichen Glauben*) caused the plague to dissipate, like the ring of Turks who had encircled Vienna. Angels carry emblems of rule down to him, as if signifying that he rules as divine regent, in keeping with contemporary ideas of the divine right of monarchs. Furthermore, the veneration of the trinity by the emperor in this monument could at this time assume an especially anti-Moslem (also possibly anti-Jewish), anti-Unitarian (Protestant) connotation.[42] The monument thus gave visual expression, or a political turn, to the popular, proto-patriotic (albeit bigoted) preaching of Abraham à Santa Clara.

Unlike the situation in Poland, this kind of militancy also assumed a specific dynastic character in Austria. In the east Sobieski had joined many other Catholic magnates at this time in commissioning works for the church of Święta Lipka (Heilige Linde), a pilgrimage spot in East Prussia focused like the Mexican shrine at Ocotlán around a miraculous *acheiron* (an image made without hands) that was promoted by the Jesuits as a focus for missionary activity. There he had paid for a painting by Altomonte. But in contrast with this general sign of devotion, the Vienna plague column stressed the traditional virtue of piety in its specifically Habsburg or imperial guise.

Understanding this aspect of Habsburg propaganda sheds light on much art and architecture done at this time. One virtue of the ancient Roman emperors with which the Habsburgs as Holy Roman Emperors could definitely associate themselves was piety, the virtue of pious Aeneas, ancestor of the Julian clan. Piety was also a virtue stressed in medieval treatises, such as the *Miroir des princes*, a model for holy behaviour. In contrast to other Renaissance notions for a ruler's behaviour, as most notoriously that of Machiavelli or the *étatisme* of Louis XIV, the Habsburgs claimed to rule through this virtue,

in conformity with seventeenth-century notions of religion as the legitimate foundation for rule. Piety had added fame to the dynasty; it had enabled them to turn back the Turks and the French. In this way the images inherent in the trinity of Justice, Wisdom and Mercy, seen on the plague column, which may all be interpreted as prototypes of monarchical virtue, could be regarded as those of the Habsburgs.[43]

In translating the history and fate of the Empire and its people into a sacred history, this project can also be related to that of Fischer in his *Entwurff,* where Fischer's own architecture is the culmination of world vision from the Temple of Solomon. Moreover, the claim of the Habsburgs for a particularly Roman Catholic devotion to the Eucharist, and their veneration of Mary, of the Cross and of the Trinity, provide a rationale for their promotion of piety and their support of the church: as a truly Holy Roman Emperor, the Habsburg dynast's aspirations could be embodied in other ecclesiastical productions. These were already present in the initial designs for the Peterskirche nearby on the Graben in Vienna, a church that had been founded by Leopold originally in 1679, but was executed, most likely by Hildebrandt, considerably later. The design of this church combines baroque towers, set at angles *alla Romana* and a Roman ideal central plan and a dome over it; along with its Italianizing style, it seems to indicate an early interest in symbolic plans and architecture on the part of the court.[44]

Fischer's designs for the Vienna Karlskirche represent the summa of ecclesiastical art in union with dynastic symbolism, the supreme expression of a quasi-Leibnizean ideal of universal harmony in an imperial guise, which was realized during Charles VI's reign.[45] This church can be interpreted as a form of imperial ecclesiastical art. As the last church in his book, Fischer's design crowns a world vision initiated by the appearance of the Temple of Solomon at the beginning. His church also embodies universal architecture by its harmonization of various elements and through its symbolism expressing the ideal of a monarchy, whose signal virtue was claimed to be its *pietas austriaca.* A votive church, the Karlskirche presents an ovoid centralized space combined with an axial arrangement, suggested by the emphasis on its Pantheon-like temple front; the Roman nature of the plan also incorporates lateral elements, with the suggestion of welcoming colonnades, as found at St Peter's, Rome. Simultaneously there remains the two-tower facade of the Middle Ages, although these towers are pushed to the sides. At the same time the ideal of an ancient temple is reinforced by the flanking victory columns. These columns in turn recall a Biblical reference to Hiram's placement of columns before the temple, while they are also capped in such a way that is even reminiscent of minarets. The imperial counsellor Carl Gustav Heraeus spoke of Vienna both as a new Rome and a new Constantinople, and finding a recollection of minarets here may not be so far-fetched, when one considers that Charles, like Leopold, was a ruler who was regarded as a conqueror of the Turks: hence he could be seen as a victor over pagans, as a new Constantine, who would

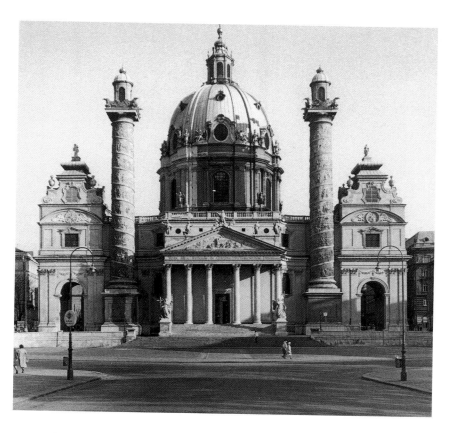

eventually retake Constantinople itself. The two columns are moreover spiral, the so-called Solomonic columns, and

Karlskirche, Vienna (begun 1716, completed 1737), by Johann Bernhard Fischer von Erlach

accordingly directly evoke Solomon's Temple; indeed Solomon's columns were named 'he who gives strength' or 'strength' itself, thereby also suggesting the Christian virtues of fortitude and constancy, which were considered to be the particular personal virtues of the Emperor Charles VI. At the same time, they suggest the traditional Habsburg device of the pillars of Hercules, whose appearance here was especially meaningful, since, as noted, Charles VI had claimed to be king of Spain, the land most closely associated with the Pillars of Hercules (Straits of Gibraltar) and with the Spanish Empire overseas, the proof of world dominion; during the War of the Spanish Succession, he had also lived in Spain. Furthermore, while the columns presented a frieze with the deeds of the saint, Carlo Borromeo, to whom the church is dedicated, in their historiation they also resemble the column of Trajan in Rome. The first idea for these columns had been to have them present narratives of the lives of Charlemagne and Charles the Bold, namesakes of the emperor and, respectively, the putative founder of the empire and his Burgundian ancestor. It may

be said that the central plan of the church recalls that of Charlemagne's Palatine Chapel in Aachen. The whole makes this work into the epitome of a Holy Roman Imperial ideal.

In ecclesiastical art and architecture the approach of churchmen does not seem so different from that of the court.[46] It should be remembered that many high clerics were in effect also aristocrats and could thus be identified with many common interests in the culture of the time. The monasteries and the secular clergy obviously supported the same cause of the Catholic Church. Moreover many monastic establishments held land directly as a result of entitlement from the crown. Churchmen were also often implicated in the affairs of the court. The close association of crown and Church pertained especially to Hungary, long a battleground with the Turks, where the sense of Christian triumph and crusade could be intense. Hence just as the Holy Roman Emperor could emphasize his piety, the Church could also assume triumphant, even imperial aspects.

One striking case is the remarkable lead sculpture created by Georg Raphael Donner (1693–1741), unusual for a work of the 1730s, which suggests the continuation of the spirit of these works through the first part of the eighteenth century. Donner was a leading artist, who had also been associated with the court, in that he had made an allegorical portrait of Charles VI in the guise of a Roman emperor. Donner was called by Imre Esterházy, the primate of Hungary (from his see in Esztergom), to work in Hungary in Poszony, the modern Bratislava, now capital of Slovakia and then of Upper Hungary, where he set up an important workshop. For the St Martin's Church in Bratislava Donner executed a sculpted altarpiece in the so-called Primatial Chapel, which, as in other works by the artist, successfully depicted the prelate's appropriate devotion by showing him in the statue with a genuine expression of piety. On the other hand, for the (former) high altarpiece of the church Donner executed a figure of St Martin on horseback sharing his cloak with a beggar; but Martin is shown in the guise of a hussar and thus almost seems to be a Hungarian warrior fighting a Turk.[47]

Comparable expressions of this spirit can also be found in the multiple monastic constructions that went up in the first third of the century. These may regarded in part as a response to immediate circumstances on the part of the monasteries, especially near Vienna, in Lower Austria, but also in Hungary in areas that had been devastated by the Turks, where there was a need to rebuild and repopulate, and also the chance to have more land. The monasteries were often the leading social and economic institutions left in the region. They thus had the means to build and also the desire to express their importance, political as well as social.

There resulted the construction of a series of impressive monasteries and cloisters, which became centres of recovery in these regions. Secular reasoning clearly does not account for all that was happening in these works. Since most of this construction was carried on by the older orders, as opposed to the

Jesuits, it cannot be equated with the thinking of the Counter-Reformation. Pastoral reasons also cannot account for the proximity of several huge monasteries situated near each other in the Traisen, Wachau and Danube area.

In these monuments there may rather be no strict division of the pious from the political, in function, design, symbolism or style. If it has been suggested that the palaces of princes are the residences of gods on earth, in their layout and space abbeys are clearly also like palaces for princes of the Church (and in fact in Germany some abbots did retain this sort of secular status as well). The allegiance to the imperial court, which also helped these institutions thrive, and the association with the empire, whose constitution gave them political importance, seem expressed in these buildings.

The comparison of palace to abbey enables us to consider the design of churches such as Melk to be like those of great fortresses. Melk has that kind of position, perched high above the Danube, where it was rebuilt from 1702 by Jakob Prandtauer.[48] While the Benedictines from the initial foundation at Subiaco on had a propensity for hillside (or hilltop) foundations, at Melk Prandtauer in fact deliberately altered the orientation of the church to make the most of the geographical situation, placing its entrance to the west, with a gateway, resembling a triumphal arch, before it. For a visitor coming down river this apparent western entry may well have seemed to suggest an image of the Church triumphant. It was however inaccessible, so the visitor must actually have had to enter from the east, through a gateway which in style and symbolism might recall the imperial architecture of Fischer von Erlach, in that the building itself resembles Fischer's Palais Trautson in its form, while the double columns placed before it recall the Pillars of Hercules, an imperial symbol.

This kind of reference also provides a key to the disposition of spaces and their decoration inside, where suites of rooms, like those in many monasteries along the Danube, were designed with *Kaisersaale* and *Kaiserstiege*. These imperial rooms and stairways were designated as such, so that the emperor himself might stay in them. Once one passed through a stairhall at Melk, one arrived at a marble room in one *enfilade* (set of rooms) on one side of the church, while the other side was occupied by a library. These rooms had ceilings frescoed with illusionistic allegorical representations by another of the leading Austrian painters, Paul Troger (1698–1762): the marble room with Hercules Heroicus, the triumph of moderation, the library with Hercules Christianus, the triumph of divine wisdom. In their appropriation of Hercules imagery, which of course is not really Christian, and in the location of these rooms at the end of an imperial suite the assumption must be that this allusion is to the emperor, a new Hercules. It is then he who in conjunction with the church triumphs over vice and promotes wisdom, and although these paintings are somewhat later than the rest of the plan, they complete its message. The church, adorned with marbles and Rottmayr's frescoes of the triumph of St Benedict and of saints of the Benedictine order, lies between. They

'Hercules Heroicus', Allegory of Virtue, fresco in the Marble Hall, Melk, 1731, by Paul Troger

complete what has rightly been called a *Gesamtkunstwerk* of the visual arts.

Melk may stand for a series of splendid monastery churches, which in their pictorial, sculptural and architectural schemes, as in their formal combination of elements, trumpet forth the church triumphant in a way not so different to the imperial baroque of *Vienna Gloriosa*. They turn the Austrian lands into a kind of sacral landscape. Out of the many examples of this sort one may pick for brief mention, St Florian in Upper Austria, as a sign of the widespread connection between the imperial house and the great monasteries of Austria, and the interconnections between the monasteries themselves. Since the rooms of Melk are not in a pristine state, a partial substitute for some missing details exists in this abbey, another work partly by Prandtauer. Here the stairway was erected in 1706–14 by Prandtauer for the ceremonial entry of the ruler, as he disembarked from his boat in a flotilla which might have passed along the Danube on its way to or from a Reichstag in Germany. This stairway, like that at the Vienna Belvedere, facilitated ceremonial, in allowing the prelate to greet his visitor on an appropriate level. The courtyard was also organized around this grand staircase, which again of course had nothing to do with the ecclesiastical function of the monastery.

Many other comparable examples can be found at places like Zwettl and Altenburg, and also in Hungary: one may point to two examples that seem especially demonstrative of that shared climate of *pietas austriaca*.[49] One late example from *c.* 1730, the monastery at Klosterneuburg, was by the younger Fischer von Erlach and Domenico d'Allio. The Escorial was clearly the idea behind Klosterneuburg. The Escorial library was one of the sources for the Vienna library. The Escorial palace was a church-cum-monastery complex built for Philip II of Spain, combining religious and royal functions. Charles VI had been king of Spain, and although he had lost his crown, he still styled himself as Spanish king. Hence here is recalled the world of Philip and even

more that of his namesake Charles V, who had been king of Spain and Holy Roman Emperor. Charles VI thought of retiring to Klosterneuburg, much as Charles V had retired to Juste, but a Klosterneuburg rebuilt according to the plan of El Escorial. In its layout and design, Klosterneuburg resembled not merely the Escorial, but became a super-imperial Escorial, just as Schönbrunn had been a super-Versailles; each of its courtyards and blocks was separate, with a dome over each block; each dome itself suggested a royal or imperial tone, made manifest by a crown placed on each block, a crown pertaining to each of the lands ruled by the Habsburgs. Though this grandiose plan was never completed, Klosterneuburg abbey thus became no longer simply a monastery, but a church turned into a palace complex, an imperial statement.

Another incomplete Escorial-like plan was made somewhat earlier, from 1719 on, at Göttweig, a Benedictine monastery relatively near to Melk, in the Wachau. This was designed by Hildebrandt and also suggests the intertwining of imperial and religious ideas. Like Melk or Klosterneuburg, it again seems like a fortress perched high near the Danube valley. This may refer to the idea of the church as a fortress of God, but, in the light of the Turkish incursions that had just occurred, it may also be a practical response to the problem of self-defence. In any instance, Göttweig also possesses the quality of a residential palace, with pedimented blocks and the church set in the centre; it is this layout combining a monastic with a palace plan that recalls the Escorial.

The imperial or royal reference is apparent in the fresco by Paul Troger that surmounts the grand imperial stairway. Here the image is not that of St Benedict in glory, nor is it an allegorical figure of the triumph of Hercules or of light, in the guise of Apollo, as at other sites. Here the procession of the sun through the heavens may in part recall the procession of the clergy, which reminds us that so much of the life of these institutions took place in ceremonial processions, whose way is indeed marked out by the layout of the monasteries themselves. The light that is to illuminate the world may also be conceived as the light of faith. But the figure who brings this light is not simply an idealized figure of Apollo; the face of the pagan god is that of Emperor Charles himself. This form of secular apotheosis of a ruler may recall the depiction of Wallenstein in a similar pose as Mars in a chariot, but in the context of the monastery, Charles VI must be seen as a true Holy Roman Emperor. On the one hand, this image expresses the triumph of *pietas austriaca*, which moved so much art and architecture during this age in the Austrian lands. On the other hand, though not directly commissioned by him, it may remind us of the intensive patronage of this Habsburg emperor, which was to provide a beacon, lighting a path for other princely patrons in the Holy Roman Empire.

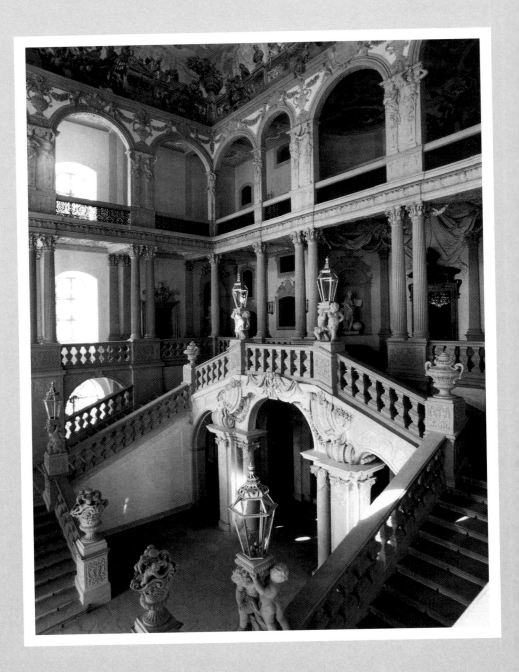

EARLY EIGHTEENTH-CENTURY ARCHITECTURE, ART AND COLLECTING AT THE GERMAN COURTS

Stairway, Schloss Weissenstein, Pommersfelden,
1711-18; building by Johann Dientzenhofer,
stairway by Johann Lucas von Hildebrandt

SPEAKING OF THE EIGHTEENTH-CENTURY RULERS OF CENTRAL
EUROPE, FREDERICK II OF PRUSSIA PROVIDED WHAT HAS BEEN TAKEN
ALMOST AS AN EPIGRAPH OF COURT CULTURE IN GERMANY DURING
THE EARLY EIGHTEENTH CENTURY. Frederick remarked,

> *There is not one of them, down to the youngest son of a youngest son of an
> appanaged line, who does not preen himself on some resemblance to Louis
> XIV. He builds his Versailles; he has his mistresses; he maintains his standing
> armies...*[1]

It would at first certainly appear true that during the late seventeenth and
especially the early eighteenth century the Sun King shone brightly on many
courts throughout the continent. Many contemporaries noted how bedazzled
German visitors were by France, despite the War of the Spanish Succession
which ranged many of the German states against the French for more than the
first decade of the eighteenth century. The physical presence of French artists
(and musicians) in Central Europe that ensued meant that a far-reaching
reorientation of culture occurred during these years. Painters such as Louis de
Sylvestre and Antoine Pesne, architects such as Nicolas de Pigage, lacquerers
such as Gérard Dagly and a host of other artists, craftsmen and gardeners came
or were called to apply their skills in Germany. Where this change had not
already occurred, they helped to turn the international language of culture in
many places from Italian to French.[2]

But while Frederick II himself was later to build a palace he called

Sanssouci, and otherwise patronize and collect works by French artisans and artists, as shall be discussed in Chapter 16, this famous Francophile was also notoriously unable to appreciate what was being done by his contemporaries in mid-eighteenth-century Germany. Although he has often been treated as a German hero and called Frederick the Great, the Prussian king in fact deprecated the culture of the lands around him.[3] He also warred against Austria and Russia, and was filled with disdain for Poland, in the first partition of whose territory he participated. Although Frederick is styled the art-loving king, it does not therefore seem likely that he would have been aware of, or would have admitted that there had been, other alternatives to the model of Versailles (including Marly and in his own case especially the Trianons) in Central Europe.

A critique of Frederick's observation thus provides a good introduction to this chapter. Without denying the impact or significance of Versailles, and more generally France, it may be suggested that the Bourbon sun may often have appeared so bright that it has blinded us to other alternatives for court art in the late seventeenth and early eighteenth centuries, and to the German translation and transformation of foreign sources. Versailles was not the only model available. Other courts took other paths: two of them, Poland and Austria, have already been examined.[4] As resplendent and captivating as it no doubt still seems to us, in order to see the fuller picture, we must therefore try to look away from the radiance of Versailles, to take the alternatives into account and also attempt to understand the more general political and social situation. In a world dominated by princes, court life was centred in the residence. As Friedrich Carl von Moser had defined it in his *Teutscher Hofrecht* of 1754–5,

> The residence is the regular constant dwelling of the ruler at that place where the actual seat of the court and the colleges [of government] are. Here the ruler is actually at home, and usual custom is to be seen in the assessment of ceremonial and the determination of its rules, since at pleasure and country houses much is left away, or rather neglected...[5]

As studies of late seventeenth-and eighteenth-century court society in the empire as well as in France have indicated, custom and ceremonial served the interests of the court in becoming 'a theatre of *Selbstdarstellung* (self-presentation)'. And as so often before, music and the arts had roles to play in the expression of authority and the search for reputation. In particular, newly built palaces provided an appropriate architectonic setting, especially for rulers whose residences had not yet recovered after the ravages of seventeenth-century warfare or who otherwise wished to modernize older settings. This process often involved the adaptation of older structures to the newer needs of ceremonial.[6]

The desire for distinction was also driven on because this was a time in which the rulers of older dynasties, including the Habsburgs and the Romanovs in Russia, and relatively new ones (the Bourbons in their role as

rulers of France may be placed among them) found a need to assert their importance. In the space of two decades several German princes became kings, including the rulers of Brandenburg, Hanover and Saxony in respectively Prussia, England and Poland. Other courts, like that of Bavaria, aspired to a similar status. The major courts were emulated by a host of princelings.

While collecting and patronage of the figural arts continued to provide possibilities for the expression of an ideology of magnificence and grandeur, the palace complex became a favoured form of expression for a further reason. Many princes in the empire were themselves interested in architecture or designed buildings. Emperor Joseph I (reigned 1705–11) had been instructed in architecture by Fischer von Erlach. Augustus the Strong of Saxony not only provided sketches for his numerous projects but talked of 'our special love of buildings with which we are wont to amuse ourselves.' Max Emanuel of Bavaria entertained himself similarly by drawing while he was in exile, saying that 'the mere thought of future building gives me pleasure when I look at my drawings'. Lothar Franz von Schönborn talked about 'his stairs' in Pommersfelden, saying 'my stair must remain, which is my invention and my masterpiece'.[7] Where in the sixteenth century it may have been *bon ton* to collect or to dabble in the arts, it now became a passion.

The expression of absolutist claims often entailed the production of vast buildings, in Germany as in France. As Moser said, 'It is clearly not easy to be a ruler in Germany without owning a regular residence, or some pleasure, hunting and country palaces'.[8] By mid-century Montesquieu (looking on from the other side of the Rhine) could observe that 'Versailles has ruined all the princes of Germany'.[9] Extensive construction in Bavaria during the early part of the century contributed to the ruin of that court's finances: its pretension to the imperial throne, and the war that resulted therefrom in the 1740s, compounded the financial disaster.[10]

Because of the complicated political and religious divisions of the empire, cultural orientations could also parallel political or ideological allegiances. On the one hand, politics no longer necessarily followed religious divisions, as the Habsburgs' alliance at the beginning of the century with England and with the north German houses against Bavaria and France or, for that matter, the Habsburgs' rivalry with Bavaria indicate.[11] Even more than had occurred previously, political or dynastic ambitions might determine actions, as was dramatically demonstrated during the 1690s, when Augustus of Saxony, the ruler of the land where the Lutheran Reformation had been introduced, converted to Catholicism in order to ascend to the Polish throne. On the other hand, theories of absolutism in the German states (and not only the Protestant ones) could be different from those in France and emphasize responsibility towards one's subjects as well as rule over them, princely reputation along with service to the state: as we shall see, these ideas also had an impact on the arts.[12]

Frederick's comments can be evaluated in this light. Conditions were favourable not only for the adaptation of projects or designs of French

inspiration, but for other schemes for self-promotion and interest as well, depending on the orientation of the individual court concerned. A rich variety of aesthetic, ideological and intellectual nourishment existed for the *Bauwurm* of the eighteenth-century courts.

In another context Frederick II himself tacitly acknowledged this variety, when he listed the major works that had been produced earlier in the century. Frederick indeed recognized the extraordinary accomplishments of the preceding era when he said that,

> *What one sees of beautiful building of the early eighteenth century stems approximately from the same time: the Schloss and the Arsenal in Berlin, the Imperial chancellery and the church of San Carlo Borromeo [the Karlskirche] in Vienna, the Schloss at Nymphenburg in Munich, the Augustus bridge and the Zwinger in Dresden, the electoral Schloss in Mannheim, and the Schloss of the Duke of Württemberg in Ludwigsburg.*[13]

Following Frederick's own recommendations, a highly selective account of the vast amount of building and decoration of the early eighteenth century may do best to concentrate on just some of these centres, starting, as he did, with the activities of his predecessors in Berlin.[14] Frederick II's domain of Brandenburg-Prussia had risen to importance in the century before his accession. Although its margrave possessed the electoral dignity, Branden-burg was long one of the poorest areas of Germany, called the 'sandbox of the Holy Roman Empire' because of its bad soil, and it was gravely damaged by the Thirty Years' War and its aftermath. Only thereafter, during the reign of the Elector Frederick William (Friedrich Wilhelm, ruled 1640–88), known to history as the 'Great Elector', did Brandenburg gain in importance. Frederick William warded off the Swedes, winning a decisive victory at the battle of Fehrbellin in 1675, whereby their domination in northern Germany was broken; in its wake Prussia gained lands in the north, as it had continued to do in the west. In 1660 the treaty of Oliva gained autonomy for Prussia from Poland. Frederick William also began to establish the economic basis for the rise of Brandenburg-Prussia. The 'Great Elector' opened his lands to Huguenots by the Edict of Potsdam of 1685; this was a fateful move, bringing many trained artisans and artists to Brandenburg. He encouraged manufacture; he began building and refurbishing residences in Berlin and its surroundings.[15]

Frederick William's successor Frederick III realized the ambitions of the Hohenzollerns in Prussia, which they had ruled extraterratorially, outside the Empire. After Sobieski's death, when Poland, the former suzerain of Prussia, fell prey to other powers, and when the Hohenzollerns did not heed Habsburg opposition, since the Habsburgs needed their support against France, Frederick took the opportunity to gain autonomy and crowned himself King Frederick I in Prussia, in Königsberg in 1701.[16] As suggested above, Prussia could thus now claim the same status as other German lands, including

Saxony, whose duke was king of Poland, and the newly created elector of Hanover (1692), who became king of England in 1714.

After the more pragmatic policies of the Great Elector, who had also allowed a place for the arts, redesigning his Berlin and Potsdam residences, Frederick I realized that one of the foundations of a great power in his day entailed large-scale patronage. In part this too was related to other practical aims, to improve manufacture and encourage commerce in the realm; the growth of the arts in Brandenburg-Prussia can be linked with the need to train artists and artisans. Hence an academy for the arts was founded in Berlin in 1696. This foundation may be associated with other educational establishments, including the university of Halle in 1694, the beginning of new schools and the foundation of an academy of sciences in Berlin. Along with the Dresden academy, whose foundation date is uncertain but unofficially may be earlier, this is the earliest court-sponsored academy in the north.[17]

Frederick I saw the need to transform his residential capital of Berlin and create a fitting forum for an ambitious new monarchy. He had sculptural monuments and buildings designed accordingly. Frederick had, however, almost to call his royal metropolis into being, founding whole quarters of Berlin, establishing institutions and constructing public buildings.

While some artists came to Brandenburg from France, the cultural orientation of Brandenburg during the time of Frederick William (the Great Elector) and the first years of Frederick I was towards the Netherlands. The Hohenzollerns had been allied to the House of Nassau, with whom they were linked by marriages. Frederick William had also been in exile in the Netherlands and was a friend of Johann Maurits of Nassau-Siegen, the important collector and patron. Alongside Holland, Brandenburg in fact fought France in 1672 and again in the 1680s. With England and the Netherlands (and the Habsburgs), Frederick I also opposed France and its allies in the War of the Spanish Succession.

The case of the sculptor Andreas Schlüter provides a good example of some of the problems of interpretation involved in an assessment of the developments in and around Berlin. Schlüter's departure from Poland and his arrival in Brandenburg in 1694 appears like a harbinger of Prussia's rise to great power status, much as his subsequent move to Russia in 1714 can be associated with the rise of Russia as a European power, looking westward. Before Frederick I's coronation the first major projects that occupied Schlüter from 1696 were an equestrian monument to the Great Elector and a figure of Frederick himself on foot. Both these statues depict the rulers attired in Roman garb.[18] The iconography of these statues thus recalls Roman imperial portraits. They also undeniably display the influence of statues made of Louis XIV. In one instance the equestrian statue reveals the inspiration of François Girardon; it is also placed on a bridge, sited similarly to the equestrian statue of Henri IV in Paris. In the other instance Antoine Coysevox's statue of the *roi soleil* is the source of inspiration. We may assume that in both instances Schlüter looked toward

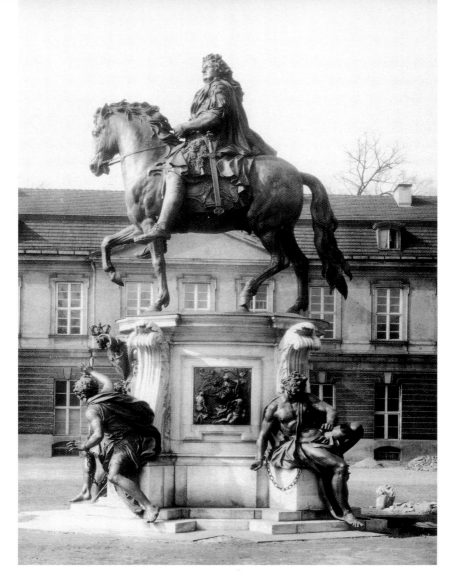

Equestrian statue of the Great Elector, now standing before Charlottenburg Castle, Berlin, 1699-1708, by Andreas Schlüter

France in attempting to produce a new imagery for Prussia.

But such possible references as do exist may also be tempered by the observation that Schlüter's affinity to French classicism does not seem initially to have been what made him attractive to the royal patrons he served, starting with Jan Sobieski of Poland and continuing with Frederick I and Peter the Great of Russia. As noted, in view of the local tradition in both Poland and Branden-burg, it was more likely that it was his perceived Netherlandish qualities that, as in Poland, specifically led to his employment at the Berlin court.[19] More importantly, something different resulted in what he did in Berlin. Schlüter's

equestrian monument can be placed within a tradition of mounted statues of rulers that goes far beyond Louis XIV, back to that of Marcus Aurelius in antiquity.[20] Medieval monuments celebrating rulers such as the Magdeburg *Reiter* may also have helped inspire it, in that Magdeburg had become Prussian after 1680. Stylistically, the attire and, more strikingly, the gesture of Schlüter's elector also recall Francesco Mocchi's monument of Alessandro Farnese in Piacenza, along with similar works by Giambologna and his followers.

On the one hand, Schlüter's image might be seen as even more vital and aggressive than others of its type, since slaves, personifying temperaments, are placed on the base; it might thus seem to express the image or mission of the new Prussian state and its growing military strength, which would eventually lead it to eclipse its neighbours and rivals, especially in the south (Saxony). On the other hand, this statue was read at the time as an image of a ruler who was bound to the service of his state.[21] Schlüter later designed sculpture in churches, including the pulpit of Berlin's Marienkirche (1703), royal sarcophagi and designs for burial chapels. All these also have little or nothing to do with French ideas.

Schlüter's engagement with architectural projects also reveals the existence of a more subtle and complicated spectrum of choices available to artists and patrons at this time.[22] The city of Berlin expanded as did the territory of Brandenburg-Prussia: several new faubourgs (Dorotheenstadt, Friedrichstadt) were added under the Great Elector and Frederick I. A tree-lined street was already planned for Berlin in the 1640s; though laid out later, this became the famed Unter den Linden. At the start of this street lies a building that occupies a key urban situation, at a point where the street turns slightly on its axis after a bridge. This is the Arsenal, a structure that also symbolically expresses quite well the direction of the state. The building was designed by Johann Arnold Nering and Jean de Bodt from 1695; by 1706 it was complete. The Arsenal has been described as a palace in the French style and compared to the work of François Blondel. But the French monarchy did not put up buildings with such elaborate designs that were intended for public use: this function again corresponds to another notion of absolutism, as does Schlüter's fine design for a postal building.[23] The difference is that structures for public purposes along with public institutions were also supported by the Prussian crown; these may be regarded as being in keeping with Enlightenment ideas, but they are also in tune with a Protestant ideal of kingship.

The finished appearance of the Arsenal is greatly affected by Schlüter's sculptural intervention. A remarkable series of heads of dying warriors is to be seen in its courtyard. Stylistically, these represent an expressive tendency in German sculpture, that is comparable to the agonized head of a damned man, done in red and white flecked marble by Balthasar Permoser in a manner that suggests the actual flames licking at the man (Leipzig, Museum). It is noteworthy that Permoser, best known for the sculpture of the Dresden Zwinger, was also to collaborate with Schlüter on the decoration of the

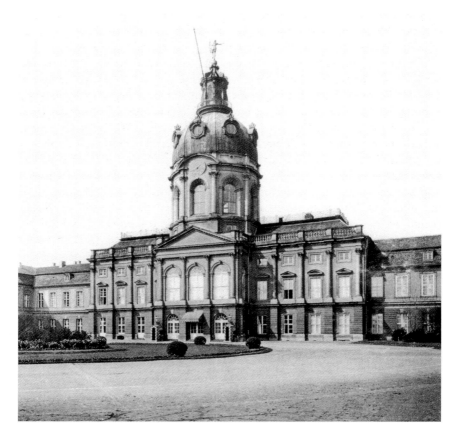

Charlottenburg Castle (Schloss), city facade, 1695-1713, by Johann Arnold Nering and Johann Friedrich Eosander Göthe (pre-war photograph)

Schloss, but what the Arsenal sculptures mean is still open to question.[24]

Unter den Linden extended for several kilometres, past what were still fields; a road and a canal would have led to a faubourg that was effectively a different city (and remained so until the incorporation of greater Berlin in the 1920s), Charlottenburg, named after the Schloss built for Queen Sophie Charlotte. This building was put up by Johann Arnold Nering and Johann Friedrich Eosander Göthe from 1695, when Nering was called in to consult on plans for the palace, and it has been argued that Schlüter was involved in the project as well.[25] In any event, the idea of the layout with canals and waterworks seen at Charlottenburg suggests the inspiration of Dutch palaces, like Honselaardijk.[26] The oval central salon was added by Nering, who himself came from Wesel near the Dutch border, and was made a dominant central feature with intercolumniations stressing its importance. The Swedish architect, Johann Friedrich Eosander Göthe, added a dome that increased the grandeur of the building. Since a dome may also be read as an image of

heaven, one might think that the palace was seen as the centre of a new Prussian religion of state, a notion which of course was to be promulgated a century later, by G. W. F. Hegel at the university on Unter den Linden.

At the start of Unter den Linden in the centre of Berlin was the Berlin Schloss, for which planning had also gone on from the start of Frederick I's reign as elector.[27] The Berlin Schloss was to become one of the largest castles in Europe, bigger than Versailles and more striking because it was placed in the middle of the city, which at the time was quite small. The royal palace thus stressed the pretensions of Berlin long before the city could grow into them.

Schlüter had to cloak the previously existing parts of the building, and solved this problem masterfully. The more or less square block which resulted may be related generically to the *cour carrée* of the Louvre, but the elevation was at least as close to the ideas of his former associate Van Gameren, and the portals with very large colossal orders of columns surmounted by sculpture, were not at all French. In the interior spaces Schlüter created majestic courtyards, leaving colonnades before the risalites (projecting or otherwise emphasized blocks, sometimes with pediments). Schlüter thereby effectively transformed what has been called an Italianate cloister courtyard into a French or northern Italian palace compound. The risalites masked large impressive stairways, with massive stucco and stone sculpture, also in some of the rooms, which were ultimately inspired by Michelangelo or Bernini, but spoke their own language. Some of the rooms also had impressive sculpture and paintings with allegorical subjects glorifying the Hohenzollerns.

Courtyard of Schloss, Berlin, beginning *c.* 1698, transformed by Andreas Schlüter (pre-war photograph)

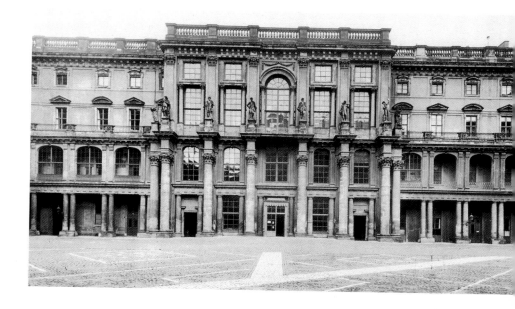

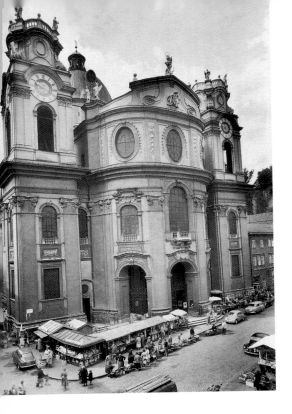

Collegienkirche (Collegiate Church), Salzburg,
1696-1707, by Johann Bernhard Fischer von Erlach

Although Berlin demonstrates that one could be opposed to France and still not follow Vienna so closely, with all due qualifications about the spread of a *Reichsstil* throughout Central Europe, it may nevertheless be argued that the image created, if not merely by the Viennese court, then by artists and architects working there, was dominant at least for those residences whose patrons were closely tied to the imperial court. Fischer von Erlach provided a plan for a *Lustschloss* (pleasure or garden palace) in Berlin for King Frederick I of Prussia; with fifty bays this plan was even more gigantic than the plan for Schönbrunn and may have had an impact on Schlüter's own plans.

Moreover, despite their setbacks in the Thirty Years' War, the Habsburgs in the eighteenth century were still hardly a negligible quantity in Germany. As R. J. W. Evans has pointed out, there is a broad belt running through the middle of Germany that stretches from Swabia through Franconia to Thuringia and even to parts of Saxony, where rulers looked to Vienna.[28] This belt began in Salzburg, which until the beginning of the nineteenth century remained an independent archbishopric but which, as Evans has also suggested, behind its grand facade resembled more and more a piece of provincial Austria. In many of these places it was exclusively Austrian families that became archbishops and canons. This situation is reflected in architecture, where in fact the most important buildings of the eighteenth century were built by Fischer von Erlach and Hildebrandt; these include the University and Hospital Church, Schloss Klesheim, Salzburg's Schönbrunn and Schloss Mirabell, Salzburg's Hofburg.

Commissions from Salzburg represent the major works executed by Fischer in the 1690s, so it may be said that the same harmonious fusion of elements that characterizes his work in Vienna was first realized there. This is evident in the Collegiate Church, which represents a synthesis of central and basilican plans; it has elements comparable to both Italian designs, like San Carlo ai Catinari in Rome, and to French, like Jacques Le Mercier's Church of the Sorbonne; it also has a Borrominesque convex facade. It also includes symbolic

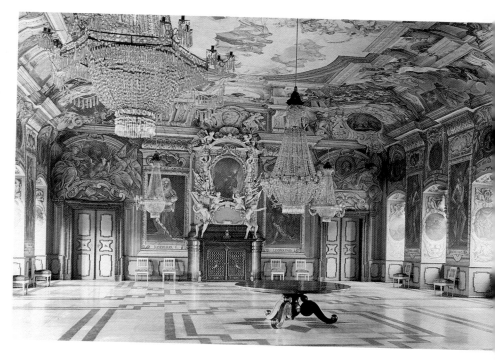

Neue Residenz (Bishop's Residence), Bamberg, begun 1695, by (Johann) Leonhard Dientzenhofer, interior of *Kaisersaal*, with paintings by Melchior Steidl, 1707-9

references, such as those to the Temple of Solomon, in interior columns. The employment of Fischer von Erlach itself results not only from the orientation to Vienna but from the break with Italians, who had earlier dominated the arts in the city, because Archbishop Thun-Hohenstein felt personal antipathy to Italians.[29]

A reconsideration of the *Reichsstil* thesis is also instructive for some of the buildings put up for members of the Schönborn family, who in their position of prince-bishops were traditional allies of the emperor.[30] From 1695 to 1704 Lothar Franz von Schönborn, prince-bishop of Bamberg, which was one of several seats among those controlled by his family in the Main region, had his residence redesigned by (Johann) Leonhard Dientzenhofer, who came from a family of Franconian architects whom we will encounter again. The building's superimposed orders were inspired by the designs of Abraham Leutner, another Franconian who had begun his career at the Černín Palace in Prague; they make it into a local variant of Italian *grandezza*. The interior of the Bamberg residence provides an early example of the system of decoration employed for palaces in the late seventeenth and early eighteenth centuries. Its ensemble includes a *Kaisersaal* with an illusionistic ceiling; rooms covered with tapestries; a room containing a Chinese cabinet with inlaid lacquer paintings of the sort that was soon to become modish; and rooms covered with boiserie.

This kind of building was however soon replaced by what Lothar Franz called the *Teutscher Gusto* and what his nephew Friedrich Karl von Schönborn more precisely called *Wiener Goût*. Resident in Vienna for three decades as vice-chancellor, then chancellor of the empire, Friedrich Karl sampled this taste directly in his garden palace, which he had built by the architect of the Vienna Belvedere, Johann Lucas von Hildebrandt. As archbishop of Mainz Lothar Franz served a key role as chancellor of the Empire, as did Friedrich Karl, who became imperial vice-chancellor after Joseph I's death; both can be identified with the *Kaisertreu* party in the Reich. Whether or not Hildebrandt's work for them can also be called evidence of a *Reichsstil*, Lothar Franz did reveal a pointed, competitive attitude when he expressed himself in macaronic Italo-German: '*per dir'il vero, man ist dahier gewiss in besser und splendideren Gusto als in Frankreich selbsten*' (to tell the truth, one is certainly in better and more splendid taste than in France itself).[31]

In 1710 Lothar Franz brought Hildebrandt to Pommersfelden to correct design problems at the Schloss Weissenstein, the country palace that served him as summer residence in his position as prince-bishop of Bamberg. This building had been begun by another Dientzenhofer, Johann. Hildebrandt transformed its facade into a semblance of the new reformed international style of Viennese architecture of *c.* 1700. The problem in calling it Viennese, however, is that it precedes similar designs in Vienna. A related problem exists in the assessment of the interior. Pommersfelden is important

Residence (Bishop's Residence), Würzburg, 1720-4 and 1729-44, by Johann Lucas von Hildebrandt and Balthasar Neumann

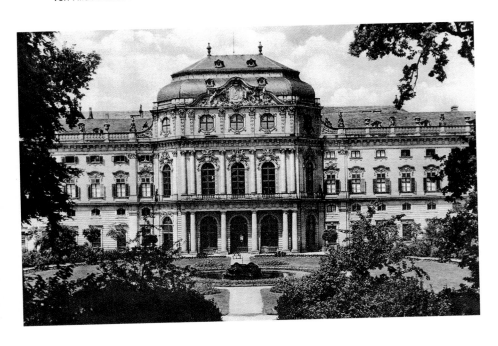

for its ensemble; on the one hand it has a grotto, a feature that can be called Italianate; on the other it has a *Spielgelkabinett,* or mirror room, as well as other rooms with French-inspired boiserie. It also has a room with Chinese porcelain and a marble gallery with important paintings adorning the walls. Many of these elements had already appeared in Bamberg, and their origins are also not Viennese. In the instance of the porcelain room, it has been argued recently that it may ultimately be Dutch and, as noted, French influences also affected it.

Pommersfelden's grand stairway, which Lothar Franz claimed for himself, combined a form resembling that of the arcaded courtyards of Bohemia and Moravia with a symmetrical, turning stairway that doubled back on itself. For this stairway the Versailles ambassadors' stairway provides an important precedent. Set in the centre of the building, the stairs at Pommersfelden furnished what has been called a grand theatrical backdrop for the elaborate etiquette of court ceremonial. But this stairway, although it has other antecedents, actually antedates that in the Vienna Belvedere. Pommersfelden also anticipates the building of the stairway in the Würzburg residence, another grand design that culminates the sequence. The stairs at Würzburg were built inside the Schloss belonging to the neighbouring archbishop, another Schönborn, Johann Philipp Franz, who had started his building in 1720–24, with an exterior designed by Hildebrandt. The final *Kaiserstiege,* the great Würzburg turning stairway, was however only finished between 1729 and 1744 by Balthasar Neumann: their design created even greater possibilities for the theatre of representation. The appearance in Würzburg of frescoes by Tiepolo from the 1750s suggest however that this complex can really be only properly considered with other monuments of a slightly later epoch.

The final work in the series of Schönborn Schlösser to be considered in this chapter is the Damiansburg at Bruchsal; this building was erected for Damian Hugo, bishop of Speyer and heir to Lothar Franz. It represents a response to the French destruction of the episcopal palace in Speyer. It also strikes a different note, and the means used to finance it speak for the difference. Damian Hugo relied on careful financing and the support of local industry, which enabled him to leave a surplus despite the costs of building; this contrasts with Friedrich Karl's graft or his extortion of Jewish subjects. Bruchsal's new tone is seen in its brick construction as well as in its spacious layout, for which there was no doubt a practical reason as well: the desire for protection from fire after the disastrous experience in Speyer. Although Bishop Damian Hugo was attached to Vienna, and Neumann worked on this building, there seems in it but a faint echo of Vienna or any possible trace of the so-called *Reichsstil;* rather, as the initial plans by Johann Conrad Schlaun suggest, connections are to be seen with Westphalia and the Netherlands.[32]

A good example of a lesser court, and of the types of choices available for rulers who were not that significant, is provided by the last court mentioned by Frederick, that of the duke of Württemberg.[33] Württemberg and its new

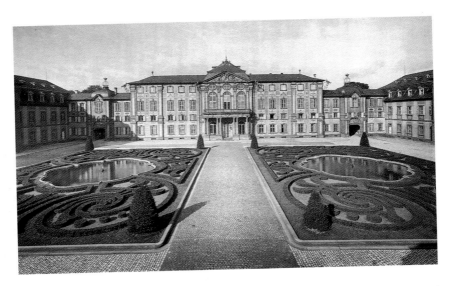

Schloss Damiansburg, Bruchsal,
1720-41, by Johann Georg Seitz, Michael
Ludwig Rohrer, Anselm Freiherr Ritter
zu Groenesteyn and Balthasar Neumann

ducal residence of Ludwigsburg may stand
for a host of other princes in south-western
Germany who also established new residen-
tial cities. Among them are the rulers of
Baden-Baden who established Rastatt; those
of Baden-Durlach, the founders of Karlsruhe; and those of the Palatinate, who
built Mannheim, which Frederick does mention.[34]

Eberhard Ludwig, duke of Württemberg, ally of the Habsburgs and the
English at Blenheim, built Ludwigsburg from 1704 (the year of the battle), in
part as an act of defiance, and later as one of need as well to rebuild his
hunting lodge, after his land had been ravaged in 1707 and his main residence
at Stuttgart had also been destroyed. His hunting lodge was however built in
the proportions of Versailles. Eberhard Ludwig seems at first to offer a typical
example of the Francophile, in that he adopted the idea of transforming his
hunting lodge into a castle. He also established a whole new town around
Ludwigsburg, much like Versailles, where a town had also developed symmet-
rically from the château. This was indeed a pattern established especially in the
German south-west, the traditional area for many petty rival rulers. In many
places a sovereign stamped his will on an entire area, calling a new city into
being; the rival Baden courts founded Karlsruhe and Rastatt, where new towns
also grew up around a Schloss.

Ludwigsburg was set up in the countryside outside Stuttgart for other good
reasons. Eberhard Ludwig was a passionate lover of hunting, and his was a real
hunting lodge. In some sense, however, Ludwigsburg was unlike Versailles, not
only because it resulted from his flight from the destruction of the residence
in Stuttgart (since one reason, after all, that Louis had moved to Versailles was
to avoid Paris and the possibility of another Fronde). Eberhard Ludwig could

not establish his court as a real centre of society in Württemberg, the way that Louis drew the aristocracy of France to Versailles. The ruler of Württemberg had to attract aristocrats from as far away as Mecklenburg; his Schloss became the centre of court life, because one of his imports, Wilhelmina von Gravënitz, 'la Graveline', became his mistress. He thus also had another reason to flee from Stuttgart, to avoid his wife and to set his mistress up

Mirror Room (*Spiegelsaal*), Schloss Ludwigsburg, stuccoes by Donato Giuseppe Frisoni

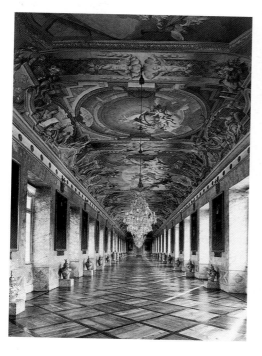

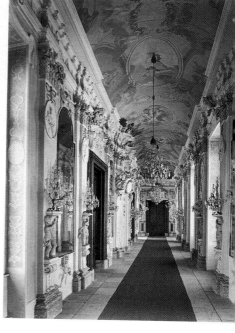

(Schloss) Ludwigsburg Palace, 1704 and from 1715; architectural design by Philipp Joseph Jenisch, altered by Johann Friedrich Nette, completed by Donato Giuseppe Frisoni; *Ahnengalerie* (Ancestral Gallery) with fresco by Carlo Carlone, 1731-83

with her own court, which understandably became a centre for play and enjoyment. The decoration and architectural design of the palace indicate its function as a site which was regarded as a place for entertainments. While the initial idea for Ludwigsburg might be related to Versailles, the actual architecture and the interior decoration are not. The exterior was designed by Germans, Philipp Jenisch and Friedrich Nette, and the interiors by Riccardo Retti, Andreas Quittainer, Donato Giuseppe Frisoni, Diego and Carlo Carlone, Giuseppe Baroffio, Pietro Scotti and Luca Antonio Columba. As their names imply, many of these were Italians; many were from northern Italy, Frisoni and Retti in fact from the Como region, like so many others of their countrymen who had come north throughout the early modern period.

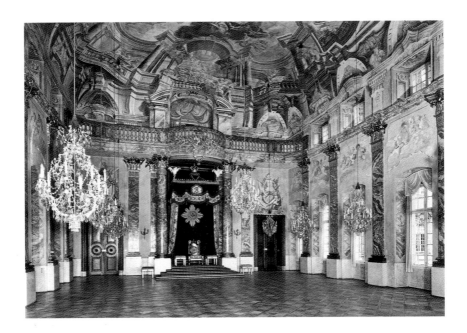

Order Hall (*Ordenssaal*), Ludwigsburg
(built 1709-12 by J.F. Nette), ceiling fresco
1731 by P. Scotti and Giuseppe Baroffio

A distinctive feature of this team is also that it had been active first in Prague: closer inspection of the elevation of the building at Ludwigsburg would bring it more into the axis of Italianate designs, like those we have encountered in the later seventeenth century in Prague or Vienna. The interiors are also quite extraordinary. The layout of spaces balances the design and explains the closed courtyard form of the whole, which also expresses the dual nature of the place as a resting spot for huntsmen and a centre for court life: the palace block consists of two ranges closed off by two *corps de logis* (wings), an older one matched by the new. Chapel matches chapel on each side, with a remarkably opulent chapel for Protestant services built in one side. A theatre is also contained in the complex. The main *corps de logis* also contains a grand stairway; an *Ahnengalerie* (gallery with ancestral portraits), with a ceiling by Carlone; grand rooms, including one for a newly founded knightly order; and not only a gallery with mirrors (*Spiegelgalerie*) but a cabinet with mirrors (*Spiegelkabinett*), as elsewhere. One of the distinctive parts of the Schloss, in addition to the theatre and the room for the order, is its area given over to gaming.

Stylistically the interiors are encrusted with stones and stucco. This is most noticeable in the *Spiegelgalerie* (a translation of the idea of the *galerie des glaces*) which shows well how the ideal of Versailles has been transformed into a different mode: this is a Versailles *à l'italienne*, where heavy stucco is matched with a suite of mirrors. In fact Ludwigsburg, though often associated with Versailles, might be seen as one of the best examples of Italianate taste. And its

idiosyncratic combination of tastes, interests and styles stands well for one of those characteristic amalgams created at the German courts of the early eighteenth century.

At the other end of the spectrum from the *Kaisertreu* party, however, was one court that can most firmly be identified with France and its culture: Bavaria.[35] The Bavarians had sided with France in the War of the Spanish Succession. After the duke of Marlborough and Prince Eugene defeated the French and Bavarian forces at the Battle of Blenheim in 1704, Max Emanuel, the Bavarian elector, went into exile. If the arts allowed a ruler to display his splendour, then in this period Bavaria could in reality claim little for itself.

Max Emanuel lived abroad in exile in the Spanish Netherlands and then in France. The French nourished his illusions of grandeur, which his dynasty was briefly to fulfil in the 1740s, when his successor Charles Albrecht became emperor as Charles VII. Max Emanuel's alliance with France and his exile there reinforced the French cultural model, so Versailles and Marly remained the ideals for Bavaria even after his return.

These experiences may account for the reason why Bavaria turned to French models. At Nymphenburg the castle which had originally been inspired by Savoy's *venaria reale* (royal hunting lodge), and was worked on by Henrico Zuccalli, became first a quasi-Netherlandish palace with canals. With the arrival of Joseph Effner, who had been sent for training with Germain Boffrand, one of the leading French architects of the day, it experienced a direct implantation of French designs. In fact Schleissheim, another major project by Effner, was built with the collaboration of the Frenchman Robert de Cotte. Schleissheim had been the site of a retreat built in the sixteenth century for William V and an early seventeenth-century palace for Maximilian I. In the 1680s Henrico Zuccalli had added

New Castle (Neues Schloss), Schleissheim, 1701-26, finished by Joseph Effner

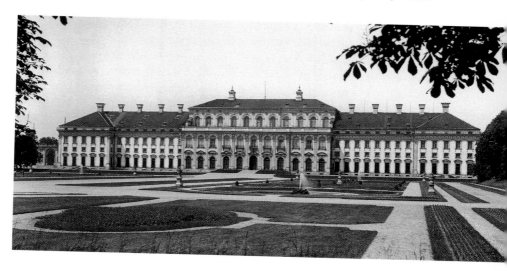

the Lustheim, an Italian-style banqueting house, with corner pavilions. Work was also begun by Zuccalli on a palace matching it, the present Schleissheim. This palace has a facade with designs that resemble those of Versailles, with separate pediments on the new wings in a manner resembling Vaux le Vicomte. In the interior rooms Effner added to Nymphenburg, and in Schleissheim the system of articulation for the walls was also later made to resemble that of French models, with its use of mirrors and portraits enclosed in *contrecourbe* (with 'C' and 'S' curves) designs. In these rooms surface ornament takes over from and dominates the structure.

Effner also collaborated with the garden designer Dominique Girard, later active in Vienna at the Belvedere, in the completion of a formal garden at Nymphenburg. Here gardens in the tradition of Girard's teacher Le Nôtre were in fact first introduced into the German-speaking lands. The Nymphenburg gardens possess axial symmetry, geometrical division into parterres and canals. As at Versailles, so at Nymphenburg a number of subsidiary garden structures were planned, including Badenburg, Pagodenburg and the so-called Magdalenenkloster, some of which will be discussed later. In response to this activity, Max Emanuel could already boast in a letter of 22 May 1712, '*Je puis vous assurer que mon jardin, bois, eaux et promenades douvoyent estre placées au milieu de la France.*' (I can assure you that my garden, woods, waters and promenades ought to be placed in the midst of France.)

Neither France nor Vienna was however the measure for another territory, whose importance in many respects even its enemy – and partial destroyer through bombardment – Frederick II was forced to acknowledge. Under Duke Friedrich August II (ruled 1694–1733), known under his title as Augustus the Strong (because of his reputed physical, not political, strength), and his son Friedrich August III the Saxon capital Dresden became a cultural leader in music and the arts.[36]

When Saxony reached its political apogee, Dresden attained a similar importance for the arts. After he had converted to Catholicism and spent huge sums on bribes, Friedrich August of Saxony was elected king of Poland as Augustus II. The acquisition of the Polish crown by the Saxon elector made Dresden the residence of a sovereign who ruled over territories from central Germany to Belorussia. Through the union with Poland, Saxony was thus transformed from what had once been a major German power into one with European pretensions. Augustus the Strong's ambitions did not stop with Poland, but after his religious conversion and the betrothal of his son to the daughter of Leopold I, he dreamed as well of obtaining the crown of the empire for the Wettin dynasty. He also dreamed of commercial and political expansion for Poland.

The radical change in Saxony's position and ambition directly affected the conduct of court life. The Saxon rulers did not neglect Poland, but their involvement of the *respublica* in the Great Northern War (the struggle for control of the Baltic region, 1700–1721) had disastrous affects on that

domain. Although in Poland the Wettin later reformed the royal administration and the army, and carried on plans for the city and palace construction (including the so-called Saxon Palace with Park) in Warsaw, the real centre of their interest lay in Dresden. It is safe to say that, whatever developments may have occurred in Warsaw or Kraków, at least for the first decades of the century, with the exception of interesting architectural developments in Lithuania, Poland did not retain its artistic energies, becoming something of a Saxon province in this regard.[37]

Augustus followed the fashion for public expression of grandeur that had been set by other monarchs, such as Leopold I and Louis XIV. The growth of the arts was thus directly related to the interests of the ruler. Having been instructed by Klengel (as Joseph I had been by Fischer von Erlach), Augustus was, as noted above, passionately interested in architecture.[38]

In order to impress visitors to Dresden and to celebrate with due pomp important events at court such as his son's betrothal, from the first decade of the eighteenth century (just the years of disaster for Poland) Augustus orchestrated festivities. Dresden thus gained fame as the festive capital of Europe. With Johann Joachim Quantz, Silvius Leopold Weiss, Johann Georg Pisendel and others in its court orchestra it may have had one of the best ensembles in Europe (introducing the oboe to Germany); eventually J. S. Bach, who had been employed at the nearby smaller court of Anhalt-Cöthen and Weimar, would also settle in Saxony, in Leipzig.

The festivities of Augustus's time surpassed tournaments and other similar events that had been held in the region in scale, duration and luxury of costumes and props. During the reign of Augustus there were masquerades, hunting parties, shooting competitions, tournaments on horseback, balls, theatrical and operatic performances, and more. In their content and scale, they not only promoted the ruler's image of grandeur but helped Dresden prosper through the creation of new trades, encouraging the visits of potentates and tourists.[39] In this way, as in many other aspects of his collecting and administration, behaviour that might be associated with absolutism could also reveal 'rational' or 'enlightened' interests.

The construction of one of the most remarkable buildings in Europe can be understood in connection with court entertainments and Augustus's interest in architecture. In much the same way the arts in Dresden in general can be connected with the interests of the monarch. For court entertainments it was important to have an appropriate setting. Hence there arose Dresden's first opera house and, more lastingly, the Zwinger. Designed from 1711 by the architect Matthias Pöppelmann, the Zwinger is a structure whose undulating curves and alternating open and closed spaces echo the quadrilles and ballets that took place inside its courtyard. The nymphs and satyrs by Permoser and his assistants that decorated its facades seem the perfect spectators for the events that occurred within. The Zwinger also served as an orangery for the rare plants that had been brought to Dresden, again suggesting the characteristic

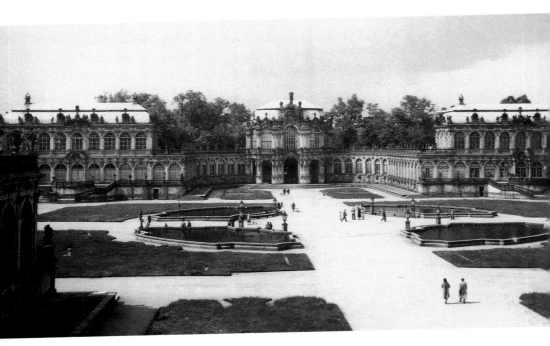

Zwinger, Dresden, begun 1709; present design by Matthias Daniel Pöppelmann (1662-1736)

eighteenth-century union of entertainment, exoticism and enlightenment.[40]

Since Augustus was a failure as a general, the Zwinger provides a good argument for the thesis that princes win immortality through great buildings as well as through great victories. The building accordingly presented a political message in the typical baroque language of allegory. Two of its focal points are a tower surmounted by a Saxon Hercules and a gateway surmounted by a crown. The crown obviously refers to that which Augustus had newly gained in Poland, while the Saxon Hercules repeats a claim made by many kings, as noted previously in this book: here it alludes however not only to a hero of invincible strength, as Augustus the Strong might have wished to be, but to the idea of a victorious sufferer. Since Hercules was also closely associated with Habsburg symbolism, he may also be a reference to the imperial ambitions of Augustus, and his ties with their house, as well as having a local resonance in Poland.[41]

The Zwinger belonged to even more grandiose plans to make Dresden into an imperial or royal capital. If Florence was the comparison with which J. G. Herder and other later visitors linked Dresden, the aim of Augustus was to make something more like a German version of Venice, a city which he had seen and admired on a visit to Italy in the early 1690s. In this vision the river Elbe would take the place of the Grand Canal. It would be flanked on either side by the beautiful palaces and linked by the great stone bridge Frederick II mentioned.

Among these palaces was to be the Dutch, later Japanese, palace. This palace was acquired in 1717 by Augustus and intended as a place for his collection. At some point in the process it was redesigned and supposed to have all its furnishings, including a whole chapel, made entirely out of porcelain.

These plans remind us that an event of capital importance occurred in Saxony at this time: the reinvention of European porcelain (whose import from China originated perhaps in Holland, as the collection's name 'Dutch Palace'

Zwinger, Dresden, begun 1709; detail, with sculpture by Balthasar Permoser and others (pre-war photograph)

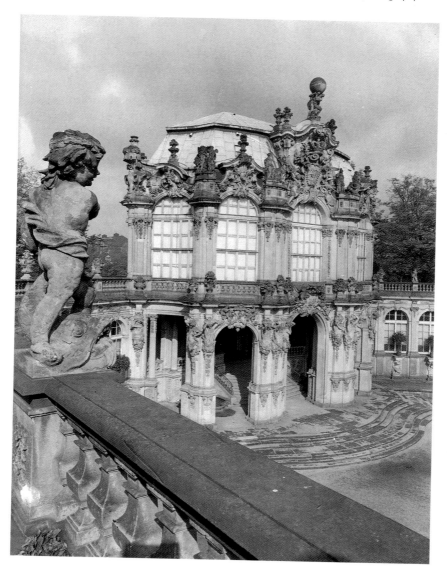

Porcelain cockerel by Johann Joachim Kändler;
European porcelain was reinvented in 1709
by Johann Friedrich Böttger (1682-1719)

implies, but spread throughout Europe). Spurred by a taste for all things oriental – the vogue for chinoiserie and japonaiserie inspired not only the Japanese Palace but the generically oriental Schloss by Pöppelmann at Pillnitz slightly up river – Augustus set as a goal the manufacture of porcelain. By 1709 Johann Friedrich Böttger had succeeded in finding a formula. Soon the production of porcelain was moved to a manufacturing site in the nearby city of Meissen, where its manufacture has continued until the present. Because of its economic as well as artistic importance an attempt was made to keep its method of manufacture secret, and Böttger was effectively imprisoned. Augustus also assembled in Dresden a huge collection of over 20,000 pieces of Chinese, Japanese and Meissen origin, which by 1730 were kept in the Dutch/Japanese palace.

Mention of these objects also brings out the central importance that Dresden also imparted to collecting.[42] After Augustus's plans for the reconstruction of the city faded, he turned his attention to the Dresden collections. It would almost seem as if collections of works of art thereby came to replace architecture as a means of expressing the splendour or fame and dignity of his court. In any event, from the 1710s while he was also enlarging them, Augustus completely reorganized the electoral collections.

This entailed a series of events of signal importance for the history of collecting in Europe. First, Augustus had the prints and the drawings removed from the Kunstkammer and placed in a newly established *Kupferstichkabinett* (print room). This was one of the first steps in a process of rationalization that was described by Caspar-Friedrich Neickel.[43] After the French example of Louis XIV the Dresden *Kupferstichkabinett* became the first German example of an independent state or royal collection of drawings and prints; its genesis attests to the increasing importance of print and drawing collections. Moreover the foundation of the *Kupferstichkabinett* may be regarded as one of the early first steps in the dissolution of the universal Kunstkammer of the Renaissance. It represents an important step towards the development of the specialized, modern museums of art and science.

In a step related to what may be regarded as the process of rationalization and enlargement of the Dresden collections – and the word rationalization is used in keeping with notions that were prevalent during the era of the Enlightenment of the eighteenth century and directed much energy in Dresden – natural history objects were weeded out. A natural history museum was established and made public.

Another event of similar importance was the foundation of the *Grünes Gewölbe*, the Green Vaults. In 1721 Augustus the Strong ordered that a suite of rooms on the ground floor of the Schloss that had previously been used as a 'Secret Deposit' be reconstructed to create an appropriate setting for a completely new sort of collection. From 1723 to 1727 these rooms were redecorated after a model that again seems to have come from Versailles. The sculptors J. J. Kändler and B. Thomae, the jeweller Johann Melchior Dinglinger and the lacquerer Martin Schnell all had a hand in the work, which was probably directed by Baron Raymond Leplat. The best sculptors and decorators Dresden had to offer created a series of rooms decorated with mirrors, lacquer, gold leaf, velvet and glass cases. In time the royal collections of small sculpture and the decorative arts were carefully sorted out and arranged in these rooms.

The Green Vaults were designed to show off to the best advantage some of the king's collections of small bronzes, ivories, silver, gold, jewels, objects made out of precious and semi-precious stones,

Grünes Gewölbe, Dresden Schloss, begun 1723; decoration by J.J. Kändler, Benjamin Thomae, Raymond Leplat and others, after designs by Pöppelmann (pre-war photograph)

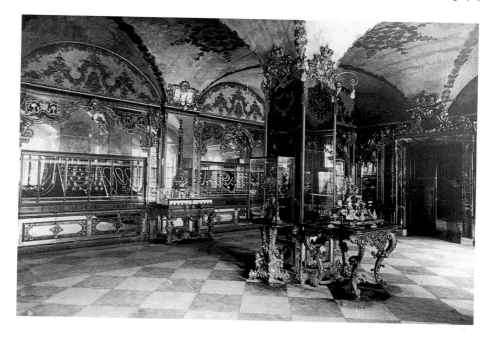

and *Kunstkammerstücke*, or cabinet pieces. These last objects, though they have precedents in some of the items that had been present in the Kunstkammer, and also can be situated in a continuing tradition of high-quality metalwork that goes back to the fifteenth century, represent the special contribution of the early eighteenth century. For example, Permoser and the court jeweller Dinglinger created incredibly elaborate concoctions of gold, enamel and precious stones. An example is the 'Birthday of the Great Mogul in India'. As well as being an example of eighteenth-century taste for the exotic, this is a beautifully crafted work of the goldsmith's art. Other equally fine pieces that make a striking impression are grotesque figures formed out of baroque pearls.

Augustus the Strong further depleted the Kunstkammer by founding a number of other specialized collections. He re-established a treasury in the palace, in which he had kept the crown jewels and other sets of precious stones, including a number of special garnitures that he ordered to be made. In the spirit of rational investigation of nature, characteristic of the Enlightenment, he established a 'mathematical-physical' salon in the Zwinger. In the mathematical-physical salon were placed many of the clocks and scientific instruments that had once been kept in the Kunstkammer. The eighteenth-century passion for archaeology was also reflected in the nucleus of a collection of antiquities, placed in the Palais im Grossen Garten – ultimately this would lead to the intellectual revolution of the mid-century and to the reaction of Johann Joachim Winckelmann.

Perhaps of greatest importance to the history of collecting and of the arts in Dresden was the establishment of an independent picture gallery. Kunstkammer had already contained paintings, but in 1722 Augustus the Strong ordered that 284 paintings be removed from the Kunstkammer, that an inventory be made and that a picture gallery be established in the Stallhof, or stables. Pictures were added to this gallery from various royal residences and from churches in Dresden and elsewhere in Saxony. Already present were such important works as Rembrandt's *Marriage Feast of Samson* and Poussin's *Realm of Flora*. Augustus also began the series of acquisitions of major paintings that increased during the reign of his son Augustus III. Agents in Antwerp, Paris and Italy bought a number of master works, including Giorgione's *Sleeping Venus*. By the time of the death of Augustus in 1733 Baron Leplat could list 1938 works in the picture gallery.[44]

Frederick Augustus III continued the series of important acquisitions that had been begun during his father's reign, using the services of agents like Count Algarotti. He completed one of the plans that his father had never realized. This was the construction of a Catholic church for the use of the court, the Hofkirche. In the 1730s a Roman architect, Gaetano Chiaveri (1689–1770), who had worked in St Petersburg and Poland and whom Frederick Augustus had met in Warsaw, was called to Dresden to design this work, whose silhouette, animated with sculpture by Lorenzo Mattielli, still makes an imposing mark on the Dresden skyline. While it employs a single

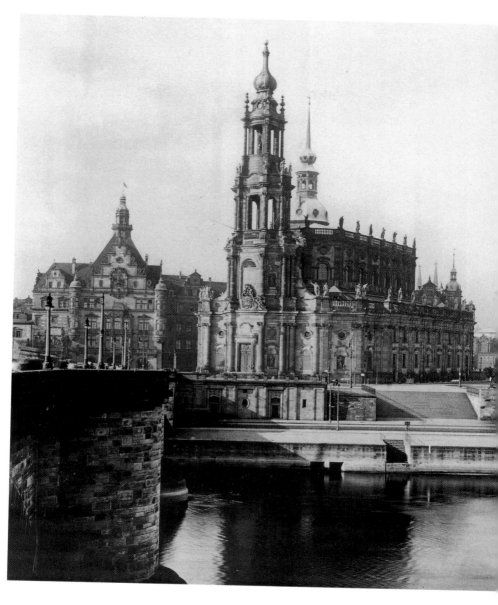

tower, as in the northern tradition, and has a choir for the court in the interior, the basic impression made is that of a monument of Roman architecture. It is like a foreign body on the banks of the Elbe in the midst of a Protestant land.

Hofkirche, Dresden, begun 1737, by Gaetano Chiaveri (pre-war photograph)

In its context the presence of this basically Italianate church can be regarded as a belated echo of the Catholic Reformation, the court's answer in

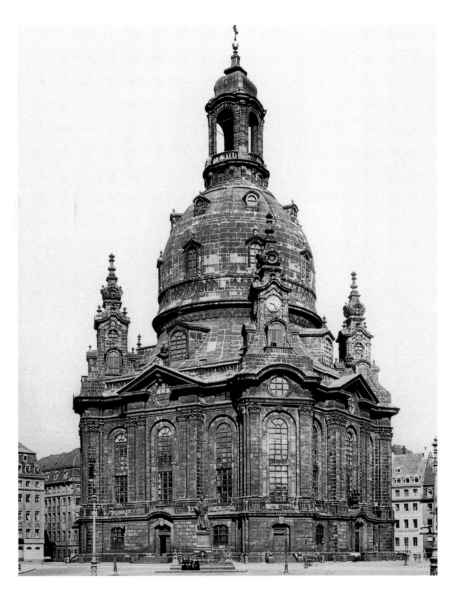

Frauenkirche, Dresden, 1726-43, by
Georg Bähr (1666-1738; pre-war photograph)

stone to the imposing church Georg Bähr had designed for Protestants nearby on the Dresden New Market. The Dresden Frauenkirche, destroyed in 1945 and now being rebuilt, was one of the great Protestant churches, a work in which the conformation of plan to liturgy led to the creation of a centralized plan, in which pulpit, organ and altar were grouped together. Octagonal galleries run around the interior, which is set within a Greek cross surmounted by an elongated dome.[45]

Works such as the Frauenkirche, with its prominently placed organ, are among the buildings that evoke recollections of the other great accomplishment of the time, the music of composers like Johann Sebastian Bach, many of whom were from this region of Germany. While it is difficult to associate Bach closely either with the Saxon residence, where he was never directly employed (although he wrote music for the court), or with the Catholic churches of southern Germany, to which he is sometimes compared, there is a way in which the comparison may nevertheless be illuminating.[46] For it can be argued that in his music Bach too was trying to create an authentic synthesis out of what were recognizably French and Italian components, infusing French forms with Italian material.[47] In the end court art and architecture of the early eighteenth century were also not determined by one exclusive direction but achieved a similarly creative synthesis, which, certainly in the instance of Dresden and other sites, led to incomparably beautiful results.

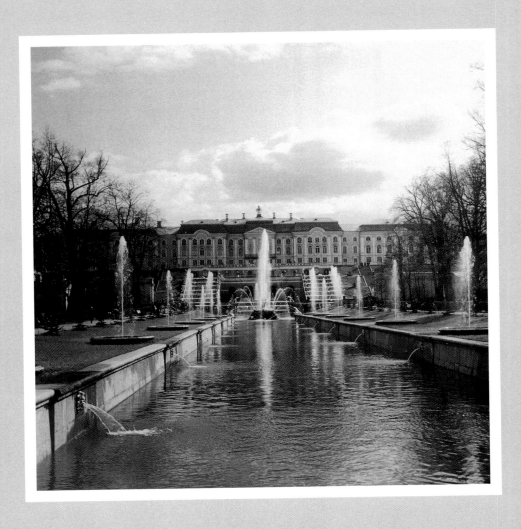

ST PETERSBURG AND ENVIRONS IN THE EIGHTEENTH CENTURY[1]

Garden view, Peterhof (Petrodvorets)
Main Palace, 1710-21, by Johann Friedrich
Braunstein and Jean Baptiste Alexandre
Le Blond (probably), with fountains and
cascades by Nicola Michetti, c. 1721-3

EAST OF THE RHINE THE LARGEST ACCUMULATION OF GRAND ARCHITECTURAL MONUMENTS FROM THE EIGHTEENTH CENTURY IS NOT FOUND IN GERMANY, AUSTRIA OR POLAND. Near the extreme north-east of the Baltic Sea, near where the River Neva flows into the gulf of Finland, Peter the Great of Russia created a city that he, his servants and successors enriched with palaces, churches and public buildings. St Petersburg and the palaces that surround it – at Peterhof (Petrodvorets), Tsarskoye Selo, Pavlovsk, Oranienbaum and elsewhere – represent perhaps the outstanding and certainly the farthest-reaching transformation wrought by princely patronage in the eighteenth century.

During the seventeenth century, and especially during the reign of Peter's father Alexis, western cultural forms had penetrated the Muscovite realms. Westerners' claims to the throne of Muscovy, wars with western powers, foreign travellers and trade had created contacts. Even the most traditional of idioms, icon painting, responded to the impact of the west, as evinced for example in the works of the Stroganov school of painters. In architecture buildings of the so-called 'Moscow baroque' also employed certain Western European ornaments. Western elements were most obviously present in the buildings and furnishings of the so-called German suburb of Moscow, the foreigners' compound, and they were emulated by westernizing Muscovites, Prince Galitsyn among them. But resistance to change also remained strong. We may remember that it was also Tsar Alexis who was particularly adverse to western 'pollution'.

Thus it remained for Peter the Great (1672–1725) to effect the transmutation of Russia. Stimulated by western culture and the desire to increase his knowledge, Peter took several journeys within his own realms. Then he followed a course which might have been expected of young western noblemen, who went on what were known as cavalier's tours, but was an extraordinary step for a tsar. During the years 1697–8 Peter travelled through Riga, Courland, Königsberg (now Kaliningrad), Berlin, Potsdam and Holland to England, visiting Dresden and the region of Lwów (L'viv/Lemberg) on his return. Like his fifteenth-century predecessors on the Muscovite throne, Peter was particularly impressed by western technical prowess, especially as evinced in England and Holland, and, it seems, by its architecture.

On his return the tsar set about transforming old Rus into a new realm that would approximate western norms. Significantly, some of the first decrees Peter promulgated on his return demonstrably bore upon matters of fashion. Peter had the beards of the boyars, the Muscovite nobles, shaved. He introduced western fashions of dress and of social life (such as carriage rides). Peter's *Drang nach Westen* (drive to the west) embroiled him in wars with the Swedes, whose empire was also expansive. Peter accordingly gained lands on the Baltic.

In 1703 he founded there the city of St Petersburg. After victories in the Great Northern War against the Swedes had secured his position, he established his capital in St Petersburg in 1712. This was to become the seat not just of a Muscovite principality, but of an empire of what henceforth was called Russia.

St Petersburg was physically to be Russia's opening on the west. Its architecture as well as its painting and sculpture display a wide variety of western forms. Their mixture of European elements also matches the imperial ambitions of the last great ruler from the Romanov dynasty (if not actually the last of the line), whose conquests (in the areas of Estonia, Latvia, Belorussia, Ukraine, etc.) made Russia an increasingly multinational realm. The city itself, laid out on a body of water traversed by canals, evokes Amsterdam, and Peter had works by Netherlandish sculptors (Thomas Quellinus and Bartholomeus Eggers) set up in his Summer Garden. But the architects and artists who were called or who came to work for the tsar were of diverse nations. They included not only Russians such as Mikhail Gregorevich Zemtsov (1688–1743) but also Swiss-Italians such as Domenico Trezzini (1670–1734), Italians such as Carlo Bartolommeo Rastrelli (1675–1744) and Nicola Michetti (1675–1759), Frenchmen such as Jean Baptiste Alexandre Le Blond (1669–1719), Germans such as Gottfried Schädel (c. 1680–1752) and also Andreas Schlüter. What they produced was as diverse as their origins.

From the first the appearance of the city expressed the general change in social and cultural outlook. The earliest works that Trezzini designed for Peter, the Peter and Paul Fortress in the middle of the River Neva (from 1706), offer a characteristic western-style appearance, comparable to

plans by Louis XIV's fortification-master Vauban. In the midst of the fortress there arose the cathedral of SS Peter and Paul (from 1712), a structure most unlike the sanctuaries on the Moscow Kremlin. Its interior recalls rather the disposition of a hall church, and its exterior, with massive tower and spire, articulated with classical forms, is reminiscent of the seventeenth- and eighteenth-century churches of northern Germany, Holland and Scandinavia. On the other hand, the original plan of the church of the Alexander Nevsky Lavra (monastery, from 1710), situated at the end of what was to become the famed Nevsky Prospekt, resembles many a centrally planned church with two-tower facade of the late seicento. Venetian sculptures also populated the Summer Garden.

Not only the form but the function of other buildings erected in St Petersburg during the first decades of the eighteenth century attest to the reorientation of Russia. Peter was exceedingly interested in the fine arts and sciences, including technical matters, and ordered the founding of an academy, as well as establishing collections in part to promote knowledge. The very name of the building, *Kunstkammera*, meant to house Peter's collections of machines, clocks, rare works of art, stuffed animals and rare foeti, indicates the Central European origins of the idea for such collections. The form of the tower surmounting this building on Vassilevsky Island also echoes that of the *Münzturm* from the Berlin Schloss; thus while Georg Johann Mattarnovy (d. 1719) is documented in its construction, Schlüter probably supplied plans for it. More certain is Schlüter's involvement in the Summer Palace that Peter had erected near the river bank on the mainland (on which building the stucco and terracotta, probably created by his workshop, is however derived from prints). This modest structure resembles town palaces in Germany and Amsterdam, as do the twelve colleges designed by Trezzini (from 1722) on the Vassilevsky Island, where they were built to house the new administrative units that the tsar established, following a Swedish model.

After Peter's visit to Versailles in the course of his second western journey of 1716–17 the cultural affiliation changed. Prince Alexander Menshikov (1673–1729), the tsar's general and favourite, had already pointed the way to a more expansive mode of design in his terraced palace at Oranienbaum overlooking the Gulf of Finland to the west of the city. From *c.* 1710 Peter had the palace and grounds of Peterhof laid out west of St Petersburg, on a site with a view of the gulf. There Michetti designed a series of terraces with fountains and watercourses descending to the gulf. These compose a nordic version of Versailles or, considering the view from a bluff, Vienna's Belvedere. The form of the original palace with parterres was soon echoed at Kadriorg (Ekaterinental) near Talinn, Estonia, also designed by Michetti. Soon the first of many changes was introduced in the plan of Peterhof's main palace, perhaps by Le Blond. Although the architects and designers (Schlüter, Michetti and others) of the pavilions erected on the grounds, and the forms they employed, otherwise point to a variety of sources and parallels, the names of the actual structures –

Marly, Ermitage, Mon Plaisir – also indicate the main source of inspiration, in France.

The Gallic emphasis increased during the next reigns, particularly during that of Tsarinas Anna (1730–40) and Elizabeth (1741–61). In St Petersburg the pattern of streets laid out in the late 1730s from the admiralty square emulates the *patte d'oie* (goose foot) pattern of the town of Versailles. Palaces placed on the Nevsky Prospekt and on other major thoroughfares, such as that built for the Stroganovs (from 1753) by Bartolommeo Francesco Rastrelli (1700–71), the Russian-born son of an Italian sculptor, recall a French hôtel or palace. Moreover, both the immense scale and, to a certain degree, the individual decorative forms of palaces built by Rastrelli for the tsarina in and near St Petersburg invite comparison with Versailles. These include extensions to Peterhof (from 1747), the construction of palaces at Tsarskoye Selo (from 1749) and the building of the Winter Palace in St Petersburg itself (from 1754). In and on many of these mid-century buildings the fashion of the rococo, to be discussed more in Chapter 15, is also evident, as exemplified in the ornament of the Jordan Stairway in the Winter Palace. At this time and later, French artists and artisans continued to pour into Russia.[2]

Although there is no proof that Rastrelli ever travelled outside Russia, he evidently had wide familiarity with many of the different architectural forms that were employed throughout the continent, since traces of them are also found in his work.[3] The Jordan Stairway may be compared with several Central European examples, including those designed by Hildebrandt and Balthasar Neumann. Other buildings, such as his pavilion of Monbezh at Tsarkoye Selo, seem to indicate a knowledge of the type of centrally planned garden building with radiating pavilions invented by Fischer von Erlach. A particularly interesting synthesis results when Rastrelli employs a western vocabulary for churches in an Orthodox mode, as at the chapel at Peterhof.[4]

The stylistic sources for buildings by Rastrelli are one of many strands that demonstrate a connection between Russia and Central Europe in the eighteenth century. Other artists active in Russia also drew from sources in Central Europe as well as reaching back to common inspirations in Italy or France. As noted, many figures came to Russia directly from Central Europe.

Strands of patronage may also have intertwined, because many of the Russian rulers were connected with the ruling houses of Germany. Peter's son Alexis married Charlotte of Braunschweig-Wolfenbüttel, daughter of the important patron and collector, Duke Anton Ulrich of Braunschweig-Wolfenbüttel; from their marriage stemmed Tsar Peter II (ruled 1727–30). Before ascending the throne, Tsarina Anna had been married to a duke of Courland, who was the nephew of King Frederick I of Prussia; it is understandable that she was noted for her favourable disposition towards Germans. The short-reigned Ivan VI (ruled 1740–41) was the son of Anton Ulrich of Braunschweig-Bevern, and thus grandson of Anton Ulrich of Braunschweig-Wolfenbüttel and of Princess Elizabeth Catherine of Mecklenburg-Schwerin.

The even shorter-reigned Peter III (ruled two months, 1762) was the son of a duke of Holstein-Gottorp. And Catherine II ('the Great', 1762–96) was a princess from the house of Anhalt-Zerbst.

For many reasons the climax of artistic developments of the 'baroque' and 'rococo' parallels movements in Central Europe. The international, or multicultural, aspects of developments in Central Europe were echoed in Russia. Through St Petersburg, Russia came to share in a common European history of art during the course of the eighteenth century, while itself becoming a centre of intense artistic exchange. This exchange in turn implicated the design of structures to the west. In Ruhental, Courland (Rundale, Latvia), Rastrelli worked on a palace for Duke Ernst Johann Biron in the 1730s and then in the 1760s; while masters were at first brought from St Petersburg and Italian painters completed ceilings there, rooms finished in the 1760s received stucco from the hand of a sculptor who had worked for Frederick II of Prussia.

By this time Russia had clearly joined the concert of the arts. During the succeeding reign of Catherine II, the stylistic changes that appeared elsewhere in Europe and that will be discussed in later chapters, were also found in Russia. New forms of architecture were for instance brought to St Petersburg by such architects as the Frenchman J.-B.-M. Vallin de la Mothe (1729–80), the designer of a newly founded Academy of Arts (1764–8); the Italian Antonio Rinaldi (1710–94), the author of the Marble Palace (from 1768); and, later, important figures such as Giacomo Quarenghi (1744–1817) and the Scot Charles Cameron (1740–1812). The foundation of the Academy of Arts, as well as Catherine's contacts with the critic Diderot, suggest that intellectual underpinnings were also being laid for these changes. For these reasons, if only in briefest summary, the parallels provided by Russia in the eighteenth century deserve mention here.

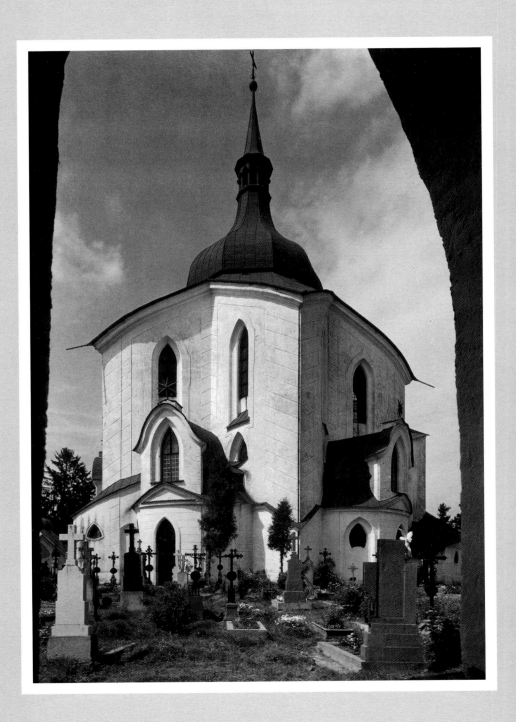

EARLY EIGHTEENTH-CENTURY ART AND ARCHITECTURE IN THE BOHEMIAN LANDS

Church of St John Nepomuk, Želená
Hora, near Žd'ár nad Sazavou, 1720-2, by
Jan Blažej (Johann Blasius) Santini Aichel

AT A TIME WHEN MANY PRINCELY RESIDENCES WERE BEING BUILT AND DECORATED ELSEWHERE IN CENTRAL EUROPE, THE ARTS FLOURISHED IN A KINGDOM IN WHICH NO RULER RESIDED. From approximately 1680 until the early 1740s, when Frederick II of Prussia seized Silesia and Karl Albrecht of Bavaria, whose imperial coronation as Charles VII in 1742 also interrupted the succession of Habsburgs to the title of Holy Roman Emperor, tried to take control of Bohemia, many works of painting, sculpture and architecture were produced in the lands of the Bohemian crown (from 1635 to 1740 consisting of Bohemia proper, Moravia and Silesia). Much was made that is outstanding for its inventive character and expressive power. In part because of the subsequent decline into provincial status of the truncated Czech lands after the mid-eighteenth century, much from the seventeenth and eighteenth centuries also survives: whole towns or city quarters, like the Malá Strana in Prague, remain from this era. Although fighting was fierce in Silesia at the end of the Second World War, a surprising amount is still to be found there as well.[1] What originated, particularly in Bohemia and Moravia, deserves separate attention not merely as striking local creations but as telling evidence of the characteristic intermingling of cultural traditions that frequently brought forth such artistic fruit in Central Europe.[2]

While some of the socio-economic conditions affecting the production of art and architecture were similar to those prevalent elsewhere in the region, special circumstances also pertained to the Bohemian lands. Developments

such as refeudalization, the relative decline of cities and the related growth of magnate and monastic holdings resemble those that can be traced in other parts of east Central Europe. Because of population losses (not recuperated until the early eighteenth century), redistribution of property and the exile of Protestants, the consequences of the Thirty Years' War were however even longer-lasting and more intense in Bohemia. An estimated 70 per cent of the land in Bohemia proper came to reside in the hands of the church and of the magnates. It has also been estimated that the number of noble families declined by 50 per cent from the mid-sixteenth to the mid-seventeenth centuries; as a result the land was concentrated in ever fewer hands. A relatively large number of these families was also not of Bohemian (or even Central European) origin, but, like the Colloredo, Piccolomini, Gallas and other families, descendants of foreign warriors or profiteers.[3]

The upper estates made themselves largely exempt from the land tax, in distinction to the rest of the population, on whom financial demands of all sorts came to weigh increasingly heavily. During the early eighteenth century taxes were raised continuously.[4] A member of the *sněm* (the Bohemian Estates General) consequently complained that the kingdom was being drained to its last drop of blood. Not only taxes, but forced labour was exacted from the peasant population; a 'second serfdom', creating conditions like those of the preceding century, had in many instances been imposed in the years following the Thirty Years' War. One result was that peasants rebelled, notably in 1680 on lands that had once belonged to Wallenstein; since a great plague epidemic in 1679 and a Turkish scare occurred at about the same time, this approximate date provides a convenient turning point for historical periodization.

In contrast, large landowners regularly accumulated more wealth. In some instances, especially in northern Bohemia, income from the land was supplemented by profits from the manufacture of glass and linen products of the kinds for which Bohemia has remained famous. While the relative status of the bourgeoisie declined in major cities, smaller residences of noblemen, their residential towns and cloisters, especially those with lands or some sort of manufacture, prospered.

These circumstances allowed for patronage of art and architecture for which, in the absence of a permanent princely court, magnates and the church, especially the cloisters in Silesia but also in Bohemia and Moravia, were primarily responsible. No one centre dominated, in contrast to the centripetal pull of residences in the German principalities or the centrifugal role of the Habsburgs in the Austrian lands, where Vienna can still be called the major centre *c.* 1700, even when arguments are allowed for the leading role of the noble families, since they built palaces in and around the city. Only Prague, the *Landeshauptstadt* (capital) and thus the site where many nobles chose to build their palaces and where many churches were also established, might be regarded as comparably important.[5] Otherwise artistic activity was propagated throughout the land.

As elsewhere, aristocrats and the church employed the arts as a form of representation, but there was an extra edge that these activities assumed in religious matters, since issues of church and state were not separate in Bohemia. While efforts to win the population over to the older faith continued in Bohemia and Moravia, in 1689 it was decreed that preaching heresy (i.e. Protestant doctrine) was a crime against the state. The missionary and combative attitude of the Roman Church made the situation not unlike that in the New World, where indeed artistic developments have been discerned that are similar to those of Central and Eastern Europe.[6] On the other hand, the Catholic Church in Silesia remained embattled in conflicts with a large Protestant population.

Extending the provisions imposed by the treaty of Westphalia that limited church construction and ownership, the treaty of Altranstadt (1707) signed during the Great Northern War (that also ravaged Poland in the early seventeenth century) returned 121 churches to the Protestants in Silesia and allowed them to build six new ones. Yet these numbers may be compared with the twenty-five new churches built by Catholics in the period from 1710. Moreover, Protestant Church art in Silesia does not have the same polemical character, nor is it in general as impressive as work done for the Catholic Church, which occupies us here.[7]

Efforts of the Roman Church might manifest the triumph of the faith in the construction of new buildings or, in many instances, the reconstruction and decoration of older structures. These attempts could also lead to the visual promotion of dogma, a 'reconquest' style, as it were. Hence there arose a predilection for representations of the Virgin, particularly in the personification of the *Immaculata*, the Trinity and especially the saints, in free-standing monuments, cult and votive images. These images could serve to promote debated beliefs (such as the immaculate conception), to symbolize the victory (or spiritual warfare on behalf) of the true faith and its adherents, or to signify loyalty to the Habsburgs.

In both the sacred and secular sphere these efforts also assumed a local colouring. Much building and decorative activity actually involved rebuilding or redecorating. In the case of the magnates, this process of renewal, or restoration of the past, could be related to an adherence to *Landespatriotismus*, not a nationalistic impulse comparable to that of later times but an allegiance to the interests of the noble estate. This attitude could be signified not only by the construction of impressive new structures but by the production of individual images and whole programmes that glorified a local dynasty, or one's ancestors, as noticed already at Legnica (Liegnitz).[8] In the church this could mean a reconnection with and revivification of local tradition. Accordingly, in several cloisters and orders, the study of local history and letters was revived. As exemplified in the late seventeenth century by the Prague Jesuit Bohuslav Balbin or in the early eighteenth century by the Cistercian centre at Žd'ár (Saar) in western Moravia established by Abbot

Václav Vejmluva, this entailed an emphasis on the Czech past. In the writings of Balbín and the Cistercians, this was not conceived as the province of one special linguistic group (be it German- or Czech-speaking), but in terms of the continuity of Catholic character in a particular place.[9]

The Žd'ár centre suggests something of the importance exercised in this process of revival by the older orders in Bohemia, the Benedictines, Cistercians (especially in Silesia) and Premonstratensians. Their involvement in many aspects of culture stands out in comparison with the earlier history of the seventeenth century, wherein the newer Counter-Reformation orders such as the Jesuits had played such a key role. The Jesuits remained important in the early eighteenth century: they built a university in Wrocław (Breslau) and in Prague promoted the canonization of St John Nepomuk (whose cult they spread throughout the world – eighteenth-century images of the saint can be seen in Laguna, New Mexico, and in Córdoba, Argentina). But now many other, pre-Reformation orders also provided major patronage.

The large monasteries of the Cistercian order in Silesia, expanded or, rebuilt from c. 1680 to 1710, are particularly prominent. Already in the 1660s the cloister in Krzeszów, where we have encountered Willmann, was modernized and decorated. The cloister residence at Lubiąż (Leubus) was erected from 1681 (until after 1715), probably on the basis of a plan with analogies to constructions in Bohemia that was prepared for Abbot Jan Reich during the 1670s. The layout has parallels with the ideal reconstruction of Solomon's temple, and thus with the Escorial in Spain; the cloister buildings stretch out along the Oder, making a grand palatial impression. In 1682–6 (with work continued to 1698) the Bavarian architect Michael Kirchberger expanded the cloister buildings at Henryków (Heinrichau), where a representational setting was also created for the Cistercians. At Krzeszów in 1690–96 Michael Klein and Martin Urban added the St Joseph's Chapel, whose decoration by Willmann has already been mentioned. From 1697 to 1725 the Cistercian nuns at Trzebnica (Triebnitz) also expanded their cloister, a site sanctified by Saint Hedwig, patron of the land.

Not only Willmann, at Lubiąż, Krzeszów and Henryków and members of his family such as J. C. Liška and G. W. Neunherz, most noticeably at Krszeszów, but also masters of diverse origins – from Austria, Bohemia, Germany and Italy – combined to make the cloisters into centres of intense artistic interchange. The cloisters became truly grand enterprises, in which sculpture in wood, stone and stucco, together with painting in fresco and oil, joined architecture to contribute to an at times overwhelming effect.

The social, even political, charge of such works is also evident, as in the extraordinary *Kaisersaal* in the Lubiąż. There the sculptor Franz Joseph Mangoldt executed a series of over-life-size figures of the Habsburg emperors. This was one of several instances in which a ruling dynasty was glorified in a local Silesian church.

The cult and canonization of Nepomuk, who was celebrated in great

ceremonies and to whom columns were erected all over Central Europe, can be taken as one sign of increased veneration for local saints. This may be related to the emergence of a concept of 'Bohemia Sancta', to echo the title of a series of engravings of Bavarian saints published in the seventeenth century.[10] This was one aspect of a more general movement that brought about a renewal and elaboration of the liturgy and the revival of venerable sites for cults, pilgrimages and monasticism. Worship of the traditional patrons of the land, such as Wenzel (Václav) in Bohemia, was renewed, just as the veneration of new figures like Nepomuk was promoted. The movement to honour Nepomuk, who had been martyred in the late fourteenth century by Wenzel (Václav) IV, can also be seen as a Catholic response to claim the spiritual ground occupied by Jan Hus, Nepomuk's near contemporary, who had also been martyred by a Czech ruler (Emperor Sigismund) and had previously been venerated by his followers in Bohemia. Since Nepomuk's martyrdom resulted from his devotion to the sacrament of confession, which the Protestants had abolished, his canonization also contained an element of religious polemic. Similarly, the Benedictines' establishment of a major church at Wallstatt (Legnickie Pole), where Henry IV of Silesia had fallen fighting the Tartars in the fourteenth century, can be interpreted as an effort to appropriate the local tradition.

Thus pilgrimage sites, statues to saints like Nepomuk and new churches burgeoned throughout the land. What began as a movement from above also touched a strand of popular, or better, local, culture, in part because of its rural character. In Bohemia, much as we shall see in contemporary Germany, strands of 'high' and 'low' culture are often inextricable in the early eighteenth century.

Eventually artists of local origins gained important commissions, but that does not mean that the art they produced was provincial in character. In sculpture and especially in architecture several of the most important international trends penetrated to the Bohemian lands; on the basis of these trends and alongside them, several distinctive and equally noteworthy, indigenous developments occurred. Patrons, especially in aristocratic circles, had international contacts, and many of them also had high positions in the church; several of the other prelates who were the abbots of major cloisters, such as Othmar Zinke of Břevnov (Breunau) in Bohemia and Bernardus Rosa of Krzeszów in Silesia, were highly educated men.[11]

The impact from the the mid-seventeenth century onwards of artists and artisans from northern Italy (and southern Switzerland), from Graubünden and particularly from the region of the Lombard lakes, such as Carlo Lurago and Francesco Caratti, has already been noted, but direct as well as indirect connections existed with some of the leading architects and sculptors of the seicento, especially from 1680. It is interesting to speculate what might have happened had Francesco Borromini, both of whose grandfathers had worked in Prague, gone north instead of south. In any instance, while several Italians

who deserve more attention, such as the architects Octavio Broggio and Giovanni Battista Alliprandi, worked in Bohemia at the end of the seventeenth and the beginning of the eighteenth century, contacts were also established with famous figures such as Bernini, Guarino Guarini and Carlo Fontana.

Italians were numerous in Silesia, where at the beginning of the 1680s the Elizabeth Chapel in Breslau (Wrocław) Cathedral was built and decorated by a team under Giacomo Scianzi for the bishop of Breslau, Friedrich von Hessen, and included works that had been ordered in Rome from Bernini's own atelier. These sculptures of the 1680s (brought north only in *c.* 1700) include figures of St Elizabeth, the cardinal's ancestress, by Ercole Ferrata, and allegorical figures as well as a statue of the patron by Domenico Guidi. A bust of the late 1660s from Bernini's workshop that has recently been attributed to the artist himself also made its way to the chapel.[12] On the other side of the apse in the cathedral a chapel was erected according to the plans of Fischer von Erlach from 1714; its cupola was decorated by the Italian Carlo Carlone, who had often worked in the Austrian lands.[13]

Guarino Guarini, the outstanding architect in Turin, provided a plan dated 1679 for the Prague Theatines. Although the church of St Mary Altötting in Prague was not built according to this plan, the scheme, like several other designs by Guarini, had an impact on local architects. Various elements, including the longitudinal ground plan in which two smaller elliptical spaces interact with a larger one, producing diagonally placed pilasters which are continued into the ovoid vaults as ribs, recur in later churches in Bohemia.[14] Carlo Fontana also communicated with several Bohemian aristocrats and sent plans for palaces on to them; his work seems to have influenced Bohemian architects, too.[15]

Architectural inventions were passed on to Bohemia through the conduit of Vienna. For the parish church of St Lawrence built from 1699 in Jablonné v Podještědí (Deutsch-Gabel), Hildebrandt supplied a design which is related to several Guarinesque ideas. The church consists of a series of interlocking ovals, with obliquely placed pilasters, covered by a dome with a lantern; it possesses a facade whose alternating convex and concave masses echo the interplay of spaces within. Related forms recur in several Bohemian churches.

Several other leading architects and *Baumeister* from Austria were also active in shaping the architectural landscape in Moravia, which has often been noted as being nearer geographically and more orientated artistically to Vienna than to Prague. After Henrico Zuccalli had supplied a plan *c.* 1688 for the Schloss at Slavkov u Brna (Austerlitz), this work was erected according to the designs of Domenico Martinelli from Lucca. Martinelli had been active in Vienna, and he supplied many plans for patrons in Moravia and Bohemia as well. Jakob Prandtauer designed the castle at Jaroměřice nad Rokytnou. Fischer von Erlach's stables of 1688 for the Liechtenstein Castle in Lednice (Eisgrub), on the Austrian border, have already been noted; he also designed an oval room executed 1688–95 for Count Althan in his mountain Schloss at

Vranov nad Dyje (Frain). This *Ahnensaal* recalls Borrominesque plans and was frescoed in 1695 by the Austrian Rottmayr. Like Fischer, Rottmayr may stand for the extension of the style being worked out in Vienna, as discussed earlier; around this time he carried out ceiling paintings in the Salzburg Residence and in several of Fischer's churches there, in the marble hall in Pommersfelden and in the Jesuit church in Wrocław, c. 1704–6.

St Lawrence's Church, Jablonné v Podještědí, begun 1699, after designs by Johann Lucas von Hildebrandt

In Bohemia proper Fischer seems to have been represented by but one important plan, the town palace in Prague for the Gallas family. His plans were however reworked and translated there by Alliprandi, another mason-architect from the Val d'Intelvi, the home of Lurago, Caratti and Borromini.[16] Fischer's plan of *c*. 1699 for a *Lustgartengebäude*, an oval garden pavilion with side wings, was introduced as a *Landschloss* in 1699 at Liblice; the elevation of this structure also closely resembles the plan illustrated later in Fischer's *Entwurff einer historischen Architektur*. Ideas like Fischer's were also realized by Alliprandi in the Prague Palais Přehořovský (later Lobkowitz/Lobkovic) from 1707. Alliprandi also seems to have drawn from Fischer's vocabulary for the oval church built from 1714 on commission from Count Trautmansdorff for the Piarist order in the eastern Bohemian town of Litomyšl: the towers placed obliquely to the central mass recall Hildebrandt's plans for St Peter's, Vienna, begun 1702.

All this suggests that Bohemia was firmly integrated into the larger web of European connections in the early eighteenth century. And yet the work of Italians and Viennese by no means covered the demands of patrons in the Czech lands. Around the turn of the century German and local architects and *Baumeister* became active in Silesia, and the same is true for Bohemia.[17] The manifold opportunities available in the Bohemian milieu enabled a distinctive architecture (and as we shall see, painting and sculpture) to be generated, often by locally born architects, out of, broadly speaking, the union of Italianate and Viennese ideas with Germanic traditions. The result was an architecture as novel in its formal inventions as it could be expressive in its communication of meaning through architectonic form: the origins and development of these formal qualities thus also call for discussion.

Earliest among the group of outstanding architects from the turn of the eighteenth century whose activity was concentrated in Bohemia was Christoph Dientzenhofer (1655–1722).[18] Dientzenhofer was a member of a clan from Upper Bavaria whose activity we have already encountered in Franconia; he had worked as a mason in the 1670s in Bohemia, when he settled in Prague, where he was accepted as a master in the next decade. From his German heritage Dientzenhofer might have learned of a tradition of building that had become instituted with the churches of the Counter-Reformation: these are the wall-pillar churches, often with choir lofts set between the pillars, evinced by the early seventeenth-century Jesuit churches at Dillingen, Eichstätt, Innsbruck and Düsseldorf.

From *c*. 1699 Dientzenhofer put this form to good use in Bohemia in a number of major commissions for churches. This form of unified sacral space appears in the reconstruction of St Nicholas on the Malá Strana in Prague, built by the Jesuits from 1702 or 1703, where a traditionally basilican plan is combined with a sequence of ovals possibly inspired by Guarini or Hildebrandt; the oscillating convex elements of the richly modelled facade, which was also praised by contemporaries, make it equally

unusual in comparison with the rather flat treatment found previously in Bohemia.

Benedictine Cloister Church of St Margaret, Břevnov, near Prague, 1708-21, by Christoph Dientzenhofer

From his initial success with the Jesuits, the elder Dientzenhofer gained a series of commissions, the most important of which may be considered the rebuilding of the Benedictine cloister church at Břevnov (Breunau) on the White Mountain west of Prague. Břevnov belonged to this older order and was the site of its oldest foundation in the land; it was associated with St Adalbert, the blessed Günther and many other notable figures in Czech history. In commissioning a design that was strikingly novel, Abbot Zinke seems to give expression to the order's desire to reassert itself against both the Protestants, who had damaged the order's churches, and the Jesuits, who were the Benedictines' competitors; he thus had a new building placed right on top of the site of an earlier Romanesque church.

In this new church Dientzenhofer, who remained in the service of this cloister until the end of his life, was given free rein to design what has been regarded as a masterpiece of the 'radical baroque'. Here principles that had been present at St Nicholas are combined with an extension of these ideas, as they had been seen in the design of the chapel at the Sternberg Schloss (from 1699) at Smiřice. Smiřice demonstrates a realization that in a wall-pillar church the walls can be made thinner and to undulate, while the pillars are treated as piers. Whereas the shape of the Smiřice plan was a centralized

oval-cum-star, at Břevnov it actually consists of a series of interlocking ovals. The groin vaults that seem to spring directly from the walls intersect each other, replicating the complicated ground plan above. In his own unique way at Břevnov Dientzenhofer also solves the problem of reconciling longitudinally and centrally planned churches: the nave is only two bays long, and the interior forehall a little over one, while the apse is also treated as if it were a bay; the whole thus produces the sensation that it is one large ellipse. The articulation of the exterior also echoes the interior: the principles enunciated at Smiřice, where the conventions of the architectural orders had already been broken, are developed even further at Břevnov. Curved walls bear curved architraves; the facade seems to be wrapped around the structure; frontons appear at the sides as well as on the front of the church; their pedimental forms are also broken. The whole obtains a dynamic character, echoing the dynamics of the interior.

At Smiřice Dienztenhofer also employed architectural elements symbolically, in a manner resembling that of Borromini (with whose designs he was probably unfamiliar). In Smiřice the Gothic vaulting assumes a star pattern. This refers both to the star of Bethlehem (the church is dedicated to the Epiphany) and to the patrons, the Sternbergs ('star-mountains').[19]

Dientzenhofer's son, Kilian Ignaz, and his contemporary Jan Blažej (Johann Blasius) Santini Aichel brought these developments to their culmination. Kilian Ignaz (1689–1751) was born in Prague, and received a mason's training, his career being prepared by his father, on whose buildings he worked. After journeying to Italy and probably returning via Vienna, when he could have seen the latest works of those centres, the younger Dientzenhofer collaborated with his father and then embarked on his own career with a Hildebrandtesque summer residence for Count Michna in Prague, the Villa Amerika (the present Dvořák Museum). While this was one of several secular projects he designed, Kilian Ignaz was also associated more with church architecture; after his father's death Kilian Ignaz inherited not only his house but his position of *aedilis* (builder) for the Benedictines of Břevnov, in which position he remained for his whole life, at times repairing his father's work.

Kilian Ignaz often quite literally completed his father's designs, as well as expanding the scope of their ideas. In the first instance this is evinced by his probable involvement in the completion at mid-century of the crossing, chancel and dome of St Nicholas in the Prague Malá Strana. The dome in particular points to Kilian Ignaz; it reveals a feeling for siting in an urban setting that may well have served the needs of the client, since a prominent visual statement in the Malá Strana might have been seen as a visual realization of the Jesuits' rivalry with the palaces and churches going up around it in the district. With his brother-in-law Jan Jiří (Johann Georg) Aichbauer, Kilian Ignaz also finished his father's project at the Loreto monastery on the Prague Hradčany. This monastery housed one of the several replicas of the *casa santa* that had been erected in Central Europe in the wake of the Council of Trent

and the battle of White Mountain. (The *casa santa*, or Holy House, was supposedly the House of the Nativity in Bethlehem,

Church of St John on the Rock, Nové Město, Prague, 1730-8, Kilian Ignaz Dientzenhofer

which had been miraculously transported by angels to, eventually, Loreto, Italy.) Kilian Ignaz's most significant contribution here was the completion of the facade. The facade creates a broad and picturesque expanse, which again makes an urban statement; it effectively answers the *grandezza* of the Černín palace across the square.

During the 1720s and 1730s, Kilian Ignaz completed many commissions for the Benedictines in an inventive manner. For example, the Benedictines had bought a site at Legnickie Pole (Wallstatt) in 1703 as part of their mission to take over or revive pilgrimage or cult sites associated with the historic past.

They called in Dientzenhofer in the 1720s. At Legnickie Pole Dientzenhofer combined several earlier traditions to create a dynamic effect: in the facade the central gable is raised almost to the height of the side towers, so that although the whole is not in fact very tall, it gives that effect; the interior is a centralized space, combining an oval with octagonal forms, again marked out by wall pillars. Dientzenhofer created another picturesque effect at St John on the Rock in Prague, where the ground plan again combines an octagon with an oval and an end crossing: the church is set high on a rock, with a stairway ascending. The oblique towers, recalling Hildebrandt and Alliprandi, add an axial accent to the centrally planned building, suggesting that the exterior forms echo those of the interior. One final work may serve further to demonstrate the process of invention in the service of the Benedictines: this is the church of St Nicholas in the Old Town in Prague, a cross-shaped structure with a dome over a polygonal drum, built from 1732. The readjustment of the impressive facade to face south and accommodate the location, in the centre of the town next to the Town Hall, again seems to serve as a kind of counterpoint to the Jesuits' St Nicholas on the other side of the city.

Another high point in the history of early eighteenth-century architecture in Bohemia was shaped by Santini Aichel (1667–1723).[20] As one of the most original personalities in the history of European architecture, who at the same time gave shape to local trends, like Dientzenhofer he is worthy of some extended attention. Jan Blažej Santini Aichel was born in Prague, the grandson of a *Baumeister* from the Val d'Intelvi region who had collaborated with Lurago, and son of a mason who had worked with Mathey. Thus despite his name he can be considered a local architect. Although he stemmed from artisanal origins, during his *Wanderjahre* Santini probably came to know architecture in Rome and Vienna. And while he collaborated with other architects during much of his career, Santini in fact represents a further stage in the development of architecture as a modern profession in Central Europe. He directed the construction of several churches in person, but he is more often documented as supplying drawings or advising on plans. He may therefore be regarded as personifying the initiation of separation and specialization in the process of building design.

Santini's first-known independent works were for the Cistercians in Bohemia at Zbraslav (Königsaal) and then at Sedlec (Sedletz). Although he also served many other orders, he seems to have gained with this order a position similar to that the Dientzenhofers enjoyed with the Benedictines; a Cistercian referred to him later as our Santini ('unser Santini'). At Sedlec Santini also had a task similar to that which Christoph Dientzenhofer fulfilled contemporaneously at Břevnov, in that he was charged by Abbot Jindřich Šnopek (who had previously employed Pavel Bayer) to rebuild the church that had been the order's first in Bohemia.

The solution Santini reached for the Cistercians was not like that of Dientzenhofer but, rather, characteristic of his idiosyncratic response to such

tasks. Santini employed an essentially Gothic vocabulary of forms, with ogive arches, ribs and buttresses, that seem deliberately to return to those of the era of the earlier structure on the site, which had been destroyed at the hands of the Hussites. Santini's use of these elements seems to serve the purposes of symbolism more than it does those of structure, since the ribs on the nave and choir vaulting have no more functional purpose than does the elaborate tracery of some of the windows. They recall not the forms of the thirteenth or fourteenth centuries, as might have been expected, but those of the Jagellonian period, as exemplified by Ried; the strange, balloon-like vaults in the side aisles have no place in that period either, however. All is generically Gothic rather than historically accurate: the pinnacles, quatrefoil and functionless flying buttresses on the facade are all ornaments that seem to state that this is a medievalizing rather than a truly medieval building.

Church of the Assumption and St John, Sedlec, facade begun 1703, Jan Blažej Santini Aichel

The next prominent examples in Santini's creative responses to monastic commissions in the Gothic manner were also built for ancient orders, for the Premonstratensians at Želív and for the Benedictines at Kladruby (Kladrau), with both of which projects he was involved from 1711 or 1712. For Želív Santini supplied abbot Jeronym Hlína with a design in which the play of concave and convex forms in the interior, while resembling Ried's, is better compared with those of contemporary late-seventeenth- and eighteenth-century architecture. If Santini is working in a Gothic idiom, he is clearly speaking a new dialect; hence his architecture has often been called 'baroque Gothic' or 'Gothicizing baroque'.

The new qualities of Santini's relationship to the past, and the meaning with which it is imbued, can be seen in the reconstruction or, better, what in a letter in 1716 he himself referred to as the restoration, of the most ancient temple (*antiquissimum templum*) of Kladruby. Santini had been chosen over Christoph Dientzenhofer for this design by the abbot Maurus Finzguth, and the choice of style seems to have been deliberate. The result was in fact not a

Exterior of Benedictine Cloister Church,
Kladruby, 1712-26, by Jan Blažej Santini Aichel

restoration of the Romanesque of the earlier church on the site, which had been destroyed by the Hussites, but a structure that combined ogive with rounded arches, with intertwining, functionless ribs in the vault and some classical elements in the piers; the crossing was surmounted by a crown-topped cupola. In a letter of 1720 from Finzguth to his fellow Benedictine abbot of Melk, which reveals the artistic awareness of the prelates who commissioned major buildings at this time, Finzguth says this cupola was done in a hitherto-unseen Gothic manner (*more gottico* [sic] *nondum visa*).

A careful reading of the content, language and context of Finzguth's letter reveals that the choice of Gothic was not only related to its suitability for ecclesiastical architecture but resounds with the rhetoric of the perennial dispute of the ancients and moderns, a debate in which architecture had an important role. A modern position in this controversy is that mores vary and

Interior of Benedictine Cloister Church, Kladruby, with frescoes by Cosmas Damian Asam, 1725-7

that it is possible to achieve something that the ancients had not produced. Modern attitudes had already cropped up in Central Europe in Rudolfine Prague, where they may have led patrons to favour new inventions in various genres of painting; the establishment of academies such as Sandrart's may also be thought to have institutionalized a new canon and have made possible the production of an indigenous art, worthy of comparison with the ancients. But Santini's stance takes this one

step further: Santini's architecture is a 'modern' Gothic, suggesting that there is a freedom to invent new forms of Gothic architecture, that can surpass efforts to emulate, even in this mode. As such he not only can be counted among the group of architects that have been called the 'first moderns' of the eighteenth century but also anticipates the incipient stylistic and historicist eclecticism of mid- and later eighteenth-century architecture.[21]

These characteristics help explain some of the extraordinary qualities of Santini's other secular and ecclesiastical designs. From early in his career, when he designed the bishop's palace in Hradec Kralové (Königsgrätz), and through the 1710s, when he designed the Moržin (c. 1713–14) and Kolovrat (later Thun-Hohenstein, from about 1716) palaces in Prague, Santini also worked for the high nobility in Bohemia. These works use the idiom of contemporary Italianate and Viennese architecture. His plans for Schloss Karlová Koruna (Karlskrone) in Chlumec nad Cidlinou (Chlumetz) extend the kind of designs that Fischer had invented for various country houses (*Landgebäude*), in which block-like elements extend from a central hexagonal space topped by a round lantern. At Chlumec Santini created a plan with a cylindrical central core and radiating cube-like blocks, on each floor of which the ground plan differs; mass and space vary, creating surprising combinations. In this way Santini culminates the tradition of spatial and formal inventiveness in Bohemian palace architecture, dating back to the Star Villa, a building near Prague he surely knew well.[22]

For many pilgrimage churches Santini also employed unusual ground plans, for instance the forms of equilateral triangles or stars, which often serve a symbolic function. For example, the star may refer to those that appeared over the head of St John Nepomuk, in whose honour the church at Běstvina (Bestvin) is dedicated.

The summit of symbolic and inventive use of forms in a Bohemian context, even exceeding Borromini, is found in the truly remarkable pilgrimage church commissioned by Vejmluva and dedicated to Nepomuk on the Green Mountain near Vejmluva's cloister at Žd'ár (Saar). Santini designed this church to house a recently disinterred relic of the tongue of Nepomuk, the tongue that had not divulged the secrets of the confessional and that was found intact when the saint's body was disinterred. The church employs ribs and pilasters with Gothic elements from Nepomuk's era but combines them in a way not found in the Middle Ages. Like the complicated ground plan, they have a symbolic dimension: the plan consists of a five-pointed, star-shaped sanctuary within a ten-pointed star, formed by an external decagon of chapels. The stucco patterns, windows and ground plan are star-shaped, standing for the stars that appeared over Nepomuk's place of birth and of martyrdom; their points are modified to assume the form of a tongue.

As distinctive as it is, the kind of imaginative achievement demonstrated by the designs of Santini was at least matched in their own way by the striking syntheses achieved by sculptors at the same time, notably Matthias (Matyáš)

Bernhard Braun and Ferdinand Maximilian Brokof. In addition to the many free-standing monuments for wells, columns and statues that were put up, extensive construction in Bohemia and Silesia required many kinds of sculptural adornment. In fact the leading sculptors frequently collaborated directly on important architectural projects with the outstanding architects of the day. As designs by Fischer von Erlach for a plague column in Brno (Brünn) or as similar projects by Kilian Ignaz Dientzenhofer suggest, they also did not decline the opportunity to provide plans for designs to sculptors.

Accordingly in 1714 Brokof executed the sculpture for the tomb of Wratislav z Mitrovic (Wratislav von Mitrowitz) in the church of St James, a design by Fischer von Erlach that he included in his *Entwurff*, a moving translation of a Berninesque approach.[23] In Silesia Brokof worked with Fischer on the remarkable sculptural decoration of the elector's chapel in Wrocław Cathedral and supplied *bozzetti* (models) for the sculptures on the facade of Antonín Jentsch's cloister church at Krzeszów (Grüssau). Brokof decorated the facade of the house 'At the Golden Stag' designed in *c.* 1726 by Kilian Ignaz Dientzenhofer in the Prague Malá Strana, including a nearly life-size, fully plastic group of St Hubert before the stag; he also provided the 1714 ornamentation of the facade of Santini's Palais Moržin, where figures of day and night appear, and two Moors act as Atlases. Braun collaborated with Fischer von Erlach, no doubt working after his design, for the extensive sculpture on the attic, supporting the doorway and in the interior of the Clam-Gallas palace, of *c.* 1714, in Prague. At about the same time he

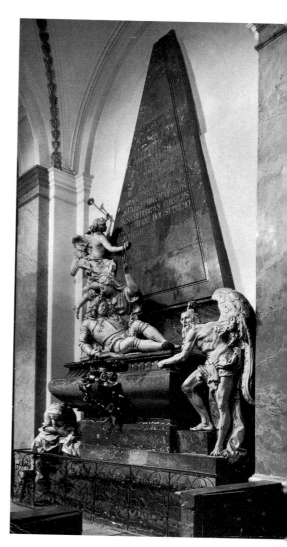

Tomb of J. V. Wratislav z Mitrovic, St James' Church (Sv. Jakuba), Prague, designed by Johann Bernhard Fischer von Erlach with sculpture, 1716, by Ferdinand Maximilian Brokof

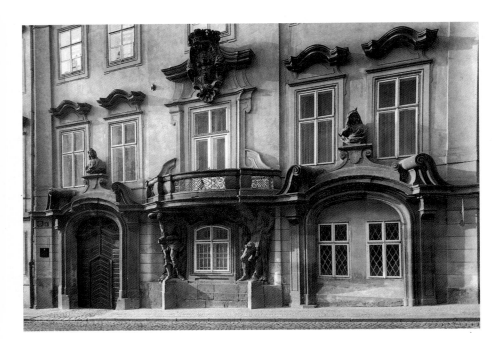

Detail of facade, Moržin Palace, Malá Strana, Prague, 1713-14, with sculpture by Ferdinand Maximilian Brokof, 1714, facade designed by Jan Blažej Santini Aichel

worked with Santini at the Kolovrat (Thun-Hohenstein) palace, where giant eagles with uplifted wings replace the giants of the Clam-Gallas palace.

This bold gesture, worthy of Santini, suggests that the collaboration of these artists might lend support to a consideration of the sculptors, like that of the architects, as producing 'radical' innovations out of a synthesis of different elements. A foretaste of the specific sort of international mixture that was to be produced in Bohemia is provided by a work from the beginning of this period, at a site which was to become a theatre of sculpture. This significantly is a statue of Nepomuk, set up on the spot on the Charles Bridge from which he was thrown, bound with weights, into the Moldau (Vltava); placed there in *c.* 1682, it provided the starting point, no doubt the catalyst, for the succeeding decoration of the bridge. In contrast to the dynastic commissions that Matthias Rauchmiller executed for the Piasts or Habsburgs, his design here of 1681 was for the commemoration of the local martyr around whom so much art revolved. The work also possesses a distinctly cosmopolitan flavour: while the *modello* (sculptured model) was supplied by the much travelled Rauchmiller, its source may have been a drawing by Mathey, and it was developed into the full-scale model for casting by Jan Brokof, a sculptor from the Spiš region in present Slovakia, where he would have experienced a tradition of Germanic sculpture going back to the Middle Ages and at the same time, as previous chapters may have

suggested, could have known Italian Renaissance works. It was Jan Brokof's son, Ferdinand Maximilian, who along with Braun was to bring Bohemian sculpture to such heights.

Ferdinand Maximilian Brokof directly continued a sculptural tradition that had by no means been killed by the Thirty Years' War in Bohemia. The *oeuvre* of Jan Jiří (Johann Georg) Bendl (*c.* 1620–80), a sculptor of Swabian origins who worked in both wood and stone attests to its health in the years after the war; his statues of Bohemian saints were most conspicuous on the St Salvator church opposite the Charles Bridge.[24]

After Bendl's death local sculpture continued to draw on its traditional sources, from Germany, from the Saxon milieu where the Süssners and the Heermanns, authors of the gigantomachy of *c.* 1705 at the Palais Troja (see p. 279), originated, and from Italy, whence Ottavio Mosto (1659–1701) came to Prague via Salzburg. All these sculptors appear to have been familiar in a mediated or immediate way with the sculpture of seicento Rome. This is obvious in the dramatic torsion of the statues of 1690–91 by Konrad Max Süssner (*c.* 1650–after 1696) for the interior niches of Mathey's crusader church and that of Mosto's St Michael (*c.* 1694) on Mathey's Prague Palais Toscana, where the deeply cut, dramatically counter-posed figure emerges from his niche to engage the viewer, charging the space before him, as do many of Bernini's works. In the crusaders' church the high altar of 1700–1701, a work of the leading sculptor of the first decade of the eighteenth century, Matyáš Václav (Matthias Wenzel) Jäckel (1655–after 1738), further translates Bernini's sacred theatre to Bohemia: it employs a device similar to that of the Cathedra Petri in St Peter's, Rome, whereby actual light suggests the divine in the *gloriola* of the Trinity.[25]

In this sculptural milieu Brokof learned, and to it Braun came. Braun was born in 1684 in the Tyrol, not far from Stams, where he must have seen the work of Thamasch, if he was too young to have been trained by him.[26] He

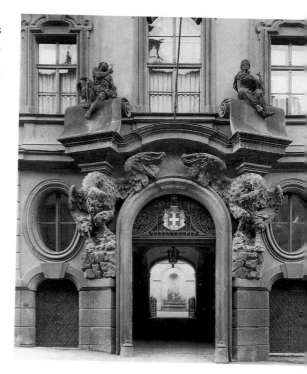

Detail of portal, Kolovrat (Thun-Hohenstein) Palace, Malá Strana, Prague, 1716-23, with sculpture, after 1720, by Matthias Bernhard Braun (1684-1738); facade designed by Jan Blažej Santini Aichel

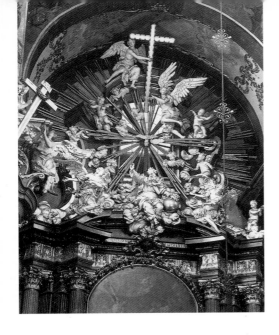

also probably visited nearby Italy, as well as passing through Austria, where he could have seen the work of the Zürn family on his way to Bohemia. Therefore both these genial sculptors were trained in wood-carving, to which the traditional Bohemian stone medium, easily cut sandstone, could be adapted.

Sculptors like Braun and Brokof employed these traditional media to transfer inventions resembling Berniniesque and post-Berniniesque designs to Central Europe. These are revealed in some of the early works by both sculptors, where traditional tasks, using traditional media, are treated with full baroque pathos. For example, in Braun's ecstatic Judas Thaddeus of *c.* 1712, Bernini's Longinus is translated into a wood figure with flowing draperies, whose motion increases the emotion of the figure. Other similar elements are to be discerned in the marvellous calvary groups by Brokof, such as that from St Gall's Church, where the life-sized, realistic polychrome figures express extreme lifelike emotions, and the angels atop beckon to viewers to participate, as they do in Italian seicento art. Direct communication with the beholder is expressed in a powerful way by Braun's moving sculptures of penitent sinners placed over the confessionals in the church of St Clement, Prague. In the land of Nepomuk the emphasis on the confessional is understandable, but the depiction of holy penitents is more than a decorous

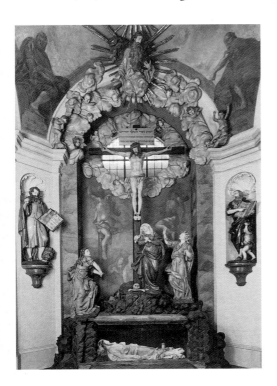

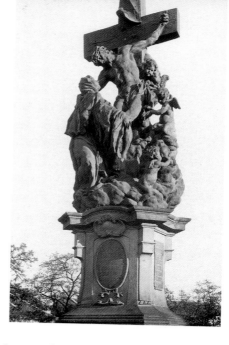

St Luitgarda, Charles Bridge, Prague, by Matthias Bernhard Braun, 1710

touch: it is also a meaningful one, designed to put the contrite in the proper state of mind, as they enter the confessional under the rags or the swine of the prodigal son.

It is significant that some of the first works by both artists, Braun's St Luitgarda of 1710 and Brokof's St Elizabeth, Adalbert, Francis Borgia and Cajetan, were commissioned for that most extraordinary of ensembles, the Charles Bridge, where between 1706 and 1714 twenty-three sculptural groups were added to the Rauchmiller-Jan Brokof Nepomuk and to works by Mosto and others that had been set up at the end of the seventeenth century. Here so much of what is distinctive from, as well as related to, Italian art, is revealed. In contrast to Bernini's adornment of the Ponte degli Angeli in Rome, to which it might be compared, this bridge possesses works by many sculptors, patrons, orders and even social groups; while it may in parts emulate Italy, it adapts Italian ideas to local customs. Appropriately many of the saints are local patrons as well as patrons of the orders. And in this process aristocratic commissions vied with the orders, and the older orders with the newer.

The early Cistercian commission of Braun's St Luitgarda, given by the abbot of Plasy (Plass), who was also a patron of Santini, can be regarded as a good reflection of this sort of command. Braun's figures, along with many of the other works commissioned by the older orders,

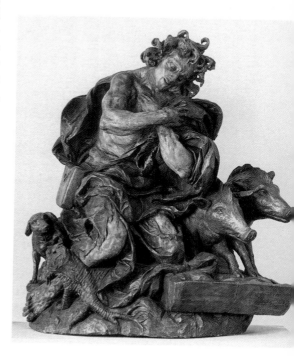

Prodigal Son, from Confessional, St Clement's Church, Prague c. 1720 by Matthias Bernhard Braun

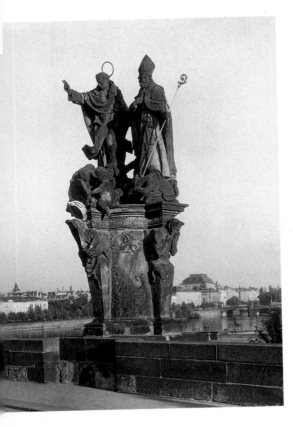

St Vincent and Prokop, Charles Bridge,
Prague, 1712, by Ferdinand Maximilian Brokof

can also be seen as being ripostes to the Jesuits, who were to commission figures of St Ignatius Loyola and Francis Xavier from Brokof, saints shown in their role as spreading a universal message. Whatever its diverse origins, the whole effect as one walks along is that of a triumphal passage – indeed the bridge lay on the traditional coronation route – that is lined not with the *tableaux vivants* that might have accompanied an earlier royal entry but by tableaux in stone.

A reverse side to this unique public theatre, a radical, personal aspect of Bohemian patronage, also existed: this is shown by the extraordinary ensembles created by Count Franz Anton Sporck (Špork) at his estates at Kuks (Kukus).[27] It is noteworthy that Sporck's plan for a statue of Charles VI for the Charles Bridge was rejected. Though educated by the Jesuits, Sporck became a Jansenist, and at Kuks he established a printing press where all sorts of works, including those that would have been regarded as heretical, were published. He championed the poor, setting up a poorhouse on his estates; he displayed an interest in folk culture, collecting folk songs; and at the same time he was involved with 'high culture', introducing the French horn into Bohemia. His estates at Kuks appropriately combine many of these high and low interests, the sacred and the secular.

After a spring found on the estates at Kuks was officially recognized in 1694 as having therapeutic qualities, Sporck founded a spa there, a type of establishment that is still a great Bohemian interest today; but to this spa he added his own residence, with a small court, baths and a chapel; then, across the valley, he laid out a church, designed by Alliprandi, with a house for philosophers, a library, a theatre and two hostelries. To these he added a casino, dovecote and various promenades, with an Invalides (rest home) for poor wounded veterans. Kuks also had a pleasure park with allegorical figures of the seasons and liberal arts, which do not survive. Then, from 1712, Braun

was commissioned to add sculpture to the terrace of a hospital church. Although these Virtues and Vices originated in rather mediocre prints by Martin Engelbrecht, they are converted into works of extreme expressive inventiveness, whose pathos, as in the personification of Envy, who eats her heart out, or the fat figure of Gluttony, accompanied by a pig, is extraordinary when converted into stone.

Not finished with this series, Sporck also established a hermitage, since like many of his time, and we may think of Nymphenburg or the hermitage in Bayreuth, he was much taken with this idea. He published two volumes on anchorites and hermits, inside which he expressed his 'special love for solitary spots and hermitages' (*sonderbares Belieben in derley Einsamkeiten und Einsiedelyen*). In nearby Bethlehem Wood he installed hermitages. After his hermits had been chased out by the Jesuits on the neighbouring property, Sporck in the mid-1720s had Braun do a sort of hermitage in stone. Although it may have forerunners in Holy Mountains or artificial Jerusalems, or Holy Lands in Italy, places where one would progress through sculpture and nature, Bethlehem is quite unique and seems almost a Bomarzo in stone.

Wisdom, from a series of Virtues and Vices, Hospital Terrace, Kuks, *c.* 1719, by Matthias Bernhard Braun

As the pilgrim from Kuks makes his excursion of some three kilometres to Bethlehem Wood, he or she encounters on the path a striking group of hermits carved out of the living stone. These include better-known figures, such as Mary Magdalene, and other more obscure hermits that Sporck had uncovered in his researches, such as Onufrius (from whose eyes water once gushed) and Juan Guarinon, who crawls on all fours across the forest path. There is a Flight into Egypt, and an Adoration of the Magi in a cave. This is not the final step in the

series of Sporck-inspired creations: on another piece of property, a wood, the count had sculptures cut out of living trees. Among other things, these projects may be regarded as some of the first true landscape gardens in Central Europe.[28]

Some brief final words about painting in Bohemia at this time are also warranted. As with sculpture, the extensive construction and refurbishing of churches and palaces produced work, much of it from the same patrons, for many ateliers in the late seventeenth and especially in the early eighteenth century. As with sculpture, in painting a similar sort of synthesis was to be achieved locally.

St Onufrius, Bethlehem Wood, Kuks, c. 1726, by Matthias Bernhard Braun

The roots of this synthesis have already been seen in the the preceding period. In addition to travelling abroad, an artist working in this area could have learned from what he might have seen locally. Substantial collections existed, especially in Prague as exemplified by the galleries of the Černín, Lobkowitz (Lobkovic), Nostitz (Nostic) and Slavata palaces, as well as that in the imperial castle itself. Foreigners continued to avail themselves of local opportunities, and from the work of previously established ateliers. Some of the outsiders, such as Carlo Carlone or Rottmayr, who was active in Moravia

and Silesia, have been mentioned; others in the late seventeenth century were, in addition to the Austrian Gran, who painted in Brno, Moravia, the Fleming Abraham Godin and the Swiss Johann Rudolf Byss, who worked in Palais Troja.

Locally, Škréta's tradition of implanted Italianism was carried on by painters such as Jan Jiří Heinsch (1647–1712). On the other hand, while centred in Silesia, Willmann, who himself continued painting into the eighteenth century (he died in 1706), delivered works for churches in Prague and elsewhere in Bohemia, including a martyrdom for Sedlec. Willmann's pupil and son-in-law, Johann Christoph Liška, may also be regarded as one of the leading painters of the early eighteenth century in Bohemia. He added to Willmann's northern tenebrism lessons learned from Italy, charging his light-struck canvases with the brio brought by a loaded brush, often applied *alla prima*. He also collaborated with the Cistercian revival, as did the sculptors, illustrating a history of the order.

The culminating synthesis was achieved by the local painter Petr (Peter) Brandl (1668–1733), who, though never in Italy, could combine local tendencies with Venetian, Bolognese, Flemish and other elements to create a new mixture.[29] His style accordingly blends a broad touch applied to produce works in which figures are set in strong chiaroscuro. From a humble background (his family were innkeepers), Brandl, like Santini, tried to take painting out of its craft status and made an abortive attempt to establish a painter's academy in Prague. His patrons were the same that we have met, nobles like Sporck and the monastery of Břevnov, for which he completed a series of altarpieces. Brandl's new synthesis also provided a foundation for the next generation of painters in Bohemia, men such as the portraitist Jan Kupecký, who was born in Slovakia, and Václav Reiner, the frescoist and religious painter.

Towards the end of Brandl's life, however, another important painter appeared on the scene in Bohemia and Silesia. This was Cosmas Damian Asam, who painted frescoes in Christoph Dientzenhofer's prelature in Břevnov, K. I. Dienztenhofer's Legnickie Pole and St Nicholas in the Old City, and in Santini's Kladruby.[30] Asam's appearance reminds us not only of the interconnectedness of art in Central Europe but of the place where a comparable, contemporary synthesis of the arts was to be achieved, neighbouring Bavaria. In Bavaria another kind of combination of the arts was effected, which also had broad appeal and far-reaching effects. It is to this aspect of art in southern Germany that we now turn.

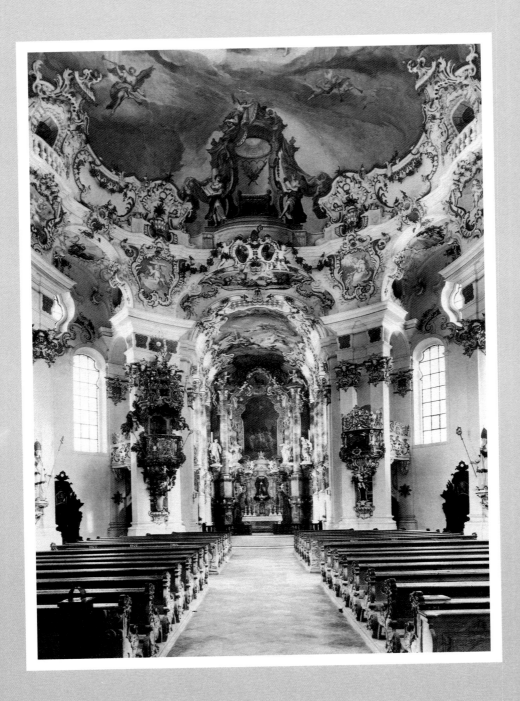

SOUTH GERMAN ART AND ARCHITECTURE OF THE EARLY EIGHTEENTH CENTURY IN ITS EUROPEAN CONTEXT

Interior of Pilgrimage Church,
Die Wies, by Dominikus and Johann
Baptist Zimmermann, 1746-54

IN THE SECOND DECADE OF THE EIGHTEENTH CENTURY, WHILE MANY PALACES IN GERMANY AND AUSTRIA AND CHURCHES IN BOHEMIA AND SILESIA WERE GOING UP, A WIDESPREAD BOOM ALSO BEGAN IN CHURCH ARCHITECTURE AND DECORATION IN SOUTHERN GERMANY. It has been estimated that at least two hundred churches of some artistic significance were erected between 1700 and 1780:[1] many of them were constructed in the period 1710–60, mainly in the Catholic areas of Bavaria, Franconia and Swabia. This boom also entailed comprehensive programmes of decoration that included painting, sculpture and stuccoed ornament. They also announce the advent of a mode that is usually associated by art historians with a new stylistic manner, the rococo.

In France this style is customarily connected first with art of the period of the Regency of Louis XV. From approximately 1715 it might seem as if the claims to grandeur of the age of Louis XIV, its fashions of life and art, were being rejected.[2] As the court moved back to Paris from Versailles, the centre of social life was displaced from the palace to the salon. With the move from the public domain of the château to the private world of the hôtel, an intimate art, more personal in character, and a new decorative style were created: these are encapsulated in the very type of room, the salon, where conversation and polite manners reigned, along with erotic dalliance (and we may remember that the regent, the Duke of Orleans, was a notorious roué).[3] In interior decorations, for which famous later examples are the rooms in the Hôtel de

Exterior, Amalienburg, Nymphenburg, begun 1733, by François Cuvilliés the Elder

Soubise, scenes of dalliance and love, not grand themes from ancient or contemporary history, are the subjects depicted. The new decorative style, which had in fact already originated at the end of the reign of Louis XIV, when it was seen in the ribbon-work designs of Pierre Lepautre, abounds in grill work and C- and S-curve patterns; where vegetative forms are employed in the new mode, the leafy plant becomes a scroll or a tendril. During the regency the heavily laden ornament popular during the preceding period of the grand monarch's reign yield further to curving, gracious, light forms; the rectilinear gives way to the *contrecourbe*. Adherence to the tradition of the classical orders of architecture in matters of decoration abates.

Ornamental forms from the French regency, and later the French-inspired *rocaille* with its rock and shell work, provided the ultimate sources for similar decorative designs in Germany and Austria. Augsburg printmakers spread their currency through engravings. And to a degree their use recurs in similar secular milieus in Central Europe as well. They are especially evident in Bavaria, where the electoral court was, as noted, closely tied to French fashion. In the second decade of the eighteenth century, after Max Emanuel had returned from exile and when French forms were being imported to Schleissheim and Nymphenburg directly by French gardeners, as well as by French-trained architects, decorative elements derived from France also appeared in interiors of new garden pavilions, for instance in the boiseries by Johann Adam Pichler in the Pagodenburg at Nymphenburg. Similar designs were

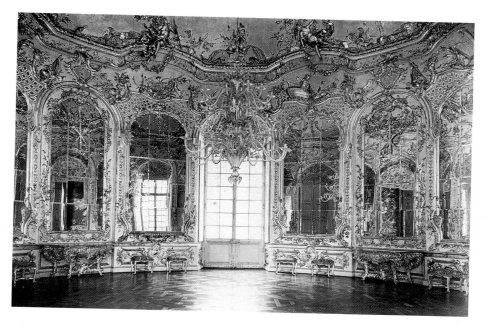

subsequently executed during the 1720s elsewhere, in the Vienna Belvedere and in Pommersfelden.

Mirror Room (Spiegelsaal), Amalienburg, by François Cuvilliés the Elder, stuccoes by Johann Baptist Zimmermann and others, 1734-9

The next stage in Bavarian design appeared after the *rocaille* style of ornament had evolved, during the reign of Max Emanuel's successor, Karl Albrecht (who was later to become Holy Roman Emperor). In the 1730s François Cuvilliés the Elder, a court architect of Walloon origins, who had been trained by Blondel in France, designed a series of splendid interiors in what has been described as a new, 'galant' manner.[4] Cuvilliés had worked in *c.* 1730 for the Bavarian elector's brother, Clemens August, the prince-bishop elector of Cologne, at Brühl, where he introduced a number of French-related interiors.[5] In palaces in and around Munich he then designed several interiors that can in fact be favourably compared to the best French creations. Rooms of the Munich residence in a rococo manner by Cuvilliés include the Green Gallery, the *Ahnengalerie* and the *Schatzkammer* (treasury). A master work of the 1730s, the Amalienburg, a casino that served as a hunting lodge-cum-retreat, arose on the grounds of Nymphenburg. The central room therein, the ovoid *Spiegelsaal*, stuccoed in silver by Johann Baptist Zimmermann, employs a device used at Versailles, mirrors that seem to extend the space. In the Amalienburg, however, the mirrors do not so much distend space, as dissolve mass. Ornament similarly tends towards the dissolution of architectonic structure, as it takes on a narrative, even pictorial character. It presents scenes related to the hunt and to the world of nature. Everything, including the silvered furniture composed of

contrecourbes, participates in a world of aesthetic play: it seems fitting that a later design by Cuvilliés was for the court theatre in the Munich residence.[6]

The *Spiegelsaal*, while comparable to the salon of the Hôtel de Soubise, is directly contemporary with it and so must be regarded as an independent invention, even if it is ultimately derived from related sources; in any case its meaning as part of a garden retreat in a court context is different. Furthermore, although there are other striking examples of rococo design in secular settings in southern Germany, such as the Palais Preysing of *c.* 1740 in Munich,[7] the Schaezler house of the 1760s in Augsburg and related forms appearing elsewhere in Germany in the 1740s, as we shall see in the next chapter, it was not in the domestic sphere nor lay environment that this style truly flourished in Germany. Although there was a circulation of motifs and personnel, like the Zimmermann brothers, between the court and church environments, it is in the church that these forms truly proliferated.[8]

The milieus, motivation for and manifestations of comparable forms in southern Germany therefore differed in most instances to those in France. Whereas Cuvilliés and similar designers worked on a relatively small scale, in garden pavilions or decorating rooms within larger structures, whether they had stood for a long time or had recently been constructed, these efforts, fine as they are, are overshadowed by the sheer quantity and quality of church construction and decoration of the same period. In Bavaria and the neighbouring German lands, as in Bohemia, large churches and new monastic buildings were built; the scale of projects, for both new and rebuilt structures, was often considerably larger than those posed by the completion of palace interiors. Although local princes might make contributions for church constructions and build their own palace chapels, many more such buildings were erected or decorated by churchmen.[9] Prelates, prince-electors, prince-bishops and abbots, and especially the more numerous abbots and priors (of both genders), seem almost to have vied with secular princes in the scope and splendour of their undertakings.

The great land holdings of ecclesiastical establishments, for whom large numbers of peasants worked, enabled prelates to find the material support for their enterprises, much as was the case elsewhere in Central Europe. Especially the older, rooted monasteries had the means to aspire to extensive interior decoration or new construction. Although the region seems not to have been particularly prosperous during this period, conditions persisted whereby incomes came directly to the lord of the demesne, secular or sacred, and thus in these instances often to the abbot, at whose disposition substantial funds were placed. In addition, the pilgrimages that the cloisters encouraged and that are associated with many of the great churches of the time – Weingarten, Wies, Vierzehnheiligen, Andechs, Einsiedeln, to name just some of the most famous – were, and (to judge from personal observation at these and many other sites) still are, genuinely popular: income from pilgrims added to the riches of the abbeys or churches who controlled them.

Inasmuch as many of the churches of note are pilgrimage churches and pilgrimage can justifiably be considered a form of popular religion in several senses of the word, the art that was produced in these settings, if paid for by the upper social strata, approaches that of the people.[10] A typical location for many of these monuments sets them picturesquely in nature: in one famous example, the church of Wies is literally set in the meadows after which it is named. A rustic setting also brings the church closer to the peasant population. In many of these churches, that are placed on mountains, in valleys or near lakes, it almost seems as if the beauty of art completes and complements that of nature, that man's and God's creation may be seen in harmony with each other: was the appeal of the site, part of the continuing attraction today, also in the mind of the founder? Certainly nature often assumes the aura of sanctity in connection with a holy site.[11]

The story of the church in the Wies also provides an example of a pilgrimage site that did not start with a prelate's sponsorship of the veneration of a cult image: it demonstrates how such churches could in fact result from spontaneous movements of popular piety. When a sculpture of a figure of Christ was about to be thrown away, a woman who lived near the Wies claimed to have seen it weep. Soon the site became a centre for pilgrimage. This popular cult grew to such an extent that the abbot of the nearby Premonstratensian abbey of Steingaden, where the Zimmermanns had worked, responded by commissioning them to construct a worthy church.[12]

As the story of the Wies church also suggests, both artists and motifs not only circulated between court and church, but also between 'higher' and more humble settings. While Johann Baptist Zimmermann worked for the Bavarian court at Amalienburg early in his career, 1723–5, then in the 1730s executed the stuccoes in the *Festsaal* (festival hall) at Schleissheim and finally at the end of his career in the 1750s contributed to the decoration of the *Festsaal* at Nymphenburg, these projects are rare among the fifty-odd commissions executed for churches by the Zimmermann brothers. It is striking that Dominikus Zimmermann, after completing the church at Wies, settled there in an adjacent dwelling. According to traditional pattern, figures like the Zimmermanns or the Asams, who may occasionally have served the court (Cosmas Damian worked at Schleissheim and Egid Quirin Asam at Mannheim), came from an artisanal family, established in long-standing craft centres, such as Wessobrunn. Many also came from humble origins, like Matthäus Günther, the most prolific frescoist of the century, who was born in the village of Hohenpeissenberg and who, after a long and successful career, in which he too worked for the court of Württemberg in Stuttgart and became academy director in Augsburg, retired to the country village of Haid near Wessobrunn.[13]

Consequently what had originated as a *Salonsprache*, a language of the salon, eventually became a *Volkssprache*, a language of the people. Important masters like Günther or the Zimmermanns often worked in very small places,

and there were many lesser-known figures who were active in towns and market places, where they followed the examples of more prominent artists.[14] Thus the accomplishments of the major foundations gradually became broadly disseminated. One outcome is that the tradition of fresco painting, that was also extended to the decoration of house facades by outstanding eighteenth-century painters such as Johann Holzer, became part of a folk tradition. *Lüftlmalerei*, facade painting of religious and secular scenes in a manner similar to that found in church interiors, appears in alpine regions to this day.[15] In recirculating designs from court or monastery to humble settings in the same regions, this aspect of German art of the eighteenth century indicates, as suggested in the introduction, that, much as popular religion can really be considered local religion, popular art can be better described as local art.[16]

Like Bohemian art, south German art in the sacred context – the rococo – was indeed a fusion of local traditions with international tendencies. Although the element of agency may differ, the conditions that account for the origins of large-scale pilgrimage and cloister churches were also not unlike those in Bohemia and Silesia where, as we have seen, the Asams, who provide a paradigm for this period, also worked. Because of local social circumstances, working conditions, intellectual traditions and artistic sources, what resulted in Germany is nevertheless quite distinctive.

The typical great rococo interior, such as Ottobeuren or Schussenried, has no obtrusive, independent paintings; sculpture, stucco, painting and architecture were fused into a whole. While happy collaborations and successful ensembles also originated in Bohemia and Silesia, they took on different aspects. The working process and the division of labour were different in those lands, where workshops had to be re-established locally after the disruptions of the war, and many foreigners, including numerous Italians, could thus easily find work. In contrast, local tradition remained vital in Germany, where teams of decorators, masons and painters collaborated through the years. Often in Germany where artists did not collaborate in teams, the same artist might combine several talents, as did the Zimmermanns or the Asams, who were simultaneously decorators (stuccoists), architects and painters.

Secondly, while in both instances local traditions of church design were conflated with external elements, German churches drew from different sources of inspiration than those in Bohemia or Silesia. Considered as architecture, many German eighteenth-century churches descend from the tradition of the wall-pillar church, also employed by the Dientzenhofers, and in some instances they are combined with the tradition of the late medieval hall choir church, in which side aisles were as high as the nave. Among many other examples, the Augustinian Church in Diessen, 1731–9, the Benedictine Abbey Church in Ottobeuren, begun 1737, and Rott am Inn, begun 1759 by Johann Michael Fischer (1692–1766), also demonstrate that designers of German churches devised plans comparable to those of the Guarininian

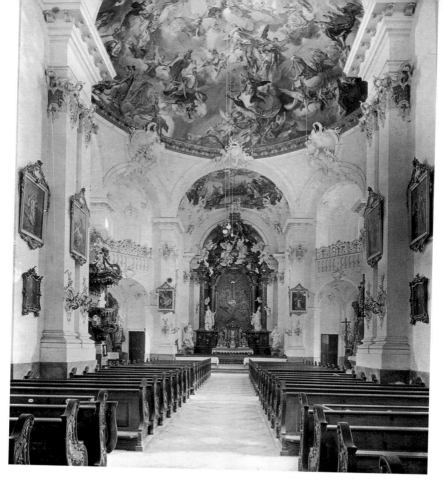

Benedictine Abbey Church, Rott
am Inn, 1759-62, by Johann Michael
Fischer; with frescoes by Matthäus
Günther, and sculpture by Ignaz Günther

tradition, since, as in Bohemian examples, they combined oval and rectangular plans.[17] They also succeeded in creating the effect of 'diaphanous walls and weightless vaults'.[18] Many churches thus resulted in which there was a centralized space, permeated by an often indirect light.

In Germany, however, other Italian tendencies, involving the illusionistic use of architecture, painting and stucco, combined with the conception of a *bel composto*, were melded with decorative elements of French origin or inspiration, which were often communicated through ornament books produced in Augsburg. These compendia are an indication that Augsburg had retained its importance as a publishing centre, a place for exchange of ideas through books. And ornament was not all that was circulated: selection and invention of content for images was also facilitated by the printing of books such as an edition (1758–60) of Cesare Ripa's *Iconologia*, the then standard compilation of personifications.[19]

To consider the question of ornament first: the forms used in Germany contrast with the decorative vocabulary of the later seventeenth century and early eighteenth century employed, in some instances, by the immediate forerunners of the eighteenth century, such as Joseph Schmuzer, who preferred heavy stucco baroque with deep leaf forms. This stucco baroque was the sort of ornament found into the 1720s in churches decorated by the Asams and was not, properly speaking, Regency or rococo decoration but a kind of vegetative design. By the 1730s these were replaced in Germany by the white and gilded stucco made by Franz Xaver Feichtmayr, which, as evinced at Diessen, uses rococo framing elements. Ultimately this new form of ornament came to replace elements of the architectural orders in the construction of ornament, and to frame and separate parts of the church. This ornament has been described as assuming pictorial qualities, and whatever the particular interpretations offered by historians, the name given it has supplied the term for a more general designation in Germany as in France, rococo.[20]

Another trend within German church designs indicates, however, that Italian inventions had an important effect at the same time. Hence art historical literature has often linked the rococo to the baroque, since ideas essentially of Italian seicento origin were also elaborated in the north.[21] These ideas of the unity of the visual arts had been developed in the circle of Bernini, and by those of his followers who worked in late seventeenth-century Rome. Painting, sculpture and architecture were combined to create one effect, in the service of religion; consequently various illusionistic devices were employed to elide the boundary between actual and fictive space, to erase the border between the earthly and heavenly.[22]

A paradigmatic figure in German development, Cosmas Damian Asam was in Rome in the early 1710s.[23] This detail is significant, because some of the earliest works in the new fashion in Germany, as well as the eventual attainment of a newer sort of synthesis of the arts, were achieved by the Asam brothers. Both Asams were architects, while Cosmas Damian was primarily a painter and Egid Quirin a sculptor. In Rome Cosmas Damian would have become familiar not only with Bernini's inventions but with the ceiling paintings of Andrea Pozzo and Giovanni Battista Gaulli, in which churches seem to open up to the heavens. In Rome he mastered what he had learned so well that he became a prize-winning member of the Academy of St Luke.[24]

The works that Cosmas Damian executed after his return to Germany demonstrate that he had brought back much that he had learned in Rome. From 1718 to 1720 in the Benedictine monastery at Weingarten, Asam devised a solution to the question of the integration of painting with architecture or sculpture, and the relationship of painting to the decoration of the whole. While innovative in Germany, this remains more or less in line with Italian designs; Asam was working in a space already assigned to him, just as Frisoni, the Italian architect who designed Ludwigsburg, had taken over someone else's project and had thus been similarly inhibited in his designs.

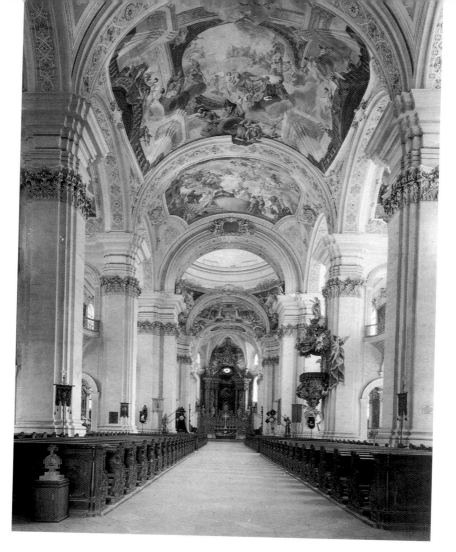

Benedictine Abbey Church, Weingarten, begun 1715, completed by Donato Giuseppe Frisoni; frescoes 1718-20 by Cosmas Damian Asam, stuccoes from 1718 by Franz Xaver Schmuzer

Significantly, the building was also rooted in tradition: as was typical for the Benedictines, the church was situated on a hill that commanded a view and was also a place of pilgrimage to the relic of the Holy Blood, to which on its Holy Day a procession on horseback still ascends. This church has an impressive, almost palace-like exterior, and the career of its architect also directly conjures up the way in which ecclesiastical architecture answers that of the court. The fabric left large expanses of interior surfaces to be covered by painting, perhaps also a response to the heavy decorations of Ludwigsburg, and it was these that Asam covered.

At Weingarten Asam's painting is distinguished by being one of the first major works in which Roman-inspired inventions are found. Asam's work here

is one of the first applications in Germany, as distinct from their earlier appearance in Habsburg lands, where Pozzo had actually worked in Ljubljana (Laibach in Slovenia), Vienna and Bratislava, of Pozzo's perspectival scheme for depicting scenes from below, *di sotto in su*. The dome, as in Pozzo's work, is extended by fictive architecture and, also as in early seicento painting, the ceiling opens up to a view of heaven.

More or less simultaneously, in the Benedictine pilgrimage church at Weltenburg in 1718–21, Cosmas Damian and Egid Quirin employed another Roman or, rather, characteristic Berniniesque invention, treating the church as a composite whole in which sculpture, painting and architecture are integral parts that add up to a single effect. In Weltenburg Asam extends and exceeds the Berniniesque invention, turning the whole into a location for a sacred drama, which is meant to increase the devotion of the pious. As one enters this building, columns, like stage flats or the entrance to an auditorium, separate one from the central space. This space opens up to reveal that it has a central plan, into which light pours; the source of this light is however hidden, as the dome over the oval nave is cut off from the higher painted ceiling; as in Bernini's sculptural composition of St Theresa of Avila (in S Maria della Vittoria, Rome), the suggestion is that its source may be other-worldly. Similarly, indirect lighting is used to suggest a divine apparition on the high altar, where the silver-gilt, hence the suggestion again is divine, figure of St George chases a polychrome dragon away from a maiden in a work by Egid Quirin; on the ceiling spectators are painted, including the artist Cosmas Damian himself. Around this time, in a design completed in 1723–4 at Rohr Egid Quirin uses the church as a backdrop to a great drama. The life-size sculpted figures represent the Assumption of the Virgin and make it seem to take place before our eyes. Here as in many other places Cosmas Damian executed the altarpieces.

In this fertile period at the beginning of the 1720s, the two brothers were able to carry out their own design for the Cistercian cloister church at Aldersbach, where they completed the decoration of the whole, altars, stucco and the painted ceiling. Here the ceiling is integrated with the architecture, and indeed its own surface is integrated into one composition, unlike Weingarten or other churches in Germany, where individual frescoes were confined to separate bays. While in its unification of the entire ceiling it somewhat resembles its Roman precedents, the frescoes in the Gesù or Sant'Ignazio, and it had been anticipated in the Jesuit Church in Wrocław (Breslau) by Rottmayr, the fictive conceit at Aldersbach is different: the edge of the architecture, marked off by stucco, is treated like a balustrade. The decorative patterns match the shapes of the fresco, and fictive, painted angels complement sculpted ones, who pull back curtains to reveal a scene of the Adoration; colouring in the fresco also matches the painted tone of the whole. The result is that a synthesis of the arts is achieved, and there is an increase in space for painting.

During the 1720s and 1730s the Asams completed many works

throughout the region, from which two may be singled out, not just for their aesthetic accomplishment, but for their more general cultural resonance. From 1724, probably on the basis of their success at Weingarten, the Asams completed the decoration of the large Benedictine abbey of Einsiedeln, near Lake Zürich. The church itself had been designed by Caspar Moosbrugger and built from the late seventeenth century, an example of what is at times called the

Benedictine pilgrimage church, Einsiedeln, begun 1721, designed by Caspar Moosbrugger, one of the 'Vorlarlberg school'

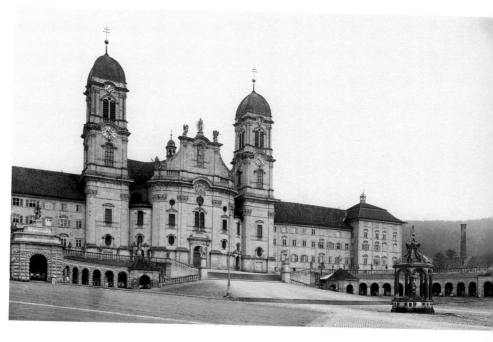

Vorarlberg baroque: it employs a complex sequence of forms, consisting of an octagon, a shape often adopted for a martyrium, followed by two circles. The octagon surrounds a shrine that had been erected by Santino Solari, the Salzburg architect. The Asams' painting and sculpture is masterfully fitted into this light-filled space.[25]

It is noteworthy moreover that this church was located near Zürich, the original centre of Zwinglianism; in the face of a religion that had introduced widespread iconoclasm and preached against pilgrimage and Marian devotion, there was good reason to counter-polemicize. The pilgrimage here was indeed associated with Marian devotion and became very popular in the eighteenth century, attracting as many as 100,000 people per year. The Marian subject matter that informs Asam's painting and the devotion to a holy image fit well in this context. The promotion and lavish decoration of pilgrimage sites, especially in response to iconoclastic tendencies has further echoes at this time.

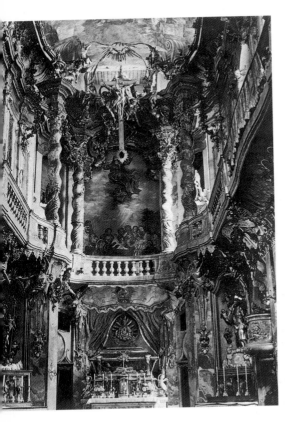

The great baroque church of Święta Lipka (Heilige Linde), built from 1687 to 1730 in East Prussia by the mason Georg Ertly, was also decorated with an illusionistic painting by the Warmian painter Mathias Johann Meyer in 1723. It housed a miraculous image, the original of which had in fact been smashed by Protestants, and the Jesuits' rebuilding of the church seems openly polemical. The encouragement of pilgrimage sites on the borders of Protestant sects has been seen in Silesia, and they certainly appeared in Braniewo (Braunsberg) on the border of the lands of the bishop of Warmia in Poland and that of East Prussia.

While in these instances the Asams might thus be involved with a kind of polemic through art of the sort already encountered in Bohemia, their own personal response in the John Nepomuk Church has a different resonance.

John Nepomuk Church, Munich, begun 1733, by Egid Quirin and Cosmas Damian Asam (photograph before restoration)

When from 1733, on their own initiative, the Asams erected a church to the saint's honour next to their house in Munich, theirs was an action of personal piety. The dedicatee of this church was not only revered in Bohemia but also, after his canonization in 1729, in Bavaria, since it was a queen from the Wittelsbach family whose secret the saint had not revealed. Thus it is appropriate that the confessionals should be adorned with admonitory figures: the importance of the confessional is emphasized by the presence of one figure who is clearly derived from Jacob Biedermann's *Cenodoxus*, a Jesuit play mentioned above (p. 264). In the Asams' church the Germanic hall form is yoked to a Berniniesque device, backlighting, to suggest the apparition of the saint in the midst of a riot of painted and stuccoed figures. There were to be sure many other examples of this successful sort of collaboration between skilled painters and sculptors, and local decorators, who were responsible for the stucco. Here, for instance, there were the Wessobrunn artists, with whom the Asams and also Matthäus Günther (1705–88), who executed more than sixty fresco cycles from the 1720s to the 1780s, worked. Throughout the region a happy integration of

the genres was found in many churches, where exquisite architectural and ornamental design was combined with paintings placed on the ceilings of the nave and side chapels, on the nave walls and beneath windows. Typically these works were achieved by painters like Günther, who like his predecessor as director of the Augsburg academy, Johann Georg Bergmüller (1688–1762), was a painter who went out in the summertime to execute frescoes in the surrounding areas.[26]

Augustinian Church, Diessen, completed 1731-9, by Johann Michael Fischer; with frescoes, 1736, by Johann Georg Bergmüller; stuccoes by F.X. and J.M. Feichtmayr; altarpieces by G.B. Tiepolo, and others

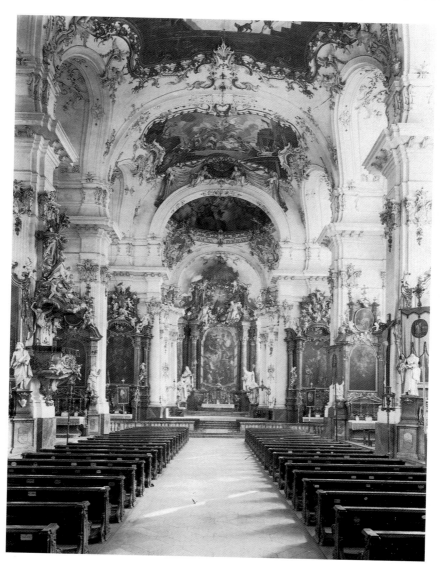

If the work of the Asams has been dwelled on, it stands for only a fragment of a much larger whole; yet this emphasis seems justifiable, not only because the Asams were responsible for the first occurrences of many of those features that later appeared in other artists' works, but also because their pupils, like Günther, often became the dominant figures among the next generation active in the area.

Out of the wealth of creation at this time, it may be sufficient, therefore, merely to mention two achievements. One is the church at Diessen, a monument already mentioned in passing, that encompassed productions of high quality in all the arts. The architectural design, in an oval form with a unified space, is, as noted, the work of Johann Michael Fischer; the fine stucco work with rococo patterns is by F. X. and J. M. Feichtmayr. The ceiling

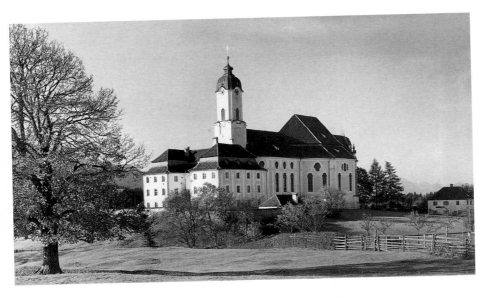

Pilgrimage Church, Die Wies, 1745-54, by Dominikus Zimmermann and Johann Baptist Zimmermann

paintings are by Bergmüller, illusionistic masterworks that can be read correctly from only one place; and there are also altarpieces by the great Venetian master Giovanni Baptista Tiepolo and the Augsburg master Johann Evangelist Holzer. Moreover, it has been noted that the view of heaven is a particular Bavarian heaven; not only do the scenes on the ceiling trace the history of the cloister but the saints depicted are Bavarian saints; in this pilgrimage church splendid art has become truly local as well.[27]

A similar result may be seen in the great and perhaps culminating monument of this period of art, a church of the 1740s that brings together many forms of the time. This is the masterwork of the collaboration of Dominikus Zimmermann (1685–1766) and Johann Baptist Zimmermann

(1680–1758), the church in the Wies, 1745–54. More than in other central-ized Bavarian churches, this one successfully solves the problem of reconciling plans for a centrally planned church and a longitudinally arranged church, not only by the creation of an oval nave, but by the suppression of the side aisles, their combination with the ambulatory, the thinning of columns separating the nave from the aisle and the piercing of the wall with openings. These apertures, together with the large side and upper windows, fill the church with light. Sculpture, stucco and mouldings take the form of *contrecourbe* designs, and as architectural elements turn into decoration, they complement painting and sculpture to create a gorgeous effect. The ceiling is adorned with a painting of the *hetoimasia*, the preparation of the throne in heaven for the Last Judgement with the opening up of doors. The revelation depicted is appropriate to the miracle that was supposed to have occurred at the site, and the aesthetic devices of light and colour are used to carry it out. It has been said that the effect of the whole is one of aesthetic play, and play is no doubt one of the qualities of aesthetic or artistic creation, that is free play of mind or its faculties. If so, play is here, however, unlike in Cuvilliés, deeply felt and rooted in the content, which aesthetic means serve; in that sense art can only be understood in part to approximate or anticipate Immanuel Kant's discussion of aesthetics, to be discussed below. In Bavarian churches like Wies the joy of religion, of beauty as an expression of the divine, is what is communicated.

Our concern here has been with churches of this period as complete phenomena, and it would be as meaningful to extract any one component from the whole as to isolate a line in musical counterpoint. Contemporary competition from Italian and especially from French masters and models captivated the Germans (as we shall see in the next chapter) in the time of Frederick the Great, who was a patron even before he became king (1740), and has tended to obscure the individual accomplishments of German painters, sculptors and architects, besides the recognition that they created a successful ensemble. In Bavaria and indeed throughout the region of southern Germany, French and particularly Italians either sent works or were active there: Giovanni Battista Pittoni, Giovanni Antonio Pellegrini, Giambattista Piazzetta, Jacopo Amigoni, all precede Tiepolo.[28]

Tiepolo's paintings may nevertheless be discussed first, because his frescoes in Würzburg suggest what was the outcome of rococo decoration. What began as an intimate style, not at all one meant for the grand gesture, circulated through an ecclesiastical context, and then recirculated into the dwelling of a prelate, where it was utilized for the expression of a sort of secular magnifi-cence. The Würzburg residence is decoration on a grand scale, and inasmuch as Tiepolo's frescoes of the 1750s are part of a decorative scheme, they may be considered decorative paintings, like those of the churches hitherto discussed. Indeed, like some of the Asams' early works, they had to be fitted into spaces already existing for them; these rooms contained stucco, gilding, mirror and

curvilinear windows, appropriate for a rococo decoration, and their combination with Tiepolo's painting creates the unusual result of grand rococo history painting.

The individual scenes relate to the history of the bishopric: in the Würzburg *Kaisersaal* the emperor Barbarossa is joined in matrimony by the Würzburg bishop, who in another scene is invested by the emperor with his lands. These pictures thus exemplify well the way art has of glorifying seemingly insignificant events, and they employ the sweep and colour of the

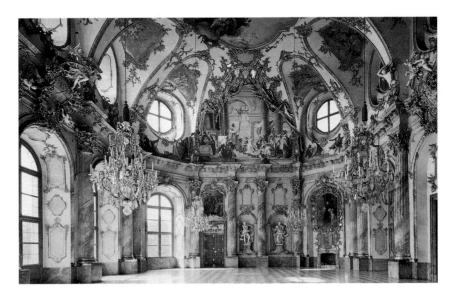

Kaisersaal, Residence, Würzburg; architecture by Balthasar Neumann; frescoes by G.B. Tiepolo and sons, completed 1752

Venetian's synthesis of previous art and devices to do so. Illusionism in the tradition of Bernini is worked in here, as stucco curtains turn into paint; a dog may have a leg half-solid, half-painted; a painted staff of a weapon may suddenly stick out as a solid object.

Over the residence's stairway Tiepolo reworks a traditional allegory of the sort that often appeared in churches of the era. This is an allegory of the four continents paying homage to a ruler, which was often readjusted to depict the spread of the Jesuit order. It corresponds to the eighteenth-century investigation of the world and its taste for the exotic, to an increasing interest in the appearance of a real sense of geographical place, of actual lands and of events anchored in reality; the frescoes correspondingly de-emphasize allegorical representations that were divorced from reality. The ruler is the Prince-Bishop Greiffenklau, a successor to the Schönborns and really an unimportant figure; the problem was to depict the ruler in his grandeur.[29]

Artists from the region may however bear comparison with Tiepolo, if we

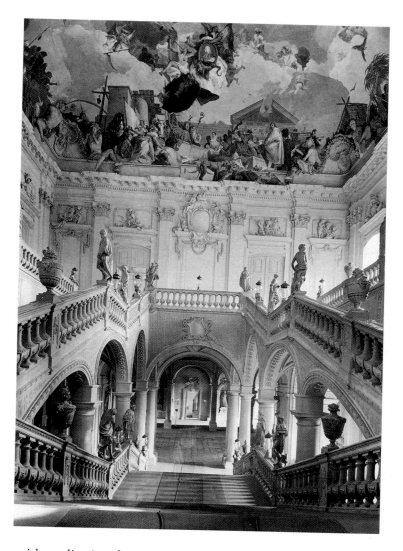

neither dismiss frescoes they executed nor demand from them, any more than we would

Staircase, Residence, Würzburg, 1737-50, by Balthasar Neumann; frescoes by G.B. Tiepolo and sons, 1752-3

from Tiepolo, that they produce paintings resembling works in the French tradition, that are based on another notion of draughtsmanship. Painters such as Johann Evangelist Holzer executed works that are noteworthy for their individual accomplishment.[30] Few of Holzer's works survive, but in his ceiling in St Anton, Partenkirchen, one can understand why he was praised by his contemporaries. In this work he created one of the great colouristic masterpieces of the eighteenth century. The iridescent beings on this ceiling are also lit by a kind of indirect light, creating a luminous masterpiece, of the

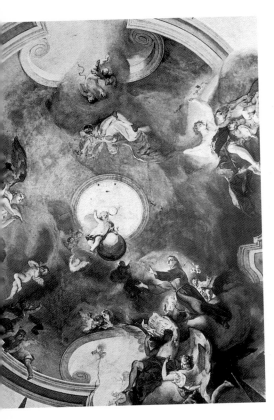

Fresco with St Anthony of Padua,
St Anton, Partenkirchen, 1736,
by Johann Evangelist Holzer

sort seldom encountered in the history of art. Such a work may claim to equal Tiepolo; certainly it is more successful in using illusionistic devices to communicate its vision of the miraculous deeds of the saint than Tiepolo is in glorifying the prince-bishop. Indeed it is necessary to comprehend that a taste existed for this sort of colouristic, as opposed to academic, painting, because it suggests why Tiepolo could be called to work in Germany. Long prior to his arrival, Holzer had been given the commissions for Würzburg and for Münsterschwarzbach, two projects that Tiepolo later completed after Holzer died young, in 1740.

Like painting, sculpture in south German ensembles was often fitted into prearranged spaces, serving set functions, and was executed as part of a design of the whole.[31] The character of sculpture was determined by the often rather standard task at hand and by questions of design. Nevertheless much sculpture of the time is worthy of attention and can be related to a long-standing tradition and its variations in the region. It may even be said that a last high point in the history of stucco and wood sculpture was reached at this time, before changes in taste determined changes in the medium as well and before polychromy in sculpture was rejected.

Many extraordinary works of sculpture were produced in southern Germany in the second, and even more in the third, quarter of the century. The significance of Egid Quirin's works within the larger ensembles in which they are located has already been noticed. At a slightly later point in time, much outstanding sculpture was produced in Swabia, for example in the pilgrimage church at Birnau near Lake Constance, where the building designed by the Vorarlberger Peter Thumb (1681–after 1758) seems almost a simplified membrane designed to house the frescoes by the painter Gottfried Bernhard Göz (1708–74) and the stucco and sculpture by Joseph Anton Feuchtmayr (1696–1770). If there are arguments about the characterization of the architecture and the decoration of the whole, there is no debate about the sculpture within this building:[32] the moving quality of the stations of the cross,

with mournful, gesticulating putti, on the one hand and the playful character of a honey-licking putto, emphasizing the sweetness of the word, on the other.

Many other sculptors created outstanding works at this time. Pieces by Bavarian sculptors such as Ignaz Günther (1725–75) at Rott am Inn, Weyarn, Dietramzell, in the Bürgersaal in Munich and elsewhere, reveal qualities of feeling and expression, of individual characterization, that resemble features found in the previous tradition of wood sculpture from the region.[33] So too does the use of sculptural means to communicate the meaning of pieces like the Annunciation of the Virgin from Weyarn. In such works the drama of emotion still possesses its exhortative, persuasive character, much as does the continuing use of polychromy to stress lifelike character, as well as the treatment of limewood, with sharp folds, far-flung draperies and exaggeratedly sharp planes.

This sculpture also merits attention because it can be related to contemporary developments in Poland.[34] Where Vilnius (Wilno) in Lithuania gave birth to a school of architecture whose undulating facades and occasionally interior forms bear some resemblance to what was done in southern Germany (and its major master, Johann Christian Glaubwitz, was a Silesian), Lwów (L'viv, Lemberg) and its environs became a centre for sculpture, almost an outpost of what was done in Germany or Bohemia. Both the architecture and the sculpture carry on farther than their more westerly contemporaries, however. The fantastic silhouettes, picturesque siting and playful use of forms in mid-eighteenth-century Lithuania exceed even those tendencies as they are found in southern Germany.

As in Germany sculpture in Lwów was connected with the newer buildings put up at this time, as a result of the prosperity of the region. These too are to be associated with international traditions, as they were designed by Netherlandish (Jan de Witte) and Swiss-Italian architects, and thus are not far from the German examples in their forms. The sculpture similarly bears an extraordinary relation to the general Central European tradition. The initiator of the tradition, Thomas Hutter (fl. 1740), was German: he completed works that are related to both the Bohemian and

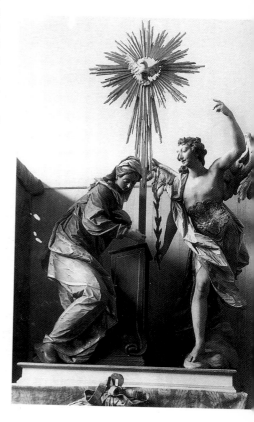

Annunciation, Augustinian Church, Weyarn, 1764, by Ignaz Günther

south German tradition. In the second generation Antoni Osiński (1720–65) evinced a tendency towards geometric abstraction, with a stress on the outlines of the folds of garments in his wood carving that lends the pieces a fabulous quality. His figures in De Witte's Lwów Dominican church, completed after 1749, also reveal extreme emotion in their faces. In the third generation, from the late 1740s to the 1760s, Sebastian Fesinger and the master known as Pinzel, whose name as well as style suggest his provenance from Central Europe, bring this school to its height. Pinzel, working in stone on the St George of the Greek Catholic cathedral in Lwów, completed after designs by Bernard Meretyn or Meretini (incorrectly called Bernhard Merderer) from

St George Cathedral (Sv. Jur), Lwów (L'viv), after 1744, by Bernard Meretyn (Meretini), with sculpture by Master Pinzel (Pinsel), 1759-60

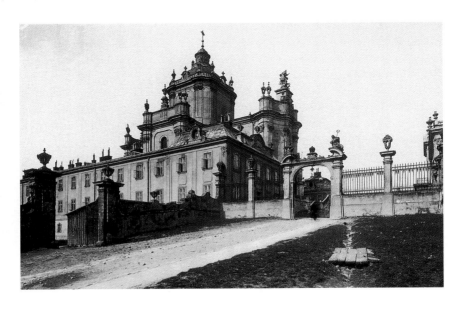

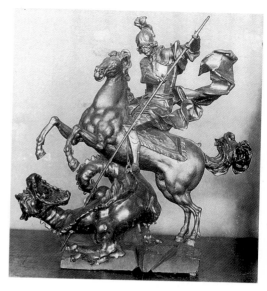

St George and the Dragon, Master Pinzel (Pinsel), *c*. 1754-60, modello for statue on facade of St George Cathedral (Sv. Jur), Lwów (L'viv), Museum of Ukrainian Art

1744, or in wood for sculpture from Hodowica, creates expressive works of amazing quality, whose features suggest a proximity to Bohemia, or Bavaria. This type of sculpture, that spread throughout the present area of western Ukraine and eastern Poland, brings to an extreme developments that did not reach such forms elsewhere. Limbs and draperies are flung far out from the wood core of the figure. Hands and arms gesticulate. Faces are deeply undercut, revealing emotion. As in contemporary architecture in Lithuania, a truly baroque pathos is achieved not found elsewhere in Europe.[35]

The work of an individual architect brings this chapter to a close. Balthasar Neumann (1687–1753) has been considered the greatest 'rococo' architect; he ties together many of the themes that have been discussed so far, and his work also points beyond the possibilities of design at this time. First of all, this outstanding designer of churches was also a notable architect of palaces. Neumann was born the son of a clothier in Eger (Erlau), a town actually in Bohemia, and received his earliest training in Franconia. Neumann however started a career in cannon and bell founding, and only later passed on to military and civil engineering and finally to civil architecture and city planning. In itself this is not so unusual: as we have noted, the transfer from the military or engineering sphere to architecture had been one that goes back to the time of the Moscow Kremlin, and Hildebrandt also came from a military background. Neumann would indeed have learned about Viennese architecture from a visit there in 1717–18, and he called on Hildebrandt for advice when he was given the task of working on the Würzburg residence.

In fact Neumann worked mainly in the service or the orbit of the Schönborns, although despite their Viennese connections he also consulted the Frenchmen Robert De Cotte and Germain Boffrand about his designs. In addition to his long-standing association with Würzburg, where it is hard to distinguish the style of his contributions on the exterior from those of Hildebrandt, he was called to complete the Schloss at Bruchsal in 1728. At Bruchsal Neumann had a hand in transforming both the splendid *Kaisersaal* and the grotto in the *piano terreno* (ground floor, completed 1731–2). His major innovation here was his insertion of a *Wendeltreppe*, a turning stairway

in the tradition that had been seen in medieval and late medieval buildings but quite unique in the Germany of his day.

More important as an example of his early production was Neumann's work on the castle in Würzburg for Johann Philipp Franz Schönborn, prince-bishop of that see and of Bamberg. Friedrich Karl, a nephew of Lothar Franz, had the means at hand to build on a large scale, as he had gained huge sums from fines at an embezzlement trial. The prince-bishop decided to site his residence in the town, which had often been antagonistic to the Würzburg bishop; the bishop had traditionally resided in the fortress on the hill opposite the town centre, and the translation of his major dwelling to a huge Schloss in town was a sign of absolutist authority, requiring the subjugation of the town to his huge Schloss. Although the involvement of De Cotte, Boffrand, Maximilian von Welsch, Johann Dientzenhofer and Neumann suggests this was almost a committee affair, to Hildebrandt can be attributed the garden facade, De Cotte and Boffrand the general layout, and Neumann the chapel and interventions in the *corps de logis*. In particular the stairway he designed is the grandest in the whole development of the genre: it turns and returns upwards in two flights, and so continually varies spatial feeling and effects; it leaves a balcony around the whole; the gallery circles round; and it leaves a huge ceiling open for decoration, where in 1752–3 Tiepolo would add his paintings.

In Neumann's palace designs he was limited in terms of what he could do; only the details of the facades and ceremonial rooms could be changed, whereas in church architecture, except for the placement of the altar and the basic orientation to it, he was little restricted by the demands of the patron and the programme; only the nature and amount of decoration would have been determined. Thus Neumann's church designs, much like Santini's and the Dientzenhofers', are his freest. In Neumann's two most important designs, at Vierzehnheiligen and Neresheim, many of the ideas encountered in earlier Bohemian and Franconian architecture are developed further. He might have learned about several details from the church designed by Johann Dientzenhofer at Banz, which he could have seen across the valley from his own site at Vierzehnheiligen. In addition to the wall-pillar types, these include smooth shell-like vaults delineated by ribs marking the torsion of their thrust, that actually define the edge of a vault shell. The vault, like the interior wall, curves. Similarly, as in Bohemian examples, the exterior of Vierzehnheiligen, while distinguished from the interior, to a degree echoes the interior's forms.

On the other hand, there are certain distinctive features in Neumann's architecture not present in Bohemian or Franconian precedents: his vaults are often done in brick (unlike lath and plaster vaults in Bavaria), supported on free-standing columns at Neresheim or on piers open at the bottom, as seen in Vierzehnheiligen. The oval forms in his churches are also placed in an axial direction, as opposed to the transversely placed sequences of ovals found in the churches of the Dientzenhofers. A greater emphasis is placed on the creation

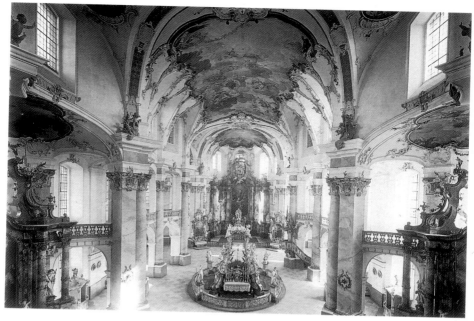

Interior, Pilgrimage Church of the Assumption of Mary, Vierzehnheiligen, begun 1742, by Balthasar Neumann; stuccoes by Johann Michael Feichtmayr

of space; the outer shell of the building's walls is articulated by wall-pilasters, but more than in Bohemia or in the Dientzenhofers' Franconian works, masonry is opened up all over by windows. The effect is that the wall or mass is interpreted negatively, as a shell enclosing the interior space in which the architect's main interest appears to lie. This space is a complex union of ovals and circles, making a majestic open area, which, through the reduction of the wall, enables light to pour in. The church is illuminated in an extraordinary way, creating the effect of glimmering white forms.

The effect of the decoration is also exceedingly important in Neumann's buildings, even at Vierzehnheiligen (from 1742), where it is restricted to the altar (by J. M. Küchel) and the ceiling. It can be said that just as Neumann reduces the masses and the walls in his buildings to a shell, so the whole building can be considered as a shell for the decoration. In Vierzehnheiligen the central altar is by Küchel, yet it fits into Neumann's oval (and it is unclear how much he planned on having the church designed around it). This altar dedicated to the fourteen saints provides an example of the dissolution of traditional forms of architecture that had been based on the orders, since in it curvilinear forms taken from ornament become the architectonic elements. The altar is completely composed out of *contrecourbe* C- and S-curve designs; here it is really meaningful to speak of an architecture of the rococo.

Neumann's final great building, the church at Neresheim, of 1747 and following, though determined to some degree by the site and the patron, is a

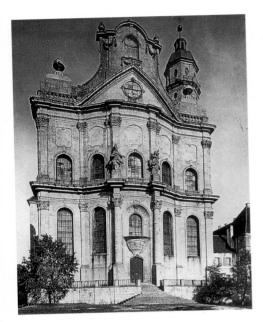

Benedictine Abbey Church, Neresheim, facade begun 1748, by Balthasar Neumann

worthy conclusion to his work. Here the torsion edges of the vaults again define the spaces of the church. As seen in sequence, these spaces themselves seem to describe a series of tholoi, with an oval at the crossing of the church, defined by free-standing columns. The outer wall has been neutralized, although the facade again reflects the oval turning of the interior. The whole church is again mightily illuminated. Within a light-saturated structure, formal dynamics dominate: as Christian Otto has said, they create the effect of space transformed into light.[36] This overpowering effect, especially when experienced at an early morning mass, on a bright day, as the light pours in from the east, is perhaps meant to suggest that God is light; here is recast an ancient belief, expressed in Gothic architecture and found in buildings in the region, for instance by the Parlers in Schwäbisch Gmund. In works such as these, Neumann seems therefore to be realizing some of the potential inherent in the design tradition that had been approximated simultaneously by the Wies church, but he proceeds further.

Changes of taste were soon to come, but one may wonder if, where ornament becomes secondary as at Neresheim and another effect is achieved, a transformation in the conceptualization of the ends of architecture may not already be in operation. Certainly at about the same time, other options for architecture were already being posed. Elsewhere in Germany where the baroque had been favoured, as in Westphalia (exemplified by the extensive palace with grounds at Nordkirchen for the Elector and Prince-Bishop Clemens August), Johann Conrad Schlaun was creating his own distinctive, even idiosyncratic works. While at times Schlaun employs rococo ornament or uses ground plans or elevations inspired by Borromini and other Italian architects, his buildings often have simplified or regular forms, a certain geometric order, and employ brick, without a coat of plaster to dress up its rough, direct appearance, They engage a local tradition, and also on occasions seem to point towards another aesthetic that is coming into play by mid-century.[37]

The inferences that it seems possible to draw from buildings such as these were already articulated by critics in the 1750s. These voices argued that

ornament detracted from effect and that paintings also did so when they seemed to be merely decorative, rather than narrative, and thus did not communicate their story as clearly as possible. At the very time when Tiepolo, the Zimmermanns and Neumann were at the height of their careers, a reaction to what their work represented was thus already beginning to set in, a reaction that has indeed never yet been overcome in the critical assessment of their accomplishments. This reaction is connected with the political, social, stylistic and critical transformations that led not only to the end of the 'rococo' but to the end of the culture and society that had sustained the arts characteristic of the old regime. These changing conditions would soon lead to the threshold of a new era.

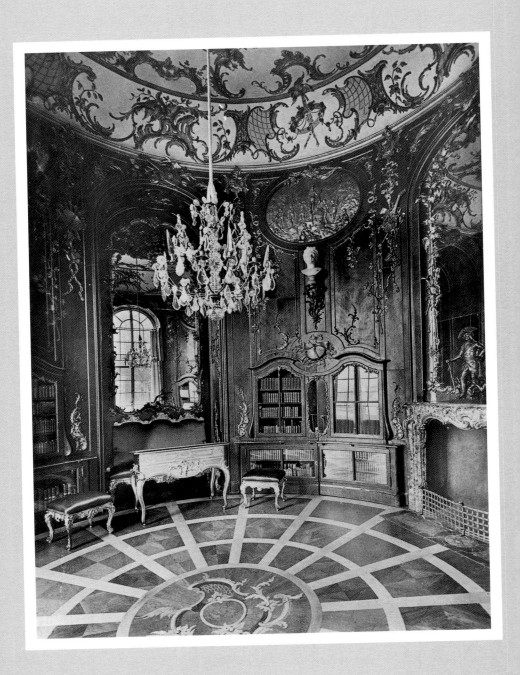

THE TRANSFORMATION OF THE ARTS AT COURT FROM THE MID-EIGHTEENTH CENTURY

The Library, Schloss Sanssouci, Potsdam,
1745-7, by Georg Wenceslaus von Knobelsdorff,
Johann August Nahl, J.M. and J.C. Hoppenhaupt

FREDERICK II OF PRUSSIA ONCE WROTE TO VOLTAIRE, THE FRENCH PHILOSOPHER,

You are right to say that our good Germans are still at the dawn of their knowledge. In the fine arts Germany is still at the period of Francis I. We love them, we cultivate them, foreigners transplant them here, but the soil is not yet propitious enough to produce them itself.[1]

Readers of the preceding chapters may be willing to grant that the king was right in his estimation of love for and cultivation of the arts in Central Europe; the Central European artistic boom provided some of the most promising commissions available in Europe during the eighteenth century, and in this sense Frederick's comments may also be taken to apply accurately enough to the ubiquity of 'foreign' artists. Yet the proposition that the region could not produce art on its own should seem dubious not just to readers of this book, but to anyone who is familiar with the contemporary music of the Bachs, G. P. Telemann and G. F. Handel. The history of the visual arts in Central Europe since at least the period corresponding to that of Francis I (1515–47) in France is, as we have seen, a long chronicle of an interplay of collaboration (and rivalry) between indigenous artists and talented emigrés from northern Europe and Italy.[2]

The king's opinions are nevertheless worth quoting, for he may have pointed towards some of the constants, as well as one of the reasons for change in the arts of Central Europe from the mid-eighteenth century. Frederick's

estimation of German culture vis-à-vis the rest of Europe indicates some of the typical feeling of inferiority combined with admiration that contributed to the continuing adaptation of foreign cultural fashions from, in his instance, France, but during the second half of the eighteenth century increasingly from England as well. Conversely, he may also suggest an aspect of the growing cosmopolitanism that was ever more evident in eighteenth-century culture. In this regard it may be noted that artists from Central Europe, exemplified already at mid-century by Jakob Philipp Hackert, Johann Georg Wille and Anton Raphael Mengs, began to occupy important roles elsewhere in Europe. More familiar still may be the furniture for which eighteenth-century France is famed: François Oeben and the Rieseners, among many other cabinet-makers who were in fact of German origins, made many striking pieces.[3]

Frederick's own predisposition suggests how during his lifetime in places where, as arguably in Prussia itself, an orientation towards France had not previously held sway, French models of various kinds became dominant. Tendencies towards absolutism were strengthened. At the same time, French cultural and intellectual prestige, emanating not just from the royal court at Versailles, reached its zenith: at several Central and Eastern European courts, both the ideals and the individual personalities of the *philosophes* came to be cherished. Hence French art and artists were imported to many other centres as well as to Brandenburg-Prussia. It can also be argued that projects sponsored by Frederick himself approximate, rather than lag behind, what was done in France.

The tendencies seen first in Brandenburg-Prussia led moreover to a more far-reaching transmutation.[4] Together with a distinctive rococo that Frederick patronized during his early years, royal commissions introduced to Berlin and Potsdam works representing several other stylistic directions. A kind of stylistic eclecticism or pluralism like that often repeated in the region resulted; yet in Prussia at least a new sense of stylistic decorum also emerged. Furthermore, works in new forms and genres were also initiated at several other centres. And the arts also began to respond to a new social context, a new audience and new aesthetic attitudes, to be discussed in the next chapters, that laid the ground for the conditions for what can be recognized ultimately as the origins of what we consider modern art.

In the mid-eighteenth century the basic state and social structure within which these transformations occurred remained, however, much the same as before. Most of the important principalities of Central Europe were effectively autocracies. Rulers promulgated laws largely without consultation with their subjects. Yet many whom we might call despots looked to the west for economic as well as for political ideas. Thus in many domains rulers tried to introduce reforms that are comparable to ideas of *Aufklärung*, Enlightenment. Enlightenment ideology in turn took up some of the tools that had been employed by the dynastic state interested in the centralization of its authority and power. Accordingly, some newer ideas were adapted that affected the

regularization of justice, economic reform and education, among other matters: in this chapter we can look at things from the side of the rulers, and their impact on art.

In Louis XIV's France goals of state control and centralization, together with the commercial aim of improving the arts and therefore gaining independence from foreigners, had led to the establishment of royal academies. Following the French model, academies had been founded in Berlin, Dresden and Vienna already by *c.* 1700. Monarchs' application of the enlightened idea of establishing educational institutions to increase the state's well-being, by creating an informed, loyal and capable population, further hastened the development of academies of art and the technical or trade schools (*Fach-* or *Gewerbeschulen*) related to them. As the historian Ernst Wangermann has said of this opinion in the Habsburg lands, 'If a good artist could revolutionize a country's economic position, a sovereign could make no better investment than to endow the school in which artists were going to be trained.'[5]

In the third quarter of the eighteenth century, a large number of academies was thus founded throughout Germany and the Habsburg lands. Among the more important German institutions, academies were established in Bayreuth in 1756, in Mannheim in 1769, in Mainz in 1757, in Düsseldorf in 1762, in Leipzig and Meissen in 1764, in Zweibrücken in 1773, in Cassel in 1775 and in Weimar in 1776. Similar interests were also involved in the later creation of trade or craft schools, where an additional motivation to improve the quality of wares by offering instruction to craftsmen also had an effect. A good example of this process is provided by the trade school that was started in Meissen, where the standards of manufacture of porcelain were thereby to be maintained or ameliorated. Considered in practice, these institutions primarily had an immediate effect on instruction in drawing, and the gathering of collections of drawings to provide models for students.[6]

Along with ideas, artists also continued to be drawn from the west. A newer artistic immigration occurred most importantly among architects: Frenchmen came to replace Italians at the courts of several German rulers. A good example is provided by the sequence of architects who served the court of Württemberg, where Pierre-Louis-Philippe de La Guêpière succeeded Leopoldo Retti, who had succeeded Domenico Frisoni. In the territories of the Count Palatine of the Rhine, which had for long been a battleground for French armies, Nicolas de Pigage represented a different sort of incursion, of up-to-date French architecture. In Hechingen and elsewhere on the Rhine other Frenchmen such as Pierre-Michel d'Ixnard were active, as was François Mangin in Mainz and Trier. In Cassel the Du Ry family, some of whose work shall be considered later, served the court for several generations.[7] Nicolas Guibal was a significant force to be counted among painters in Württemberg, one of a host of such artists who came to ply their skills in Central Europe.[8]

This chapter concentrates largely on Prussia and the lands ruled by the Habsburgs (Austria, Bohemia, Hungary) and just interjects other sites such as

Anhalt and Mecklenburg-Schwerin. While some other sites such as the Palatinate or Württemberg might also deserve some attention, apart from lack of space, the present approach is offered in response to the relative political importance, as well as cultural significance, of the rulers considered. During the course of the second half of the eighteenth century the Habsburgs and Hohenzollerns became unquestionably the dominant political powers, beside Russia, in Central and Eastern Europe. Through a series of partitions in 1772, 1792 and 1795, Russia, Austria and Prussia divided the territory of Poland, so that by the end of the century Poland had ceased to appear on the map. Power relationships within the empire were also transformed with the growth of states related to dynasties, and the only other German states that had previously been of consequence enough to compete, Saxony and Bavaria, had been eclipsed politically by the end of the century. Saxony was threatened with being absorbed by Prussia. Although it consolidated its territories with the Palatinate, Bavaria lost the *Innviertel* (Inn region), was disregarded by other powers, bankrupted by its earlier ambitions and narrowly escaped having its heartland absorbed into Austria. Thus even before territorial alterations were effected at the beginning of the nineteenth century, the stage was being set for a play of forces that lasted until the early twentieth century, in which the Austrian Empire, Prussia and Russia were the leading actors in the region.[9]

Despite the later fame of Frederick II, an observer from the beginning of the century who returned to survey the scene at its end, might have found Prussia the somewhat surprising new addition to this group. Frederick II completed the transformation of Brandenburg, and particularly Berlin and Potsdam, from what had once been sleepy north central German provincial backwaters into what eventually became respectively the predominant power and the capital of Germany. Frederick further built up the population of his state, encouraging settlement and manufacture. Correspondent of the *philosophes* and author of theoretical tracts himself, he reformed the Prussian legal code and educational system. Taking advantage of the armies his father Frederick William I (the 'soldier king') had expanded and forged into an effective force, upon becoming king Frederick II immediately seized Silesia from the Habsburgs, initiating a series of wars with Austria and other powers of Europe, that occupied fifteen out of the first twenty-three years of his reign. Prussia thus shot into European prominence.

While the merits of Frederick's dynastic politics may be open to debate, for our concerns it is undeniable that his policies had an important impact on the arts; the greatest period of conflict was moreover also the great period for court patronage in Prussia.[10] Frederick II's father, Frederick William I, though a painter himself, had had little use for expenditure on the arts during his relatively austere reign. In contrast, Frederick II was an accomplished flautist, also a composer, a man with literary inclinations, even if they found expression in the French language, and one who reorientated Prussian taste. As prince, Frederick had already given an inkling of what was to come when he

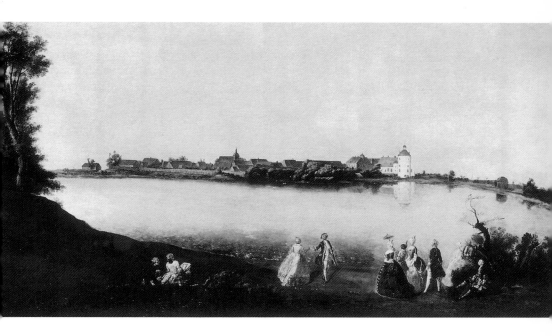

View of Rheinsberg, c. 1737, painting by
Georg Wenceslaus von Knobelsdorff and (figures
by) Antoine Pesne, Berlin, Schloss Charlottenburg

established his court at Rheinsberg,
north of Berlin, whither he attracted
the French portraitist Antoine Pesne
(1683–1757), who created for him
characteristically modish works of a type derived from the portraiture of the
age of Louis XIV, but handled with a softer and more painterly touch,
influenced by the Rubensist currents in eighteenth-century French art. As an
architect, Georg Wenceslaus von Knobelsdorff (1699–1754) modified
Rheinsberg for Frederick. As a painter, he collaborated with Pesne in creating
the perfect image for this time. This is a view of the Schloss at Rheinsberg with
Frederick and his entourage (Pesne's 'staffage', or figures in a landscape)
depicted in a garden in the foreground, a work that is full of the spirit of
engagement in nature that had been made popular by the pictures of Antoine
Watteau, Nicolas Lancret and Jean-Baptiste François Pater, just those French
painters Frederick most admired, whose works he eagerly tried to acquire and
his painters emulated.

Already in Rheinsberg Frederick had two rooms decorated with these
French artists' paintings. He later succeeded in obtaining important pictures
by Antoine Watteau (1684–1721) and his followers, masterpieces such as the
L'Embarquement pour Cythère, *La Leçon d'Amour* and *L'Enseigne de Gersaint*,
which are still the treasures of the Berlin collections. Frederick also had Pesne
paint appropriate complements to works from the Watteau circle, first in
decorations for Rheinsberg, and then for other residences.[11] Pesne also painted
his own versions of Watteau's themes, such as the dancer Marianne Cochois or

other paintings with elusive imagery. Frederick, moreover, brought into his service a nephew of the famed painter of Louis XV, Carle van Loo, namely Charles-Amédée Philippe Vanloo, who painted his own *L'Embarquement pour Cythère* as a pendant to Watteau's famed picture, a work still in Berlin.

Soon after Frederick's accession, Knobelsdorff collaborated with Pesne and a team of decorators and sculptors, including Johann Michael and Johann Christian Hoppenhaupt, and Johann August Nahl, to create splendid ensembles in the royal castles in Charlottenburg, in Potsdam and, to judge from photographs (since the Schloss, alas, is gone), somewhat later and less impressively, in Berlin. In all these places they worked after plans and under close supervision of the ruler. Especially in the interiors of palaces designed or approved by the king, this team generated an elegant variation of the style that had reigned somewhat earlier in French salons but represented a novelty in Germany, the Frederician rococo. In spaces such as the Music Room in the (now destroyed) Potsdam Stadtschloss, and even more in the famed Golden Gallery inside the new wing appended by Knobelsdorff to Charlottenburg, these artists gave expression to a sensibility that suggests an openness to pleasure and the appreciation of nature, akin to that of Watteau and French society of the regency period, and not a demonstration of power. In the Golden Gallery the walls are green, and the gilt ornamental forms climb over the walls, metamorphosing into vines and inhabited by all kinds of creatures.[12]

The building of the 1740s that best incarnates these ideals is Sanssouci. The telling French name, given by the sovereign, reveals his attitude towards this intimate, personal summer residence placed in a garden outside the town of Potsdam, a structure sited and executed by Knobelsdorff according to Frederick's own plans. Although the king later brought to Potsdam a number of French sculptors, François-Gaspard Adam, later Jean-Pierre-Antoine Tassaert and Sigisbert-François Michel, father of the better-known Clodion, and the inspiration for Sanssouci was French, the execution was again a distinctive Central European – if one will, Prussian – translation, devised by the ruler himself.

The plan of Sanssouci is unique. Frederick's palace is a garden retreat located at the top of a series of terraces, which were enclosed with glass and are in fact a series of gardens or greenhouses, intended primarily for viniculture. The palace itself displays a rounded cupola, as it sits, crownlike, atop the procession of glassed enclosures, and this cupola might suggest the idea of a dome, with all its celestial and imperial overtones.[13] The visual, and hence symbolic, effect is however diminished, since in conformity with the character of buildings made for gardens and pleasure purposes, Sanssouci is only one storey tall. The king had determined that as a *maison de plaisance* the palace was to be close to the ground and without a basement: thus Sanssouci resembles the Amalienburg at Nymphenburg, which also had a round central space, again much more than a pretentious palace. Its windows and doors also open directly onto the outside; thus it is like an orangery, in

accord with the viticultural aspects of the terraces. The connection with viticulture is also reflected in the sculpted decoration of the building, on which disport Silenus and nymphs, as on the Zwinger, the pleasure palace at Dresden: here they suggest that they are the suite of Bacchus, appropriate for the cultivation desired on the spot. Yet during the summer Sanssouci also served as the main residence of the king, and it thus came to possess a colonnade of Corinthian columns, the order that was regarded as having a

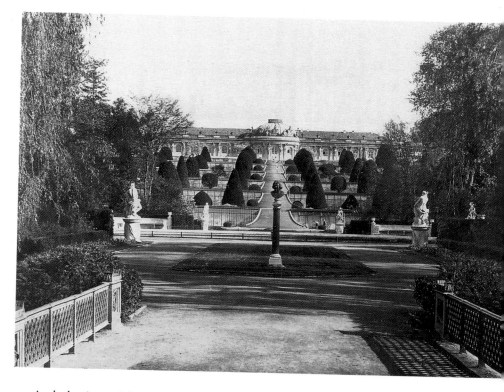

particularly imperial resonance. Sanssouci's function as a royal residence called for this small seat to evoke an imperial setting, hence its colonnade and cupola. These elements

Sanssouci Palace, 1745-7, designed by Georg Wenceslaus von Knobelsdorff, after an idea of Frederick II

otherwise appear to contradict other features of the building, which suggest that the enlightened monarch, as servant of the state, has little need for representation.

The interior offers a similarly curious combination of associations.[14] Its central marble hall, a formal room used for dining, was, according to the king, supposed to be like the Pantheon in Rome, and it does have the appearance of a dome; yet it also has vine motifs in the floor, a Bacchic reference which contradicts the austerity of the dome and internal space. Neighbouring is one

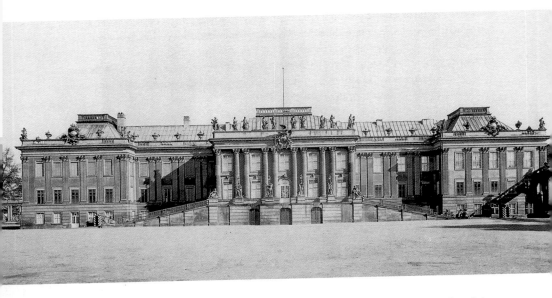

of the most famous interiors of the era, the height of the Frederician rococo, the Concert Room, adorned with paintings by Pesne; this is the room in which Frederick, an accomplished musician, would himself have performed, with musicians of the stature of Johann Joachim Quantz or Carl Philip Emanuel Bach. This room and the jewel-like library induce the atmosphere in which Frederick would have liked to have seen himself, as '*le philosophe de Sans Souci*', a true ruler for '*le siècle des lumières*'.

Nevertheless, in the colonnade at the Stadtschloss at Potsdam, and even more in similar features at Sanssouci, there appear certain stylistic features that are not in accord with this theme and are even more striking than in structures to which the Frederician rococo might be compared, the slightly earlier buildings in Bavaria such as the Amalienburg. Although the interior of the Potsdam Stadtschloss possessed a number of rooms that were designed by Knobelsdorff in a manner and with an effect at least the equal of Sanssouci, the exterior, which also antedated Sanssouci by a few years, and was again inspired by a drawing by the king, made a quite different impression. It presented a monumental order on a rusticated basement, with a colonnade of doubled columns. In other words, it resembled a whole series of earlier Central European palaces, which also ultimately descended from Italian models. The king seems to have described the situation, when he said that in this building Knobelsdorff preferred the exterior architecture of the Italians and had not followed the French, still less the English.[15]

The existence of a similar set of contrasting stylistic allusions in Knobelsdorff's Berlin Opera House (1741–3) thus seems to indicate that in Frederick's circle there was an awareness about matters of stylistic discrimination, which

allows us to draw inferences about intentionality. The Opera House is of interest as evidence both for the court's concern with public works – in its function as a place for entertainment and in its location on a newly designed public square, the Forum Fridericianum on Unter den Linden – and for Frederick's personal predilections, his love for music and opera. Its exterior is free of rococo ornament, and its facade on Unter den Linden is strikingly like a temple front. It thus recalls the tradition of Palladian architecture, as interpreted especially by English architects. On the other hand, the interior (before it was gutted) was in a rococo manner, like the Cuvilliés theatre of the 1730s in the Munich residence.

Stylistic variation was indeed evident in Potsdam even before Frederick II made it his primary residence. During the years 1737–40 the Amsterdam-born architect Johann Boumann had executed one of the major projects of eighteenth-century city planning, the so-called *Holländisches Viertel* (Dutch quarter). This, the first of many sets of buildings that Boumann was to construct for Potsdam, was set up for the Flemish and Huguenot refugees who came to work for the king, and consists of rows of brick buildings in the Netherlandish style.

Some years later (1754) elsewhere in Potsdam, in the gardens laid out near Sanssouci, a building designed by J. G. Büring appeared in a radically different style: that of a Chinese teahouse. A centrally planned

Holländisches Viertel (Dutch Quarter), Potsdam, 1737-40, by Johann Boumann

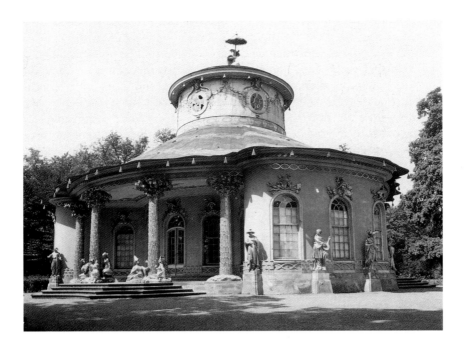

Chinese Teahouse, Sanssouci, 1754-6, by Johann
Gottfried Büring, with sculpture 1755-6 by Johann
Peter Benkert and Johann Gottlieb Heymüller

structure, the Chinese Teahouse is one
of the earliest of a number of structures
in this fashion erected in Germany
during the late eighteenth century. The
taste for chinoiserie expressed here belongs to a current in Germany, already
found in Pöppelmann's fantastic Sino-Indian palace at Pillnitz or his Japanese
Palace in Dresden, or in the numerous porcelain chambers and furniture in the
Chinese manner in German Schlösser, including fine examples at Charlotten-
burg. These are not only a sign of the love for the exotic of the fable but, in
Frederick II's case, may correspond to some of the sense of Montesquieu's
Lettres persanes, where the refined foreigner stands as a foil to the European.
This grew out of a form of Enlightenment critique, whereby in literature
visitors from exotic lands were made mouthpieces for criticisms of the
European situation. At Potsdam the mandarin philosopher-artist-king appears.
Certainly the gilt sandstone figures of the Chinese (by Johann Peter Benkert
and Johann Gottlieb Heymüller) who drink tea at Potsdam embody the ideal
of refined pleasure that epitomizes the spirit of Sanssouci — and it may be
noted that the *Lettres persanes* similarly contributed to the cult of *sensibilité*
(*Empfindsamkeit* is the German equivalent).[16]

The Chinese Teahouse is but the most startling of many stylistic variants
found in Potsdam and Berlin. In addition to those buildings already described,
there were works in yet other styles. The Nauen gate in Potsdam (1754–5)
recalls the Gothic in its ogive arches. On the other hand, from the late 1740s

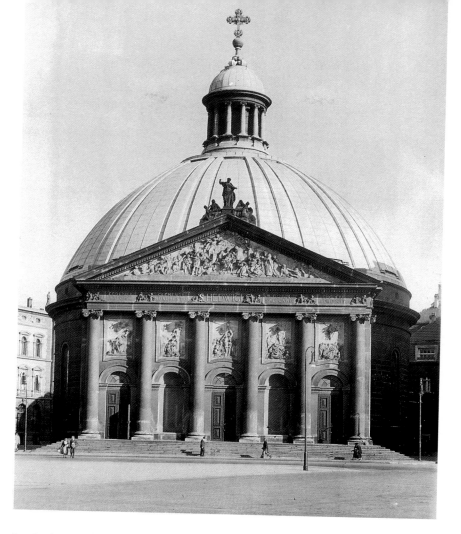

in Berlin, on the Forum Frideri-
cianum, a church was constructed
for the newly incorporated Catholic
population of Prussia (for the king

St Hedwig's Cathedral (Hedwigskirche), Berlin,
begun 1747, plans by Frederick II (?) and Jean-Laurent
Legeay, executed by Johann Boumann and others

had seized Silesia). The Hedwigskirche was designed by a French architect,
Jean-Laurent Legeay, who had belonged to the circles of antiquarian enthu-
siasts in Rome around Charles-Louis Clérisseau and Giambattista Piranesi, in
which he seems to have played an important role in contributing to the
creation of a new vision of antiquity. In his engravings Legeay revealed both
an enthusiasm for the monuments of the past and an archaeological interest in
their reconstruction, and his church, with its rotunda and suggestion of a
portico (though executed in rather flattened form), recalls the Pantheon.[17]

Although his role is not yet completely clear, Legeay was also, however,
probably involved in a very different sort of enterprise, the construction of the

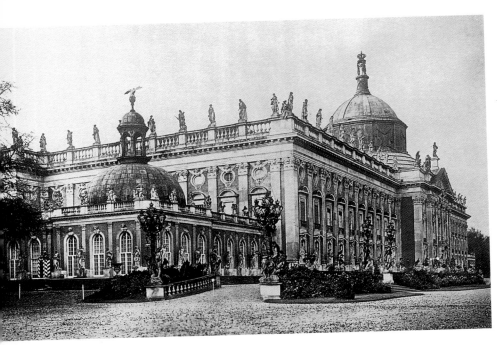

Neues Palais, Potsdam, 1763-6, by Johann Gottfried Büring, Heinrich Ludwig Monger, Jean-Laurent Legeay and Karl von Gontard

Neues Palais at Potsdam during the 1760s. Set at one end of the grounds, this is a building in brick, with a giant order of pilasters. This work results in part from the impact of a visit by Frederick to Holland (in 1755), and it has also been regarded as a reflection of Castle Howard, the grand English country house. The king himself called the not entirely successful product a *fanfaronade*.[18]

This plethora of formal styles produced at the same time for the same patron, who was closely involved in their planning, introduces a problem of interpretation. These works might be described as early examples of architectural eclecticism, much like that eclecticism which is associated with the nineteenth century.[19] Frederick did sponsor the erection of twenty houses in different styles placed at key points in Potsdam. This example of patronage might seem to lend support for this view.

Yet other reasons exist for the appearance of stylistic pluralism in eighteenth-century art and architecture. One explanation was supplied by Count Francesco Algarotti, a correspondent of Frederick and one of those agents who were instrumental in acquiring works of art for the German courts, for Dresden as well as for Berlin/Potsdam.[20] Algarotti suggested that Potsdam was to become a school of building, as Venice, Rome and Athens were. This interpretation might very well fit both the king's undervaluation of works of German art and also the possible enlightened aim of attempting consciously

to constitute a school of architecture. But if Frederick's building of twenty works in mixed style was intended to provide examples for the rest of the local citizenry, this effort had little effect, and it thus remains unclear if this was his intention, rather than Algarotti's flattery.[21]

Other insights into Frederick's attitude may be offered by contemporary discussions of taste in relation to the choice of style in literature and music. The writings of the most influential literary critic of the second quarter of the century, Johann Christoph Gottsched, seem particularly germane here, because Gottsched regularly calls the visual arts into account in his discussion of the formation of good taste. Like the Prussian king, Gottsched saw French writers and theorists from Boileau to the king's correspondent Voltaire as paragons of good taste, and in this regard Gottsched introduces classicism in German letters. Yet it should not be overlooked that in his *Critische Dichtkunst*, a work that claims itself to be critical, Gottsched also advocated the emulation of a variety of works from the literature of different languages.[22]

Statements about music by Johann Quantz, Frederick's flute teacher and accompanist, may similarly offer insights into the Prussian panoply of styles. Many musicologists believe that J. S. Bach achieved what Quantz later described (though not specifically in reference to Bach); it may be further remembered that Bach was also admired by Frederick, to whom he presented the *Musical Offering*, his set of pieces on a theme by the king. In 1752 Quantz wrote that

> If one has the necessary discernment to choose the best from the styles of different countries, a mixed style results that, without overstepping the bound of modesty, could well be called the German style, not only because the Germans came upon it first, but because it has already been established in different places in Germany for many years, flourishes still and displeases in neither Italy nor France, nor in other lands.[23]

This ideal may also be interpreted as an enlightened, not a nationalist, one, because the end Quantz had in mind was explicitly the creation of a universal style through the German. The mixture of different styles in one building might then suggest a parallel in three dimensions to this ideal in literature and music.[24] Given Frederick's close personal connection with Quantz, it certainly seems justified to consider this text.

In any event, a new sense of stylistic decorum, one based on a distanced, historicized notion of forms, does to a degree seem to have existed in Frederician Prussia. A sense of the match of form to function may have come into play. It is reasonable to assume that with the increasing stylistic consciousness of the eighteenth century, which, just at this time, as we shall see, witnessed both the origins of philosophical aesthetics and sharp critical debates about style (to be discussed further in Chapter 18), it may have been possible to realize in actual constructions this kind of discrimination. Hence for a middle-class district constructed for Netherlandish refugees, a Dutch style was used; for a stately city palace, a grand Italianate design; for a *maison de plaisance*, a

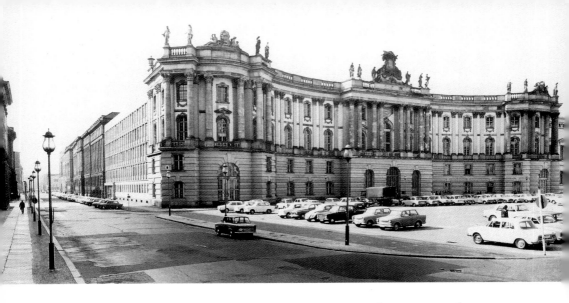

Royal Library, Berlin, 1775-80, by Georg
Friedrich Boumann after designs by Georg
Christian Unger, view from 'Forum Fridericianum'

French retreat; for an opera house,
designated as a temple of the Muses (it
was inscribed '*Fridericus Rex Apollini
et Musis*'), a temple design; and simi-
larly for a place of worship (a temple) for the Roman (Catholic) rite, a Roman
temple (the Hedwigskirche is modelled on the Pantheon). This type of
thinking may help explain the choice of model for a later building put up on
the Forum Fridericianum in Berlin, the Royal Library of 1774–80, which was
based on the *Michaelertrakt* (Michael Range) of the Vienna Hofburg.
Although mocked by Berliners, who called it the '*Kommode*' (cabinet), we may
recall that it is precisely the new construction of the Hofburg that Frederick
had singled out for praise in Viennese architecture, and the choice of this
palatial form also fits the urbanistic plan, as it did in Vienna, where indeed the
younger Fischer von Erlach had also created an imperial library.[25]

The mocking Berliner description may rather indicate that a changed
climate existed for the reception of this building. In the Berlin of the 1770s an
Austrian model that derived from an earlier date might have seemed increas-
ingly outmoded, as it would have done at home as well. Instead, as the decora-
tion of rooms during the 1760s within the Neues Palais was also indicating,
an increasingly restrained style was emerging, and with it newer architectural
forms, such as neo-Palladianism, evinced in the Opera House, and nascent
neoclassicism, found in the more archaeological conceptualization of the
Hedwigskirche.[26]

The fragmentation of stylistic unity in Prussia, its lack of internal
coherence, may finally be a sign of something more than a change in taste and
decorum. Even its admirers, such as Voltaire and J. J. Winckelmann, noted the
discrepancy in Prussia between its role as a military Sparta and its pretension
to be a German Athens, a home for enlightenment. The Athenian element
seems to have been restricted to the entourage of the king, who otherwise

imposed discipline on the rest of this closed society.[27] Modern historians have thus also been able to discern elements of crisis and conflict within Prussian culture of the later eighteenth century.[28]

A foil for Brandenburg-Prussia, where the tension between Enlightenment and what liberal historians called despotism seems to have been acute, is offered in the small neighbouring realm of Anhalt-Dessau, which through various family relations and its connections with the house of Orange was closely tied to Prussia. In the first half of the eighteenth century the ruler of this typical 'duodecimo principality' or pocket-book principality, Prince Leopold of Anhalt-Dessau (reigned 1693–1747), had been closely tied to the Prussian throne. Known as the 'old Dessauer', he was involved in the remaking of the Prussian military under Frederick I and served as a Prussian general under Frederick II. Similarly, he ruled his own small state as an absolute monarch, turning it into his own private estate. It is understandable that in matters of the arts Anhalt-Dessau, like the neighbouring Anhalt-Zerbst in the 1740s, would then also follow Prussia. Indeed Knobelsdorff was responsible for the addition of a wing to the Schloss at Dessau (now destroyed), and the crew of Knobelsdorff and Hoppenhaupt was employed in the design and decoration of the (intact) Schloss at Mossigkau near Dessau in the 1750s, that reveals elements much like those that would have been found at Potsdam.[29]

Leopold's successor Leopold III Friedrich Franz (1740–1817, ruled from 1758) made a decisive step away from the Prussian model, starting with his departure from the Prussian colours during the Seven Years' War (1756–63). His turn to peaceful activity in a time of war made his state a small model of Enlightenment in practice. In the absence of the impediments that could have been set by other large landowning aristocrats, whose importance had been reduced by his father's policies, the prince introduced a series of agricultural experiments. 'Father Franz', as he is called, also inaugurated real school reform: he called the pedagogue Basedow to Dessau; he was the first ruler to separate the organization of schools from church control; and, inspired by Rousseau, he started a Philanthropopeum (a school for friendship with all mankind). He had arranged for the relief of the poor, and he also allowed for tolerance of the Jewish population of the principality; the court architect, Friedrich Wilhelm von Erdmannsdorff (1736–1800), designed buildings for the Jewish community, including a synagogue on the grounds of the ruler's palace at Wörlitz.[30]

In a chain of gardens extending thirty kilometres westward from Wörlitz Franz Leopold established what was to become in the words of Christoph Martin Wieland 'the ornament and epitome of the eighteenth century' (*Zierde und Inbegriff des 18. Jahrhunderts*).[31] The Wörlitz park, laid out from 1764 by the gardener J. F. Eyserbeck (1734–1818) and others, was the first public, communal park in Germany, something unthinkable at Sanssouci, especially at the height of the Prussian king's power.[32] Franz's 'garden realm' was also intended for economic as well as educational purposes. It was moreover the

first garden in Germany laid out expressly according to the principles of the English garden: its trees, lakes and walks were not confined to classical principles of symmetrical order, but were allowed to grow in a way that suggested more the spontaneity of nature itself. The prince and his 'cavalier architect' had visited and admired England and the values for which it stood. Opening the garden to the public, the construction of public buildings, extensive planning in Dessau by Erdmannsdorff and the employment of the architect even for small buildings for public utility, such as watch-houses and school buildings (in Rehsen and elsewhere), can be further interpreted as expressions of a public-minded spirit. The later (1782) creation of a Rousseau island, modelled on that of the first memorial to the *philosophe* (who died in 1778) at Ermenonville, gave visual expression to another source for the ruler's inspirations. This structure is noteworthy as a monument to a thinker, not a ruler.

Franz Leopold commissioned several buildings whose layout and interior decoration resemble British design. At Wörlitz the so-called '*Englisches Sitz*' of 1765, a garden pavilion with a Serlian motif that was inspired by a structure in the garden at Stourhead, Wiltshire (1765), started things off. The Schloss itself at Wörlitz (1769–73) was the most noteworthy such building. This building most closely resembles the work of the Adam brothers in England in its symmetrical, unornamented facade with central portico, and its ground plan, derived from English country houses; its Anglophilism extends to the presence of Wedgwood ware and chairs in a Chippendale mode in the interior.

As with the work of the Adams, at Wörlitz the Neo-Palladian current is pushed further in the direction of what may justifiably be called Neoclassicism, in the sense of an approach to the use of ancient forms that attempts to be more exactly and rigorously correct and is informed by archaeological considerations. Erdmannsdorff had earlier visited Rome, where he was associated with Charles-Louis Clérisseau, who had introduced him to the ruins of the ancient city, Giambattista Piranesi and indeed the Adams. Erdmannsdorff derived the forms of the Wörlitz Schloss, as did the English architects for some of their country houses, from the conception of a reconstruction of Roman villas. At the time of the construction of the building (1770), Erdmannsdorff even corresponded with the prince from Rome specifically about his desire to create a new art opposed to the unpure taste of the architecture of the fatherland, saying that this art was to be based on classical antiquity. From this aim there seem also to derive numerous additional archaeological reminiscences in the Schloss, including the presence of antique artefacts. In fact the princess's cabinet in Wörlitz possesses a marble mantlepiece manufactured from antique fragments by Piranesi himself.

This building at Wörlitz is thus one of the earliest manifestations in visual form of the re-evaluation of the classical tradition that is now associated with eighteenth-century Neoclassicism. Critics like Gottsched had anticipated a turn to a stricter conception of the antique. Scholars, notably at the newly founded university at Göttingen, had taken up a more exacting approach to

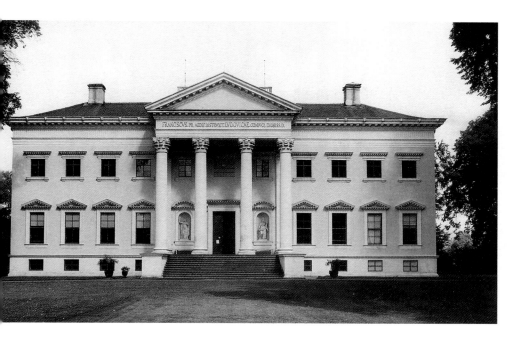

the study of the ancient past. And historians, philosophers and critics (like Winckelmann, on whom more below) held this pagan era up as a model for modern behaviour. Wörlitz bodied forth these Enlightenment beliefs and practices.

The revolutionary nature of the Schloss at Wörlitz, considered as a princely residence, goes beyond matters of style, as can be seen by a comparison with the exactly contemporary Neues Palais at Potsdam (from 1763) or the equally

grandiose Schloss at Ludwigslust with attendant buildings built in 1764–70 for Duke Frederick the Pious of Mecklenburg-Schwerin. Since the designers of these buildings can be associated with the same circles in which Erdmannsdorff circulated in Rome, the difference in approach is underscored: the bombastic *communs*, the grand temple-like structures that are merely auxiliary service buildings to the Neues

'*Englisches Sitz*' in Wörlitz
Park, 1765, by Erdmannsdorff

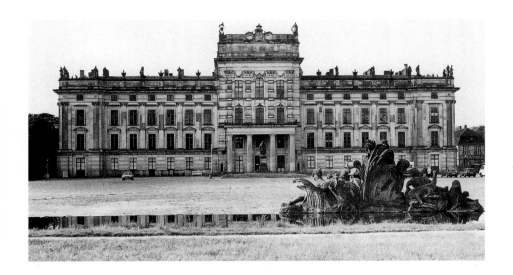

Ludwigslust, Schloss,
begun 1785, by J.J. Busch

Palais at Potsdam, may be ascribed at least in part to Legeay, while the architect of Ludwigslust, J. J. Busch, also put up a *Schlosskirche* there, with a facade whose pyramidal form suggests a familiarity with Piranesi. Busch's central castle at Ludwigslust is accompanied by a sequence of cavaliers' buildings, indeed by a whole town in brick, which resembles more the material of the Neues Palais and even more closely in form and style the work of the Westphalian architect Schlaun: these works thus still embody the image of a court in attendance on the monarch. In contrast Wörlitz not only offers a different style but, in its scale and placement in an English garden, articulates a different image of the ruler as an enlightened country gentleman.

Other buildings at Wörlitz, and the nearby parks of Luisium and Georgium, speak both for the archaeological inclinations of the prince and for their appeal to a new public. By the end of the century, when Neoclassicism was in full bloom, there had appeared at Wörlitz reproductions of several ancient buildings, including a temple of Venus, a Nymphaeum and a Pantheon, as well as the synagogue in the form of the temple of Vesta. Elsewhere, for the relatively simple and unadorned Schlösser at Luisium and Georgium, Nicholas Goldmann's *Vollständige Anweisung zu der Civil-Baukunst* (Braunschweig, 1699) served as a model: these suggest the transposition of the bourgeois to the princely milieu, just as the prince's foundations had suggested the converse.

There are even more remarkable stylistic interventions in the grounds around Wörlitz. As at many other places in Europe, a 'pre-Romantic' or *empfindsam* taste for ruins appeared, and artificial ruins were built in the grounds in a number of styles. Perhaps most remarkable is the appearance of the Neo-Gothic, first in the so-called Gothic House at Wörlitz by

Erdmannsdorff and Georg Christoph Hesekiel, started in 1773, and then in other structures. It is Erdmannsdorff, not Karl Friedrich Schinkel, Gotthard Langhans or Friedrich Gilly at the end of the eighteenth and the beginning of the nineteenth century, who introduced both the stricter Neoclassical and Neo-Gothic styles to Germany. Inspired by Venetian buildings, the Gothic House is the German Strawberry Hill; although it dates from the time of Goethe's paean to Strassburg Cathedral, *Von deutscher Baukunst* (1773), to be discussed more below, it does not call for a national revival and is even striking in its evocation of English, French and Italian models, but lack of German

ones.[33] The Gothic House had a personal meaning for the prince, becoming his private residence, the place for his collections. In contrast with the world of Wörlitz, Potsdam's Neues Palais has almost the air of a past era; Franz Leopold seems to anticipate rather the aims, and even the incomplete accomplishments, of the contemporary Habsburg rulers.

Gotisches Haus, Wörlitz, 1773-4, by Erdmannsdorff, expanded by Georg Christoph Hesekiel from 1785

In the Austrian lands a change of taste and patronage to a more restrained, ultimately Neoclassical manner was also evident during the reigns and under the impact of the reform-minded monarchs Maria Theresa (1740–80) and her son Joseph II (emperor from 1765, sole ruler 1780–90). Maria Theresa reorganized government, established new educational institutions such as the Theresianum, a school for noble youths, and also had an effect on the arts. As

with her antagonist Prussia, her reign is characterized by stylistic pluralism, the co-existence of more than one style or form of art present in the same area at the same time at the court and, as we shall see later, in other milieus.[34]

Art sponsored by the Habsburg court during the mid-eighteenth century turned away from traditional forms, which, as shall be discussed in the next chapter, still abounded in the region, and in particular from the kinds of works patronized during the reign of Charles VI (died 1740), with its universal-imperial vision. Much like the diplomatic revolution that produced the Franco-Austrian alliance of the 1740s and 1750s, the grandiose synthesis of the age of *Austria Gloriosa* was rejected in favour of a new type of architecture and sculpture. When Franz Stephen of Lorraine, husband of Maria Theresa, came to Vienna as emperor in 1745, he brought with him a predilection for French styles as well as for newer forms of Italian art (he had ruled in Tuscany prior to coming to Austria); his architect, Jean-Nicolas Jadot de Ville Issey (1710–61), was a Frenchman who had in fact been active in Italy. Franz ignored and spurned the architecture of the era of Hildebrandt and Fischer von Erlach: when, on a visit to Würzburg, Friedrich Karl von Schönborn spoke well about Hildebrandt, he said he knew nothing of the person.[35] Instead, Jadot introduced a French style to Vienna, as seen in the Schönbrunn menagerie, modelled after a design by Blondel.

In the more important Old University Building built from 1753, a court-sponsored project, the architecture Jadot created is not one of exuberant rococo, but rather that of the later period of the reign of Louis XV, a somewhat sober and restrained style with a foretaste of neoclassicism. It is comparable to a degree to the buildings of Jacques-Ange Gabriel in Paris (one thinks of the Place de la Concorde), more than Versailles, since the whole is meant to be part of an urban complex, a square that would incorporate the university building in Vienna. It may also contain meaningful symbolic references: the portico resembles that of the Louvre, a sign of royal authority, while the temple front is like that of a temple of wisdom, and the fountains on the building are perhaps also meant to be read as those of wisdom.[36]

This building is noteworthy in its demonstration of the court's involve-ment with education. In this regard it can be associated with the ideas of the Enlightenment, a theme of the reign, which, as noted, undertook a general reform of education.[37] This reform also included an emphasis on the arts, as indicated by the foundation of a new academy for engravers (*Kupferstecher-akademie*). The vogue for founding academies was in progress at this time and, starting in the 1750s and continuing through the 1770s, several distinguished figures – the Swiss critic Johann Christoph Gottsched, the poet Friedrich Klopstock, the dramatist and critic G. E. Lessing and others – tried (and failed) to establish an academy of letters, like those for the visual arts. The architecture of the Vienna academy building may resonate, or rather may fail to resonate similarly, in that it remained without impact: since architects in Vienna did not follow Jadot's style.

Jadot was probably put at a disadvantage by a growing taste for another type of architecture and design that was being supplied from the 1740s by his rival and successor in certain projects, Nicolà Pacassi (1716–90). From 1744 to 1749 Pacassi realized Maria Theresa's wishes to undertake the remodelling of Schloss Schönbrunn. It is a sign of the sort of change undertaken by the court of Maria Theresa that many of the important projects which issued from the direct patronage of the monarch represent alterations of previously existing plans or buildings, or additions to them, rather than completely new creations. The redecoration of Schönbrunn encompasses even the colouring of the exterior, which took on the tell-tale hue that is still called Maria Theresa ochre or yellow and contrasts vividly with the tints of the often brightly painted buildings of an early period, such as are still seen in Prague and St Petersburg. This more sober and subdued effect was matched architecturally by the disruption of the facade designed by Fischer: the large pediment was eliminated, and an attic level added instead; the grand exterior stairway was replaced by a simple two-sided staircase; a mezzanine floor was inserted, and the giant order of columns, something we have associated with palace design, was thereby lost.

The external transformation was matched by one on the interior. Many more rooms were inserted in place of the large spaces that had previously existed. There was a practical reason for this: Schönbrunn became the regular summer residence of the empress and her large staff, much larger than that of her immediate predecessors. The increased number of rooms also reflects a change of taste: it has been said that from a sense of grandeur there was a move to serene and joyous gracefulness. This sense may also be felt in the appearance of some of the few manifestations of true rococo decoration in the Vienna region at this time – a decor that employs naturalistic elements, tendrils and garlands as well as *contrecourbe* abstractions in both boiserie and ormolu; in Austria the design of these new spaces is probably to be associated with the importation of a French design. More intimate rooms, so characteristic of French salon society for which this style was initially designed, resulted. It is rather ironic that these forms appear in a grand palace and are even found in a large ballroom, with paintings by the Italian Gregorio Guglielmi.

The move towards a smaller, more intimate style, as suggested by the rococo salon, was accordingly by no means the dominant option in court art at this time. As Jadot's university building also suggests, much emphasis was laid upon urban siting, if not on planning, as in Brandenburg, Anhalt or Mecklenburg. Although in the Habsburg lands there may have been a turn away from the forms of the era of Fischer von Erlach and Hildebrandt, it is thus not correct to say that the ideal often attached to them, the expression of grandeur, indeed of the power and authority of the crown, was eschewed. A concern with creating an impressive urban effect, with consolidating a whole, seems to underlie Pacassi's additions of the 1760s to the sides of the imperial library in Vienna, to create three wings of a square, the present Josefsplatz.

A similar expression of grandeur is evident in Hungary at the royal castle in Buda, where work went on from 1753, probably under the direction initially of Jadot, followed by Pacassi, but mainly led by Franz Anton Hillebrandt.[38] A massive structure resulted that still dominates Budapest much the way that Hradčany castle dominates Prague. In Bratislava, now in Slovakia, Theresan planning similarly led to the transformation (by Hillebrandt) of the royal castle into an impressive mass. This planning seems significant, since this was also a time in which conflict with the Hungarian nobility was increasing, and it does not seem unreasonable to see these structures in part as a response to the large-scale building projects undertaken by Hungarian clergy and aristocrats at this time.

Construction directed by Pacassi at the royal palace of Prague made an even stronger statement. In Prague from 1756 the disparate structures on the Hradčany were masked in a Theresan surround and painted in the same colour. Cloaked in a sober mantle, that has been described as impersonally correct, the whole was combined into one vast expanse; a great urbanistic effect was created, that sets off St Veit's Cathedral and dominates the skyline of the city. These forms contrasted markedly with the attractive facade, with rococo cartouches over the windows, that was designed by J. J. Wirch for the Archbishop's Palace in Prague and resembled many of the same architect's designs for Bohemian nobility in the countryside. Pacassi's reconstruction thus dramatically expressed the power and position of the Habsburgs in Bohemia, as he had done in Hungary.

At the time of the Archbishop's Palace in Prague (1764–5), a design promoted by a contemporary Hungarian bishop that can also be associated with the throne, there were however already indications of the advent of a newer style. This is evinced at Vác, in a work by a Frenchman with an Italian name, Isidore Canavale, who was already present in Vienna in 1761.[39] In 1764 Christoph Migazzi, bishop of Vác, later archbishop of Vienna, had a triumphal arch erected for Maria Theresa and Franz Stephen. The immediate cause for the erection of this arch may be a response to the conclusion of the Seven Years' War and a desire to flatter the monarchs (for what was hardly a triumph), but it clearly also belongs to a tradition of erecting temporary architecture for greeting a ruler, as has been seen in Fischer von Erlach's arch of 1690. In Vác the monument was made permanent, as indeed a triumphal arch of 1765 built to commemorate the marriage of Archduke Leopold (the future Emperor Leopold II) in Innsbruck, Tyrol, also was.

On the Vác arch ornament and decoration are limited to garlands, medallions and an inscription. A relationship is clearly established with the forms and symbolism of the triumphal arches of the classical tradition and, compared to Fischer, the spirit of the work is archaeological. The pruning down of details and closer reliance on ancient works – this is the period of the recovery of Pompeii and Herculaneum, of Stuart and Revett's publications – seem to announce the arrival of Neoclassicism in the Habsburg lands.

In Austria – and it is also significant that these tendencies are found at the beginning of the period of rule of Joseph II, who became emperor in 1765 – Neoclassicism did not merely represent a return to antiquity, and this is seen in another sort of triumphal arch made permanent: the Gloriette at Schönbrunn, completed in 1775 by J. Ferdinand Hetzendorf von Hohenberg. This congeries of forms also represents a coming to terms with another period of classical revival, the Renaissance, and, as in Frederician Prussia, a more general historicized attitude toward the past. These traits are exemplified by the Gloriette, which culminates the gardens and serves as an eyecatcher at Schönbrunn: it is one of the latest in the early modern history of garden structures built for the Habsburgs; significantly it employs *spolia* from the Renaissance Neugebäude of Maximilian II. This attitude towards the fragmentation and reuse of the past, paralleling Piranesi's mantelpiece composition in Wörlitz, can also be compared to the cult of ruins found in the gardens of Anhalt, at Georgium and Luisium. In fact artificial ruins were also found at Schönbrunn. They are part of that attitude towards art and sculpture that was not only archaeological in character (as also evinced by the works by the sculptor Wilhelm Beyer placed in the grounds at Schönbrunn) but would grow into Romanticism.[40]

Other works of the 1770s are more closely associated with the Josephinian programme of reform.[41] In 1775 in a spirit like that of Wörlitz, but some years later, the emperor opened up a private park in the Augarten to public entertainment, '*zum Nutze des Menschen*' ('for the people's use'), as he said; the portal to the park bore the further dedication '*allen Menschen gewidmeter Erlustigungsort von ihrem Schätzer*' (a place for pleasure dedicated to all men from their admirer). The gateway to the Augarten of 1775 was done in a severe, classical manner, which, in comparison to the Gloriette, seems in more than one sense a truer propylaeum. The design of this structure thus seems to fit some of the aims of the reign; it represents a rationalized architecture, that evokes the ancient centre for democracy, Athens, and, in a manner appropriate to Enlightenment ideology, transfers a structure often associated with sacred precincts into an entrance for a park for public enjoyment.

In this regard it is worthy of note that, particularly from the period after Joseph's personal reign began in 1780 with the death of Maria Theresa, the major public buildings in Vienna, often with innovatory stylistic elements, are not large court-connected structures, for which Joseph II, who regarded himself as the servant of the state, had little use; they are rather public institutions, often connected with his aims of social and political reform.[42] For instance the design of 1783–5 by Canavale for the Josephinum, a school for medical surgery, may be related to certain manifestations of the Louis XVI style in France; it may be that the emperor was impressed by the École de Chirurgie (built 1769–75) that he had seen on a visit to Paris in 1777, most evident in its *Festsaal*. While the courtyard of this building on Vienna's Währingerstrasse recalls the ground plan of the imperial library, suggesting that the Josephinum

may have been thought of as similar to that other forum of learning, the facade resembles contemporary French forms of the severe Louis XVI style.

In Josephine Vienna an even more radical concept of design appeared soon thereafter and was given direction in works put up for the ruler himself. Instead of establishing a grandiose garden residence, or even something like Wörlitz, Joseph II set up as his favourite dwelling outside Schönbrunn at the so-called Joseph-Stöckl (1780–83 by Canavale) in the Augarten. Modest in size, scale and pretension, this building may be contrasted with the retreat Frederick II of Prussia was still using, his Sanssouci built forty years earlier. The Joseph-Stöckl eschews external ornament, except for bare recollections of classical trim.

This palace seems to reveal a turn to what may be described as a rationalist architecture. This is also suggested in the rebuilding of the General Hospital (*Allgemeines Krankenhaus*) in Vienna. The hospital is a huge mass, anticipating the large expanses of similar modern structures; the newly built tracts within it are, with the exception of their entryways, nearly devoid of ornament, creating an almost functionalist effect like that of the Joseph-Stöckl. In the Garrison Hospital range (*Garnisonspitaltrakt*), the cylindrical *Narrenturm* (Fool's Tower) and the polygonal chapel are crystalline in design and radical in their reduction of formal features to their most fundamental elements. In these increasingly abstract designs semiotic elements traditionally found in architecture are suppressed. These works may be compared to aspects of the

revolutionary classicism of Claude-Nicolas Ledoux, Jean-Jacques Lequeu, and Étienne-Louis Boullée in France; it has even been suggested that the *Narren-turm* is one of the most successful buildings in this manner that was actually executed.

On the one hand, it seems warranted to suggest a connection between the function of these works and their form, between the moral or political and the aesthetic ideas of the later eighteenth century. The ideal forms utilized in the Vienna hospital seem fitting complements to the rationalized vision of society and religion promoted by the ruler. A work radical in form went along with radical ideas. With such works we begin to approach both some of the ideology and its realization in forms of our own era.

But this vision was not realized elsewhere, and its apparent coherence of form and function seems increasingly rare. Earlier works of art are enmeshed in a seamless web of political, social and cultural history. Already in this chapter some of the contradictions and conflicts that we have encountered may suggest that this web is becoming unravelled. It is in response to this increasing separation and the fragmentation in our time that has ultimately resulted from it, that the last chapters of this book analyze as separate threads the political, social, intellectual and cultural strands with which the visual arts were intertwined.

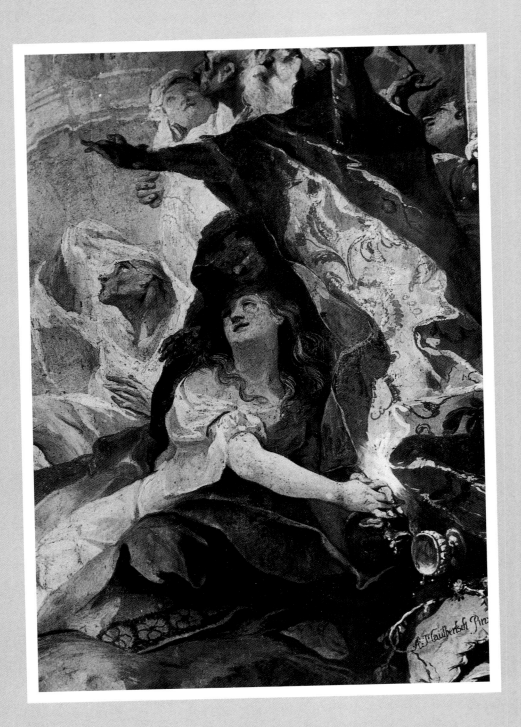

Arts and Audiences of the Later Eighteenth Century: Painterly Pyrotechnics and its Alternatives

Detail (of the right side viewed from the nave) of the High Altar Fresco of the Ascension of Christ, 1757-8, Sümeg Parish Church, by Franz Anton Maulbertsch

The monuments of the mid- and later eighteenth century that have been considered to this point seem to suggest that a pattern of stylistic change can be discerned in the arts of Central Europe, particularly architecture, resembling that described in conventional histories of the arts of Western Europe, particularly France. As it is often recounted, this is the progression of styles from baroque to rococo to Neoclassicism. The preceding chapter has associated this development with the patronage of several courts and with what is called 'Enlightened despotism' (or absolutism). It can also be suggested that this pattern extended further eastward to Poland.

Yet, as is often the case in the history of Central Europe and as the previous discussion of stylistic pluralism will have indicated, neither the stylistic pattern nor the social situation of the arts in the later eighteenth century is so clear cut. While similar developments may be perceived in many areas, the determination of a single paradigm of stylistic change, and certainly one that emphasizes stylistic progress, does not take into account some of the most splendid and distinctive achievements that appeared in the Central European region in this era. Other remarkable currents ran against the apparent tide of artistic progress and flowed into what might thus seem diverse eddies and pools of art.

Moreover, inasmuch as apparently new features emerged in the art of the region, the courts were not the exclusive catalysts for cultural change in the mid- and especially the later eighteenth century. Other patrons and social

Dominican Church, Lwów (L'viv),
by Jan de Wette, 1745-64

milieus also had an important impact on the visual arts, as they did on literature and music. What resulted in turn exercised a reciprocal influence on the courts. Thus a more dynamic metaphor than that of a historic tapestry is needed to describe the history of art in Central Europe at this time and that of multiple currents as well as cross currents fits better.

We may start with the lands to the east. In the Polish Commonwealth, as in neighbouring Prussia, works were produced that possess a wide variety of visual characteristics; these can be ascribed not merely, as might earlier have been the case, to regional differentiation. The brief treatment offered here can in fact do little justice to the rich diversity of striking architecture of this time. Through the third quarter of the eighteenth century both ecclesiastical and aristocratic patrons – until the 1780s bourgeois commissions in Poland hardly seem to have been of note – chose modes of design that may be regarded as

highly conservative, in comparison with the newer phenomena found in the ambit of the Habsburg and Hohenzollern courts. The same observation applies to sculpture.

As in southern Germany, the sculptors who were centred around Lwów (mentioned in Chapter 15) and who worked largely for church projects, operated well into the 1770s in a manner that has long been recognized as an equivalent of the rococo.[1] Contemporary architects in Lithuania developed their own original forms, that can also be regarded as an extraordinary extension of the baroque or rococo tradition. But churches in Lwów, such as that of the Dominicans or St George's (Sv. Jur), on which the works of the Lwów sculptors appear, suggest comparisons with buildings of another stylistic orientation: Austrian architecture of the earlier eighteenth century. Jan de Witte's Dominican church (1745–64) is a version of the Vienna Karlskirche, while Bernard Meretyn's St George's follows the ideas of Fischer's Collegiate Church in Salzburg.[2] The appearance in Lwów of fashions of building from an earlier time in the Habsburg realm is in keeping with tendencies of much contemporaneous church architecture found elsewhere in Poland, outside Lithuania. In Masovia (the region around Warsaw), for instance, styles of design deriving from the Italian seicento and early settecento, or from Vienna, persisted; until the end of the century the Viennese baroque was also in vogue in relatively remote regions, such as Volhynia, to the east of Lwów (now in Ukraine).[3]

The history of architecture built for aristocratic patrons in Poland provides similar examples. At Radzyn Podlaski in central Poland another member of the same Potocki family that patronized several of the sculptors in Lwów (and was responsible for the Dominican church there) had Jakub Fontana, a Pole from a family of Italian origins who was the most important Warsaw architect of mid-century, put up a large country residence during the 1750s. This structure is impressive in size, but its elevation and layout around a courtyard are quite typical for palace design of the late seventeenth and early eighteenth centuries throughout Europe; its main distinguishing characteristics are its massive sculptural decoration by Jan Chryzostom (Johann Chrysostom) Redler, who also worked at another major Polish palace of the time, the Branickis' residence at Białystok.

In contrast, the Polish court, if effective as an initiator of stylistic innovation slightly later than royal patrons who made a similar stamp on the arts elsewhere in eighteenth-century Europe, resumed its role as a cynosure for artistic fashion. The arts flourished during the reign of Stanisław August Poniatowski (from 1764), a period otherwise infamous as one in which Poland suffered truncation and ultimately disappeared as an independent state.[4] Already earlier in *c.* 1740, the Saxon king August III had called Gaetano Chiaveri, the architect of the Dresden *Hofkirche*, to Warsaw: Chiaveri was one of several such servants of the Saxon crown to make plans for the Warsaw castle and for a major urban palace-cum-garden project, giving rise to the so-

called Saxon axis.[5] While these projects represent a belated playing out of earlier eighteenth-century architecture in Saxony and seem limited to the court milieu, Stanisław August made a mark more broadly on the development of classicizing trends in Polish art, which consequently are frequently called by his name.

The king's interest and involvement started to have an effect on the arts soon after his accession. In 1765 Stanisław August called the French architect Victor Louis to Poland. Louis is a figure prominent in the history of French eighteenth-century architecture as the designer of the theatre in Bordeaux, among several other buildings.[6] Much as the arrival of Jadot signalled a realignment of the arts at the Austrian court, so did the appearance of Louis represent a distinct reorientation of design in Poland. More precisely, the employment of Louis stands for the adaptation of some of the tendencies of French architecture evinced at the end of the reign of Louis XV and during that of Louis XVI; in these an increasingly strict conceptualization of the classical was manifest. Although this French architect was not the first of his nation to appear in Poland in the mid-eighteenth century, and Louis neither stayed long nor carried out any major works in the east, the impact of the presence of a major French figure, who brought with him some of the most up-to-date Neoclassical currents is nonetheless significant.

If not unique, the tone set by Louis's classicizing drawings for the castle in Warsaw had great resonance: they are some of the many produced by a score of architects that were never realised in the intensive planning focused on this edifice, now reconstructed.[7] They reverberated not only in changes made to this originally baroque palace, which had been begun by Trevano and transformed by Pöppelmann and others during the reigns of the Saxon kings, but in many other buildings that were designed by Jakub Fontana, Jan Christian Kamsetzer, Domenico Merlini and Ephraim Schroeger (more properly Efraim Szreger) among others. At Stanisław August's behest, Szreger, Merlini and Fontana transformed in particular the interiors of the Warsaw castle into an impressive building in the Neoclassical manner. These figures also worked at the royal palace at Ujazdów; the newer court-sponsored style can still be seen at the Łazienki palace near (now in) Warsaw, whose combination of a relatively austere style with gardens may recall some of the later constructions at Versailles, although in a more strictly classicizing mode.

While the king was personally interested in the arts and, together with his court painter and artistic adviser Matteo Bacciarelli, directed activities at the court, comparable stylistic elements appear however in numerous churches in the Warsaw region, in Szreger's Church of the Discalced Carmelites, for example, as early as the 1760s.[8] Outside Warsaw, too, Szreger's rebuilding during the 1770s of the interior of Gniezno (Gnesen) Cathedral and of the collegiate church and its facade at Poznań can be situated in the context of some of the oldest churches in Poland, yet introduces a new note. On the other hand, Simon Gottlieb Zug executed one of the most radical designs of

the age for the Lutheran church in Warsaw (1771–81): this is a centrally planned church, whose rusticated drum (with dome) has four pedimented structures around it. Late in the century Zug also laid out for Helena Radziwiłł one of the most important new landscape gardens in east Central Europe, Arkadia; with its ruins, in part composed out of Renaissance buildings, strewn about the gardens along with other structures, it is steeped in some of that pre-Romantic spirit found in Anhalt.[9]

The building of these churches shows that, as was the case with the advent of the Renaissance in Central and Eastern Europe two and a half centuries before, the reception of the new classicizing style of the later eighteenth century was a complicated process. Neoclassicism had a basis broader than that provided by the court alone in Poland, as it also did in Hungary.

A renewed period of building from the mid-eighteenth century forms an episode in the history of the Christian reconquest and resettlement of Hungary. Military circumstances had long delayed an architectural boom, but renewed prosperity created possibilities for palace construction, and not only on the part of the Habsburg kings mentioned in the last chapter. Because there was less remaining in the way of surviving monuments from an earlier age, it has also been suggested that Hungary was more open to architectural innovation.[10]

In any event, the reflection of French architectural forms of the sort identified with both the older and the newer styles of the eighteenth century was much in evidence in Hungary. This is seen for example in the work of Jakob Fellner, such as the bishop's palace of 1760 in Veszprem, where the ground plan is like that of Vaux-le-Vicomte and certain ornamental details on the facade are those of an earlier rococo that was being abandoned elsewhere. French influence is also obvious at the castle of Eszterháza, built from 1761 to 1781 at Fertöd. This is the palace with which Joseph Haydn was intimately associated, the place where he worked for Nikolaus Eszterházy (called the *Prachtliebende*, or *Prunkliebende*, i.e. 'ostentatious'). The idea for Eszterháza comes from Versailles, which Eszterházy had seen in 1764 and 1767, although this observation perhaps holds better for its scale than for exact elements of its style. Eszterháza is also like Versailles in being a huge summer Schloss, possessing formal gardens and roads centring on the palace.

The more radical forms associated with Neoclassicism also spread to the Hungarian lands, where they were also well received. And, strikingly, these often appeared in connection with the church, as for instance in the designs of 1778–81 for the primate's palace by Melchior Hefele in Bratislava. This is in some respects a rather unremarkable late eighteenth-century palace, but it is noteworthy in its spare use of ornament, which allows the basic structural features to dominate the visual effect and thus pushes in the direction of a reformed classicism. In his 1763–77 construction of Vác Cathedral, Canavale, the architect of the triumphal arch earlier discussed (Ch. 16) as ushering in Neoclassicism in the Habsburg lands, provided a design that almost seems to

Schloss Eszterháza, Fertöd, Hungary, from 1761, detail of court facade, 1760s

anticipate the revolutionary architecture of later French designers like Ledoux. The cathedral at Vác is a block-like building, with central dome and a portico attached, an extremely rationalized work, in which a temple (of wisdom?) seems to have become a church.

The utilization of this kind of design for projects that are not directly associated with the imperial and royal court, and thus to a degree with the ideas of the Enlightenment, as in Josephine Vienna, reveals some of the complications of the reception of the arts at this time. For in Hungary these sorts of buildings are connected with the church, and moreover with person-alities who were not associated with the party of reform. While the architec-ture of Vác possesses what might be called a progressive character in its Neoclassicism, its patron, Christoph Migazzi, was an implacable foe of Theresan reforms and became an antagonist of Joseph's efforts as well. Since

the cathedral was done just at the time Joseph became emperor, it is necessary to reconsider the relationship of stylistic change to patronage and ideology in a more balanced manner. Among the discrepancies that need to be considered, the newer style is not so neatly to be associated with enlightened absolutism.[11] In addition to interests generated by social milieu and ideology, aesthetic attitudes were informed by other concerns, as the next chapter will argue.

A complicated interaction of forms and stylistic differences among the different media may also be observed in the Austrian lands. At the beginning of Maria Theresa's reign and even well into it, indigenous traditions of architecture and sculpture like those described in earlier chapters also continued undisturbed, as it were, by artistic changes or developments elsewhere, especially in rural or mountainous areas of Austria. In the great library designed by Joseph Hueber in the Benedictine monastery at Admont there appears, for example, sculpture in an older, dramatic, one might say baroque, manner in the traditional wood medium. This is the work of J. Th. Stammel, who, in a relationship similar to that which had governed the work of sculptors in previous periods, was attached to the monastery from 1726 until his death in 1765. In 1760 Stammel carved the traditional subject of the Four Last Things (death, judgement, damnation and salvation), expressed with all the direct dramatic pathos that one might have expected from later seventeenth- or earlier eighteenth-century wood carvers.

This sort of provincial milieu also experienced the last extraordinary flowering of mural and ceiling painting. While metropolitan centres were open to the newer trends, many smaller village churches and also some important abbeys in southern Germany up to the end of the century received decoration in an older mode from the hands of artists such as Matthäus Günther (died 1788) or Januarius Zick (died 1797). As in the earlier part of the century, such works constitute part of a larger decorative ensemble. In the Habsburg lands decoration of this sort could even be found in the newer constructions of the time, somewhat incongruously, it might seem (such as F. A. Maulbertsch's paintings in Vác). The works of the Austrian artists in particular represent a final efflorescence of the grand tradition of European fresco painting that goes back to the Renaissance and earlier.

In their working methods, including the use of the oil sketch as a preparatory procedure, their formal elements, including illusionistic views seen from below, their stylistic sources and even their identities like, for instance, the Italians Carlo Carlone (1686–1775) and Gregorio Guglielmi (1714–73), the artists of Central Europe and especially the painters from Austria, long continued to be attracted to Italian models. This pattern is not unlike that found in the history of music; the attraction of Italians and Italian-style music for Austrians lasted through the early part of the century. It was not until the 1750s that an important local school of painters developed in the Habsburg lands, which, like that of musicians – this is, in fact, the time of Haydn's early maturity and Mozart's birth – could more than stand up to the best that Italy

had to offer at the time. Then a formidable series of artists, Johann Wenzel Bergl, Franz Anton Maulbertsch, Franz Anton Palko and many others, appeared on the scene. The work of Maulbertsch in particular forms a topic for discussion here, not only for its quality but because it brings into focus some of the tensions and contradictions of the time.

In the Austrian lands the painters who began their careers at mid-century were much shaped by an artist whom we have already encountered in Chapter 12, pp. 303-5, Paul Troger.[12] As master of religious art, Troger developed a style in which expression was intensified without the realistic nature of a scene being impaired, so that even allegories could be set in concrete surroundings. Troger's pictorial qualities combined dramatic light effects, derived from the Neapolitan Caravaggist tradition via Francesco Solimena, who had worked in Austria during Troger's youth, with a free handling of paint and bright colouring inspired by the Venetian works he had seen on an Italian journey during the 1720s; the lighter palette evinced in his frescoes may also be derived from the latter source. Troger was professor in the Vienna academy in 1751 and 1754–7, and his prestige, combined with his teaching, made him responsible for the creation of a Viennese 'academic style', found in the work of many of the artists of the generation who dominated painting from the 1750s onward.

This style is not what we might have expected from the French academy of art in the way of studied painting of the human figure, based on drawing from the nude. In the Vienna academy drawing was also done from the nude, but no uniform drawing style resulted, although some artists picked up Troger's linear manner of drawing.[13] In fact representatives of varying styles, such as Maulbertsch and the more restrained Martin Knoller, were taught or influenced by Troger. Nevertheless, the style carried on or developed by many of Troger's direct pupils and those held in his sway, because of his status, was a type of painting in which colour, light and the free handling of the brush take over from form as the chief elements of painting – exactly the opposite of what might be expected from French nineteenth-century 'academic' painting. In the third quarter of the eighteenth century these were the characteristics of the leading Austrian painters, very different to what might have been anticipated as a parallel to the coming movements in architecture and sculpture identifiable with Neoclassicism.

The most outstanding figure of this group, Franz Anton Maulbertsch (1724–96), a native of Langenargen on Lake Constance, provides a test case for an evaluation of the tendencies of the time.[14] Maulbertsch's career spanned the period from c. 1750 until almost the end of the century, and his field of activity encompassed Vienna and Lower Austria, Moravia and Bohemia, and Hungary, including Slovakia, with a foray to Dresden, leaving frescoes in over forty places and many altarpieces besides. The range and shift in Maulbertsch's patronage is also telling: he was long popular with the lesser nobility and the newer orders, such as the Piarists; while at the height of his career he received

some court commissions, both from the Habsburgs and the Wettins in Saxony, but his patronage came more often from newly founded bishoprics and new and restored abbeys in the east, and he produced works for the residences of lesser nobles and for small churches.

By 1745 Maulbertsch was an independent master. The first works that can definitely be attributed to him do not appear until 1748, however, and his first really important commission was not executed until 1752–3. This was for the Vienna church of the Piarist order, an order dedicated to education, in a building that had probably been designed by the great architect Hildebrandt; this church also has associations with music, since it houses the organ on which Anton Bruckner later played and served as the spot where in 1771 Haydn conducted his 'Stabat Mater'. Among other works by the artist in this church (one of the altarpieces is a pictorial version of 'Stabat Mater'), the most spectacular is the scene overhead, depicting the Assumption of the Virgin. This dramatic fresco yields nothing in quality to what was accomplished elsewhere in Europe at the time;[15] it is one of several great colouristic masterpieces of the eighteenth century that stem from the artist's hand. It may be called a specimen of painterly pyrotechnics: painterly, with reference to the formal, stylistic qualities of paint, where free or loose handling, not line, becomes a key element of execution, and pyrotechnics, because the figures seem to explode upward and out of the ceiling. The traditional image of the *Assumpta* carried by angels is transformed, so that the Virgin seems propelled

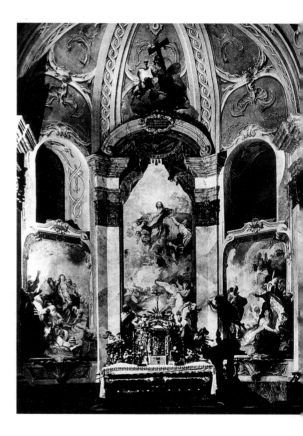

Fresco of the Ascension, High Altar, Sümeg, 1757-8, by Franz Anton Maulbertsch

heavenward. The figures are suffused with light, out of which they seem to materialize; they seem ethereal, in a way comparable to that of great music played in this church.

Maulbertsch also used the loaded, active brush he demonstrated here to create many easel paintings, in which, especially in his early career, forms

dissolve in a torrent of light and colour. These effects are noticeable in several other frescoes from the 1750s, most remarkably in a church in Sümeg (1757–8) in western Hungary, near Lake Balaton, one product of the resettlement and growth of the Church that called for new construction. Maulbertsch frescoed this small building for the bishop of Veszprem, painting the ceiling and walls, adding fictive architecture and making fictive altars that enclose altarpieces in fresco. On the one hand, these paintings thereby represent the height of baroque illusionism; on the other hand, they are masterworks of painterly expression, executed in a palette permeated with light, which results in the creation of gleaming figures, produced in brilliant passages of handling. The frescoes are also extraordinary in their power of invention, in that old themes from the Gospels and the lives of the apostles are given new meaning. In this regard, and to a degree also in their treatment of colour and light to convey pictorial meaning as well as in their illusionistic effects, they are comparable to Tintoretto's capacity to invent a whole new sequence of traditional subjects, as evinced by his large canvases for the Scuola di San Rocco in sixteenth-century Venice. It can thus be said that Maulbertsch succeeds in creating great colouristic masterpieces that are, at the same time, some of the last, fantastic examples of the long tradition of history painting.

In the development of his art, and particularly in his use of colour and light, Maulbertsch surpasses some of what might be called the premises and interests of contemporary painting (often described as 'rococo'),[16] and moves towards the development of pictorial qualities as autonomous elements in art. In his frescoes of 1759 in the bishop's palace in Kroměříž (Kremsier), a seventeenth-century building mentioned earlier (Ch. 11 pp. 266 and 274), he gives prominence to subsidiary figures and moreover emphasizes broad areas of cloth and brocade in them, so that these areas seem to become more important visually than do the figures themselves. In these scenes glorifying the history of the bishopric of Olomouc, attendant figures become instead carriers of colour, with hues shifting remarkably over a limited area. They take on the effect of materialized light. At Mistelbach (1760) the allegorical subject matter – an inscrutable allegory in Enlightened taste on the progress and fruits of science – may even seem to be placed in a subsidiary role in comparison to the pictorial effects.[17] The broad patterns of colour again seem the most striking elements in the painting. The present description cannot merely be characterized as one informed by an anachronistic formalist point of view, since contemporary observers also reacted to similar elements in Maulbertsch's work.[18]

In the 1760s and early 1770s Maulbertsch attained the height of his reputation. For a Schloss designed by Hildebrandt in Halbturn in western Hungary (now Burgenland, Austria), he executed a fresco in 1765, where the figures seem to implode out of the light in a way that fits the subject, an allegory of light. On the other hand, the small village church of Korneuburg possesses an illusionistic fresco (1773) representing the institution of the

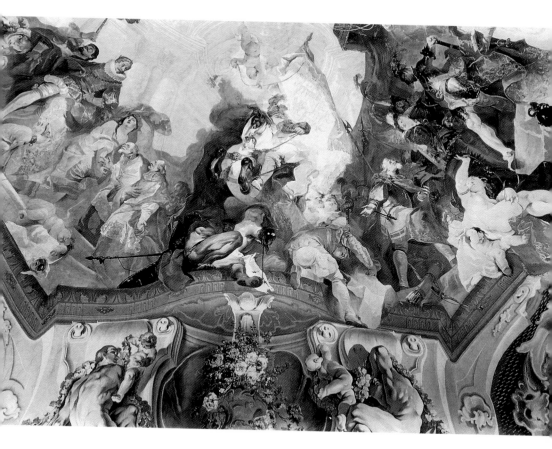

Eucharist. The depiction of the Last
Supper is obviously inspired by Leonardo,
but this is combined with techniques of

Detail of fresco in *Lehensaal*, Bishop's Palace,
Kroměříž, 1759, by Franz Anton Maulbertsch

baroque illusionism, in such a manner that the space of the actual church
seems to be continued by fictive columns. The illusion is thus created that the
institution of the Eucharist takes place behind the altar, the consecrated spot
where it is re-enacted in the Mass. Colour harmonies of pastel shades here
accompany Maulbertsch's genius at invention; this is not merely decorative
painting, but painting with a punch, a meaning, because iridescent colour
combinations are often used in the Germanic tradition of painting to suggest
the divine.[19]

It is often believed that painting in Central Europe in the seventeenth and
eighteenth centuries is undistinguished in comparison with that of the western
European lands, and that it is retarditaire in comparison with developments
elsewhere.[20] But Maulbertsch seems to call for a completely different standard
of comparison; for there is really nothing of his time that can be compared to
his work, which was moreover generated in specific circumstances. Looking at

Maulbertsch's painting of this date, one might instead recall the remarks made by local critics who praised him, saying that 'his rich source of invention, his ease in execution, his ability to order objects, to render each object its due expression, and the other techniques with which he knows how to enliven his works, have created for him a mass of jobs'.[21] Maulbertsch at this time was indeed much in demand. He was admitted into the *Kupferstecherakademie*, engravers' academy in Vienna, and was commissioned by Maria Theresa to fresco a ceiling in the residence in Innsbruck, his major imperial commission.[22]

In works of *c.* 1770, as also exemplified in Moravia at Královo Pole (Königsfeld) near Brno in 1769, Maulbertsch perfected an extraordinary technique that served his pictorial ends. It is characteristic of this master and of others like him, that they carried the techniques of mural painting to their extremes. True fresco is a technique that requires careful preparation, in which a cartoon with a composition is applied to an underlayer of rough plaster by pouncing or incision with a tool, and then to the superficial layer of plaster the visible layer of paint is applied with earth pigments mixed with water and lime. The plaster is put on in segments, each section of plaster being applied according to the amount a painter could accomplish per day, while the plaster was still wet. But Maulbertsch's painting, like much contemporary mural painting in Central Europe, is in fact not true fresco at all but *Kalkmalerei*, a technique that employs pigments mixed with lime and water applied to dry plaster. This medium allows for a much broader scale of pigments to be used and explains the uncommon wealth of colour that appears in Maulbertsch's work.[23]

Maulbertsch also seems to follow the recommendation of Pozzo in his treatise on perspective to *impastare* and *caricare*, to use impasto (thick paste-like application of paint) and load up his brush.[24] Details of his frescoes seen from close up call to mind features found in oil painting. Maulbertsch paints wet in wet, at times with a thin application of paint, over a neutral ground; in some instances it almost appears as if he uses in murals the sort of translucent glazes that are employed in oil painting. In wall painting Maulbertsch also handles his brush quite freely, applying paint thickly, building up surfaces, thus creating an almost sketch-like effect akin to that of impasto in oils. At times he uses the end of the brush to dig up the surface of the plaster, to outline or work forms. For some evanescent figures, like that of Christ or God the Father in Královo Pole, he goes farther and paints on unprepared rough plaster, not only using the end of the brush to dig into plaster to make the outlines of the forms, but actually utilizing plaster itself, not paint, to suggest the substance of the forms themselves. This technique represents an extreme in the development of the painterly tendencies of the epoch, understanding that word not only as a general stylistic description but also in terms of the manipulation of technical aspects of art to achieve effects of pictorial brilliance.

After Maulbertsch had produced this kind of painting without paint, as it were, mural painting as a medium could proceed no further in this direction, and it did not. For if we set this kind of free painting against especially the formal developments that were occurring in architecture, and to a degree sculpture, from the 1760s and 1770s, in the Habsburg lands as elsewhere, Maulbertsch's art might seem to be running against an incoming tide. Tastes in art were changing, and different sorts of demands were made in Central Europe, as elsewhere. Corresponding to the newer strain of taste for a classicizing architecture, a somewhat more *bieder* (honest), restrained style of painting and a more subdued palette came into vogue. In Austria it was served by such artists as Martin Johann Schmidt, ('Kremser Schmidt' [1718–1801]), or, in his production of a more controlled, classicizing art, by Martin Knoller, whose paintings can be seen in several sites in the Tyrol or at Neresheim.

By the time of Maulbertsch's later career, to be considered further in the next chapter, the possibilities for receiving commissions that would allow for demonstrations of his kind of mastery of medium had in large measure passed from Central Europe. In Maulbertsch monumental history painting in the traditional manner, that is, the representation of significant human action, found in religious, secular and allegorical mural pictures, mainly for prominent ecclesiastics and aristocrats, had its last flowering during the old regime. Not only the medium and the milieu but the genre in which artists worked were changing – indeed Maulbertsch had to respond to these changes, too. In Central Europe, as in the west, pictorial art was no longer exclusively the province of the upper estates of society. Pictures were now also being made for a new audience, affecting the types and status of genres of painting. Easel painting and print-making, not murals, became the media that engaged leading artists. What in traditional art theory, and the academy, had been regarded as the lower genres (the painting of everyday life known as genre, portraiture, landscape and still life) had gained in importance.

Many of the newer developments in painting can be associated with the new public that had come into being along with new public spaces, such as the Augarten in Vienna, the Tiergarten in Berlin or the Englischer Garten in Munich, that its members frequented. A new painting accompanied similar developments in other spheres of culture. The culture of mid- and late eighteenth-century Central Europe is indeed more familiar for the music of Haydn and Mozart and for the writings of Goethe and Schiller than for the visual arts. In music the public concert originated in the time of Mozart and Haydn, and scores were published for public consumption, for performance at home. Orchestras such as the Leipzig Gewandhausorchester were formed. The novel became a popular form, and literary journals proliferated; public theatres flourished in many places in Central Europe. From Klopstock and Wieland to the nineteenth century, this is also one of the great periods of German letters.

While it is not so familiar, a newer sort of visual art also arose for a new audience in Central Europe. Just as different patterns were established for

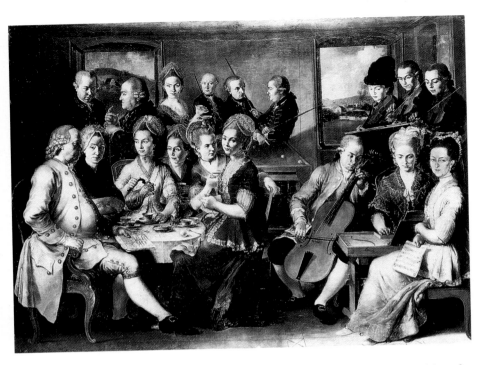

The Remy Family, 1776, by Januarius Zick,
Nuremberg, Germanisches Nationalmuseum

literature by a new reading public, for
theatre and popular opera by a theatre-
going crowd and for music by *Hausmusik*
and public concerts, so there came to be new charges for the visual arts. For
instance, in addition to traditional demands for the dissemination of religious
imagery and for book illustration that printmakers served, a new market
originated for popular prints, with narratives and stories. During the course of
the century hand-coloured prints and wood engraving and coloured engrav-
ings were invented and developed among several new graphic media. The
demand for prints also contributed to the foundation of a separate *Kaiserliche
Franciscische Akademie* in mid-century Augsburg for printmakers, and a new
Kupferstecherakademie, in Vienna in 1766. Throughout the century numerous
artists in Nuremberg, and especially in Augsburg, from Georg Philipp
Rugendas (1666–1742) at the beginning of the century to Johann Gottfried
Eichler (1715–70), Johann Elias Ridinger (1698–1767) and Johann Esaias
Nilson (1721–88), provided designs for prints. In Berlin and northern
Germany this market was served by Daniel Nikolaus Chodowiecki (1726–83),
who made prints depicting popular literature and other middle-class
subjects.[25] Even Maulbertsch came to respond to these demands: he joined the
Kupferstecherakademie in 1770, and in the 1780s designed prints with popular
subjects, a peep show and a quack physician (1785; preparatory paintings in
Smart Gallery, University of Chicago).

A newer kind of genre painting, that is the depiction of scenes of everyday life, thus emerged along with the growth of these subjects in the print media. Seventeenth-century Dutch painting had long been popular with collectors in Central Europe; early eighteenth-century collectors in Germany, such as Augustus the Strong of Saxony or Anton Ulrich of Braunschweig-Wolfenbüttel, the mid-eighteenth-century landgraves of Hesse-Kassel (Cassel) and Hesse-Darmstadt, and Carl Theodore of the Palatinate shared this taste.[26] As a result of its popularity, Dutch art, and particularly the work of Rembrandt, was emulated in many media by many German and Austrian eighteenth-century artists.[27] Beside Rembrandt's exotic types and biblical subjects, artists such as Christian Wilhelm Dietrich (1712–74) and Januarius Zick (1730–97) found inspiration in the depictions by Rembrandt and other Dutch artists of the middle and lower orders of society.

By the mid-eighteenth century Netherlandish topics had been translated into scenes placed in contemporary settings. Thus Johann Conrad Seekatz (1719–68) adapted Netherlandish depictions of peasants to German eighteenth-century scenes and found a ready market in both bourgeois and court circles.[28] By the later eighteenth century Chodowiecki, Johann Eliezar Schenau, called Zeisig (1737–1806), and Johann Christian Klengel (1751–1825), to mention but some of the better-known artists, had made scenes of domestic life in the city popular in Germany.

Village Festival (*Kleines Kirchweinfest*) in Gross-Gerau, after 1760, by Johann Konrad Seekatz, Darmstadt, Hessiches Landesmuseum

'The Swing' (Party in the Country), by Norbert Grund (1717-61), Národní Galerie, Prague

The relationship of these sorts of works to their audience may even be suggested by their treatment of subject matter. The transformation of genre subjects in Central European painting is most striking when bourgeois figures come to occupy the place in pictures once held by aristocrats, often in a quite literal manner. Already in the translation of Watteau's painting to Germany at the hands of Knobelsdorff and Pesne, scenes of loving couples had been set in naturalistic landscape parks, in which the figures are dwarfed by nature; in one collaborative work of 1744 Pesne's staffage seems to represent a middle-class couple. Similarly in pictures made in mid-century Bohemia by Norbert Grund (1717–61) such as *Party in the Country* or *'The Swing' (Party in the Country)*, a theme that had once been executed by Jean Antoine Watteau and Jean-Honoré Fragonard for aristocratic patrons in France, is transposed to accommodate what seem to be bourgeois participants. Likewise, in the *Party in the Tiergarten* by Chodowiecki figures from the world of theatre or the imagination that had appeared in Watteau's or Fragonard's gardens, showing a world of love and courtship, are replaced by

middle-class types who disport themselves in the new public garden of Berlin.

A new type of informal representation came to replace the older, official portraiture of rulers and aristocrats.[29] Members of the middle classes are shown with the accoutrements of or actually involved in everyday activities. This type of portraiture had been anticipated in the early eighteenth century by the informal manner of presenting his subjects used by Johann Kupetzky (Jan Kupecký, 1667–1740), a cosmopolitan artist who had been born of Czech parents in Slovakia, was trained in Vienna, spent

Party in the Tiergarten, Berlin, by Daniel Chodowiecki (1726-83), Museum der Bildenden Künste, Leipzig

twenty years in Italy and then worked in Vienna and Nuremberg.[30] Kupetzky presented his sitters in humble, unidealized poses: his portraiture was much admired by later eighteenth-century portraitists such as Anton Graff (1736–1813), another peripatetic artist who hailed from Wintherthur but worked largely in Dresden and Berlin. Balthasar Denner (1685–1749) was another precursor of the more modest later eighteenth century portraiture: from English and Dutch portraiture Denner developed a manner of portraying character studies and series of types.

From this background, portraiture of bourgeois types had become highly developed by the mid-century, especially in north German centres. Individual portraits, series and conversation pieces were all painted. New sorts of series were also developed. In place of such series as Denner's character studies or the sequences of ladies of the court, such as Pesne painted in Berlin or Rosalba Carriera in Dresden, or series of the ruling family and its court servants, such as Georg David Matthieu did in Schwerin, middle-class enthusiasts made collections of portraits of their friends and those they admired. One of the more remarkable examples of this sort is the collection established by the writer G. W. L. Gleim, that still survives in his house in Halberstadt.[31]

A newer type of more direct, intimate portraiture exemplified in Graff's *oeuvre* replaced the older type of idealized depictions.[32] In Graff's paintings the subjects are scholars and literati, instead of rulers. The creation of newer types also allowed a place for women artists. Perhaps for the first time in Central European art, several notable women artists gained respect as specialists in portraiture, especially in the north German residential cities, where they portrayed members of the court as well as the bourgeoisie. Anna Dorothea Lisiewska Thierbusch (1721–82), painter of a notable *Self-Portrait* of 1755, and her sister Anna Rosina Lisiewska de Gasc (1713–93) worked in Berlin. They represent a tradition that would be continued in the next generation by Angelika Kauffmann (1741–1807), who gained renown not only as a portraitist but as a painter of histories in a classicizing manner.

Thierbusch's work suggests the way these developments in turn had an effect upon portraiture at court. Rulers and aristocrats had themselves portrayed in the mode that had been adapted for middle-class portraiture. In Cassel for instance Johann Heinrich Tischbein's portraits show rulers in informal poses.[33] In Hanover Johann Georg Ziesenis could even portray a ruler in deshabille.

It has been claimed that the best accomplishments of German painting of the last third of the eighteenth century were found in the genres of landscape as well as in portraiture. Like portraiture, the rise in landscape has also been associated with the breakdown of the hierarchy of genres that attended a change in the social situation of the arts in the eighteenth century in Central Europe.[34] Like genre painting and portraiture, landscape painting also had earlier roots, and in the earlier eighteenth century it had also been fostered by the courts. Artists such as Franz Joachim Beich (1665–1748) and Johann

Andreas Thiele (1685–1752) supplied topographic views for the courts of Bavaria, Mecklenburg and Saxony among others. But as landscape developed into an important genre on its own, it seems to have attracted an increasingly bourgeois audience.

Self-portrait by Angelika Kaufmann, 1788, Uffizi, Florence

The connection of the growth of landscape with a new audience is most evident in Switzerland, where of course no court was present to enforce the traditional social and cultural hierarchies, and in fact no academy existed – Zürich, a centre for landscape, did not obtain a drawing school until 1773.

With J. J. Bodmer, J. J. Breitinger, and J. H. Füssli and J. R. Füssli, Zurich was however a literary centre, and the poet Salomon Gessner (1730–88), was also a painter and drawer of nymphs and shepherds as well as landscape. He was one of many Swiss specialists in the genre, including Sigmund Freudenberger and Joseph Aberli; of these the most significant was Caspar Wolf (1735–89), in whose drawings and paintings alpine scenery became a prominent subject.

Landscape flourished in may centres, however, and there were several important, expatriate German artists such as Johann Georg Wille (1715–1808) and Franz Edmund Weirotter (1713–71) in Paris, and Jakob Hackert in Italy. Franz and Ferdinand Kobell made Mannheim into a centre for landscape. In Dresden Johann Christian Klengel, Christian Wilhelm Dietrich, Adrian Zingg and Jacob Wilhelm Mechau all attest to the existence of an important school of landscape before Caspar David Friedrich; indeed Friedrich cannot be understood without knowledge of this tradition. In Vienna, too, a lively school of landscape drawing and painting existed. The term may be used fairly precisely, since, after returning to Vienna, Weirotter became professor for landscape drawing at the academy, attesting to the importance of the genre. This school had important representatives such as Martin von Molitor and Johann Christian Brand at the end of the century.[35]

Conversely, when they had larger aspirations, non-aristocratic patrons could have an impact on the introduction of the new styles in architecture and sculpture. In Austria after the end of the Seven Years' War in 1763 the middle classes recovered some of their prosperity, enabling them to play an increasingly important role in the civic life of Vienna, and for some of them to support the arts on an even grander scale. This applies no less to the visual arts than to music (one thinks of public concerts and the Theater an der Wien, where Mozart's work was performed) and letters.

Wealth gained from commerce was the source for the final work to be mentioned in this chapter: a new town palace, built in 1783–6, that closes off the square on which the imperial library sits. This palace (see illustration, p. 440) was erected by the court architect Hetzendorf von Hohenberg, the designer of the Schönbrunn Belvedere, as a residence not for a ruler but for a Swiss-born banker and contractor, a maker of cotton and brass goods, Johann Fries, who was ennobled in 1783.[36] Fries seems to have chosen for his palace a version of the simplified new architectural style of the reign. In the wake of the changes made at Schönbrunn, the Palais Fries substitutes a mezzanine floor for the *piano nobile*, the first floor above ground in which grand reception rooms had been located in earlier palaces. Several innovations are evident, however. Figures of classical inspiration and style are placed on the attic, and caryatids by Franz Anton Zauner support the lintel of the portal: classically correct in conception, they evoke figures found in Athens and hence also reverberate with archaeological associations. They also represent a break with earlier styles of palace architecture.[37]

The passing of major palace patronage from Joseph and his court to a nouveau-riche entrepreneur aspiring to ape the fashions of aristocrats also suggests that by the mid-1780s European society was in a time of transition. Revolution in France was not far off, when Joseph's sister and brother-in-law were to be executed. In the Habsburg lands revolution would be staved off, and Joseph's reforms would be aborted. Yet change was nevertheless to come, bringing an end to those institutions that had once supported the arts and introducing new conditions for artistic activity. These changes were also induced by new ideas towards the arts.

Although we have remarked that his reforms were not entirely successful, Joseph II can nevertheless be regarded as a harbinger of change. He issued an Edict of Toleration, which ran against the hopes of the Church for a kind of union of Church and State; he also suppressed all those monasteries that did not serve a useful educational or economic function. These very actions were in fact to lead to the sort of disentanglement mentioned, to a dissolution of the cultural nexus of the arts as they had hitherto been known in the history of Central Europe. Almost as if symbolizing the fulfilment of some of the more radical notions of the Enlightenment, the Palais Fries was built on the site of one of the many monasteries Joseph II had abolished.

THE CRITICAL RESPONSE: COLLECTING, CRITICISM, THE ENLIGHTENMENT AND THE VISUAL ARTS

(Pallavicini) Fries Palace, 1783-6, by
Ferdinand Hetzendorf von Hohenberg

CONTROVERSY GREETED THE PALAIS (PALLAVICINI) FRIES WHILE IT WAS STILL UNDER CONSTRUCTION. At the end of 1783 one observer remarked that the architect Von Hohenberg 'had shown good taste, and has realized in a building which can be seen as a whole, that the simple is to be preferred to the overly ornate'.[1] However, soon thereafter, in a tract of 1784, Gottlieb Nigelli, who in 1786 was to assume the position of court architect, attacked the building on the basis of a similar appeal to taste. Using the pseudonym *Baumeister*, Nigelli's tract was also addressed to all 'lovers of building and promoters of good taste' (*allen Bauliebhabern und Beförderern des guten Geschmackes*). The sculptor Wilhelm Beyer, who had himself supplied a plan for an *hôtel* for the location of the palace, in turn assumed the guise of *Antibaumeister* and defended his former collaborator, who was his favourite architect. Hohenberg seems to have paid attention to this dispute: he changed details in the design of the facade of the building before it was finished in 1786.[2]

The critical response to the Palais Fries is but one piece of evidence indicating that by the late eighteenth century the circumstances in Central Europe in which buildings and other works were built and received had become considerably more complex. More than the demands of patrons or even of the market had become involved in artistic enterprises. Other voices and concerns, beyond those of the artist, would have a say in what was be to done. The reception of the Palais Fries reveals something about these new

discourses and the language that emerged, together with new institutions, during a period when a different type of patron for major projects, like Fries, also appeared on the scene. While Fries's parvenu position may in this instance have made the architect particularly sensitive to criticism, the new institutions and discourses to be discussed in this chapter had an increasingly synergistic effect on the production of objects.

In good measure the creation of newer institutions and forms of discussion related to the visual arts, like those related to the newer literature and music, can be associated with the social groups who constituted what can be described as the newer cultural public, whose provision of an audience for the arts has been discussed in the last chapter. This public comprised city dwellers of non-noble status. In this group were included state and court servants, members of the learned professions, lawyers, students, and in the north and west ministers and theologians, as well members of some trades. The social bounds governing these groups, the forerunners of *Bildungsbürgertum* (educated middle classes), were more elastic than earlier constraints had been. Skill and education, not social estate or birth, became criteria: it has been said that 'these new groups, unlike the sixteenth-century burghers, who had been integral members of a self-governing community, were burghers because they happened to live in cities or towns, and they were distinguished from the nobility and peasant by lesser or greater rights'.[3]

A well-known analysis by Jürgen Habermas has outlined a supposedly structural change in the composition of this new bourgeois public.[4] Whether or not one subscribes to the idea that a separate new public sphere was thereby created, it can be recognized that in the eighteenth century a new conception of private life, and of entertainment related to it, also emerged. There was a growing sense of public entitlement to culture. And this process was hugely affected by the fundamental force of fashion, with obvious consequences for the arts in general. As one late eighteenth-century observer noticed, 'In a nation where luxury introduces fashion and this has penetrated all aspects of private and social life; there the number of things which excite the appetites of men is endless; and every day offers them something new, which they either strive after with impetuosity or do without with dissatisfaction'.[5]

The basic force of fashion took shape in the new institutions that created spaces, if not a separate sphere, in which members of the newly composed social groups could associate with each other. Habermas and many historians of the eighteenth century have discussed some of them: salons, clubs, readers' societies and markets. In the absolutist states of Central Europe, however, the development of new institutions could not take place completely independently of a hierarchical society, many aspects of whose culture were still more dominated by the courts and aristocracy than in other lands such as England or France.[6] As in earlier times, the spread of an interest in the visual arts was also undoubtedly encouraged when rulers personally indulged in them, as they did in music: Maria Theresa and her daughters, for example, received

instruction in drawing. Furthermore, the salons and circles of certain areas, for example in Moravia, also centred around noblemen, who could even be attached to the ruling courts.[7]

Some of the new institutions established by rulers such as Maria Theresa and Joseph II also played a role in forming what the writers who discussed the Palais Fries called 'taste'. Joseph von Sonnenfels, a member of the new group of court officials, himself the centre of a salon circle in Moravia and an art collector, expounded the principle according to which the state's involvement in the arts was conceived as more than an expression of the ruler's grandeur. Sonnenfels, who was also secretary of the Vienna Kupferstecherakademie, believed that the strength of the state reflects and depends on the function of art; art can serve broader purposes. Maria Theresa's counsellor Count Wenzel Anton Kaunitz also stressed the importance of the fine arts and their contribution to industrial development in relation to a population more generally educated in the arts. As he said, 'Good taste... has an effect on manufacture and trades. It can bring into existence new sections of the economy; it stimulates industry. A lot of money... which previously... flowed out of the country remains inside it, and more and more money flows in from outside...'[8]

In practice, producing good taste and promoting art was in part facilitated by the training offered in the new institutions founded by princes and in older ones reformed by them. Instruction in the academies served this end, and drawing instruction was also given central importance by the foundation of technical schools and also of the so-called reformed schools of drawing (Zeichenschulen) for artisanal training. But education in the arts could become even more far-reaching: as part of the more general reorganization of schools effected during the reign of Maria Theresa, drawing was also made an element in the regular school curriculum.[9]

The development of art collections and the establishment of new institutions related to them also eventually involved the new public. Therefore only collections of rulers have occupied our attention, but while these continued to be of importance, they must be considered in the context of a more general institutional transformation. Famous graphic collections, such as the fabled Veste Coburg and the Vienna Albertina, were founded in the later eighteenth century by rulers and nobles like Franz Friedrich Anton of Saxe-Coburg-Saalfeld (1750–1806) and Duke Albert Casimir of Saxe-Teschen; important painting collections were established by the landgrave of Hesse-Kassel and the Elector Carl Theodore of the Palatinate, later of Bavaria.[10] In places like Dresden court councillors also established important collections, the most famous of which is that of Count Brühl, for whose picture collection one of the first independent gallery buildings was erected.[11] Although these collections were not generally accessible, they stand for a more general phenomenon whereby other, private, middle-class individuals, like Johann Friedrich Städel in Frankfurt am Main or, at the end of the century, F. F. Wallraf in Cologne,

also formed collections. Important dealers, such as Domenic Artaria, Johann Heinrich Frauenholz and Christian von Mechel, operating in Mannheim, Vienna, Frankfurt am Main and Basel, serviced the needs of this market, which was served at another level by fairs; some of the effects of this on production have already been discussed.[12]

A connection with teaching is suggested by another type of collection that had also long existed, but burgeoned in the eighteenth century: that of the artist's atelier. In a workshop, collections of drawings, paintings and bozzetti could serve not only as a record but as a source for inspiration, a stock of images for potential clients and also for teaching material for apprentices. To mention but some compendia of drawings, that contained much more than a workshop's own products and eventually entered public collections, there were those assembled by Martin Johann Schmidt, Martino Altomonte and Martin Knoller, by the Moravian sculptors J. J. Wintherhalter the Elder and Andreas Schweigl and by the architect Franz Grimm in the Habsburg lands, by Lambert Krahe in Düsseldorf and by Martin von Wagner in Würzburg. Finally drawings, prints, casts and other works were kept in the various art academies to serve for purposes of instruction.[13]

More significant still was a transformation in the nature of princely collections themselves. Earlier in the eighteenth century the Dresden rulers had led the way in the rational reorganization of princely collections, and in making them openly accessible to visitors. In the course of the century rulers' collections also came to be conceived as having a role in the promotion of the general public good. In establishing a 'Palais des sciences' in the Dresden Zwinger, Augustus the Strong specifically determined that it should be dedicated '*dem public zum besten*'; when in the 1770s the Japanese Palace (Japanisches Palais) there was given over to collections, it too was made into a museum for public use (*museum usui publico*).[14]

A similar change in attitude towards the audience for the arts, from privileged to popular, and in their function, from representation or decoration to education, transpired in the Habsburg lands. After the disruption of the Seven Years' War (1756–63) paintings owned by the dynasty were later gradually gathered together in Vienna; inventories of the works were drawn up in 1773, and plans were made for a picture gallery. These plans were realized in the early 1780s under Joseph II, when the Belvedere palace was transformed into a gallery and opened to the general population, who were admitted free of charge. A catalogue of the collection was produced by the Swiss scholar-dealer Mechel and published in 1783. This catalogue reflects the actual hanging of the paintings, which followed a historicist principle of organization, whereby pictures were grouped by date and school, rather than, as previously, by medium, size or subject, or without any organizing principle whatsoever. The aim seems to have been to provide a visible history of art, allowing for lasting instruction, rather than just ephemeral pleasure.[15]

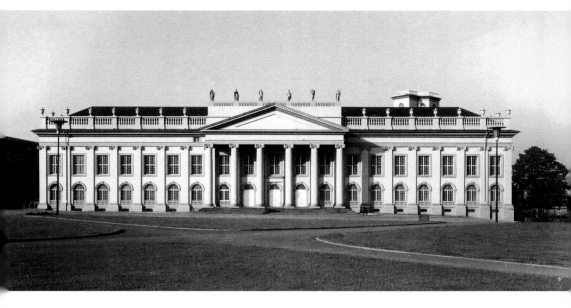

Museum Fridericianum, Cassel,
begun 1769, by Simon Louis du Ry

Like others of Joseph II's plans, the opening of the Belvedere had been anticipated by another prince, Frederick II of Hesse-Kassel. In Cassel the Museum Fridericianum had already been established as the first free-standing museum building in Germany. Begun by Simon Louis du Ry (1726–99) in 1769, the year of the Wörlitz Schloss, it too relies on English Palladian models, taken from Colen Campbell's *Vitruvius Britannicus* (1715, 1717, 1725). But Ry's building translates a country residence type into a city palace and effectively does away with a basement level, so the meanings of this reference, other than a general allegiance to British culture, are uncertain.[16]

The courts' sponsorship of new institutions, which were to spread an interest in and familiarity with the arts – and thus among other things improve taste – represented in practice the realization of certain dicta of Enlightenment thought. For instance, Enlightenment thinkers regarded schools as serving not merely practical but also moral goals, in the arts as in other fields of human activity. As the theoretician Johann Georg Sulzer expressed it, art could also serve broader public, educational ends. The *Kulturpolitik* pursued by the Enlightened party at the Vienna court and elsewhere, as represented by officials such as Von Sonnenfels, therefore corresponded to – in some instances, such as that cited, indeed responded to – a current in contemporary writings.[17]

These writings were formulated for a new reading public, and appeared in the form of new kinds of publications.[18] These publications served an increasingly avid reading public, who formed readers' societies (*Lesegesellschaften*) in several German cities. Reading and exchange of ideas also took place in the café.

Some of these newer forms of publications were in fact directly connected with collections. Mechel's catalogue was not even the first of its kind in this regard. Representative works publishing reproductions of objects in princely collections had long been produced, starting for example in the Habsburg lands with the record of Ferdinand of the Tyrol's armour collection in the sixteenth century and continuing in the seventeenth century with the Flemish painter David Teniers' *Theatrum pictorium*, a compendium of reproductions of Archduke Leopold Wilhelm's picture collection, and in the eighteenth with the antiquarian Carl Gustav Heraeus's publication of Charles VI's coin collection. In Dresden Karl Heinrich von Heinecken's *Recueil d'Estampes* of 1753 served a similar function as a work illustrating the Dresden picture gallery. Within a decade of its publication the need for a handbook and reference tool for visitors to the collections had become such that a catalogue of the Dresden collection was published, first in French in 1765 and then in German in 1771.[19] These publications obviously indicate further the growing involvement in the visual arts on the part of a larger literate public.

Sulzer's comments, mentioned above, in fact represent another of the new forms of literature on art that arose as art historians and critics assumed a mediating position between art and its new audience. Sulzer's words appear in his *Allgemeine Theorie der schönen Künsten* of 1771–4. This multi-volume work by the Prussian teacher and academician was a typical product of the era, a work in which stock notions of Italian art theory were made broadly accessible and through which other considerations of art, such as the concept of art as a form of beauty (implied by the idea of *schönen Künsten*) became disseminated. Sulzer's book can thus be regarded as an example of the incipient art criticism of the eighteenth century that contributed to the growing discussion of the visual arts.

Posthumous portrait of Johann Georg Sulzer (1720-79), 1781, by Anton Graff, Crocker Art Musem, Sacramento

In eighteenth-century Central Europe art criticism developed alongside the growth of literary theory and criticism, stemming from Gottsched and his antagonists Johann Jakob Bodmer and Johann Jakob Breitinger. Both developments constituted part of a more general movement of criticism, which has been identified with the Enlightenment.[20] From the 1750s, and especially from the 1760s, numerous essays on the visual arts appeared by, among others, writers such as Von Heinecken, Christian Ludwig von Hagedorn, J. J. Wilhelm Heinse and Johann Heinrich Merck, and the painters Anton Raphael

Mengs and Salomon Gessner, on various aspects of painting and drawing.[21] The connection of these writings with the newer literary criticism, and its organs of publication, is evident: essays such as Heinse's and Merck's appeared in one of the journals for the reading public, J. G. Herder's *Teutscher Merkur*.

Probably the most famous of these writings on art, those of Johann Joachim Winckelmann, are also closely connected with contemporary collections. Winckelmann was obviously stimulated by the Dresden collections: one of his first writings was a fragmentary description in 1752 of the Dresden paintings collection.[22] Winckelmann also had the Dresden collections in mind when he wrote his path-breaking *Gedanken über die Nachahmung der Werken der Griechen in der Malerei und Bildhauerkunst* (*On the Imitation of Works of the Greeks in Painting and Sculpture*) of 1755, whose first words express the idea that 'good taste', which was being disseminated throughout the world, began to be formed in Greece. For Winckelmann seeking the sources of art meant travelling to Athens, and through its collections Dresden had become Athens for artists. Winckelmann says that 'good taste' had been made widespread through Augustus the Strong and Augustus III's collecting of pictures; he specifically says the Saxon rulers acquired and displayed paintings for the education of good taste (*zu Bildung des guten Geschmackes*).

In Winckelmann's criticism an ethical or moral norm informs his aesthetic approach; it also lies behind the first independent book in German bearing in its title the history of art, his *Geschichte der Kunst des Altertums* (History of the Art of Antiquity) of 1764. In this book Winckelmann tries to account for the origins of the Greek accomplishment. His work places this norm, or artistic standard – exemplified by the 'noble simplicity and quiet grandeur' of the ancient statue the Laocoon group – in history. It represents a classicist notion of the idea, that the antique embodies an ideal, which for Winckelmann is realized in history – the Platonic idea becomes flesh. Winckelmann thus gives voice to what is obviously a historicist consciousness, that certain things are appropriate to certain times, that the development of art can be traced from its origins to its perfection in classical Greece and that the style of a work is related to its place in history. His work therefore is usually regarded as representing an innovation in the historiography of art, in that it no longer merely presents a series of biographies of artists. Rather, close study and description of individual works of art are employed to determine qualities of style, and therefore date; a meticulous description of the formal qualities of the parts of a work leads to an induction of general principles; these in turn are used to shape a general argument.

Beside establishing the foundations of a subsequent history of art, Winckelmann's work contained a fateful historical presupposition, because built into it was the normative opinion common to classicism that upheld the ancients as paragons. This belief was rephrased in a new way, namely that the Greeks represented the summit of artistic achievement. Read together with his essay on imitation, Winckelmann's approach can be regarded as Neoclassical,

since the pattern in history that he finds is one that values and urges the emulation not only of ancient art but also of the Renaissance, as exemplified by Raphael's Sistine Madonna, as well as that of seventeenth-century classicism, exemplified by Guido Reni or the Carracci.

In Winckelmann's writing there is also a quite explicit ethical charge, leading to a specific and direct rejection of contemporary artistic movements, that for the sake of convenience may be called rococo, and all for which they stand. In *Über die Nachahmung* Winckelmann says that artists should emulate the great masters of the past, so that art can once again be like that of the ancients. This is because he believes that decoration has declined from the time that the Romans first introduced grotesque ornament, and as he says recent decoration is even worse. 'Our *Schnörkel* work' – his term for rococo flourishes and shell ornament – he says has no more of nature inherent in it than the kind of grotesques that Vitruvius (V:7) had attacked. Moreover, Winckelmann attacks a particular kind of painting, for which the contemporary work of Maulbertsch may stand (and Maulbertsch, somewhat later, did indeed paint in Dresden), saying that

> *Paintings on ceilings and over doors stand there more to fill up the empty space, to cover a blank spot, that the gilding did not cover up; they don't have any logical relation to the space of the observer, but in fact even work to his disadvantage ... like placing the earth on the sky ...* Horror vacui *fills the wall ... paintings are empty of thought.*[23]

Inherent here was a demand for a new, logical history, that was also directed against the kind of painting of allegory practised by artists such as Maulbertsch, among many others. Indeed, Winckelmann (along with Lessing) wrote a tract offering a critique of allegories. The effort at veiling truth, at presenting it in new forms, was criticized; instead an effort at intelligible allegory was demanded.

Winckelmann's assault on the rococo was part of a more general critique. Similar ideas were suggested by the Saxon critic and classicizing architect Friedrich August Krubsacius in *Thoughts on the Origin, Growth and Decline of Decoration in the Fine Arts*. Krubsacius said that

> *buildings can be made much more noble if one refrains altogether or at least as much as possible from decorating them. They have their essential beauty and need no extraneous assistance ... the only purpose is to indicate to passers-by the use of a building or the status and dignity of its owner and so to make them view its true beauty with attention.*[24]

This kind of argument, with its aesthetic and ethical edge, and especially the beliefs of Winckelmann, had a tremendous effect on the formation of opinion throughout Central Europe, far beyond Saxony, and exercised an impact on state policy as well as on individual choices. In Bavaria in 1770 Elector Max III Joseph issued a mandate that determined that state approval was necessary for plans for country churches, to 'prevent all exaggeration ... so that in this way a pure and regular architecture may be preserved, eliminating

all superfluous stucco-work and other, often nonsensical and ridiculous ornaments, and showing altars, pulpits and statues a noble simplicity appropriate to the veneration of the sanctuary'.25 The appearance of the words 'noble simplicity' point to the influence of Winckelmann. Similar restrictions were promulgated in Prussian-ruled Silesia.

This kind of thinking was also clearly known and well received in Austria. The notion that art could serve ethical and moral ends, as well as the political goals of the state, plainly circulated in court circles, as the statements of Von Sonnenfels and Kaunitz suggest. It has also been argued that the redirection of Josephine patronage 'under the influence of bourgeois culture' from buildings with representational functions to those with a charitable or educational aim suggests that the court itself was 'evidently appealing to a new criterion of judgement', that of public opinion.26

It is clear that Winckelmann had a powerful impact on the formation of aesthetic opinion in the Habsburg lands. Winckelmann in fact died on his way back from triumph in Vienna, where Maria Theresa gave him medals, when he was murdered in the then Austrian city of Trieste. His ideas were circulated in the Habsburg lands by counsellors such as Sonnenfels. Freiherr von Spergs, an assistant of Kaunitz in the state chancellery, cared for the posthumous edition of Winckelmann's *Gesamtausgabe*.27

Allegory on the Fate of Arts, 1770, by Franz Anton Maulbertsch (Maulbertsch's *Aufnahmestuck*), Vienna, Akademie der Bildenden Künste

The sort of historical consciousness directed towards art evinced in Winckelmann's *Geschichte* seems evident in the later organization of paintings in the Belvedere, and the cataloguing of them, according to nation and school. Restrictions like those in Bavaria were also promulgated in Hungary. The term 'good taste', which informed the discussion about the Palais Fries, also indicates the currency of these ideas.

The later career of an artist already used in this book as an exemplar – Maulbertsch – sheds light on the effect of critical response on artistic production. Even as he attained success and recognition in the early 1770s, Maulbertsch increasingly had to accommodate his work to criticism.

Parnassus by Anton Raphael
Mengs (1728-79), fresco,
Villa Albani, Rome, 1760-1

Although he succeeded in becoming a member of the painters' academy in 1759 and then later, in 1770, of the academy of engravers, headed by his eventual father-in-law Jacob Schmutzer, he also repeatedly failed to win election to the post of professor. In one debate over his election it was remarked that 'while the fire [one thinks of pyrotechnics here] of Herr Maulbertsch is fine, his work could perhaps be as damaging to young students as it could be helpful'.[28] His *Aufnahmestuck*, the piece he submitted in order to be accepted into the engravers' academy, is accordingly a monochromatic allegory, with regularized lighting and clarified composition, which a contemporary critic in one of the new *Kunstzeitungen* (art journals – another new form of publication for the expanding literary public) explicitly recognized as an effort to approximate Winckelmann's ideal.[29]

But this effort was not enough. Beside the alternatives offered by artists such as Schmidt and Knoller in the Austrian lands, the newer painting relating to Winckelmann's ideal was instead embodied by the work of his friend and associate Anton Raphael Mengs. And Mengs, who portrayed Archduke Leopold in 1769–70, was surely known at the imperial court. Mengs's allegories contain figures taken from Renaissance and classical sources; they are clear and easily legible; the bodies of the figures and their colouring is not distorted; even in ceiling frescoes, figures are to be read as if they were placed on the earth. As suggested by the more famous work by French painters such

as Jacques Louis David in the 1770s and 1780s, this kind of painting indicated that one should go to Rome and look to the antique for inspiration, in stories and in style. Even portraitists, such as Anton von Maron, the Austrian pupil, brother-in-law and successor of Mengs in Rome, expressed the new ideology in their works: Maron depicted himself in the course of illustrating a subject from Virgil's *Aeneid*.

The rise of this sort of painting had consequences for artists who worked in other modes. During the course of the 1770s Maulbertsch's commissions came from places farther and farther from the imperial centre in Austria, either in provincial village churches or in Hungary. The more cosmopolitan centres turned to other figures.

Even when Maulbertsch worked for patrons in Hungary, he had further to change his style. For in Hungary an edict had also been passed that restricted the types of decoration permitted. Patrons like Migazzi, who had been taken by the newer fashion in other media, demanded clarity and rationality in painting along with their sponsorship of a classical, rationalized architecture. The bishop of Eger (Erlau) could accordingly stipulate that Maulbertsch should not create 'horrifying and frightening' figures: this may express a reaction to the highly emotional, even ecstatic, figures that the artist had earlier painted in Hungary. It was also demanded of Maulbertsch that 'in place of the *sotto in su* he was to give a more orthogonal rendering of architecture in profile' and 'a good view of the main figures'.[30]

Self portrait, Rome, 1787, by Anton von Maron, Historisches Museum der Stadt Wien, Vienna

Maulbertsch's frescoes of the 1780s and 1790s in Hungary show how he came to grips with these demands. In the parish church at Pápa he set figures in a scene of St Stephen preaching in oblique perspective, locating them firmly on fictive architectural supports. Where earlier, for instance in Halbturn, his fictive architecture had employed rococo ornament, now he depicted decorative elements that approximated the ornamental style based on the antique that was being introduced in Central Europe into contemporary architecture and interiors, indeed in the very palaces such as the episcopal residence in Szombathely (Steinamanger) where he was also to work. In Szombathely Maulbertsch set his figures

Allegory on the Revelation of Divine Wisdom,
1794, ceiling, Library, Premonstratensian Monastery,
Strahov, Prague, by Franz Anton Maulbertsch

standing, somewhat oddly, on the fictive architecture of classicizing structures. Where, as in the chapel of the Lyceum in Eger, Maulbertsch had to depict figures as if they were in heaven, he adjusted their perspective and disposed them more regularly around the surface of the composition. He also toned down his extreme colour contrasts and bright palette, particularly in his easel paintings, and gave a firmer sense of form to his figures.

As was the case with the reception of the Renaissance in Central Europe, the interactions of artists with the intellectual and social movements of their times was, however, not so simple. In one of Maulbertsch's last works from 1794, a fresco for the library of the Premonstratensian order at Strahov in Prague, Maulbertsch was specifically ordered to paint a work *not* in traditional *di sotto in su*. Yet this seemingly rationalist proscription was directed toward the execution of painting whose programme entailed a complicated allegory of the revelation of Divine Wisdom, stressing the guiding light of religion over the recognition of the power of natural reason. The choice of this subject after Joseph's death may be taken as a reaction to the Josephine Enlightenment, and in context the theme of the painting certainly assumes an anti-Enlightenment character. To judge from this work, or from the patronage from reactionary clergy that Maulbertsch received at the very end of his career, or from his ecstatic colouristic works with religious themes, as well as from the critical response to his work in his later days, we might thus not immediately associate him with the interests of reform or Enlightenment in the Habsburg lands.

Yet it has also been suggested that Maulbertsch was a supporter of ideas that can be identified with the Enlightenment, taken in the Kantian sense of the dictum *sapere aude* (dare to know) of man's freedom from his self-imposed tutelage.[31] Paintings already executed early in Maulbertsch's career depict themes such as allegories on education, both at the hands of such orders as the Piarists who commissioned works from him and also in apparently uncommissioned works on the education of aristocrats. It has been argued that such depictions of education as a method of societal improvement demonstrate the artist's sympathy with Enlightenment goals. Works from later in Maulbertsch's career, as exemplified by his frescoes (1775–6) on the riches and trades of the Tyrol in the Innsbruck residence (sketch in J. P. Getty Museum) indicate that he was attempting to heed the demands of the publicists of the Enlightenment for plain truth and likeness to nature, as well as trying to produce clear and rational images within the limits of traditional allegory. In these frescoes, whose programme was designed by Spergs, he also accompanied his central allegory on the union of Austria and the Tyrol with naturalistic vignettes of human activity representing the material resources of the Habsburg lands and the human skills by which they were exploited. Ernst Wangermann has suggested that he thereby expressed characteristic Enlightenment beliefs, such as an intense delight in nature's bounties and man's productive energy.[32]

In other images Maulbertsch wrestled with the problem of depicting traditional allegories without eliminating references to time and place; while his allegory of the Tyrol is anchored in the here and now, his allegory of Joseph II of 1777 alludes to an event that occurred in Slavikovice in Moravia, where Joseph took up the plough during a drought: this symbolizes the enlightened ideal of rule, depicting the ruler in the service of the state, but represents a novel combination of traditional ruler iconography with a particular historical

Allegory on the Edict of Toleration (Bild der Duldung), 1785, etching, by Franz Anton Maulbertsch

event and also a newer conception of dynasty – of details from life. A later allegory similarly shows Kaunitz distributing prizes to the painters' academy. A consummate problem is present in Maulbertsch's depiction of actual application of Enlightenment ideals in the Austrian domains, where, as has been noted, the Enlightenment was associated with enlightened despotism. Specifically, Maulbertsch's *Bild der Duldung*, his allegory on Joseph's promulgation of an Edict of Toleration, that granted religious freedom as well as civil rights to Protestants and Jews, encapsulates a problem of representation. Maulbertsch approaches the subject by including, along with actual historical figures, personifications from traditional allegory like *Ratio triumphans*, where the light of Reason would seem to stand for Enlightenment. Here what has been called a highly developed art of baroque eloquence is used to promote the often naive rationalism of Enlightenment. This combination shows the stretching of art for new purposes, which was soon to be encountered in French revolutionary iconography.[33]

Maulbertsch's struggle to make paintings in the face of new criticism and to find a pictorial imagery and style to fit newer themes, supports the thesis

that (as French revolutionary art also demonstrates in contrast) there was no 'Enlightenment style in the arts'.[34] Like Maulbertsch, Januarius Zick could also celebrate a hero of the Enlightenment such as Isaac Newton in an allegory on his *Service to Optics*, which moreover was executed in a style that does not extend far beyond the rococo.[35] Despite criticism that condemned the rococo and seemed to sponsor those artistic movements that can be identified with classicism, there was not merely one pathway open to artists who might sympathize with the Enlightenment. Zick's and Maulbertsch's work indeed suggests that there may be a more fundamental dichotomy between the ethical and the aesthetic in Enlightenment thought.

It was during Maulbertsch's lifetime that Alexander Baumgarten (1727–62) developed the philosophy of beauty, aesthetics, from the philosophy of Leibniz and his follower Christian Wolff. In his *Metaphysica* of 1739 and his *Aesthetica* of 1750 Baumgarten developed a definition of aesthetics as the science of knowing the beautiful: the beautiful did not consist in an object – say, a poem – but in the mind of the beholder which perceives it. This creation of the idea of *aesthetica*, as applying also to the senses, as distinguished from *noeta*, applying to the mind, had moreover a tremendous appeal in the critical debates around 1740, when Bodmer and Breitinger could utilize it in their debates with Gottsched, and his normative poetics. In stating that beauty resided in the act, not the object, of cognition, critics could separate the conjunction of morality and aesthetics that had existed in the writings of critics like Gottsched. They could also use Baumgarten's Leibnizean argumentation as a weapon to attack Gottsched's conjunction as a product of indistinct and confused concepts.[36]

This distinction created possibilities for considering what applies to the aesthetic alone; in the reception of the idea of aesthetics that occurred in the 1760s with the republication of Baumgarten's work in 1761, it was also applied to the visual arts. It was adopted by Mengs, and by Sulzer, whose definition of art as pertaining to beauty has been referred to (p. 446). Now the place of beauty in art, and the role of art itself, could be conceived exclusive of the particular subject represented, or the function served.

The term aesthetic, though not used precisely in Baumgarten's sense, was also employed in 1766 in Lessing's famous treatment of the *Laocoon*, the group specifically praised by Winckelmann as representing 'noble simplicity and quiet grandeur'. Lessing directly contradicts this point and in his essay *Laocoon* also implicitly lays the ground for another direction for the arts. This runs against the principles exhorted by Winckelmann and was to appear in the work of Jacques Louis David or his Central European equivalents, such as Friedrich Heinrich Füger, Martin Knoller or Maron.

Lessing, who in his *Hamburgische Dramaturgie* had extended the critique of a restrictive Neoclassicism, as exemplified by Gottsched in literature, thereby achieved the same results in his discussion of the visual arts. At the same time he overthrew the ideal of Neoclassicism and its overblown claims

for art. Lessing did this when he attacked one of Winckelmann's notions, that sculpture could be like poetry, that it could express emotions and actions in the same way. Instead Lessing argued that the visual arts (such as painting) and poetry work on their own independent principles and lines, independently of each other.

The foundations on which were established not only a Winckelmann-type classicizing aesthetic, but a hierarchy of the genres according to which history was supreme, was thus effectively undermined. For this hierarchy was based on the understanding that the highest form of art should be the highest genre and that history, as the representation of significant human action, rightly assumed this place. Most criticism in the mid-eighteenth century, including notably that of Winckelmann, thus operated on the assumption of rhetorical or poetic principles into discussions of the visual arts. This argument was founded on the comparison of poetry and painting, the idea that the values of one could be applied to the other, as it had been expressed in the Horatian dictum *ut pictura poesis* (as is painting so is poetry). Since the standards of criticism in the arts were the same, what applied in one realm applied to the other. But Lessing severed the connection: after him the visual arts not only had a history, given them by Winckelmann, but they now must also have their own independent criticism, one that was not merely like literary criticism but independent of it, and one moreover that was founded on what might be conceived of as pictorial considerations.

Lessing's work was widely known throughout Central Europe, through his publications, personality and appearances. He was, for example, certainly well known in circles in the Habsburg lands, with which he maintained contacts, especially in the early 1770s with the court and with Count Kaunitz. He sought to get an academy position in Vienna and in 1775 was received at court.[37] It is thus not unreasonable to consider Lessing's explosion of the principle on which earlier theories of the visual arts had been founded, namely that they were forms of story-telling related to history, as one more complication in the growing problematic of the visual arts in Central Europe in the late eighteenth century. For this was an idea implicit both in works of Neoclassical painters, whose paintings might be regarded as antithetical to those of Maulbertsch, as well as in Maulbertsch's own pictures.

In any event, during the 1760s other views of aesthetics were crystallizing, and they also attained their greatest reception in the early 1770s; these alternatives were also not without consequences for the visual arts. In 1762, a year after the republication of Baumgarten's work, Johann Georg Hamann's *Aesthetica in nuce* appeared. Here the reasoned analysis of the philosopher was rejected for the enthusiastic pronouncements of the mystagogue or, as Hamann styled his own work, a 'rhapsody in cabalistic prose'.[38] Hamann's enthusiasm (*Schwärmerei*) was in keeping with other anti-rational movements of the time.[39] His works were of great attraction for many figures, including Johann Gottfried von Herder and the Swiss mystic and physiologist Johann

Kaspar Lavater. And it was Lavater, and along with him the physiognomist theorist Franz Anton Mesmer, who had an effect on the transformation seen in the art of the late 1760s and early 1770s and on the remarkable sculpture of Franz Xaver Messerschmidt (1736–83).[40]

A native of Swabia, Messerschmidt studied with his uncle, the important Bavarian sculptor in wood, Johann Baptist Straub (1704–84), and then in the Vienna academy. His career as a sculptor at first seems to echo the main themes of later eighteenth-century art: establishing his career with a bronze bust of Maria Theresa and her husband Franz *c.* 1760, he then made allegorical figures of the rulers; these were however followed with works that reduced the trappings of office and concentrated on the expression of the virtues of the individual figure, unadorned. In the later 1760s and 1770s impulses from Rome elicited the introduction of a classicizing style that corresponds to Winckelmann's values. But at the same time Messerschmidt began to devote himself to his infamous character heads, figures that represent the various physiognomic types according to a Lavaterian interpretation. Messerschmidt seems to have become obsessed with these images, which appear in his *oeuvre* just when he himself seems increasingly to have become mentally ill.[41]

While in Messerschmidt the anti-rational verged on the irrational, his work represents only one of the sorts of challenges that were being issued to a 'Neoclassic' aesthetic of the beautiful. They also ran along with those currents of sensibility (*Empfindsamkeit*) that preached emotive attunement to the world. The attitudes that sympathized with *Empfindsamkeit*, for instance, favoured Gessner's poems and the drawings that he created as well.[42]

But this attitude, familiar in the history of literature, also had consequences for the visual arts. Arising out of an appreciation for the complexity, variety and dynamism of nature, conceptualizations of the sublime entailed a different response to a confrontation with the infinite than was allowed by notions of the beautiful. As the sublime was pitted against the beautiful, so was genius against rule. In place of a Neoclassicism based on regularity, calm and repose, there arose a different kind of taste for the picturesque and the sublime in landscape, and in representations thereof. This taste can be connected with the predilection for the kind of rugged, snow-covered mountain scenery that first arose in later eighteenth-century art in Central Europe, as in the painting of Caspar Wolf.[43]

The best-known outgrowth of tendencies towards enthusiasm, irrationalism and the cult of genius in the 1760s and 1770s is designated the movement of *Sturm und Drang*, and this movement, too, had its implications for the visual arts. In literature the most famous products of *Sturm und Drang* are no doubt Goethe's *Götz von Berlichingen* and *Die Leiden des jungen Werthers*, but Goethe also contributed a famous essay on architecture to a compilation of essays published in 1773 by Johann Herder, Paolo Frisi and Justus Möser, *Von deutscher Art und Kunst*, which has been described as a manifesto of the movement.[44] Goethe wrote a paean to Strassburg Cathedral,

and to its maker: this is perhaps the first important evocation of the Gothic, significantly treated as a national style.[45] Just at the time when 'the tyranny of Greece over Germany' was being established, there were strong voices arguing that another norm might be established.[46] Herder, in whose editions other important treatises on the visual arts appeared, took Winckelmann's historicism a step further in works such as *Auch eine Philosophie der Geschichte* of 1774, allowing for a multiplicity of art forms, which originated according to the times when they were made and the people who created them.

A convincing argument has been made that it was in response to the anti-rational *Schwärmerei* of the 1760s and 1770s, and specifically to some of the work of Herder, that the last great thinker to be discussed, albeit briefly, refined and redefined criticism into philosophical critique.[47] As Ernst Cassirer long ago suggested, in Immanuel Kant's third critique the traditions of discussion stemming from the debates of the literary critics and philosophers come to their culmination.[48] For our purposes, it is sufficient to note that the eighteenth-century criticism of traditional views pertaining to art – notions of the ideal, of harmony and decorum, and of the effect of art on the viewer, taken over from rhetoric – were all sublated (the Hegelian *aufgehoben*), as it were, in Kant's *Critique of Judgement*. In this work, which Kant conceived as the capstone of his philosophical project, he reversed the traditional sensationalist or empiricist approach to beauty and redefined judgement and beauty in terms of the free play of cognitive faculties, the mind's operation in its organization of the manifold in perception. Beauty was defined as disinterested interest, meaning interest in an object that is not related to its subject, to its purpose, but to cognitive pleasure, to the mind's imposition of order on the world. Furthermore, the problem of genius versus rule was resolved by Kant in the conception that the genius gives rules to art.

The implication from Baumgarten that beauty can be independent of purposes or function is hence given further grounding in Kant's critique. To draw out a major inference from this argument, art can become pure aesthetic creation. The possibility thus exists that art can be made for its own sake. Moreover, since the cognition of beauty works independently of its objects, form can also be conceived as existing independently from content. The possibility lies open for an art whose aesthetic values are purely formal.

Kant therefore made it possible to conceive of two of the principles on which much subsequent art has been founded, that art has no purposes other than itself and that its values are purely formal ones. Although these ideals – of an art made for its own sake and an art whose values were internally derived, as in the pictorial qualities of painting – might seem already to be present in the work of a painter like Maulbertsch, he, like all other artists of his time, was after all representing definite subject matter; in most instances he had moreover been commissioned to execute his compositions. In these matters Maulbertsch did not effectively operate differently from Mengs or other contemporary artists of a different stylistic direction.

Writing at the end of the eighteenth century, Kant's critical revolution therefore points beyond the actual accomplishments of artists in his own time, much as do other aspects of his thought. The problems and possibilities that Kant raised were already being addressed c. 1800, but they lead into the art, literature, criticism and philosophy of another time, not only of the generation identified as that of 'Romanticism', but into the critical debates of the twentieth century. The implications of Kant's arguments are thus even more far-ranging than those presented by the creation of new styles and new genres in the late eighteenth century.

In the sequence of developments initiated by the critical response that led to the creation of a history of art, an independent art criticism, aesthetics and the conceptualization of the possibility of art for art's sake, an artistic and aesthetic tradition seems effectively to have come to a close. When considered alongside the political and social revolutions of the later eighteenth and early nineteenth centuries, these developments seem to spell the end of an era.

CONCLUSION:

THE END OF THE OLD ORDER

N<small>OT JUST AN AESTHETIC OR CRITICAL REVOLUTION SPELLED THE END OF AN ERA FOR THE VISUAL ARTS.</small> The political and social transformations that occurred at the end of the eighteenth and the beginning of the nineteenth century also had a fundamental impact on the culture of Central Europe. Although not as violent as the events of the Revolution beginning in 1789 in France with which they are interconnected, these events were equally momentous for their own region. An end to the circumstances in which art and architecture had been made in Central Europe was only one outcome.

Most significantly, the two major political entities which have defined the limits of this book disappeared at this time. As a result of the partitions of 1792 and 1795, the Polish Commonwealth ceased to exist. Its territories were divided between Russia, Austria and Prussia. Not until after the conclusion of the First World War did a Polish Republic re-emerge, with different boundaries and a political system different to that of the ancient *respublica*.

In 1806 Emperor Francis II also put an end to the history of the Holy Roman Empire, when he abdicated its throne.[1] This action was the culmination of a series of events, accelerated by the French Revolution, by which the empire was dissolved. In the 1790s victorious French armies occupied the west bank of the Rhine. The Habsburgs and their German allies were repeatedly defeated and were forced to recognize the territorial reorganization of

Germany, including the establishment of a Confederation of the Rhine dominated by France in 1806. In response to Napoleon's coronation as emperor, in 1804 Francis made himself emperor of Austria, emperor in his own territories. This laid the foundation for a purely dynastic Austrian (later Austro-Hungarian) empire that lasted until the end of the First World War. The reconstitution of Germany which was to occur in the nineteenth and twentieth centuries would thus have to take into account different constituent entities, in which the relationship of the Habsburg lands to Germany was not so clear as before.

Before the demise of the Holy Roman Empire, its internal constitution had also been changed. Compensation for the loss of the west bank of the Rhine to the armies of France gave the larger secular states an excuse for the secularisation of the ecclesiastical territories. Secularization occurred in 1803: the prince-bishoprics, prince-abbeys, imperial abbeys and nunneries, and the whole multitude of independent ecclesiastical foundations, whether they remained in the hands of Catholics or Protestants, vanished. At the same time most of the territories of the knights were dissolved, finally in 1806. By that year, with only a very few exceptions such as Hamburg and Bremen, the imperial free cities also ceased to exist.

With the disappearance of these political entities, many of the social conditions that have been traced in this book ended, and not only many possibilities for patronage and reception. The bases for whole categories of church and civic art disappeared. With the drastic reduction in the number of polities within Germany from many hundred (or counting the knights, several thousand) to roughly a score, the social and cultural orientations of unifying forces would by necessity be different.

Kleinstaaterei, the division of Central Europe into myriad small states, had allowed and even created conditions for a tremendous variety of cultural forms, a diversity so great that it has needed to be considerably simplified in the present account. This diversity was also manifest in the polyglot domains of the Habsburgs. And we have also repeatedly noted vast regional differences within the Polish Commonwealth. While some small princedoms such as Goethe's Saxe-Weimar still managed to support tremendous literary achievements after 1806, many of the grounds for distinction, and accomplishment, were gone. The new empires and kingdoms had other centripetal tendencies, not to mention those involved in the movement for another sort of purely German empire.

The demise of the Holy Roman Empire and the Polish Commonwealth, and the reconstitution of the Habsburg realms into an Austrian empire, thus also had consequences for the reception of foreign art and artists. All these realms had been at least multi-ethnic; cosmopolitanism, not narrow nationalism and certainly not one determined by ethnicity, had been their *raison d'être*. In practice the division of Central Europe into princely houses opened the field for foreign influences, for marriages could create liaisons throughout

the continent. As a concept, the Empire for many thinkers stood until its end for a universal ideal independent of particular interests. It had long been a matter of course to draw art and artists from varied regions, not just within Central Europe, but from all over.

The openness and diversity of the region also had a more general effect on the reaction to other cultures. Divided and diverse themselves, the peoples of the region were open to adopting forms that had been made elsewhere, and to translating or transforming them to their own purposes. As the dicta of Quantz, epitomizing those of numerous other writers on many aspects of social and cultural existence suggest, even the Germans' own national self-identity, their definition of national character, could be related to this capacity to adopt and recombine others' inventions.[2]

As thinkers who wrote about the identity of the Empire suggested – and *mutatis mutandis,* the same arguments could apply to Poland – the very conditions that made the Empire weak, and ultimately disappear, were its strength. For the empire stood 'not for the acquisition and centralization of power, but for its limitation and dispersal'. Indeed the values that it promoted were not 'political, but cultural', the 'fulfilment of moral and spiritual potential'. The balance of states in the region, and to this Poland must be added, 'permitted the growth of diverse social, economic and cultural conditions within the various territories of the Empire, thus presenting the German a broad range for choice with respect to the kinds of environment in which his own growth as an individual might best be nurtured.' The freedom in diversity was not simply a political one, but a cultural or even spiritual one.[3]

Thinkers would later take up these notions, and Germany and Poland would be constructed anew, culturally as well as politically. Other states in the region, now including Austria, Hungary, the Czech and Slovak Republics, Slovenia, Croatia, Lithuania, Belorussia and Ukraine, would also come into existence on different national bases, when nationalism, not cosmopolitanism, would have its say. Just as *raison d'état* and *Realpolitik* would become the bases for dynastic, and later national, politics, so ethnic and nationalistic, even racist, conceptions would be heard in the realm of culture.

But these run contrary to the 'comparatively open fabric of learned contacts and scope for pluralism' which were sustained by the 'plethora of political entities' of the old regime. Even when they were expressed, definitions in terms of nationhood did not constitute themselves in terms of exclusion. In the Empire, 'paradoxically ... common purpose with fellow "Germans" across the immediate frontier meant openness to foreign influences too; while the roots of the characteristic German notion of *Kultur,* sustained by an educated middle class or *gebildeter Stand* ... were associated precisely with that fragmentation and anarchy from which the nineteenth century thought it had to be delivered.'[4]

In the new Europe that is being composed at the end of the twentieth century, universal messages of cosmopolitanism and enlightenment that were

voiced during the old regime may also give expression to the faded hopes of that moment. They, and the splendidly varied art and architecture they paralleled, should still speak across the ages, an admonition against the shrill claims of unenlightened self-confinement and the ethnic, regional, nationalist and racist assertions, and hatred, that are again in the air. To many people in the region, that other, older, cosmopolitan message not only determined the nature of the culture of Central Europe as it was in the past, but, as a definition of tradition and value, it can still help now to determine a new Central Europe.

A Note on Notes and Bibliography

I HAVE TRIED TO LIMIT THE NUMBER AND LENGTH OF THE NOTES FOR THE INDIVIDUAL CHAPTERS IN THE INTEREST OF KEEPING THE TEXT OF THIS BOOK RELATIVELY UNENCUMBERED AND INVITING. The notes that are given indicate the sources especially for quotations, and in general for particular interpretations on which I have relied. They are also intended to suggest the first sources which I have utilized, and to which the reader might turn in search of support for the arguments advanced in this book, as well as for further information.

In many instances I have cited more general and more recent works. I have done this with the intention in mind that the notes themselves might thereby serve the interested reader as a font of suggestions for further reading. Given the abundance of literature on Central Europe, I thought that this approach would in fact serve most readers better than an attempt to compile a comprehensive bibliography, which in any event would have far exceeded the limits of a manageable volume.

Indeed, I can attest from experience that beyond questions of language the compilation of a useful bibliography on the art and architecture of Central Europe runs up against extraordinary circumstances. While surveys of the whole area and general interpretations are exiguous, an extensive specialized literature, much of it of a local nature, exists. For example, although the topic of seventeenth-century architecture in Poland must seem not only specialized but also obscure to almost all native English (and for that matter German)

readers, it has received considerable attention. The bibliography presented in the series of the history of Polish art (*Dzieje sztuki polskiej*) by Adam Miłobędzki, *Architektura polska XVII wieku*, Warsaw, 1980, listed 2,096 titles.

In the face of this mass of publication I have thought that the selective approach that has governed the writing of this book should also determine suggestions for further reading. My own *Art and Architecture in Central Europe 1550–1620: An Annotated Bibliography*, Boston, 1988, offers convenient access and comments on literature in this time period. Other volumes in this series, published by G. K. Hall, by Patrick de Winter, *European Decorative Arts 1400-1600: An Annotated Bibliography*, Boston, 1988, and by Peter and Linda Parshall, *Art and the Reformation*, Boston, 1985, cover those topics.

It appears easier to obtain access to the huge literature on the periods before the seventeenth century. For the historic Hungarian, Bohemian and Polish lands (and also to a degree for Russia) the twenty-five pages of sources listed in Jan Białostocki, *The Art of the Renaissance in Eastern Europe*, Ithaca, N. Y., and Oxford, 1976, provide a still useful orientation. This may be complemented by the individual titles on Polish and Hungarian subjects listed in the notes to the chapters, and for Bohemia by the bibliography in Jaromír Homolka *et al.*, *Pozdně Gotické umění v Čechách*, Prague, 1978, and that in *Dějiny Českého výtvarného umění, Od Počátku renesance do závěru baroka*, 2, pt. 2.

Some idea of the vast bibliography on the 'Old German Masters' is given by Matthias Mende, *Dürer Bibliographie: Zur 500. Wiederkehr des Geburtstages von Albrecht Dürer*, Wiesbaden, 1971, which lists over 10,000 titles that had appeared by that date on that one artist alone. For the period before my own bibliographic volume, a convenient, if not extensive, selection of titles (better for art history than history) in German is to be found in two volumes of the relatively recent survey edited by Ernst Ullmann, *Geschichte der deutschen Kunst 1470–1550: Architektur/Plastik*, Leipzig, 1984, and *Deutsche Malerei, Graphik, Kunsthandwerk*, Leipzig (and Gütersloh), 1985.

No such comprehensive overview of the comparable literature on the seventeenth and eighteenth centuries exists. The extensive bibliographies of sources cited in my own *Drawings from the Holy Roman Empire 1540–1680*, Princeton, 1982, and *Central European Drawings 1680–1800*, Princeton, 1989, contain many references to works that concern many subjects in addition to the ostensible topics of the exhibitions to which these publications were related. Again, Polish and Bohemian (including Moravian) materials are relatively better serviced by the bibliographies in Miłobędzki, *op. cit.*, and especially in *Dějiny Českého výtvarného umění*, than are German, Austrian and Hungarian topics, for which one must consult more limited compendia, including in many instances exhibition catalogues. Literature related to German-speaking artists from the final period covered by this book can however be obtained from the bibliographies in two recent surveys, Peter H. Feist, ed., *Geschichte der deutschen Kunst 1760–1848*, Leipzig, 1986, and

especially Helmut Börsch-Supan, *Die Deutsche Malerei von Anton Graff bis Hans von Marées 1760–1870*, Munich, 1988.

In his important survey, *The Making of the Habsburg Monarchy 1550–1700*, Oxford, 1979, p. 443, n. 59, R. J. W. Evans remarked similarly that 'some good general works exist on Baroque art in the region, and there is a vast specialized literature ... But very little relates it securely to its historical base.' The situation has not changed from when Evans wrote these lines, and I hope that the present book goes beyond those few older sources that Evans cited in this regard, and points to future cultural and social history of art in the region.

It is also not the intention of this book to provide an introduction to the vast historical literature on Central Europe. Extensive bibliographies can be obtained from relatively recent works in English such as Evans, *ibid.*, Gagliardo, *Germany and the Old Regime*, and from a book whose translation appeared during the course of publication of the present work, Jean Bérenger, *A History of the Habsburg Empire 1273–1700*, London and New York, 1994, second volume forthcoming. Bérenger's scope is larger than its title, and he does make an effort, pp. 366–76, to discuss 'baroque art' in context.

Citations in the notes as in the text follow the orthography (and forms for capitalization) as they have been found, even where, as in older titles, they do not correspond to modern usage, or, as in newer titles, they do not correspond to standard norms.

Notes to the Introduction

1. See J. H. Hexter, 'The Historian and His Day', in *Reappraisals in History: New Views on History and Society in Early Modern Europe*, New York, 1963, pp. 1–13.

2. See, for example, Robert Darnton, *Berlin Journal: 1989–1990*, New York, 1991.

3. See the somewhat proleptic observations in my 'Editor's Statement' to 'Images of Rule: Problems of Interpretation', *Art Journal*, 48, no. 2, Summer, 1989, pp. 119–22 on the relation of historical interpretation to contemporary events. See also, however, for Marxist thinking, *After the End of History*, with an introduction by Alan Ryan, London, 1992.

4. For an excellent introduction to the question of nationalism and its inflections, with further references, see E. J. Hobsbawm, *Nations and Nationalism Since 1780: Programme, Myth, Reality*, Cambridge, 1990. I have treated the issue with reference to the historiography of Central European art in my 'Drawings from the Holy Roman Empire 1540–1680: An Essay Toward Historical Understanding', in *Drawings from the Holy Roman Empire 1540–1680: A Selection from North American Collections*, Princeton, 1982, especially pp. 4–8; 'Introduction', *Art and Architecture in Central Europe, 1550–1620: An Annotated Bibliography*, Boston, 1988, pp. xix–xxxvii; and 'Central European Drawings: An Introduction', in *Central European Drawings 1680–1800: A Selection from American Collections*, Princeton, 1989, pp. 6–7. See also Benedict Anderson, *Imagined Communities*, London, 1991.

5. For example in Belorussia, for which an early example is A.V. Aladava *et al.*, *Zhivopis Belarusi XII–XVIII Stagoddzayu* [Belorussian Painting of the Twelfth to Eighteenth Centuries], Minsk, 1980; in Ukraine, V. A. Ovsiechuk, *Ukrainskoe Mistetstvo XIV–Pershoi Polovini XVII Stolittya* [Ukrainian Art of the Fourteenth to the First Half of the Seventeenth Century], Kiev, 1985, and *idem*, *Ukrainskoe Mistetstvo Drugoi Polovini XVI-Pershoi Polovini XVII Stoletti* [Ukrainian Art of the Second Half of the Sixteenth to the First Half of the Seventeenth Century], Kiev, 1985. (Where not otherwise noted, all translations in this book are my own.) The general phenomenon is discussed in Eric Hobsbawm and Terence Ranger, *The Invention of Tradition*, Cambridge, 1983.

6. See Jerzy Lileyko, *Le château de Varsovie*, Warsaw, 1981, p. 84; Stanisław Lorenz, *Walka o Zamek 1939–80*, Warsaw, 1981, p. 17. For the general subject of the treatment of Eastern Europe in German scholarship, see Michael Burleigh, *Germany Turns Eastwards: A Study of Ostforschung in the Third Reich*, Cambridge, etc., 1988. It is interesting to read current debates about the reconstruction of the Berlin *Schloss* in this context.

7. Barbara Rose, 'The Sudden End of Art as Ideology', *The Journal of Art* 4, no. 8, October 1991, pp. 1ff., reports on this wave of iconoclasm, but rather naively identifies the notion of art as ideology only as a recent conception. For a more complete discussion, see the issue devoted to 'Der Fall der Denkmale', *Kritische Berichte*, 20, no. 3, 1992.

8. The term 'map of forgetting' was I believe first coined by Czeslaw Milosz; for the origins of these conditions in the east, see his classic *The Captive Mind*, New York, 1981 (first edn. 1951). As discussed in the next section, it is significant, however, that German-speaking culture is not often what Milosz has in mind.

9. See the discussion in Timothy Garton Ash, in *The Uses of Adversity: Essays on the Fate of Central Europe*, New York, 1990, pp. 179–213 ('Does Central Europe Exist?'); Ash's book is important for this issue in general.

10. Besides Ash, *The Uses of Adversity*, the question of the history of the definition of Central Europe in the light of recent change is discussed in Ferenc Fehér, 'On Making Central Europe', *Eastern European Politics and Societies*, 3, no. 3, 1989, pp. 412–47. The problem of the definition of Central and Eastern Europe is also discussed in the essays in 'Eastern Europe...Central Europe…Europe', *Daedalus*, vol. 119, no. 1, Winter, 1990; and George Schöpflin and Nancy Wood, *In Search of Central Europe*, Oxford, 1989. Hans-Jürgen Bömelburg 'Osteuropa – Mitteleuropa – Ostmitteleuropa', *Das Historisch-Politisch Buch*, 41, 1993, pp. 234–7, provides a review of recent publications in German on the subject. On 1 September 1994 the U.S. Department of State issued instructions to drop the use of Eastern Europe – a historical anachronism – and to use Central Europe instead, the term employed before the Second World War.

11. Friedrich Naumann, *Central Europe*, trans. Christabel M. Meredith, with an introduction by W. J. Ashley, London, 1917.

12. See Burleigh, *Germany Turns Eastwards* (n. 6). In art history this tendency was epitomized by the series *Ausstrahlungen der Deutschen Kunst*, led by Wilhelm Pinder and Richard Sedlmaier, which produced a sub-series *Deutsche Kunst im Böhmisch-Mährischen Raum*, ed. Karl M. Swoboda, e.g. H. Gerhard Franz, *Die Deutsche Barockbaukunst Mährens*, Munich, 1943, or Dagobert Frey's description of Kraków, the former royal capital of Poland, as a great German city, in *Krakau*, Berlin, 1941.

13. An example of this approach in post-war historiography is Oscar Halecki's treatment of definitions, *The Limits and Divisions of European History*, London and New York, 1950. More recently, Jacques Rupnik, 'Central Europe or Mitteleuropa', in 'Eastern Europe…Central Europe… Europe' (n. 10), pp. 249–79, offers a good discussion of the question of the relationship of the German question to Central Europe. The historical dimensions of the question of nationalism were also already discussed as a problem in post-Second World War Europe: see for example Reinhard Wittram, *Nationalismus und Säkularisation* (*Beiträge zur Geschichte und Problematik des Nationalgeistes*), Lüneburg, 1949. These themes are discussed in relation to art history most recently by Adam S. Labuda, '"eine sinnvollen zweckgefühlen gefühlte Kolonialkunst…" Zum kunsthistorischen Diskurs über Ostmitteleuropa', *Zeitschrift für Kunstgeschichte*, 56, 1993, pp. 1–17.

14. I owe this observation to an insight of Hellmut Lorenz. There are many examples of this tendency, which led for example to the neglect of Saxony in many histories of art written before 1990. Even work in English, for example the definition of Michael Baxandall, *The Limewood Sculptors of Renaissance Germany*, New Haven and London, 1980, is not untouched by this restriction to the areas of the Bundesrepublik as it existed before 1990. See also, and in general, for the continuing problem of the German historiography of German art, Hans Belting, *Die Deutschen und ihre Kunst: Ein Schwieriges Erbe*, Munich, 1992, p. 8; Belting's book also represents a response to the altered circumstances brought about by events since 1989, and the ensuing demands for a reckoning with German art history as an aspect of the cultural history of the nation.

15. Jan Białostocki, *The Art of the Renaissance in Eastern Europe*, Ithaca, N.Y., and Oxford, 1976. Białostocki also considers the question of geographical definition at length in his 'Rinascimento polacco e Rinascimento europeo', in *Polonia-Italia: Relazioni artistiche dal Medioevo al XVIII Secolo. Atti del Convegno tenutosi a Roma 21–2 Maggio, 1975*, Wrocław, Warsaw, Kraków, Gdańsk, 1979, pp. 21–58, where on pp. 31–2 he specifically postulates the notion of East-Central Europe, which in fact corresponds to that he advances for Eastern Europe in his book on the Renaissance there; he thus also excludes consideration of Germany from having contributed to 'artistic culture' of the Renaissance period. This argument seems symptomatic for the issues discussed here. Recent literature on the revival of nationalism in the region is discussed in Tony Judt, 'The New Old Nationalism', *New York Review of Books*, 41, no. 10, May 26, 1994, pp. 44–51.

16. It should be noted that this definition is geographically more restricted than that proposed by Lajos Vayer, as translated into the Holy Roman Empire and criticized by Białostocki in 'Rinascimento polacco' (n.15).

17. See in particular Janusz Tazbir, 'La conscience nationale', in *La République nobiliaire et le monde: Études sur l'histoire de la culture polonaise à l'époque du baroque*, Wrocław, etc., 1986, pp. 28–56.

18. For this point see Hobsbawm, *Nations and Nationalism* (n. 4). The development of notions of 'nations' in the period of the old regime is treated in Orest Ranum, ed., *National Consciousness, History and Political Culture in Early-Modern Europe*, Baltimore and London, 1975, containing an essay on Germany by Leonard Krieger, pp. 67–97.

19. The best introduction in English to these issues concerning the Holy Roman Empire is John G. Gagliardo, *Reich and Nation: The Holy Roman Empire as Idea and Reality, 1763–1806*, Bloomington and London, 1980.

20. For the problem of national aspects of the Renaissance, see recently Peter Burke, 'The Uses of Italy', in Roy Porter and Mikuláš Teich, eds., *The Renaissance in National Context*, Cambridge, 1992, especially pp. 13 ff. See also Peter Burke, 'The Spread of Italian Humanism', in Anthony Goodman and Angus MacKay, eds., *The Impact of Humanism on Western Europe*, London and New York, 1990, pp. 1–22.

Subsequent to the completion of this text an exhibition of 'baroque' art was organized in Budapest, with a catalogue whose essays also brought out the international character of the artists active in Central Europe: *Barokk Művészet Közép – Európában. Utak és Jalákozások* (*Baroque Art in Central-Europe [sic] Crossroads*), exhibition catalogue, Budapest, 1993.

21. For one well-charted area of exchange, see Otto Kurz, *European Clocks and Watches in the Near East*, London and Leiden, 1975.

22. In James Clifford's lucid discussion in *The Predicament of Culture: Twentieth-Century Ethnography, Literature, and Art*, Cambridge, Mass., and London, 1988, they may be regarded as circulating a system of values and concepts ranging from the notion of the original and singular (implied by art), to the traditional and collective (in culture). Clifford has also supplied a useful capsule summary for the complicated history of the concept of culture, saying that the term has long designated 'a rather vague "complex whole" including everything that is learned group behavior'.

23. The first definition is that of Raymond Williams, *Culture and Society, 1780–1950*, New York, 1966; the second phrase is taken from E. H. Gombrich, *In Search of Cultural History*, Oxford, 1969, reprinted in *Ideals and Idols: Essays on Values in History and in Art*, Oxford, 1979, pp. 24–69.

24. See E. H. Gombrich, *In Search of Cultural History*, and 'The Logic of Vanity Fair: Alternatives to Historicism in the Study of Fashions, Style and Taste', in *Ideals and Idols* (n. 23), pp. 60–92.

25. To paraphrase John Onians, *Bearers of Meaning: The Classical Orders in Antiquity, the Middle Ages, and the Renaissance*, Princeton, 1988, p. 3. As Onians suggests, successful

architects and craftsmen, like successful employees and servants in general, succeed precisely by being able to internalize the requirements and expectations of their superiors.

26. For an introduction to what is meant by this term, see Lynn Hunt, ed., *The New Cultural History*, Berkeley, Los Angeles, London, 1989. I am very much aware that the present book enters into the problem of how to measure the discussion of art as an aspect of cultural history at a time when the definition of cultural history is itself at stake. See further Dominick La Capra, *Rethinking Intellectual History: Texts, Contexts, Language*, Ithaca, N.Y., 1983.

27. For an introduction to this topic, see Peter Burke, *Popular Culture in Early Modern Europe*, London, 1978; Burke offers an overview of more recent considerations of the issue in an essay on 'Popular Culture Reconsidered', *Storia della Storiografia*, 17, 1990, pp. 40–9. As it is often defined, popular culture is also often related to the 'mental universe', or mentality, of a time, as in Robert Muchembled, *Culture populaire et culture des élites dans la France moderne*, Paris, 1978. This consideration is implied by such notions as 'popular religion', defined primarily by the evidence of a superstitious belief in magic, the cult of relics and pilgrimages. Yet as William Christian, *Local Religion in Sixteenth-Century Spain*, Princeton, 1981, demonstrates, it is difficult to distinguish between popular and high culture. Rulers and elites must share the general mentality of an age, as it is generally defined (and indeed a great patron such as Rudolf II Habsburg clearly shared many of the beliefs in magic that his subjects did). In Central Europe, as elsewhere, what is said to characterize 'popular religion', namely a devotion to relics and pilgrimages, also pertains to the supposedly elite groups of society as much as to the general population: Albrecht of Brandenburg's devotion to his famous collection of relics and the Wittelsbachs' and Habsburgs' interest in pilgrimages indicate this conjunction of interests.

A considerable literature has now grown up around this issue of interaction: for a guide to it see Natalie Z. Davis, 'From "Popular Religion" to Religious Cultures', in *Reformation Europe: A Guide to Research*, ed. Steven Ozment, St Louis, 1982, pp. 321–2. See further P. Cinzelbacher, 'Zur Erforschung der Geschichte der Volksreligion: Einführung und Bibliographie', in *Volksreligion im hohen und späten Mittelalter Werken und Quellen und Forschungen aus dem Gebiet der Geschichte*, NS 13, Paderborn, 1990, pp. 9–28; and *idem*, 'Volkskultur und Hochkultur im Spätmittelalter', in *Volkskultur des europäischen Spätmittelalters*, ed. *idem* and H. D. Mück, Stuttgart, 1987, pp. 1–14.

28. As did Luther and those who participated in the Peasants' Revolt. Prints and illustrated books, as well as applied works of art such as ceramics and other cultural mediators, including educational practices, served as vehicles by which cultural goods were assimilated by one group in a society or expropriated by another. Thus in speaking of buildings and paintings, this book will assume that one can also be speaking more generally of certain telling, even representative, aspects of culture as a whole.

29. With the attention given to various ethnic groups in Anglophone studies in the humanities, it would be interesting to chart this question. It would seem that the various

groups who earlier emigrated to the west, especially to the United States and Canada, often did not emphasize this aspect of the cultural tradition of their own lands, but rather what might at best be called their 'folk' culture. In response, this book seeks to avoid the suggestion that an undifferentiated discussion of art of an earlier era in Central Europe might evoke images of the folk dance or beer hall for many English speakers.

30. Out of all that was created, from the earlier era perhaps only Albrecht Dürer and some of his contemporaries and from the nineteenth century only the isolated figure Caspar David Friedrich may be broadly familiar, even among art historians.

31. The last major attempt to see the region as a whole was published three decades ago, by Eberhard Hempel, *Baroque Art and Architecture in Central Europe*, trans. Elisabeth Hempel and Marguerite Kay, Baltimore and Harmondsworth, 1965; Hempel was an octogenarian at the time, and his book covered but the seventeenth and eighteenth centuries.

To some extent the present perspective has informed a series of recent volumes edited by Wolfgang Braunfels, *Die Kunst im Heiligen Römischen* Reich, 6 vols., Munich, 1979–85. In these volumes, however, there remains a distinctive Germanic bias and prejudice in favour of national distinctions, as clearly indicated by the volume devoted to *Grenzstaaten im Osten und Norden: Deutsche und slawische Kultur*, 5, 1985. In this volume Bohemia, an integral part of the Holy Roman Empire (its only kingdom), is treated as a *Grenzreich*: but why should Bohemia be any more of a border state than Brandenburg? Furthermore, how can we speak about linguistic groups in this area forming 'cultures' – an idea which at best seems to derive from the linguistic theory of the nineteenth century but seems totally inappropriate for the polyglot and Latinate culture of the earlier period. Moreover, this work does not include the other territories, besides Bohemia and Austria, that were ruled by the Habsburgs and lie between East Prussia and the rest of Germany, not to mention Poland. Finally, of course, the work remains as a broken torso, without its historical structure: it promised to offer a historical sequence from 750 to 1870, but the last three volumes, the books for the period after 1250, covering the time of the present work, remain unwritten with the death of Braunfels. More typical is the general attitude that leads to the phrasing of such questions as that governing Daniel Chiat, ed., *The Origins of Backwardness in Eastern Europe*, Berkeley, Cal., 1989.

32. I see, however, a problem in employing the notion of artistic metropolises too broadly for the period 1450–1650: see my 'Das Problem der Kunstmetropolen in frühzeitlichen Ostmitteleuropa', in *Die Mitteleuropäische Metropolen im Zeitalter des Humanismus und der Renaissance (ca. 1450–1650)*, ed. Winfried Eberhard, E.M. Engel and Karin Lambrecht, Berlin, forthcoming. To give a few examples, before this time Prague in the era of Charles IV certainly fits this description and during it Prague in the era of Rudolf II. Later Vienna *c.* 1700 might also qualify.

33. For an overview in English, see Karel Stejskal, *European Art in the 14th Century*, trans. Till Gottheinerová, London, 1977, and *Gothic Art in Bohemia: Architecture, Sculpture and*

Painting, ed. Erich Bachmann, New York, 1977. The spread of Caroline art is demonstrated at length in *Die Parler und der Schöne Stil 1350–1400: Europäische Kunst unter der Luxemburger*, exhibition catalogue, Cologne, 5 vols., 1978–80. (See, e.g., Ch. 2, n. 19, below.)

34. The subject of the Hussites and art is the topic of continuing research by Robert Suckale (see Ch. 2, n. 19, below). In the meantime, Pavel Kropáček, *Malířství doby husitské: Česká desková malba prvě poloviny XV. století*, Prague, 1946, can still be consulted.

35. Stephan Skalweit, *Der Beginn der Neuzeit: Epochengrenze und Epochenbegriff*, Darmstadt, 1982, offers a thorough discussion of the problem of chronological division for the 'modern' or 'early modern' period with regard to the Renaissance, with many further references. The question of Hussitism and the arts is also raised in Chapter 2 below.

36. We need only think of such major figures as Giovanni Dalmata in the fifteenth century, Giambologna in the sixteenth, François Duquesnoy, Nicolas Poussin and Claude Lorrain in the seventeenth, or at the end of that century and the beginning of the next Pierre Legros along with a flock of other French academicians in the eighteenth. This issue is discussed in my 'Italian Sculpture and Sculptors outside of Italy: Problems and Possibilities of Reception', in Claire Farago, ed. and intro., *Reframing the Renaissance: Visual Culture in Europe and Latin America 1450–1650*, New Haven and London, 1995, Chapter 2.

37. See, in general, for an overview of the idea of metropolitan centres in relation to the rest of Europe William H. McNeill, *The Shape of European History*, New York, London, Toronto, 1974. See also the convenient overview in Peter Burke, *The Renaissance*, Atlantic Highlands, New Jersey, 1987, that takes this approach to the Renaissance. See also, and for further bibliography, my 'Das Problem der Kunstmetropolen' (n. 32).

38. This is in general the theme of the country by country review of Roy Porter and Mikuláš Teich, eds., *The Renaissance in National Context* (n. 20), as enunciated most clearly by Peter Burke, 'The Uses of Italy', pp. 6ff.

39. See Clark Hulse, *The Rule of Art: Literature and Painting in the Renaissance*, Chicago and London, 1990, p. 16, where these have been described as constituting an 'epistemological break', involving 'a change in aesthetic thinking, initially in Italy, then elsewhere', about 'a few grand ideas'. These were about (pp. 16–17) '*mimesis*, about composition, about mental labor, and about the social status of the artist that are formed in a few brilliant minds in quattrocento Florence and that then are slowly diffused, diluted, and reworked by other minds in other places and at later times'.

40. For the relation of these questions to the history of art and culture, see E. H. Gombrich, 'Technology and Tradition in the Arts', in E. Fox Keller *et al.*, *Three Cultures*, Rotterdam, 1989, pp. 169–72.

41. For the notion of 'cultural diffusion' as it has been applied to history, see Thomas F. Glick and Oriol Pi-Sunyer, 'Acculturation as an Explanatory Concept in Spanish History', *Comparative Studies in Society and History*, 11, 1969, pp. 136–54. This approach has been applied to art history by Jonathan Brown, *The Golden Age of Painting in Spain*, New Haven and London, 1991, see p. vii n. Note however that there are more nuanced notions of cultural exchange: see Marshall Sahlins, *Islands of History*, Chicago and London, 1987.

NOTES TO CHAPTER ONE

1. See Peter Nitsche, '*Translatio Imperii*: Beobachtungen zum Historischen Selbstverständnis in Moskauer Zartum um die Mitte des 16. Jahrhunderts', *Jahrbuch für die Geschichte Osteuropas* 35, 1987, pp. 321–8.

2. Białostocki, *The Art of the Renaissance in Eastern Europe* (Intro. n. 15), p. 11.

3. The most accessible recent treatment of Fioravanti and other Italians active in fifteenth- and early sixteenth-century Russia is provided by the series of articles in *Arte Lombarda*, 1976, particularly Werner Oechslin, 'La fama di Aristotele Fioravanti, Ingegnere e architetto', pp. 102–20 and Jolán Balogh, 'Aristotele Fioravanti in Ungheria', pp. 225–7.

4. In addition to Oechslin, *op. cit.*, see Brian Curran and Anthony Grafton, 'A Fifteenth-Century Site Report on the Vatican Obelisk', *Journal of the Warburg and Courtauld Institutes*, forthcoming.

5. Janusz Tazbir, *Polskie przedmurze Chrześciajanskiej Europy: Mity a Rzeczywistość Historyczna*, Warsaw, 1987, handles this subject.

6. In the subsequent absence of good general treatments in English, the reader can still consult George Heard Hamilton, *The Art and Architecture of Russia*, Harmondsworth, 1983 (3rd edn.), which, p. 191, mentions the technical question. Kathleen Berton, *Moscow: An Architectural History*, London and New York, 1990 (1st edn., 1979), provides an introduction for the general reader.

In Central and Eastern Europe the role of the expert or specialist in artistic matters was, however, not limited to Italians. For example, throughout the early modern period German-speaking artists and artisans were employed in various centres: in the 1470s Veit Stoss was called to Kraków to execute a wood altarpiece; somewhat later Hans Witten was brought to Chemnitz to work on carving in stone; in the early sixteenth century stonemasons were called from Silesia to work on the new constructions in the Saxon cities and towns (Annaberg and Dresden); subsequently, later in the mid-sixteenth century Saxon masons and stone-carvers were brought to Berlin; and one may finally think of the activity of Andreas Schlüter and others in St Petersburg.

7. This subject is treated among others in two books by Mariusz Karpowicz, *Artisti Ticinesi in Polonia nel '500*, Lugano, 1987, and *Artisti Ticinesi in Polonia nel '600*, Lugano, 1983.

The more general European phenomenon is the topic of the essays collected in Edoardo Arslan, ed., *Arte e Artisti dei Laghi Lombardi*, 2 vols., Como, 1959, 1964.

8. In an unpublished essay, Daniel Rowland argues that Russia in the fifteenth and sixteenth centuries was in this regard more comparable to the Carolingian Empire than to the Renaissance in Italy. Rowland suggests that the iconography of Ivan the Terrible thus still remained bound, even in the sixteenth century, to an eastern tradition that was tied up with Old Testament models of kingship and had little to do with contemporary ideas in the west.

9. The introductory essays to *The Gates of Mystery: The Art of Holy Russia*, exhibition catalogue, Fort Worth, 1993, now provide access to, and further literature on, the state of these questions on the relation of Russia to western and eastern traditions.

10. See Arthur Voyce, *Moscow and the Roots of Russian Culture*, Norman, Oklahoma, 1964, for a convenient introduction to these issues.

11. Richard Pipes, *Russia under the Old Regime*, Harmondsworth, 1982 (1st edn., London, 1974), pp. 232ff., outlines elements of the new ideology.

12. The story of Russian relations with the west is considerably more complicated, as events during the reign of Alexis himself suggest: standard histories of the subject (e.g. Lionel Kochan, *The Making of Modern Russia*, London, 1962) state that it was during this time that western influences actually began to penetrate Russia on a large scale, setting the stage for Peter the Great's transformation of the country. Reinhard Wittram, *Russia and Europe*, London and New York, 1973, provides an overview of the theme of Russian relations with the west.

13. A few examples of the phenomena here described are discernible in *Gates of Mystery* (n. 9), cat. nos. 17, 28, 29, 30, 34, 35, 36.

14. This last statement is based on the view of Hans Belting, *Bild und Kult: Eine Geschichte des Bildes vor dem Zeitalter der Kunst*, Munich, 1990, pp. 880ff., (English trans. Edmund Jephcott, *Likeness and Presence: A History of the Image before the Era of Art*, Chicago, 1994) which otherwise provides a history of the pictorial tradition related to the icon.

15. I rely here on the insights of Ernst Kitzinger, 'The Hellenistic Heritage in Byzantine Art', *Dumbarton Oaks Papers*, 17, 1963, pp. 95–115.
 The relation of this tradition to Russian art and the intentions of the latter, are discussed in the essays in *Gates of Mystery* (n. 9).

16. As quoted in Hamilton, *The Art and Architecture of Russia*, p. 161 (n. 6).
 For the notion of artistic progress in Italy see E. H. Gombrich, 'The Renaissance Conception of Artistic Progress and its Consequences', reprinted in his *Norm and Form:*

Studies in the Art of the Renaissance, London and New York, 1971 (2nd edn.), pp. 1–10; idem, *Kunst und Fortschritt: Wirkung und Wandlung einer Idee*, Cologne, 1978.

17. For the general differences in attitude towards the icon in the Eastern cult, see Belting, *Bild und Kult* (n. 14).

18. The latest account of this development is V.P. Vygolov, *Architektura Moskovskoi Rusi serediny XV veka*, Moscow, 1988, which takes the history of the Dormition (Uspensky) Cathedral just through the period of 1472–4, thereby regarding this moment as the end of a phase in the history of Muscovite architecture.

19. See Spiro K. Kostof, ed., *The Architect: Chapters in the History of the Profession*, Oxford, 1977, especially the chapter by Catherine Wilkinson.

20. This issue is discussed, and a contrast made with secular architecture, in Hamilton, *Art and Architecture in Russia* (n. 6), and Białostocki, *Art of the Renaissance in Eastern Europe* (Intro. n. 15), p. 4, with further references.

21. Anthony Grafton reminded me that there is a parallel to the retention of seemingly contradictory building types in the architecture of Brunelleschi and Alberti: see Christine Smith, *Architecture in the Culture of Early Humanism: Ethics, Aesthetics and Eloquence 1400–1470*, New York and Oxford, 1992.

22. This subject is now well treated in English by James Cracraft, *The Petrine Revolution in Architecture*, Chicago, 1988.

23. The work of Jolán Balogh is fundamental for art at the court of Matthias Corvinus and the sources for its study: her *Die Anfänge der Renaisance in Ungarn: Matthias Corvinus und die Kunst*, Graz, 1975, provides easiest access to the material, with reference, p. 196, to German sculptors working for court servants. Gyöngy Török, 'Beiträge zu Verbreitungen einer niederländischen Dreifaltigkeitsdarstellung im 15. Jahrhundert', *Jahrbuch der Kunsthistorischen Sammlungen in Wien*, 81, 1987, pp. 29–31, provides information on Netherlandish paintings at the court of Matthias Corvinus.

24. Most recent evidence for these connections is presented by Alice Mezey-Debreczeni and Edit Szentesi, 'Neue Forschungen zur Abteikirche von Ják', *Kunstchronik*, 44, no. 10, October, 1991, pp. 575–84.

25. This material was presented in an exhibition devoted to art at the court of King Louis, *Müvészet Lajos Király Korában, 1342–1382*, exhibition catalogue, Székesfehérvár, 1982.

For wall painting in Slovakia, see most completely Vlasta Dvořáková, Josef Krása, Karel Stejskal, *Středověká nástenná malba na Slovensku*, Prague and Bratislava, 1978, with reference to the *volto santo* in Štitník, p. 154.

26. The latest summary of this material, with further references, also relating it to the period of Matthias Corvinus, is available in the essays collected in *Budapest in Mittelalter*, exhibition catalogue, Braunschweig, 1991.

27. Beside Balogh's books, relatively recent useful summaries of the historical and art historical development are available in *Matthias Corvinus und die Renaissance in Ungarn*, exhibition catalogue, Schallaburg, 1982.

28. Curran and Grafton, 'A Fifteenth-Century Site Report on the Vatican Obelisk' (n. 4), remake the case for Fioravanti's involvement and his collaboration with Alberti in Rome.

29. '*magistrum Aristotelen Fieravantis architectum et ingignerum communis Bononiae*', see Jolán Balogh, 'Fioravanti in Ungheria' (n. 3), p. 20, and *A Müveszet Mátyás Király Udvarában*, 1, Budapest, 1966, p. 495, and also Rósza Feuer-Tóth, 'The "Apertionum Ornamenta" of Alberti and the Architecture of Brunelleschi', *Acta Historiae Artium*, 24, 1978, pp. 147–52.

30. For this topic, see Michael Baxandall, *Giotto and the Orators: Humanist Observers of Painting in Italy and the Discovery of Pictorial Composition*, Oxford, 1971.

31. These paragraphs rely on Rósza Feuer-Tóth, *Art and Humanism in Hungary in the Age of Matthias Corvinus*, Budapest, 1990, and 'Writings on Art at King Matthias's Court between 1474–76 and 1490', *Acta Historiae Artium*, 32, 1986, pp. 27–58; pertinent sources are also published in her 'Müvészet és humanizmus a korareneszánsz Magyarországon (Art and Humanism and the Early Renaissance in Hungary)', *Müvészettörténeti Értesítö*, 1987, pp. 1–53. See also Tibor Klaniczay, 'Hungary', in *The Renaissance in National Context* (Intro. n. 20), pp. 164–79.

32. The most complete recent treatment of the subject is the exhibition catalogue, *Bibliotheca Corviniana 1490–1990*, Budapest, 1990. See also Otto Mazal, *Königliche Bücherlieber*, Graz, 1990.

33. Balogh, *A Müveszet* (n. 29), assembles passages related to these artists.

34. See Gombrich, 'The Style *all'antica*: Imitation and Assimilation', reprinted in *Norm and Form* (n. 16), pp. 122–8, for this conception.

35. This is discussed in *Budapest in Mittelalter* (n. 26).

36. I owe this interpretation to an unpublished paper by Holly Getch.

37. There is an extensive literature on this theme; the most comprehensive treatment, with specific reference to Central Europe, is Jerzy Banach, *Hercules Polonus: Studium z Ikonografii sztuki nowożytnej*, Warsaw, 1984.

38. The ubiquity of the Renaissance in Hungary, especially its appearance outside the royal court, is emphasized by Gyöngyi Török, 'Matthias Corvinus und die Renaissance in Ungarn', *Sitzungsberichte der Kunstgeschichtlichen Gesellschaft zu Berlin*, n.s. 37, October 1988–July 1989, pp. 19–22. Evidence is accumulated by her and her colleagues in *Matthias Corvinus und die Renaissance in Ungarn* (n. 27), pp. 560–726.

39. See Joseph Macek, 'Bohemia and Moravia', in *The Renaissance in National Context* (Intro. n. 21), p. 203.

40. Ivo Hlobil, who has treated the Moravian monuments discussed here in previous publications (e.g., most accessibly 'Zur Renaissance in Tovačov während der Aera Ctibors Tovačovský von Cimburk', *Umění*, 22, 1974, pp. 509–19), has in a recent book (Ivo Hlobil and Eduard Petrů, *Humanismus a raná renesance na Moravě*, Prague, 1992) emphasized the separate development of art in Moravia from that in Bohemia in the fifteenth century, and the close connections of the former with the Hungarian crown. Following earlier scholarship (e.g. K. Chytil and J. Muk), Hlobil, in *Raná renesance*, p. 116, suggests that the distinction between Moravská Třebová and Tovačov may be related to the dependence of the former on the architecture of Benedikt Ried in Prague. Hlobil, who by Moravia means largely the region of Olomouc, summarized and placed further emphases in his arguments, while adducing further northern Italian models for Moravská Třebová, in 'Die Anfänge der Renaissance in den böhmischen Ländern – namentlich in Mähren', in Thomas Gaehtgens, ed., *Kunstlerischer Austausch/Artistic Exchange: Akten des XXVIII. Internationalen Kongress für Kunstgeschichte 1992*, vol. 2, Berlin, 1993, pp. 199–212. To my eye these associations with Prague and northern Italy seem tenuous; all that seems in common with Prague is the assimilation by indigenous masons of Italianate work. There seems no reason to look further than Tovačov for immediate sources for Moravská Třebová.

41. Białostocki, *The Art of the Renaissance in Eastern Europe* (Intro. n. 15), p. 85.

42. See Jan Białostocki, 'Mannerism and "Vernacular" in Polish Art', in Georg Kaufmann and Willibald Sauerländer, eds., *Walter Friedländer zum 90. Geburtstag: Eine Festgabe seiner europäischen Schüler, Freunde und Verehrer*, Berlin, 1965, pp. 47–57. See also Białostocki's 'Some Values of Artistic Periphery', in *World Art: Themes of Unity in Diversity. Acts of the XXVIth International Congress of the History of Art*, University Park and London, 1989, pp. 49–58.

NOTES TO CHAPTER TWO

1. As in Gert Van der Osten and Horst Vey, *Painting and Sculpture in Germany and the Netherlands*, Harmondsworth, 1969. For discussion of the courts of this era, bringing out common features and differences, see the essays collected in Ronald G. Asch and Adolf M. Birke, eds, *Princes, Patronage and the Nobility: The Court at the Beginning of the Modern Age c. 1450–1650*, Oxford, 1991, especially those by Peter Moraw, Volker Press, Antoni Mączak and R. J. W. Evans, respectively pp. 103–37, 289–312, 315–27 and 481–91. A

recent exhibition catalogue, *Maria van Hongarije. Koningin tussen Keizers en Kunstenaars 1505–1558*, Zwolle, 1993, was more sensitive to the Habsburg–Jagellonian connection and to the international situation in general.

2. Useful summaries of various aspects of the culture of this period are presented in essays, along with the objects exhibited, in *Polen im Zeitalter der Jagiellonen 1386–1572*, exhibition catalogue, Schallaburg, 1986.

3. The phrase 'mini-architecture' is that of Adam Miłobędzki, 'Architecture under the Last Jagiellons in its Political and Social Context', in Samuel Fiszman, ed., *The Polish Renaissance in its European Context*, Bloomington and Indianapolis, 1988, pp. 291–301. Miłobędzki's essay is one of several in this volume that present useful introductions to the Renaissance in Poland. In addition to Białostocki, *The Art of the Renaissance in Eastern Europe* (Intro. n. 15), other recent works available in English that can be consulted for more information on the topics discussed in the following pages include Helena and Stefan Kozakiewicz, *The Renaissance in Poland*, Warsaw, 1986; Antoni Mączak, 'Poland', in *The Renaissance in National Context* (Intro. n. 20), pp. 180–96; and Harold B. Segel, *Renaissance Culture in Poland: The Rise of Humanism, 1470–1543*, Ithaca, N.Y. and London, 1989.

4. Mosca is the subject of a forthcoming book by Anne Markham Schulz.

5. Segel, *Renaissance Culture in Poland* (n. 3), provides the best introduction in English to this topic.

6. See most recently for a discussion of this monument in relation to the general issue of Renaissance sculpture, 'Renaissance Sculpture in Poland and its European Context: Some Selected Problems', in *The Polish Renaissance in its European Context* (n. 3) , pp. 281–90. The most thorough recent discussion of Renaissance sculpture in Polish, a work on which I have relied, is the monograph by Helena Kozakiewiczowa, *Rzeźba XVI wieku w Polsce*, Warsaw, 1984.

7. Quite extensive literature exists on the Wawel palace, for which see Białostocki, *The Art of the Renaissance in Eastern Europe* (Intro. n. 15). Peter Farbáky, 'Der Königspalast von Buda im Zeitalter der Renaissance', in *Budapest im Mittelalter* (Ch. 1, n. 26), pp. 259–71, especially pp. 261, 271 n. 23, offers the latest comments on the sources of the Wawel, contradicting Białostocki's observations.

8. See Białostocki, 'Rinascimento polacco e Rinascimento europeo' (Intro. n. 15), for the hypothesis of the impact of Buda on Sigismund.

9. Białostocki, *The Art of the Renaissance in Eastern Europe* (Intro. n. 15), pp. 11ff., and especially Miłobędzki, 'Architecture under the Last Jagiellons' (n. 3), pp. 291ff., argue, however, that special features of the late Gothic in Eastern Europe helped prepare the ground for the reception of the Renaissance.

10. Again, there is a large literature on the topic, which is discussed at length in Białostocki, *The Art of the Renaissance in Eastern Europe* (Intro. n. 15), pp. 35ff. Stanisław Mossakowski, 'Bartolomeo Berrecci à Cracovie: la chapelle Sigismond', *Revue de l'art* 101, 1993, pp. 67–85, offers the most up-to-date analysis of the monument, with a summary and references to his (and others') previous work on the topic.

11. It is fair to say that quantitatively more sixteenth-century monuments with effigies are to be found in historic Poland than anywhere else in Europe with the possible exception of Italy: see Kozakiewiczowa, *Rzeźba XVI wieku* (n. 6), for the most complete account of sculpture. Similarly the centrally planned tomb chapel with cupola proliferated in Poland, where there are more examples than elsewhere: see Jerzy Z. Łoziński, *Grabowe kaplice kopulowe w Polsce 1520–1620*, Warsaw, 1973.

12. Although in the absence of a thorough statistical survey such remarks can only only be taken as approximate, it has been estimated that in Poland, much less than 1 per cent of the buildings of the sixteenth century were designed in a Renaissance manner: see Adam Miłobędzki, 'Architektoniczna Tradicja Średniowiecza w krajobrazie kulturowym Polski XVI–XVIII w. Sześć Propozycji Problemowych', in *Symbolae Historie Artium: Studia z historii sztuki Lechowi Kalinowskiemu dedykowane*, Warsaw, 1986, pp. 369-79, especially p. 370; Miłobędzki expatiates on some of the implications of this information in 'Architecture under the Last Jagiellons' (n. 3).

13. Białostocki, *Art of the Renaissance in Eastern Europe* (Intro. n. 15), p. 23.

14. In any event there is no way of determining exactly that the Italianate architecture built around the slab actually post-dates the sculpture, so this last point is moot. The latest evaluation of the question is in Kozakiewiczowa, *Rzeźba XVI wieku w Polsce* (n. 6), pp. 13–18.

15. This last comment is related to a suggestion by Slobodan Ćurčić in a review in *American Historical Review*, June 1990, p. 869, of J. Cracraft, *The Petrine Revolution in Russian Architecture*.

16. For more on this point, see my review of Białostocki, *The Art of the Renaissance in Eastern Europe*, in *The Art Bulletin*, 58, 1978, pp. 164–9. The situation of these courts makes considerably problematic any interpretation that wishes to deal with the formation of Polish national consciousness, e.g. Jerzy Wyrozumski, 'Die Ausbildung des Polnischen Nationalbewusstseins', in *Polen im Zeitalter der Jagiellonen* (n. 2).

17. Białostocki represents the Polish point of view in *The Art of the Renaissance* (Intro. n. 15). For a summary of the Czech view, see Jaromír Homolka *et al.*, *Pozdně gotické umění v Čechách 1471–1526* (with English summary), Prague, 1978, which contains the most complete account of the art of the period as well as a good introduction to its history and many further references. The avoidance of mention of the Jagellonians in the title of a work

whose time period is devoted to that of their reign gives some sense of the framing conception. Josef Macek, 'Bohemia and Moravia' in *The Renaissance in National Context* (Intro. n. 20) also distinguishes between a court and an estate party and their effect on culture. For the historical situation see further *idem, Jagellonský věk v českých zemích*, Prague, 2 vols, 1992 and 1994.

18. Jagellonian building activity is most thoroughly charted in Homolka, *Pozdně gotické umění* (n. 17); this work may be supplemented by the standard monograph by Götz Fehr, *Benedikt Ried*, Munich, 1961, and by the pages by Erich Hubala in *Renaissance in Böhmen*, ed. Ferdinand Seibt, Munich, 1985, pp. 31–52. A parallel to the approach to 'ornament' taken here is found in R. K. Vos and Fred Leeman, *Het nieuwe ornament: Gids voor de renaissance architectuur-decoratie in de 16de eeuw in Nederland*, The Hague, 1986.

19. Hussite views about art are assembled in an older study of Czech panel painting of the first half of the fifteenth century, Kropáček, *Malířství Doby Husítské* (Intro, n. 34). Robert Suckale, in 'Die Bedeutung des Hussitismus für die Bildende Kunst, vor allem in den Nachbarländern Böhmens', in Gaehtgens, *Kunstlerischer Austausch* (Ch. 1, n. 40), pp. 65–70, has offered an important revision of the question of the Hussites and art. Although Suckale qualifies the iconoclasts as belonging only to the radical wing of the Hussite movement, his characterization of their art also distinguishes it from that of the 'beautiful style' associated with the court.

For the 'beautiful style', see *Prag um 1400: Der Schöne Stil: Böhmische Malerei und Plastik in der Gotik*, exhibition catalogue, Vienna, 1990.

20. For these places, see Klaus Kratzsch, *Bergstädte des Erzgebirges: Städtebau und Kunst zu Zeit der Reformation*, Munich and Zurich, 1972.

21. For the Albrechtsburg in Meissen, see Ernst Ullmann, 'Spätgotische Hallenkirchen in Obersachsen', in his *Von der Romanik bis zum Historismus. Architektur – Stil und Bedeutung*, Leipzig, 1987, pp. 92–4 and *idem*, ed., *Geschichte der deutschen Kunst 1470–1550: Architektur und Plastik*, Leipzig, 1984, pp. 78–9.

22. The works discussed in the preceding paragraphs can again be studied in Homolka, *Pozdně gotické umění* (n. 17).

23. See Homolka, *Pozdně Gotické Umění* (n. 17).

24. Recommended for these is Kratzsch, *Bergstädte des Erzgebirges* (n. 20).

25. The most extensive treatment of this subject is provided by Jan-Dirk Müller, *Gedecthnus: Literatur und Hofgesellschaft um Maximilian I*, Munich, 1982.

26. '*Bella gerant alii, tu felix Austria nube*', the tag runs. The history of Maximilian I's era is served by H. Wiesflecker, *Kaiser Maximilan I: Das Reich, Österreich und Europa an der*

Wende zur Neuzeit, 5 vols., Vienna, 1971–86. See also *Maximilian I*, exhibition catalogue, Innsbruck, 1969.

27. For Frederick III see *Friedrich III*, exhibition catalogue, Wiener Neustadt, 1966. For the patronage as well as the collecting of Frederick and all succeeding Habsburg emperors, Alfons Lhotsky, 'Die Geschichte der Sammlungen', in *Festschrift des Kunsthistorischen Museums*, 2 vols., Vienna-Horn, 1941–5, can still be consulted with profit.

28. As, for instance, does Białostocki, *Art of the Renaissance in Eastern Europe* (Intro. n. 15), following a distinction made famous by Erwin Panofsky.

29. The phrase is that of Müller, *Gedecthnus: Literatur und Hofgesellschaft um Maximilian I* (n. 25), p. 279, the best source for this topic.

30. See Frank Borchardt, *German Antiquity in Renaissance Myth*, Baltimore and London, 1971.

31. For these ideas, see in addition to Müller (n. 25), Werner Goez, *Translatio Imperii*, Tübingen, 1958, where notions of the transference of empire are studied at length.

32. These images and other works by Dürer made to celebrate the emperor discussed in this chapter are treated by Larry Silver, 'Prints for a Prince: Maximilian, Nuremberg, and the Woodcut' in Jeffrey Chipps Smith, ed., *New Perspectives on the Art of Renaissance Nuremberg: Five Essays*, Austin, Texas, 1985, pp. 6–21.

33. A good explication of the ideological background not only to the images designed by the artist himself but in general to projects initiated by Maximilian I is provided by Tilman Falk, *Hans Burgkmaier: Studien zu Leben und Werk des Augsburger Malers*, Munich, 1968. A similar combination is to be found in works produced by Dürer in collaboration with Conrad Celtis, to be discussed further below: see for example Dieter Wuttke, 'Dürer und Celtis: Von der Bedeutung des Jahres 1500 für den deutschen Humanismus', in Lewis W. Spitz, ed., *Humanismus und Reformation als kulturelle Kräfte in der deutschen Geschichte*, Berlin and New York, 1981 (Veröffentlichungen der Historischen Kommission zu Berlin, 51), pp. 121–50.

34. The latest overview, with further references, of Maximilian I and the arts is given by Karl Schütz, 'Maximiliano y el Arte' in *Reyes y Mecenas: Los Reyes Catolicos, Maximiliano I y las Inicios de la Casa de Austria en España* (also in German and Italian), exhibition catalogue, Toledo, 1992, pp. 233–51; the catalogue also contains examples of this patronage.

35. A brief but useful summary of these works is provided by Hans Rupprich, 'Das literarische Werk Kaiser Maximilians I' in *Maximilian I*, exhibition catalogue, Innsbruck, 1969, pp. 47–55.

36. This and other works by Burgkmaier are treated by Falk, *Burgkmaier* (n. 33). For a discussion of the Magdeburg equestrian figure in this context see Virginia Roehrig Kaufmann, 'The Magdeburg Rider: An Aspect of Frederick II's Revival North of the Alps', in *Intellectual Life at the Court of Frederick II Hohenstaufen*, ed. William Tronzo (*Studies in the History of Art* 44), 1993, pp. 63–85.

37. 'Wer ime in seinem leben kain gedachnus mach der hat seinem tod kain gedächtnus und desselben menschen wird mit dem glockendon vergessen.'

38. See Silver, 'Prints for a Prince' (n. 32). A book by Professor Silver is in progress on this topic.

39. See Paul Kirn, 'Friedrich der Weise und Jacopo de' Barbari', *Jahrbuch der Preußischen Kunstsammlungen*, 46, 1925, pp. 130–4.

40. This is a theme of Keith Moxey, *Peasants, Warriors and Wives: Popular Imagery in the Reformation*, Chicago and London, 1989, recapitulating his earlier essays on the topic.

Notes to Chapter Three

1. For a summary of the history of these well-known contrasts, see Kratzsch, *Bergstädte des Erzgebirges* (Ch. 2, n. 24), p. 109.

2. Rudolf Kaufmann, *Der Renaissancebegriff in der deutschen Kunstgeschichtsschreibung*, Wintherthur, 1932, especially pp. 140–51, treats this historiographic development.

3. The most important statement of this thesis was made by Georg Dehio, 'Die Krisis der deutschen Kunst im 16. Jahrhundert', *Archiv für Kulturgeschichte* 12, 1916, pp. 1–16 and disseminated through the many editions of his *Geschichte der deutschen Kunst*, 6 vols, Berlin, 1919–26. This view was common to writers such as Wilhelm Pinder, and it recurs even in more recent writing, in Gert van der Osten and Horst Vey, *Painting and Sculpture in Germany and the Netherlands*, Harmondsworth, 1969, and Baxandall, *The Limewood Sculptors of Renaissance Germany* (Intro., n. 14), p. 216.

4. These arguments recapitulate those developed in the introduction to my *Art and Architecture in Central Europe, 1550–1620* (Intro. n. 4).

5. Among earlier surveys, only the synthesis of Johannes Jahn, *Deutsche Renaissance*, Leipzig, 1969, seems to reveal a consciousness that the evaluation of German art of this period, if it is to be treated as a phenomenon of the Renaissance conceived in relation to Italy, must come to terms with the meaning of the concept of the Renaissance that allows for different sorts of related accomplishments in different places.

6. As elsewhere in this chapter, it will be seen that I am responding to Baxandall, *Limewood*

Sculptors (Intro. n. 14), because the treatment of 'visual culture' in this book has received a lot of attention and may have informed the opinions of many English readers.

7. This is particularly a theme of Baxandall, *ibid* (Intro. n. 14), but the theme has been widely expressed.

8. An extensive historiography on this period in Germany exists. For an introduction to the social and economic circumstances of art in one city, see Jeffrey Chipps Smith, *Nuremberg: A Renaissance City, 1500–1618*, Austin, Texas, 1983, which also presents an entrée to this material.

9. Gerald Strauss, *Nuremberg in the Sixteenth Century: City Politics and Life between Middle Ages and Modern Times*, Bloomington and London, 1976 (rev. edn.), provides an introduction in English. *Reichsstädte in Franken*, exhibition catalogue and essay volume, Munich, 1987, accumulates information on a broader sample. Peter Burke, *The Historical Anthropology of Early Modern Italy*, Cambridge, 1987, also employs the notion of conspicuous consumption in a similar manner. See further *idem, Venice and Amsterdam: A Study of Seventeenth-Century Elites*, London, 1974, and for the theoretical basis, *idem, History and Social Theory*, Ithaca, N.Y., 1993, pp. 67ff.

10. There is again an extensive literature related to these phenomena. Gerald Strauss, ed., *Manifestations of Discontent in Germany on the Eve of the Reformation*, Bloomington, Indiana, 1971, provides, for example, English translations of some of the complaints voiced at this time.

11. The town is discussed in Kratzsch, *Bergstädte des Erzgebirges* (Ch. 2, n. 20), pp. 11 ff., the church in art historical context in Ullmann, 'Spätgotische Hallenkirchen in Obersachsen', in *Von der Romanik* (Ch. 2, n. 21), pp. 92–104. The symbolism of the decoration of these churches was treated by Paul Crossley, 'The Return to the Forest: Natural Architecture and the German Past in the Age of Dürer' in Gaehtgens, *Kunstlerischer Austausch* (Ch. 1, n. 40), pp. 71–7.

12. The fundamental study of these conditions remains Hans Huth, *Kunstler und Werkstatt der Spätgotik*, Darmstadt, 1967 (rev. edn.), on which among others Baxandall, *Limewood Sculptors*, has drawn.

13. Martin Warnke, *Hofkünstler: Zur Vorgeschichte des modernen Künstlers*, Cologne, 1985 (English translation, Chicago, 1992), provides much information on the general situation of art at court.

14. For Dürer and his circumstances, one may now consult Jane Campbell Hutchison, *Albrecht Dürer*, Princeton, 1990. For a sense of the aspects, variety and conditions pertaining to artistic production, see most recently *Meisterwerke Massenhaft: Die Bildhauerwerkstatt des Niklaus Weckmann und die Malerei in Ulm um 1500*, exhibition catalogue,

Stuttgart, 1992; Ingo Sandner, *Spätgotische Tafelmalerei in Sachsen*, Dresden and Berlin, 1993; and *Lucas Cranach: Ein Maler Unternehmer aus Franken*, exhibition catalogue, Kronach, 1994.

15. Baxandall, *Limewood Sculptors* (Intro. n. 14), p. 117.

16. Besides Baxandall's *Limewood Sculptors* (Intro. n. 14), recent overviews are contained in Ullmann, *Geschichte der deutschen Kunst* (Ch. 2, n. 21), and Michael Liebmann, *Deutsche Plastik 1350–1550*, Gütersloh, 1984 (orig. edn. Leipzig, 1982).

17. This discussion summarizes that of *Limewood Sculptors* (Intro. n. 14), pp. 172ff.

18. In addition to the treatment in Baxandall, *op. cit.* (Intro. n. 14), Riemenschneider, on whom there is a large literature, has received renewed attention, e.g. *Tilman Riemenschneider. Frühe Werke*, exhibition catalogue, Berlin and Würzburg, 1981.

19. The latest complete view of Altdorfer and his *oeuvre* is presented by Hans Mielke, *Albrecht Altdorfer: Zeichnungen, Deckfarbenmalerei, Druckgraphik*, Berlin and Regensburg, 1988, with references to other works and artists. A recent publication in English, Christopher S. Wood, *Albrecht Altdorfer and the Origins of Landscape*, Chicago and London, 1993, offers another view. For Otto Benesch, see his *The Art of the Renaissance in Northern Europe*, London, 1965 (1st edn. 1945), pp. 44ff., and *Der Maler Albrecht Altdorfer*, Vienna, 1940 (1st edn. 1938). Recently, however, Horst Bredekamp, *Sandro Botticeli La Primavera: Florenz als Garten der Venus*, Frankfurt am Main, 1988, has proposed a different reading of the relationship of this famed Italian painting to nature.

20. For Witten, see Walter Hentschel, *Hans Witten: Der Meister H.W.*, Leipzig, 1938, and Walter Grundmann, *Der Meister H. W.: Das Schaffen Hans Wittens*, Berlin, 1970. A new monograph on this interesting artist would be most welcome.

21. Some general idea of the economic history of the region in this time can be gained from recent works in German, if not yet in English, e.g. Horst Rabe, *Reich und Glaubensspaltung: Deutschland 1500–1600*, Munich, 1989; an overview of the whole area would be in order.

22. Though renewed by Baxandall, *Limewood Sculptors* (Intro. n. 14), arguments that allow too much for the material determination of a work of art were already exploded by Alois Riegl, *Stilfragen*, Vienna, 1893. Many sculptors, not only in southern Germany, worked in a variety of materials, and the effects they achieved were not dependent upon materials: this is demonstrated by the *oeuvre* of Hans Witten, a Saxon, whose stone 'tulip pulpit' in Freiberg exhibits the same sort of deep undercutting and 'florid' effects that are visible in his woodcarvings.

23. See Lynn F. Jacobs, 'The Marketing and Standardization of South Netherlandish Carved Altarpieces: Limits on the Role of the Patron', *Art Bulletin*, 71, 1989, pp. 208–29.

24. William D. Wixom, 'The Art of Nuremberg Brass Work', in *Gothic and Renaissance Art in Nuremberg 1300–1550* (exhibition catalogue, New York and Nuremberg), New York and Munich, 1986, pp. 75–80, provides an introduction. This catalogue and collection of essays can be recommended in general for its treatment of art and architecture in Nuremberg.

25. See Joachim Friedrich Seeger, '*Hans Schenck (genannt Scheußlich)*: Ein deutsche Bildhauer des 16. Jahrhunderts', Ph.D. dissertation, Leipzig University, 1932 (also in *Mitteilungen des Vereins für die Geschichte Berlins*, 49, 1932, pp. 33–50, 65–86). This interesting artist deserves more attention; some is now given in Jeffrey Chipps Smith, *German Sculpture of the Later Renaissance: Art in an Age of Uncertainty*, Princeton, 1994, pp. 143–7, 394–6.

26. '*dass er von freyen und deutschen Eltern und nicht wendischen art, aus einem keuschen Ehebett erzeuget und geboren sey*', quoted in Oskar Schurer and Erich Wiese, *Deutsche Kunst in der Zips*, Brünn, Vienna, Leipzig, 1939, p. 18.

27. For the older view, see for example Schurer and Wiese, *Deutsche Kunst in der Zips* (n. 26); Gustav Barthel, *Die Schlesische Bildende Kunst als Gestalt und Form der Kulturkräfte des Schlesischen Raumes*, Breslau, 1941; *idem, Die Ausstrahlungen der Kunst des Veit Stoss im Osten*, Munich, 1944; Franz, *Die Deutsche Barockbaukunst Mährens*, (Intro., n. 12). For my view of the 'new art history', see my 'What is New about the "New Art History"', *The Philosophy of the Visual Arts*, ed. Philip Alperson, New York and Oxford, 1992, pp. 515–20; and (together with Anthony Grafton), 'Holland without Huizinga: Dutch Visual Culture in the Seventeenth Century', in *Journal of Interdisciplinary History*, 16, 1985, pp. 255–65. The interpretation of Stoss's work in Kraków is discussed in similar manner in a paper of which I become aware after writing these pages, Labuda, 'eine sinnvollen zweckfühlen gefühlte Kolonialkunst', (Intro. n. 13), pp. 5–6, 12–14.

28. Balancing Barthel, *Ausstrahlungen der Kunst* (n. 27), see Alicja Karłowska-Kamzowa, 'Der Einfluß der Kunstideen des Veit Stoß in Mittelosteuropa: Ein Diskussionsbeitrag', in *Veit Stoß, die Vorträge des Nürnberger Symposions*, ed. Rainer Kahsnitz, Munich, 1985, pp. 260–8; Anna Ziomecka, 'Veit Stoß und die spätgotische Skulptur Schlesiens', *ibid.*, pp. 269–79; Andrzej Mieczysław Olszewski, 'Wpływy sztuki Wita Stwosza w Polsce i na Słowacji', in *Wit Stwosz w Krakowie*, ed. Lech Kalinowski and Franciszk Stolot, Kraków, 1987, pp. 62–72, also discusses the impact of this monument. For the concept of 'prime object' see George Kubler, *The Shape of Time*, New Haven and London, 1962.

29. Baxandall, *Limewood Sculptors* (Intro. n. 14), p. 86. It is noteworthy that Baxandall's secondary sources are exclusively drawn from the older German literature.

30. See the essays collected in Kalinowski and Stolot, *Wit Stwosz w Krakowie* (n. 28); also Adam Labuda, ed., *Wit Stosz: Studia o Sztuce i Recepcę*, Warsaw and Poznań, 1986; Piotr Skubiszewski, *Veit Stoss und Polen*, Nuremberg, 1983.

31. If the whole document is not itself a forgery from the time in the sixteenth century when, unlike the situation that pertained in the late fifteenth, the Germans were under pressure, it is possible that Heydecke's note reflects the situation of the 1530s, since the Germans lost the church in 1537. For the original documents and an evaluation of their reliability, see Szczesny Dettloff, *Wit Stosz,* Wrocław (Breslau), 1961, 2 vols.

32. Zdzisław Kępiński, *Veit Stoss,* Dresden and Warsaw, 1981, provides a reliable account of the circumstances of the altarpiece's origins, including this information on Heydecke. See also Tadeusz Dobrowolski, *Ołtarz Mariacki, Epoka i Środowisko,* Kraków, 1980; Skubiszewski, *Veit Stoss und Polen* (n. 30), also supplies some of the bases for the interpretation offered here. For a summary of more recent Polish scholarship see Janusz Kębłowski, 'Die neuere polnische Veit Stoß-Forschung: Ein Überblick', in *Veit Stoß, Vorträge* (n. 28), pp. 38–48.

33. For a critique of this and other aspects of Baxandall's arguments, see further Eberhard König, 'Gesellschaft, Material, Kunst: Neue Bücher zur deutschen Skulptur um 1500', *Zeitschrift für Kunstgeschichte* 47, 1984, pp. 535–58.

34. This point is emphasized by Jerzy Gadomski, 'Dzieta Stwosza w Polsce', in *Wit Stwosz w Krakowie* (n. 30), pp. 52–61.

35. The basic work on Stoss's sepulchral sculpture, including discussion of the royal tombs and fine illustrations, is Piotr Skubiszewski, *Rzeźba nagrobna Wita Stwosza,* Warsaw, 1957.

36. For Stoss and Callimachus, in addition to the sources cited above, see Jolanta Maurin Białostocka, 'W sprawie wpłwów włoskich w płycie Kallimacha', *Biuletyn Historii Sztuki,* 19, 1957, pp. 178–82; Adam Bochnak, 'Pomnik Kallimacha', *Studia Renesansowe,* 1, 1956, pp. 124–39; and Jerzy Kowalczyk, 'Filip Kallimach i Wit Stosz', *Biuletyn Historii Sztuki,* 45, 1983, pp. 3ff. (also as 'Filippo Buonacorsi e Vita Stoss' in V. Branca and S. Graciotti, eds., *Italia Venezia e Polonia tra medio evo e età moderna* (*Civiltá veneziana: Studi 35*), Florence, 1980, pp. 247–69.

37. See Fritz Koreny, 'Die Kupferstiche des Veit Stoß', *Veit Stoß, Vorträge* (n. 28), pp. 141–68.

38. For example, Schurer and Wiese, *Deutsche Kunst in der Zips* (n. 26).

39. Illustrations and information on Pavol z Levoča are to be obtained from J. Homolka *et al., Majster Pavol z Levoče: Tvorca vrcholného diela Slovensky neskorej gotiky,* Bratislava, 1964.

40. This theme is treated by Michael Murrin, *History and Warfare in Renaissance Epic,* Chicago and London, 1994.

41. These monuments are illustrated in Karel Sourek, ed., *Die Kunst in der Slowakei: Eine Sammlung von Dokumenten,* Prague, 1939.

42. See Müller, *Gedecthnus: Literatur und Hofgesellschaft um Maximilian I* (Ch. 2, n. 25).

43. See the information in *Polen im Zeitalter der Jagiellonen* (Ch. 2, n. 2).

44. See in general the essays in Asch and Birke, *Princes, Patronage and the Nobility: the Court at the Beginning of the Modern Age* (Ch. 2, n. 1), especially the introduction by Asch, pp. 1–38 and Müller, *Gedecthnus* (Ch. 2, n. 25), for this theme.

45. See the papers collected in Jan Harasimowicz, ed., *Sztuka miast i mieszczaństwa XV–XVIII wieku w Europie środkowowschodniej* (with German summaries) Warsaw, 1990, especially Mieczysław Zlat, 'Nobilitacja przez sztukę – jedna z funkcji mieszczańskiego mecenatu w XV i XVI w.', pp. 77–101.

Notes to Chapter Four

1. See Earl Rosenthal, 'The Diffusion of the Italian Renaissance Style in Western European Art', *The Sixteenth Century Journal*, 4, 1978, pp. 33–45.

2. Erwin Panofsky, 'Conrad Celtes and Kunz von der Rosen. Two Problems in Portrait Identification', *Art Bulletin*, 29, 1942, pp. 52–3.

3. Jane Campbell, Hutchinson, *Albrecht Dürer: A Biography*, Princeton, 1990, pp. 3ff., supplies this information.

4. Erwin Panofsky, *The Life and Art of Albrecht Dürer*, Princeton, 1943. It is an indication of how much this subject has become taboo in Germany, that although there have been recent monographs on the artist and his work taken as a whole (e.g. Peter Strieder, *Albrecht Dürer: Paintings, Prints, Drawings*, trans. Nancy Gordon and Walter Strauss, New York, 1982), Panofsky's book has still not been surpassed.

5. Jan Białostocki, *Dürer and his Critics, 1500–1971: Chapters in the History of Ideas Including a Collection of Texts*, Bamberg, 1986. Białostocki's account of the Dürer literature is probably the most convenient source for more information on the story recounted above. The huge bibliography on Dürer, amounting to over 10,000 titles in 1971, is assembled in Matthias Mende, *Dürer Bibliographie zur 500. Wiederkehr des Geburtstages von Albrecht Dürer*, Wiesbaden, 1971.

6. This interpretation was presented in Panofsky's 'Dürers Stellung zur Antike', *Jahrbuch für Kunstgeschichte*, 1, 1921–22, pp. 43–92, when Panofsky was associated with the Warburg Institute in Hamburg; it is reprinted (as 'Dürer and Classical Antiquity') in *Meaning in the Visual Arts: Papers in and on Art History*, Garden City, N. Y., 1955, pp. 236–94.

7. A recently discovered nature study by Schongauer (now in the J. Paul Getty Museum,

Malibu) was presented in the exhibition, *Circa 1492*, Washington, DC, 1991, cat. no. 202, pp. 296–7.

For Dürer's nature studies, see Fritz Koreny, *Dürer and the Plant and Animal Studies of the Renaissance*, New York, 1985, and the essays collected in *Albrecht Dürer und die Tier- und Pflanzenstudien der Renaisance: Symposium, Jahrbuch der Kunsthistorischen Sammlungen in Wien*, 82–3, 1986–7.

8. These issues are discussed in my *The Mastery of Nature: Aspects of Art, Science and Humanism in the Renaissance*, Princeton, 1993.

9. See Jan Białostocki, 'The Renaissance Concept of Nature and Antiquity', in *The Message of Images: Studies in the History of Art*, Vienna, 1988, pp. 64–8, 246–8.

10. See E. H. Gombrich, *Art and Illusion*, New York, 1960.

11. See Teresio Pignatti, 'The Relationship between German and Venetian Painting in the Late Quattro- cento and Early Cinquecento', in J. R. Hale, ed., *Renaissance Venice*, London, 1974, pp. 244–73.

12. See Dieter Wuttke, 'Dürer and Celtes', *Journal of Medieval and Renaissance Studies*, 10, 1980, pp. 73–129 and *idem, Humanismus als integrative Kraft: Die Philosophia des deutschen 'Erzhumanisten' Conrad Celtes. Eine ikonologische Studie zu programmatischen Graphik Dürers und Burgkmaiers*, Nuremberg, 1985.

13. See Niklas Holzberg, *Willibald Pirckheimer: Griechischer Humanismus in Deutschland*, Munich, 1981.

14. Smith, *Nuremberg: A Renaissance City* (Ch. 3, n. 8), p. 42.

15. See Karl Giehlow, 'Die Hieroglyphenkunde des Humanismus in der Allegorie der Renaissance' Besonders der Ehrenpforte Kaisers Maximilians I. Ein Versuch, *Jahrbuch der Kunsthistorischen Sammlungen des allerhöchsten Kaisershauses*, 32, pt. 1, pp. 1–232.

16. This issue is discussed in context in Rainer Brandl, 'Art or Craft? Art and the Artist in Medieval Nuremberg', in *Gothic and Renaissance Art in Nuremberg* (Ch. 3, n. 24), pp. 51–60.

17. See Panofsky, 'The History of Human Proportions as a Reflection of the History of Styles', in *Meaning in the Visual Arts* (n. 6), pp. 55–107.

18. See *The Mastery of Nature* (n. 8).

19. For this notion see David Summers, 'Contrapposto: Style and Meaning in Renaissance Art', *Art Bulletin*, 59, 1977, pp. 336–61. For the general question of rhetorical notions and

artistic composition, see Michael Baxandall, *Giotto and the Orators: Humanist Observers of Painting in Italy and the Discovery of Pictorial Composition*, Oxford, 1971. Dürer shows his awareness of aesthetic issues in his excursus to the third book of his *Underweysung der Messung*. The relationship of Dürer's ideas here, and their reception to Italian art theory are best discussed by Peter W. Parshall, 'Camerarius on Dürer – Humanist Biography as Art Criticism', in Frank Baron, ed., *Joachim Camerarius (1500-74). Beiträge zur Geschichte des Humanismus im Zeitalter der Reformation/Essays in the History of Humanism during the Reformation*, Munich, 1978, pp. 11–29.

20. Baxandall, *Limewood Sculptors* (Intro. n. 14), p. 144.

21. The work of Dieter Wuttke is an exception to this: see, e.g., 'Dürer and Celtes', (n. 12).

22. For an introduction to this idea of the group of artists 'around Albrecht Dürer', see *Meister um Albrecht Dürer,* exhibition catalogue, Nuremberg, 1960–1. For Dürer's impact, see Chapter 5, below, and further sources mentioned there. For further references see in general *Gothic and Renaissance Art in Nuremberg* (Ch. 3, n. 24). Although there is a substantial literature on these figures many of them (e.g. Hans Schäuffelein) merit new studies.

23. See *Gothic and Renaissance Art* (Ch. 3, n. 24), pp. 332–3; and *Circa 1492* (n. 7), cat. no. 210, p. 302.

24. See in general Lewis Spitz, 'The Course of German Humanism', in *Itinerarium Italicum*, ed. H. Oberman and T. Brady, Jr, pp. 371–436; 'Humanism and the Protestant Reformation', A.Rabil, ed., *Renaissance Humanism, Foundations, Forms and Legacy*, 3, Philadelphia, 1988, pp. 380–411; *idem*, 'Humanism in Germany', in Anthony Goodman and Angus Mackay, eds, *The Impact of Humanism on Western Europe*, London and New York, 1990, pp. 202–19.
For Nuremberg, see Smith, *Nuremberg: A Renaissance City* (Ch. 3, n. 8), who, pp. 39–43, specifically discusses 'Art and the Rise of Humanism'. For further information on Nuremberg, see J. Pfanner, 'Geisteswissenschaftlicher Humanismus', and J. Hoffmann, 'Naturwissenschaftlicher Humanismus', in *Nürnberg: Geschichte einer europäischer Stadt*, Munich, 1971, pp. 127–33, 134–7.

25. Besides the works of Wüttke (e.g. n. 12), in English see Lewis Spitz, *Conrad Celtis* [sic]: *The German Arch-Humanist*, Cambridge, Mass., 1957. Spitz discusses the phenomenon more broadly in 'Humanism in Germany' (n. 24).

26. For the work of the younger Vischer and its association with humanists, see first, although still not complete, Heinz Stafski, *Der Jüngere Peter Vischer*, Nuremberg, 1962.

27. See Ludwig Grote, 'Die Vorderstube des Sebald Schryer – Ein Beitrag zur Rezeption der Renaissance in Nürnberg', *Anzeiger des Germanischen Nationalmuseum Nürnberg*, 1954–9, pp. 43–67.

28. For this group and the works associated with it, see Dieter Wuttke, *Die Histori Herculis des Nürnberger Humanisten und Freundes der Gebrüder Vischer, Pangratz Bernhaubt gen. Schwenter*, Cologne and Graz, 1964.

29. For Hering, see P. Reindl, 'Studien zu Loy Hering', Ph.D. dissertation, Erlangen University, 1970. A comprehensive new monograph on the Dauchers is still a desideratum.

30. *Limewood Sculptors* (Intro. n. 14), p. 135.

31. See Pierre Bourdieu, *Distinction: A Social Critique of the Judgement of Taste*, trans. Richard Nice, London, 1986.

32. For an analysis of the Fugger Chapel in the context of the advent of the Renaissance to German architecture, including a discussion of its relation to Venice, see Henry-Russell Hitchcock, *German Renaissance Architecture*, Princeton, 1981, pp. 3ff. See also now Bruno Bushart, *Die Fuggerkapelle bei St Anna in Augsburg*, Munich, 1994. As Anthony Grafton has reminded me, the onion dome, or *welsche Haube*, also prevalent in Augsburg, was another great contemporary case of syncretism. For the question of cultural and economic relations between the upper (e.g. southern) German cities and Venice, see essays in Bernd Roeck et al., eds., *Venedig und Oberdeutschland in der Renaissance. Beziehung zwischen Kunst und Wirtschaft*, Sigmaringen, 1993.

33. Cf. Baxandall, *Limewood Sculptures* (Intro. n. 14); the quotation is from p. 134.

34. *Ibid.*, p. 135.

35. Hulse, *The Rule of Art* (Intro. n. 39), p. 183, n. 21. Hulse also suggests, pp. 23–4, that 'the history of Renaissance (for which one may read the history of culture generally) is not a history of smooth development and transmission of cultural forms, but one of gaps, ruptures, and misunderstandings, of regional accents and grotesque local variations'.

36. This is the theme of the classic account of Paul Joachimsen, *Geschichtsauffassung und Geschichtsschreibung in Deutschland unter dem Einfluß des Humanismus*, Leipzig, 1910; also Frank L. Borchard, *German Antiquity in Renaissance Myth*, Baltimore and London, 1971.

Notes to Chapter Five

1. Baxandall, *Limewood Sculptors* (Intro. n. 14), pp. 135–42.

2. See in general Homolka, *Pozdně Gotické Umění* (Ch. 2, n. 17) for the implications for the arts.

3. See Erwin Panofsky, Fritz Saxl and Raymond Klibansky, *Saturn and Melancholy: Studies in the History of Natural Philosophy, Religion and Art*, London and New York, 1964.

4. Translation adapted from Erwin Panofsky, *The Life and Art of Albrecht Dürer*, Princeton, 1967 (rev. edn.), p. 151, whose argument is replicated here.

5. See Panofsky *et al.,Saturn and Melancholy* (n. 3); this interpretation is also adumbrated in Panofsky's *Dürer* (n. 4). More recently Peter-Klaus Schuster, culminating in *Melencolia I: Dürers Denkbild*, 2 vols., Berlin, 1991, has reviewed interpretations of this image and, building on Panofsky, Saxl and Klibansky, has offered a learned interpretation of the engraving and its reception that is the most serious rival to theirs. If I have understood his premises correctly, Schuster argues for the ready legibility of the image and accordingly rejects the idea that H. C. Agrippa may have served as a source. The thesis of legibility, however, seems just what is at stake in all interpretations.

6. Frances A. Yates, *The Occult Philosophy in the Elizabethan Age*, London, Boston and Henley, 1979, pp. 49–59. See also *idem*, 'Chapman and Dürer on Inspired Melancholy', *The University of Rochester Bulletin*, 34, 1981, pp. 25–41.

7. These pages summarize my 'Hermeneutics in the History of Art: Remarks on the Reception of Dürer in the Sixteenth and Early Seventeenth Centuries' in *New Perspectives on the Art of Renaissance Nuremberg: Five Essays*, ed. Jeffrey Chipps Smith, Austin, Texas, 1985, pp. 22–39. Further references to the artists and interpretations of their images can be found there, especially p. 38, nn. 32ff. Of these the extensive handling by Linda Hults Boudreau, 'Hans Baldung Grien and Albrecht Dürer: A Problem in Northern Mannerism', Ph.D. dissertation, University of North Carolina, 1978, and in subsequent publications, should be mentioned. Schuster, as summarized in *Melencolia I* (n. 5), also treats many of the images by Dürer discussed here and their reception. Most recently a work with its own particular approach to the reception of Dürer that became available after the completion of this text, Joseph Leo Koerner, *The Moment of Self-Portraiture*, Chicago and London, 1993, has reprised some of the themes discussed here and in the previous literature, as treated most thoroughly by Schuster: the present text is also supplemented by materials presented in numerous unpublished lectures delivered at Princeton University since 1980.

8. For Cranach, see *Lucas Cranach: Gemälde, Zeichnungen, Druckgraphik*, exhibition catalogue, Basel, 1974; Werner Schade, *Cranach: A Family of Master Painters*, trans. Helen Sebba, New York, 1980. See also *Lucas Cranach: Ein Maler* (Ch. 3, n. 14).

9. For Albrecht of Brandenburg and works of art associated with him, see now *Albrecht von Brandenburg: Kurfürst, Erzkanzler, Kardinal*, exhibition catalogue, ed. Berthold Roland, Mainz, 1990.

10. The discussion of Albrecht's patronage and related phenomena in Germany presented here is based on the following sources: Eberhard Rühmer, 'Die Meister der Hallischen Dom-Skulpturen', *Zeitschrift für Kunstgeschichte*, 21, 1958, pp. 209–24; Heinrich L. Nickel, *Der Dom zu Halle*, Leipzig, 1963 (*Das Christliche Denkmal* 63/64); Ulrich Steinmann, 'Der Bilderschmuck der Stiftskirche zu Halle: Cranachs Passionszyklus und

Grünewalds Erasmus-Mauritius Tafel', *Staatliche Museen zu Berlin: Forschungen und Berichte*, 11, 1968, pp. 69–104; Rolf Hünicken, *Halle in der mitteldeutschen Plastik und Architektur der Spätgotik und Frührenaissance 1450–1550*, Halle, 1936; Hans Joachim Krause, 'Das erste Auftreten italienischer Renaissance-Motive in der Architektur Mitteldeutschlands', *Acta Historiae Artium*, 13, 1967, pp. 99–114; Ernst Ullmann, 'Zur Rezeption der Renaissance in Sachsen und zu den gesellschaftlichen Grundlage der deutschen Frührenaissance', republished in *Von der Romanik bis zum Historismus* (Ch. 2, n. 21), pp. 137–42. See further Andreas Tacke, *Der Katholische Cranach*, Mainz, 1992

In contrast with the practice I have in general adopted, I have taken pains to cite this bibliography at some length (and titles could be added), because, despite the catalogue mentioned in the previous note, this seems to me to be a topic worthy of further attention.

11. For the place of nobility in Austria, see most recently *Adel in Wandel: Politik, Kultur, Konfession 1500–1700*, exhibition catalogue, Rosenburg, 1990.

12. See R. J. W. Evans, 'Calvinism in East Central Europe: Hungary and her Neighbours, 1500–1700' in *International Calvinism 1541–1715*, ed. Menna Prestwich, Oxford, 1986, pp. 167–96.

13. For a good introduction to the huge literature on the Reformation and art, and debates about it, see Linda B. and Peter Parshall, *Art and the Reformation: An Annotated Bibliography*, Boston, 1985; see also Carl C. Christensen, 'Reformation and Art' in Steven Ozment, ed., *Reformation Europe: A Guide to Research*, St Louis, 1982, pp. 249–70.

Christensen's *Art and the Reformation in Germany*, Athens, Ohio, 1979, provides a useful overview in English to the topic.

14. For iconoclasm, arguments pro and con, see David Freedberg, *Iconoclasm in the Revolt of the Netherlands 1566–1609*, New York, 1988; *idem*, 'The Problem of Images in Northern Europe and its Repercussions in the Netherlands', Hafnia, 1976, pp. 25–45; Ernst Ullmann, 'Bildersturm und bildende Kunst im XVI. Jahrhundert', *ibid.*, pp. 46–54; and the essays collected in Judith Herrin, ed., *Iconoclasm*, Birmingham, 1977, and in R. W. Scribner and M. Warnke, eds., *Bilder und Bildersturm in Spätmittelalter und der frühen Neuzeit* (*Wolfenbütteler Forschungen 46*), Wiesbaden, 1990.

15. See Dehio, 'Krisis' (Ch. 3, n. 3); G. Stuhlfauth, 'Künstlerstimmen und Künstlernot aus der Reformationsbewegung', *Zeitschrift für Kirchengeschichte*, 56, 1937, pp. 498–514; Carl Christensen, 'The Reformation and the Decline of German Art', *Central European History*, 6, 1973, pp. 207–32. One of the older dissenting opinions, although not by an art historian, is Karl Holl, *The Cultural Significance of the Reformation*, trans. Karl and Barbara Hertz and John H. Lichtblau, intro. Wilhelm Pauck, Cleveland and New York, 1959 (1st edn. 1948, based on a text of 1911).

16. In addition to the work of Christensen, recent important works dealing with various dimensions of the Protestant Reformation and art include *Kunst der Reformationszeit*,

exhibition catalogue, Berlin, 1983; *Luther und die Folgen für die Kunst*, exhibition catalogue, Hamburg, 1983; Ernst Ullmann, ed., *Von der Macht der Bilder*, Leipzig, 1983; Jakub Pokora, *Sztuka w służbie Reformacji: Śląskie ambony 1550–1650*, Warsaw, 1982; Jan Harasimowicz, *Treści i funkcje ideowe sztuki śląskiej Reformacji 1520–1650*, Wrocław, 1986; Sergiusz Michalski, *Protestanti a Sztuka*, Warsaw, 1989 (revised English translation: *The Reformation and the Visual Arts: The Protestant Image Question in Western and Eastern Europe*, London and New York, 1993). Jan Harasimowicz, *Mors Janua Vitae. Śląskie epitafia i nagrobki wieku reformacji*, Wrocław (Breslau), 1992. Harasimowicz is preparing a larger study of the subject. For Cranach, see Tacke, *Der Katholische Cranach* (n. 10).

17. For the general subject of Protestant propagandistic imagery, see most recently Robert W. Scribner, 'Reformatorische Bildpropaganda', in *Historische Bildkunde Probleme – Wege – Beispiele*, ed. Brigitte Tolkemitt and Rainer Wohlfeil, Berlin, 1991, pp. 83–106.

18. This topic has been best studied in reference to Nuremberg: for introductions in English, see Christiane Andersson, 'Polemical Prints in Reformation Nuremberg', in *New Perspectives on the Art of Renaissance Nuremberg* (n. 7), pp. 41–62, and Moxey, *Peasants, Warriors and Wives* (Ch. 2, n. 40), pp. 19–34, both with further references to works in German.

19. This is a reference to what remains the best book on the topic, Robert Scribner, *For the Sake of Simple Folk: Popular Propaganda for the German Reformation*, Cambridge, 1981.

20. For the first printed books in the Hungarian language, see *Matthias Corvinus und die Renaissance in Ungarn* (Ch. 1, n. 26), cat. nos. 889–90, pp. 721–2; see also pp. 695–6, where however an emphasis is placed rather on the national aspect of this occurrence. These works are discussed in *A History of Hungarian Literature*, Budapest, 1982.

21. In addition to the works cited in n. 8, see Werner Schade, 'Die Epitaphbilder Lucas Cranach d. J.' in *Ze Studiów nad sztuka XVI wieku na Śląsku i w krajach sąsiednich*, Wrocław, 1968, pp. 63–76. See further the recent treatments by Katerzyna Cieślak, *Epitafia obrazowe w Gdański XV–XVII w.*, Wrocław, Warsaw, Kraków, 1993; Karin Tebbe, 'Epitaphien aus dem Weserraum um 1600', in *…uns und unseren Nachkommen zu Ruhm und Ehre…* (*Materialien zur Kunst-und Kulturgeschichte Nord- und Westdeutschlands 6*), Marburg, 1992, pp. 9–67.

22. The issues in this and the preceding paragraphs are well summarised by Christensen, *Art and the Reformation in Germany* (n. 13).

23. In addition to the sources cited above, nn. 8, 21, 22, from which the preceding paragraphs draw, see further Christiane D. Andersson, 'Religiöse Bilder Cranachs im Dienste der Reformation' in Lewis W. Spitz, ed., *Humanismus und Reformation als kulturelle Kräfte in der deutschen Geschichte. Ein Tagungsbericht*, Berlin and New York, 1981, pp. 43–79.

24. In addition to Harasimowicz, *Mors Janua Vitae* (n. 16), see *idem*, 'Lutherische Bildepitaphien als Ausdruck des "Allgemeinen Priestertums der Gläubigen" am Beispiel Schlesiens', in *Historische Bildkunde* (n. 17), pp. 135–64 and *idem*, 'Tod Begräbnis und Grabmal im Schlesien des 16. und 17. Jh.', *Acta Poloniae Historica*, 65, 1992, pp. 5–54 (all with further references). This subject is also treated in comprehensive manner, with reference to Silesia, by Bożena Steinborn, 'Malowane epitafia mieszczańskie na Śląsku 1520–1620', *Roczniki Sztuki Śląski*, 4, 1967, pp. 7–138 (with German and French summaries).

25. This is pointed out by Jan Harasimowicz, 'Rola Sztuki w religijnych i spolecznych konfliktach wieku Reformacji na Śląsku', *Rocznik Historii Sztuki*, 18, 1990, pp. 31–95 (with French summary).

26. See Peter Poscharsky, *Die Kanzel: Erscheinungsform im Protestantismus bis zum Ende des Barocks*, Gütersloh, 1963; Pokora, *Sztuka w służbie Reformacji* (n. 16).

27. This was followed by a series of churches in Gotha, Freiberg, Dresden, Schwerin and Augustusburg; two types of church, one with tribunes supported on superimposed columns as opposed to superimposed arcades, were developed. See, for an overview, Hans-Joachim Krause, *Die Schlosskapellen der Renaissance in Sachsen*, Berlin, 1970.

28. See *Renaissance in Böhmen* (Ch. 2, n. 18), pp. 193–5, fig. 139–41.

29. See Horst Stierhof, *Wand und Deckenmalereien des Neuburger Schlosses im 16. Jahrhundert*, Munich, 1972.

30. For these buildings and Protestant chapels in general, see Hitchcock, *German Renaissance Architecture* (Ch. 4, n. 32).

31. Philipp Melanchthon, *Encomium eloquentiae* (from R. Stupperich, ed., *Werke in Auswahl*, 3, p. 46) in *Glaube und Bildung: Texte zum christlichen Humanismus*, Stuttgart, 1989, pp. 152–4: Et quemadmodum in fingendis corporibus ea/enim elegantia est, ubi iusta proportione membra omnia inter se consentiunt, si quid secus facias, monstrosum erit, ita cum germanam orationis speciem nova compositione deformaveris, monstrosam plane atque ineptam facies.

32. See the discussion of this passage in William S. Heckscher, 'Melancholia (1541): An Essay in the Rhetoric of Description by Joachim Camerarius', Edition, Translation, and Notes in Baron, ed., *Joachim Camerarius* (Ch. 4, n. 19), pp. 31–120.

33. For a discussion of this matter in relation to the spread of Melanchthon's teaching and for further references, see my 'The Eloquent Artist: Towards an Understanding of the Stylistics of Painting at the Court of Rudolf II', *Leids Kunsthistorisch Jaarboek*, 1, 1982, pp. 119–48.

1. See the discussion of these issues in my 'Introduction', *Art and Architecture in Central Europe, 1550–1620* (Intro. n. 4). More recently these questions have been treated in *Renaissance der Renaissance*, exhibition catalogue, Lemgo, 1992.

2. Jeffrey Chipps Smith, *German Sculpture of the Later Renaissance* (Ch. 3, n. 25), has now given this material its due. I am grateful to Professor Smith for allowing me to read a typescript of his book before publication; his work expands the observations here.

3. There is an absence of extensive scholarship that considers these issues; for a recent revision, which however takes the longer view, see the collection of papers in *Sztuka Miast i Mieszczaństwa* (Ch. 3, n. 45).

4. For example in *Renaissance in Böhmen* (Ch. 3, n. 18) pp. 18–19, F. Seibt notes that it is not easy to determine whether the sixteenth century represented good or bad times for the inhabitants of Bohemia.

5. One of the few efforts to deal with this issue is the recent treatment by Klaus G. Püttmann, 'Das Motiv des Bauherrn – Anmerkungen zur bürgerlichen Selbstdarstellung in der Architektur des 16. Jahrhunderts', in *Renaissance im Weserraum*, Munich and Berlin, 1989, pp. 210–35, also commenting on the economic situation. This sort of information clearly needs to be controlled against studies of other regions: see for example *Die Renaissance im Deutschen Südwesten zwischen Reformation und Dreissigjährigen Krieg*, exhibition catalogue, 2 vols, Heidelberg, 1986. The organization and contents of burghers' houses in Prague in the late sixteenth century is the topic of a dissertation now (1995) completed at New York University by James R. Palmitessa: 'House, Home & Neighborhood on the Eve of White Mountain: Material Culture and Daily Life in the New City of Prague'.

6. This is the famous thesis advanced by Robert S. Lopez, 'Hard Times and Investment in Culture', in his *The Renaissance: Six Essays*, New York and Evanston, 1962 (first edn., New York, 1953), pp. 29–54. The most recent reconsideration of this thesis appears in another context in Michael North, *Kunst und Kommerz im goldenen Zeitalter: Zur Sozialgeschichte der niederländischen Malerei des 17. Jahrhunderts*, Cologne, Weimar, Vienna, 1993.

7. See Richard Goldthwaite, *The Building of Renaissance Florence: An Economic and Social History*, Baltimore and London, 1980, whose arguments are summarized here.

8. This thesis is of course related to that of Max Weber, *The Protestant Ethic and the Spirit of Capitalism*, trans. Talcott Parsons, New York, 1958, which has engendered another huge debate; for a trenchant critique, see Kurt Samuelsson, *Religion and Economic Action* (trans.), New York, 1961. It seems to me that the debate has yet to deal fully with specific historical examples involving works of art, however.

9. Jeffrey Chipps Smith, 'The Transformations in Patrician Tastes in Renaissance Nuremberg', in *New Perspectives on the Art of Renaissance Nuremberg* (Ch. 5, n. 7), pp. 83–100, is one of the few efforts to try to account for what happened to patronage in one important place in particular. Smith's *Nuremberg: A Renaissance City* (Ch. 3, n. 8) also offers much information on the question of the effect of the arts in the wake of Luther's teaching. The issue of sculpture in Germany after 1530 has been illuminated by Smith's new book *German Sculpture of the Later Renaissance* (Ch. 3, n. 25).

10. Hubertus Günther *et al.*, *Deutsche Architekturtheorie zwischen Gotik und Renaissance*, Darmstadt, 1988, treats some of the themes.

11. For mid-sixteenth-century architecture in Bohemia, and for illustrations thereof, consult Eva Šamanková, *Architektura České Renesance*, Prague, 1961; Jarmila Krčálová in J. Hořejší *et al.*, *Die Kunst der Renaissance und des Manierismus in Böhmen*, Prague, 1979; *idem*, in *Dějiny Českého výtvarného umění: Od Pocátku renesance do záveru baroka*, vol. 2, Prague 1989, pt 1; and *Renaissance in Böhmen* (Ch. 3, n. 18).

12. For the continuing history from the Renaissance onwards of Italian artists in Prague, see Pavel Preiss, *Italští umělci v Praze: Renesance, Manyrismus, Baroko* (with French summary), Prague, 1986.

13. See most recently for example James S. Ackerman, *The Villa: Form and Ideology of Country Houses*, Princeton, 1990.

14. For instance in 1570: see my *Variations on the Imperial Theme in the Age of Maximilian II and Rudolf II*, New York and London, 1978, pp. 28–33.

15. As discussed by Eliška Fučíková, 'Zur Konzeption der rudolfinischen Sammlungen', in *Prag um 1600: Beiträge zur Kunst und Kultur am Hofe Rudolfs II*, ed. E. Fučíková, Freren, 1988, pp. 59–62.

16. For this building, see Earl Rosenthal, *The Palace of Charles V in Granada*, Princeton, 1985.

17. See Renate Wagner-Rieger, *Das Schloss zu Spittal an der Drau in Kärnten*, Vienna, 1962.

18. See Onians, *Bearers of Meaning* (Intro. n. 25) for an extended history.

19. Olga Frejková, *Palladianismus v České Renesance*, Prague, 1941, first elaborated the point about Wohlmut's classicism.

20. For this and other centrally planned buildings of the Renaissance in Bohemia, see Jarmila Krčálová, *Centrální Stavby České Renesance* (with German summary), Prague, 1974. Ferdinand of the Tyrol and the arts, and the literature on the topic, have been summarized

recently in Christian Gries 'Erzherzog Ferdinand von Tirol: Konturen einer Sammlerpersönlichkeit', *Früh Neuzeit Info*, 4, 1993, pp. 162–173.

21. Here, as in my review of his book (*Art Bulletin*, 58, 1978, pp. 163–9), I am responding to Białostocki, *Art of the Renaissance in Eastern Europe* (Intro. n. 15), who argues, p. 74, for the isolation of the Habsburg court.

22. For Maggi's buildings and these connections, see further Jarmila Krčálová, *Renesanční stavby B. Maggiho v Čechách a na Moravě*, Prague, 1986.

23. Work is continuing on this important structure, whose restoration is planned. The best study to date, with further references, is Hilda Lietzmann, *Das Neugebäude in Wien: Sultan Süleymans Zelt – Kaiser Maximilians II. Lustschloß*, Munich and Berlin, 1987.

24. For Renaissance monuments in Austria, see the overview by Rupert Feuchtmüller, 'Die Architektur der Renaissance in Osterreich' in R. Feuchtmüller, ed., in *Renaissance in Österreich*, 1974, pp. 185–95; also *idem* 'Die Architektur', in R. Feuchtmüller, Peter von Baldass and Wilhelm Mrazek, *Renaissance in Österreich*, Vienna and Hannover, 1966, pp. 5–40; for Hungary, see Rósza Feuer-Tóth, *Renaissance Architecture in Hungary*, Budapest, 1977.

25. Literature on this important castle has increased in the last decades. Besides the remarks in Lietzmann, *Neugebäude* (n. 23), see Jarmila Krčálová, *Zámek v Bučovice*, Prague, 1979, and her comments in *Dějiny Českého výtvarného umění* (n. 11).

26. See the analysis of Reinhart Koselleck in 'Modernity and the Planes of Historicity', reprinted in his *Futures Past: On the Semantics of Historical Time*, trans. Keith Tribe, Cambridge, Mass., and London, 1985, pp. 3ff.

27. See H. Thoma and H. Brunner, *Stadtresidenz Landshut*, Munich, 1956 (2nd edn.).

28. See most comprehensively *Schloss Schallaburg*, ed. Rupert Feuchtmüller, Vienna and St Pölten, 1975. For arcaded courtyards see in general Elisabeth Plonner, *Arkadenhöfer nördlich der Alpen. Zur Entwicklungsgeschichte eines Typus in der Profanarchitektur*, Munich, 1989.

29. Carl C. Christensen, *Princes and Propaganda*, Kirksville, Missouri, 1992, offers a treatment of the Saxon example.

30. In addition to the works on Halle cited in the previous chapter, Hitchcock, *German Renaissance Architecture* (Ch. 4, n. 32), remains the first point to turn for an orientation in English to German buildings of the sixteenth century.

31. This is exemplified by the Lynar tomb in the Spandau parish church (see illustration)

or by the scattered works of Schenck von Schweinsberg in Berlin, Magdeburg, Halberstadt and elsewhere.

32. See Monika Meine-Schawe, *Die Grablege der Wettiner im Dom zu Freiberg: Die Umgestaltung des Domchores durch Giovanni Maria Nosseni*, Munich, 1989.

33. For sculpture in Dresden, see Walther Hentschel, *Dresdener Bildhauer des 16. und 17. Jahrhunderts*, Weimar, 1966. Architecture in Saxony still deserves much attention. For the Dresden Schloss, see recently *Das Dresdener Schloss: Monument sächsischer Geschichte und Kultur*, exhibition catalogue, Dresden, 1989 (1st edn.).

34. For Schwerin, see Walter Ohle *et al.*, *Schwerin*, Leipzig, 1984, pp. 46ff.

35. Other noteworthy structures that in their forms seem to have fallen between the rival courts of Wismar and Güstrow are the buildings in Gadebusch and Schwerin.

36. A similar pattern of rebuilding after fires occurred in Bohemia and Moravia during the 1540s and 1550s at Pelhřimov, Telč, Třeboň and Jihlava; for this section of the chapter, consult Krčálová, in *Dějiny Českého výtvarného Umění* (n. 11). Macek, *Jagellonský věk* (Ch. 2, n. 17), pp. 321–2, provides a table indicating how widespread conflagrations had been 1479–1526 in Bohemian cities.

37. Jerzy Kowalczyk, *Zamość, Cittá ideale in Polonia: Il Fondatore Jan Zamoyski e L' architetto Bernardo Morando*, Wrocław etc., 1986, provides an accessible introduction. I have been informed by Jakob Goldberg that Jan Zamoyski brought Sephardic Jews from Italy to Zamość: the choice of an Italianate architecture for the synagogue may therefore also have been fitting as one designed to make the new population feel at home. Nevertheless, it is interesting to note that because of the protection offered by nobles, many synagogues in Poland were actually built by architects who served nobles' courts.

38. The historical circumstances are detailed in Josef Janáček, *České Dějiny: Doba Předbělo-horská*, 2 vols., Prague, 1968 and 1984; see also F. Seibt in *Renaissance in Böhmen*, (Ch. 3, n. 18), pp. 20–22.

39. 'um allhier einige Gebäude in antiker Weise zu machen, welche Antiken man jetzt für die höchste Kunst erachte, von welcher Kunst man aber hier in der Stadt nichts finde.' Quoted in Nikolaus and Rosemarie Zaske, *Kunst in Hansestädten*, Leipzig, 1985, p. 88.

40. For Vredemann de Vries in Danzig see Eugeniusz Iwanoyko, *Gdański okres Hansa Vredemanna de Vriesa*, Poznań, 1963; in Wolfenbüttel, Friedrich Thöne, 'Hans Vredemann de Vries in Wolfenbüttel', *Braunschweigisches Jahrbuch*, 41, 1960, pp. 47–68; in Prague, my *The School of Prague: Painting at the Court of Rudolf II*, Chicago and London, 1988, pp. 287–91.

For Opbergen, see Eugeniusz Gasiriowski, 'Anthonis van Opbergen', *Hafnia*, 1976, pp.

71–90. The use of Netherlandish model books is discussed by Barbara Uppenkamp, who is finishing a dissertation on the subject for the University of Hamburg, in 'Roll – und Beschlagwerk der Weserrenaissance', *Baudekoration als Bildungsanspruch, Materialien zur Kunst und Kulturgeschichte in Nord- und Westdeutschland* 6, Marburg, 1993, pp. 9–48.

41. E.g. by Białostocki, 'Mannerism and the Vernacular' (Ch. 1, n. 41) and in *The Art of the Renaissance in Eastern Europe* (Intro. n. 15). The remarks here repeat some of the observations in my review thereof, *Art Bulletin* (n. 21), 1978.

Notes to Chapter Seven

1. See Van der Osten and Vey, *Painting and Sculpture in Germany and the Netherlands* (Ch. 2, n. 1), pp. 254-5.

2. For an introduction to these works see Julius von Schlosser [-Magnino], *La letteratura artistica*, trans. Filippo Rossi, 3rd rev. edn. Otto Kurz, Florence and Vienna, 1964 (reprint 1967),pp. 276–80. Panofsky, 'History of Human Proportions' (Ch. 4, n. 17) pp. 104ff., refers to these texts in a disparaging manner, but they deserve more attention.

3. Works from Nuremberg are conveniently presented in *Gothic and Renaissance Art in Nuremberg* (Ch. 3, n. 24); see also Smith, *Nuremberg: A Renaissance City* (Ch. 3, n. 8); and Van der Osten and Vey, *Painting and Sculpture* (Ch. 2, n. 1). There is of course a literature in German on them as well.

4. The literature in English on the early history of collecting is surprisingly slim: see Niels von Holst, *Creators, Collectors and Connoisseurs*, trans. Brian Battershaw, London, 1967. A good introduction in German is contained in Elisabeth Scheicher, *Die Kunst- und Wunderkammer der Habsburger*, Vienna, Munich, Zurich, 1979. An overview of Habsburg collecting is now available in English in my 'From Treasury to Museum: The Collections of the Austrian Habsburgs' in *The Cultures of Collecting*, ed. Roger Cardinal and John Elsner, London, 1993, pp. 137–54. Although Werner Pallavicini, 'The Court of the Dukes of Burgundy: A Model for Europe', in Asch and Birke, eds., *Princes, Patronage and Nobility* (Ch. 2, n. 1), pp. 69–102, seeks to mitigate this impression, the effect of Burgundy, especially its impact on the Habsburgs and in general on the Central European courts and observers (see note below), seems hard to doubt. For a concise summary of the more standard view of the impact of Burgundy in the cultural realm, see C. A. J. Armstrong, 'The Golden Age of Burgundy: Dukes that Outdid Kings', in A. G. Dickens, ed., *The Courts of Europe: Politics, Patronage and Royalty 1400–1800*, London, 1977, pp. 55–75.

5. See for this point Scheicher, *ibid.*, p. 37. See also Burke, *Historical Anthropology* and *History and Social Theory* (Ch. 3, n. 5).

6. See Pallavicini, 'The Court of the Dukes of Burgundy' (n. 4), pp. 75–6.

7. See Lhotsky, 'Geschichte der Sammlungen' (Ch. 2, n. 27), pp. 14ff. See also my *Variations on the Imperial Theme in the Age of Maximilian II and Rudolf II*, New York and London, 1978, and *The Mastery of Nature* (Ch. 4, n. 8).

8. Julius von Schlosser, *Die Kunst- und Wunderkammer der Spätrenaissance*, Leipzig, 1908 (1st edn.).

9. See Joy Kenseth, ed., *The Age of the Marvelous*, exhibition catalogue, Hanover, N.H., 1991, presenting collecting as a pan-European phenomenon and giving access to some of the more recent literature on the question.

10. Saba da Castiglione, *Ricordi, ne quali si ragionadi tutte le materie che si ricercano a un vero gentil'huomo*, Venice, 1554 (1st edn. 1540). A brief selection from this work, including the passage here cited, is available in Robert Klein and Henri Zerner, *Italian Art 1500–1600: Sources and Documents*, Evanston, Illinois, 1989, pp. 23–5.

11. This and the following paragraphs repeat some of the arguments made in *The School of Prague* (Ch. 6, n. 40), pp. 11–17, and in Chapter 7 of *The Mastery of Nature* (Ch. 4, n. 8), where further references can be found. See for later examples Hubert Ch. Ehalt, *Ausdrucksformen absolutistischer Herrschaft: Der Wiener Hof im 17. und 18. Jahrhundert* (Sozial- und wirtschaftshistorische Studien 14), Munich, 1980, with further bibliography.

12. H. Brunner, ed., *Schatzkammer der Residenz*, Munich, 1979, pp. 7–18.

13. Lhotsky, 'Geschichte der Sammlungen' (Ch. 2, n. 27), pp. 285ff.

14. Cited by Rudolf Distelberger, 'The Habsburg Collections in Vienna during the Seventeenth Century', in *The Origins of Museums: The Cabinet of Curiosities in Sixteenth- and Seventeenth-Century Europe*, ed. Oliver Impey and Arthur Macgregor, Oxford, 1983, p. 40, and also by Lhotsky, 'Geschichte der Sammlungen' (Ch. 2, n. 27), p. 302; the original document was published by H. Zimmermann, 'Acten und Regesten aus dem Archiv des k.k. Ministeriums des Inneren', *Jahrbuch der Kunsthistorischen Sammlungen des Allerhöchsten Kaiserhauses* 7, pt. 2, 1888, p. lxii, reg. no. 4701.

15. Barbara Gutfleisch and Joachim Menzhausen, '"How a Kunstkammer should be Formed": Gabriel Kaltemarckt's Advice to Christian I of Saxony on the Formation of an Art Collection, 1587', *Journal of the History of Collections*, 1, 1989, pp. 3–32.

16. See Bruce T. Moran, 'Wilhelm IV of Hesse-Kassel: Informal Communication and the Aristocratic Context of Discovery', in Thomas Nickles, ed., *Scientific Discovery: Case Studies* (*Boston Studies in the Philosophy of Science 60*), Dordrecht, Boston and London, 1978, especially pp. 70–73.

17. For Strada's activities see Renate von Busch, 'Studien zur süddeutschen Antikensamm-

lungen des 16. Jahrhunderts', Ph.D. dissertation, Munich University, 1975. A comprehensive study is being finished by Dirk Jacob Jansen, who has written essays on the topic, (e.g. 'Jacopo Strada, Antiquario della Sacra Caesarea Maestá', *Leids Kunsthistorisch Jaarboek*, 1, 1982, pp. 57–70; 'Example and Examples: The Potential Influence of Jacopo Strada on the Development of Rudolphine Art', in *Prag um 1600: Beiträge* (Ch. 6, n. 15), pp. 132–46.

18. Gutfleisch and Menzhausen, 'How a Kunstkammer should be formed', (n. 15).

19. See in general Francis Haskell and Nicholas Penny, *Taste and the Antique*, New Haven and London, 1981; P. P. Bober, *Renaissance Artists and Antique Sculpture*, London, 1986.

20. For this approach, see *The School of Prague* (Ch. 6, n. 40); the actual display of contemporary collections is discussed in the essays collected in Impey, *Origins of Museums* (n. 14).

21. For good illustrations, including many in colour, of these sorts of objects, see Scheicher, *Die Kunst- und Wunderkammer der Habsburger* (n. 4); also *Prag um 1600*, exhibition catalogue, Essen and Vienna, 1988. For Dresden, see Joachim Menzhausen, *Dresdener Kunstkammer und Grünes Gewölbe*, Leipzig and Vienna 1977.

22. See Frances A. Yates, *The Art of Memory*, London, 1966; *idem*, *Theatre of the World*, London and Chicago, 1969; Paolo Rossi, *Clavis Universalis*, Milan, 1960; and in relation to their application to the Kunstkammer, my 'Remarks on the Collections of Rudolf II: The *Kunstkammer* as a Form of *Representatio*', *Art Journal* 38, 1978, pp. 22–8; more recent literature and approaches to this topic are discussed in *The Mastery of Nature* (Ch. 4, n. 8).

23. See Lina Bolzoni, 'L' "invenzione" dello Stanzino di Francesco I', in *Le Arti del Principato Mediceo,* Florence, 1980, pp. 255–99; Giuseppe Olmi, 'Science–Honour–Metaphor: Italian Cabinets of the Sixteenth and Seventeenth Centuries', in *The Origins of Museums*, pp. 5–16; and *idem*, 'Dal "teatro del mondo" ai mondi inventariati: Aspetti e forme del collezionismo nell'età moderna', in P. Barocchi and G. Ragionieri, eds, *Gli Uffizi: Quatro secoli di una galleria*, Florence, 1983, p. 243.

24. See Elisabeth Scheicher, 'The Collection of Archduke Ferdinand II at Schloss Ambras: its Purpose, Composition and Evolution', in *The Origins of Museums* (n. 14), pp. 29–38, and 'Zur Entstehung des Museums im 16. Jahrhundert: Ordnungsprinzipien und Erschliessung der Ambraser Sammlung Erzherzog Ferdinands II'. in *Der Zugang zum Kunstwerk, Schatzkammer, Salon, Ausstellung, 'Museum',* (*Akten des XXV. Internationalen Kongresses für Kunstgeschichte, Wien 1983, 4*), Vienna, Cologne, Graz, 1986, pp. 43–52.

25. See more for this point, *The Mastery of Nature* (Ch. 4, n. 8)

26. Friedrich Polleross, ' "Joyas de las Indias" und "Parvus Mundus": Sammlungen und Bibliotheken als Abbild des Kosmos', in *Federschmuck und Kaiserkrone: Das barocke Amerikabild in den habsburgischen Ländern*, exhibition catalogue, Schlosshof, 1992, p. 38.

27. An important part of the objects listed in the 1607–11 inventory of Rudolf II's Kunstkammer consists of so-called 'scientifica', instruments that could be utilized for scientific investigations. For this point and the references which substantiate the point made in this paragraph, see my *The Mastery of Nature* (Ch. 4, n. 8), Chapter 7, where the problem of the possible uses of collections are discussed. Issues pertaining to the contents, importance, and use of collections, especially in Italy, are discussed in the essays now gathered in Giuseppe Olmi, *L'inventario del mondo: Catalogazione della natura e luoghi del sapere nella prima età moderna*, Bologna, 1992. The relationship of the Kunstkammer and library as places for research are also discussed in Jörg-Ulrich Fechner, 'Die Einheit von Bibliothek und Kunstkammer im 17. und Privatbibliotheken im 17. und 18. Jahrhundert: Raritätenkammern, Forschungsinstrumente oder Bildungsstätten', in *Wolfenbütteler Forschungen* 1, 1977, pp. 11–31.

28. Kenseth, 'A World in on Closet Shut', in *The Age of the Marvelous* (n. 9), p. 88.

29. For Van Mander's comments, see *Het Schilderboeck...*, Haarlem, (*Voorreden*), fol. ivr. See, for the collection, *Prag um 1600* (n. 21), with further references.

30. This and the following paragraphs repeat the arguments advanced in the Chapter 7 of *The Mastery of Nature* (Ch. 4, n. 8). Examples of this sort of collecting from the time of the dukes of Berry, whose patronage activities hardly seem distinguishable from their collecting, are so manifold that it seems almost superfluous to name them; for a notable counter-example to the argument that patronage, decoration and collecting are disconnected, see Steven Orso, *Philip IV and the Decoration of the Alcazar of Madrid*, Princeton, 1986.

For a more complete view of the interrelationship of patronage and collecting at the early modern courts, see Martin Warnke, *Hofkünstler* (Ch. 3, n. 13), especially pp. 224ff.

31. For much information on this theme in general, see Warnke, *Hofkünstler* (Ch. 3, n. 13), pp. 240ff., 286ff., *et passim*.

In reference to the Habsburg courts, this is one of the themes of Lhotsky's 'Die Geschichte der Sammlungen' (Ch. 2, n. 27), where a vast amount of material is gathered demonstrating the interconnection of the Habsburgs' patronage of court artists with the development of the court collections. In a 1963 lecture Erwin Neumann also specifically emphasised that the work of the the court artists was one of the sources of Rudolf II's Kunstkammer, see Bauer, in 'Inventar', p. 19.

32. For the so-called 'Dürer-Renaissance' *c.* 1600 and aspects of this subject see *The Mastery of Nature* (Ch. 4, n. 8), Chapter 3, and especially Gustav Gluck, 'Fälschungen auf Dürer's Namen aus der Sammlung Erzherzog Leopold Wilhelms', *Jahrbuch der Kunsthistorischen Sammlungen des Allerhöchsten Kaiserhauses* 28, 1909–10, pp. 1–35; Hans Kauffmann, 'Dürer in der Kunst- und im Kunslerturteil um 1600' in *Anzeiger des Germanischen' National Museums, 1940–53*, pp. 18–60; *Dürer Renaissance*, exhibition catalogue; Munich, 1971; Fučíková, 'Umělcí na dvoře Rudolfa II' *Umění*, 20, 1972, pp. 146–66; Hans Georg Gmelin, 'Dürerrenaissance um 1600', *Im Blickpunkt 7*, 1979; Gisela Goldberg, 'Dürer-

Renaissance am Münchener Hof', in *Um Glauben und Reich: Kurfürst Maximilian I*, 2, pt. 1: *Beiträge zur Bayerischen Geschichte und Kunst 1573–1657*, Munich, 1980, pp. 318–23; 'Zur Ausprägung der Dürer-Renaissance in München', *Münchener Jahrbuch der bildenden Kunst* 31, 1980, pp. 129–76.

33. Gutfleisch and Menzhausen, *op.cit.* (n. 15), p. 28.

34. For Munich, see *Wittelsbach und Bayern: Kurfürst Maximilian I*, exhibition catalogue, 2 vols., Munich, 1980; for the interpretation of Prague offered here, see *The School of Prague* (Ch. 6, n. 40) and the next chapter.

35. See Pallavicini, 'The Court of the Dukes of Burgundy' (n. 4), p. 76.

Notes to Chapter Eight

1. Van Mander, *Schilderboeck...*, *loc. cit.* (Ch. 7, n. 29); Joachim von Sandrart, *L'academia Todesca, oder die Teutsche Academie* 1, Nuremberg, 1675, p. 356.

2. For the subject of turning and sovereigns' involvement, see Joseph Connors, '*Ars Tornandi*: Baroque Architecture and the Lathe', *Journal of the Warburg and Courtauld Institutes*, 53, 1990, pp. 217–30, and Klaus Maurice, *Der drechselnde Souverän: Materialien zu einer fürstlichen Maschinenkunst – Sovereigns as Turners: Material for a Machine Art by Princes*, Zürich, 1985.

3. These paragraphs paraphrase *The School of Prague* (Ch. 6, n. 40) pp. 17–24 (with further references, pp. 120ff.); in general this chapter summarises the arguments of that book.

4. These are summarized in part in my *Variations on the Imperial Theme in the Age of Maximilian II and Rudolf II*, New York and London, 1978, pp. 105ff.; as yet unpublished (I am grateful to Dr Fröschel for informing me of them) research by Dr Thomas Fröschel of the University of Vienna sheds much further light on this subject.

5. Gifts to Saxony are discussed in the works mentioned in the previous note. The connection with Salzburg is discussed in my 'Die Kunst am Hofe Rudolfs II in Bezug auf das Salzburg Wolf Dietrichs', in *Fürsterzbischof Wolf Dietrich von Raitenau: Gründer des barocken Salzburg*, exhibition catalogue, Salzburg, 1987, pp. 185–9. Kurz, *European Clocks and Watches* (Intro, n. 21), discusses gifts to the Porte.

6. Even smaller centres like Wolfenbüttel (for which see Friedrich Thöne, *Geist und Glanz einer alten Residenz*, Munich, 1963) could offer employment to widely travelled figures like the Netherlander Hans Vredeman de Vries, who was later to work in Prague and Gdańsk.

7. The most comprehensive view of the sculptor is still provided by Lars Olof Larsson, *Adrian de Vries*, Vienna and Munich, 1967.

8. See *The School of Prague* (Ch. 6, n. 40), Chapter 2, and 'The Eloquent Artist' (Ch. 5, n. 33) for this theme. See also, though not completely convincing, Walter S. Melion, 'Love and Artisanship in Hendrick Goltzius's *Venus, Bacchus and Ceres*', *Art History*, 16, 1993, pp. 60–94.

9. The general subject is most accessible in Roy Strong, *Splendour at Court*, Boston and London, 1973. For the Habsburg court, see *Variations on the Imperial Theme* (n. 4); Karl Vocelka, *Habsburgische Hochzeiten 1550–1600*, Vienna, Cologne, Graz, 1977; and for the following period, Herbert Seifert, *Der Sig-prangende Hochzeit-Gott: Hochzeitfeste am Wiener Kaiserhof 1622–1699*, Vienna, 1988.

10. The Prague works are mentioned in *The School of Prague* (Ch. 6, n. 40). Outstanding works for religious contexts were also done for other Protestant courts. They include altarpieces for the church in Wolfenbüttel by Hans Vredemann de Vries and the Freiberg sculptor Bernhard Ditterich; Ebbert Wolff's tabular altar and Christoph Gertner's *Last Judgement* (replacing a composition originally commissioned from Joseph Heintz) for the Bückeburg Schlosskapelle; Adriaen de Vries's baptismal font for the town church there; and his tomb for Count Ernst in the mausoleum designed by Nosseni in Stadhagen. For the works in Bückeburg, see Robert Bruck, *Ernst zu Schamburg, Ein Kunstföderndes Fürst des 17. Jahrhunderts*, Berlin, 1917, and Johannes Habich, *Die Kunstlerische Gestaltung der Residenz Bückeburg dürch Fürst Ernst 1601–1622*, Bückeburg, 1969. For Stadthagen see more recently Monika Meine, 'Das Stadthagener Mausoleum der Grafen von Holstein-Schaumburg', in *Renaissance in Weserraum*, 2, ed. G. Ulrich Grossman, Munich and Berlin, 1989, pp. 145–58.

11. See Mariann Jenkins, *The State Portrait*, New York, 1947 and *Vorstenportretten uit de eerste helft van de 16de eeuw*, exhibition, Amsterdam, 1972; the subject still requires systematic treatment.

12. See, for the discussion of this work presented here, Chapter 4 and its Excursus in my *The Mastery of Nature* (Ch. 4, n. 8) and my 'Arcimboldo's Serious Jokes: '"Mysterious but Long Meaning"' in *The Verbal and the Visual: Essays in Honor of William Sebastian Heckscher*, ed. Karl-Ludwig Selig and Elizabeth Sears, New York 1990, pp. 59–86.

13. This interpretation repeats the arguments of my *Variations on the Imperial Theme* (n. 4) and 'The *Kunstkammer* as a Form of *Representatio*' (Ch. 7, n. 22).

14. This paragraph recapitulates some material in Chapter 7 of *The Mastery of Nature* (Ch. 4, n. 8).

15. This is true no less for Munich than for Prague. Matthias Kager painted a miniature that aimed to glorify the rule of Maximilian I of Bavaria, while Von Aachen and Spranger made small, elusive coppers glorifying the reign of Rudolf II. It is significant that an important contemporaneous claim, such as that for Maximilian I of Bavaria's aspiration to

electoral dignity, could be expressed in an allegorical miniature by Johann König done in 1616. For the works for Munich, see *Wittelsbach und Bayern, Kurfürst Maximilian I*, exhibition catalogue, Munich, 1980.

16. For further arguments, see my '*Éros* et *poesia*: la peinture à la cour de Rodolphe II', *Revue de l'art*, XVIII, 1985, pp. 29–46. Christoph Gertner purveyed scenes of nude and often recumbent goddesses, at times with sexually suggestive subjects, to the court of Wolfenbüttel, where several other artists did such themes, and perhaps the Oldenburg and Bückeburg courts thus also received them. Among other Dresden court artists, Anton Gasser and Hans Kellerthaler represented such themes. Similarly, the embracing Venus and Mars in Hubert Gerhard's large bronze group that once adorned the Fuggers' summer residence (now Munich, Bayerisches National Museum) are hardly chaste figures.

17. Charles Hope, 'Problems of Interpretation in Titian's Erotic Painting', in *Tiziano e Venezia: Convegno Internazionale di Studi, Venezia, 1976*, Vicenza, 1980, pp. 112–13.

18. See *The Mastery of Nature* (Ch. 4, n. 8), Ch. 5 and 'The Eloquent Artist' (Ch. 5, n. 33).

19. For the intellectual circumstances of this court, see R. J. W. Evans, *Rudolf II and his World: A Study in Intellectual History*, Oxford, 1973, and also *The Making of the Habsburg Monarchy*, Oxford, 1979.

20. See *School of Prague* (Ch. 6, n. 40), pp. 56–8.

21. For these works see first Th. A. G. Wilberg Vignau-Schuurman, *Die emblematischen Elemente im Werke Joris Hoefnagels*, Leiden, 1969, and Marjorie Lee Hendrix, 'Joris Hoefnagel and the *Four Elements*: A Study in Sixteenth-Century Nature Painting', Ph.D. dissertation, Princeton University, 1984. The bibliography on Hoefnagel is ever expanding.

22. See *The Mastery of Nature* (Ch. 4, n. 8) for the other side of things.

23. Such as Hoefnagel's son Jacob, Hans Hoffmann, and Dirck de Quade van Ravesteyn. See first *Prag um 1600* (Ch. 7, n. 21). Other aspects of and approaches to art at the court are discussed in the essay volume to this exhibition catalogue, in E. Fučíková *et al.*, *Die Kunst am Hofe Rudolfs II*, Hanau, 1988, and in the essays collected in *Jahrbuch der Kunsthistorischen Sammlungen in Wien*, 85–86, 1989–90 (published 1992).

24. See Marie-Christiane Maselis *et al.*, *De Albums van Anselmus de Boodt (1550–1632): Geschilderde natuurobservatie aan het Hof van Rudolf II te Praag*, Tielt, 1989.

25. *Mastery of Nature* (Ch. 4, n. 8), Chapter 1, some of whose arguments are repeated here.

26. See '*Die Kunst am Hofe Rudolf II*' (n. 23); the other material is discussed in *The Mastery of Nature* (Ch. 4, n. 8) and in *The School of Prague* (Ch. 6, n. 40).

27. See *The Mastery of Nature* (Ch. 4, n. 8), Chapter 6.

28. These include metaphor, annomination, asyndeton, metonomy and synecdoche. See Roland Barthes, *Arcimboldo*, Rome and Paris, 1980 and Giancarlo Maiorino, *The Portrait of Eccentricity: Arcimboldo and the Mannerist Grotesque*, University Park and London, 1991.

29. See 'The Eloquent Artist' (Ch. 5, n. 33).

30. In addition to the discussion of knowledge of court works in *The School of Prague* (Ch. 6, n. 40), nobles' collections of this era are discussed (most accessibly) by Jaroslav Pánek, 'Zwei Arten böhmischen Adelsmäzenatentums in der Zeit Rudolfs II' in *Prag um 1600: Beiträge* (Ch. 6, n. 15).

31. See Jiří Pešék 'Porträts in den Bürgerhäusern des rudolfinischen Prags', in *ibid.* pp. 244–8 and *idem*, 'Inwestycje kulturalne mieszczań praśkich przed 1620 r. Stan i perspektywy badań na podstawie inwentarzy sprodkowych i testamentów', in Jan Harasimowicz, ed., *Sztuka Miast i Mieszczaństwa*, pp. 317–35.

32. Zlat, 'Nobilitacja przez sztukę – jedna z funkcji mieszczańskiego mecenatu w XVI i XVI w.', *ibid.*, pp. 77–102.
 Although Jiří Pešék, 'Obrazy a grafiky a jejich majitele v předbělohorské Praze', *Umění*, 39, 1991, pp. 369–83, regards the spread of collecting as a form of emulation of the activities of Ferdinand of the Tyrol, in his study of the Rudolfine period he also considers that through collecting the Prague bourgeois were seeking to demonstrate their cultural qualifications, to represent individual or family property and to move upwards socially.

33. In addition to the discussion in *The School of Prague* (Ch. 6, n. 40), much information on these figures in available in *Zeichnung in Deutschland: Deutsche Zeichner 1540–1640*, exhibition catalogue, ed. Heinrich Geissler, Stuttgart, 1979–80.

34. An engraving by Aegidius Sadeler after Heintz (*School of Prague* [Ch. 6, n. 40], cat. no. 7.3) provided the source for a large painting in the church of St Nicholas in Elbląg, Warmia (Ermland), as also for a painting on an altarpiece formerly in the Lutheran church of Insterburg, East Prussia (*c.* 1623; illustrated in Hempel, *Baroque Art and Architecture in Central Europe* [Intro. n. 31], fig. 25); in Slovakia Von Aachen was frequently copied in paintings. In mid-seventeenth-century Gdańsk (Danzig) Michael Philip copied engravings of Müller after De Vries for presentation drawings (drawings now in private collections); and in 1674 an altarpiece in Wiener Neustadt was still being made in a style after Spranger.

35. These phenomena are discussed in *The School of Prague* (Ch. 6, n. 40); see further my 'Addenda Rudolphina', in *Annales de la Galerie Nationale Hongroise* (*Études sur l'histoire de l'art en honneur du soixantième anniversaire de Miklós Mojzer*), Budapest, 1991, pp. 141–7. The importance of Prague for 'Dutch Mannerism' has been reconfirmed by *Dawn of the Golden Age: Northern Netherlandish Art 1580–1620*, exhibition catalogue, Zwolle, 1993.

Notes to Chapter Nine

1. For the situation in Wolfenbüttel, see *Von herzöglichen Hoftheater zum bürgerlichen Tourneetheater*, exhibition catalogue, Wolfenbüttel, 1992, pp. 16ff. The activities of English theatrical troops in the area stretching to Königsberg in Prussia are discussed by Jerzy Limon, *Gdański Teatr 'Elzbietanski'*, Wrocław etc., 1989, and more generally, *Gentlemen of a Company: English Players in Central and Eastern Europe, 1590–1660*, Cambridge, 1985. Ironically Hesse at this time also experienced a wave of state-organized iconoclasm.

2. For Heinrich Julius, see now Hilde Lietzmann, *Heinrich Julius zu Braunschweig-Wolfenbüttel (1564–1613): Persönlichkeit und Wirken für Kaiser und Reich* (*Quellen und Forschungen zur Braunschweigische Geschichte*, 30), Wolfenbüttel, 1993. For Herzog August, see first *Sammler Fürst Gelehrter: Herzog August zu Braunschweig und Lüneburg 1579–1666*, exhibition catalogue, Wolfenbüttel, 1979.

3. An introduction to some of this activity is provided by Evans, *Rudolf II and his World* and *The Making of the Habsburg Monarchy* (Ch. 8, n. 19); Erich Trunz, 'Der deutsche Späthumanismus um 1600 als Standes Kultur', in *Deutsche Barockforschung*, ed. R. Alewyn, Cologne and Berlin, 1968 (3rd edn.), pp. 147–81; Wilhelm Kühlmann, *Gelehrtenrepublik und Fürstenstaat*, Tübingen, 1982.

4. For the interconnection of library and Kunstkammer, see Jörg-Ulrich Fechner, 'Die Einheit von Bibliothek und Kunstkammer im 17. und 18. Jahrhundert, dargestellt an Hand zeitgenössiger Berichte', in *Offentliche und Private Bibliotheken im 17. und 18. Jahrhundert: Raritätenkammern, Forschungsinstrumente oder Bildungsstätten* (*Wolfenbütteler Forschungen* 1), ed. Paul Raabe, Bremen and Wolfenbüttel, 1977, pp. 11–31 (Ch. 7, n. 27). For the debate over the use of the Kunstkammer, see *The Mastery of Nature* (Ch. 4, n. 8), Chapter 7.

5. See Ivan Muchka, 'Die Architektur unter Rudolf II, gezeigt am Beispiel der Prager Burg', in *Prag um 1600* (Ch. 7, n. 21), 1, pp. 85–93; and *idem* 'Rudolf II als Bauherr', in *Die Kunst am Hofe Rudolfs II*, Hanau, 1988, pp. 180–209.

6. For Sigsimund and the arts, see in English, *Sztuka Dworu Wazów w Polsce, Court Art of Vasa Dynasty in Poland*, exhibition catalogue, Kraków, 1976.

7. The subject is worthy of more attention. For a general overview, covering more than its title suggests, see Werner Schade, *Dresdener Zeichnungen 1550–1650*, exhibition catalogue, Dresden, 1969.

8. See in general for German architecture of this time Hitchcock, *German Renaissance Architecture* (Ch. 4, n. 32).

9. See Frances A. Yates, *Theatre of the World* (Ch. 7, n. 22) and also *The Rosicrucian Enlightenment*, London, 1972, for this notion of Vitruvianism.

10. See Yates, *Rosicrucian Enlightenment* (n. 9); Richard Patterson, 'On the Hortus Palatinus at Heidelberg and the Reformation of the World', *Journal of Garden History*, 1, 1981, pp. 67–104, 179–202.

11. An introduction is provided by the exhibition catalogue and accompanying essay volumes, *Um Glauben und Reich: Kurfürst Maximilian I* (*Wittelsbach und Bayern*), 2, exhibition catalogue, Munich, 1980; *Beiträge zur Bayerischen Geschichte und Kunst* (*1573–1657*). See also the essays in Hubert Glaser, ed., *Quellen und Studien zur Kunstpolitik der Wittelsbacher*, Munich, 1980. For sculpture see further the essays Dorothea Diemer, 'Bronzeplastik um 1600 in München: Neue Quellen und Forschungen I', and 'Neue Quellen und Forschungen II', *Jahrbuch des Zentralinstituts für Kunstgeschichte* 2, 1986, pp. 107–1777, and 3, 1987, pp. 109–68 and *idem*, 'Hubert Gerhard und Carlo Pallago als Terrakottaplastiken', *ibid.*, 4, 1988, pp. 19–141.

12. See the essays by Gabriele Dischinger, 'Die Jesuitenkirche St Michael in München: Zur frühen und Baugeschichte', and particularly Heinz Jürgen Sauermost, 'Zur Rolle St Michaels im Rahmen der wilhelminisch-maximilianischen Kunst', in *Beiträge zur Bayerischen Geschichte und Kunst* (n. 11), 1, pp. 152–74.

13. See *Fürsterzbischof Wolf Dietrich von Raitenau* (Ch. 8, n. 5).

14. See Francis Haskell, *Patrons and Painters: Art and Society in Baroque Italy*, New York, etc. (reprint), 1971, pp. 63ff.

15. Bernadoni had previously employed a similar design for the Jesuit church in Nieśwież: for architecture in Poland mentioned in this chapter, see Adam Miłobędzki, *Architektura Polska XVII Wieku*, 2 vols. (with brief English summary), Warsaw, 1980; these buildings are treated 1, pp. 119ff. See also Władysław Tatarkiewicz, *O Sztuce Polskiej XVII. i XVIII. wieku: Architektura Rzeźba*, Warsaw, 1966.

16. For this subject see in general Hermann Hipp, *Studien zur Nachgotik des 16. sund 17. Jahrhunderts in Deutschland, Böhmen, Österreich und der Schweiz*, 3 vols., Hannover, 1979.

17. This comment again is a response to Baxandall, *Limewood Sculptors* (Intro. n. 14). A study of sculpture in this medium could profitably consider these works as well.

18. See Monika Meine-Schawe, *Die Grablege der Wettiner im Dom zu Freiberg: Die Umgestaltung durch Giovanni Maria Nosseni, 1585–1594*, Munich, 1992.

19. See most recently Monika Meine, 'Das Stadthagener Mausoleum der Grafen von Holstein-Schaumburg', (Ch. 8, n. 11).

20. See Hilda Lietzmann, 'Die Deutsch-Lutherische Dreifaltigkeits-, die spätere Ordenskirche St Maria de Victoria auf der Kleinen Seite zu Prag', *Zeitschrift für*

Kunstgeschichte, 40, 1977, pp. 205–26; Georg Skalecki, *Deutsche Architektur zur Zeit des Dreissigjährigen Krieges: Der Einfluß Italiens auf das Deutsche Bauschaffen*, Regensburg, 1989, pp. 45ff.

21. Hitchcock, *German Renaissance Architecture* (Ch. 4, n. 32), p. 339, makes the comparison with estipites.

22. This is the *Krotka Nauka Budownicza Dworow, Palacow, Zamkow **podlug Nieba y zwyczáiu Polskiego*** (author's emphasis), published in Kraków in 1658. Białostocki, 'Mannerism and Vernacular' (Ch. 1, n. 42), and *The Art of the Renaissance in Eastern Europe* (Intro. n.15) describes these buildings as examples of a Polish vernacular, but given that the 'Mannerist' court architect Santi Gucci is responsible for one of the prime examples of this trend (Książ Wielki) a consideration from the perspective suggested here might also be fruitful.

23. See Feuer-Tóth, *Renaissance Architecture in Hungary* (Ch. 6, n. 24).

24. Renaissance town halls in Slovakia are now the subject of a separate study' by Fedor Kresák, 'Staré slovenské radnice', *Ars*, 2, 1992, pp. 156–74.

25. An introduction to this rich topic is provided by the objects and essays in the exhibition catalogue, with essay volume, *Welt im Umbruch: Augsburg zwischen Renaissance und Barock*, 3 vols., Augsburg, 1980–81. For the bronze monuments in Augsburg, see especially Helmut Friedel, *Bronzebildmonumente in Augsburg, 1589–1606: Bild und Urbanität*, Augsburg, 1974. Buildings are treated in general studies such as Hans-Joachim Kadatz, *Deutsche Renaissancebaukunst von der frühbürgerlichen Revolution bis zum Ausgang des Dreißigjährigen Krieges*, Berlin, 1983.

26. For this interpretation, see Jürgen Zimmer, 'Das Augsburger Rathaus und die Tradition', *Munchener Jahrbuch der bildenden Kunst* 28, 1977, pp. 191–218; see in general *Elias Holl und das Augsburger Rathaus*, exhibition catalogue, Regensburg, 1985.

27. See *Das alte Nürnberger Rathaus*, exhibition catalogue, Nuremberg, 1978.

28. See *Renaissance in Weserraum* (Ch. 8, n. 11), and for Nördlingen, Christopher R. Friedrichs, *Urban Society in an Age of War: Nördlingen, 1580–1720*, Princeton, 1979. Some of the other local studies of Nuremberg and Augsburg cited here provide related information, but a comprehensive study of the German towns relating cultural developments to their social and economic nexus would be most welcome.

29. Among other contributions, see Jeffrey Chipps Smith, 'Netherlandish Artists and Art in Renaissance Nuremberg', *Simiolus*, 1990, pp. 153–68; Ilja M. Veldmann, 'Protestant Emigrants: Artists from the Netherlands in Cologne (1562–1612)', in *Kunstlerischer Austausch* (Ch. 1, n. 40), 1, pp. 163–74, and 'Keulen als toefluchtsoord voor Nederlandse

Kunstenaars', *Oud Holland*, 107, 1993, pp. 34–58. Margaretha Kramer, 'Die Probleme einer Malerschule in Frankenthal', *Zeichnung in Deutschland: Deutsche Zeichner 1540–1640*, 2, pp. 193–6.

30. Gdańsk (Danzig) still needs adequate study; among older literature, consult Georg Cuny, *Danzigs Kunst und Kultur im 16. und 17. Jahrhundert*, Frankfurt am Main, 1910; a recent overview of painting is provided by Teresa Grzybkowska, *Złoty Wiek Malarstwa Gdańskiego*, Warsaw, 1990, with further references.

31. For Schickhardt see now Ehrenfried Kluckert, *Heinrich Schickhardt, Architekt und Ingenieur: Eine Monographie* (Herrenberger Historische Schriften 4), Herrenberg, 1992.

32. Skalecki, *Deutsche Architektur zur Zeit des Dreissigjährigen Krieges* (n. 20); Skalecki, pp. 30–36, also emphasizes the assimilation of Italianate art theory.

33. See Jan Białostocki, 'The Baltic Area as an Artistic Region in the Sixteenth Century', *Hafnia*, 1976, pp. 11–24.

34. This is an extremely rich topic on which it is impossible to divagate at the required length here; some hints to the Lublin school are offered in Białostocki, *The Art of the Renaissance in Eastern Europe* (Intro. n. 14); see also Tatarkiewicz, *O Sztuce Polskiej* (n. 15). The varieties of forms in Poland are also suggested in Miłobędzki, *Architektura* (n. 15). My point is that this wide variety makes it difficult to talk about any particular 'vernacular'.

NOTES TO CHAPTER TEN

1. Herbert Langer, *The Thirty Years' War* (trans.), Poole, 1978, is one of the few attempts at presenting a cultural history of the period. The recent survey by John Gagliardo, *Germany under the Old Regime 1690–1790*, London and New York, 1991, also presents a more nuanced view of the effects of the conflict, but only by stating that (p. 78) the 'mediocre level of German cultural achievement' must be weighed against the view that 'no great wave of cultural creativity was in evidence in 1618 to cut short by the war'; the criterion for these views is that no 'national' schools of literature or the arts emerged before or after. This book argues against these points, and against this criterion, which is inappropriate.

2. There is a huge literature on the Thirty Years' War, little of it dealing with the cultural question. To mention just one book out of many in English, the reader can now turn for a reliable introduction to Geoffrey Parker, ed., *The Thirty Years' War*, London, 1984.

3. Joachim von Sandrart, *Teutsche Academie*, Nuremberg, 1675, as translated by Dieter Graf in 'Introduction' to *German Baroque Drawings*, exhibition catalogue, London, 1975, which also briefly adumbrates the historiography of the art of the period. See for a contrasting view my *Drawings from the Holy Roman Empire 1540–1680* (Intro, n. 4), pp. 4ff.

4. As suggested recently by *Baroque Goldsmiths' and Jewellers' Art from Hungary*, exhibition catalogue, Washington, D.C., 1993, and *Schätze des Ungarischen Barock*, Hanau, 1991, a German version of the same. An enlarged version of the same exhibition presenting the arts of Hungary, containing examples of paintings and prints, was presented (with catalogue containing new essays) in New York, Bard Graduate Center for Studies in the Decorative Arts, in 1994.

5. A book such as Hugh Trevor-Roper's *The Plunder of the Arts in the Seventeenth Century*, Oxford, 1967, while undoubtedly correctly emphasizing a recurrent phenomenon of the time, in this sense nevertheless contributes to the perpetuation of the traditional image of devastation, rather than analysing what is distinctive about the seventeenth century. A comparative analysis with wars of the eighteenth century would have been informative in this regard. (One thinks of the bombardment of Dresden by Frederick II of Prussia or the French armies' sacking of artistic treasures.)

6. See for example Skalecki, *Deutsche Architektur* (Ch. 9, n. 20).

7. As discussed in Yates, *The Rosicrucian Enlightenment* (Ch. 9, n. 9).

8. See Yates, *The Rosicrucian Enlightenment* (Ch. 9, n. 9), pp. 144ff.

9. See Mirjam Bohatcova, *Irrgarten der Schicksale: Einblattdrucke vom Anfang des Dreissigjährigen Krieges*, trans. Peter Aschner, Prague, 1966; among earlier treatments, E.A. Beller, *Caricatures of the 'Winter King'*, Oxford, 1928, and *Propaganda in Germany during the Thirty Years' War*, Princeton, 1940, can still be consulted with profit.

10. As is demonstrated in David Sabean, *Power in the Blood: Popular Culture and Village Discourse in Early Modern Germany*, Cambridge, etc., 1984, pp. 61–93.

11. See Holger Reimers, *Ludwig Münstermann: Zwischen protestantischer Askese und gegenreformatorischer Sinnlichkeit* (*Materialien zur Kunst- und Kulturgeschichte in Nord- und Westdeutschland* 8), Marburg, 1993. Reimers' book also provides a good description of the general situation of Protestant sculpture-making in northern Germany and an overview of sculptural workshops of the early seventeenth century.

12. For the Gröninger of the early seventeenth century, see Christoph Stiegemann, *Heinrich Groeninger, um 1578–1631: Ein Beitrag zur Skulptur zwischen Spätgotik und Barock in Fürstentum Paderborn*, Paderborn, 1989: The best introduction to sculpture of the seventeenth century in northern Germany is provided by the essays and entries in Jörg Rasmussen, ed., *Barockplastik in Norddeutschland*, Mainz, 1977.

13. Quoted in Werner Schade, 'Dresden und Prag um 1600', *Prag um 1600:* (Ch. 6, n. 15).

14. For the continuing development of the arts in Augsburg, with references to further literature, see *Augsburger Barock,* exhibition catalogue, Augsburg, 1968.

15. For art and artists in Frankfurt in the late sixteenth and early seventeenth centuries, see now the important exhibition catalogue, *Georg Flegel*, Frankfurt am Main, 1993.

16. The actual role of the Jesuit Order in Central Europe has recently been detailed for Bohemia by Francesco Gui, *I Gesuiti e la Rivoluzione Boema: Alle origini della guerra dei trent'anni*, Milan, 1989.

17. See Skalecki, *Deutsche Architektur* (Ch. 9, n. 20) and Hitchcock, *German Renaissance Architecture* (Ch. 4, n. 32) for these buildings.

18. This is the argument of R. J. W. Evans, 'The Significance of the White Mountain for the Culture of the Czech Lands', *Bulletin of the Institute of Historical Research*, 44, 1971, pp. 34–54; and *idem, The Making of the Habsburg Monarchy, 1550–1700* (Ch.8, n. 19).

19. For these and related buildings in the Austrian lands, see Enrico Morpurgo, *L'opera del Genio Italiano all'Estero: Gli Artisti in Austria*, 2, Rome, 1962; Günter Brucher, *Barockarchitektur in Österreich*, Cologne, 1983. The Dominican Church may be after plans by Giovanni Pietro Tencalla.

20. For later Protestant uses of emblems in churches see Katarzyna Cieślak, 'Über Emblematik in Danziger Kirchen und ihren kirchengeschichtlichen Hintergrund', in *Zwei Hanseatische Städte Bremen und Danzig im Laufe der Jahrhunderte* (*Materialien des wissenschaftlichen Kolloquiums vom 10./11. December 1993 und der Universität Gdańsk [Danzig]*), ed. Andrzej Gorth, Gdańsk, 1994 pp. 73–96. A later north German example of such emblematic decoration that still survives is in the church in Lucklum, Lower Saxony.

Emblems and the arts are an ever-growing topic of investigation, with an increasingly large literature. A starting point is provided by Mario Praz, *Studies in Seventeenth-Century Imagery*, 2 vols., Rome, 1964, 1972. For the later German scene, see for example Cornelia Kemp, *Angewandte Emblematik in süddeutschen Barockkirchen*, Munich and Berlin, 1981.

21. For these buildings, see Pál Voit, *Barock in Ungarn*, Budapest, 1970.

22. See Konstanty Kalinowski, *Barock in Schlesien, Geschichte, Eigenart und heutige Erscheinung*, Munich, 1990.

23. See Konrad Renger, *Peter Paul Rubens, Altäre für Bayern*, exhibition catalogue, Munich, 1990. Gdańsk sculpture has still not been adequately treated as a whole.

24. For these artists among a general account of German painters of the seventeenth century, see Götz Adriani, *Deutsche Malerei im 17. Jahrhundert*, Cologne, 1977.

25. The best introduction to the subject, with extensive notation, is Peter Amelung, 'Die Stammbücher des 16./17. Jahrhunderts als Quelle der Kultur- und Kunstgeschichte', in *Zeichnung in Deutschland: Deutsche Zeichner 1540–1640*, exhibition catalogue, Stuttgart, 1980, 2, pp. 211–22.

26. For Elsheimer, see Keith Andrews, *Adam Elsheimer*, Oxford, 1977 (2nd edn. 1985).

27. For Liss, see chiefly *Johann Liss*, exhibition catalogue, Augsburg and Cleveland, 1975.

28. They include Govaert Flinck from Cleves; Juriaen Ovens from Schleswig-Holstein (then under Danish suzerainty), known for having replaced Rembrandt's painting in the Amsterdam town hall; Christoph Paudiss; Nicolas Knupfer, from Leipzig, the teacher of Jan Steen; the portrait painter, Caspar Netscher; the genre painter, Johannes Lingelbach; and the still-life artists, Jacob Marel and Abraham Mignon, who had been pupils of Georg Flegel in Frankfurt am Main. See Georg Troescher, *Kunst- und Künstlerwanderungen in Mitteleuropa 800–1800*, 1, *Deutsche Kunst und Künstler in der französischen und in der niederländischen Kunst*, Baden-Baden, 1953.

29. For Schönfeld, see Herbert Pée, *Johann Heinrich Schönfeld: Die Gemälde*, Berlin, 1971.

30. For Sandrart's biography and paintings, see now most completely Christian Klemm, *Joachim von Sandrart: 'Kunst-Werke und Lebens-Lauf'*, Berlin, 1986. For the critique of Rembrandt, see Seymour Slive, *Rembrandt and his Critics*, The Hague, 1953.

31. Some of this material has recently been made more generally accessible in English in Jane O. Newman, *Pastoral Conventions: Poetry, Language, and Thought in Seventeenth-Century Nuremberg*, Baltimore and London, 1990. There is of course an extensive literature in German, to which this work provides some access.

32. Around the Baltic littoral the Netherlands, in whose hands a good part of the trade as well as of the arts still resided, had an immense impact: see David Kirby, *Northern Europe in the Early Modern Period: The Baltic World 1492–1772*, London and New York, 1992. In other portions of the land, such as Lublin or Lwów (Lemberg), there were already resident groups of north Italian artisans. They spread a local style of stucco in one instance and stone-carving in another: see Karpowicz, *Artisti Ticinesi in Polonia nel '600* (Ch. 1, n. 7).

33. For this subject, see in general *Sztuka Dworu Wazów w Polsce/Court Art of Vasa Dynasty in Poland* (Ch. 9, n. 6), and Tatarkiewicz, *O Sztuce Polskiej* (Ch. 9, n. 15).

34. See Julius Chrościcki, *Sztuka i Polityka: Funkcje Propagandowe Sztuki w Epoce Wazów 1587–1668*, Warsaw, 1983.

35. See Tazbir, 'La conscience nationale', in *La république nobiliaire et le monde* (Intro. n. 17).

36. See Tazbir, 'Le sarmatisme et le baroque européen', *ibid.* (Intro. n. 17), pp. 7–27, for the cultural situation in Poland. Miłobędzki, *Architektura Polska* (Ch. 9, n. 15), charts the architectural developments there.

For other contemporary examples of this kind of 'conspicuous consumption' and

'competitive consumerism', see Peter Burke, *Venice and Amsterdam*, and for the concepts themselves, Burke, *History and Social Theory*, and *idem*, *The Historical Anthropology of early Modern Italy* (Ch. 3, n. 9).

37. See Eugeniusz Linette, *Jan Catenazzi i jego dzieło w Wielkopolsce*, Warsaw and Poznań, 1973.

38. The term is Miłobędzki's, *Architektura Polska* (Ch. 9, n. 15), where a thorough discussion of these buildings is given. This sort of architecture had made its earliest appearance in Poland at the Lubomirski palace at Wiśnicz Nowy (from 1615).

39. This subject was first defined in his doctoral dissertation by Otto von Simson, *Die weltliche Apotheose im Zeitalter des Barock*, Munich, 1936.

40. Wallenstein's patronage is still lacking a complete study. A book on the Prague palace is in preparation by Ivan Muchka; for Jičín it is still necessary to consult the older literature, as for example J. Morávek and Zdeněk Wirth, *Waldštejnův Jičín*, Prague, 1946. The comments in this text result from the author's ongoing research and interest in this topic.

41. Similar arguments are made in regard to Spain by H. R. Trevor-Roper, 'Spain and Europe 1598–1621', in J. P. Cooper, ed., *The Decline of Spain and The Thirty Years' War* (*The New Cambridge History*, 4), Cambridge, 1970, pp. 260–82.

Notes to Chapter Eleven

1. This passage, as well as the one previously quoted, were also cited by Wolfgang J. Muller in his introduction to *Deutsche Maler und Zeichner des 17. Jahrhunderts*, exhibition catalogue, Berlin, 1966, p. 9. In *Baroque Art and Architecture in Central Europe* (Intro, n. 31), Hempel also called the section devoted to the period between 1640 and 1682 'the years of recovery'.

2. Readers may wish to consult one of the recent histories of Poland for this sort of information, such as Norman Davies, *God's Playground: A History of Poland*, 2 vols, Oxford, 1981; Adam Zamoyski, *The Polish Way*, London, 1987, also nicely interweaves an account of cultural developments.

3. Paul Hazard, *La Crise de la Conscience Européenne*, Paris, 1935, trans. as *The European Mind 1680–1715*, Cleveland and New York, 1963.

4. Answering the arguments of Notker Hammerstein, this thesis is proposed by R. J. W. Evans, 'German Universities after the Thirty Years' War', *History of Universities*, 1, 1981, pp. 169–80.

5. The interested reader may turn to the following works for an introduction to this period: Wilfried Barner, *Barockrhetorik*, Tübingen, 1970; Wilhelm Kühlmann, *Gelehrtenrepublik*

und Fürstenstaat, Tübingen, 1982; Günther E. Grimm, *Literatur und Gelehrtentum in Deutschland: Untersuchung zum Wandel ihres Verhältnisses vom Humanismus bis zur Frühaufklärung*, Tübingen, 1983. Anthony Grafton, 'The World of the Polyhistors: Humanism and Encyclopedism', *Central European History*, 18, 1985, pp. 31–47, offers an elegant overview in English.

6. For the general problem of historical interpretation of 'recovery' in the later seventeenth century, see Walther Hubatsch, *Deutschland zwischen dem Dreissigjährigen Krieg und der französischen Revolution*, Frankfurt am Main, 1974. See also Friedrichs, *Urban Society in an Age of War* (Ch. 9, n. 28); Mack Walker, *German Home Towns, Community State and General Estate, 1648–1871*, Ithaca, N.Y., 1971.

7. See Norbert Conrads, *Ritterakademien der frühen Neuzeit: Bildung als Standesprivileg im 16. und 17. Jahrhundert*, Göttingen, 1982.

8. Otto Brunner, *Adeliges Landleben und europäischer Geist: Leben und Werk Wolf Helmhardt von Hohberg, 1612–88*, Salzburg, 1949, and *Adel im Wandel: Politik–Kultur–Konfession*, exhibition catalogue, Rosenburg, 1990, give an idea of the general situation of aristocratic patronage in this period.

9. See Siegfrid Asche, *Drei Bildhauerfamilien an der Elbe: Acht Meister des 17. Jahrhunderts und ihre Werke in Saschen, Böhmen und Brandenburg*, Vienna and Wiesbaden, 1961. For an overview, see Heinrich Decker, *Barockplastik in den Alpenländern*, Vienna, 1943; this work is valuable for illustrations, but has been superseded by the scholarship mentioned in the following notes.

10. The basic monograph is Claus Zoege von Manteuffel, *Die Bildhauerfamilie Zürn 1606–1666*, Munich, 1969. This work is supplemented by *Die Bildhauerfamilie Zürn 1585–1724*, exhibition catalogue, Braunau am Inn, 1979, with many useful essays on the situation of sculpture in the regions in which the family worked.

11. The most important works on these sculptors are *Die Bildhauerfamilie Schwanthaler 1633–1848. Vom Barock zum Klassizismus*, exhibition catalogue, Reichersberg am Inn, 1974 (also *Thomas Schwanthaler 1634–1707*, exhibition catalogue, Vienna, 1974–5); Heinrich Decker, *Meinrad Guggenbichler*, Vienna, 1949; and Ulrike Gauss, *Andreas Thamasch (1639–1697). Stiftsbildhauer in Stams und Meister von Kaisheim*, Weissenhorn, 1973.

12. As strongly argued recently by John Shearman, *Only Connect ... Art and the Spectator in the Italian Renaissance*, Princeton, 1992.

13. Johann Heiss was probably his pupil, and a line of painters from Hans Ulrich Franck, Isaak Fisches, Melchior Schmittner and Jonas Umbach to Johann Rieger and Georg Rugendas in the eighteenth century felt his impact. Augsburg again became a centre for

painting, to which artists from afar, like Johann Spillenberger from Košice (Kaschau, Kassa) in Upper Hungary (Slovakia) or the Bern-born Joseph Werner, who had been at Louis XIV's court, would come to associate with Schönfeld and Sandrart. See for these artists *Augsburger Barock* (Ch. 10, n. 14).

14. This topic was the subject of an exhibition in Prague in 1993, with catalogue edited by Lubomír Slavíček, *Artis Pictoriae Amatores: Evropa v Zrcadle Pražského barokního sběratelství*, Prague, 1993, with English translations of the catalogue essays. See also Hana Seifertová in the introduction to *Nemecké malířství XVII. stoleti*, exhibition catalogue, Prague, 1989, pp. 9ff (German summary, pp. 136–46), and the essays in *Baroque Art in Central Europe – Crossroads* (Intro. n. 20), also valuable for a general discussion of the arts at this time.

15. In English see now Newman, *Pastoral Conventions* (Ch. 10, n. 31), with further references. See also Martin Bircher, 'The Fruchtbringende Gesellschaft and Italy: Between Admiration and Imitation', *The Fairest Flower: The Emergence of Linguistic National Consciousness in Renaissance Europe*, Florence, 1985, pp. 121–31, and for general introductions, *idem* and Ferdinand van Ingen, ed., *Sprachgesellschaften, Sozietäten, Dichtergruppen* (Wolfenbütteler Arbeiten zur Barockforschung 7), Hamburg, 1978.

16. Some of Von Zesen's and Leibniz's writings on the subject are now conveniently available in English in *Seventeenth Century German Prose*, ed. Lynne Tatlock, with a foreword by Günter Grass, New York, 1993. R. J. W. Evans, 'German Universities', and 'Culture and Anarchy in the Empire, 1540–1680', *Central European History*, 18, 1985, pp. 14–30, provides an introduction to the last activity.

17. Strobl, an interesting artist, is the topic of ongoing research (and articles) by Jacek Tylicki, whose forthcoming dissertation promises to replace the older monograph by Eugeniusz Iwanoyko, *Bartolomiej Strobl*, Poznań, 1957.

18. An extensive literature exists on seventeenth- and eighteenth-century art in Silesia. Konstanty Kalinowski, who has made a number of important contributions to its study, has recently provided an accessible introduction to this material, *Barock in Schlesien* (Ch. 10, n. 22). Willmann was the subject of a monograph by Ernst Kloss, *Michael Willmann: Leben und Werk eines deutschen Barockmalers*, Breslau [Wrocław], 1934, but, as even the title of this book might suggest, he could stand renewed attention. This may be stimulated by an exhibition in Salzburg and Wrocław in 1994 devoted to Willmann: see *Michael Willman (1630–1706): Studien zu seinem Werk*, ed. Franz Wagner, Salzburg, 1994. See also the new monograph by Hubertus Lossow, *Michael Willman (1630–1706): Meister der Barockmalerei*, Würzburg, 1994.

19. Besides Kalinowski, *Barock in Schlesien* (n. 18), of particular relevance to this time period is *idem, Architektura Barokowa na Śląsku w Drugiej Polowie XVII Wieku* (with German summary), Wrocław etc., 1974. See also, in general, *idem, Architektura Doby Baroku na Śląsku*, Warsaw, 1977, and *Rzeźba Barokowa na Śląsku*, Warsaw, 1986.

20. See Konstanty Kalinowski, *Gloryfikacja Panującego i dynastii w sztuce Śląska XVII i XVIII wieku* (with German summary), Warsaw and Poznań, 1973, particularly pp. 55–73. For Rauchmiller, see Veronika Birke, *Matthias Rauchmiller: Leben und Werk*, Vienna, Freiburg, Basel, 1981.

21. John P. Spielmann, *Leopold I of Austria*, London, 1977, is an English-language account, with, however, almost no attention to the arts, for which one must still turn to the older literature, as for Ferdinand III, e.g. Lhotsky, 'Geschichte der Sammlungen' (Ch. 2, n. 27), pp. 335ff. Much archival material on which a study could be based is included in the articles of Herbert Haupt, 'Archivalien zur Kulturpolitik des Kaiserhofes', Pt. 1, 'Kaiser Ferdinand III: Die Jahre 1646–1656, Pt. 2, Leopold I: Die Jahre 1657–1660', Pt. 3, 'Leopold I: Die Jahre 1661–1670', in *Jahrbuch der Kunsthistorischen Sammlungen in Wien*, 75, 1979, pp. 195ff.; 76, 1980, pp. 179ff.; 79, 1983, pp. 133ff.

22. Lhotsky, 'Geschichte der Sammlungen' (Ch. 2, n. 27), p. 363.

23. For these and other treatises see Miłobędzki, *Architektura Polska* (Ch. 9, n. 15), pp. 47ff.; Jerzy Baranowski, *Bartłomiej Nataniel Wąsowski jak teoretyk i architekt XVII wieku* (with English summary), Wrocław, etc., 1975, makes this text accessible.

24. We may also remember that as in music the seventeenth and eighteenth centuries were a time of aristocratic and imperial amateurs, such as Emperor Leopold I. Friedrich Polleroß, 'Dem Adl und fürstlichen Standt gemes Curiosi: Die Fürsten von Liechtenstein und die Barocke Kunst', *Früh Neuzeit Info*, 4, 1993, pp. 174–85, provides a review of recent literature on aristocrats and the arts in Central Europe, with special reference to the Liechtensteins, a topic also pertinent for later chapters in the present book.

25. See the information accumulated on theory, education and patronage in *Adel im Wandel* (n. 8). The classic work on Von Hohberg is Brunner, *Adeliges Landleben* (n. 8).

26. As translated by Alistair Laing, in Anthony Blunt, ed., *Baroque & Rococo Architecture & Decoration*, New York, etc., 1978, p. 178. Laing notes that 'his naive views as to what constituted "the Italian manner" can be seen in his admonition: "never never for all time put up any building without architectural adornment … and this consists in nothing other than the 5 Orders of columns and in these alone." For him the ideal palace was one which would have "60 or more columns succeeding one another the same distance apart and in 3 tiers"…'. Laing does not note the contrast with the earlier period, however.

27. See *The School of Prague* (Ch. 6, n. 40) and *The Mastery of Nature* (Ch. 4, n. 8), Ch. 7.

28. See Victor Fleischer, *Prinz Karl Eusebius von Liechtenstein als Bauherr und Kunstsammler* (*1611–1684*), Vienna and Leipzig, 1910. It is also interesting to note that like many other patrons and theorists in Central Europe, the prince, p. 194, also suggests the adaptation of the best that every nation has to offer.

29. Franz, *Deutsche Barockbaukunst Mährens* (Intro. n. 12), seems to have been the first to have made this point. See also *idem, Bauten und Baumeister der Barockzeit in Böhmen*, Leipzig, 1962, p.25.

30. See Hellmut Lorenz, 'Barockarchitektur in Wien und im Umkreis der kaiserlichen Residenzstadt', in Karl Gutkas, ed., *Prinz Eugen und das barocke Österreich*, Salzburg and Vienna, 1985, pp. 235–48.

31. Hellmut Lorenz, 'Zur Internationalität der Wiener Barockarchitektur', in *Wien und der Europäische Barock* (*Akten des XXV. Internationaler Kongress für Kunstgeschichte*), Vienna, ed. Elisabeth Liskar, Cologne, Graz, 1986, pp. 21–30,

32. See especially Hellmut Lorenz, 'Vienna Gloriosa Habsburgica?', *Kunsthistoriker: Mitteilungen de Österreichischen Kunsthtistorikerverbandes*, 2, No. 4/5, 1985, pp. 49–54 and also *idem*, 'Ein "exemplum" fürstlichen Mäzenatentums der Barockzeit – Bau und Ausstattung des Gartenpalasts Liechtenstein in Wien', *Zeitschrift des deutschen Vereins für Kunstwissenschaft*, 43, 1989, pp. 7–24.

33. This important building is covered most recently by Vilém Lorenc and Karel Tříska, *Černinský Palác v Praze* (with summaries), Prague, 1980, supplementing the older archival study by Johann Joseph Morper, *Das Czernin Palais in Prag*, Prague, 1940.

34. These buildings are discussed most recently in *Adel in Wandel* (n. 8), and also Günther Brucher, *Barockarchitektur in Österreich*, Cologne, 1983; Pál Voit, *Der Barock in Ungarn*, Budapest, 1971, also treats the palace in Eisenstadt (then Kismarton) together with buildings in Hungary.

35. Laing, *Baroque & Rococo Architecture* (n. 26), and Franz, *Deutsche Barockbaukunst Mährens* (Intro. n. 12), pp. 41ff., 76ff. (ill.), point to the connection with Liechtenstein's treatise, where the superposition of orders in this building coincides with Liechtenstein's ideal (and is even more extraordinary when seen from below the escarpment on which the Schloss rests).

36. For architecture (and the other other arts) of the seventeenth and eighteenth centuries in Bohemia (and Moravia) discussed in this chapter, see also Karl M. Swoboda, ed., *Barock in Böhmen*, Munich, 1964; Oldřich J. Blažíček, *Baroque Art in Bohemia* (trans. Slaveš Kadečka), Feltham, 1968; Jaromír Neumann, *Das Böhmische Barock*, Prague, 1970.

37. Rudolf Chadraba, *Staroměstská Mostecká Věž a Triumfální Symbolika v Umění Karla IV* (with German summary), Prague, 1971.

38. This is of course a simplified version of the developments outlined in Anna Coreth, *Pietas Austriaca: Ursprung und Entwicklung Barocker Frömmigkeit in Österreich*, Vienna, 1959, and Gerhardt Kapner, *Barocker Heiligenkult in Wien und seine Träger*, Vienna, 1978.

39. For the work of Zuccalli, see Sabine Heym, *Henrico Zuccalli (um 1642–1724): Der kurbayerische Hofbaumeister*, Munich and Zurich, 1984. This work helps to correct the account given in Hempel, *Baroque Art and Architecture* (Intro. n. 31), p. 76, where from a nationalist reaction to this structure, it is suggested that this building did Bavaria 'more harm than good', impeding the development of a Bavarian architecture.

40. For Loth, see Gerhard Ewald, *Johann Carl Loth, 1632–1695*, Amsterdam, 1965.

41. See Jaromír Neumann, *Karel Škréta*, exhibition catalogue, Prague, 1974; since then a monograph in Russian by L. I. Tananayeva, *Karel Shkreta: Iz Istorii Cheshskoi Zhivopisi Epochie Barokko*, Moscow, 1990, has appeared, but more attention could be given to the painter.

42. Until more studies are undertaken in Dresden, one can consult for the earlier fabric of the city Fritz Löffler, *Das alte Dresden: Geschichte seiner Bauten*, Dresden, 1955. A useful collection of essays relating relating to the period here discussed, <u>Johann Georg II. und sein Hof: Sachsen nach dem Dreissigjährigen Krieg</u>, *Dresdner Hefte [Beiträge zur Kulturgeschichte]*, 11, Heft 33, 1993, has recently appeared; see further, and for earlier and later periods, the collection *Das Dresdner Schloss – Geschichte und Weideraufbau*, Dresdner *Hefte*, 12, Heft 38, 1994.

43. Walter May, 'Die höfische Architektur in Dresden zur Zeit Johann Georgs II', in *Johann Georg II und Sein Hof*, pp. 42–52, most recently re-emphasized the importance of the Palais im Grossen Garten. The castle also has notable sculpture by the Heermann family from Freiberg, including a baroque, almost Italianate, design of statues cascading down the stairway at the front of the building: see Asche, *Drei Bildhauerfamilien an der Elbe* (n. 9), pp. 124 ff., and the illustration here, p. 278.

44. This argument about the importance of Netherlanders recapitulates my 'Alternatives to Versailles in Central and Eastern Europe', to be published in *Versailles: French Court Style and its Influence*, ed. H. Collinson, Toronto, forthcoming. A paper on Dutch silver and furniture was to be published in the papers of the same conference.

Notes to Chapter Twelve

1. While there is abundant historical literature on Sobieski, it is surprising that there is no complete overview of his involvement with the arts. See, however, Mariusz Karpowicz, *Sztuka Oświeconego Sarmatyzmu: Antykizacja i klasycyzacja w środowisku warszawskim czasów Jana III*, Warsaw, 1970 (1st edn.) and *idem, Sztuka Warszawy Czasów Jana III*, Warsaw, 1987, (nearly identical) with further references.

2. Martino Altomonte (for whom see Hans Aurenhammer, *Martino Altomonte*, Vienna, 1965) is also important in this connection as someone who worked in Austria and Bohemia as well as in Poland. See for this point Wojciech Fijalkowski, 'L'arte e gli artisti italiani alla

corte di Jan III Sobieski', in *Polonia-Italia. Relazioni artistiche dal Medioevo al XVIII secolo* (Intro. n. 15), pp. 83–116.

3. These and other buildings patronized by Sobieski are discussed by Miłobędzki, *Architektura Polska* (Ch. 9, n. 15). In general Miłobędzki's *Zarys dziejów architektury w Polsce*, Warsaw, 1963, pp. 153–97 (4th rev. edn., 1988, pp. 197 ff.), may also be consulted.

4. Stanisław Mossakowski, *Tylman z Gameren, architekt polskiego baroku*, Wrocław etc., 1973, is the standard monograph; a German translation with substantial revisions, *Tylman van Gameren: Leben und Werk*, Munich and Berlin, 1994, has recently been published. In this book, p. XI, and in a recent article for the *Festchrift* for Jerzy Kowalczyk ('Nowe identyfikacje projektów rysunkowych Tylmana z Gameren [Puławy, Ujazdów, Łazienki] i domniemane studia architektoniczne Tytusa Liwiusza Burattiniego,' in *Między Padwą a Zamościem. Studia z Historii Sztuki i Kultury Nowożytnej ofiarowane Profesorowi Jerzemu Kowalczkowi*, Warsaw, 1993, pp. 209–24), Mossakowski has supported doubts cast by Miłobędzki (*Architektura Polska* [Ch. 9, n. 15], pp. 397–8, 423–4) on the traditional attribution of the Gdańsk royal chapel to Van Gameren; the style of this chapel nevertheless remains close to his and can thus still serve to introduce the discussion here.

5. An introduction to the Polish artistic situation is Mariusz Karpowicz, *Barok w Polsce*, Warsaw, 1988 (with co-editions in various languages). For Warsaw itself, an overview is now available in Jolanta Putkowska, *Architektura Warszawy XVII wieku*, Warsaw, 1991.

This statement does not mean to overlook the outstanding accomplishments of this time in Lithuania, including the Camauldalensian monastery at Pożailis (Pożaijście) near Kaunas, or the church of St Peter and Paul in Antokol, near Wilno (Vilnius). But perhaps the key monument of the day, the Casimir chapel in the cathedral of Wilno, another Italianate masterwork, was the result of continuing royal patronage.

6. See Tadeusz Mańkowski, 'Rzeźby Schlütera w pałacu Krasińskich w Warszawie', *Biuletyn Historii Sztuki* 12, 1951, pp. 118–37; *idem*, 'Nieznane rzeźby Andrzeja Schlütera', *Dawna Sztuka* 2, 1939, pp. 219–34, deals with his works in Żółkiew (Nesterjov), which, after having been vandalized, are now being restored.

7. Besides works already cited, the standard account of this building, with sources, is Juliusz Starzyński, *Wilanów: Dzieje budowy pałacu za Jana III*, Warsaw, 1933 and 1976.

8. For the discussion of Schlüter presented here, see my 'Schlüter's Fate: Comments on Sculpture, Science, and Patronage in Central and Eastern Europe *c.* 1700', in *Kunstlerischer Austausch* (Ch. 1, n. 40), vol. 1, pp. 199–212.

9. An accessible introduction to this and other idiosyncratic aspects of east Central European culture in the seventeenth and eighteenth centuries, including those to which mention is made in this book, is Andreas Angyal, *Die Slawische Barockwelt*, Leipzig, 1961.

10. From the fourteenth century a linguistic definition also served to demarcate nation-hood in Poland, but this usage does not seem to have been so prevalent as the Sarmatian ideology. See Tazbir, 'Le sarmatisme et le baroque européen' and 'La conscience nationale', in *La République nobiliaire et le monde* (Intro. n. 17), pp. 7–56.

11. A book in Russian by L. I. Tananayeva, *Sarmatskii Portret: Iz Istorii Polskoğo Portreta Epoxi Barokko*, Moscow, 1979, treats this subject, on which there have been numerous publications and exhibitions in Poland and elsewhere, e.g. *Stolz und Freiheit: Das Bild des Polnischen Adels im Zeitalter des Barock*, exhibition catalogue, Cismar and Bonn, 1990–91, with further references. Abundant material is made accessible by the English summaries, notes and bibliography in *Portrait of Sarmatian Type in 17th Century Poland, Bohemia, Slovakia and Hungary* (also in Polish), *Niedžica Seminars 2*, Kraków, 1985.

12. See Tazbir, *Polskie Przedmurze* (Ch. 1, n. 5) and *La république nobiliaire* (Intro. n. 17).

13. Notably by Karpowicz, *Sztuka Oświeconego Sarmatyzmu* (n. 1).

14. E.g. by the Polish painter Jerzy Szymonowicz-Siemiginowski; for this subject see in general Mieczysław Morka, *Polski nowożytny portret konny i jego Europejska Geneza* (with English summary), Wrocław, etc., 1986.

15. That is, until at least several decades later in the eighteenth century.

16. See in general Ehalt, *Ausdrucksformen absolutistischer Herrschaft* (Ch. 7, n. 11); more recently two useful summaries have appeared that are relevant to this chapter, Friedrich B. Polleross, 'Zur Repräsentation der Habsburger in der bildenden Kunst' and Elisabeth Kovács, 'Die Apoteose des Hauses Österreich: Repräsentation und politischer Anspruch', in Kovács and Rupert Feuchtmüller, eds., *Die Welt des Barock*, Vienna, Freiburg, Basel, 1986, 1, pp. 87–104 and 53–86. This section of the chapter also repeats some of the arguments in my 'Alternatives to Versailles' (Ch. 11, n. 44).

17. The foundation of this overview was laid by Hans Sedlmayr, *Österreichische Barockar-chitektur*, Vienna, 1930, but see the other works cited.

18. The standard accounts of Fischer, from which this book draws, are Hans Sedlmayr, *Johann Bernhard Fischer von Erlach*, Vienna, 1976 (2nd edn.) and Hans Aurenhammer, *J. B. Fischer von Erlach*, Cambridge, Mass., 1973. Another view is presented in the recent monograph by Hellmut Lorenz, *J. B. Fischer von Erlach*, Berlin, 1992.

19. This is the theme of Lorenz, 'Vienna Gloriosa Habsburgica?' (Ch. 11, n. 32).

20. For Habsburg triumphal arches see Herta Blaha, 'Österreichische Triumphpforten...', Ph.D. dissertation, Vienna, 1950; Barbara Chabrowe, 'Baroque Temporary Structures built for the Austrian Habsburgs', Ph.D. dissertation, Columbia University, New York, 1970;

and my *Variations on the Imperial Theme* (Ch. 7, n. 7), pp. 5–13, and *The Mastery of Nature* (Ch. 4, n. 8), Chapter 5 (also as 'Astronomy, Technology, Humanism and Art at the Entry of Rudolf II into Vienna, 1577', *Jahrbuch der Kunsthistorischen Sammlungen in Wien*, 85–6, 1989–90, [published 1992], pp. 99–121).

21. '...und dieses war ein sehr schöner Triumph und Ehrentag an welchem nicht allein Ihre königliche Majestaet als wie ein zur Frolockung des sämmtlichen Volcks vom Himmel herabgeschikter Engel in das Weltherrschende Wienn, mit einer unvergleichlichen und von der Teutschen Weisheit wohlangeordneten Pracht Sieg-Prangend eingeritten, sondern an welchem auch die Teutsche Kunst und Geschicklichkeit wider die Hochachtung der Ausländer in den Gemüthern aller Zuschauer einen sehr herrlichn Sieg erhalten hat...' as quoted by Hans Sedlmayr, 'Johann Bernhard Fischer von Erlach', in *Epochen und Werke: Gesammelte Schriften zur Kunstgeschichle*, 2, Vienna and Munich, 1960, p. 158; see also *idem*, 'Die politische Bedeutung des Deutschen Barock: Der "Reichstil"', in *Epochen und Werke*, pp. 140–56.

22. See also Laing in *Baroque & Rococo* (Ch. 11, n. 26), pp. 177–8.

23. 'Kaiser sein, heisst nichts anderes, als grösster Herr der Erde sein', as quoted in Brucher, *Barockarchitektur in Österreich*, (Ch. 11, n. 34), p. 143.

24. For an overview, see Ernst Wangermann, *The Austrian Achievement 1700–1800*, London and New York, 1973.

25. Hellmut Lorenz, 'Der habsburgische Reichsstil – Mythos und Wirklichkeit', in *Kunstlerischer Austausch* (Ch. 1, n. 40), offered an important revision of this thesis, including an analysis of this building. For earlier treatments see Sedlmayr, 'Politische Bedeutung' (n. 21) and *Fischer von Erlach* (n. 18), and Aurenhammer, *Fischer von Erlach* (n. 18).

26. See G. Kunoth, *Die Historische Architektur Fischers von Erlach*, Düsseldorf, 1956.

27. For the concept of the transference of empire, see Werner Goez, *Translatio Imperii*, Tübingen, 1958. For universal history, see Arnaldo Momigliano, 'The Origins of Universal History', in his *On Pagans, Jews and Christians*, Hanover, N. H., 1987, pp. 31-57.

28. For a related approach, see in general Werner Oechslin, 'Fischer von Erlachs "Entwurff einer Historischen Architektur": die Integration einer erweiterten Geschichtsauffassung in die Architektur im Zeichnung des erstarkten Kaisertums in Wien', in *Wien und der Europäische Barock* (Ch. 11 n. 31), pp. 77–81.

29. By Aurenhammer, *Fischer von Erlach* (n. 18). Pamela H. Smith, *The Business of Alchemy: Science and Culture in the Holy Roman Empire*, Princeton, 1994, deals with J. J. Becher and early proposals for alchemy and the arts at court.

30. See most easily Hellmut Lorenz, 'Ein "exemplum" fürstlichen Mäzenatentums der Barockzeit', and *idem, Liechtenstein Palaces in Vienna from the Age of the Baroque*, New York, 1980, p. 63.

31. See Dwight C. Miller, *Marcantonio Franceschini and the Liechtensteins: Prince Johann Adam Andreas and the Decoration of the Garden Palace at Rossau-Vienna*, Cambridge, 1991.

32. For the programme and extraordinary position of these frescoes, see Hellmut Lorenz, 'Zu Rottmayrs Treppenhausfresken im Wiener Gartenpalast Liechtenstein', *Acta Historiae Artium*, 34, 1989, pp. 137–44; for the artist in general see Erich Hubala, *Johann Michael Rottmayr*, Vienna, 1981.

33. See Lorenz, *Liechtenstein Palaces in Vienna* (n. 30); *idem, Domenico Martinelli und die Österreichische Barockarchitektur*, Vienna, 1985.

34. Bruno Grimschitz, *Johann Lucas von Hildebrandt*, Vienna, 1932 (2nd edn. 1959), awaits replacement as the basic monograph; for Prince Eugene see *Prinz Eugen und das barocke Österreich*, exhibition catalogue, Schlosshof and Niederweiden, 1986 (with related essay volume), and in English Derek McKay, *Prince Eugene of Savoy*, London, 1977.

35. The pioneering essay on this topic is Hugh Murray Baillie, 'Etiquette and the Planning of the State Apartments in Baroque Palaces', *Archaeologia*, 101, 1967, pp. 169–99; pp. 193ff. are specifically on Germany. See also H. Ch. Ehalt on the idea of a '*Theatrum precedentiae*' in 'Schloss und Palastarchitektur im Absolutismus', in Hannes Stekl, ed., *Architektur und Gesellschaft von der Antike bis zur Gegenwart*, Salzburg, 1980, pp. 161–249, especially pp. 207ff., quoting Friedrich Carl von Moser's notions from the *Teutsches Hoff-Recht*, Frankfurt and Leipzig, 2 vols., 1754–5. These and other comments by Moser are also cited in what is now the most thorough study of any single court in relation to this topic, Samuel John Klingensmith, *The Utility of Splendor: Ceremony, Social Life and Architecture at the Court of Bavaria, 1600–1800*, Chicago and London, 1993.

36. See Siegfried Asche, *Balthasar Permoser: Leben und Werk*, Berlin, 1975.

37. See Werner Loibl, 'Ideen im Spiegel: Die Spiegelkabinette in den fränkischen Schönborn-Schlössern', in *Die Grafen von Schönborn: Kirchenfürsten, Sammler, Mäzene*, exhibition catalogue, Nuremberg, 1989, pp. 80–90.

38. 'Horti et loca recreationis, omnes vel vastitate immensi, vel ab aedificiis variis et superbis, vel a floribus fructibusque aliarum regionum mirandi, peristromatis arboribus, sylvulis integris, statuis, picturis, aliisque hortensibus delicis amoeni, non minorem Viennensi urbi gloriam quam animis ipsi genuinam delectatum pariunt et voluptatem.' The creation of a wreath of buildings around the city was also noted by Lady Mary Wortley

Montagu in 1716, who said, 'I must own I never saw a place so perfectly delightful as the faubourg of Vienna. It is very large and almost wholly composed of delicious palaces.' Quoted in Laing, *Baroque & Rococo* (Ch. 11, n. 26), p.272. See now also in English for the urban history of Vienna John P. Spielman, *The City and the Crown: Vienna and the Imperial Court, 1600–1740*, West Lafayette, Indiana, 1993.

39. See Franz Matsche, *Die Kunst im Dienst der Reichsidee Kaiser Karls VI*, 2 vols., Berlin and New York, 1981.

40. See Aurenhammer, *Fischer von Erlach*, pp. 146–52.

41. For Gran's work see Eckhart Knab, *Daniel Gran*, Vienna and Munich, 1977, with references to the extensive literature on Austrian baroque ceiling decoration, which was a particularly popular subject in the 1950s.

42. Besides the literature on Fischer, Birke, *Rauchmiller* (Ch. 11, n. 20) pp. 44–9, 73–7, can be consulted for the earlier history of the monument. Manfred Koller, *Die Brüder Strudel. Hofkünstler und Gründer der Wiener Kunstakademie*, Innsbruck and Vienna, 1993, pp. 73–4, 182–6, with sources on pp. 275–89, provides the latest overview of the history of the monument; beside his work as a sculptor, Koller suggests that Strudel played the leading role directing the execution of the Pestsäule.

43. See Coreth, *Pietas Austriaca* (Ch. 11, n. 38).

44. See Brucher, *Barockarchitektur in Österreich* (Ch. 11, n. 34), pp. 197ff.

45. The classic account of the iconography of this work is that of Sedlmayr, reprised in his monograph, *Fischer von Erlach*, pp. 174ff.

46. See in general Elisabeth Kovács, 'Die österreichische Kirche im Zeitalter des Barock', in *Welt des Barock* (n. 16), 2, pp. 123–40.

47. See *Georg Raphael Donner*, exhibition catalogue, Vienna, 1993. A forthcoming monograph by M. Pötzl will assemble material on Donner in Bratislava, including his earlier work. In the meantime see *Georg Raphael Donner*, exhibition catalogue, Bratislava, 1992.

48. For Melk, see *Jakob Prandtauer und sein Kunstkreis*, exhibition catalogue, Melk, 1960; *900 Jahre Benediktiner in Melk*, exhibition catalogue, Melk, 1989.

49. Brucher, *Barockarchitektur in Österreich* (Ch. 11, n. 34) provides a good overview of these buildings. For the second part of this chapter, a general overview is now provided by the essays collected in *idem*, ed., *Die Kunst des Barock in Österreich*, Salzburg and Vienna, 1994.

1. As translated by Alastair Laing, in *Baroque & Rococo: Architecture and Decoration* (Ch. 11, n. 26), p. 271.

2. This point is emphasized by many writings: see for pertinent quotations, Adrien Fauchier-Magnan, *The Small German Courts in the 18th Century,* trans. Mervyn Savill, London, 1958, one of the few works in English, however, that, though belletristic, attempts to set the arts at the German courts in their social and cultural circumstances. It is still necessary to turn to older literature, such as W. H. Bruford, *Germany in the Eighteenth Century: The Social Background of the Literary Revival,* Cambridge, 1971 (1st edn. 1935), for social and cultural history. For one accumulation of evidence on the impact of France, see Pierre du Colombier, *L'architecture Française en Allemagne au XVIIIe Siècle,* 2 vols., Paris, 1956.

 For Pesne and Sylvestre, see respectively Helmut Börsch-Supan, *Der Maler Antoine Pesne: Franzose und Preuße,* Friedberg, 1986, and Harald Marx, *Die Gemälde des Louis de Sylvestre,* Dresden, 1975.

3. Frederick's relationship to contemporary literature is documented in *Friedrich II, König von Preußen, und die deutsche Literatur des 18. Jahrhunderts: Texte und Dokumente,* ed. Horst Steinmetz, Stuttgart, 1985.

4. The present section of this chapter repeats my 'Alternatives to Versailles' (Ch. 11, n. 44).

5. 'Die Residenz ist die ordentliche, beständige Wohnung des Regenten an dem Ort, wo der eigentliche Sitz des Hofs und der Collegien ist. Hier ist der Regent eigentlich zu Haus und bey Abmessung des Ceremoniels und Feststellung dessen Regeln ist eigentlich auf den in der Residenz gewöhnlichen Gebrauch zu sehen; indem auf Lust- und Land-Häusern viles weggelassen und resp. nachgegeben wird [sic]…', quoted in Wilfried Hansmann, *Baukunst des Barock: Form, Funktion, Sinngehalt,* Cologne, 1978, p. 88.

6. For France see Norbert Elias, *The Court Society,* trans. Edmund Jephcott, New York, 1983; for the Habsburgs see chiefly Ehalt, *Ausdrucksformen absolutistischer Herrschaft* (Ch. 7, n. 11), with further references; the notion '"Theatrum" der Selbstdarstellung' is applied *ibid.,* pp. 92ff., to the Schloss. See also Ehalt, 'Schloß und Palastarchitektur im Absolutismus' (Ch. 12, n. 35) and also Jürgen Freiherr von Kruedener, *Die Rolle des Hofes im Absolutismus,* Stuttgart, 1973.

 Recently Klingensmith, *Utility of Splendor* (Ch. 12, n. 35), and Goerd Peschken, 'Statt einer Einführung: Leben unter Barocken Himmeln', in Liselotte Wiesinger, *Deckengemälde im Berliner Schloss,* Frankfurt a. M. and Berlin, 1992, pp. 11–25, have provided an excellent introduction to the layout of palaces in relation to the practices and demands of the courts of the time.

7. The quotations are gathered and translated by Laing, *Baroque & Rococo* (Ch. 11 n. 26), pp. 276, 278, 287.

8. 'Es ist wohl nicht leicht ein Regent in Teutschland, welcher nicht nebst seiner ordentlicher Residenz noch ein oder etliche Lust-Jagd- und Land-Schlösser hätte', quoted in Hansmann, *Baukunst des Barock* (n. 5), p. 88.

9. Quoted in Laing, *Baroque & Rococo* (Ch. 11, n. 26), p. 271.

10. Germany was obviously not however France: although absolutist in intention or claim, the German princes could not be so in reality; they ruled over states of varying sizes, and the Thirty Years' War had ended any one dynasty's hegemony. Often princes had to deal with parsimonious or antagonistic estates. See, for the political realities, F. L. Carsten, *Princes and Parliaments in Germany from the Fifteenth to the Eighteenth Century*, Oxford, 1959, and G. Benecke, *Society and Politics in Germany, 1500–1750*, London and Toronto, 1974.

 Hence the drive for distinction, to use Pierre Bourdieu's term, was often incommensurate with social or economic circumstances. At smaller courts building often grew out of proportion with specific needs, and even overwhelmed the economic bases that could support it, as the bankruptcy of Bavaria in the course of the century demonstrates.

11. For readings in English on the historical situation for this, and indeed for much of the period, Hajo Holborn, *A History of Modern Germany 1648–1840*, Princeton, 1964, can still be consulted with profit; see also Gagliardo, *Germany under the Old Regime* (Ch. 10, n. 1).

12. Ulrich Keller, *Reitermonumente absolutistischer Fürsten: Staatstheoretische Voraussetzungen und politische Funktionen*, Munich, 1971, summarizes some of these differences, although it should be remarked that by mid-century the Catholic courts had taken up similar ideas. Some of the background for this philosophy, particularly in Prussia, is provided by G. Oestreich, *Geist und Gestalt des frühmodernen Staates*, Berlin, 1969.

 More recent assessments of the question of absolutism, with indications of previous bibliography, are available in John Miller, ed., *Absolutism in Seventeenth-Century Europe*, Basingstoke and London, 1990; particularly pertinent are H. W. Koch, 'Brandenburg-Prussia', pp. 123–55, and Jean Bérenger, 'The Austrian Lands: Habsburg Absolutism under Leopold I', pp. 157–74.

13. 'Was man an schönen Baukunst im Norden sieht, stammt ungefähr aus der gleichen Zeit: das Schloß und das Zeughaus in Berlin, die Reichskanzlei und die Kirche des heiligen Karl Borommeo in Wien, das Schloss zu Nymphenburg in Bayern, die Augustusbrucke und Zwinger in Dresden, das Kurfürstliche Schloss in Mannheim, das Schloss des Herzogs von Württemberg in Ludwigsburg.' The best survey in English of the topic is Laing's in *Baroque & Rococo* (Ch. 11, n. 26); recent surveys in German include Hansmann, *Baukunst des Barock* (n. 5), and Rolf Hellmut Foerster, *Das Barockschloß: Geschichte und Architektur*, Cologne, 1981. See also Ekhart Berkenhagen, *Barock in Deutschland: Residenzen*, exhibition catalogue, Berlin, 1966.

14. Ingrid Mittenzwei and Erika Herzfeld, *Brandenburg-Preußen 1648–1789*, Berlin, 1987, provide an introduction to the cultural history of this entire period, and Helmut Börsch-

Supan, *Die Kunst in Brandenburg-Preußen*, Berlin, 1980, an introduction to the art history of the land, on the basis of objects in the Berlin museums.

15. For the Great Elector, and his relationship with the arts, see *Der Grosse Kurfürst: Sammler, Bauherr, Mäzen*, exhibition catalogue, Potsdam, 1988.

16. The title is itself significant, as the only king in the empire itself was the king of Bohemia and Bohemia was ruled by the Habsburgs.

17. See (in English) for this and other academies Nicholas Pevsner, *Academies of Art Past and Present*, Cambridge, 1940, and more recently Anton W. A. Boschloo, ed., *Academies of Art from the Renaissance to Romanticsm* (*Leids Kunsthistorisch Jaarboek* 5–6), Leiden, 1985–6.

18. See Margarethe Kuhn, 'Andreas Schlüter als Bildhauer', in *Barockplastik in Norddeutschland* (Ch. 10, n. 12), pp. 105–81, for a general discussion of Schlüter's sculpture.

19. The interpretation developed here elaborates my 'Schlüter's Fate' (Ch. 12, n. 8).

20. This account is based on Keller, *Reitermonumente* (n. 12).

21. See Keller, *Reitermonumente* (n. 12).

22. For the general issue, also pertinent to much of this book, see Günter Brucher, *Zum Problem des Stilpluralismus: Ein Beitrag zur kunstgeschichtlichen Methodik*, Vienna, Cologne, Graz, 1988; Brucher, pp. 92ff., refers to Austrian architecture of the seventeenth century.

23. For Schlüter's architecture (and sculpture), starting points remain Heinz Ladendorf, *Der Bildhauer und Baumeister Andreas Schlüter: Beiträge zu seiner Biographie und zur Kunstgeschichte seiner Zeit*, Berlin, 1935; *idem, Andreas Schlüter*, Berlin, 1937; see also Franz-Eugen Keller, *Andreas Schlüter*, in W. Ribbe and W. Schäche, eds., *Baumeister, Architekten Stadtpläner*, Berlin, 1987, pp. 47–70.

24. Hempel, *Baroque Art and Architecture* (Intro. no. 31), pp. 210–11, sees them as evidence of Schlüter's genius and in some sense as monuments to the vanquished and as signs of the horrors of war, but this seems unlikely, given the decorum of the place; Kuhn, 'Schlüter als Bildhauer' (n. 18), p. 127, raises the possibility that they are a 'Ruhmessymbol des Siegers – oder des Kriegers überhaupt, dessen Tod wir im Hof erlebten' (symbol of the fame of the victor – or of the warrior in general – whose death we experienced in the courtyard), and it is possible that they are some kind of peculiar trophies. Further research on this topic is now (1994) under way in Germany.

25. Goerd Peschken, 'Andreas Schlüter und Schloß Charlottenburg', in *Schloss Charlottenburg, Berlin, Preussen: Festschrift für Margarethe Kuhn*, ed. Martin Sperlich and Helmut Börsch-Supan, Munich and Berlin, 1975, pp. 139–168.

26. This was also the inspiration for other German gardens, such as that at Herrenhausen. See in general Berckenhagen, *Barock in Deutschland: Residenzen* (n. 13). For the Dutch prototypes of an earlier era, see now Vanessa Bezemer Sellers, 'Garden Architecture in the Netherlands: the Gardens of Frederik Hendrik Prince of Orange (1584–1647)', Ph.D. dissertation, Princeton University, 1992.

27. Schlüter took over the design of the palace from 1698, and although he was dismissed in 1706, this was fittingly the last major project of the reign. See for recent studies Margarethe Kühn, 'Das Berliner Schloss Andreas Schlüters – Eine Metropole in europäischen Kunstlandschaft', in *Die Zukunft der Metropolen*, exhibition catalogue, Berlin, 1984, pp. 226–40; Goerd Peschken and Hans-Werner Klünner, with the collaboration of Fritz-Eugen Keller and Tilo Eggeling, *Das Berliner Schloss*, Frankfurt a. M. and Berlin, 1982 (2nd printing 1991); Poeschken, *Berliner Schloss*, Bonn, 1987; Liselotte Wiesinger, *Das Berliner Schloss von der kurfürstlichen Residenz zum Königsschloss*, Darmstadt, 1989; all with further references.

28. See Evans, *Making of the Habsburg Monarchy* (Ch. 8, n. 19), pp. 275ff., especially 281–2.

29. The archbishop consequently hired Rottmayr and the Austro-Italian Altomonte as well; see Aurenhammer, *Altomonte* (Ch. 12, n. 2), and *idem, Fischer von Erlach* (Ch. 12, n. 18), and Hubala, *Rottmayr* (Ch. 12, n. 32).

30. An overview is available in Erich Hubala, 'Die Grafen von Schönborn als Bauherrn', in *Die Grafen von Schönborn: Kirchenfürsten, Sammler* (Ch. 12, n. 37), pp. 24–52, summarizing the earlier literature; the essays in this catalogue treat many other aspects of Schönborn patronage, including Friedhelm Jürgensmeier, 'Politische Ziele und kirchliche Erneuerungsbestrebungen der Bischöfe aus dem Hause Schönborn im 17. und 18. Jahrhundert', pp. 11–23.

Hubala does not however deal with Bamberg, for which see Milada Vilimková and Johannes Brucker, *Dientzenhofer: Eine bayerische Baumeisterfamilie in der Barockzeit*, Rosenheim, 1989, especially pp. 25 ff. on Leonhard Dientzenhofer by Brucker, pp. 30ff., 34ff. For the interiors, see Erich Bachmann and Burkard von Roda, *Neue Residenz Bamberg: Amtlicher Führer*, Munich, 1983. See also Heinrich Gerhard Franz, *Dientzenhofer: Haustätter, Kirchenbaumeister in Bayern und Böhmen*, Munich and Zurich, 1985.

31. See in general Hubala, 'Die Schönborn als Bauherren' (n. 30).

32. For Bruchsal, see, in addition to previously cited works, *Barock in Baden-Württemberg*, 2 vols., exhibition catalogue, Bruchsal, 1981.

33. For this section, see in addition to Fauchier-Magnan, *The Small German Courts* (n. 2), Werner Fleischhauer, *Barock in Herzogtum Württemberg*, Stuttgart, 1958; Gustav Passavant,

Studien über Domenico Egidio Rossi und seine baukünstlerische Tätigkeit, Karlsruhe, 1967; and *Eberhard Ludwig: Herzog von Württemberg*, exhibition catalogue, Stuttgart and Ludwigsburg, 1976.

34. And there are of course many other places worthy of attention: Rudolstadt, Bayreuth, Mergentheim, etc.

35. *Kurfürst Max Emanuel: Bayern und Europa um 1700*, ed. Herbert Glaser, Munich, 2 vols., 1976, contains many essays that provide a comprehensive introduction to the subject.

36. Recent general introductions are provided by the essays in the exhibition catalogues *The Splendor of Dresden*, Washington, etc., 1978–9; *Barock und Klassik: Kunstzentren der Deutschen Demokratischen Republik*, Schallaburg, 1984; *Barock in Dresden*, Leipzig, 1986; *Ecclesia Triumphans Dresdensis: Christliche Kunst am Hofe der sächsischen Könige von Polen*, Vienna, 1988; *Königliches Dresden: Höfische Kunst im 18. Jahrhundert*, Munich, 1991. For the academy in Dresden see: *Von der Königlichen Akademie zur Hochschule für bildenden Künste*, Dresden, 1990.

37. The standard Polish view of the early eighteenth century is negative: see for example Mariusz Karpowicz, *Sztuka polska XVIII w.*, Warsaw, 1985. More recently, however, Saxon rule in Poland has been positively reassessed: see Maria Gordon Smith, 'Die Verdienste Augustus II. und Augustus III. um das Polnisch-Litauische Großreich', in *Königliches Dresden: Höfische Kunst im 18. Jahrhundert* (n. 36), pp. 31–7; this book provides a general review of the subject of Dresden as a royal residence. Older literature on the topic of the Saxons in Poland includes Walter Hentschel, *Die sächsische Baukunst des 18. Jahrhunderts in Polen*, Berlin, 1967.

38. Augustus could even say of himself: '...we, from our special love of the art of building, wherein we are particularly wont to amuse ourselves, have before now ourselves invented various designs, put them down on paper, and ordered Our architects in Our own Person to put them into complete execution...and have reserved the final say once and for all to Ourselves as Master,' translated by Laing, *Baroque & Rococo* (Ch. 11, n. 26), p. 278.

39. Festivities are emphasized in *The Splendor of Dresden* (n. 36), pp. 131ff. See further Hellmut Lorenz, 'Barocke Festkultur und Räpräsentation in Schloss zu Dresden', in 'Das Dresdner Schloss' (Ch. 11, n. 42), pp. 48–56, and the literature related to Pöppelmann cited in the next note. These are also the subjects of new dissertations by Claudia Schnitzer (for Marburg) and Elisabeth Mikosch (for New York University).

40. For Pöppelmann and architecture in Dresden, see Hermann Heckmann, *Matthäus Daniel Pöppelmann: Leben und Werk*, Munich and Berlin, 1972; Harald Marx, ed., *Matthäus Daniel Pöppelmann: Der Architekt des Dresdner Zwingers*, Münster, 1989–90; Kurt Milde, ed., *Matthäus Daniel Pöppelmann 1662-1736 und die Architektur der Zeit August des Starken*, Dresden, 1990. For the sculpture of the Zwinger, see Sigfried Asche,

Balthasar Permoser und die Barockskulptur des Dresdner Zwingers, Frankfurt a. M., 1966, who also stresses the festive nature of the spot.

41. For the connection of the Saxon Hercules theme with the iconography of the subject in Poland, see Jerzy Banach, *Hercules Polonus: Studium z Ikonografii Sztuki Nowożytnej*, Warsaw, 1984.

42. For the most recent overview of this phenomenon, including a discussion of the history of porcelain collecting, and further references, see Gerald Heres, *Dresdener Kunstsammlungen im 18. Jahrhundert*, Leipzig, 1991.

43. Caspar-Friedrich Neickel, *Museographia oder Anleitung zum rechten Begriff und nutzlicher Anlegung der Museographischen oder Raritäten Kammer*, Leipzig, 1727.

44. One final aspect of the collecting activity at the Saxon court was its acquisition of bronzes. In a series of purchases arranged chiefly by Leplat and occurring mainly in 1699 and 1755 in Paris, many fine works were acquired. Here the impact of Louis XIV could be felt, in that Louis provided an example for the collecting of small bronzes and their placement throughout the palace. Thus many Saxon-owned bronzes were further versions of works made for the French king. For a different view of the new display in Dresden, see however Debora J. Meijers, *Kunst als Natuur*, Amsterdam, 1991.

45. Hempel's summary of these buildings, *Baroque Art and Architecture* (Intro. n. 31), pp. 195ff., based on his long personal familiarity, researches and publications, has not yet been superseded.

46. Hempel, *Baroque Art and Architecture* (Intro. n. 31), p. 198, relates the importance of organ music in the time of Bach to the design of the Frauenkirche. *Barock: Bildkunst im Zeitalter Johann Sebastian Bachs*, exhibition catalogue, Bremen, 1971, and *Kunst der Bachzeit*, exhibition catalogue, Leipzig, 1985, draw further connections between art and music. Henry-Russell Hitchcock, *German Rococo: The Zimmermann Brothers*, London, 1968, p. 16, discusses the problem of comparing Bach and Handel to the rococo. The subject can still be approached using a more rigorous analysis of style and a feeling for historical aptness.

47. The subject of the synthesis achieved by Bach's music, a common topic for musicologists, is one of the themes analysed in a forthcoming book by Laurence Dreyfus on Bach, (tentatively) entitled *The Power of Invention*.

Notes to Excursus

1. In view of the intention of this book to concentrate on the art and culture of Central Europe, references in this excursus will be kept to a minimum. Readers interested in St Petersburg may consult the following works (all in English): Cracraft, *The Petrine*

Revolution in Russian Architecture (Ch. 1, n. 22); George Heard Hamilton, *The Art and Architecture of Russia*, Harmondsworth, 1985; Audrey and John Kensett, *The Palaces of Leningrad*, London, 1973.

2. See *La France et la Russie au Siècle des Lumières. Relations culturelles et artistiques de la France et de la Russie au XVIIIème siècle*, exhibition catalogue, Paris, 1986. A similarly accessible introduction to a somewhat later period, with however reference to the eighteenth century, is provided by another exhibition catalogue, *St Petersburg um 1800. Ein goldenes Zeitalter des russischen Zarenreichs. Meisterwerke und authentische Zeugnisse der Zeit aus der Staatlichen Ermitage, Leningrad*, Essen (pub. Recklinghausen), 1990.

3. Although it is often assumed that the wide range of references found in his work must presume a first-hand knowledge of foreign sources and hence essential travel, there is no documentary evidence that Rastrelli ever journeyed outside the Russian empire (including Estonia, and Courland, now in Latvia). On the contrary: K. Malinovsky of the State Central Archives, formerly USSR, now Russia, informs me that there is no record of a passport having been issued to the younger Rastrelli. Without such permission to travel, Rastrelli could not have left Russia, all the more so because he was a court servitor.

4. A Fischerian inspiration seems to lie behind plans even for such buildings as the orthodox church of St Andrew in Kiev (Kyiv, Ukraine) as well. This subject deserves further attention.

Notes to Chapter Fourteen

1. As indicated by the descriptions in Kalinowski, *Barock in Schlesien* (Ch. 11, n. 18).

2. In addition to the works by Swoboda, *Barock in Böhmen*, Blažíček, *Baroque Art in Bohemia*, and Neumann, *Das Böhmische Barock* (all Ch. 11, n. 36), numerous exhibition catalogues have offered surveys of this material. The latest overview is given by the second volume of *Dějiny Českého vytvarného Umění* (Ch. 6, n. 11), which also can be consulted for photographs for those without Czech.

3. 2. See Evans, *Making of the Habsburg Monarchy* (Ch. 10, n. 18), pp. 202ff.

4. See Robert Joseph Kerner, *Bohemia in the Eighteenth Century*, New York, 1969 (reprint of 1932 edn.), for an introduction in English to the economic and social history of the time.

5. For a summary of the situation there, see *Prager Barock*, exhibition catalogue, Schallaburg, 1989. The essays by Josef Petráň, Josef Janáček, Eduard Maur, Jan Diviš and Zdeněk Mika offer good summaries of the social and cultural situation, on which the previous paragraphs have also drawn.

6. For instance by Białostocki, 'Some Values of Artistic Periphery' (Ch. 1, n. 42).

7. In addition to the books by Kalinowski on Silesia that have already been cited, see Jan Wrabec, *Barokowe kościoły na Śląsku w XVIII wieku. Systematyka typologiczna* (with German summary), Wrocław, etc., 1986.

8. See Kalinowski, *Gloryfikacja panującego i dynastii* (Ch. 11, n. 20).

9. See Zdeněk Kalista, *Česká barokní gotika a její Žďárské ohnisko* (with brief summaries), Brno, 1970. For Balbín, see *Bohuslav Balbín a kultura jeho doby v Čechách: Sborník z konference Památníku národního písemnictví*, Prague, 1992.

10. See Carsten-Peter Warncke, *Bavaria Sancta – Heiliges Bayern: Die altbayerischen Patronen aus der Heiligengeschichte des Matthaeus Rader in Bildern von J. M. Kager, P. Candid und R. Sadeler*, Dortmund, 1981.

11. See Beda Menzel, *Abt Othmar Daniel Zinke 1700–1738: Ein Prälat des Böhmischen Barocks, Studien und Mitteilungen zur Geschichte des Benediktiner-Ordens und seiner Zweige* 89, Ottobeuren, 1978, pp. 7–300; and Ambrosius Rose, *Abt Bernardus Rosa von Grussau*, (*Die Dominsel*, 4), Stuttgart, 1960.

12. Illustrated as Bernini workshop in Kalinowski, *Barock in Schlesien* (Ch. 11, n. 18), fig. 8, p. 30, this work has been attributed by Kalinowski to Bernini himself in a forthcoming article in *Biuletyn Historii Sztuki*.

13. See the monograph by Amalia Barigozzi Brini and Klára Garas, *Carlo Innocenzo Carlone*, Milan, 1967.

14. See recently H. A. Meek, *Guarino Guarini and his Architecture*, New Haven and London, 1988, pp. 127–30, 164–5.

15. See Preiss, *Italští umělci v Praze* (Ch. 6, n. 12); Franz, *Bauten und Baumeister* (Ch. 11, n. 29), p. 209.

16. See Vera Naňková, 'Die Architektur Böhmens um 1700 und die Tätigkeit des Architekten Giovanni Battista Alliprandi', in *Wien und der europäische Barock*, pp. 71–6. See further Hellmut Lorenz, *Domenico Martinelli*, Vienna, 1991.

17. For Silesia, see the comments by Kalinowski, *Barock in Schlesien* (Ch. 11, n. 18), p. 2.

18. For an orientation to Christoph and Kilian Ignaz Dientzenhofer, consult Franz, *Dientzenhofer und Hausstätter* (Ch. 13, n. 30); Vilimková and Brucker, *Dientzenhofer* (Ch. 13, n. 30); Christian Norberg-Schulz, *Kilian Ignaz Dientzenhofer e il barocco Boemo*, Rome, 1968; Milada Vilimková, *Stavitelé paláců a chrámů. Kryštof a Kilián Ignác Dientzenhoferové*

(with German précis), Prague, 1986; *Kilian Ignác Dientzenhofer a Umělcí jeho Okruhu*, exhibition catalogue, Prague, 1989.

19. The proximity to Santini-Aichel's similar symbolic use of architecture has also at times led to attributions of these works to him.

20. The literature on Santini is growing: for a preliminary orientation, related to the present treatment, see my 'Jan Blažej Santini Aichel', *Encyclopedia of Architects*, 3, New York, 1982, pp. 660-63. Fundamental for Santini (though without a summary) is Viktor Kotrba, *Česká barokní gotika: Dílo Jana Santiniho-Aichla*, Prague, 1976; see further Bruno Queysanne, Claude Chautant and Patrick Thepot, *Santini-Aichl: un architecte baroque-gothique en Bohème*, Grenoble, n.d. [1985]; Jan Sedlák, *Jan Blažej Santini: Setkání Baroku s Gotikou*, Prague, 1987; Xavier Galmiche, *Santini: Architecte gothico-baroque en Bohême* [sic], Paris, 1989; Michael Young, *Santini-Aichel's Design for the Convent of Plasy in Western Bohemia*, Boulder, Colorado and New York, 1994.

21. These paragraphs summarize '"Gottico More Nondum Visa": The "Modern Gothic" Architecture of Jan Blažej Santini Aichl', in *Porta Mortis: Essays in Memory of Jan Bialostocki*, supposed to be published in Warsaw. Christine Smith, *Architecture in the Culture of Early Humanism* (Ch. 1, n. 21), indicates of course the complexity of the issue of the Gothic even in the origins of Renaissance art theory. For the general phenomenon see Giles Worsley, 'The Origins of the Gothic Revival', *Transactions of the Royal Historical Society*, sixth series, 3, 1992, pp. 105–150.

The term 'first moderns' derives from Joseph Rywkwert, *The First Moderns: The Architects of the Eighteenth Century*, Cambridge, Mass., and London, 1980.

22. Santini is now generally given credit for the design of the votive church and cloister erected to commemorate the battle of White Mountain, near the Star Villa (Villa Hvězda).

23. For Brokof, see Oldřich J. Blažíček, *Ferdinand Brokof* (with brief précis), Prague, 1976, and *Ferdinand Maxmilian Brokof 1684–1731* (with German summary), exhibition catalogue, Prague, 1981.

24. See for Bendl *Jan Jiří Bendl* (with German summary), exhibition catalogue, Prague, 1982.

25. For the whole tradition, see Oldřich J. Blažíček, *Sochařství Baroku v Čechách: Plastika 17. a 18. věku* (with French and German summaries), Prague, 1958.

26. For Braun, see *Matyáš Bernard Braun* (with German summary), exhibition catalogue, Prague, 1984; Emanuel Poche, *Matyáš Bernard Braun: Sochář Českého Baroka a jeho dílna* (with German précis), Prague, 1986 (1st edn. 1965); *Matyáš Bernard Braun: Studie a Materiály 1684–1738* (with German summaries), Prague, 1988.

27. See Jan Lukaš and Jaromír Neumann, *Sporkův Kuks*, Prague, 1950, for photographs;

Pavel Preiss, *Boje s dvouhlavou Sáni: František Antonín Špork a barokní kultura v Čechách* (no summary), Prague, 1981, treats the cultural and intellectual aspects of the question.

28. See Erich Bachmann, 'Anfänge des Landschaftgartens in Deutschland', *Zeitchrift für Kunstwissenschaft*, 5, 1951, pp. 203–28.

29. See Jaromír Neumann, *Petr Brandl 1668–1735* (with extensive German summary), exhibition catalogue, Prague, 1968.

30. See Pavel Preiss, 'Zu den Werken der Asam in Böhmen und Schlesien', in Bruno Bushart and Bernhard Rupprecht, eds., *Cosmas Damian Asam 1686–1739: Leben und Werk*, Munich, 1986 (exhibition catalogue, Aldersbach), pp. 69–75.

Notes to Chapter 15

1. This is the estimate of Max Hauttmann, *Geschichte der kirchlichen Baukunst in Bayern, Schwaben und Franken 1550–1780*, Munich, 1921, cited in Hitchcock, *German Rococo* (Ch. 13, n. 46), p. 17.

2. The subject of the rococo and its origins in France has garnered a huge literature; a representative sample of important contributions would include Fiske Kimball, *The Creation of the Rococo Decorative Style*, New York, 1980 (1st edn. 1943); *Europäisches Rokoko*, exhibition catalogue, Munich, 1958; J. Philippe Minguet, *Esthéthique du Rococo*, Paris, 1966; Hans Sedlmayr and Hermann Bauer, *Encyclopaedia of World Art*, 12, 1968, pp. 230–74; Hermann Bauer, *Rokokomalerei*, Mittenwald, 1980.

3. This summary is a more pointed account than that by which it is also informed, Thomas Crow's authoritative *Painters and Public Life in Eighteenth-Century Paris*, New Haven and London, 1985.

4. The term is taken from Wolfgang Braunfels, *François Cuvilliés: Der Baumeister der galanten Architektur des Rokoko*, Munich, 1986, the standard monograph on the architect.

5. See *Kurfürst Clemens August*, exhibition catalogue, Brühl, 1961.

6. The terms 'pictorialization of ornament' and 'aesthetic play' are developed in Karsten Harries's important study of the rococo, *The Bavarian Rococo Church: Between Faith and Aestheticism*, New Haven and London, 1983, pp. 19ff., 144ff., but I find the latter concept even more appropriate in the secular context than in association with 'religious play', as Harries employs it.

7. As Braunfels, *Cuvilliés* (n. 4), p. 178, says, although this building is often attributed to Cuvilliés, as by Hempel, *Baroque Art and Architecture* (Intro. n. 31), p. 231, it is probably not by him.

8. For the distinction between the French and the Bavarian rococo, see Harries, *Bavarian Rococo Church* (n. 6), pp. 10ff.

9. See for this point Hitchcock, *German Rococo* (Ch. 13, n. 46), pp. 20 ff., and *idem, Rococo Architecture in Southern Germany*, London, 1968, pp. 10–11.

10. A good introduction to the literature on pilgrimage, its historical and present-day aspects, is provided by *Wallfahrt kennt keine Grenzen: Themen zu einer Ausstellung des Bayerischen Nationalmuseums und des Adalbert Stifter Vereins, München*, exhibition catalogue, Munich and Zurich, 1984.

11. For some of the relationship between art and the sacral landscape, see 'The Sanctification of Nature', reprinted as Chapter 1 in *The Mastery of Nature* (Ch. 4, n. 8).

12. For the Zimmermann and the Wies, see the extended treatments in English in Hitchcock, *German Rococo* (Ch. 13, n. 46) and Harries, *Bavarian Rococo Church* (n. 6).

13. Various aspects of Günther's extensive *oeuvre*, which, regrettably, space does not allow us further to discuss here, are presented and analysed in *Matthäus Günther*, exhibition catalogue, Augsburg, 1988.

14. See Fritz Markmiller, ed., *Barockmaler in Niederbayern: Die Meister der Städte, Märkte und Hofmarken*, Regensburg, 1982.

15. See Alois J. Weichslgartner and Wilfried Bahnmüller, *Lüftlmalerei*, Freilassing, 1977 (2nd printing 1981).

16. See the works cited in notes 24–6 of Chapter 1.

17. Fischer is accessible in English through Hitchcock, *Rococo Architecture* (n. 9) and Harries, *Bavarian Rococo Church* (n. 6); a basic German source for his and other churches is Bernhard Rupprecht, *Die bayerische Rokoko-Kirche*, Kallmünz, 1959.

18. The terms are those of Harries, *Bavarian Rococo Church* (n. 6), pp. 112ff., whom I have followed particularly for the accounts of Wies and Aldersbach herein.

19. See *Cesare Ripa Baroque and Rococo Pictorial Imagery: The 1758–60 Hertel Edition of Ripa's 'Iconological' with 200 Engraved Illustrations*, ed., intro. and trans. Edward A. Maser, New York, 1971.

20. In addition to the works cited in note 2, and the books by Harries and Hitchcock cited above (nn. 6 and 9 and Ch. 13, n. 46), see Anthony Blunt, *Some Uses and Misuses of the Terms Baroque and Rococo as Applied to Architecture*, London, 1972.

21. The direct role of Italians has been re-emphasized in several publications recently: see for example *Himmel, Ruhm und Herrlichkeit: Italienische Künstler an rheinischen Höfen des Barock*, exhibition catalogue, Bonn, 1989; a series of publications on Italians in Bavaria has been announced.

22. For this theme see Irving Lavin, *Bernini and the Unity of the Visual Arts*, New York and London, 1980.

23. See now *Cosmas Damian Asam 1686-1739: Leben und Werk*, exhibition catalogue, Munich, 1986; Helene Trottmann, *Cosmas Damian Asam (1686–1739): Tradition und Innovation im malerischen Werk*, Nuremberg, 1986.

24. See *Prize-winning Drawings from the Roman Academy 1682–1754*, exhibition catalogue, Rome, 1990, pp. 102–4, cat. no. 45.

25. See *Vorarlberger Barockbaumeister*, exhibition catalogue, Bregenz and Einsiedeln, 1973.

26. An introduction to the work and milieu of this important painter, teacher and writer is provided by *Johann Georg Bergmüller 1688–1762: Zur Widerkehr seines Geburtjahres, Ausstellung im Schloß in Türkheim*, exhibition catalogue, Weissenhorn, 1988.

27. See Harries, *Bavarian Roccoco Church*, (n. 6), pp. 160ff.

28. If the Venetian painted some of his last major works outside Italy, it may conversely say something about the relative fate of Venetian and Italian painting, that better opportunities were available outside Italy. The subject of Venetian painters in Germany was the focus of an exhibition, *Venedigs Ruhm in Norden: die grossen Venezianische Maler des 18. Jahrhunderts, ihre Auftraggeber und ihre Sammler*, Hannover and Düsseldorf, 1991.

29. This interpretation relies on Mark Ashton, 'Allegory, Fact and Meaning in Giambattista Tiepolo's *Four Continents* in Würzburg', *Art Bulletin* 60, no. 1, 1978, 109–25, who also provides a useful introduction to this monument. The literature on Tiepolo is extensive, of course: a monograph by Michael Levey, London, 1990, provides a useful introduction to it.

30. For Holzer, see Ernst Wolfgang Mick, *Johann Ev. Holzer: Ein frühvollendetes Malergenie des 18. Jhs.*, Munich and Zurich, 1984.

31. For an introduction, see now *Bayerische Rokokoplastik: Vom Entwurf zur Ausführung*, exhibition catalogue, Munich, 1985, and *Entwurf und Ausführung in der europäischen Barockplastik*, Munich, 1986; an orientation to the large literature on sculpture can be gained from the former.

32. This debate is discussed in Harries, *Bavarian Rococo Church* (n. 6), pp. 223–5.

33. For Günther, see G.P. Woeckel, *Der große Bildhauer des bayerischen Rokoko*, Regensburg, 1977.

34. Jan K. Ostrowski, 'Die polnische Barockskulptur im 18. Jahrhundert: Probleme und Forschungsaufgaben', *Zeitschrift für Kunstgeschichte*, 52, 1989, pp. 89–113, provides an accessible introduction and a good bibliography to the topic. See also the latest overview provided in *idem*, ed., *Sztuka Kresów wschodnich*, Kraków, 1994. Another introduction is provided by Mariusz Karpowicz, 'Lemberger Rokokoskulptur als künstlerisches Phänomen und ihre Genese', in Konstanty Kalinowski, ed., *Studien zur europäischen Barock- und Rokokoskulptur*, Poznań, 1985, pp. 203–14.

35. This sculpture, along with that of Silesia from a slightly earlier period, is now most easily accessible in the bilingual catalogue, *Teatr i Mystika: Rzeźba barokowa pomiędzy Zachodem a Wschodem / Theater and Mysticism: Baroque Sculpture between West and East*, exhibition catalogue, Pozan, 1993. The articles by Stanisław Lorentz, 'O architekturze wileńskiej', and Jerzy Kowalczyk, 'Późnobarokowa architektura Wilna i jej europejskie związki', in *Biuletyn Historii Sztuki*, 55, 1993, pp. 153–67 and 169–97, have provided recent overviews (with French summaries) and decent illustrations of architecture in Vilnius (Wilno) and other sites in Lithuania.

36. See Christian Otto, *Space into Light: The Churches of Balthasar Neumann*, New York, Cambridge, Mass. and London, 1980 (2nd printing), on which this account relies.

37. For Schlaun, see the series *Schlaun Studien*, 5 vols., Münster, 1973, 1979, 1986, 1992. An exhibition of 1995 in Münster on Schlaun ties him better into broader European currents. I have dealt further with the problem of the relation of Schlaun to the history of European architecture in 'Schlaun–ein unzeitgemäßer Zeitgenosse?' in *Johann Conrad Schlaun: Architektur des Spätbarock in Europa*, exhibition catalogue, Münster, 1995, pp. 594-7, the essay volume for this show.

Notes to Chapter Sixteen

1. The king wrote similarly to his sister Sophia Wilhelmina in a letter of 1746: 'We are emerging from barbarism and are still in our cradles. But the French have already gone a long way and are a century in advance of us in every kind of success.' Both are quoted in Fauchier-Magnan, *The Small German Courts in the Eighteenth Century* (Ch. 13, n. 2), p. 29.

2. These sentences repeat arguments in my *Central European Drawings 1680–1800: A Selection from American Collections* (Intro. n. 4), where further information of this nature is given.

3. Information on this subject is accumulated in Troescher, *Kunst- und Künstlerwanderungen in Mitteleuropa*, 2 vols. (Ch. 10, n. 28), useful for periods other than the eighteenth century as well.

4. An introduction to the subject of Frederick and the visual arts, with many further references, is provided by the essays in *Friedrich II und die Kunst*, exhibition catalogue, 2 vols., Potsdam, 1986.

5. See E. Wangermann, 'Maria Theresa: A Reforming Monarchy', in A. G. Dickens, ed., *The Courts of Europe: Politics, Patronage and Royalty 1400-1800*, London, 1977, p. 303.

6. See *Central European Drawings* (Intro. n. 4), pp. 10-11, from which this summary is drawn and where references to further literature are given; the consequences for instruction in drawing are discussed further *ibid.*, pp. 13f, 23. In English, the basic source for this information is Pevsner, *Academies of Art Past and Present* (Ch. 13, n. 17). See also the essays in Boschloo, ed., *Academies of Art* (Ch. 13, n. 17).

7. See Du Colombier *L'Architecture française en Allemagne au XVIIIe siècle* (Ch. 13, n. 2).

8. See Troescher, *Kunst- und Künstlerwanderungen* (Ch. 10, n. 28), 2, *Französische und niederländische Kunst und Künstler in der deutschen Kunst.*

9. This is the standard story reported in histories of the region. In English see for example Holborn, *A History of Modern Germany* (Ch. 13, n. 11); Gagliardo, *Germany under the Old Regime* (Ch. 10, n. 1); see further Wangermann, *The Austrian Achievement* (Ch. 12, n. 24); G. Ritter, *Frederick the Great: An Historical Profile*, London, 1968.

10. Essays in two recent exhibition catalogues have treated the subject of Frederick's patronage and collecting *in extenso: Friedrich II. und die Kunst* (n. 4), and *Friedrich der Große: Sammler und Mäzen*, Munich, 1992.

11. See Börsch-Supan, *Der Maler Antoine Pesne* (Ch. 13, n. 2).

12. See Börsch-Supan, *Die Kunst in Brandenburg-Preußen* (Ch. 13, n. 14), pp. 121–2.

13. E. Baldwin Smith, *The Dome*, Princeton, 1950.
 Hans-Joachim Giersberg, 'Friedrich II. und die Architektur', in *Friedrich II. und die Kunst* (n. 4), 2, pp. 192ff., and in 'Die Bauten Friedrichs des Großen', in *Friedrich der Große: Sammler und Mäzen* (n. 10), pp. 52 ff., offers a different interpretation of this feature, however.

14. The authoritative work on Knobelsdorff's interior designs in Brandenburg is Tilo Eggeling, *Studien zum Friderizianischen Rokoko: Georg Wenceslaus von Knobelsdorff als Entwerfer von Innendekorationen*, Berlin, 1980. A similar work is still needed on him as an architect.

15. As discussed by Hempel, *Baroque Art and Architecture* (Intro. n. 31), p. 269.

16. For the historical context of the *Lettres Persanes* and their relation to *sensibilité*, see the discussion in Robert Shackleton, *Montesquieu: A Critical Biography*, Oxford, 1961, pp. 27–45.

17. For Legeay and his circle see John Harris, 'Le Geay, Piranesi and International Neo-classicism in Rome 1740–1750', in *Essays in the History of Architecture Presented to Rudolf Wittkower*, ed. Douglas Fraser, Howard Hibbard and Milton J. Lewine, London and New York, 1967, pp. 189–96; Wend Graf Kalnein and Michael Levey, *Art and Architecture of the Eighteenth Century in France*, Harmondsworth, 1972, pp. 301ff. and passim.

18. See Hempel, *Baroque Art and Architecture* (Intro. n. 31), p. 272.

19. See H. J. Giersberg in *Barock und Klassik*, exhibition catalogue, Essen, p. 163. A useful introduction to aspects of this phenomenon in German, particularly in the area of Brandenburg, with further references to other literature, is Karl-Heinz Klingenburg, ed., *Historismus – Aspekte zur Kunst im 19. Jahrhundert*, Leipzig, 1985.

20. Haskell, *Patrons and Painters* (Ch. 9, n. 14), pp. 347ff.

21. Quoted by Giersberg, in *Barock und Klassik* (n. 19), p.163: Friedrich werde den 'Architekten Venedigs dieselbe Ehre zu Theil werden lassen, wie Sie denen von Rom und Versailles erwiesen, die nämlich, einige bei sich heimisch zu machen und mit Ihren eigenen vermischen. Potsdam wird eine Schule der Baukunst werden, wie es eine Schule der Kriegskunst ist.'

22. See Johann Christoph Gottsched, '*Versuch einer Critischen Dichtkunst für die Deutschen*', (first edn. Leipzig, 1737), as in *Schriften zur Literatur*, Stuttgart, 1972, pp. 68ff.

23. Quantz, *On Playing the Flute*, trans. Edward R. Reilly, 2nd edn., New York, 1985, p. 341. The original, Johann Joachim Quantz, V*ersuch einer Anweisung die Flöte traversiere zu spielen*, Berlin, 1752, reads: 'Wenn man aus verschiedener Völker Ihren Geschmacke in der Musik, mit gehöriger Beurtheilung, das Beste zu wählen weiss: so fliesset daraus ein vermischter Geschmack, welchen man, ohne die Gränze der Bescheidenheit zu überschreiten, nunmehr sehr wohl: den deutschen Geschmack nennen könnte …'

24. For music, see Reilly, trans., *On Playing the Flute* (n. 23), p. 342.

25. This interpretation responds to the critique offered in Hempel, *Baroque Art and Architecture* (Intro. n. 31), p. 273.

26. This distinction follows Rudolf Wittkower's separation between the enthusiastic approach to an architecture based on antiquity, that still follows basically in the tradition of Palladio and, as in England, may even take its lead from him, and an approach more concerned with archaeological exactitude: see *Palladio and English Palladianism*, New York

and London, 1974. For discussions of the meaning of the term, the interested reader can still turn to Hugh Honour, *Neo-classicism*, Harmondsworth, 1968, and *The Age of Neo-classicism*, exhibition catalogue, London, 1972.

27. See *Barock und Klassik* (n. 19), p. 163.

28. See Henri Brunschwig, *Enlightenment and Romanticism in Eighteenth-Century Prussia*, Chicago and London, 1974.

29. An overview is provided in the picture book, *Anhaltische Schlösser in Geschichte und Kunst*, Niedernhausen, 1991.

30. See Erhard Hirsch, *Dessau-Wörlitz: Aufklärung und Frühklassik*, Leipzig, 1985.

31. Wieland is quoted by Hirsch, *Dessau-Wörlitz* (n. 30), p. 7. For the gardens and buildings around Dessau and Wörlitz and Erdmannsdorff's role, see Hans-Joachim Kadatz, *Friedrich Wilhelm von Erdmannsdorff 1736–1800: Wegbereiter des deutschen Frühklassizismus in Anhalt-Dessau*, Berlin, 1986; *Friedrich Wilhelm von Erdmannsdorff von 1736 bis 1800: Sammlung der Zeichnungen*, exhibition catalogue, Dessau, 1986; and the essays collected in *Friedrich Wilhelm von Erdmannsdorff: Leben, Werk, Wirkung*, Wörlitz, 1987.

32. Good photographs of these and other gardens mentioned in this chapter and book can be found in *Gardens in Central Europe*, New York, 1991.

33. See further Peter H. Feist, 'Klassizismus und Neugotik in Wörlitz: Das Gotische Haus und sein "Gotisches Zimmer"', in his *Künstler, Kunstwerk und Gesellschaft*, Dresden, 1978, pp. 64–77.

34. For this notion, see Renate Wagner-Rieger, 'Architektur in Theresanischen Zeitalter', in Walter Koschatzky, ed., *Maria Theresia und ihre Zeit*, Salzburg and Vienna, 1980, pp. 259ff., which offers an overview of architecture during the empress's reign.

35. As quoted in Hempel, *Baroque Art and Architecture in Central Europe* (Intro. n. 31), p. 291.

36. As suggested by Brucher, *Barockarchitektur in Österreich* (Ch. 11, n. 34), p. 284.

37. See James van Horn Melton, *Absolutism and the Eighteenth-century Origins of Compulsory Schooling in Prussia and Austria*, Cambridge, 1988.

38. A monograph on the architect exists in Magyar (with German summary): György Kelényi, *Franz Anton Hillebrandt*, Budapest, 1976.

39. The discussion of architecture in this chapter at the time of Joseph II, including this work, in this chapter is based on Wilhelm Georg Rizzi and Mario Schwarz, 'Die

Architektur zur Zeit Josephs II', in *Österreich zur Zeit Kaiser Josephs II*, exhibition catalogue, Melk, 1980, pp. 200–210, where photographs of the pertinent buildings can be found.

40. See for the gloriette, Wangermann, 'Maria Theresa' (n. 5), pp. 287, 293. Renate Goebl, 'Architektur', in *Klassizismus in Wien: Architektur und Plastik*, exhibition catalogue, Vienna, 1978, pp. 32–42, covers the classicist aspect of architecture in later eighteenth-century Vienna.

41. For this subject, see (in English) T. C. W.Blanning, *Joseph II and Enlightened Despotism*, Burnt Hill, 1970; Derek Beales, *Joseph II*, 1, *In the Shadow of Maria Theresa 1741–1780*, Cambridge, 1987; *idem*, 'Was Joseph II an Enlightened Despot?', in Ritchie Robertson and Edward Timms, eds., *The Austrian Enlightenment and its Aftermath* (*Austrian Studies II*), Edinburgh, 1991, pp. 1–22, which volume contains much further bibliography; and for various aspects of art, culture and society, *Österreich zur Zeit Kaiser Josephs II*.

42. A similar observation is made by Wangermann, *The Austrian Achievement* (Ch. 12, n. 24), pp. 129–30.

NOTES TO CHAPTER SEVENTEEN

1. See Ostrowski, 'Polnische Barockskulptur' (Ch. 15, n. 34), p. 109.

2. For the Dominican church in Lwów, see J. Adam Miłobędzki, 'Viennese Church Models in the Late Baroque Architecture of Eastern Europe', in *Wien und der europäische Barock*, ed. Elisabeth Liskar, Vienna, Cologne, Graz, 1986, especially pp. 93ff., and Harald Keller, ed., in *Die Kunst des 18. Jahrhunderts*, Berlin and Vienna, 1985 (new printing); for Lithuania, see Andrzej Josef Baranowski, 'Medieval Tradition in Late Baroque Sacral Architecture of Central Europe', in Liskar, *ibid.*, pp. 147–51.

3. See Miłobędzki, *Zarys* (Ch. 12, n. 3), pp. 208ff., for a reliable account of eighteenth-century architecture in Poland. Mariusz Karpowicz, *Sztuka polska XVIII w.* (Ch. 13, n. 37), also deals with the Polish monuments mentioned in this chapter and points to further bibliography. For Volhynia, see *Sztuka Kresów wschodnich* (Ch. 15, n. 34).

4. Marek Kwiatkowski, *Stanislaw August: Król-Architekt* (with English summary), Wrocław, etc., 1983, discusses the impact of royal patronage and participation in architecture.

5. In addition to works already cited, see Eberhard Hempel, *Gaetano Chiaveri*, Dresden, 1955.

6. For Louis in France, see Kalnein and Levey, *Art and Architecture in France* (Ch. 16, n. 17), pp. 337–40.

7. For this work in relation to the question of 'currents' and 'variants' in Polish architecture of the time, others of which are also discussed in this chapter, see further Tadeusz Stefan

Jaroszewski, *Architektura Doby Oświecenia w Polsce: Nurty i Odmiany* (with extensive French summary), Wrocław, etc., 1971.

8. See in general Stanisław Lorentz, *Efraim Szreger: Architekt Polski XVIII Wieku* (with English and German summaries), Warsaw, 1986.

9. Mieczysław Zlat, 'Polnische Kunst', in Harald Keller, *Die Kunst des 18. Jahrhunderts*, pp. 263ff., provides a good discussion of these buildings and of other aspects of Polish eighteenth-century art mentioned in this book. For architecture, see also Miłobędzki, *Zarys* (Ch. 12, n. 3).

10. For Fertöd and other Hungarian buildings mentioned here, see Voit, *Der Barock in Ungarn* (Ch. 11, n. 34), pp. 87ff.; for the general situation of the arts, see the essays by Klára Garas, Ladislav Sasky and Dorottya Dobrovits in *Maria Theresia als Königin von Ungarn*, exhibition catalogue, Halbturn, 1980, pp. 120–38.

11. Béla K. Király, *Hungary in the Late Eighteenth Century: The Decline of Enlightened Despotism*, New York and London, 1969, discusses the social and political situation. A cultural history of Hungary during the eighteenth century by R. J. W. Evans is in progress.

12. For Troger, see most recently Maja Schrenzel, *Paul Troger: Maler der Apocalypse*, Vienna, 1985. A revised, complete monograph on the artist would still be most welcome.

13. See my *Central European Drawings* (Intro. n. 4), p. 23, for more on this point. The Neapolitan-Austrian connection has now been surveyed by an exhibition held 1993–4 in Vienna and Naples, *Sotto le ali dell'aquila*, exhibition catalogue, Naples, 1993.

14. For the paintings by Maulbertsch discussed here, out of the extensive literature on the artist, see Klára Garas, *Franz Anton Maulbertsch*, Budapest, Vienna, Graz, 1960; *idem*, *Franz Anton Maulbertsch*, Salzburg, 1974; *Franz Anton Maulbertsch*, exhibition catalogue, Vienna, Halbturn, Heiligenkreuz-Gutenbrunn, 1974; *Franz Anton Maulbertsch und sein Kreis in Ungarn*, exhibition catalogue, Sigmaringen, 1984: Karl Möseneder, *Franz Anton Maulbertsch: Aufklärung in der barocken Deckenmalerei*, Vienna, Cologne, Weimar, 1993.

15. Maulbertsch's colourism has been discussed primarily by Ivo Krsek, whose views are most accessible in his introduction to a compendium of good illustrations, *František Antonín Maulbertsch*, Prague, n.d. [1974].

16. See in general for descriptions of what can be meant by this term Bauer, *Rokokomalerei* (Ch. 15, n. 2).

17. See E. H. Gombrich, 'Icones Symbolicae: Philosophies of Symbolism and their Bearing on Art', in his *Symbolic Images: Studies in the Art of the Renaissance*, London, 1972, pp. 123ff.: Mistelbach is illustrated as fig. 132 and referred to on p. 123.

18. Garas, *Maulbertsch* (n. 14), 1960, pp. 241ff., provides documentation on contemporary comments on the artist, including several of this nature, e.g. no. XL, p. 249.

19. I have in mind paintings of artists like Mathias Nithardt called Grünewald, but this subject would seem to merit further consideration.

20. This is treated as a fact in standard histories as well, even recently in Gagliardo, *Germany under the Old Regime* (Ch. 10, n. 1), p. 210, n. 6.

21. 'Seine reiche Quelle der Erfindung: die ihm eigene Leichtigkeit in der Ausführung; indem er mit einer verthelhaften Anordnung, mit einem den Gegenständen angemessenen Ausdruck, und mit andern Kunstgriffen seine Werke zu beleben weis, haben ihme eine Menge Arbeit verschafft ...' From a report of 1771 printed in Garas, *Maulbertsch* (n. 14), p. 250, no. XLIII.

22. For the background to this commission in Maria Theresa's relationship with the Tyrol, see *Maria Theresia und Tirol*, exhibition catalogue, Innsbruck, 1958.

23. The subject of mural painting technique in Central Europe has not received its due. See however, also for bibliography, Bärbel Hamacher, *Entwurf und Ausführung in der Süddeutschen Freskomalerei des 18. Jahrhunderts*, Munich, 1987; see also *eadem, Arbeitssituation und Werkprozeß in der Freskomalerei von Matthäus Günther (1705–1788)*, Munich, 1987.

24. Imparted initially in Andrea Pozzo, *Prospettiva de Pittori e Architetti*, Rome, 1692.

25. The most convenient introduction in English to the biographies and works of figures mentioned here can be found in *Central European Drawings* (Intro. n. 4). The latest on the subject of German book illustration of the eighteenth century, discussing it in relation to the dissolution of history painting, is Hans Jakob Meier, *Die Buchillustration des 18. Jahrhunderts in Deutschland und die Auflösung des überlieferten Historienbilds*, Munich, 1994.

26. For Carl Theodore, see *Zeichnungen aus der Sammlung des Kurfürsten Carl Theodor*, exhibition catalogue, Munich, 1983, and *Von Mantegna bis Watteau: Zeichnungen aus der Sammlung des Kurfürsten Carl Theodor*, exhibition catalogue, Düsseldorf, 1988; for Anton Ulrich, see *Herzog Anton Ulrich von Braunschweig: Leben und Regieren mit der Kunst*, exhibition catalogue, Braunschweig, 1983.

27. See Elisabeth Herrmann-Fichtenau, *Der Einfluss Hollands auf die Österreichische Malerei des 18. Jahrhunderts*, Vienna, Cologne, Graz, 1983; Ina Maria Keller, *Studien zu den deutschen Rembrandtnachahmungen des 18. Jahrhunderts*, Berlin, 1981; and *In Rembrandts Manier: Kopie, Nachahmung und Aneignung in den Graphischen Künsten des 18. Jahrhunderts*, exhibition catalogue, Bremen and Lübeck, 1987.

28. See *Darmstadt in der Zeit des Barock und Rokoko*, exhibition catalogue, Darmstadt, 1980, pp. 245–65. See also *Franfurter Malerei zur Zeit des jungen Goethe*, exhibition catalogue, Frankfurt am Main, 1982.

29. As exemplified in *Höfische Bildnisse des Spätbarock*, exhibition catalogue, Berlin, 1966.

30. See František Dvořák, *Kupecky: Der grosse Porträtmaler des Barocks*, Prague, 1956.

31. See Horst Scholke and Gerlinde Wappler, *Briefe und Porträts* (*Die Sammlungen des Gleimhauses I*), Halberstadt, 1986.

32. See Ekhart Berckenhagen, *Anton Graff: Leben und Werk*, Berlin, 1967; further, *Anton Graff: Selbstbildnis vor der Staffelei*, exhibition catalogue, Leipzig, 1986.

33. See *Johann Heinrich Tischbein 1722-1789*, exhibition catalogue, Cassel, 1989.

34. See Helmut Börsch-Supan, *Die Deutsche Malerei von Anton Graff bis Hans von Marées, 1760–1870*, Munich, 1988, p. 110. Börsch-Supan's book is in general the best starting point of reference for the figures mentioned in the chapter.

35. This subject is treated by Peter Pötschner, *Wien und die Wiener Landschaft: spätbarocke und biedermeierliche Landschaftskunst in Wien*, Salzburg, 1978; Börsch-Supan, *Die Deutsche malerei* (n. 34), provides an introduction to the artists mentioned here.

36. See Wangermann, *Austrian Achievement* (Ch. 12, n. 24), p. 127.

37. Antonio Canova's sculptural group of Theseus and the Minotaur (Vienna, Kunsthistorisches Museum), which was originally found inside the palace, heralds the arrival of a new stylistic era in sculpture as well. This subject is treated in my essay on 'The Urban Fabric of Schubert's Vienna: Sculpture and Architecture', based on two lectures delivered at Aston Magna Academy and being prepared for publication in R. Erickson, ed., *The Culture of Vienna in the Time of Franz II* (tentative title, forthcoming).

Notes to Chapter Eighteen

1. *Die Brieftasche*, 18 December, 1783, quoted in Ernst Wangermann, *The Austrian Achievement* (Ch. 12, n. 24), 1973, p. 127, where, however, the existence of the debate between Nigelli and Beyer, discussed by Rizzi and Schwarz, 'Die Architektur zur Zeit Josephs II' (Ch. 16, n. 39), is ignored.

2. See Rizzi and Schwarz, 'Die Architektur zur Zeit Josephs II' (Ch. 16, n. 39), pp. 206, 210, nn. 27–9.

3. Holborn, *A History of Modern Germany* (Ch. 13, n. 11), p. 306.

4. Jürgen Habermas, *Strukturwandel der Öffentlichkeit*, Frankfurt am Main, 1962, in English as *The Structural Transformation of the Public Sphere: An Inquiry into a Category of Bourgeois Society*, Cambridge, Mass., 1979.

5. Christian Garve, quoted in Larry Vaughn, *The Historical Constellation of the Sturm und Drang*, New York, Bern, Frankfurt, am Main, 1985, p. 32, which book can be consulted in general for the social history of art and literature in this time period.

6. The essays collected in Franklin Kopitzsch, ed., *Aufklärung, Absolutismus und Bürgertum in Deutschland*, Hamburg, 1982, provide a good introduction to these themes.

7. For a drawing by Maria Antoinette, see *Maria Theresa und ihre Zeit* (Ch. 16, n. 34), cat. no. 36.05; for aristocratic circles, see the Moravian example discussed in Jiří Kroupa, *Alchymie Štěstí 1770–1810: Pozdní osvicenství a moravská společnost* (with German summary), Kroměříž and Brno, 1986.

8. See for the paraphrase and the quotation Wangermann, 'Maria Theresa', (Ch. 16, n. 5), pp. 302–3.

9. See in general for the subject of drawing instruction for broader circles Wolfgang Kemp, '...einen wahrhaft bildenden Zeichenunterricht überall einzuführen' – Zeichnen und Zeichenunterricht der Laien 1500-1870: Ein Handbuch*, Frankfurt am Main, 1979; Melton, *Absolutism and the Eighteenth-Century Origins of Compulsory Schooling* (Ch. 16, n. 37).

10. For the origins of the collection in Coburg, see the comments by Joachim Kruse in *From a Mighty Fortress: Prints, Drawings and Books in the Age of Luther, 1483–1546*, exhibition catalogue, Detroit and Ottawa, 1983, pp. 20–24; in *Old Master Drawings from the Albertina*, exhibition catalogue, New York and Washington, 1984–5, pp. 13–20, Walter Koschatzky provides an outline of the history of the collection of Albrecht of Sachsen-Teschen; Carl Theodore's collection is treated in *Zeichnungen aus der Sammlung des Kurfürsten Carl Theodor*, exhibition catalogue, Munich, 1983, and in *Von Mantegna bis Watteau: Zeichnungen aus der Sammlung des Kurfürsten Carl Theodor*, exhibition catalogue, Düsseldorf, 1988.

11. By Johann Christoph Knöffel, 1742–4, Heres, *Dresdener Kunstsammlungen*, pp. 99ff.; see this work for further information on the Dresden collections.

12. For Städel, see *Städels Sammlung im Städel*, exhibition catalogue, 2 vols., Frankfurt a.M., 1991. For Wallraf, see Rainer Budde, 'The Wallraf-Richartz Museum and its Collections', in *Three Centuries of German Painting and Drawing*, exhibition catalogue, Washington, 1985, p. vii; for Frauenholz, see Edith Luther, *Johann Heinrich Frauenholz*, Münster, 1988; Artaria, whose own collection is now in the Graphische Sammlung Albertina, Vienna and Mechel, who as we shall see was also involved with the Viennese collections, deserve more study.

13. Information on these collections, and references to them, are provided in *Drawings from the Holy Roman Empire* (Intro. n. 4), pp. 14–16, p. 29, nn. 73–4.

14. See Heres, *Dresdener Kunstsammlungen*, p. 157 (Ch. 14, n. 42).

15. See Lhotsky, 'Geschichte der Sammlungen', (Ch. 2, n. 27), 2, pp. 413–66.

16. The architecture of this building (for which see also Peter H. Feist *et al.*, *Geschichte der deutschen Kunst 1760–1848*, Leipzig, 1986, p. 61, fig. 15) again seems to suggest it was dictated by its purpose to provide enlightenment, but its actual connections may be more double-edged, in that the affiliation with Britain may also be related to the fact that the British were also paying for Hessian mercenaries to fight in America and elsewhere and this was one source of Hessian wealth that paid for constructions and collections.

17. Jiří Kroupa, 'Poznámky k Sonnenfelsové koncepci umění', in *Umelecko-historický Sborník* (with German summary), 1985, pp. 195–209, is one of the few essays to tackle this sort of issue; see also *Central European Drawings* (Intro. n. 4), p. 11.

18. A good general social history of literature in the eighteenth century is Helmut Kiesell and Paul Münch, *Gesellschaft und Literatur im 18. Jahrhundert*, Munich, 1977; see also Reinhard Wittmann, *Geschichte des Deutschen Buchhandels*, 1992 (I am grateful to Robert Darnton for these references).

19. For the Habsburgs, see Lhotsky, 'Geschichte der Sammlungen' (Ch. 2, n. 27), 1, pp. 191ff., 357, 399ff., and my 'From the Kunstkammer to the Kunsthistorisches Museum'; for Dresden, see Heres, *Dresdener Kunstsammlungen* (Ch. 14, n. 42), pp. 159–60, 122 for Dresden. For a dissenting view, see Meijers, *Kunst als Natuur* (Ch. 13, n. 44).

20. See for example Reinhard Kosseleck, *Kritik und Krise*, Freiburg and Munich, 1959, or Peter Gay, *The Enlightenment*, 2 vols., New York, 1967, 1969.

21. See Wilhelm Waetzoldt, *Deutsche Kunsthistoriker 1, Von Sandrart bis Rumohr*, Berlin, 1986 (3rd edn.), for some of these; also Schlosser-Magnino, *La Letteratura artistica*, pp. 656ff., 676ff. Ulrich Schütte, *Ordnung und Verzierung: Untersuchung zur deutschsprächigen Architekturtheorie des 18. Jh.*, Braunschweig and Wiesbaden, 1986, provides the best introduction to this body of literature. Other aspects of the extensive literature on the visual arts in Central Europe in the late seventeenth and early eighteenth centuries are outlined and introduced in my 'Before Winckelmann: towards the Origins of the Historiography of Art', forthcoming.

22. See Gerald Heres, 'Winckelmanns Beschreibung der Dresdener Gemäldegalerie', in *Johann Joachim Winckelmann: Neue Forschungen*, Stendal, 1990, pp. 93–7, and in general for the subject, *idem*, *Winckelmann in Sachsen*, Berlin and Leipzig, 1990.

23. Johann Joachim Winckelmann, *Gedanken über die Nachahmung der griechische Werke in der Malerei und Bildhauerkunst*, ed. Ludwig Uhlig, Stuttgart, 1969, p. 38. Winckelmann's historiography and his criticism have been surveyed in English in a series of essays by Alex Potts, from whom a book on the subject has now appeared: *Flesh and the Ideal: Winckelmann and the Origins of Art History*, New Haven and London, 1994. The assessment of Winckelmann's contribution to historiography has however been problematized in my 'Before Winckelmann' (n. 21), which represents the first expression of ongoing research on the topic. Winckelmann's reception by later writers and relation to contemporaries are discussed in the essays in Thomas W. Gaehtgens, ed., *Johann Joachim Winckelmann 1717–1768*, Hamburg, 1986, a good first lead into the subject.

24. Friedrich August Krubsacius, *Gedanken von dem Ursprunge, Wachstums und Verfalls der Verzierungen in den schönen Kunsten*, Leipzig, 1759. See E. H. Gombrich, *The Sense of Order: A Study in the Psychology of Decorative Art*, Oxford and Ithaca, N.Y., 1979, p. 26, whence this quotation is taken.

25. As quoted in Harries, *Bavarian Rococo Church* (Ch. 15, n. 6), p. 196.

26. Wangermann, *Austrian Achievement* (Ch. 12, n. 24), p. 130.

27. See Günther Heinz, 'Die figürlichen Künste zur Zeit Josephs II.', in *Österreich zur Zeit Josephs II* (Ch. 16, n. 39), pp. 181ff.

28. Quoted in part in Hempel, *Baroque Art and Architecture in Central Europe* (Intro. n. 31), p. 296.

29. Garas, *Maulbertsch* (Ch. 17, n. 14), pp. 97, 249.

30. As quoted in translation in Hempel, *Baroque Art and Architecture* (Intro. n. 31), p. 296.

31. See especially Pavel Preiss, 'Alegorie vychovy mládeže v díle F. A. Maulbertsche', *Umění* 26, 1978, pp. 348–64. Möseneder, *Maulbertsch* (Ch. 17, n. 14) handles themes of Maulbertsch's relation to the 'Catholic *Aufklärung*', in a manner different from that here.

32. See Wangermann, 'Maria Theresa' (Ch. 16, n. 5), p. 287, for this description and the comparison with the imperial councillor Van Swieten's *Seasons*, set to music by Haydn.

33. See J. A. Friesen, 'Franz Anton Maulbertsch und sein "Bild der Duldung"', *Mitteilungen der Österreichischen Galerie*, 17, 1973, pp. 15–55.

34. Gay, *The Enlightenment: An Interpretation. Volume II: The Science of Freedom* (n. 20), p. 218.

35. As noted by Gay, *ibid.* (n. 34), p. 218; the painting is reproduced in Michael Levey, *Rococo to Revolution: Major Trends in Eighteenth-Century Painting*, New York and Washington, 1966, p. 155, fig. 97.

36. I owe this information on the reception of Baumgarten to an unpublished lecture by Hans Reiss, 'Baumgarten and the Rise of Aesthetics', delivered at Princeton University in April 1992; I am now engaged in research on the origins of Baumgarten's own thought. For Baumgarten and his predecessors, and succeeding thinkers, see e.g. Alfred Baeumler, *Das Irrationalitätsproblem in der Ästhetik und Logik des 18. Jahrhunderts*, Darmstadt, 1974, and Ursula Franke, *Kunst als Erkenntnis*, Wiesbaden, 1974 (rev. edn.).

37. See Wangermann, 'Maria Theresa' (Ch. 16, n. 5), p. 301. Given the nature of the present book, it would seem superfluous to point to the extensive literature on Lessing and the other well-known figures mentioned here.

38. See Johann Georg Hamann, *Sokratische Denkwürdigkeiten: Aesthetica in nuce*, with a foreword by Sven-Aage Jorgensen, Stuttgart, 1979, p.76.

39. An accessible introduction to these issues is offered by Isaiah Berlin, 'The Counter-Enlightenment' and 'Hume and the Sources of German Anti-Rationalism', in *Against the Current: Essays in the History of Ideas*, Harmondsworth, 1982, pp. 1–25, 162–87. See however the fine new work by John H. Zammito, *The Genesis of Kant's Critique of Judgment*, Chicago and London, 1992, pp. 35ff.

40. For Mesmer, see Robert Darnton, *Mesmerism and the End of the Enlightenment in France*, Cambridge, Mass., and London, 1968. Maria Pötzl-Maliková, *Franz Xaver Messerschmidt*, Vienna and Munich, 1982, provides information on Messerschmidt and these movements, as well as illustrations of his works.

41. See Ernst Kris, 'A Psychotic Sculptor of the Eighteenth Century', in his *Psychoanalytic Explorations in Art*, New York, 1971 (1st edn. 1952), pp. 128–50.

42. See *Maler und Dichter der Idylle: Salomon Gessner 1730–1788*, exhibition catalogue, Wolfenbüttel, 1982 (2nd printing).

43. For which see Willi Raeber, *Caspar Wolf 1735–1783: Sein Leben und sein Werk*, Zürich and Munich, 1979.

44. See in general Zammito, *Genesis of Kant's Critique* (n. 39), pp. 36ff.

45. See Herder, Goethe, Frisi, Möser, *Von deutscher Art und Kunst*, ed. Hans Dietrich Irmscher, Stuttgart, 1977 (1st edn. Hamburg 1773). I have deliberately treated this idea separately from that of the Gothic in Anhalt, as I believe they come from different impulses. Among other things Franz Leopold of Anhalt seems to have little conception of the Gothic as something particularly German in his choice of it as a style.

46. I am evoking the well-known book by E. Butler, *The Tyranny of Greece over Germany*, Oxford, 1935.

47. This is a major thesis of Zammito, *Genesis of Kant's Critique* (n. 39).

48. Ernst Cassirer, *The Philosophy of the Enlightenment*, trans. Fritz C. A. Koelln and James G. Pettegrove, Princeton, 1951 (orig. edn. Tübingen, 1932). Cassirer's excellent study must still stand for English-readers as a basic introduction to the themes of the subject.

Notes to the Conclusion

1. The best available historical account in English of the end of the empire is Gagliardo, *Reich and Nation* (Intro. n. 19).

2. Gagliardo, *Germany under the Old Regime* (Ch. 10, n. 1), pp. 363–4, has put it: 'The generous but not uncritical receptivity to the contributions of other peoples in all areas of human endeavour which so many Germans saw as uniquely characteristic of their race was also inseparable from the variegated nature of the national community in which they lived.'

3. See Gagliardo, *Reich and Nation* (Intro. n. 19), pp. 290–92, from which these quotations are taken. Gagliardo not only offers a full account of the issues involved in the dissolution of the empire but attempts to evaluate the values for which it stood, or helped to realise.

In a recently published essay Jörg Jochen Berns, 'Zur Frühgeschichte des deutschen Musenhofes oder Duodezabsolutismus als Kulturelle Chance', in Berns and Detlef Ignasiak, eds., *Frühneuzeitliche Hofkultur in Hessen und Thüringen* (*Jenaer Studien* 1), Erlangen and Jena, 1993, pp. 10–43, has also argued for the positive effect on the development of political freedom, culture and learning of *Kleinstaaterei*, what Samuel von Pufendorf described as the 'monstrous' nature of the empire. Berns has also stressed the importance of multi-confessionality and internationalism for the shaping of a multicultural dimension in German courtly society.

4. See R.J.W. Evans, 'Culture and Anarchy in the Empire, 1540–1680' (Ch. 11, n. 16), pp. 29-30.

INDEX

INDEX TO COURT, CLOISTER & CITY

The index does not refer to the endnotes.

Until well after the Renaissance people often used patronymics, nicknames or place names rather than surnames in the modern sense. In such cases they are listed by first name, except where they are usually known by a different name. Rulers of states are listed by first name rather than the name of the state, except where the reference is not to a personal name. Buildings and other features in towns are listed under their own name if this is distinctive, otherwise under the name of the town. Districts and streets in towns are listed under the town name. Accents are ignored in alphabetical order. Page numbers in italics refer to illustrations.

PICTURE CREDITS

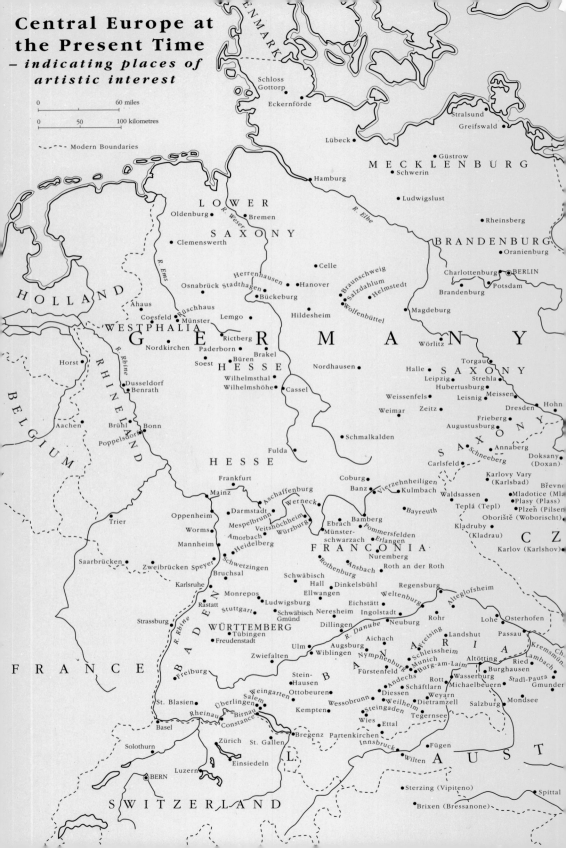

Central Europe at the Present Time
– *indicating places of artistic interest*

0 ——————— 60 miles
0 —— 50 —— 100 kilometres
– – – — Modern Boundaries

DENMARK

Schloss Gottorp
Eckernförde
Stralsund
Greifswald
Lübeck

MECKLENBURG
Güstrow
Schwerin
Hamburg
Ludwigslust
Rheinsberg

LOWER
Oldenburg Bremen
R. Weser
SAXONY
Clemenswerth
Celle
Herrenhausen
Osnabrück Stadthagen Hanover
Braunschweig
Salzdahlum
Helmstedt
Bückeburg
Hildesheim
Magdeburg

BRANDENBURG
Oranienburg
Charlottenburg ● BERLIN
Brandenburg Potsdam

R. Elbe

HOLLAND
Ahaus
Coesfeld Rüschhaus
Münster
Lemgo
WESTPHALIA G E R M A N Y
Rictberg
Nordkirchen Paderborn Brakel
Soest Büren
Wilhelmsthal
Wilhelmshöhe Cassel
Wörlitz
Nordhausen
Torgau
Halle SAXONY
Leipzig Strehla
Hubertusburg
Weissenfels Leisnig Meissen
Weimar Zeitz
Dresden Hohn
Frieberg
Augustusburg S
Annaberg
Schneeberg A
Carlsfeld X Doksany
(Doxan)
O Karlovy Vary
(Karlsbad)
Břevno
N Mladotice (Mla
Y Plasy (Plass)
Teplá (Tepl) Plzeň (Pilsen
Oboriště (Woborischt)
Kladruby (Kladrau)
C Z
Karlov (Karlshov)

R. Ems

Horst
RHINELAND
R. Rhine
Dusseldorf Benrath
Aachen Brühl Bonn
Poppelsdorf
BELGIUM
Trier

HESSE
Fulda
Schmalkalden

Frankfurt
Mainz Aschaffenburg
Oppenheim Darmstadt Werneck
Worms Mespelbrunn Veitshöchheim
Amorbach Würzburg
Mannheim Heidelberg
Saarbrücken
Zweibrücken Speyer Schwetzingen
Bruchsal
Karlsruhe Monrepos
Rastatt Ludwigsburg
Strassburg Stuttgart
BADEN WÜRTTEMBERG
Tübingen
Freudenstadt
Freiburg

Coburg Banz
Vierzehnheiligen
Kulmbach
Waldsassen
Bayreuth
Ebrach Bamberg
Münster- Pommersfelden
schwarzach Erlangen
FRANCONIA Nuremberg
Rothenburg Ansbach Roth an der Roth
Schwäbisch
Hall Dinkelsbühl
Ellwangen Regensburg
Weltenburg
Eichstätt Neresheim
Schwäbisch Ingolstadt Abensberg
Gmünd Dillingen Neuburg Rohr
Alteglofsheim
Lohe
Osterhofen

FRANCE
St. Blasien
Überlingen Salem
Rheinau Birnau
Basel Constance
Solothurn
Zürich St. Gallen
Luzern Einsiedeln
BERN

SWITZERLAND

Ulm Aichach
Augsburg Schleissheim Passau
Zwiefalten Wiblingen B Munich Kremsmün
A Burg-am-Laim Lambach
Nymphenburg Ried
Stein- Fürstenfeld Altötting Stadl-Paura
Hausen Ottobeuren Andechs Rott Michaelbeuern
Wessobrunn Schäftlarn Weyarn Burghausen
Kempten Diessen Dietramzell Wasserburg
Steingaden Weilheim Salzburg Gmunden
Wies Tegernsee Mondsee
Ettal
Bregenz Partenkirchen
Innsbruck A U S T
Fügen
Wilten

Sterzing (Vipiteno) Spittal
Brixen (Bressanone)

R. Danube
R. Rhine
Freising
Landshut
Neuburg